Romanesque Art

Romanesque Art

Meyer Schapiro

GEORGE BRAZILLER / New York

Published in the United States in 1977 by George Braziller, Inc.

Library of Congress Cataloging in Publication Data

Schapiro, Meyer, 1904–
 Romanesque art.

 (His Selected papers)
 Includes index.
 CONTENTS: The aesthetic attitude in Romanesque art.—The Romanesque
sculpture of Moissac.—The sculptures of Souillac.—On geometrical schematism
in Romanesque art. [etc.]
 1. Sculpture, Romanesque—Addresses, essays, lectures. 2. Art, Romanesque—
Addresses, essays, lectures. I. Title. II. Series.
NB175.S28 709′.02′1 76–11842

ISBN 0–8076–0853–x
Printed in the United States of America
First Printing
DESIGNED BY RONALD FARBER

ACKNOWLEDGMENTS

The author and the publisher wish to extend their sincere thanks to all those listed below who graciously granted their permission for the reproduction of the material contained in this volume of *Selected Papers:*

Art and Thought: Issued in Honor of Dr. Ananda K. Coomaraswamy on the Occasion of His 70th Birthday, K. Bharatha Iyer, Ed., 1947, "On the Aesthetic Attitude in Romanesque Art," pp. 130–150. Reprinted by permission of the publishers, Luzac and Company Ltd., London.

The Art Bulletin, Vol. XXI, 1939, "From Mozarabic to Romanesque in Silos," pp. 312–374. Reprinted by permission of the College Art Association of America.

Medieval Studies in Memory of A. Kingsley Porter, Volume II, W. R. W. Koehler, Ed., Cambridge, Massachusetts: Harvard University Press, copyright © 1939, 1967 by the President and Fellows of Harvard College, "The Sculptures of Souillac," pp. 359–387. Reprinted by permission of the publishers.

The Art Bulletin, Vol. XIII, no. 3, September 1931, part I (1), pp. 248–351; and Vol. XIII, no. 4, December 1931, part I (2), pp. 464–531: "The Romanesque Sculpture of Moissac." Reprinted by permission of the College Art Association of America.

Kritische Berichte zur Kunstgeschichtlichen Literatur, "Ueber den Schematismus in der romanischen Kunst," ("On Geometrical Schematism in Romanesque Art"), Jahrgang, 1932–33, pp. 1–21. Reprinted in German by Georg Olms Verlag, Hildesheim, 1972.

Studies in Western Art: Acts of the Twentieth International Congress of the History of Art, Vol. I, Romanesque and Gothic Art, Millard Meiss et al., Eds. (copyright © 1963 by Princeton University Press): Meyer Schapiro, "A Relief in Rodez and the Beginnings of Romanesque Sculpture in Southern France," pp. 40–66. Reprinted by permission of Princeton University Press.

Studies in Art and Literature for Belle Da Costa Greene, Dorothy Miner, Ed. (copyright © 1954 Walters Art Gallery), published by Princeton University Press: Meyer Schapiro, "Two Romanesque Drawings in Auxerre and Some Iconographic Problems," pp. 331–349. Reprinted by permission of Princeton University Press.

The Art Bulletin, Vol. XVII, 1935, "New Documents on St. Gilles," pp. 414–431; Vol. XIX, 1937, "Further Documents on St. Gilles," pp. 111–112. Reprinted by permission of the College Art Association of America.

Contents

Prefatory Note

I HAVE selected from my published articles on Romanesque art those which I believe still have some interest for students of that art. I'm aware of many imperfections, inconsistencies, and unclear formulations in those papers, but to correct them would require more rewriting than I can undertake now. I have tried to improve the language of certain of the writings, most of all the work on the cloister and portal of Moissac, without changing the observations and ideas. Except in a few places, it has not been possible for me to add references to more recent literature. Where I have inserted such references and new comments, they are enclosed in brackets.

In preparing this volume I owed much to my wife, Lillian Milgram (M.D.). The index is her work. I thank also the staff of George Braziller, Inc., for their helpful suggestions and care in planning and editing the book.

On the
Aesthetic Attitude
in Romanesque
Art

(1947)

CRITICS of modern culture, for a hundred years already, have contrasted the place of art in our own society with its role in the Middle Ages. In the latter, they suppose, it was an essential part of social life, while today art is a "mere ornament," without utility or high spiritual ends. This judgment of the inorganic character of modern art rests on a narrow, simplified conception of the nature of art and of how art functions today. Lacking sympathy for modern art, these critics can hardly be expected to serve as guides to its qualities and aims. One could easily show that contemporary art, though unreligious—and precisely because unreligious—is bound up with modern experiences and ideals no less actively than the old art with the life of its time. This does not mean that if you admire modern works, you must also accept modern social institutions as good—much of the best art of our day is, on the contrary, strongly critical of contemporary life; in the same way, admiration of mediaeval art does not require that we accept feudalism as an ideal human order or the legends and dogmas represented in the church sculptures as true beliefs. What concerns us here, however, is not the defense of modern art, but rather the inquiry into the common view that mediaeval art was strictly religious and symbolical, submitted to collective aims, and wholly free from the aestheticism and individualism of our age. I shall try to show that by the eleventh and twelfth centuries there had emerged in western Europe within church art a new sphere of artistic creation without religious content and imbued with values of spontaneity, individual fantasy, delight in color and movement, and the expression of feeling that anticipate modern art. This new art, on the margins of the religious

work, was accompanied by a conscious taste of the spectators for the beauty of workmanship, materials, and artistic devices, apart from the religious meanings. That such attitudes and qualities existed in the Latin and vernacular poetry of that time is well known; the aestheticism of troubador poems does not have to be pointed out. But the parallel aims of the contemporary sculptors and painters are less familiar to students of the Middle Ages.

It is true, of course, that mediaeval art was closely connected with religion, and we must reject the idea that Christian art was simply secular art in the service of the church. That may hold of most religious art today, but in the Middle Ages it was in the projects of the church, and in the attempt to solve artistic problems arising from religious aims and viewpoints, that mediaeval artists created certain of their most original and imposing forms. Yet it must be said that within so highly organized an institution as mediaeval Christianity, it is often hard to distinguish between religious and secular aims. The church was not simply a religious organ, outside material affairs. It claimed a temporal power and was subject to all the solicitations of social and economic development and the changing forms of community life. As a great landholder possessing, it has been estimated, almost one-third of the landed property in France, the church exercised feudal authority over vassals and serfs, and its bishops carried arms, made war, and engaged openly in the political struggles of the time. Like the kings and nobles of the same feudal world, the high dignitaries of the church assumed a corresponding style of life, whatever their spiritual duties within the system of feudal relations.

On a lower social level, too, material conditions affected the established religious forms, either by provoking reactions against the power and corruptness of the clergy or by promoting new religious ideals more in accord with the needs of secular life. The urban development, the social relationships arising from the new strength of the merchants and artisans as a class, suggested new themes and outlooks to religious thought and thereby helped to transform religious art, even while the framework of Christianity remained broadly the same. Originating within these lower strata, the artists and often the lower clergy were more open to the secular currents of their time.

But the relationship of religion and art is independent of the question whether the artists themselves were laymen or monks. The style of Louis XV, in the wonderfully refined and elegant rococo objects of that manner, whether buildings, furniture, textiles, porcelain, or sculpture and painting, instantly conveys to us the quintessence of the aristocratic spirit of that moment; yet much of this was created by artisans who lived another life than their patrons and had other ideals. At least, it was not their own thoughts and outlook that they wished to express, but the

thoughts and outlook of the dominant group which could scarcely produce such works. In a similar way, the creation of mediaeval art did not require deeply religious artists, but rather artists who had been formed within a stable religious milieu, and whose craft had been developed in tasks set by the church. They grasped intuitively its requirements of expression and were selected accordingly by the bishops and abbots. Giotto, the author of a great cycle of Franciscan paintings in Florence, indeed the artist often admired (perhaps mistakenly) as the one who made the final and perfect statement of the Franciscan content, was critical of Franciscan ideals and the life of the order; the single literary work of his that has come down is an attack on the commitment to poverty. Hegel said very justly that in an age of piety one does not have to be religious in order to create a truly religious work of art, whereas today the most deeply pious artist is incapable of producing it. This discrepancy between the personal religious aim and the present condition of art was expressed in another way by Van Gogh, a man of passionate Christian insight, when he wrote that one could not paint the old religious subjects in an Impressionist style.

The widespread idea that mediaeval art was the work of monks or of profoundly religious lay artisans inspired by a humble attitude of selfless craftsmanship and service to the Church rests on the assumption that this art is through and through religious and that the people of the Middle Ages esteemed art only as it was useful, devotional, and directly imbued with spiritual conceptions in accord with the traditional teachings of the church. The monuments and the writings, especially of the twelfth and thirteenth centuries, tell us otherwise.

In the buildings there is an enormous quantity of elements which, from a religious-didactic and structural viewpoint, are entirely useless. It would be unnecessary to labor this point, which is evident enough from the profusion of ornament in mediaeval churches. But the vicissitudes of taste and theory of art have blinded many students to the significance of all that decoration. Two centuries ago mediaeval architecture, and especially the Gothic, was judged to be inartistic because of the extraordinary caprice and irrationality of its forms, the multiplied details that could not be justified by any practical norm. A hundred years later, this view was converted into its opposite: Gothic was held up as the paragon of a completely functional art. In the opinion of the Catholic convert, Pugin, and the free-thinking rationalist architect, Viollet-le-Duc, every element in the stone fabric of the Gothic cathedral, even the ribs, shafts, moldings, pinnacles, gargoyles, crockets, etc., was structurally necessary. Gothic architecture thus became the model of a functional style and the notion that the greatest, most deeply stirring architecture created in the western world was of this kind helped to stimulate the growth of a modern secular style

closely allied to engineering, and of which two of the basic tenets were, remarkably enough, the elimination of all ornament and the abandonment of stone as a building material. Even the Catholic Church has been sympathetic to this new mode; a recent writer, a canon of the Church, has recommended the new architecture of reinforced concrete as most in accord with the teachings of Thomas Aquinas and as the only possible style for the Church today.[1]

Modern scientific study of construction has refuted that conception of Gothic. The inspired technological interpretation of Viollet-le-Duc now appears to be mechanically incorrect. The Gothic church does not form, as he supposed, an ideal system of equilibrium, in which the thrusts of self-adjusting vaults are transmitted by the ribs to the flying arches and thence to the outer buttresses which are poised through the weight of the pinnacles. The building is an aesthetic creation and certain parts once declared to be constructive are now seen to be expressive and ornamental.[2]

But even if his theory were acceptable for the core of the structure, there would remain in the mediaeval buildings much that could not be derived from constructive or religious intentions. A simple example is the variety of capitals in the Romanesque arcade. This is no "organic" variety, for the members can obviously be interchanged without affecting the stability or general appearance of the building. These varied members of a common series have identical functions. In a Greek temple, they would be undistinguishable, like the Doric columns or capitals of the Parthenon. But the Romanesque artist thought it better to individualize the parts, regardless of their functional identity. In certain works this variation seems to be occasioned by a didactic aim; the capitals are sculptured with different incidents from the life of Christ or the saints or the figures of the Old Testament. But only a small fraction of capitals are historiated, and such variety occurs still earlier in foliate and animal capitals and in regions, like Normandy and Belgium, where religious themes are rarely applied to these members.

The fact, moreover, that the variation often appears on bases and on the pillars themselves, and even on the barely visible modillions under the high cornices, shows how deeply rooted is this tendency of the artists which goes beyond the requirements of a fixed religious program of didactic or symbolic imagery.

It might be asked whether we do not exaggerate the aesthetic significance of such variation; perhaps it is simply a by-product of a piecemeal method of work, each mason or sculptor having particular capitals to carve in his own way, unconcerned with the total effect and unhampered by the paper designs of an architect regulating all the details in advance. Even then it would be significant to us as a fruitful instance of liberty of

individual conception such as we meet only rarely in the corresponding members in classical buildings; and we would ask in turn whether this is not also the training ground of the audacious authors of the great Romanesque tympana who were so original and personal in their designs. I shall cite, however, one text, among many, which conveys the enthusiasm of contemporaries for this kind of variation, their awareness of it as an aesthetic accomplishment pervading the whole of a work. It is a passage from a chronicle of the abbots of St. Trond, near Liège, and concerns the abbot Wiricus in 1169.

"So much care did the industrious architect devote to the decoration of the monastery that every one in our land agrees that it surpasses the most magnificent palaces by its varied workmanship (*operosa varietate*). Tastefully and artfully he inserted distinct alternating courses of white and black stone and beautified the entire structure of the chapel in an extraordinary manner on the interior and exterior by an original revêtment of black and speckled columns with finely polished bases and sculptured capitals of a wonderful variety. By the beauty of the work he gave immortality to the author of the enterprise."[3]

This variety occurs equally in an art that is no work of hired artisans, but a domestic product of the most pious groups, the illumination of religious manuscripts. Besides the miniatures which illustrate a religious text and in which we discern a connection with doctrine and rite, there are innumerable initials of a fantastic nature, elaborations which smother or lose the initial form in entanglements with a complex play of human figures, beasts, and vegetation, often aggressive and brutal and suggesting a masochistic preoccupation of the author. It is characteristic of this engrossing art that the ornament of the initial, proliferating freely, not only oversteps the boundaries of the letter, but also has in most cases no apparent connection with the meaning of the text. Here, as in the capitals in the buildings, the same element, an initial letter, assumes a different form and a different decorative filling, highly spontaneous, in each recurrent example.

Was this thought perhaps inspired by an underlying Christian conception of human individuality, expressed through the uniqueness of the forms of members in a common group?

It is an attractive idea, though difficult to test. But we are forced to reject or at least to qualify it because such individualization is rare or undeveloped in Christian architecture before the Romanesque period and is more marked in the Romanesque than in the Gothic style; it precedes by two centuries the scholastic ideas about form as a principle of individuation in living creatures. In the interiors of churches of the thirteenth century there is a greater uniformity of parts, an approach to the Renaissance, at the expense of that exuberant fantasy which delights us in

from worship and an un-Christian indulgence and extravagance. "They attract the worshipper's gaze and hinder his attention. . . . They are admired more than holiness is venerated. . . . The funds for the needy are consumed for the pleasure of the eyes of the rich. The curious find things to amuse them, but the poor find no relief."

Bernard is aware also of the sacred and didactic aspect of the imagery of the church, but with cunning rhetoric he observes it overtly only in the pavements where holy figures are trodden under foot. "Often they spit on the face of an angel, often the passers-by step on the faces of saints. If you do not spare these sacred images, why not at least spare the precious colors? Why beautify what must soon be fouled? Why decorate what will have to be stepped on? Of what good are these beautiful forms in places where they are continually spoiled by dirt?"

A surprising solicitude for the arts in a monk who, in his own words, has abandoned all the beauties and delights of the senses for the sake of Christ and regards them as dung.

Yet, recalling the monstrous sculptures of the cloisters, we are impressed by the fact that although Bernard condemns these works as meaningless and wasteful, he has written so vivid an inventory of their subjects and characterized them with such precision; every theme he mentions may be found in surviving Romanesque churches and cloisters. The saint has perused these capitals no less attentively than have the monks whom he reproaches for meditating the sculptures instead of the Bible or the Fathers. Only a mind deeply drawn to such things could recall them so fully; and only a mind with some affinity to their forms could apply to these carvings the paradoxical phrase: "that marvellous deformed beauty, that beautiful deformity (*mira quaedam deformis formositas ac formosa deformitas*)," which resembles in its chiasmic, antithetic pattern a typical design of Romanesque art.[9] The concept of a beautiful deformity reminds one of the unclassical aesthetics of the nineteenth century, of Baudelaire and Rodin; but this juggling phrase should not be interpreted in a modern sense or even as an attempt of Bernard to define a Romanesque aesthetic. More likely, it is a justification of Bernard's hostility to these works as belonging to an inferior order of the beautiful and reproduces a thought of his beloved Augustine that "there is a beauty of form in all creatures, but in comparison with the beauty of man, the beauty of the ape is called deformity."[10] This reminiscence of the early father accounts, perhaps, for the inception of Bernard's list of the cloister sculptures with "the unclean apes."

No doubt Bernard was intensely fascinated by these useless and spiritually dangerous works. Ordinarily he turned his eyes away from the distractions of art and could not remember the simplest details of his surroundings. His biographer records some examples of that remarkable indifference. "He had spent a whole year in a novice's cell without know-

ing, when he left, whether the house had a vaulted ceiling. He had often frequented the church, going in and out, and yet he supposed that there was but one window in the chevet, which really had three. Having mortified his sense of curiosity, he had no perceptions of this kind; or, if by chance he happened to see something, his memory, occupied with other things, did not advert to it. . . ."[11]

He remembered, however, with a surprising fullness, the details of cloister decoration. We may interpret this psychologically by supposing that Bernard responded with excitement to images of living creatures as kindred to his own feelings, but was cold to the lifeless geometrical forms of windows and vaults. This would agree with his hostility to the dialectic of Abelard and to all systematic theologizing of faith. He is a man of passion rather than reason who transposes an enormous energy of desire into love of Christ and his virgin mother. When he attacks the art of the cloisters, he is reacting against the concupiscence of his own eyes and the irrationality of his own impulses. Bernard's writings are rich in figures of movement and life; he appeals constantly to metaphors of sensory delight for religious expression: "Jesus is honey on my lips, melody in my ears, jubilation in my heart."[12] He loves striking contrasts, violent and astounding oppositions, the monstrous-grotesque, the antithetic and inverted. Thinking of his double life as monk and statesman of Christendom, he called himself: "the chimera of my age."[13] The great heretic, Arnold of Brescia, he characterized with the fantasy of a Romanesque *imagier*: "head of a dove, tail of a scorpion."[14] And when he had to speak of his own religious order, he imagined the Cistercians as acrobats and jongleurs of the spirit who provide a most beautiful spectacle to the angels, although they incur the contempt of the proud and worldly. "All that they [*i.e.*, the worldly] desire, we, on the contrary flee, and that which they flee, we desire, like those jugglers and dancers, who, with head down and feet up, in an inhuman fashion, stand or walk on their hands and attract the eyes of everyone."[15]

This is an authentic image from Romanesque art. How often on the portals of southern and western France are there carved just such figures juxtaposed to holy personages—acrobats and dancers among fantastic beasts! They occur in liturgical manuscripts too, in tropers and breviaries, and in other religious books.[16] The elders of the Apocalypse who appear beside them with their viols or zithers acquire from this proximity a profane connotation; we are led to wonder if they too have not been chosen because of their appeal as virtuosi of music.

The sculptures that Bernard denounced so fervently, unrolling their vanity and monstrousness, are a considerable field of Romanesque art. What he rejects is no particular work or school, but a widespread, essential tendency manifest in thousands of examples that still survive. At one time, scholars thought to win these sculptures for the unity of religious

art by discerning a hidden theological or moral symbolism in their grotesque, profane types. Bernard's letter discredits such an approach, although in certain works the context allows us to suppose that they were conceived in a symbolic mode. But is it right to call the others "purely decorative" because they have no religious sense? Are the religious and the ornamental the only alternatives of artistic purpose? Apart from the elements of folklore and popular belief in some of these fantastic types, they are a world of projected emotions, psychologically significant images of force, play, aggressiveness, anxiety, self-torment and fear, embodied in the powerful forms of instinct-driven creatures, twisted, struggling, entangled, confronted, and superposed. Unlike the religious symbols, they are submitted to no fixed teaching or body of doctrine. We cannot imagine that they were commissioned by an abbot or bishop as part of a didactic program. They invite no systematic intellectual apprehension, but are grasped as individual, often irrational fantasies, as single thoughts and sensations. These grotesques and animal combats stand midway between ancient and modern art in their individualized, yet marginal character, as feudalism occupies a place between ancient and modern society. The Romanesque initial or capital does not exist fully in itself, like a modern work; it belongs to a larger whole of the building or the book. But neither is it rigidly subservient in meaning or form to the whole of which it is a part, like old Asiatic and Greek ornament. The initial is often unframed or breaks through its frame and encroaches on the adjacent parts. Itself a part, it has a special, pronounced physiognomic and completeness, its own axis and expression.

Very little that is comparable to this aspect of Romanesque art exists in the Byzantine Church. A letter like Bernard's is inconceivable in the East. And the fact of this difference illuminates the western peculiarity and development. Imagery has a different status in the two Christianities: in Byzantium, created for worship, whether defined as veneration or homage; in the West, since the Libri Carolini, officially restricted to decoration and instruction, whatever the popular or clerical trends toward an image-cult. Hence the church imagery in the East can hardly admit types which are so secular in spirit; the image as such is already an object of cult and is therefore submitted more stringently to tradition and dogma than in the West, where the image is in principle equally an object of decoration. But the positive content acquired by the "decorative" in the West cannot be deduced directly from religious problems and needs. The everyday profane world has its say here, and its evolution in the course of the Middle Ages toward an urban secular spirit and individuality penetrates the monasteries and churches, which are parts, and often most active ones, of this great development.

* * *

If Bernard's letter is a negative testimony of Romanesque aesthetic, there is also a body of contemporary statements which express the positive reactions to art in this time. We should not expect, of course, an aesthetic literature like our own in the twelfth century; art had not yet become a central sphere of culture or way of life through which men as lay personalities might freely shape their ideals and intuitions of things. The statement of individual response to art and the reflection on its aesthetic were still unproblematic, incidental, and summary. But we encounter in scattered passages in chronicles, biographies, letters, and sermons—sometimes pieces of considerable length—expressions of admiration and even of aesthetic insight that surprise us by their resemblance to the more developed critical awareness of later periods when art criticism and the theory and history of art have emerged as distinct fields. The random texts of this kind have never been excerpted and collected as a group; these reactions to art in the Middle Ages have still to be investigated with the same care as the documents of the feeling for nature. I can cite only a few of the passages that I have come upon by chance or have found in the collections of texts made for other purposes, like Mortet's *Recueil* for the history of mediaeval architecture in France. Contrary to the general belief that in the Middle Ages the work of art was considered mainly as a vehicle of religious teaching or as a piece of craftsmanship serving a useful end, and that beauty of form and color was no object of contemplation in itself, these texts abound in aesthetic judgments and in statements about the qualities and structure of the work. They speak of the fascination of the image, its marvellous likeness to physical reality, and the artist's wonderful skill, often in complete abstraction from the content of the object of art. There is, no doubt, a strong current of aestheticism in the culture of the twelfth century, flowing through different fields, the plastic arts no less than the Latin and vernacular poetry. It affects the forms of religious life in ritual, costume, and music, as well as church building and decoration. The moralists and chroniclers of this period, especially in England and France, have much to say about the elaborateness of dress and the new self-consciousness concerning the aesthetics of the clothed body.

A text of that time offers a remarkable evidence of this sensibility to forms and colors as values in themselves. It is the account written toward 1175 by Reginald, a monk of Durham, of the translation of the remains of St. Cuthbert into the new cathedral in the year 1104, and was evidently based on the testimony of an eye-witness.[17] The body of the saint was wrapped in decorated textiles which evoked the highest enthusiasm of the writer. To the description of these ancient objects belonging to another age and culture than his own he devotes a discerning, warm, and personal appreciation beyond the necessities of the religious record. He admires the ornament, the animal images, the color, and the workman-

ship, even the texture of the materials, for their own sake, without inquiring into their possible symbolism; they are splendid artistically and therefore worth this extended notice.

". . . He was clad in tunic and dalmatic, in the manner of Christian bishops. The style of both of these, with their precious purple color and varied weave, is most beautiful and admirable. The dalmatic, which as the outer robe is the more visible, offers a reddish purple tone, quite unknown in our time even to connoisseurs. It still retains the bloom of its original freshness and beauty throughout, and when handled it makes a kind of crackling sound because of the solidity and compactness of the fine, skilful weaving. The most subtle figures of flowers and little beasts, very minute in both workmanship and design, are interwoven in this fabric. For decorative beauty its appearance is varied by contrasted sprinklings of rather uncertain color that proves to be yellow. The charm of this variation comes out most beautifully in the purple cloth, and fresh contrasts are produced by the play of scattered spots. The random infusion of yellow color seems to have been laid down drop by drop; by virtue of this yellow the reddish tonality in the purple is made to shine with more vigor and brilliance. . . .

"Above the dalmatic the holy body is covered with other precious silks of an unfamiliar style. Over these was placed a sheet about nine cubits long and three and a half in width, in which the whole collection of sacred relics had been most reverently wrapped. On one side were long fringes of linen thread the length of a finger; for the sheet itself was undoubtedly linen. But all round the edges of this rectangular sheet the weaver had ingeniously worked a border an inch in breadth. On this material may be seen a most subtle relief standing out in considerable elevation from the linen warp and bearing the forms of birds and beasts, inserted somehow into the border. Yet between every two pairs of birds and beasts there emerges a certain definite pattern, like some leafy tree, which here and there separates these motifs and isolates them distinctly. The figure of the tree is finely drawn and appears to bud forth its leaves, however tiny, on both sides. Under them, in the bounding adjacent row, arise again figures of animals woven in relief; and both patterns stand out in high relief in the same way up to the very edges of the robe throughout the entire border."

What a surprise to come upon these observations on the nuancing and mutual effect of colors in a writing of the twelfth century! And this desire for exactness in describing the structure of a decorative pattern! It makes us think of the preeminence of the English literature on ornament at the end of the nineteenth century. The same Reginald has still other acute remarks on the objects of art in Cuthbert's tomb. I cite only one which is interesting as a rare instance of an empirical aesthetic statement about proportions.

Of an ivory comb of great antiquity he observes that its size is "finely proportioned to the breadth, for the length is almost equal to the breadth, except that for artistic effect the one differs a little from the other"[18]—a judgment of the deliberate and necessary deviation from a perfect square that is often made by modern painters and designers.

What is so remarkable in these texts is not the admiration for the beautiful objects—this is often a primitive taste for the rare and costly, the golden and jeweled—but the keen observation of the work itself, the effort to read the forms and colors and to weigh their effects.

Parallel to this objective attitude are statements about the observer himself as a responding sensibility. They do not inform us about the deeper content of fantasy or feeling provoked by the contemplation of art, but they convey the spectator's excitement and fascination as an experience of its own kind, sometimes so intense as to recall descriptions of religious ecstasy.

There is such a document in the history of the bishops of Le Mans in an extended account of the constructions of the bishop William in his episcopal manor toward 1158. He built himself a private chamber, finely illuminated by windows of which "the workmanship surpassed the quality of the materials; their execution and the arrangement of the room were a proof of the artist's ingenuity which they reflected in a beautiful and subtle way. Next to this room and continuous with it he constructed a chapel; and if this chapel was beautifully resplendent as a work of architecture, the pictures painted on its walls, conforming expressly, with an admirable skill, to the appearances of living creatures, held enrapt not only the eyes of the spectators, but also their minds, and so attracted their attention that in their delight with the images they forgot their own business; those for whom tasks were waiting, were so entranced by the paintings that they seemed almost idlers. On a third site, beside the chapel, he built a chamber of which the entire composition (and especially the windows) was so beautiful that it seemed to have been designed by a more skillful artist than the other two constructions; or one might suppose that the same artist had surpassed himself in this new work. Moreover, below, on the sites of houses that he had purchased, the bishop set out a garden with exotic fruit trees; they were also beautiful to the eye, so that men looking out from the windows of the building and others standing in the garden might delight in the mutual aspect, those in the building enjoying the beauty of the trees, those in the garden, the view of the beauty of the windows."[19]

This text is one of the most precious we have. It combines in a single description so many sides of the experience of art in that time: the appreciation of the architect and his craft, the love of light and of fine fenestration, the response to painting as a rapture that takes the beholder away

from his normal cares; finally, the deliberate planning of views in build-ings and gardens for the eye's delight. All these are common interests in the twelfth century and can be documented by other texts. There is the famous account of his new church of St. Denis by Suger, in which the abbot proudly tells how the enchantment of the beautiful building, with its incomparable treasure of precious stones, disposes him to a high mood of spiritual contemplation.[20] But more often the experience of the deco-ration of the church is described as a pure ecstasy without religious con-tent or consequence. An English writer, William of Malmesbury, employs as a formula of artistic power this rapture of the eyes and heart. "In the multicolored paintings an admirable art ravished the heart by the allur-ing splendor of the colors and drew all eyes to the ceilings by the charm of its beauty."[21] That is how he conveys the effect of the pictures in Lanfranc's new cathedral of Canterbury; the language reminds us of a great modern critic, Fromentin, on a painting by Rubens: "Elle charme l'esprit, parce qu'elle ravit les yeux; pour un peintre, la peinture est sans prix." But in the same passage, William, speaking of the other half of the ornaments of the cathedral, the cloths and sacred vestments, knows only the skill of the craftsmen, "surpassing the preciousness of the materials" —a distinction which anticipates the future divergence of the status of artisanship and fine art.

But whether paintings or jewels or textiles, they call out alike the same admiration for their surface qualities. In these statements of the twelfth century we are struck by the intense enthusiasm for color, light, lustrousness, and rich contrast, an enthusiasm incredible today, since the old buildings have lost, for the most part, the objects that evoked this sen-timent. The great treasures of gold and silver vessels, often jeweled, the glowing windows and the deeply colored textiles that hung from the walls, have disappeared; for us the art of that time emerges chiefly in the naked stone and its carvings. When William of Malmesbury describes the church of Rochester, the stone pillars and walls fall away; we see only a blaze of colored lights. The bishop Ernulf, he says, rebuilt the church "with such splendor that nothing like it could be seen in England for the luminosity of the glass windows, the glistening marble pavement, the multicolored pictures."[22] In similar terms, another monk of Malmesbury, in a poem on the abbot Faricius of Abingdon, praises the radiance of his new building:

> He transferred to the inside all the church's splendor;
> The pomp of beauty glistens throughout the golden ceilings;
> Metallic shell, gemmed fabric, inspiring wonder.[23]

Without these texts, we could scarcely conceive the original quality of the buildings and the dazzling spectacle that the church offered to the

eyes of the people. The aesthetic appeal of the precious substances of high reflecting power or translucence is something elementary and instantaneous and, for the naive beholder, independent of spiritualistic notions on the affinities of light and the divine nature. The secular rulers of the Middle Ages, whether in the West or in Byzantium, in the Christian world or the Moslem, never failed to exploit this attractive power of gold and jewels in order to overwhelm the rustic and provincial or the foreign envoys. The church aspired to be a model of the divine palace, the heavenly Jerusalem, which mediaeval poets saw as an architecture of gold and jewels.[24]

There were other visions of the church beside this one of jewels and light. Certain minds, disposed to hidden meanings and symbolism, interpreted every part of the building in a mystical or allegorical sense. But the greater mass of statements about new churches by chroniclers, travelers, and hagiographers is free from such interpretation. Instead, they dwell on the beautiful construction, the preciousness of the materials, the decorative carvings, the wonderful lifelikeness and variety of the images. The same terms: *pulcherrimum, subtilissimum, splendidum, mirum, mirificum, decus*, recur throughout this literature in the mention of buildings. There is, however, also a perception of form by writers of a more modern sensibility to architecture, who feel the space and proportions and the beauty of the masonry. The author of the Pilgrim's Guide to Santiago concludes his detailed account of the interior structure of the church of Compostela with these words: "In this church you will find no crack or defect. It is marvellously wrought. Large, spacious, clear, suitable in size, well-proportioned in breadth, length and height, it is considered a wonderful and ineffable work, which is even built in two storeys, like a royal palace. Whoever walks through the upper galleries, if sad when he ascended, becomes happy and joyful at the sight of the exceeding beauty of the temple."[25]

The effect of architectural beauty upon feeling, its refreshment of the eye and the spirit, is more commonly noted in descriptions of refectories, chapter-houses, and the private chambers of bishops and abbots, that is, in buildings not destined for worship. I mentioned before an example in the manorial buildings of the bishop of Le Mans. There is another in the history of the abbots of St. Trond which was quoted earlier in this article. "The abbot built a very beautiful room where the provost of the church enjoyed himself in the company of his friends and where he reckoned the budget for the brothers of the monastery. Above it, the abbot laid the foundations for a higher building where he himself was to dwell and to rest; and putting his whole mind to the job, he gave distinction to this house by its wonderfully fine workmanship. For he constructed in it large and airy windows that provided a long vista to anyone standing in the

house, and offered to the beholder's eyes a full view of almost half the city. And this building, which was completely and marvellously perfected by the architect's ingenious art, he enhanced further with a fireplace and a system of water supply flowing through the middle of the chamber."[26] The combination of advanced equipment, comfort, beauty, and the delights of air and outdoor perspectives is scarely monastic in spirit; it pertains to secular architecture in the modern sense and entails a new aesthetic viewpoint.

A century later, the author of the history of the abbots of Auxerre justified this extravagance by its contribution to human well-being. "Since the joyous beauty of buildings sustains and refreshes the bodies of men and delights and comforts the heart, the abbot John built in the monastery for himself and his successors a most beautiful hall with galleries above the court. From it one can see the entrances of the abbey and almost all its buildings and enjoy the loveliness of the atmosphere."[27]

Writers of the twelfth century condemned such constructions as an un-Christian luxury and display. Hugo of Fouilloi singled out in his criticism the bedroom of a bishop with paintings of pagan themes, the Homeric tales and classic myths.[28] The perfection of these buildings was not for the glory of God, nor was it required by the functions of the church. The chronicler of St. Bertin, writing toward 1180, makes this unequivocally clear; of a new refectory in his abbey he says: "It is like a mirror and an ornament, yet considering its great cost, it is more beautiful than useful."[29]

* * *

Nothing in our culture has seemed to its critics so evident a sign of decadence as the taste of artists for works of different times and places and the miscellaneous collecting of objects of many styles. Both have been contrasted with the closed character of mediaeval taste, which was free from exoticism. Yet there is in western art from the seventh to the thirteenth century an immense receptivity matched in few cultures before that time or even later; early Christian, Byzantine, Sassanian, Coptic, Syrian, Roman, Moslem, Celtic, and pagan Germanic forms were borrowed then, often without regard to their context and meaning. A great part of research has been occupied with this process of incorporation of foreign motifs in mediaeval art; it is too well known to require an extensive list of examples. But I shall cite two striking signs of the prevalent curiosity about non-Christian arts. One is the taste for classical gems, of which many have been preserved in mediaeval church treasures and on reliquaries and the covers of liturgical manuscripts. The abbot or craftsman who inserted an antique engraved jewel in a sacred object rarely asked what the carving meant; it was enough that the stone was precious,

that it sparkled wonderfully with luminous color and was cut in a mysterious way on an incredibly minute scale to represent with exactness the form of a beautiful human being, whatever its pagan significance. If the figure suggested a Christian type, so much the better; but this was an exceptional, fortunate chance.[30]

The second evidence is the frequent practice of western artists—in stone, wood, enamel, and paint—to reproduce bits of Arabic writing as an ornament on the borders of their own works, without consulting the possibly un-Christian sense of these inscriptions. They were excerpted from Moslem objects, mainly textiles and ivories, on which the Cufic letters form either an inscribed text, often with invocations of Allah, or a stylized, repeated pattern of the *lam* and *alif* of the holy name. Such pseudo-Cufic writing occurs on the impost of a capital in the cloister of Moissac, on a wooden door of a church in Le Puy, and in the Beatus manuscript from St. Sever.

Not only small details, but complete objects of Saracenic origin were adopted for Christian works at a time when the two peoples were bitter enemies. In the *Liber Miraculorum Sanctae Fidis* it is told that the local count, Raymond II of Rouergue (961–1010), presented to the monks of Ste. Foy in Conques a Saracen saddle which was admired as a work of incomparable fineness. According to the contemporary author, no native goldsmith could equal it in skill and knowledge; it was incorporated in its totality (*salva integritate*) in a silver cross for the church,[31] like the ancient engraved gems of which I have spoken.

The same admiration for the Moslem's art obtained among the Byzantines, who also reproduced as ornament the forms of Cufic writing. The booty brought from conquered Crete to the imperial capital in the tenth century, the textiles and precious objects displayed in triumph, were praised as marvels of the highest art by the Greek chronicler.[32]

This is a common sentiment among the mediaevals in face with the workmanship of neighboring and distant peoples. Reading such texts, we are less astounded by Dürer's admiration for the primitive American objects that he saw in Antwerp in 1520.[33] The treasures of the great churches were once immensely rich in accumulations of exotic handicraft, like the cabinets of modern collectors.

The literature of the twelfth century also abounds in passages concerning the beauty and artistic superiority of the older native arts, of styles which had long before been replaced. The text of Reginald of Durham concerning the vestments of Saint Cuthbert is an example. Equally interesting is his appreciation of the wooden coffin of the saint, a work that modern students believe to be of the end of the seventh century; it is decorated with incised forms of a style much less cultivated than the art of Reginald's time. Seeing its surface of black oak, he speculates whether

this blackness is due to age or to artifice or is the natural color of the wood. But concerning the quality of the carvings he has no doubts; they are of a minute and subtle workmanship that fills him with amazement and that he can hardly credit to the knowledge or skill of the artist.[34]

In his readiness to admire the ancient objects, there is surely an element of religious feeling. Everything that belongs to the venerated relics —the wrappings, the coffin, the metal objects—is touched with the virtue of the saint, which manifests itself in these material things in their beauty of substance, their artifice and patterns. We detect also an antiquarian piety, an absorbing interest in the fact of antiquity itself, which is shown in the repeated observations on the evidences of time, the changes effected by the passage of the centuries. On the ivory comb he remarks that "its natural appearance of white bone is changed by its great age into a reddish tint."[35] But the inclination to exalt the secondary human works that have enclosed or accompanied the sacred body remains an example of the aesthetic viewpoint we are considering, for it is applied to ornament, artistic skill, and imagination. The author of the description of the coffin ignores the content of the images; he does not even record the incised Latin names; the forms and surfaces impress him more than the meaning of the religious figures which are still visible in the wood today.

A similar attitude appears in judgments of old architecture, even of the pagans. Remains of classical antiquity were standing throughout western Europe in greater number than today, and Christians of the twelfth century could hardly be indifferent to them. By their strange unused presence they invited fantastic interpretation, taking their place in the web of folklore and magical belief, or they evoked the curiosity and admiration of artists who saw in these works the hand of the craftsman and the force of a powerful will. The same William of Malmesbury described "the wonderful constructions of the Romans" in the ruined walls of York, and he remembered in Carlisle "a triclinium vaulted in stone, which had never been shaken by any storm." Of the finely preserved buildings at Hexham, he wrote that there was nothing comparable on this side of the Alps; "those coming from Rome, who see Hexham, swear that they see the walls of Rome."[36]

The small objects of Roman art excavated from time to time called out a similar emotion. The chronicle of St. Peter's at Oudenburg, near Bruges, composed toward 1084, speaking of the fortifications of the abbey built of materials from different sites, including Roman remains from the region of Cologne, remarks on the ancient objects discovered in these classic sites: "Very beautiful and shapely vases, cups, dishes and other utensils, cleverly fashioned and sculptured by the ancients, have been found there recently; these could scarcely be formed and sculptured so elegantly today by clever artists in gold and silver."[37]

By this time, the sculptors were beginning to copy details of classic ornament and to observe the pagan statues as models for their own art. They were preceded by the writers who studied Ovid and Virgil as masters for imitation in poems of a profane content, and read the Roman theoreticians of prose and verse for rules of art.

This is not the place to consider the deeper reasons for the responsiveness to classic art. It is enough perhaps to say that if in the ninth century it was promoted by the political aims of the northern rulers who wished to assume the role of the Roman emperors, and if in later centuries the consciousness of Roman antiquity was intensified by the ambitions of empire, the conflicts between papacy and state, and by the strivings for a secular culture in the growing urban society, the interest in the ancient remains supported an aesthetic attitude. During the Romanesque period a distinction was already made between the worth of a pagan sculpture as a finely proportioned object with intrinsic aesthetic value, and its unacceptable religious sense. The French abbot, Guibert of Nogent (1053–1124), could write then in his autobiography: "We praise the rightness of proportion in an idol of any material, and although, where faith is concerned, an idol is called a thing of naught by the apostle (I Cor., viii, 4), nor could anything be imagined more profane, yet the true modeling of its members is not unreasonably commended."[38] A contemporary bishop, Hildebert of Le Mans, regretting the ruins of pagan Rome, expressed the same judgment with less reservation:

> What faces have these divinities! They are worshipped rather for
> Their makers' skill than for their godliness.[39]

Dante, in describing the region of the Proud in Purgatory (Canto X), conceives of the sinners and their punishment in an elaborate and beautiful artistic metaphor, in which the contrasts of mediaeval and classical styles and the various levels of reality in art and nature supply the terms. He beholds first a bank of pure white marble adorned with sculptures "which put to shame not only Polykleitos, but nature itself." These sculptures are of ideal figures of Humility, beginning with the Virgin Mary at the Annunciation; "the angel before us appeared so veraciously carved there in gentle mien that it seemed not an image which is dumb." Dante was aware, no doubt, of the ancient definition of sculpture as a mute poetry, but he plays here also on the theme of the speaking angel rendered in stone. This marvellous power of representation of reality is then discovered in a still more amazing form in the singing choir in a relief of King David humbly dancing before the Ark; this sculpture, addressed to both ear and eye, made the first say, "no," the other, "yes, they do sing." Dante comes then to the proud who, in contrast to the humble with their ideal forms and harmonious erect postures like beautiful classic statues,

are described as uncertain, bent, agonizing creatures, struggling to support great burdens of stone. They recall to him in their unhappy servitude the crouching corbel figures in mediaeval churches who carry a ceiling or roof, joining knees to breast in a posture which "though unreal begets real discomfort in him who sees it."[40]

This original expression of insight into opposed styles has its forerunners in the twelfth century, although none approaches the depth of Dante. Confronted by the surviving works of different lands and ages in literature and art and occupied constantly with tradition, good minds were bound to observe the varying styles and to reflect upon them. The chronicler speaks of a church as being in the Roman or the native mode. The novelty of style of building in the historically crucial moments of architectual invention was often remarked.

William of Malmesbury, discussing the works of Aldhelm who wrote in a precious, ornate style some four hundred years before, defends his admiration for his hero by reminding the importunate, but ignorant critics that "the styles of writing vary according to the customs of peoples. For the Greeks are wont to write in an involved way, the Romans with splendor, the English pompously. . . ." But Aldhelm knows how to unite all these: "if you read him thoroughly, you will think him a Greek for his acumen, you will swear he is a Roman for his brilliance, you will know he is English from his pomp."[41]

Through such comparisons and the experiences of taste in different lands, mediaeval writers came to recognize the relative aspect of aesthetic judgments, even if they admitted that the beautiful resides in properties of the admired object. The philosopher and physicist Witelo, who traveled much and was interested in the sciences of several peoples, Arabs, Greeks, and his European contemporaries, could not help remarking the variations of taste. His aesthetics, sometimes quoted as an evidence of the ideas and tastes of the Christian West in the thirteenth century, is for the most part a literal translation of an earlier writer, Alhazen. But after repeating the Arabic scholar's examples of particular beautiful objects and appearances (the heavenly bodies, almond-shaped eyes, the sphere and the cylinder, a green meadow, the textures of various cloths, the symmetry and variety of the human form, distant views), he adds that custom and personal inclination affect aesthetic judgment: Moors and Danes prefer other colorings and proportions of the human body and the German taste lies between theirs.[42] Yet, just as the West, divided into opposing philosophical camps, could appreciate the philosophies of Arabs, Jews, and ancient Greeks in which might be found solutions of problems actual to mediaeval European thought, so foreign artistic forms were judged and adopted with a considerable latitude.[43]

By the twelfth century historians were concerned enough with the dif-

ferences between various periods in their arts to specify them concretely through comparison of corresponding parts of works of the same type, much as a modern student of art. Gervase of Canterbury, in his unusually full account of the building of the new cathedral of Canterbury after 1175, not only reports the progress of the work step by step, the decisions and plans and method of construction, but he enters into a lengthy description of the previous buildings, the Saxon church which he knew only from old accounts and perhaps a drawn plan, the Romanesque church of Lanfranc and his successor which he had seen himself; the latter especially he compares with the new structure in plan, proportions, vaulting, and decoration in a manner which surprises us by its anticipation of the modern literature on mediaeval building.[44] He avows that such a verbal account, addressed to the mind, is less clear and less delectable than would be a direct experience of the forms. But he writes "in order that the difference between the new building and the old might be recognized," although the latter has been destroyed. And he describes the earlier choir of Conrad to preserve "the memory of so great a man and so splendid a work."

Gervase's account appeals to us most of all, however, because it is the first report of a mediaeval building in which the architect appears as a living power, a creative personality whose existence is fatefully bound up with his work. In the earlier narratives of building enterprise the abbot or bishop was the hero. The monks of Canterbury invite architects from England and France to submit their ideas for the repair of the church which has been ruined by fire. These architects disagree, and the monks despair of seeing the church reconstructed during their own lifetime by any human skill. They choose finally a foreigner, the Frenchman William of Sens. He has carefully examined the ruined building in the company of the monks, and with great astuteness, by his tact and long silence and by his cogent reasoning, he has won the monks to his plan. He is a man of extraordinary ability, energetic and ingenious, gifted as designer, organizer, and craftsman. He makes drawings or models for the stone cutters to follow; he prepares a program for successive stages of the building campaign; he moves about on the high scaffold supervising the great enterprise. And one day he falls and is grievously hurt. He tries to continue the supervision from his bed, directing the work through a young monk whom he has chosen for his industry and intelligence. But this is too difficult. The local doctors are unable to help him. He returns to France a sick man, and his role is given to another William.

From this early account of an architect at work one fact is important to retain for the understanding of the growth of an autonomous artistic taste: a foreigner was called to design the most important cathedral in England, the seat of the primate of the country. Sometimes artists were

full of such incongruities, accidental and designed, and can tolerate the
unfinished and the partial, points to a conception of the beautiful in art
fundamentally different from the ancient. Even that *"claritas"* which is
equated sometimes with radiance, sometimes with bright, sweet, or fresh
color, according to whether a metaphysical or empirical attitude presides
over the context, can be applied only with difficulty to the discrimination
of the beautiful in mediaeval color. All three criteria of Thomas come
ultimately from the classical definitions of the beauty of natural creatures,
above all, of man, and designate the perfection of a fixed type with a
definite structure and proportioning of limbs and a certain characteristic
coloring. Whenever we encounter such terms in mediaeval writing about
art, we suspect that the author has read the classical writings or their
Christian commentators. How shall we apply these criteria to Roman-
esque sculpture, so rich in distorted bodies, interlacings, and unnatural
proportions? Several canons of the human figure exist in this art, even
within the same work. And if the requirements of this classical-scholastic
theory of the beautiful are transformed into a more subtle view of the
internal coherence and expressive unity of an imaginative work, individ-
ual and independent of the canons of natural beauty, the criteria of
Thomas become still more difficult to apply, especially to an art like the
Romanesque in which there are often no fixed boundaries—I have in
mind the unframed, freely projecting imagery of the margins of build-
ings and manuscripts.

No, the aesthetic of Thomas is inadequate for characterizing or judg-
ing the beauty of mediaeval art; and his theory of art, on the other hand,
admirable as an account of what is involved in fabrication in general,
offers little to an understanding of the mediaeval work designed for aes-
thetic, expressive ends. He does not know or seem to know that there is a
making that aims at beauty and expression. From other parts of his writ-
ing—his account of being and becoming, of form and substance, of the
potential and actual, and his social ideas—one can derive perhaps some
concepts for the ideological interpretation of mediaeval forms as a mode
of seeing and composing inspired by a particular world view. But here
Thomas becomes a witness or document of his time rather than a direct
illumination. He himself nowhere hints at the connection of his meta-
physics and contemporary art.

His classic definition of the beautiful remains a valuable sign. It
points to or reflects the developing taste for nature and the curiosity
about its forms, which are apparent already in the Gothic images of his
time. But this recognition of the beautiful as an end or good in itself was
well established in the Middle Ages long before Thomas, and was formu-
lated more radically and more concretely by other writers with respect to
works of fine art. The difference between the practical and the aesthetic

in art is stated with a striking conciseness in the twelfth century by a German theologian and polemist, Gerhoh of Reichersberg (1093–1169): "If a column is moved, the whole building is threatened with ruin. If a picture is destroyed, the eye of the beholder is exceedingly offended."[48] The value of the constructive member is therefore in the static function, the value of the painting lies in the visual effect. This aesthetic conception of the painting as an object for the eye, contrary to the tradition of painting as mainly a vehicle of doctrine or Bible of the illiterate, had the powerful support of Augustine, who wrote in his commentary on the gospel of John some sentences which might serve as a slogan of the modern schools opposed to "literary" or symbolic painting. "When we see a beautiful script, it is not enough to praise the skill of the scribe for making the letters even and alike and beautiful; we must also read what he has signified to us through those letters. With pictures it is different. For when you have looked at a picture, you have seen it all and have praised it."[49]

NOTES

1. G. Arnaud d'Agnel, *L'art religieux moderne,* Grenoble, 1936, 2 volumes. See also *Review of Religion,* New York, May, 1939, pp. 468–473.

2. See Pol Abraham, *Viollet-le-Duc et le rationalisme médiéval,* Paris, 1934, and the discussion by various writers in the *Bulletin de l'office international des Instituts d'archéologie et d'histoire de l'art,* Paris, II, 1935. Several German writers, notably Gall and Frankl, had insisted before on the expressive and plastic aspect of the Gothic forms, although they accepted the older constructive interpretation of the developed ribs.

3. See Victor Mortet and Paul Deschamps, *Recueil de textes relatifs à l'histoire de l'architecture et la condition des architectes en France au moyen âge, XIIe–XIIIe siècles,* Paris, 1929, p. 12.

4. See Migne, *Patrologia latina,* CLXXXII, cols. 914–916, and V. Mortet, *Recueil de textes, XIe–XIIe siècles,* 1911, pp. 360–370 for the entire text. I borrow here, with a few changes, the translation of G. Coulton, *Life in the Middle Ages,* 3rd ed., New York, 1935, IV, pp. 174 ff.

5. They are reproduced by C. Oursel, *La miniature du XIIe siècle à l'abbaye de Cîteaux d'après les manuscrits de la bibliothèque de Dijon,* Dijon, 1926, plates XXII–XXIX.

6. See Mortet and Deschamps, *XIIe–XIIIe,* p. 38 (Cistercians), 265 (Carthusians), 247 (Dominicans), 236,286 (Franciscans). On curiosity as the lowest step of the ladder of pride, see Bernard, *De gradibus humilitatis et superbiae,* Migne, P. L., CLXXXII, col. 941 ff., where he treats curiosity at greater length than any of the other steps of pride. See also Bernard's *Liber de modo bene vivendi,* on curiosity as a dangerous presumption which provokes heresy and sacrilege.—In the same period, the Carthusian prior-general, Guigo, speaks of the aesthetic attitude as psychologically harmful: "those beauties and worldly (*forenses*) graces quickly enervate the man and render the masculine heart effeminate" (Mortet and Deschamps, p. 40).

7. Mortet and Deschamps, *op. cit.,* p. 214. See also pp. 36–38 for statutes ordering removal or destruction of particular works of art in other monasteries of the order.

8. See Martène and Durand, *Thesaurus novus anecdotorum,* Paris, 1717, V, col. 1584.

9. I have analyzed examples of this form in Moissac (*Art Bulletin,* XIII, 1931, pp. 473 ff.), Silos (*ibid.,* XXI, 1939, p. 347) and Souillac (*Medieval Studies in Memory of Arthur Kingsley Porter,* Cambridge, Mass., 1939, pp. 359 ff.) [reprinted below, pp. 56–57, 87n. 116, 106, 108, 114ff., 187, 207, 217, 250].

10. See his *De natura boni*, Migne, P.L., XLII, col. 555, cap. xiv. Augustine in other passages speaks of beauty in antithetic terms, e.g., in *De civitate Dei*, XI, 18, where God is an artist who employes antitheses of good and evil to form the beauty of the universe, and in *De ordine*, I, 2 (Migne, P.L., XXXII, col. 979), where beauty is a compound of opposites, including ugliness and disorder. On his aesthetic ideas, see K. Svoboda, *L'esthétique de Saint Augustin et ses sources*. Brno, 1933.

It is interesting that at the same moment as Bernard's letter, an English writer, William of Malmesbury, independently (I imagine) addresses Christ as an artist who is able to give form to our deformities: tu, Domine Jhesu, . . . bone artifex, multumque potens formare nostra deformia . . ." (*Gesta pontificum Anglorum*, V, 251, ed. N. E. Hamilton, London, 1870, p. 403).

11. Migne, P. L., CLXXV, col. 238; Mortet and Deschamps, *op. cit.*, pp. 23, 24.

12. *Sermo in Cantica*, XV, 6.

13. *Epistola*, 250: "clamat ad vos mea monstruosa vita, mea aerumnosa conscientia. Ego enim quaedam chimaera mei seculi, nec clericum gero, nec laicum." In an earlier letter he says of his great opponent Abelard: "sine regula monachus . . . nec ordinem tenet, nec tenetur ab ordine. Homo sibi dissimilis est, intus Herodes, foris Joannes; totus ambiguus . . ." (*Ep.* 193).

14. *Ep.* 196.

15. *Ep.* 87, 12.

16. For examples, see *Art Bulletin*, XXXI, 1939, pp. 339 ff. [see pp. 42 ff. below].

17. See *Reginaldi monachi Dunelmensis Libellus de admirandis beati Cuthberti virtutibus*, ed. James Raine: Surtees Society Publications, I, London, 1835, cap. xlii, pp. 87 ff. Also Charles Eyre, *The History of Saint Cuthbert*, 3rd ed., London, 1887, pp. 173 ff. It is possible that Reginald also had direct access to the tomb and saw the textiles himself.

18. *Op. cit., Reginaldi*, p. 89.

19. Mortet, *Recueil, XIe–XIIe siècles*, p. 166, for the Latin text.

20. *De Rebus in Administratione sua gestis*, XXXIII, now admirably translated and edited by Erwin Panofsky, *Abbot Suger*, Princeton, 1946, pp. 62 ff.

21. *Op. cit.*, I, 43, pp. 69, 70; a similar passage on Tewkesbury abbey, IV, 157, p. 295. (Cf. also the same writer's *Gesta Regum Anglorum*, II, 10, on Roman art.)

22. *Ibid.*, p. 138.

23. *Ibid.*, II, 88, p. 193.

24. For a fine example see the sequence for the feast of Mary Magdalene by the eleventh-century poet Hermannus Contractus, beginning "Exsurgat totus almiphonus" (Clemens Blume, "Sequentiae ineditae. Liturgische Prosen des Mittelalters," in *Analecta Hymnica Medii Aevi*, 9te Folge, vol. 44, 1904, p. 205); on the church building as a model of the heavenly Jerusalem, cf. also the prologue to book III of Theophilus Rogerus, *Schedula diversarum artium*—there is an English translation by G. Coulton, *op. cit.*, IV, pp. 194 ff.

25. Mortet, *Recueil, XIe–XIIe siècles*, pp. 400, 401, and now the edition with French translation by Jeanne Vielliard, *Le guide du Pèlerin de Saint-Jacques de Compostelle*, Mâcon, 1938, pp. 90 ff.

26. Mortet and Deschamps, *Recueil, XIIe–XIIIe siècles*, p. 14.

27. *Ibid.*, p. 76. See also Mortet, *XIe–XIIe siècles*, p. 95 for an earlier construction of a bishop's palace (c. 1116–1136) with a loggia and a beautiful view.

28. Mortet and Deschamps, *Recueil, XIIe–XIIIe siècles*, p. 92.

29. Mortet, *Recueil, XIe–XIIe siècles*, p. 122.

30. For examples of such preservation of classic carved gems in the Middle Ages and their Christian interpretation, see E. Babelon, *Guide illustré du Cabinet des médailles*, Paris, 1900, p. 61 (no. 2101), amethyst bust of Caracalla inscribed O PETROS in Greek in the Middle Ages, and preserved on the cover of an evangeliary in the Sainte-Chapelle in Paris; p. 85 (no. 1), sardonyx from Chartres; p. 96 (no. 42), sardonyx of Venus, nude, regarded as the Virgin Mary—from a mediaeval reliquary arm; p. 102 (no. 98), sardonyx, with Sacrifice to Priapus, from the Châsse of the Virgin's shirt in the cathedral of Chartres; p. 104 (no. 128), agate, with the goddess Roma, from the cover of an evangeliary in the church of St. Castor in Koblenz; etc.

31. *Liber Miraculorum S. Fidis*, 1, 12, ed., Bouillet, p. 42.

32. Leo Diaconus, *Historia, Migne, Patrologia graeca*, CXVII, col. 699.

33. "In all my life, I had never seen things that delighted my heart as much as these. For I saw among them wonderful artistic objects and I marvelled at the subtle ingenuity of the men in foreign lands. Yes, I can hardly say enough about the things that I had before me."—*Dürers Briefe, Tagebücher und Reime*, übersetzt von Moritz Thausing, Vienna, 1872, p. 90.

34. *Op. cit.*, p. 90; on the wooden coffin, see G. Baldwin Brown, *The Arts in Early England*, London, 1921, V, pp. 397 ff.

35. *Op. cit.*, p. 89.

36. *Gesta Pontificum*, III, 99, 117, pp. 208, 255.

37. Mortet, *Recueil, XIe–XIIe siècles*, p. 172. Cf. also in William of Malmesbury's *Gesta Regum*, II, 6, the description of an onyx vase, carved with highly realistic figures in a landscape; it was a gift of the German ruler Henry I to Athelstan (Migne, *Pat. Lat.*, CLXXIX, col. 1102).

38. Migne, *Pat. Lat.*, CLVI, col. 840 (I, 2); and the translation in the Broadway series: *The Autobiography of Guibert*, tr. by C. C. S. Bland, London, 1925, p. 9.

39. Migne, *Pat. Lat.*, CLXXI, col. 1409 (De Roma); the entire poem is quoted by William of Malmesbury, *Gesta Regum*, IV, 2.

40. I quote for the most part the translation by T. Okey, in the Temple Classics edition, pp. 118 ff.

41. *Gesta Pontificum*, V, 196, p. 344.

42. See Clemens Baeumker, *Witelo, ein Philosoph und Naturforscher des XIII*, Jahrhunderts, 1908, p. 175, for the Latin text, pp. 203, 204, 639, on its relation to Alhazen.

43. Cf. the corresponding appreciation of early Gothic art from France by the Mongol rulers of Central Asia, recently studied by Leonardo Olschki, *Guillaume Boucher, a French artist at the Court of the Khans*. Johns Hopkins University Press, Baltimore, 1946, pp. 26–28.

44. For the text, see Mortet, *Recueil, XIe–XIIe siècles*, pp. 206–228.

45. *Ibid.*, p. 164.

46. *Ibid.*, pp. 292–294.

47. Poem VI, 36, ed. Jeanroy. On the relationship of Romanesque art of Southern France and troubador poetry, see *Art Bulletin*, XXI, 1939, p. 347 [reprinted, p. 46 below].

48. Liber de aedificio Dei, Migne, *Pat. Lat.*, CXCIV, cols. 1242, 1243.

49. In Joannis evangelium tractatus XXIV, 2, Migne, *Pat. Lat.*, XXXV, col. 1593.

From Mozarabic to Romanesque in Silos

(1939)

I N SPAIN, unlike France, the Romanesque styles of architecture and imagery were formed in almost abrupt transition from the preceding native styles. Whereas in France it is difficult to demarcate, even roughly, a Romanesque from a pre-Romanesque art because of the slow and continuous growth of the forms since the tenth century, in Spain, outside of Catalonia, it is evident that a new art appears in the second third of the eleventh century, and that the traditional native style is soon replaced by it. The sudden emergence of Romanesque art in Spain has been explained by circumstances outside art: the activity of French Cluniac monks in Spain transformed the Spanish church and, together with the French alliances of the Spanish kings, made possible the introduction of the Romanesque style of France into León, Galicia, Aragon, and Castille. That these circumstances account for specifically French elements in the new Spanish art is undoubtedly true; but this statement reduces the change to a mere influence of a stronger on a less powerful church or state and tells us nothing about the effect of the native situation on the content and style of the art. It neglects in Spain, as it does in France, the mode of operation of such factors as religious organization and politics within the art itself. If a great mass of evidence confirms the connections between Spanish centers and the foreign sources of the new style, little has been said of the local conditions which made this new art appropriate and even necessary. Yet the documents exist which enable us to see the active side of this absorption of foreign art and the creation of a native Romanesque style. In the great monastery of Santo Domingo de Silos, especially, we can follow the emergence of the new style, because both Mozarabic and Romanesque styles were practiced

in the abbey at the same moment and their products have survived. We can observe here the interaction of the two arts and their influence on each other. And in the light of documents of the time, it is possible to see how new conditions in the church and the secular world led to new conceptions of the traditional themes or suggested entirely new subjects. In studying the art of Silos during this brief but crucial moment, I shall isolate a few works in which the relations of the two styles are most apparent. A more comprehensive study might lead us to change the conclusions; but it would have to follow the method employed here, the critical correlation of the forms and meanings in the images with historical conditions of the same period and region.

It is at the end of the eleventh century that we find two distinct and, in many ways, opposed styles in Silos. At this period the east and north galleries of the lower cloister were being sculptured[1] and the monks of Silos were producing the copy of the Commentary of Beatus on the Apocalypse now in the British Museum (Add. ms. 11695). The sculptures are works of Romanesque art, the manuscript is a typical, though belated, example of Mozarabic style. By 1100 the latter was already dying out, while great Romanesque buildings were rising everywhere in Christian Spain.

The practice of these two styles in the same monastery was not simply a matter of two stages of a development carried by overlapping generations. The Romanesque can hardly be considered a gradually evolved form of Mozarabic art. Nor is the coincidence due to a chance survival of random works from a time when one of these styles was predominant. The Beatus manuscript was a great enterprise of more than a hundred paintings, and the sculptures in question form one of the largest groups of monumental carving in Spanish Romanesque art. The creation of the manuscript was in fact a long activity spread over a period of at least twenty years. The writing, undertaken during the rule of the abbot Fortunius, was completed in 1091 and the painting, under one of his successors, in 1109. Several colophons attest the deliberate character of the project.[2] The names of no less than six individuals—monks and abbots— are cited in connection with the work.

The same opposition of styles appears again in Silos in a single monument. On the portal of the Virgins, a remnant of the Romanesque upper church constructed after the cloister in the first half of the twelfth century, the outer frame of the doorway facing the cloister is a molded and sculptured semicircular arch of common Romanesque type (Fig. 3); the inner doorway, however, is unmolded, undecorated, and horseshoe in form, like the Mozarabic arches of the tenth century (Fig. 2).[3]

Such a coincidence of styles is not unparalleled in mediaeval art. It appears especially in times of crucial historical change. Then new forms

may emerge beside an older art not simply as a development from it, but also as its very negation, and the old may persist beside the new in affirming an opposed or declining culture. During this period in England the old Anglo-Saxon manner and the new post-Conquest style exist side by side within single works.[4]

In Silos the opposition of Mozarabic and Romanesque is hardly so thorough as would appear from these larger contrasts. If the Beatus manuscript is Mozarabic in style several of the miniatures already betray the existence of Romanesque art. And, in the same way, we shall find in the Romanesque sculptures qualities and details that recall the local Mozarabic art.

But there is an evident difference between the persistence of qualities of Mozarabic style *within* Romanesque art, as a matter of historical continuity or transition, and the persistence of Mozarabic style as a whole *beside* Romanesque art, as an effort of conservation. It is these varying relations of Mozarabic and Romanesque which will be investigated, in their broader historical contexts, in this paper.

I

In the manuscript, the Romanesque qualities and details appear only in marginal or terminal miniatures, in every case unframed and without a painted background (Figs. 4 and 5), unlike the apocalyptic scenes[5] (Fig. 6). With one exception (Fig. 7), they are small isolated figures, usually an angel or a personage, loosely related to the adjoining text (Fig. 5). Their Romanesque character is more a tendency than a developed practice; they are still inert, distinct spots of intense color, with broadly outlined silhouettes and schematic, unmodeled, linear folds, like the Mozarabic figures in the same manuscript. It is mainly in the expansiveness of a drapery edge, in a slight vivacity of posture or incipient complexity of line that Romanesque art is suggested.[6] Their incidental marginal character in the illustration of the book corresponds to the limited and superficial role of the new Romanesque forms. The Mozarabic nucleus is only barely touched by the Romanesque elements.

There are two miniatures, however, in which the Romanesque character is more apparent. One is a painting of a musician and a knife-dancer, the latter grasping a bird which bites his face (Fig. 9); the second is an image of Hell placed before the Apocalyptic text (Fig. 7).[7]

Observe in this frontispiece painting the elongation of the angel Michael, his unstable, pirouetting posture, the flying draperies and energetically contrasted lines, and the complicated involvement of surfaces. A very similar Michael stands at the entrance to Hell in a fresco of the twelfth century in St. Loup-de-Naud (Fig. 8),[8] and corresponding forms may be cited in many French works of the same period.[9]

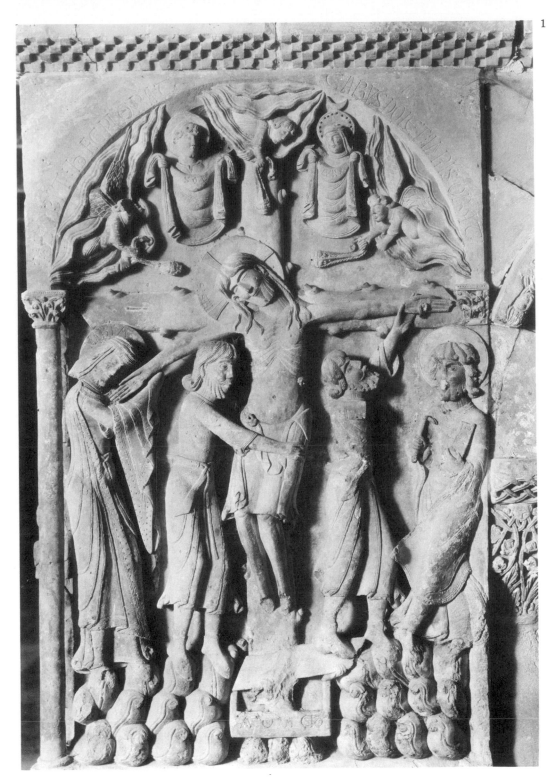

Fig. 1. Silos, Abbey of Santo Domingo, Cloister; Relief of Northeast Pier:
Descent from the Cross. *Harvard Fine Arts Library, A. K. Porter Collection*

2

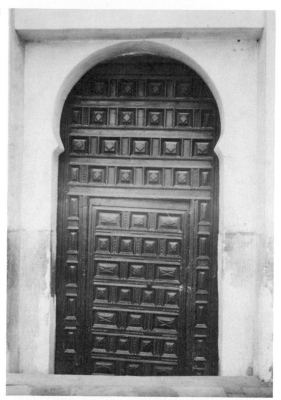

Fig. 2. Silos, Portal of the Virgins:
Inner Doorway before Restoration.
*Reproduced by permission of Walter
Muir Whitehill.*

Fig. 3. Silos, Portal of the Virgins:
Outer Doorway after Restoration.
*Reproduced by permission of Walter
Muir Whitehill.*

3

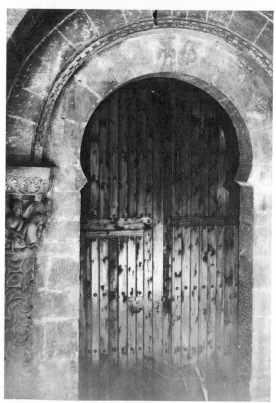

Fig. 4. London, British Museum:
St. John; Beatus Commentary on the
Apocalypse; Add. Ms. 11695, f. 163v.
*Reproduced by permission of the
British Library Board*

Fig. 5. London, British Museum:
A King; Add. Ms. 11695, f. 102.
*Reproduced by permission of the
British Library Board*

Fig. 6. London, British Museum:
Add. Ms. 11695, f. 105v.
*Reproduced by permission of the
British Library Board*

7

Fig. 7. London, British Museum:
Hell; Add. Ms. 11695, f. 2.
*Reproduced by permission of the
British Library Board*

If in Mozarabic art the figures in a common action are detached from each other and immobilized (Fig. 6), in Romanesque art the activity of a figure, in other respects increasingly naturalistic, often exceeds in its energy of response the natural organic adjustment to the surrounding objects. The movement seems disengaged from any external cause and is concentrated within the figure itself as an unstable, tense, and intricate play of crossed limbs and draperies.[10] And similarly, when an isolated Romanesque figure is immobilized and lengthened, as on the columnar sculptures of the portals, it is rigid rather than relaxed, as if subject to constraining forces.

This characteristic ambiguity of the posture of the angel, who is stationed yet unstable, active but self-constrained, is only one element in a larger play of unstable axes and opposed movements which pervades the entire conception of the Hell scene.

The quatrefoil shape of Hell would seem to entail a closed, strictly centralized scheme with an inner radial cross pattern, corresponding to the rectangular form of the page, as in the frequent cosmographic images in mediaeval art. But no two elements realize the implied accord. There is, indeed, a central figure—the symbol of Avarice—with four surrounding demons; it is not, however, the precise iconographic or formal center of the field. Not only is there a second competing vice, Unchastity, with which two of the demons are concerned, but the angel Michael outside the frame negates the centrality of the quatrefoil scheme. One of the demons, Barrabas, is occupied both with the archangel's scales and the unchaste pair, and in this double action crosses the frame. The four devils, far from repeating the static arrangement of the uniform lobes of their frame, show in their postures a gradation and progression of movements: Barrabas is completely turned away from the lovers whom he pricks with his rod, but faces Michael and manipulates the scales outside the field of Hell; Beelzebub assails Dives more directly, but his legs are turned vigorously away from the center of the field; in Radamas the ambivalence of posture is still present, but the inward movement begins to dominate; in Aqimos, the smallest of the demons, there is no weapon for action from a distance but an immediate contact, a direct grasping of the figure which he faces fully, with his hand and crab's claws issuing from his body. Here, significantly, the demon has only one leg and one arm, and is therefore the least capable of the double movement of the others.

This larger rotation of the field is maintained in the inscriptions. And even the small filler spots, the floating islands in a cartographic space, sustain the effect of a dynamic, accelerating whole not only in their plasmic, mobile forms, but in their progressively varied axes which seem to respond to the churning movement of the whole—a liquid field with swarming infusorial elements. The rotation, the lambent and liquid

shapes—even in the flamelike hair and feet of the demons—evoke in their purely dynamic aspect, abstracted from the content, the qualities of Hell described by mediaeval ascetics in their most gruesome visions which sometimes include, characteristically enough, the spectacle of a great wheel of torment, as well as alternations of fire and water.

It is this rotation that binds the excluded figure of Michael to the field of Hell. He is suspended horizontally at the top of the field and disoriented, as if the common ground-line were the vertical side of the page. The painting can therefore be seen in two ways—with respect to the position of Michael or the position of Dives in the center of Hell. If we turn the page in order to stabilize the archangel, then Dives is unstable. In either case one of the stable elements becomes detached from the imaginary ground-line of the other. But even the remaining stably oriented figure is formally unstable. We have already observed the pirouetting, unsupported posture of Michael. In Dives the conflict of directions assumes an even denser and more expressive form. Whereas the aristocratic Michael stands on a narrow pointed base of inwardly converging toes, Dives sits or squats with feet far apart and turned outward on a tensely expanded base.[11] In the very moment of contraction into a compact central mass his body is stretched out, pulled apart by his own effort; this centrifugal tendency of the limbs corresponds to the movement of the emptying moneybags. But at the same time he is attacked from without by four beasts—serpents and toads—which converge on his body in centripetal movements opposed to his own. The axes of the four beasts do not correspond, however, to the axes of the quatrefoil field, despite the evident relation of number. Whatever rigid objects appear in the painting —the weapons of the devils and Michael, the bed, the four finials—are all diagonal and unstable, all opposed to the axes of the quatrefoil frame.

Thus if the radial orientation with respect to the central Dives suggests Mozarabic, maplike or pavement composition and space, the movement of elements toward this center is everywhere countered by contrasting movements in a characteristic Romanesque manner. The devils turn back in tormenting their victims, and the pointed finials of the quatrefoil create as vigorous centrifugal directions.

Such diffused energy and complication of movement are foreign to Mozarabic art. Yet within this page we detect an evident Mozarabic substratum in the complex silhouettes which are formed of simple elements, short geometric lines composed independently of the organic character of the body. The involvement of the angel's limbs is not sustained throughout, but is lost in places under the more rigid surfaces of swathing drapery. The forms of the lovers in bed show a typically Mozarabic compactness.

We can judge better the distance between this page and Mozarabic art (which creates also qualities of movement and shares in its symbolism

and schematized imagery many of the mediaeval characteristics of Romanesque art), if we compare the representation of Hell with a Beatus page of corresponding radial design. In the painting of the Elders Adoring the Lamb (Fig. 37), there is not only a circular grouping of objects around the central lamb and a figure of Christ outside and above the circle, like Michael in the painting of Hell, but various elements of the vision, especially the symbols of the evangelists and the angels below, are designed to revolve clockwise, as in the first page. The immediate impression is very different, however; the motion appears less sustained, less energetic and free. In the Mozarabic image it is the fixed structure of the visionary world, with its hierarchy of assigned positions and magnitudes, that dominates the living forms, unlike the painting of Hell, where the action of the figures pervades the structure itself. The individual objects, compact and inflexible in contour, are usually built on single axes. With all the subtle divergent directions and asymmetries of color, the whole is tied finally to the cardinal points, and the symmetry of the stable majestic Christ arrests the movement below. The revolving elements are minor in scale, and in their repetition in single file are submitted statically to an enframing form and to the broader symmetrical structure of the great fields. If the heads of the four beasts change in direction, they are very small and incidental; their movement is perceived as something added to the major stable form. Their color, in fact, reduces the force of the deviation by minimizing the contrast of the heads with the lavender background: the heads of the bull and lion are pale blue, of the man, gray.[12] The latter is the only human head in the entire circle to be colored—undoubtedly to diminish its contrast with the background. The eagle alone has a yellow head, and this color relates it to the yellow spots of the books of the lamb and Christ (and of Christ's tunic) that define a shift from the central vertical axis. In contrast, between the wings of the four symbols are rigorously symmetrical cardinal disks of red-orange. The more powerful colors, the reds, greens, and oranges within the circle, are arranged in more regular and stable schemes than the yellows.

It is interesting to see how both the stabilizing and the mobile relationships of the page depend finally on the color. In the main circular field pairs or groups of similar objects are connected diagonally through their common hue and contribute to the rotating effect by the resulting alternation of their colors in a circular path; a shift of axis from the center is produced by a common color of objects along the deviating line; but the symmetry and centrality of the whole are reaffirmed by the strength of cardinally placed, intense spots of red, green, and orange. Even in the angels' wings below the great outer circle, the pronounced leftward turn depends as much on the color as on the direction of lines. The sharp diagonal of the figure and wing is divided into three

color units, so that the recurrent shift in color contrasts becomes the vehicle of the moving form. A minute analysis of the color of this page would give us a ready insight into the processes of Mozarabic design, but this is impossible here for technical reasons; extensive comparison with other works would be necessary to establish the principles of Mozarabic color composition. However, several important differences may be indicated here between this page and the color of the more Romanesque painting of Hell.

In the latter, the freer mobile outlines are joined to a new coloring, less intense in contrast of hues than the Mozarabic pages of the manuscript and relatively submerged in the play of lines. Unlike the opaque, band-and-spot coloring of the older style, which isolates each figure as a compact emblematic unit against its varied field, the color of the miniature of Hell is applied in thin, fluid, transparent washes on a blank ground. This ground should not be confused with the blank surface in the simpler Mozarabic paintings of the commentary of Jerome on Daniel (Fig. 11) at the end of the Beatus manuscripts. It is more richly broken by the filler elements and the densely juxtaposed, pulsating silhouettes of the moving figures. But the choice of colors is already a sufficient distinction from the Mozarabic works.

In the painting of Hell, a predominantly cool coloring, with purple, blue, and lavender that approach a tonal harmony in their low key and reduced intervals, replaces the older contrast of hues. This coloring is common to the demons and the angel; only in the smaller figures of the vices does bright yellow break through in contrast to the subdued tones.[13] The same coolness prevails in the minor polychrome fields; while in the Mozarabic pages the yellow of a figure or a background zone is often enlivened with many small touches, dots, or circles of red, here a green is imposed on yellow, a blue or green on purple. These additions in a local color are themselves the solid local colors of defined parts, unlike the evenly dispersed Mozarabic touches which are more impressionistic and ornamental and produce a fine vibration throughout.

But the polychromy of the Romanesque page is freer in another sense: a single piece of costume may be divided irregularly into different color areas; so the tunic of the rich man is blue and yellow, without accented boundaries or a distinction of substance in the robe—a common practice in the manuscripts of southern France in the same period.[14] The freedom in the coloring of the figure corresponds to the whimsical and seemingly accidental disposition of the color units.[15] In the Mozarabic pages, the colored areas, though surprisingly irregular, especially within the mosaic of a single figure, are sharply defined units in strong contrast to the background or the adjacent colors and are grouped together in regular bands, often parallel to the background zones or concentric with the divisions of

a circular field. Hence the effect of constantly varied, maximum oppositions in the color through the contrasts of hue (and, to a lesser extent, of value) and of pervasive likeness of the ornamentally repeated and stable shapes, which is so characteristic of Mozarabic art. In the Romanesque page, on the other hand, the maximum contrasts are of lines and areas, the contrast of hues being reduced; but in the play of the mobile, irregular areas on the white ground there appears a new tendency toward tonal harmony and light-dark contrast prophetic of later art.

Mozarabic painting is an art of color, even more essentially than the stained glass of the twelfth and thirteenth centuries in which the drawing has a competing energy and vivacity. In the earlier Beatus manuscripts color is felt as a universal force, active in every point in space and transcending objects; it appears in its greatest intensity and with an exemplary pureness in the empty spaces of the geometrized abstract environment and is most limited in the figures—coarse vessels containing the same radiant substance as the laterally unbounded zones. This coloristic unity of objects and surroundings is derived from the corresponding unity in late classic illusionistic painting. But what belonged to nature and phenomena in the ancient style has here been spiritualized to the last degree. The melting bands of delicate color, which in classic art rendered atmospherically the gradations of sky and ground, have been transformed into the brilliant, unearthly zones of an abstract cosmos; the articulated bodily forms have stiffened into an immobile mass and the plastic draperies into vestigial ornamental markings. In force of expression the passivity of the figures is the pole opposite the intensity of the color, although both the schematized shapes and the grouping of spots of color show common archaic characters. Like an accessory object, the human figure has no will or direction of its own, only a position in a group; what power it has comes mainly from its color—a mosaic of arbitrary hues, a localized, circumscribed bit of the unbounded color substance of the stratified zones. The connection of objects and ground is tense and full of subtle contrasts: the horizontal bands of the field are formed by a division of the whole surface from top to bottom, while the figures, with their varying colors, are juxtaposed from side to side (Fig. 16).

Unlike Byzantine painting, where the gold background is constant and differs in luminosity and substance from the earthly objects, in the Mozarabic works the horizontal bands vary from page to page with the affective values of the theme and derive from the naive assimilation of the visionary text their changing color schemes and spacing, in interaction with the qualities of the figures. Where themes of violence suggest diagonal movements, the horizontal bands are drastically traversed in all directions, but the page as a whole preserves the system of colored zones, the strong contrasts, the schematic drawing and the aggregated disposition of the parts

which underlies the archaic appearance of the calmer paintings. Each grouping, though adjusted to the constants of the field, has a unique order inherent in the spiritual moment represented. As the four angels holding the mandorla of Christ are arranged quadrilaterally, so in an Apocalyptic action the grouping seems to be an emblematic form. In the Beatus manuscripts the successive scenes appear as rearrangements of heraldic attributes; each incident is a new state of the world scheme, an historical manifestation of the divine order.

The relation of the human being to his surroundings in these Mozarabic images, with their peculiar spaces, colors, and forms so remote from a naturalistic art, presupposes a specific stage of the familiar Christian dualisms of God and man, spirit and matter. I cannot undertake to consider here the possible theological counterparts. But I think the conception is clearly distinguishable from those of the Romanesque period when secular interests acquire an independent value and begin to modify the extreme spiritualistic views of the early Middle Ages. Then the human figure, no longer a mere vessel of color but more individualized, flexible, and active within the persistently religious framework, becomes increasingly the vehicle of expression and acquires, for the first time in Christian art, a monumental relief form; the environment also is more concrete, and new qualities of movement, line, modeling, and tonal relations replace the older static forms and ungraded intensity of color in an abstractly stratified space.

If we consider now the content of the image of Hell, we shall find some peculiarly Romanesque conceptions which point more directly to the immediate sources of the attitudes underlying the change of style.

Avarice and Unchastity are brought together here as in Romanesque sculptures in southern France.[16] It is difficult to say whether this choice of the two vices originated in France or Spain; there are Spanish examples of Avarice and Unchastity as old as the first French representations.[17] But undoubtedly the idea is un-Mozarabic and foreign to earlier mediaeval iconography.[18] In the miniatures of the Psychomachia of the Spanish poet, Prudentius—of which, incidentally, we have no mediaeval illustrated manuscript of Spanish origin—the vices are conceived in a quite different way. Avarice and Unchastity are not singled out as a central or major pair; they are only two among a whole series of vices and are symbolized by female figures fighting with personifications of the militant virtues.[19] In the Silos manuscript the vices are pictured directly and concretely: Unchastity by a pair of lovers embracing in bed; Avarice by the rich man (Dives) with his moneybags, one suspended from his neck, the others in his hands.[20] Not the allegorized psychological inner struggle between vice and virtue is shown in this miniature, but the enacted vice and its physical punishment in the afterworld. Monstrous devils, serpents, and toadlike creatures

torment the miser, and a demon of unchastity with one leg and one arm, with prominent genitals and a crab's claws (for the missing limbs), attacks the lovers.

In its central position Avarice replaces the more feudal and theological vice of Pride as the *radix omnium malorum*.[21] The very linking of Avarice and Unchastity—like the manner of presenting them—expresses an elementary realism and betrays the growing strength of secular interests. These basic vices had always existed for the Christian world, but not until the Romanesque period did they become the main subjects of painted and sculptured moral homilies. In singling them out for a special criticism, the church attacked the twin sources of worldliness and secular independence. Sexual love was the chief theme of vernacular poetry, especially in southern France where the higher feudal nobility, more stable than in the North and enriched by its military conquests, by the expansion of agriculture and the reestablishment of commerce and town-life, promoted an aristocratic, libertine culture. Avarice was for the church, and even for this aristocracy,[22] the vice of the newly formed and growing burgher class, the money-lenders and merchants for whom money was itself a means of acquiring further wealth.[23] The accumulation of money wealth through an expanding production and trade cut at the roots of feudalism and indirectly of Catholic Christianity; it made it possible to substitute a cash payment for the personal services to the seigneur or protector and freed individuals from the local ties and the bonds of domestic production on which were founded certain religious and moral ideas of the early Middle Ages. In the miniature from Silos the miser is labeled Dives, just as on some Romanesque portals the parable of Lazarus and the rich man accompanies the image of Unchastity.[24] The sculptures of these vices on the outer walls of churches were not directed against the simony or libertine life of certain churchmen, which was so often assailed in the councils of the period.[25]

Unchastity and Avarice, more than any other vices, were identified at this time with aggressive classes; they implied new individual standards or goals that drew men away from the guidance of the church. Just as those who valued sensuality or economic enterprise were attached to immediate pleasures and gains, placing their real desires, their consciousness of individual rank and power, and their everyday interests above the supernaturally grounded teachings of the church, so the counterimaging of their vices and punishment in the Romanesque church art became increasingly realistic, but also more grotesque. As men came to know themselves and their own world more and more intimately, the monstrous images of Hell had to be as detailed and specific, as convincing in their concreteness, as the everyday scene. The systematic picture of the invisible region of Hell, far from being a mere aggregate of emblems of sinners and devils, acquired

the dynamic continuity and the explicit energies of situations of violence and torment in the familiar world.[26]

The embracing lovers in the miniature of Silos are in this respect more realistic than the typical Romanesque versions of Unchastity.[27] Usually a naked woman with serpents at her breasts, and sometimes with toads at her private parts, personifies the vice (Fig. 10). In Silos these animals are shown attacking Dives.[28] It may be that the Spanish artist has misunderstood a foreign model; perhaps, ignoring the specificities of vice and punishment, he has transferred the torments of Unchastity to the central figure of Avarice, in terms of the general, more primitive, Apocalyptic conception of loathsome beasts devouring the wicked.[29] On a Romanesque capital of the later eleventh century in Toulouse[30] there is just such an Avarice, with moneybags and four serpents. The toads, however, are lacking.[31]

The conception of the miser with the moneybag tied to his neck and the unchaste woman tormented by serpents is common to Romanesque and Moslem fantasy. Such images are found in Auvergne, Languedoc, Aquitaine, and northern Spain in the late eleventh and twelfth centuries;[32] they are unknown in Moslem art, but Arabic literary accounts of the afterlife describe these very torments.[33] One might suppose that, with Islam so near, the painter in Silos simply drew upon a Spanish Moslem tradition. But the form here is so much closer to the French Romanesque examples that a direct Moslem source seems less certain. Even if absorbed from the Moslems, these conceptions, as iconographic types, would belong to the Romanesque rather than Mozarabic phase of Spanish art, just as the translation of Arabic philosophic and scientific texts into Latin by Spanish Christians is more characteristic of Romanesque[34] than of Mozarabic culture.[35]

Among Romanesque images of Hell the painting from Silos is nevertheless a highly individual and exotic work. The names of the four devils, Barrabas, Aqimos, Radamas, and Beelzebub, have an evident Semitic flavor. Beelzebub is common enough, Barrabas is a gnostic demon,[36] Radamas suggests the gnostic Adamas;[37] but Aqimos I have been unable to identify in the literature of demonology.[38] He is perhaps a variant of Achamoth, the abortive child of Sophia in Valentinian gnosticism.[39] Older Spanish Christian and Moslem literature are rich in demons with Semitic names, but Barrabas, Radamas, and Aqimos seem to be unknown among them.[40] Is their presence in Silos due to obscure native traditions reaching back to the early Christian period[41] or to a more recent, esoteric contact with Semitic demonology?[42] Since the twelfth century Toledo was famous throughout Europe as a center of occultism and demonological studies;[43] in the later Middle Ages, European magic was nourished by Jewish and Moslem literature from Spain.[44] But gnosticism had estab-

8

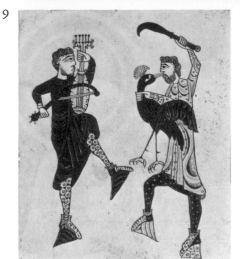

9

10

Fig. 8. St.-Loup-de-Naud: Angel
Michael in Last Judgment; Wall
Painting

Fig. 9. London, British Museum:
Jongleurs; Add. Ms. 11695, f. 86.
*Reproduced by permission of the
British Library Board*

Fig. 10. Santiago de Compostela:
Luxuria, Relief

11

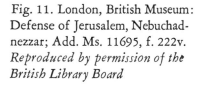

12

13

Fig. 11. London, British Museum:
Defense of Jerusalem, Nebuchad-
nezzar; Add. Ms. 11695, f. 222v.
*Reproduced by permission of the
British Library Board*

Fig. 12. Paris: Halitgarius, Treatise on
the Eight Vices, from Moissac;
Lat. 2077, f. 163. *By permission of the
Bibliothèque Nationale*

Fig. 13. Paris: Lat. 2077, f. 173.
*By permission of the Bibliothèque
Nationale*

lished deep roots in Spain long before.[45] In denouncing the ravages of the Basilidean heresy between the Pyrenees and the ocean, Jerome cites Armagil, Barbelon, Abraxas, and Balsamus as demonic names drawn from Hebrew sources to impress feminine and superstitious minds.[46] And the Spanish heretic Priscillian, answering the charges of gnosticism, repudiates Saclam, Nebroel, Samael, Belzebuth, Nasbodeum, and Beliam.[47] The possibility of a gnostic source appears finally in the strange demon Aqimos, with one leg and one arm; similar monsters are represented on gnostic gems,[48] although never identical with the figure from Silos.

If these demons are indeed gnostic, how shall we explain their unique presence in a Romanesque painting, at a time when religious art seems to be completely subject to the teachings of the church? The profuse repertoire of gnostic (and the related Manichean) motifs survived in mediaeval Christianity in quite distinct ways. From the very beginning, the texts of Christianity resemble gnostic writings in many details, either because of direct borrowings from the latter or because of a common dependence on Greek and Oriental systems.[49] Especially in forming their conceptions of beings intermediate between God and man and in picturing the regions of heaven and hell, Christians had to draw upon foreign and esoteric cosmologies more elaborate than the official pagan and Jewish beliefs. A Christian who wanted to trace in detail an itinerary for the soul moving from and toward a divine center turned to non-Christian speculations which had already constructed or explored the same ground, and fused them with dualistic systems accounting for good and evil. In the second place, gnostic ideas were directly available to orthodox Christians in résumés in the anti-gnostic and anti-Manichean writings of the church fathers; these provided elements which could be revived from time to time for new cosmological fancies[50] or as heretical alternatives to the established beliefs, alternatives more favorable to the aspirations of a sect. And, since Manicheism was influenced by gnostic systems, the Manichean revivals in the eleventh and twelfth century gave a new life to certain gnostic conceptions,[51] although the Christian context of the new heresies limited the use of the older Manichean terminology. Finally, gnosticism survived as an endless catalogue of magic names and formulas interesting to individual practitioners of occult arts and to more orthodox connoisseurs of the diabolical.[52] Already in the Early Christian period popular magic had become thoroughly impregnated with gnostic terms;[53] their recurrence in the Middle Ages therefore need not be a sign of a living gnostic tradition or cult. In Silos it is not the metaphysical or theological gnostic elements that appear, but the purely demonic, those which had been absorbed in popular magic. The conception of the whole image has its closest analogues in Roman amulets against the evil eye or some enemy, in which various beasts, including serpent, toad, scorpion and

crab, are grouped in a circle around a central object in order to attack it.[54] The isolation of four demons is typical of late antique and mediae- val magic;[55] and the very naming of the figures, so rare in Romanesque art, which knows only Satan and Beelzebub and a horde of anonymous devils, belongs also to magic.[56] These potent, abracadabrous, "barbara onomata" are usually Hebraic in sound, like so many of the formulas in exorcisms of the time.[57] The conception of the demons with their open mouths and bared teeth as running loose, as unbound, as piercing or threatening the victims with pointed instruments, in contrast to the demons "bound, sealed, hobbled, silenced" in exorcisms for the individu- al's protection,[58] all this is related to the techniques of countermagic and the *"defixiones"*[59] of the late Empire which survived into the Middle Ages. The artist by his drawing invokes and unlooses the devils against the sinners. The monstrous body of Aqimos, a kind of half-man, is also known to European folklore as a voracious ogre,[60] and the crab's claws are a demonic symbol important in popular superstition.[61] That we are dealing here not simply with an image issuing directly from the illustra- tion of Latin theological texts, but with a monastic work affected by a less institutionalized popular culture is evident from the vernacular inscription *peso* beside the scales of Michael.[62] The character of the whole set of inscriptions on this page, their fractioned and scattered all-over form, reminds us forcibly of folk-art.[63]

Nevertheless it would be incorrect to describe the painting as a work of folk-art in distinction from more cultivated church art. It is, in fact, characteristic of Romanesque art that it introduces into the decoration and imagery of the church fresh elements of popular fantasy, everyday observation and naive piety, beside and even within the doctrinal themes elaborated by centuries of theological meditation. In the present case, the popular elements are so strange and esoteric that their lay aspect is easily overlooked. But they are wonderfully appropriate to the monstrosity and violence of the theologically orthodox infernal subject; the terror of Hell and demons attracts to the closed religious eschatology the corresponding images of folklore and magic. The latter are readily applied to a nonmag- ical content closely related in its supernaturalism and violence to the levels of folk superstition. And since the most developed Romanesque art still employs archaic methods of representation, it can absorb folk mate- rial without losing the latter's directness of form. In treating a theme for the first time, the skilled Romanesque artist often invents ideographs and affective distortions like those of far more primitive artists and children.

In considering primitive formal details of this painting of Silos, like the scattered inscriptions, we must distinguish between the spontaneous domestic archaism of the unskilled, which does not know the rigorous order of book script, and the expressive adjustments made in a firmly

crystallized, long-practiced archaic style by artists freshly responsive to a new theme. In two respects the inscriptions belong to the highly traditional Mozarabic art. They are written largely in the pre-Romanesque, so-called Visigothic script, employed in Mozarabic books. In the second place, the very profuseness of the labels—even the scales are accompanied by an inscription—which supports the cartographic effect, recalls the Mozarabic miniatures in the same manuscript; there detailed inscriptions accompany the figures, and objects like crowns and instruments are labeled (Fig. 16).[64] These inscriptions are not functional elements or active extensions of the character of the figures, like the speaking scrolls of later Romanesque art which even when empty suggest a verbal activity or prophetic nature in gesticulating persons; they merely identify the object. The objects in turn become the heraldic, pictorial equivalents of words. Yet the painter's freedom in disposing these written elements is already far removed from the severe stylizations of Mozarabic art; the words are freshly strewn, and the scattering of the inscriptions, coherent with the larger rotating form, helps to dynamize the painting as an image of action. The primitive, naively realistic aspect of the writing in the miniature is in harmony with the most advanced qualities of drawing and design.

Similar considerations apply to the literary content of the main inscription: A CALORE NIMIO TRANSIBUNT AD AQUAS NIVIUM, ET AB AQAS NIVIUM TRANSIBUNT AD CALORE NIMIUM. "They shall pass from great heat to snow waters, and from snow waters they shall pass to great heat." The revolving inscription has then a corresponding movement in its sense; it refers to the cyclical alternation of heat and cold in the torment of the damned, a traditional theme in visionary accounts of Hell. These apparently formalized lines do not appear in the text of the Beatus commentary.[65] They are an independent reworking of the Vulgate mistranslation of the text of Job, "ad nimium calorem transeat ab aquis nivium et usque ad inferos peccatum illius" (xxiv, 19). Whereas the Hebrew original speaks simply of the drought and the heat which carry off the snow waters, as the grave carries off those who have sinned, the Vulgate has a dogmatic eschatological meaning: the sinner will pass from snow waters to great heat, even to Hell.[66] This passage of Job was already quoted in the Latin Life of Saint Brendan in the description of Judas in Hell tormented by alternating heat and cold—"et sic verificatum est verbum Iob, quod in suppliciis ibunt ab aquis nivium ad calorem nimium."[67] There was, in fact, a copy of this Life in the library of Silos,[68] and no doubt the conception of the painting was directly influenced by it.[69] But in the Spanish miniature the simple contrast of Jerome has been transformed into a more explicit sequence of opposed and alternating motions. Thus the nature metaphor of the Hebrew poet, converted into

an eschatological doctrine by Jerome, becomes in Silos an incantation of chiasmically repeated words,[70] like the diagonally symmetrical designs of Romanesque art. Such citation of single Biblical passages is frequent in magical exorcisms[71] and the reversal of a phrase is also a potent device in magic song and speech.[72]

The miniature itself is not an illustration of this text; the latter is only an accompanying inscription, like the epigrams or tituli in older art. But few mediaeval works show so intimate an accord of a text and a pictorial form. The quatrefoil corresponds to the symmetrical fields of fire and snow water, each of which occurs twice in the inscription. The rotating scheme translates the cyclical passage and alternation of the elements;[73] the oppositions of converging and diverging forms translate the contrasts of heat and cold. Finally, the lambent shapes already cited, the flamelike hair and feet of the demons, the transparent streaks of color, parallel the physical torments of fire and water. But these correspondences remain free and suggestive rather than literal—unlike the static, more systematized, visionary diagrams of a Hildegard of Bingen.[74]

I I

The second miniature of Romanesque tendency—the musician and dancer (Fig. 9)—is unmotivated by the adjoining text.[75] Like the painting of Hell, it is found in none of the earlier Mozarabic copies of the Beatus commentary. It forms no initial and makes no comment on the substance of the manuscript. But it differs from the other marginal independent miniatures in that the content here is entirely secular; the others are at least images of angels and saints and are therefore broadly consistent with the text. As a profane, untraditional motif, a free invention of an artist, drawn from the festive experience of everyday life, this painting of the musician and dancer is an early example of the marginal realism that underlies the drôlerie of later Gothic art.

Musicians are common enough in the Beatus manuscripts. In the scenes of the vision of the twenty-four elders, they are reproduced with their guitars. But whereas in the traditional Mozarabic paintings of this book the musician elders are always tied to their religious context of adoration, in the added miniature the musician and dancer are contemporary jongleurs,[76] unreligious, secular figures with an accented energy of movement and vehemence of conception.

In this secularized sense, they recall the frequent musicians and acrobats on Romanesque portals[77] and in liturgical manuscripts of the eleventh and twelfth centuries in southern France. Images of dancing and playing figures accompany the music and liturgical verse in the tropers and other service books (Fig. 18).[78] Sometimes in French sculptures,

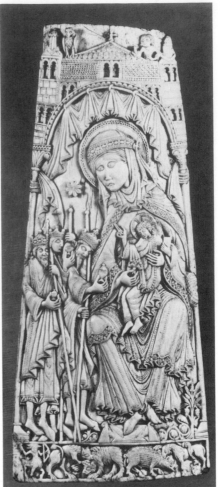

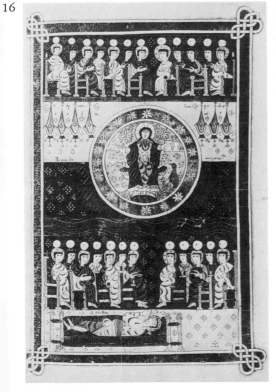

Fig. 14. Avranches: Cartulary of
Mont-St.-Michel; Ms. 210.
*By permission of the Bibliothèque
Municipale d'Avranches*

Fig. 15. London: Adoration of the
Magi, Ivory Carving. *Crown Copy-
right. Victoria and Albert Museum*

Fig. 16. London, British Museum:
The Twenty-four Elders; Add. Ms.
11695, f. 83. *Reproduced by per-
mission of the British Library Board*

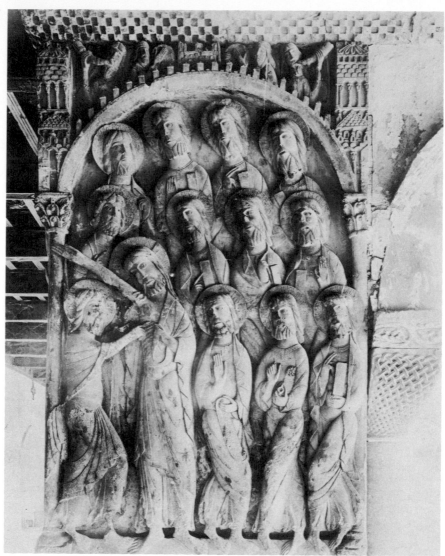

Fig. 17. Silos, Cloister; Relief of Northwest Pier: The Doubting Thomas. *Harvard Fine Arts Library, A. K. Porter Collection*

Fig. 18. London, British Museum: Harley Ms. 4951, f. 297v, 298v, 300v. *Reproduced by permission of the British Library Board*

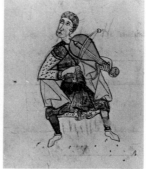

especially on the enframing archivolts, the crowned Apocalyptic elders are abstracted from their text, multiplied beyond their canonical number and set among acrobats and grotesques[79]—an expression of a secular kinship of music with physical entertainment, courtliness, and power.[80]

This typically Romanesque conversion of the elders is suggested also in the cloister of Silos. On the one historiated capital (Fig. 19) of the early galleries are carved the Apocalyptic musician-elders with their instruments and phials.[81] Nothing in their disposition refers to a specific religious moment. They are not the adoring canonical elders, around the Lamb or Christ, but are shown independently, aligned in order, some with legs crossed. They are so remote from any religious allusion that Bertaux could mistake them for figures of a Moorish harem, musicians and slaves with jars of perfume.[82]

Now it is interesting to observe, with reference to the relations of Mozarabic and Romanesque art in Silos, that the elders of the cloister are iconographically independent of the Beatus manuscript. In the Beatus of Silos (Fig. 16), as in the other Mozarabic copies, the elders are beardless;[83] in the cloister, as in French Romanesque sculpture,[84] and as in the one Beatus manuscript of the eleventh century executed in southern France,[85] the elders are bearded.[86]

The jongleurs of the Silos manuscript represent a more advanced stage in this conversion of the text. If they do not illustrate the Apocalypse and are an intrusion in the old cycle of Beatus paintings, they are ultimately inspired by the text. For they are placed in a blank corner at the end of the "story" of the enthroned Christ, the homage of the musician elders and the four beasts, and precede a full-page miniature of this vision of the heavenly court. They disengage from its supernatural and ceremonial sense a core of secular life: they dance and play, not for God, but for the people or an earthly court; they belong to the fairs and the world of secular pleasure from which issue the Avarice[87] and Luxury condemned in the painting of Hell in the same manuscript.

Such figures intrude also on the margins of one of the large religious sculptures of the cloister. In the Doubting Thomas (Fig. 17) the enclosing arch is surmounted by battlements and superposed buildings, with four little figures—two men blowing horns, two women clapping on disks or tambours. Such a frame is unique in the entire series of sculptures. In this crenelated architecture, evidently inspired by the *fores clausae* of the Gospel text, the figures have no apparent iconographic relation to the scene below. They may be interpreted as lay figures designed to illustrate the excluded, outer, profane world, in contrast to the apostles to whom Christ revealed himself behind closed doors, especially since the doors of the buildings above are opened wide.[88] But even as such, their presence indicates a consciousness of a nonreligious reality, distinct from the

demands of the theme, which is new in the representation of the incident. In Mozarabic and contemporary Catalonian miniatures, figures are sometimes shown above crenelated walls; there, however, they are not part of a frame but necessary actors in the scene. They are the armies which defend Jerusalem (Fig. 11)[89] or the inhabitants who denote a specifically represented religious center.[90]

I do not know of a pre-Romanesque Spanish example of such a framework in a purely religious subject. The architectural canopy frame is common enough in Mozarabic and early Catalonian art, but nowhere in these arts is it filled with musicians or corresponding secular figures.[91]

They are common, on the other hand, in French Romanesque art, especially in miniature painting. In the Bible of St. Benigne at Dijon, a manuscript of the early twelfth century, little figures blowing horns are set in the architecture crowning the canon tables.[92] Another clear instance is the miniature of the vision of St. Aubert in the cartulary of Mont-St.-Michel, now in the library of Avranches (MS. 210) (Fig. 14).[93] Nor is the motif limited to manuscripts. It appears also in a North French or English ivory of the late eleventh century in the Victoria and Albert Museum (Fig. 15),[94] of which the peculiar conception of the Adoration of the Magi was reproduced almost literally in a Spanish Romanesque sculpture,[95] and attains a monumental symbolical form in the south porch of Moissac where two figures blowing horns are carved on the crenelations which surmount the portal.[96] On several Romanesque capitals in the museum of Toulouse[97] and on the portal of St.-Pierre-des-Cuisines in the same city, religious scenes are framed by arches and crenelated walls, but lack these figures of watchmen and musicians.

It may be that such a motif could have been conceived independently by the Spanish artist; but a small detail of the same architectural design in Silos suggests that South French models have been copied. I refer to the peculiar inversion of the flat, imbricated scales that cover the roofs and gables of the buildings. This is the typical pattern of such scales in the Romanesque churches of Aquitaine, especially in the regions of Poitou, Perigord, Saintonge, and Angoumois. The conical spires of Notre-Dame-de-Saintes, Périgueux, Civray, and Angoulême are covered in this way. The practice extended from the Loire to the Garonne.[98]

The conical form of these spires was copied in several Spanish buildings.[99] In the old cathedral of Salamanca such spires were built on the Torre del Gallo which surmounts a crossing that the abbot Nebreda of Silos (c.1580) declared was similar to the crossing of his own church.[100] But in these Spanish Romanesque spires the imbricated scales are not inverted as in their French models. It is therefore more likely that the inverted form in the relief at Silos is the result of first-hand knowledge of French architecture, or the copying of a French image.[101]

Even if the relief of Thomas lacked these peculiarities of the roofing and the musicians, the very use of a crenelated architecture with turrets as a frame in this scene alone—in the group of six—would indicate ultimately northern prototypes. For it is in precisely this kind of structure that the incident is shown in Carolingian art.[102]

The dependence on foreign art, however, should not distract us from the local and contemporary factors in the conception of such marginal secular details in religious imagery. More important is the urban and feudal context of the musicians in the sculpture. They are identified with the city, and in this identification assume a double significance, as watchers in a bellicose feudal society who call out to or warn the townspeople and as popular entertainers.[103] The first sense is directly realized on the porch of Moissac which has already been cited. The crenelations there are carved with real figures who enact in a permanent manner the role of watchmen.

These figures, "singing out and blowing on a horn," as Guibert of Nogent,[104] a contemporary of the sculptors of Silos and Moissac, describes the watchmen of his time, are the forerunners of the sculptured men and women—the bourgeois Jacquemards—who strike the hours in the municipal belfries of the later Middle Ages.[105] They are among the oldest examples of a specifically burgher form of artistic illusionism. In the fifteenth century, as in the Hôtel de Ville in Bourges and in the House of Jacques Coeur, real beings in contemporary dress are carved in false windows, or looking down to the spectator from balustrades and crenelations.[106] The sense of architecture as inhabited, as genuinely domestic and urban, and as part of a city with which it communicates, is directly concretized by such images.

We can perhaps identify the figures on the city walls of the relief of Silos through their peculiar instruments. They are the popular *tromperos* and *tamboreros* mentioned in Spanish documents of the Middle Ages.[107] A folk couplet of Burgos, in the region of Silos, runs:

> *Oh que buen amor saber yoglar*
> *Saber yoglar de la tambora Rana-cata-plan!*[108]

The presence of these figures, with their suggestion of gaiety and love, is all the more remarkable since the Mozarabic penitential of Silos expressly condemns jongleurs.[109] The biographer of St. Domingo tells how a local priest suffered a miraculous contortion of the face for venturing to entertain the people before the door of the church.[110] In the sculpture there are even women musicians, the *juglaresas,* whose profession was often denounced by the church.[111] But the church could not suppress a popular form of entertainment which penetrated even into the religious cult.[112] Berceo, a later poetic biographer of Domingo, called

himself the *juglar* of the saint, just as the Franciscans were known as the *joculatores Dei*.[113] In the towns of the early twelfth century the jongleurs were respectable burghers, privileged like the artisans with whom they were allied in uprisings against the church.[114]

In representing the musicians—jongleurs who improvise a sensual music, in contrast to the set liturgical music of the church—the sculptor expresses also the self-consciousness of an independent artistic virtuosity. He inserts in a context controlled by the church and committed to religious meanings figures of lay artists, free, uninstitutionalized entertainers whose performance is valued directly for its sensuous and artisan qualities; just as in modern art, which is wholly secular, painters so often represent figures from the studio or from an analogous world of entertainment—acrobats, musicians, and harlequins—consciously or unconsciously affirming their own autonomy as performers and their conception of art as a spectacle for the senses. On a capital in Conques we can see this secular affinity in a rudimentary stage in the image of a figure, perhaps a watchman, blowing a horn beside the building artisan with his tools on the walls of a town (Fig. 20).

Like certain Romanesque sculptors of the South, the jongleurs conceived of their art as ingenious, intricate, and woven.[115] The terms in which they describe their poetry apply also to sculptures of the region.[116] They show similar conceits of manipulation; and it is hardly by accident that Gilabertus of Toulouse signs his sculpture as the work of *vir non incertus*, like his contemporary, the jongleuresque troubador William of Aquitaine, who refers to himself in one of his poems as *maiestre certa*.[117] The autonomy of the profane poets, depending on classes with different social and cultural interests, is expressed in conflicting tendencies toward realism and satire, on the one hand, and toward eroticism, courtliness, and a playful preciosity of content, on the other. The intricate form in varying degree is common to both groups, but the moralizing realists are the jongleurs of peasant and middle-class origin, the courtly poets belong to the aristocracy.[118]

It is in the eleventh and twelfth century, in Romanesque art, that such details of secular life begin to appear in the frames of religious miniatures and sculptures. This conception of the frame implies also the loss of absolute concentration on the religious image. The margins become populated without direct reference to the central field,[119] as in late Gothic miniatures, and suggest the larger, competing, environing world in which religion is only one element.

In Silos the urban, secular milieu occurs significantly in the one subject among the six religious reliefs that embodies the antitheses of faith and experience. The sense of the incident of the Doubting Thomas for the mediaeval church is given by the words of Christ, "Thomas, because

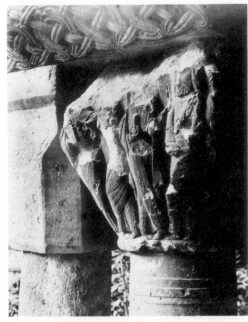

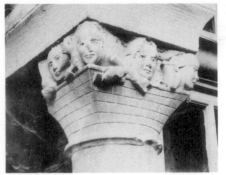

Fig. 19. Silos, Cloister; Capital:
The Apocalyptic Elders.
*Harvard Fine Arts Library,
A. K. Porter Collection*

Fig. 20. Conques, Church of Ste. Foy:
Romanesque Capital

21

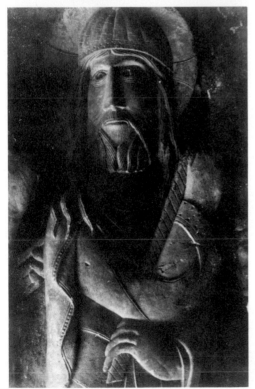

Fig. 21. Silos, Cloister; Relief of
Northwest Pier: Christ, Detail of
The Pilgrims to Emmaus.
By permission of the Abbey

Fig. 22. Silos, Cloister; Relief of
Southeast Pier: The Ascension.
*Harvard Fine Arts Library,
A. K. Porter Collection*

22

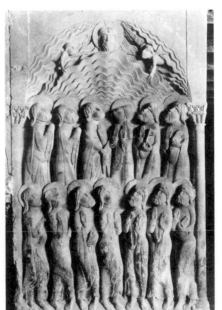

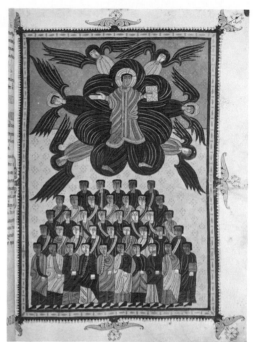

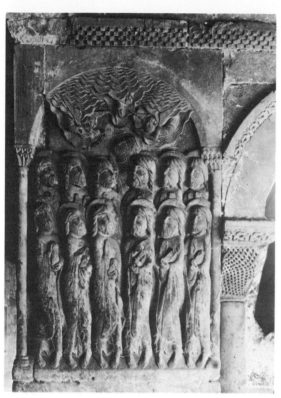

Fig. 23. Silos, Cloister; Relief of
Southeast Pier: The Pentecost.
Harvard Fine Arts Library,
A. K. Porter Collection

Fig. 24. London, British Museum:
Christ Appearing in the Clouds;
Add. Ms. 11695, f. 21.
Reproduced by permission of the
British Library Board

Fig. 25. Capua, Museum: Roman
Mosaic. *Museo Provinciale Campano*
di Capua

thou hast seen me, thou hast believed; blessed are they that have not seen and yet have believed."[120] It is in accord with this elevation of faith above first-hand experience that the figure of Paul has been prominently inserted in the group of apostles beside Christ himself, even though he was not present at this scene and his dignity as an apostle lay partly in the fact that he was the very one who believed in Christ without having known him in his physical person. "For we walk by faith, not by sight," he wrote.[121] Yet this elevation of faith, expressed also in the inscription of Paul's halo—*Magnus Sanctus Paulus*—implies for the church a humility of the individual, in contrast to the irreligious self-reliance which follows from the empirical tendencies and the logic of secular life. Hence the further inscription on Paul's roll, *Ne magnitudo revelationum me extollat* (II Corinthians xii, 7). But this opposition of religious and secular values is not strictly resolved by the religious doctrines, since these doctrines, no matter how spiritualized and mystical, must call constantly on the evidence of history and the senses, on the Biblical story and the order of nature, to justify the content of belief. In making this appeal to the senses, the church promotes forms of naturalistic representation that seem to contradict the denial of the senses on which the underlying doctrine is grounded. Or, rather, it is compelled to argue its doctrines more rationally and to present them in art in a more concrete form, as the society which it would steer (and which includes the church itself) is directed more and more by earthly, secular interests and is increasingly influenced by the burgher class with its practical calculations and critical spirit.[122]

Here then in Silos this characteristic inner conflict appears in a sculptural form: the church commands a highly tangible and detailed image of an historical event—the Doubting Thomas—of which the chief meaning is that the eyes and the hands are not to be trusted, that faith alone counts; but the authority of this doctrinal meaning depends further on the material aspect of the incident, since the reappearance of Christ to his disciples after his death is the material evidence of the Resurrection. Yet in this image the church introduces, as a spiritualistic emphasis, a figure whose significance lies in the fact that he was *not* present at all, and whose distinguishing faith is a matter for humility, not pride. The marginal figures of the entertainers, introduced presumably by the artist or with the consent of an abbot responsive to these profane forms, reveal to us the force of secular interests which are beginning to place experience above or beside faith; but they are conceived aesthetically, that is, from the special experience of the spectator and lay artist, rather than of active worldly individuals, though congenial also to these.[123]

That an architectural frame should be populated in this free manner, beyond, or even contrary to, the immediate needs of religious representa-

tion, is a phenomenon foreign to Mozarabic art. The latter belongs to the provincial society of Christian Spain under Moorish dominance, to the period of primitive, scattered agricultural communities, with independent, mutually antagonistic rulers, and a native, uncentralized Spanish Church, distinct from the Roman in its liturgy and tradition and even in its reckoning of years.[124] Romanesque art in Spain, on the other hand, belongs to the period of disintegrating Moorish power and the resulting expansion of the Christian kingdoms of the North, the conquest of Moorish urban centers of industry and trade, and the struggles to establish powerful, centralized states. It is the period of alliance with the rulers of neighboring European states and the adoption of highly disciplined, universal, and centralized forms of church and monastic organization which support the new royal power. The freshly conquered and the older abandoned lands were now repopulated and colonized for economic and strategic uses; and with the increased productivity and wealth there were formed new urban communities of free farmers, artisans, and merchants. The beginnings of an aggressive middle class date from this moment. Modern municipal institutions, vernacular literature, and a high secular culture arise at the same time.[125]

Of the new Spanish towns, some were formed in part by emigrants from southern France, attracted by promises of special rights, by the favorable economic conditions in the conquered Moorish territories, and the initial protection of the great abbeys and the militant state power.[126]

It is well known that such a community was founded beside the monastery of Silos. It included Gascon emigrants, after whom a quarter of Silos bears to this day the name of Barbascones (Varrio Gascones).[127]

The commercial importance of the town of Silos seems to have depended largely on its connection with the powerful growing abbey, which was unique among the monasteries of the region of Burgos—one of the chief commercial centers in northern Spain—in the extension of its domain considerably beyond the diocese.[128] As a religious center, possessing the body of Domingo, the new national saint of Castile, Silos attracted numerous pilgrims and traders.[129]

No document tells us the exact date of the founding of the Gascon quarter. It existed perhaps as early as 1085.[130] A charter of 1096[131] established the right of colonists to settle in Santo Domingo de Silos, and later charters of 1135 and 1209[132] reaffirm the rights of the citizens. Documents of the thirteenth and fourteenth centuries mention the existence of two mayors in Silos, a native Castilian and a Frenchman;[133] the same institution is provided in the *fueros* of other towns in the eleventh and twelfth centuries.[134]

The presence of artisans from southern France in the region of Silos in the late eleventh century is confirmed by an inscription of 1081 in the

church of San Pedro at Arlanza, a powerful abbey eight miles northwest of Silos: GUILLELME ET OSTEN P(ate)R EIUS FECERUNT HANC OPERA(m) GUVERNAN(te) DOM(in)O ABBA(te) VICEN(tio) IN ERA M(cxix).[135] Férotin[136] had already observed that the names of the builders are not Spanish, but did not take the trouble to determine their source. The name Guillelme is undoubtedly French; while Osten (Ostennus, Austennus) is especially common in the Middle Ages in the region of Bordeaux.[137] Saint Ostindus or Ostent (modern Ostinde, Austinde), a native of Bordeaux and bishop of Auch in the eleventh century, is venerated in Béarn to this day.[138] In an early chronicle of Bordeaux, the history of Cenebrun[139] (of which there was a copy in the mediaeval library of Silos),[140] the murderer of the Spanish usurper of the throne of Gascony in the eleventh century is named Guillelmus Austencii.

It would be a mistake to explain the emergence of Romanesque art in Spain simply by such colonization from southern France, or even by the preponderance of Frenchmen in the reorganized religious life of Spain. These are only single factors or results in the larger, more complex economic and political change. The material bases of Romanesque art in Spain were not produced by France or Frenchmen; they depended more directly on the conditions and struggles within Spain itself, although finally affected by a larger European and Moslem world. Without the native movement the influence of French culture would have been very limited or even impossible. No foreign noblemen would have been tempted to fight here against the Moors; no Benedictines would have been invited into Spain by the Spanish rulers, no Roman liturgy imposed. Foreign elements, like the Cluniac monks, the landless feudal adventurers, and the Gascon colonists, were welcomed insofar as they served the varying needs of the ruling layer and provided models and means for the newly developed interests in Spain. Certain parts of France, having preceded Christian Spain in the growth of cities and trade and in the organization of disciplined monastic and ecclesiastical powers, could facilitate the corresponding process in Spain. But the precedence of France was temporally very slight, and the example of her art could be absorbed so readily because of the independent and sometimes more active emergence of similar conditions in Spain. Recent historians even assert the priority of Spain in creating the codes of municipal law, and trace to Spain the formulae of individual rights in the cities of France and northern Europe.[141] In the expansion of agriculture, too, Spain seems to have preceded the South of France.[142] The well-documented early dates of various works of Spanish Romanesque art appear improbable only to those who have neglected their native basis and regard them simply as provincial copies of French art.

On the other hand, the Roman Church and its Cluniac ally, the upper

feudality and the merchants in France, could only watch with a deep interest the struggles of Christians and Moors in Spain and the resulting changes in every aspect of Spanish life. They were concerned not only because it was a combat of their coreligionists against a heathen race— that was an ideological veil appropriate to the Christian morality of the time and prepared them for the greater crusade against the Moslems in the East—but because of the possible effects of the outcome of these struggles on their own interests. Early in the eleventh century the papacy in its battle against the emperors had recognized in Spain a new field in which to assert the temporal supremacy of the church. In 1077 Gregory VII laid claim to Spain as a fief of the church, a fief which he entrusted to the victorious, but respectful, Spanish kings. At the same time he called upon the Christians of other countries to give them aid. The support of the Spanish rulers by the counts of southern France cannot be viewed simply as a religious act. To take one instance, the wealth of the powerful counts of Béarn, who were strategically entrenched near the Spanish border, depended on the tolls and péages levied on the foreign merchants whose chief trade was with Moorish centers, especially Saragossa, in northern Spain. The coins struck by the house of Béarn were the main currency of southwest France from the tenth to the twelfth century; their metal came from Spanish mines. The counts of Béarn had therefore a double interest in strengthening the Christian kingdoms of Spain: it meant not only the facilitation of imports from Spain, but a greater flow of goods through Béarn to the new Christian centers in Spain, enriched by the lands and tribute of the conquered Moors.[143] Toward 1080 the count of Béarn rebuilt the city of Oloron, the chief market for trade with Saragossa as well as for Franco-Spanish trade in general in southwest France. At the same time he founded the abbey of Sainte-Foi at Morlaas which he gave to Cluny, then powerful in both the Spanish church and the court of Castile. Hunaldus, the half-brother of the count of Béarn, was abbot of Moissac, the greatest of the Cluniac abbeys in the Southwest, and in the closest contact with the French ecclesiastics—bishops and abbots—in the Spanish church.

The intrusive appearance of the inhabited city wall with its secular musicians follows from only one aspect (though affected by the whole) of the movement in society which underlies the change from Mozarabic to Romanesque art. In the latter, the urban motif does not emerge as a central pervading theme. It could only be marginal, since the economy is essentially agricultural: the dominant groups are still the aristocratic, military, and ecclesiastical powers, and within this society monumental sculpture is mainly an art of the church, the only group with claims to an embracing and universal role. But this urban theme marks the emergence of a middle class and of widespread secular interests which ultimately

transform even church art. The expansion of the upper classes, the forma-
tion of a stronger, centralized monarchical and ecclesiastical authority, in
fact intensified the development of merchant and artisan groups. The
Reconquest in Spain brought new wealth to Castile in the form of trib-
ute, a steady annual revenue which was expended on luxuries, construc-
tion, and war. The great architectural enterprises of the time—castles,
fortifications, and churches—the elaborate forms of courtly entertainment
and ceremony (even in the church), undoubtedly affected the numbers
and status, the technical levels and fantasy, of the artisans and contrib-
uted also to the wealth of merchants and moneylenders.[144] In a similar
way the political and administrative needs of the new centralized church
and state promoted diplomatic skill, statecraft, legal studies, critical obser-
vation of human behavior, a superior documentation, and historical
writing.[145] Thus the new practical and cultural needs of the upper
classes indirectly advanced the growth of the towns and those interests in
everyday experience and the norms of empirical knowledge which under-
lie the broad naturalistic tendencies of later mediaeval art. These tenden-
cies were qualified, however, by the changing situation of the groups for
which the art was produced, so that the level of naturalism, actively
achieved in preceding generations and under other conditions, could
become a purely conventional idiom and embody a newer range of reli-
gious and courtly values, often opposed to the viewpoints out of which
the naturalism had come.

Although essentially religious in content, the large Romanesque reliefs
of Silos are conceived in a far more naturalistic way than any Mozarabic
representations. The very idea of monumental narrative sculpture implies
already—beside the advance in the techniques of working stone—a degree
of concreteness and verity opposed to the emblematic illumination and
the inert, minuscule ivory carving which were the chief fields of imagery
in the preceding period. The sculptures of Silos abound in marvelously
precise and refined details of human form and costume. This multiplicity
and precision, realized mainly in the geometrically shaped and decorative
elements like hair, drapery folds, and the ornaments of dress, confer on
the figures the appearance of densely detailed and varied fabrications of
luxury artisanship, characteristic of a primitive, growing, naturalistic art.
The completeness of represented objects is at first identified with their
substantial aspect, only later—under the stimulus of an advancing and
more critical interest in nature, individuality, and the everyday world
—with their environment, activity, and inner life. Thus Christ in the
relief of the Meeting with the Pilgrims is shown as a contemporary pil-
grim to Santiago, with the familiar wallet and cockle shell of Saint James,
which are rendered with a scrupulous, minute fidelity; but his head,
which is equally detailed in the drawing of the features and the hair, is

utterly impassive, a shallow mask smoothed like the surface of a column[146] (Fig. 21).

The positive growth of this art in a naturalistic sense, its departure from an older style in which the figure was a rigid, emblematic unit, may be judged within the series of reliefs in the successive rendering of such details. In the first reliefs—the Ascension and Pentecost (Figs. 22, 23)— the garments obscure the legs or bodily structure beneath; in the later works these are more and more sharply disengaged. In the former, when the artist tries to animate a static figure by the crossing of the legs, he creates an anatomically uncertain and inconsistent shape. We are not sure that the legs are really crossed: they appear to converge toward the knees and then part instead of cross.[147] The original flatness of the unbroken drapery surface is preserved and conflicts with the conception of an articulated, active body. The indecisive rendering recalls the archangel Michael in the Beatus manuscript.

But in some schematic forms of the sculptures it is difficult to distinguish the specifically Romanesque archaism from persistent tendencies of Mozarabic style. Especially in the reliefs with groups of uniform apostles like the Ascension (Fig. 22), the Pentecost (Fig. 23), and the Doubting Thomas (Fig. 17), the regular repetition of the unit figure and the impersonality of the human elements, suggest Mozarabic as much as Romanesque art. The apostles of the Ascension in the cloister (Fig. 22) resemble the corresponding series of figures in the miniature of Christ Appearing in the Clouds in the Beatus manuscript[148] (Fig. 24). They show a similar alignment of uniform elements, a similar compactness of masses and ornamental grouping. There are other Romanesque sculptures in which figures are arrayed in this manner, but nowhere else have I seen so clear and insistent a reduction of congregated human figures to ornamental units.

A resemblance to Mozarabic art may be found also in the unusual spatial arrangement of the Doubting Thomas. In Romanesque sculpture such groups (cf. also the Ascension, Pentecost, Last Judgment, etc.), are generally disposed in a single row in one plane, or, if there is a second row, the figures behind are so abbreviated that we see only their heads, and these in the same plane as the figures before them. Their bodies, and especially the feet, are completely omitted. The horizontal ground-plane implied in the succession of rows is nowhere realized; but the ground-line of the first row becomes the ground of the whole group. In this way the clarified order of the surface arrangement governs also the composition of a group with spatially overlapping figures, but only through an abbreviation of the distant elements which reduces them to a row of superposed or interposed heads like dittos to the main series of figures. In the reliefs of Silos, on the other hand, there is, as in occasional Mozarabic min-

Fig. 26. London, British Museum: Dream of Nebuchadnezzar, The Hebrews in the Fiery Furnace; Add. Ms. 11695, f. 229. *Reproduced by permission of the British Library Board*

Fig. 27. London, British Museum: Elders Adoring the Lamb; Add. Ms. 11695, f. 164. *Reproduced by permission of the British Library Board*

Fig. 28. Silos, Cloister; Relief of Northeast Pier: The Angel, Detail of the Three Marys at the Tomb. *Reproduced by permission of Foto Mas, Barcelona.*

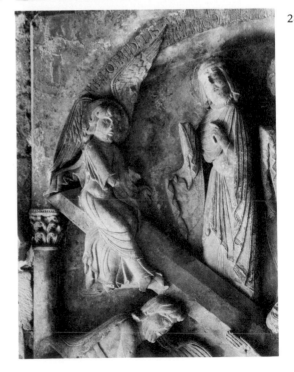

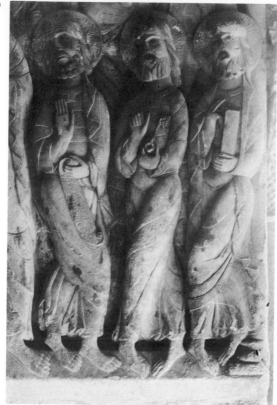

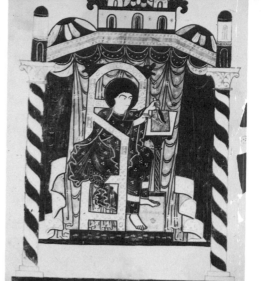

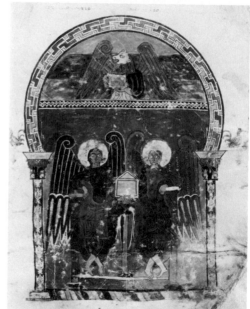

Fig. 29. Silos, Cloister: Apostles Paul, Peter, and Andrew; Details of the Relief of the Doubting Thomas. *By permission of the Abbey*

Fig. 30. Paris: Beatus on the Apocalypse; Ms. Latin 8878, f. 217v. *By permission of the Pierpont Morgan Library.*

Fig. 31. New York: Beatus on the Apocalypse; Ms. 644, f. 9. *By permission of The Pierpont Morgan Library*

iatures,[149] a gradation of overlapping rows, with at least two distinct ground levels implied in the position of the feet. The first row in the Doubting Thomas (Fig. 17) consists of entire figures; in the second, some figures are obscured by the lower row; but the elevated legs and feet of the two central saints are visible between Christ and Paul and Peter. Only in the upper row are the apostles entirely restricted to busts. Though the composition as a whole is tied to a surface arrangement, the more distant elements are clearly presented behind as well as above the nearer figures.

Both conceptions are based on a late classical method of perspective representation (Fig. 25)[150] which persisted in the West into the twelfth century, an adjustment of a synthetically composed horizontal depth plane to superposed zones on a common vertical plane, somewhat as in a topographical map. In the more common mediaeval (and Romanesque) versions, the deep ground-plane, or the isolated fragments of such a ground (applied to individual elements), is reduced to a horizontal ground-line, and the play of overlapping elements resolved into a simple alignment of distinct bodies. In Mozarabic painting, however, the ground-plane of late classic art was preserved as one zone of a background in which the vertical and horizontal planes of the setting of the figures fuse in a single banded surface; on the latter, in turn, are projected the overlapping superposed figures. A common ground-line was not always crystallized as an integral element, and the figures therefore seem suspended in the coloristic void. It is this relation of figures and ground that reappears in the reliefs of Silos, though modified already by the use of the lower frame as a horizontal ground-line or band for the nearest row of figures.

Although this arrangement may plausibly be interpreted as a vestigial classic form transmitted through Mozarabic art, it functions freshly in the sculptures as an expressive element and satisfies also the naturalistic search for concreteness and fullness of represented forms.[151] For while it was not a fixed solution in Mozarabic art (which practiced also the more typical mediaeval reductions, Fig. 26), this spatial device is most marked in the sculptures of Silos in the Doubting Thomas, one of the last of the reliefs to be carved, and is less evident in the older reliefs, the Ascension and Pentecost, which show in other respects the closest resemblance to Mozarabic design.[152]

Within these common aspects of the sculptures and miniatures of Silos there are essential differences. In the manuscript the arrayed figures, densely packed and regular, are unarticulated as a group, without signs of individual life or movements other than the general governing direction of the mass. They have been stiffened as if each were an immovable printed unit with an assigned place in a pictographic text (Fig. 26). In the scene of Christ Appearing in the Clouds (Fig. 24), the figures are

completely detached from the group above them, in spite of the connection in the text. Even the musicians adoring the lamb (Fig. 27) do not look directly at the object of their adoration. The profile view, which would bind one figure to another through the glance, is practically unknown. In some of the reliefs, however, the attention of the apostles is already tied to a common central object, or, if they are detached in the Mozarabic manner as in the Doubting Thomas, they show an independent turn of the head or mobility of posture. The subjective participation of the figures is reflected in the varied adjustments of the bodies and in the fine pulsation which animates the schematic order of the whole. Their flexibility is still limited by a dominant axis, as in Mozarabic art, but the silhouettes are now disengaged as curved lines with a delicate flamboyant undulation.

If this quality of movement in the reliefs is still subordinate to the ornamental scheme, a more individualized and emphatic Romanesque energy appears among the rigid groups in isolated single figures. The angel at the tomb, for example, in the relief of the Three Marys (Fig. 28), with his flying mantle and extended drapery of the legs, is a fully developed Romanesque conception. If we looked for a precedent for this figure in the Beatus manuscripts we would not find it in the Mozarabic copies, but in the version of Saint-Sever, a South French work of the third quarter of the eleventh century (Fig. 30).[153]

In the force with which the angel crosses the architectural frame, in the independent vitality of the lines, expecially of the costume, he is thoroughly unlike the Mozarabic figures. The expansiveness of the sculptured Romanesque angel, its movement in space, is realized in the overlapping of the frame as well as by the extension of limbs and drapery; in Mozarabic art the occasional overlappings of figure and frame are simply devices of surface pattern, brilliant in color, but without the spatial and plastic suggestiveness of the Romanesque form.

Of the sculptures in the cloister the relief of the Doubting Thomas offers the richest evidence of this interaction of Romanesque and Mozarabic design. It is all the more striking because the interplay appears in the subject of the work as well as in the forms, and within the field enclosed by the urban theme discussed above (Fig. 17).

According to the character of our attention, two opposed qualities will appear to dominate the outward form of the relief: the regular serial ordering of the figures as a collective group, and the unstable, pirouetting postures of the three saints at the lower right. Proceeding from the first quality, we see the dancing figures as fixed, repeated units; proceeding from the second, the whole composition appears to us a pulsing rather than rigid whole.

In the same manner, if we observe the relation of the upper figures to the frame, we sense the latter as an *a priori* limiting form: the heads seem to bend or rise according to the shape of the frame. But if we attend instead to the lower band of figures, we experience the less bounded existence of the figures: the outer saints, Thomas and Andrew, overlap the frame. Their limbs and flying draperies cross the enclosing columns. In the same way, the extended hand of Christ reaches across the frame.[154]

A similar opposition governs also the thematic content of the relief. The apostles as a group of witnesses are subordinate in meaning to the primary pair of Christ and Thomas; Christ is rendered as superhuman in scale. But the two actors are placed in the lower left corner. What is central in the episode appears almost marginal in the composition.[155] The glances of the apostles are all directed to an eccentric axis at the left of the field corresponding to the body of Christ.

Just as the primitive zoning of the figures includes also suggestions of depth, so the Mozarabic alignment of expressionless, uniform heads is modified by details which individualize the single figures. The faces are minutely distinguished from each other by deliberate variations of the hair and the features, however synthetic and archaic. The bust rather than the head alone is rendered, and the hands are shaped in gestures varied enough to symbolize at least the particularity of individuals. Each halo is inscribed with the name of an apostle.

In the lower row (Fig. 29) this individuation is more emphatic, more detailed, even if through accessory and inorganic devices. The inscriptions have unique characterizing forms: instead of the common *sanctus* and the name of the upper figures, the inscriptions below read: THOMAS UNUS DE XII, MAGNUS SANCTUS PAULUS, SANCTUS PETRUS APOSTOLUS, ANDREAS FRATER SIMONIS PETRI. Of the three saints with accessory objects, one bears a scroll (Paul), a second, keys (Peter), the third, a book (Andrew).

In contrast to these elementary and relatively static variations which distinguish the individuals in a collective group the apostles of the lower band seem to embody the stages of a common rotation or pirouetting movement. It is a characteristic Romanesque mobility foreign to Mozarabic style. The individual postures are not motivated directly by the incident as reported in the Gospels—these postures are rare in images of the theme—but are developed here as an independent, animating expression, recalling in some respects Renaissance mannerist art. Thomas alone has a uniform, outwardly directed movement of the arms and legs; the others, with arms bent inward and legs constrained, are turning on their own axes. The extension of Christ's arm is rigid and spontaneous in a body otherwise soft and submissive. (One may see in this strange contrast an

expression perhaps of the conflict of the secular attitudes and the religious values which constitutes the heart of this subject for Christian thought, and which acquired during the Romanesque period a greater poignancy and depth.) Paul, the central figure, faces Christ. If his body is turned away from Christ, it is in opposition to Thomas's aggressive approach, but also in paradoxical repetition of the movement of Thomas's right leg. These directions may be grasped, of course, simply as the necessary adjustments of a balanced scheme in which the predominant leftward movements of Christ and the apostles are countered by the accented rightward movements of the others. The twisted figure of Paul in the very center of the field would then be a mediating element turned in both directions and embodying in one person the formal oppositions of the whole group. But such an account, however justified as a reading of the linear equilibrium of the work, would overlook the expressive character of the whole which has been brought to balance by these highly original devices, and the significance of the allocations of posture for the religious meanings of the episode, especially in St. Paul. The unique profile of Thomas, like his aggressive posture and gesture, isolates him within the group of self-constraining apostles whose pathetically inclined heads and delicate curved forms echo the passive, feminine aspect of Christ.

The postures of these figures are motifs valuable to the artist beyond their role as compositional means; the latter would hardly be possible were not the postures valid in themselves as expressive, communicating forms. We have already observed the unstable stance on symmetrically crossed legs in the St. Michael of the Beatus manuscript. The motion of the body is not directed toward other objects or determined by some apparent external force, but is narrowly confined, originating entirely within the figure and proceeding in no specific direction, just like the gestures of the figures in the relief. To describe it as pirouetting is also inexact, since this implies a motivated, unconstrained activity, as in classical images of female dancers. The figure of Peter, on the other hand, is immobilized and rendered unstable by a gesture of his own legs, the whole body being supported on the point of the inwardly converging toes; in the corresponding immobile classical figures, one leg is vertical and the weight is carried in a balanced and more relaxed manner on a stably set foot. Or, if a moving body is represented, the posture is unstrained, and adequately motivated by the action of the figure. Just as the immobile classical posture differs from the postures in old Oriental art in expressing the rich articulation of the body, a potential mobility or momentary rest issuing freely from the figure, so the Romanesque posture differs from the normally inert Mozarabic form as an expression of active energies, but spiritualized, constrained, and tense. The greater naturalism

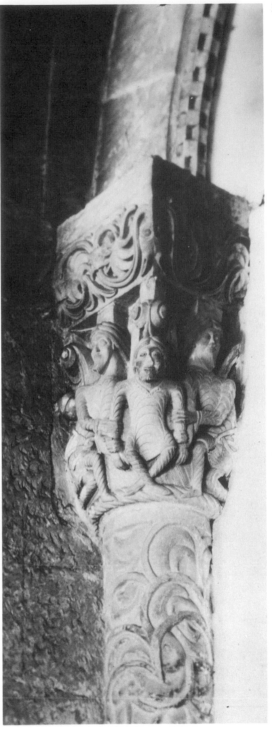

Fig. 32. Silos, Cloister: Epitaph of the Abbot Domingo. *By permission of the Abbey*

Fig. 33. Silos, Portal of the Virgins: Capital. *By permission of the Abbey.*

Fig. 34. Paris: Ms. Lat. 1822, f. 1. *By permission of the Bibliothèque Nationale*

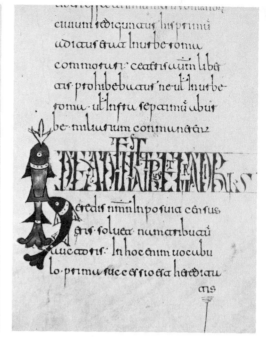

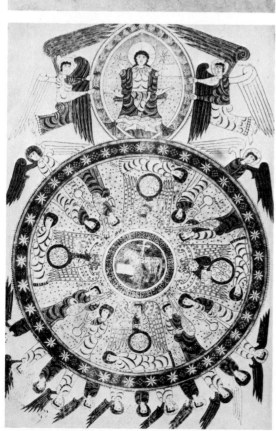

Fig. 35. Paris: Nouv. Acq. Lat. 2176, f. 57. *By permission of the Bibliothèque Nationale*

Fig. 36. Paris: Nouv. Acq. Lat. 2169, f. 191. *By permission of the Bibliothèque Nationale*

Fig. 37. London, British Museum: Adoration of Lamb; Add. Ms. 11695, f. 86v. *Reproduced by permission of the British Library Board*

presupposed in this activity and plastic disengagement of the limbs from the older, unproblematic, rigid mass is confined or redirected in varying degree by ascetic fantasies. The seemingly arbitrary chiasma of the legs, in violating the natural tectonic of the stable body, confers a suggestion of inwardness on the saint. The X form constitutes an inverted autonomy of action, a preventive countermovement which chastens and deforms the limbs. In some Romanesque sculptures (as in Souillac, Moissac, and Toulouse) the crossing of the legs is so pronounced that the whole body appears the more vigorous and vehement in its motion. But in Silos the self-entanglement of the figure is extraordinarily effortless, graceful, and aestheticized, in harmony with the feminine contours of the body, the undulant drapery arabesques, and the delicate swelling of the relief.

The immediate historical source of the new posture was undoubtedly France.[156] The earliest Mozarabic manuscripts show, indeed, figures with legs crossed; these, however, are vestiges of late classical postures, not innovations of the Middle Ages. The legs are crossed in the more relaxed and physically motivated manner of pre-Christian art (Fig. 31).[157] For real parallels to these apostles of Silos we must turn to the manuscripts of southern France. A figure in the initial P (Fig. 34) of the first page of the Latin manuscript no. 1822 in the Bibliothèque Nationale, from the abbey of Moissac,[158] a work of the end of the eleventh century, might stand beside Peter and Paul (Fig. 29). They have the same slender bodies, with narrow, rounded, feminine shoulders, crossed legs, and systematically banded draperies, the same effortless, unmotivated movement and detachment. The scalloped contour of the folds of the thigh and hip, which is misunderstood in Silos and prolonged as an ornamental calligraphic form, is more naturalistically conceived in the miniature.[159] The beast that devours the indifferent figure is like the animals on the capitals of Silos.[160] The twisted posture and the foliate tail appear frequently in the cloister. Even the accompanying lines of majuscule writing illustrate the close connection of the Spanish and South French styles. In their superposed letters enclosed by larger capitals and in their monogram-like grouping they resemble the epitaph of Domingo (Fig. 32).[161]

The content of the inscriptions of one of these figures in the Doubting Thomas throws a further light on the un-Mozarabic aspect and the French connections of the Romanesque sculptures of Silos. I refer again to St. Paul (Fig. 29), whose halo is inscribed MAGNUS SANCTUS PAULUS, and whose roll reads NE MAGNITUDO REVELATIONUM ME EXTOLLAT (II Corinthians xii, 7).

Biblical personages are often presented with such rolls in mediaeval art; and even Paul, who is no antetype or predictor and has no part in the dramatic sermons which inspired some images of figures with pro-

phetic inscriptions, frequently bears such a speaking roll.[162] But I have found none with this particular verse. In the Mozarabic lectionary of Silos this chapter of II Corinthians is not cited, although a considerable part of the epistles of Paul is included.[163] Neither on the feast day of Paul nor on the first Sunday after Easter, when the doubt of Thomas was recited, does this portion of II Corinthians appear as a reading in Mozarabic liturgical books.[164]

It is, however, an antiphon sung on the feast of Paul (June 30) in the Roman rite[165] which replaced the Mozarabic in 1081.[166]

The probability that the choice of this verse was indeed dependent on the new Roman liturgy is strengthened by the corresponding Roman origin of the inscription of Paul's halo. "Magnus sanctus Paulus" are the opening words of an antiphon sung in the Roman Church on the feast of Peter and Paul;[167] it was unknown to Mozarabic liturgy, and was probably introduced in Castile with the new rite in the later eleventh century. In the indigenous Spanish service the closest approach to this phrase was "Magnorum apostolorum Petri et Pauli" in the Mozarabic reading for the same day.[168]

The contrast of Paul's greatness and humility was not in itself an invention of the foreign liturgy. What is new here, beside the particular context of the Doubting Thomas (which has already been analyzed), is the specific means of illustrating this contrast, the reference to Roman Catholic liturgy, the use of inscriptions on marginal attributes or extensions of the figure, the halo and scroll. Mozarabic literature knew the same contrast in another form. In the Beatus commentary on the Apocalypse, the name of Paul and an excerpted statement of his lowliness are contrasted, as on the relief in the cloister: "Latine autem Paulus a modico dictus, unde et ipse ait: Ego autem sum minimus apostolorum [I Cor. xv, 9]; quando enim Saulus superius [sic] et elatus, quando vero Paulus humilis et modicus."[169]

These inscriptions of Paul not only confirm the intimate dependence of the sculptures on the historical changes in the Spanish church, but also permit us to infer a *terminus post quem* of the earlier galleries of the cloister. They are probably later than 1081, when the Roman liturgy was adopted in Castile.[170]

The inscription of the relief of the Descent from the Cross (Fig. 1) also points to a foreign source. It is a peculiar, symmetrical leonine hexameter, with disyllabic rhyme and a structure of formally analogous subjects and predicates: HIC OBIT HEC PLORAT CARUS DOLET IMPIUS ORAT. Inscriptions of similar character appear on sculptures, miniatures, and metalwork in Lombardy and Germany,[171] and indicate a common tradition of descriptive tituli in the arts of these regions. The form is especially common, nearer to Spain, in the poetry of western France in the later

eleventh and twelfth centuries, in the works of Hildebert, Marbode, and Geoffrey of Vendôme. Thus Hildebert writes:

"Hic silet, haec fatur; hic supplicat, illa minatur."[172]

This narrative form is ultimately classical and recalls such lines as Ovid's:

"Hac queritur, stupet haec, haec manet, illa fugit."[173]

The Ovidian analogy is all the more relevant, since it is precisely the group of poets mentioned above whose work has suggested to Traube the name "Ovidian" for this moment in mediaeval Latin verse.[174] Some of their poems were in fact long attributed to the pagan writer.[175] These Ovidians of the eleventh and twelfth centuries did not limit themselves to pagan subjects. They composed also short poems to accompany religious images, and among them are several related to the inscription of the cloister.[176] The titulus for a Descent from the Cross by Hildebert has also an iconographic resemblance to the relief in Silos.[177]

The foreign character of the inscription of the Descent from the Cross will be evident also from a comparison with the inscribed epitaph of Domingo in the same cloister (Fig. 32).

> "Hac tumba tegitur diva qui luce beatur
> Dictus Dominicus nomine conspicuus;
> Orbi quem speculum Christus concessit honestum.
> Protegat hic plebes sibi fida mente fideles."

Here a pseudo-leonine form is used; tegitur is paired with beatur, Dominicus with conspicuus, etc.[178] The epitaph was written by a monk of the cloister, Grimaldus, who seems to have maintained an older tradition.[179]

Interesting in this context are also the palaeographic forms of the inscriptions. I shall not undertake at this stage in our studies to distinguish sharply the Mozarabic and Romanesque styles in inscriptions. Several shapes transmitted from the common late classic tradition may be found in both arts; and even modes of arrangement unknown or rare in classical inscriptions, like the enclosing and superposed letters,[180] occur in both Romanesque and Mozarabic writing (Figs. 35 and 36) independently, perhaps derived from a common pre-Carolingian source. Certain uncial forms (CEꟽ) were used in Mozarabic writing before the Romanesque period; but uncial Ͼ in Silos is, I think, a Romanesque innovation.[181] The Mozarabic manuscripts and inscriptions include the square T and also a characteristic Visigothic form, Ɤ, which is common in the manuscripts of Silos (Fig. 36), yet does not appear in the sculptures. This Visigothic form was current among Spanish Romanesque sculptors, for it persists into the twelfth century on the figured columns of the Santiago

altar[182] which are related to the sculptures of Silos. A more specifically Visigothic element found in the inscriptions of Silos is the uncial T with a long descending central leg.[183] It occurs often in the pre-Romanesque manuscripts of Silos.[184]

A remarkable peculiarity of the inscriptions of Silos are the foliate appendages of several of the letters (Figs. 1 and 32).[185] They have been compared with French Romanesque examples of 1148 and later to confirm an attribution of the sculptures to the middle of the twelfth century.[186] But such foliate endings may be found in Mozarabic Latin inscriptions of the tenth and eleventh century in Granada, Cordova, and Málaga,[187] in regions occupied by the Moors. This distribution of the earliest known examples is all the more significant because of the corresponding practice of florid Cufic writing in the East in Arabic inscriptions since the ninth century.[188] It is possible that the Romanesque practice of such forms in stone was suggested by Moslem and Spanish art, though Latin manuscripts in France show a similar foliate elaboration of majuscules since the eighth century. But even if we lacked the earlier Moorish and Mozarabic examples, we could not accept the view that the foliate forms in Silos are necessarily of the middle of the twelfth century. An inscription on a relief from Sahagún, probably made toward 1100, if not a little before, already exhibits the florid appendages of Silos.[189]

It is significant, finally, that the Mozarabic forms in these inscriptions of Silos are, apparently without exception, only such as occur also in French Romanesque inscriptions, or at least (like the uncial M) resemble the latter. The distinctively Visigothic T, the peculiar native ligatures and orthography, are missing.

According to tradition a council held in León in 1091 abolished the native Visigothic-Mozarabic writing and made the French hand mandatory in the service books of the newly Romanized Spanish Church.[190] The ecclesiastical power could hardly overlook in its reform a field like script which was essentially a function of the church and so obvious a mark of the cultural independence of the suppressed rite. How eminent an activity was Mozarabic writing is attested by the extreme fullness and ornamental elaboration of the colophons of Mozarabic scribes, beyond those of any region in Europe. The new script was called French by the Spaniards themselves; in a catalogue of the library of Silos of the thirteenth century there is an item, "dos reglas de letra fransisca."[191] Already in 1080 and 1088 documents of councils held near Silos are written in this French hand,[192] but the native script survives sporadically into the twelfth century.[193] The Romanesque aspect of the inscriptions of the reliefs of Silos is therefore not surprising; it agrees with the elements of the new rite incorporated into the sculptures. And in the same way, the Mozarabic forms in the inscriptions recall the corresponding traditional aspect of the reliefs.

III

Is it not remarkable that in Silos, where the new religious order—the *lex Romana*, as it was called in the documents and chronicles of the period—was probably adopted in 1081, the displaced and no longer canonical writing should be employed up to 1109 in the Beatus manuscript,[194] and that this work should be painted so sumptuously in the style of the Mozarabic church?

There are no published documents which refer directly to the attitude of the monks and abbots of Silos to the liturgical change, or speak of the relations of Silos to the Cluniacs and the French bishops who introduced the new rite.[195] But in the Roman service books of Silos appear the names of Cluniac saints, the abbots Odilo, Odo, and Mayeul,[196] and various saints of southern France.[197] The new church building of Silos was consecrated in 1088 by Peter, archbishop of Aix, and in the presence of the French cardinal, Richard, the legate of the pope in Spain.[198] A priory of Silos, San Frutos, was dedicated in 1100 by the French archbishop of Toledo, Bernard.[199]

Despite the lack of more explicit documents, it is probable that Silos played an active part in the change of religious rule in Castile.[200] The abbey was intimately dependent on the kings of Castile who directly promoted the foreign rite in order to unify the Spanish Church and win the support of the Catholic hierarchy in Italy and France in their own struggles for power. The introduction of the Roman rite, like the restoration of the Benedictine rule and practice whether through Cluny or through local zeal, was simply a step in an already advancing reorganization of religious life. To maintain its place in the changing feudal structure, the monastery was drawn more and more into the secular world. It now had to play an exemplary role, to influence larger and often more antagonistic communities, and, above all, to order its own life as a great proprietor and stabilizing force. The discipline, activity, and rationalized regime of the monasteries in the early Romanesque period derive not so much from the inherent conditions of ascetic piety as from the necessity of adjustment to new economic and social conditions. The new forms of monastic life were indispensable to the existence of the great abbeys.

As one of the leading monasteries in Castile,[201] located in the region of warfare with the Moors on the one hand and with the kingdom of Navarre on the other, Silos was constantly involved in the schemes of the energetic Castilian rulers to extend their power.[202] The abbot Domingo was a refugee from Navarre invited to Castile by the rival king expressly to restore the abbey which had fallen into decay during the Moorish invasions and the anarchy of the local counts. His restoration of Silos was parallel to the rise of the kingdom of Castile; Silos enjoyed several large donations of the victorious kings, mainly agricultural properties which were

intensively exploited for the abbey.[203] In the documents of the time Domingo appears frequently as the councilor of the kings of Castile and as an agent in their political and ecclesiastical affairs.[204] His immediate successors continued this alliance which enriched the abbey and imposed on it the necessity of a model piety and discipline. The period of great constructions in Silos begins with Domingo and continues under Fortunio and his successors into the early twelfth century.

In the councils of Burgos concerning the new Roman liturgy the abbot of Silos was undoubtedly a prominent figure.[205] Domingo had been present at the consecration of the royal basilica of S. Isidoro of León following the victories of Fernando in Seville, a ceremony attended by the French papal legate and other powerful ecclesiastics from southern France.[206]

The canonizing of Domingo and the change of the vocable of the church of Silos from its traditional Sebastian to Domingo after 1076 are also significant of the general shift in Spain.[207] Domingo was a modern saint in his time, not a martyr or pure ascetic; he established the power of his abbey as the kings established their secular power; and even his miracles were contemporary in spirit and related to the economic and political needs of his age. He recaptured runaway Moorish slaves employed in the new agricultural enterprises of the abbey, and rescued Christians who had been captured in the Moorish campaigns.[208] In this he resembled other saints of the time, Domingo de la Calzada, Lesmes, Veremund, Inigo, etc., who engaged in ultimately secular activities, exploiting new lands, building bridges and hospices, and aiding travelers on the newly improved roads.[209] It was an age of great practical abbot-saints, energetic leaders in the material expansion of the church.

How shall we explain then the belated survival of the older Mozarabic art in Silos toward 1100, twenty years after the fundamental religious change, at a time when the Romanesque style was already practiced in the abbey?

The fact is that the great changes in Spanish society during the eleventh century, which till recently provoked historical controversy over their value, their promotion or destruction of a Spanish national spirit,[210] were not accepted in their time by all classes of society in a uniform way, but led to real conflicts of interest. To the degree that the oppositions were national or regional (Spanish Christians against Moors, Castile against Navarre) several classes—the kings and their vassals, the church and the free peasantry—often shared a common interest in the conquest of new lands.[211] But within the Christian kingdoms an internal struggle is evident. The Reconquest as a whole, the establishment of new kingdoms and a centralized state, requiring as they did important economic and political displacements, entailed a break in the older relation-

ships. The lower strata of the nobility, which had often plundered the weak and isolated abbeys, lost their local power with the ascent of the kings and the strengthening of the church; certain elements of the local churches, bishops and abbots, large groups of priests and monks, hostile to a centralized church authority, found themselves subjected to a new liturgy and rule, imposed from above, and their institutions dominated by foreigners more cordial to this change. And the burghers in the cities, with their new codes of individual rights, were often antagonistic to the bishops or abbots to whom they were still bound by feudal obligations.

The documents of the struggles against the new order are relatively few. The canons of Toledo revolted against the French archbishop, Bernard, and the monks of Cardeña against their Cluniac head; petty noblemen even joined the enemy Moors; and in the towns there were struggles between the people and the church. When a French monk in Sahagún, in a court intrigue against the papal faction, supported the king in his momentary resistance to Rome, he could win over, according to the pope, a hundred thousand of the people to repudiate the new liturgy as a foreign form.[212] When the new Roman liturgy was proposed in the 1070s, the whole country was disturbed.[213] Champions of the Mozarabic and Roman cults fought to decide the superiority of cult; but although the native champion won and a trial by fire vindicated the Mozarabic book when the Roman burned,[214] the king of Castile imposed the Roman form as more suited to his needs. The outcome of an older supernatural, juridical test and the wishes of the people could not alter the realistic decision of an ambitious royal power. By strengthening the church, by planting colonists in the reconquered regions and establishing free towns subject to the crown or the church, and by acting as arbiters in the conflicts between citizens and church, the kings consolidated the support essential to their new regime.

The older religious tradition and the interests which sustained it were too strong to be completely dismissed. Besides, the native Christianity was identified with traditions of Visigothic political unity and with a national feeling awakened by this conflict with the Moors and therefore valuable to the rising kings.[215] Hence in the new ecclesiastic scheme, the Mozarabic church was acknowledged in a provision that its liturgy was to be preserved in several parishes and in a single chapel of the cathedral of Toledo, the center of the Roman Catholic primate of Spain.[216] Independently of this concession, monks and priests in various parts of Spain continued for several generations to employ the Visigothic hand and to cultivate the traditions of the older church.[217] In Silos the monks executed the copy of Beatus on the Apocalypse in its traditional script. The content of the book belongs to the old national church. The production of this copy affirms an independent, though weakened, monastic

tradition,[218] and includes lengthy colophons in the spirit of the Mozarabic scriptoria.[219] It is, in fact, to St. Sebastian, the older patron of the abbey, rather than to Domingo, that the book is dedicated.[220] There were still monks who had learned to paint and write in the older style, but their belated practice betrays, in its congealed forms, its increasingly divided and flecked coloring, and in the marginal Romanesque intrusions, the distance from the earlier Mozarabic art.

If Mozarabic design is still a formative element in the Romanesque sculptures, it is a further evidence that these are native works and depend on the recent historical change. The church, because of its character and function and its place in the feudal scheme, could not readily incorporate the new secular values and conceptions or even the practical action of its own leaders as central elements of doctrine. It could compromise with them, adjust itself to them and even use them to maintain its own position; but the ideological importance of the church to the friendly rulers and its influence on the masses of people lay finally in its religious teachings and the claims to transcendence over merely individual or class interests, by which alone it mediated between Christian society and God. Hence the strengthening of the church as a secular power during the Reconquest required also a rigorously supervised renewal of cult and the restoration of old monastic rules. And since the church was the main support of the monumental arts, the newer values emerging in society could be expressed in these arts only in a form qualified by the special interests of the church. The Romanesque forms of church art embody naturalistic modes of seeing (and values of the new aristocracy) within the framework of the church's traditional spiritualistic views and symbolic presentation. The persistence of Mozarabic qualities in the early Romanesque art of Silos may be seen then not only as incidental to a recent cultural transition, but as a positive aspect of the expansive development of the church. That the conservative, emblematic forms of design should be Mozarabic follows from local tradition, from the available forms at the moment of the crucial change, and from the special conditions of this change in Silos. The economic and religious upswing of Silos began in the 1040s almost two generations before the sculptures were carved, at a time when Mozarabic art was still the only art in the abbey and the reform of monastic life had all the appearance of a local restoration rather than an abrupt break with the past.[221] In Silos, unlike the Aragonese abbeys which were submitted directly to Cluny, the reform was largely a domestic work. The abbey was itself a responsive and self-adjusting factor in creating the local conditions out of which the new forms grew. The action of the abbots which prepared the way for a new art took place within the framework of the older culture that was not always directly or immediately affected.[222] In the light of these conditions we can explain

perhaps the special persistence of Mozarabic forms in the Romanesque sculptures.

In the ornament of the cloister, where the religious factor is almost entirely absent, the Mozarabic element is less apparent. Although certain details of their carving recall the late Mozarabic ivories, the Romanesque capitals in the cloister are in type, motifs, and style decidedly different from the capitals in Mozarabic buildings. The common, but incorrect, attribution of the early capitals of Silos to Moorish workmen is to this extent plausible: it recognizes, if only implicitly, the nonchurchly, secular character of the ornament. But this ornament is also distinct from the Moorish in numberless details which I cannot discuss here. The capitals with animals and foliage are a freer secular field of artisanship independent of the doctrine of the church, but finally congenial to the church insofar as its outward dress has become important. The abbey assumes a luxurious, aristocratic appearance as a great proprietor in a hierarchy of social groups of which the highest and the most closely allied, the feudal royalty, acquires at this moment a similar sumptuousness in furnishings and costume. This change corresponds not only to its royal patronage, its new wealth and standards of monastic comfort, but to the increasing elaborateness and aestheticism of liturgical rites.[223] The monks as a class depend on the new hierarchical apportioning of functions in the abbey and on the division of monastic labor; the lay brethren, tenants, and slaves carry on the basic agricultural work, and the regular monks devote themselves to elaborate prayer, procession, and song, as if for their own sakes, in contrast to the early Cistercians for whom the necessary participation of the monk in productive work entailed a rigorous puritanism of outward forms. In the great reliefs of Silos the naturalism and monumentality made possible by the material advances of the time assume a delicate, spiritualized, even feminine form, mobile and individualized in detail, and with a quasi-ritual regularity of grouping that resembles a native Mozarabic tradition.

The physical character and even the location of the Mozarabic and Romanesque works in Silos toward 1100 may be regarded metaphorically in judging the larger historical bases of the two styles. The Mozarabic work is a book, a product of the monastic scriptorium, an intimate work destined for the library and the readings at the services. It is traditional and native, referring to a model of the eighth century created in a primitive, mediaeval, conquered Spain and rarely copied beyond its borders. Its content is Apocalyptic, fantastic, and exegetical, and the paintings are conceived as colorful but static emblems. The Romanesque work, on the contrary, is an exterior architectural sculpture, monumental, expansive, public, designed for ambulant rather than sedentary contemplation; in its stone material it constitutes a novel art, rare in Mozarabic culture, and

only recently reestablished after a lapse of centuries, but an art common to western Europe. It is also international, not merely local, in its iconographic conception, its forms and verse inscriptions. In contrast to the more private, domestic, ritual character of the Mozarabic book, the sculpture is a product of lay artisanship of a high technical order and with a larger element of secular motifs, especially in the numerous ornamental capitals. Instead of the fantasy and abbreviated emblematic forms of the manuscript, tied literally to the text, it offers, beside the exuberant inventions of the capitals, animated scenes, a cycle of epic-narrative character, with deeper reference to the mobility and concreteness of human individuals.

In the same manner we may compare the two arches of the surviving Romanesque portal of Silos, the Mozarabic comprised within the Romanesque, a subordinate doorway silhouetted against the interior of the church; and the salient Romanesque, expanded by the concentric, modeled archivolts and columns, with droll, vivacious, secular figures turned toward the spectator outside the church (Figs. 2, 3, and 33).

NOTES

1. The date of the sculptures is still a highly controversial matter. I have indicated some of the reasons why the palaeographical arguments for a dating before 1073 or in the second quarter of the twelfth century are untenable in *The Art Bulletin*, XII, 1930, pp. 103 ff. The closest stylistic parallels to the sculptures of Silos are to be found in works of the end of the eleventh century (the cloister of Moissac, especially the capitals of the south gallery) rather than in the sculptures of Souillac and of St.-Etienne in Toulouse, which are plastically far more advanced. I have also presented in the course of this article new evidence from manuscript painting and liturgy confirming a date after 1081 and toward the end of the eleventh century. See especially notes 166 and 215 below.

2. Folios 6v, 265v, 275v, 276, 277v, 278. The colophons are published by Férotin, M., *Histoire de l'abbaye de Silos,* Paris, 1897, pp. 265–268. They seem to be contradictory, since two of them state that the manuscript was completed in 1091, and another says that on the death of the abbot Fortunius (who is last recorded, as alive, in an inscription of 1100 in S. Frutos) *minima pars ex eo facta fuit* (f. 275v); but the context of the latter suggests that only the painting was incomplete then, for *ad ultimum vero, tempore Iohannis abbatis, . . . dominus Petrus prior . . . complevit et conplendo ab integro illuminabit . . . era 1147* (1109 A.D.). On f. 198 a painting of the abbot John with a crozier, in the style of the unframed marginal miniatures, also indicates that part of the painting of the manuscript was done not long before 1109.

3. See Whitehill, Walter M., *The Destroyed Romanesque Church of Santo Domingo de Silos,* in *The Art Bulletin*, XIV, 1932, pp. 317, 318, figs. 1 and 5; and Gómez-Moreno, Manuel, *El arte románico español,* Madrid, 1934, pl. CXIX, and pp. 99, 100. On the contemporaneity of the two arches see Gómez-Moreno, *ibid.,* pp. 99, 100. That the horseshoe arch was used in Spanish Romanesque churches in the twelfth century is evident from the example of Porqueras, dated in 1182 (Lampérez, *Historia de la arquitectura cristiana en España,* second ed., II, p. 269). L. Huidobro Serra has supposed, however, that the horseshoe arch in Silos is a relic of a Mozarabic church prior to the elev-

enth century (See *Boletin de la Comision provincial de monumentos historicos y artisticos de Burgos*, VIII, 1929, p. 398). He reports a tradition, recorded in the *Libro de Visita* of Silos in the year 1709 (now in the diocesan archives in Burgos), that when Fernán González conquered Silos in the tenth century, he found there a Christian basilica that must have been Mozarabic, since he mistook it for a Mohammedan mosque and entered it on horseback with his soldiers. When he learned his error, the horses were unshod and the horseshoes placed on the portal as amends for the profanation. The portal survived in this form to 1709. Is not this story perhaps a late legend to account for the horseshoe form in the old buildings of the region? It seems to be an amalgam of familiar elements, the horseshoe hung over doors to bring good luck and the chains of Christian prisoners of the Moors suspended near the tomb of their deliverer, St. Domingo, in Silos.

4. I refer to the two crucifixions in the Winchester psalter, British Museum, Arundel 60, and to the contrast of the prefatory miniatures and the initials in the manuscript of Augustine's City of God in the Laurentian Library, Pl. XII, 17 (Biagi, *Reale Biblioteca mediceo-laurenziana. Reproductions from Illuminated Manuscripts*, Florence, 1914, pls. X–XII, and New Palaeographical Society, *Facsimiles*, Series I, II, pls. 138, 139). The Laurentian manuscript has been regarded by Biagi and the editors of the New Palaeographical Society as a continental work of the late eleventh century, but is more probably, I think, an English work of the early twelfth century related to Canterbury—as will be evident from a comparison of the initials with British Museum, Cleopatra E 1, a register of the See of Canterbury (*ibid.*, I, pl. 60), Cambridge, Corpus Christi College MS. 157 (*ibid.*, pl. 87), and British Museum Vitellius CXII, f. 121 (both from Canterbury); and with Rochester manuscripts in the British Museum (Royal 12 E XX, etc., *Catalogue*, IV, pl. 73c).

5. Folio 2 (Hell), 82v (St. John), 86 (musician and dancer), 59 (angel), 63v (angel), 64 (eagle), 77 (angel), 102 (king), 131 (angel), 163v (St. John), etc.

6. A symptomatic detail in distinguishing the "Romanesque" from the Mozarabic in this manuscript is the drawing of the angels' wings. In the "Romanesque" miniatures the wings are scalloped and imbricated (f. 131)—unlike the stiffer Mozarabic shapes—and approach the wing forms in the sculptures of Silos and in the Beatus manuscript of Saint-Sever (Paris, Bibl. Nat., lat. 8878).

7. It belongs to a gathering—a union of f. 1 and f. 2—physically and textually independent of the Beatus Commentary, but it is possibly related to a lection on the Day of Judgment and to the monastic canons at the end of the manuscript (f. 273–275). (F. 3 is an isolated leaf; f. 4 and 5, 6 and 7, form separate unions, but are decorated in Mozarabic style.) The association of a vision of Hell, like f. 2, with the Apocalypse is not uncommon in the Middle Ages; the *Visio sancti Pauli* is sometimes included in manuscripts of the Apocalypse (cf. Toulouse manuscript of the fourteenth century, published by Meyer, P., in *Romania*, XXIV, 1895, p. 361). [Among the Beatus manuscripts the scene of Hell pictured in Silos is unique as a prefatory page and in content. In the Gerona Beatus (975 A.D.) the painting of Hell on f.17v is part of a miniature representing Christ's Descent into Limbo, which concludes a cycle of Gospel scenes. See Neuss, W., *Die Apokalypse des hl. Johannes in der altspanischen und altchristlichen Bibel-Illustration (Das Problem der Beatus-Handschriften)*, Münster in W., 1931, I, fig. 36 and pp. 130, 131.]

8. See *Mon. et Mém. Piot*, XXI, 1913, pl. XII. The conception of the archangel at the gate of Hell goes back apparently to the eighth or ninth century; cf. an ivory carving of c. 800 in the Victoria and Albert Museum attributed to Tours (Goldschmidt, *Elfenbeinskulpturen*, I, 178), but possibly English, in view of its characteristically Anglo-Saxon Hell-mouth and the insular ornament on its mate (*ibid.*, I, 179). The identification of the archangel with the scales as Michael occurs in the same period as the miniature of Silos on a capital in Chauvigny in Poitou. On a capital in Moissac, the same inscription as in Silos, *S.M.*, is used to designate the angel who puts the devil in the abyss. On the north portal of S. Miguel in Estella (Porter, *Romanesque Sculpture of the Pilgrimage Roads*, ill. 783) Michael appears first in combat with the dragon, then weighing souls and disputing with the devil. Künstle (*Ikonographie der christlichen Kunst*, I, p. 249) is therefore wrong in saying that the inscription of Michael's name in Chauvigny is simply

an error of the ignorant sculptor. It is evidently traditional in southern France and in Spain. Cf. also Didron, *Christian Iconography,* London, 1886, II, pp. 178 ff. and fig. 217, for other examples of Michael as the angel who weighs souls.

9. Cf. the Matthew symbol on the tympanum of Moissac (Porter, *Romanesque Sculpture of the Pilgrimage Roads,* ill. 340), the Isaiah in Souillac (*ibid.,* ill. 344), the "Jeremiah" of Moissac (*ibid.,* ill. 363), and figures in Toulouse (*ibid.,* ill. 310, 440) and Cahors (*ibid.,* ill. 429) [the illustrations of Moissac (Figs. 95, 132) and Souillac (Fig. 6) are reprinted here]. The type is also common in the manuscripts of Limoges (Paris, Bibl. Nat., lat. 8, 1987, etc.). For a Spanish example contemporary with the Silos miniature, cf. the drawing of bishop Arnulfus, reproduced by Porter in *Burlington Magazine,* March, 1928, pl. VI D, opp. p. 127.

The crossed legs of Michael in Silos may have been suggested by the analogy to the ruler or judge who at this time is often shown with legs crossed to symbolize his deliberation or judicial function.

10. The peculiar interlacing of the mantle and the left arm of Michael appears in the elders of the tympanum of Moissac (see *The Art Bulletin,* XIII, 1931, Figs. 100, 101 [reprinted here, Figs. 100, 101]). For Spanish examples, cf. the initials in the *Diurno* of Sancho, 1055 (Gómez-Moreno, *op. cit.,* pl. IV, lower right) and in a manuscript from S. Millán de la Cogolla (*ibid.,* pl. XV a), undoubtedly influenced by French art. Also significant for the Romanesque character is the conception of the silhouette of Michael as an emphatically scalloped form analogous to the curves of the quatrefoil of Hell (cf. the portal of Moissac, *The Art Bulletin,* XIII, 1931, p. 523 and Figs. 129, 131 [reprinted here, Figs. 129, 131]).

11. Observe in the silhouette of Dives how the projections of the feet, the moneybags, and the serpents are progressively larger and more curved, and give the whole mass an insectlike or crustacean form.

12. The reproduction is not faithful to the values of the original painting and therefore distorts the compositional accents. [The page is reproduced in color in a series of postcards with minatures of the Beatus manuscript, published by the British Museum—C. Mss. 19.]

13. The choice of yellow for the miser, the scales, and the lovers' bed was perhaps symbolic. I have not been able to find any texts of the same period supporting such a symbolism (for the theological color symbolism of the Middle Ages, see Braun, J., *Die liturgische Gewandung,* pp. 728–760; and for secular views, see Bartholomaeus Anglicus, *Liber de proprietatibus,* lib. XIX, cap. viii ff., who speaks of colors as expressing the passions, but in a physiological sense, the face being pallid or red according to the emotions; also Petrus Berchorius, (*Reductorium morale,* lib. XIII, in *Opera,* Antwerp, 1609, III, p. 559). E. A. Wallis Budge (*Amulets and Superstitions,* London, 1930, p. 487), in listing colors of evil, includes orange as luxury, yellow as avarice, but gives no reference to texts or images. For yellow as a color of evil and symbol of money in folklore, see the *Handwörterbuch des deutschen Aberglaubens,* s.v. "Gelb," pp. 575 ff. A sixteenth-century writer, Alciati (*Emblemata,* Leyden, 1591, no. cxvii, pp. 431, 432) says on colors: "Est cupidis flavus color, est et amantibus aptus. Et scortis, et queis spes sua certa fuit. . . ."

There is in the text of the Silos Beatus one interesting example of color symbolism. On fol. 125v a rectangle in solid yellow illustrates the passage on the half hour of silence in heaven. Here, as Francis Wormald suggests to me, silence is golden. But it may be said that in general there is no fixed symbolism governing the choice of colors in the Mozarabic manuscripts, with a special denotation for each color.

14. As in the Bible from Montpellier in the British Museum (Harley 4772), and in manuscripts from Limoges.

15. The distribution of yellow and blue on Dives is also symptomatic of the Romanesque taste and method of design. It is based on an X scheme more arbitrary with respect to representational values than any I could find in the Mozarabic pages. The right hose of Dives is yellow, the left, blue; the right shoe is blue, the left, yellow. This crossing is hardly naturalistic, but a formal manipulation related to the crossed legs and other chiasmic devices in Romanesque works in southern France. It appears again in the Silos manuscript on fol. 86 in the two jongleurs already cited as Romanesque (Fig. 9). In the

left figure, the shoes are green, the hose, yellow and the tunic, green; in the right, the shoes are yellow, the hose, green and the tunic yellow. The rigor of this X pattern is broken by the blue of the knife, the green and purple (dense red dots on blue) of the bird, the purple of the under surface of the left tunic, the yellow of the instrument.

Also characteristic of the color system is the arbitrary division of the quatrefoil of Hell and the general distinction between the qualities of this inner frame and its contents. In the quatrefoil, each lobe has its own central color band, red on left and right, green above, and blue below; but all of these lobes are bordered by yellow within and without. The enclosure is warm in contrast to the cool figures of the field, just as the strictly concentric and quartered bands of the frame are contrasted with the fluid, dispersed elements inside.

16. Cf. the south transept portal of St.-Sernin in Toulouse, and the portals of Moissac, Beaulieu, and Ste.-Croix in Bordeaux.

17. In Santiago and in S. Isidoro of León, but not juxtaposed as in southern France. The oldest Spanish example of Luxuria known to me is a capital in the Panteón of León, 1063; the oldest Avarice, a capital in Iguácel, dated 1072.

18. That is, to artistic tradition. These two vices were already isolated in theological commentary (as in Paul, *Colossians*, iii, 5, "Mortificate . . .") in the early Middle Ages. In one instance (*Allegoriae in universam sacram scripturam,* falsely attributed to Rabanus Maurus, but probably of the same period (see Wilmart, *Revue bénédictine*, 1920, pp. 47–56), they are associated with the twin matters of punishment in Hell, fire and water, which are mentioned in the inscription of our miniature (see below, at note 66)—"Aqua cupiditas saeculi, ut in Evangelio 'eum in ignem et in aquam misit, ut eum perderet' (Matt. xvii, 15, Mark ix, 22), quod diabolus eos, quos possidet nunc ardore luxuriae concremat, nunc sorde cupiditatis foedat, ut eos perdat" (Migne, *Pat. lat.,* CXII, 860). Avarice and Unchastity are juxtaposed in the glossed penitential from Silos, British Museum, Add. MS 30853 (tenth or eleventh century)—VIII, *De cupidiis,* IX, *De diversis fornicationibus* (see R. Menéndez Pidal, *Origenes del Español*, in *Rivista de filologia española, Anejo* I, 1929, p. 18). A synod in Gerona in 1078 also unites these sins—"Concubinarii vero et usurarii, nisi resipiscant, excommunicentur" (Migne, *Pat. lat.,* CLV, 1644, no. IX); and the Gascon troubador Marcabru, who lived in Spain, in listing the sinners destined to Hell, couples "the lustful and avaricious who live by noisome trades" (poem XL, ed. Dejeanne, 1909). A Spanish writer of the second quarter of the twelfth century, Peter of Compostela, in presenting the vices, selects Luxuria, Avaritia and Gula in the order named. He calls avarice the sister of luxury and the mother of usury. See Soto, P. B., *Petri Compostellani De consolatione rationis libri duo,* in *Beiträge zur Geschichte der Philosophie des Mittelalters,* VIII, Heft 4, Münster, 1912, pp. 78, 79. There are also found together in Spanish mediaeval manuscripts two poems by Adam Clericus against money (nummus) and against woman (published by J. Amador de los Ríos, *Historia de la literatura española,* Madrid, 1865, II, pp. 355–357).

19. See Stettiner, R., *Die illustrierten Prudentiushandschriften,* Berlin, 1895.

20. The emptying moneybags of Dives recall the same motif in the Prudentius miniatures (cf. Stettiner, *op. cit.,* pl. 7), where the bag of Avaritia is emptied for the poor by the victorious Largitas. But the conception in Silos was based more likely on the Biblical texts, frequently cited in the Middle Ages, on the vanity of riches. Cf. Job xx, 15, 20— "Divitias, quas devoravit, evomet, et de ventre illius extrahet eas Deus" (15), and "Nec est satiatus venter eius, et cum habuerit quae concupierat, possidere non poterit." These two passages are all the more interesting for the miniature since Job xx, 16 refers to the serpent: "Caput aspidum suget et occidet eum lingua viperae," and since another passage from Job (xxiv, 19) is actually inscribed in the miniature (see above, p. 41). In the later mediaeval images of Frau Welt, coins fall out of the beltlike serpent around her waist (see Saxl, in the *Festschrift für J. Schlosser*, 1927, pp. 104 ff.). Another Biblical passage relevant to the same idea is Ecclesiastes v, 9—"Avarus non implebitur pecunia: et qui amat divitias, fructum non capiet ex eis: et hoc ergo vanitas." It was quoted together with Sirach x, 13—"Cum enim morietur homo, hereditabit serpentes, et bestias et vermes"—and Paul's "neque sperare in incerto divitiarum," apropos of the rich man or miser (cf. Halitgarius, *De octo principalibus vitiis,* Migne, *Pat. lat.,* CV, col. 665). Mr. Benjamin Nelson

suggests to me that the emptying moneybags may indicate more specifically the instability of *money* wealth, a common charge of religious and feudal critics of the merchant class.

21. For the central Superbia in the group of vices, cf. Fig. 12, a drawing in a manuscript of the early eleventh century from Moissac, Paris, Bibl. Nat., lat. 2077, f. 163 (Halitgarius, *De octo principalibus viciis et unde oriuntur*).

Such shifts in the cataloguing and illustration of vices are characteristic in both antiquity and the Middle Ages. In the oldest Greek records, the chief vices listed are disobedience or lack of piety to parents and the older brother; violations of hospitality, oath, and family laws are the gravest misdeeds; at the end of the fifth century, treason to the state is the worst vice; avarice and unchastity are stressed in very late writings, especially among the Stoics (see Dieterich, A., *Nekyia*, 2nd ed., 1913, pp. 163 ff.) For the general variations in catalogues of the vices in the Middle Ages, see the detailed study by Marie Gothein, *Die Todsünden, Archiv für Religionswissenschaft*, X, 1907, pp. 416–484; in her analysis of the numerous lists and citations, she neglects, however, the significant changes in the accent on Superbia or Avaritia as the chief vice. Early Christianity, following Hellenistic tradition and Paul, taught that "radix enim omnium malorum est cupiditas" (I Tim. 6, 10). But after the sixth century pride replaced avarice in the same Pauline formula—"radix vitiorum et malorum omnium superbia" (Gregory, *Moralia in Job,* Migne, *Pat. lat.,* LXXVI, col. 744), and dominated the catalogues of vices in monastic literature. The *De Coenobiorum Institutis* of Cassian, which was widely read in the monasteries (there was an eleventh-century copy in Visigothic script in Silos—Paris, Bibl. Nat., Nouv. Acq. lat. 260), in listing the vices, says of Superbia: "origine et tempore primus est" (Migne, *Pat. lat.,* XLIX, col. 421, 422); Isidore writes: "principalium septem vitiorum regina et mater superbia est" (*Sententiarum liber* II, *ibid.,* LXXXIII, col. 639). For this change a Biblical authority could be cited—Sirach x, 15, "initium omnis peccati superbia" (cf. Alcuin, *Liber de virtutibus et vitiis, de octo vitiis principalibus et primo de superbia,* Migne, *Pat. lat.,* CI, col. 632). Early monastic writers sometimes link Pride with Unchastity as the chief vices (cf. Odo, abbot of Cluny, c.930–940, *Collationes, ibid.,* CXXXIII, col. 528 ff., 554), a connection which survives into the twelfth century, as in a manuscript by an English nun, c.1100 (Bodleian MS. 451) which begins a treatise on the vices thus: "De superbia et fornicatione. Principaliter his duobis vitiis . . ." Because of the persistence of feudal institutions and the varying local relations of aristocracy, church and middle class in the later Middle Ages, avarice never replaced pride completely as the greatest vice, but the two dominate variably according to circumstances and conflicts. A contemporary of the artist of Silos, Guibert of Nogent, whose hostile description of the commune of Laon is classic ("communio autem novum ac pessimum nomen," Migne, *Pat. lat.,* CLVI, col. 922), also speaks of avarice as "propagatrix vero totius malignitatis quasi infiniti populi," *ibid.,* col. 156). The feudal sense of pride as the chief vice is clearly illustrated in a miniature in the Hortus Deliciarum of Herrade of Landsberg (ed. Straub and Keller, pl. XLIII; ed. Engelhardt, pl. II) showing the different vices in battle with the virtues. Only Superbia is mounted; she wears a turban (cf. the later Frau Welt, whose vice of Superbia is located in the turbaned head) and sits on a lion skin. The Carolingian writer, Theodulf, describing the vices, also speaks of her as "dux harum" (*Carmina* II, 11). Especially interesting examples of the later monastic conception of pride as the source of all the vices are the stemmatic illustrations in the late twelfth and thirteenth century manuscripts of the Speculum Virginum of the Cistercian Conrad of Hirsau—Berlin, Staatsbibliothek 73, from Igny, and Troyes, Bibliothèque municipale 252, f. 29vo, from Cîteaux.

22. Andreas Capellanus, in listing the twelve principles of love, begins: "Avaritiam sicut nocivam pestem effugias et eius contrarium [sc. largitatem] amplectaris." (*Andreae Capellani regii Francorum, De amore libri tres,* ed. E. Trojel, 1892, p. 106). Cf. also the troubador Marcabru: "for he has his heart below his navel, the baron who demeans himself for money" (poem XXXVIII, ed. Dejeanne, 1909). The critique of the bourgeois in terms of an inherent incompatibility of avarice and love persisted up to the beginning of the twentieth century. But the independence of the merchant as an individual with greater freedom of movement, not tied like a peasant or petty nobleman to a fixed piece of land, was also favorable to Luxuria. The common libertine values of the aristocracy and the

merchants in the cities underlie the anecdote of Etienne de Bourbon concerning a count of Poitiers (identified by modern scholars with the poet, William of Aquitaine, a contemporary of the artists of Silos), who had tried various professions in disguise in order to compare their pleasures; he would have given the palm to the merchants at the fairs, "qui intrant tabernas . . . ," if there had not followed the cruel necessity of paying the bills. (See A. Jeanroy's edition of the poems of Count William, p. x.)

23. Cf. the sermon of Jacques de Vitry addressed "to the bourgeois," in which he attacks them as usurers and identifies the communes with usury (A. Luchaire, *Les communes françaises à l'époque des Capétiens directs,* Paris 1890, pp. 242–244). The unChristian character of money wealth is implied in the verses of Peter, a canon of St. Omer, contemporary with the Silos painting—"Denarius regnat, regit, imperat, omnia vincit . . . Quisquis habet nummos, Jupiter esse potest"; and in the poem of Adam Clericus mentioned above (note 18)—"In terra summus Rex est hoc tempore nummus." Cf. also the Goliardic quatrain—"Jupiter dum orat Danaem, frustra laborat; Sed eam deflorat Auro dum se colorat." The verses of Peter of St. Omer were paraphrased in the Hortus Deliciarum of Herrade of Landsberg beside the miniature of the Expulsion of the MoneyChangers from the Temple. Here there is a figure of a merchant labeled Judas Mercator, with a purse at his waist, a coin in the right hand and scales in the left. The text reads: "Judas mercator pessimus significat usurarios quos omnes expellit Dominus, quia spem suam ponat in diviciis et volunt ut nummus vincat, nummus regnet, nummus imperet." (ed. Straub and Keller, pl. LX, p. 46). Also excluded from the temple are two embracing lovers labeled "Fornicator eicitur qui amat iuvenculam."

There is an almost literal echo of such mediaeval criticism of money wealth in Balzac, who speaks of "l'omnipotence, l'omniscience, l'omniconvenance de l'argent" (Nucingen). The bourgeois Crevel in *La Cousine Bette* hails "la sainte, la vénérée, la solide, l'aimable, la gracieuse, la belle, la noble, la jeune, la toute-puissante pièce de cent sous!" The dependence of love on money, their antagonism to feudal-Christian morality, is one of the constant themes of Balzac who describes the bourgeois triumphant over the landed aristocracy, just as Peter of St. Omer describes, from the viewpoint of the church, the primitive emerging bourgeois. As the wealth of the church increases with the economic growth of society, the church is subject to the same criticism: in an acrostic of the twelfth century the first letters of *Radix Omnium Malorum Avaritia* spell out ROMA (cf. Dobiache-Rojdestvensky, Olga, *Les poésies des goliards,* Paris, 1931, pp. 76 ff.).

24. As in Moissac and Toulouse. In Vézelay there are capitals of Lazarus and Dives and of Unchastity inside the church. The story of Lazarus and Dives is also carved on the portal of S. Vicente in Avila. On the importance of money wealth in Silos, see note 128 below.

25. Cf. Hefele, *Conciliengeschichte*[2], 1886, IV, p. 691 (Bourges 1031), and p. 789 (Toulouse 1056); V, p. 116 (Poitiers 1078), p. 223 (Clermont 1095), and p. 245 (Nîmes 1096); and nearer to Silos, the council of Burgos in 1080—*ibid.,* p. 158. In Burgos, two bishops had recently been deposed for simony (see Serrano, L., *El Obispado de Burgos y Castilla primitiva desde el siglo V al XIII,* Madrid, 1935, I, pp. 272, 316), and the Roman church had led a campaign against clerical marriage and concubinage, practices which depleted the church economically and weakened its moral prestige. But if the images of Avarice and Unchastity in the manuscript of Silos referred to these vices within the church itself, they would quite show other attributes. The simonists attacked by the church were kings, nobles, and higher churchmen who sold episcopal offices, not the merchants or burghers shown in Romanesque images of Avarice. Simony was more likely to be symbolized in a theological manner through the figure of Simon Magus (who offered money to Peter for the power to lay on hands—Acts viii, 20; see the citation by Atto of Vercelli in Migne, *Pat. lat.,* CXXXIV, col. 71). He appears between devils and is contrasted with Peter, the true church, in a sculpture in St.-Sernin in Toulouse (Porter, *op. cit.,* ill. 318) and a wonderful capital in Autun (*ibid.,* ill. 73, 75). In a fifteenth-century German manuscript, Casanatense 1404, f. 31r, discovered by Saxl, Simony is personified in a miniature by Ecclesia Vacans, next to which is a wagon led to the jaws of Hell by Cecitas Mentis; in the wagon are Acceptor and Collector, whom the devil inflates with five bellows (*Festschrift J. Schlosser,* 1927, p. 120).

26. Miguel Asín Palacios observes, after d'Ancona, that the literary visions of Hell in the West before the eleventh century are relatively poor and abstract, whereas after the eleventh century a new type of description arises, more detailed and concrete (*Dante y el Islam,* Madrid, 1927, p. 194). He asks how this could come about. Ignoring the internal development in Christian Europe and the corresponding changes in its secular literature, map making, and plastic imagery, he attributes the new fullness of descriptions of Hell simply to the direct influence of Islam. See also note 33 below.

27. Miss Georgiana King has attempted to derive the lovers in bed from Oriental art, by reproducing a similar group from a Persian manuscript of the seventeenth century (see her *Divagations on the Beatus, Art Studies,* 1930, p. 39 of the offprint and pl. VI). But the context is entirely different here, and the lovers in bed are too common in Christian art, Greek and Latin, to require such an hypothesis. Cf. the Vienna Genesis (ed. Wickhoff, pl. X), the English psalter in Munich (Clm. 835, f. 20v), the Egerton Genesis in the British Museum (published by M. R. James), etc. Actually the same conception as in Silos appears in an early fourteenth-century painting of the Last Judgment in S. Maria del Casale in Brindisi (Toesca, *Storia dell' arte italiana,* III, 1, 2, p. 968, fig. 667). Here, too, the lovers are near the archangel with the scales; and there is even a figure of Avarice.

A good example of bourgeois realism in rendering Luxuria and Avaritia is British Museum, Add. MS. 27695, a Genoese work of the later fourteenth century. Luxuria is illustrated by a bed scene and Avaritia by a transaction in the interior of a money-lender's shop.

28. The animals at his feet are six-legged, but they resemble (in other respects) the toads, which accompany serpents, in the illustration of Hildegard of Bingen's vision of Hell (Liebeschütz, H., *Das allegorische Weltbild der heiligen Hildegard von Bingen,* 1930, pl. VI). They recall also the frogs in the illustrations of the fable of Jupiter and the frogs in the Leyden Aesop from Limoges, a manuscript of c.1025 (Thiele, G., *Der illustrierte lateinische Aesop der Hs. des Ademar,* Leyden, 1905, pl. VII), although different from the frogs on f. 178v of the Silos Beatus. It is possible that the Spanish artist has confused the eschatologically cognate types of the scorpion, toad, and tortoise which are rendered so vaguely in provincial and folk art of late antiquity and the early Middle Ages. The scorpion, especially, appears six-legged.

29. Cf. the torment of the usurers in the *Visio sancti Pauli,* published by M. R. James after a manuscript of the eighth century: "et vidi . . . flumen repletum multitudine virorum et mulierum et vermes comedebant eos" (*Apocrypha Anecdota,* in *Texts and Studies,* ed. by J. A. Robinson, II, no. 3, Cambridge, 1893, p. 30). Cf. also the Gerona Beatus (f. 17v) for serpents biting sinners in the scene of the Anastasis. On a Biblical source of the serpents and other beasts tormenting the miser, see note 20 above.

30. Musée des Augustins, no. 653 (?). On a capital in the south aisle of Vézelay, a serpent spans the two purses hanging from the bed of the dying Dives.

31. There is, however, a mediaeval tradition of the toad as the tormentor of Avarice. See Sébillot, P., *Le Folk-Lore de France,* III, 1906, p. 295, who cites an anecdote of Etienne de Bourbon about a toad which attacks the face of a miser. Caesarius of Heisterbach (*Dialogus Miraculorum,* XII, 18) speaks of a usurer who lives in Hell on toads and snakes cooked in the sulphurous flames. The toad has also a prominent place in Brueghel's drawing of Avaritia in London (Tolnai, *Die Zeichnungen Pieter Bruegels,* 1925, pl. 30).

32. For examples of *Luxuria,* see the list in Mâle, *L'art religieux en France au XIIe siècle,* 1922, pp. 375, 376. In Spain there are examples in Santiago, León, S. Isidoro de Dueñas, etc. An example in a relief in Monopoli in southern Italy (c.1100) is associated with sculptures of the Marys at the Tomb and the Descent from the Cross related iconographically to the reliefs in the cloister of Silos and stylistically to South French art. There are examples of *Avaritia* in Clermont-Ferrand, Brioude, Ennezat, Orcival, St. Nectaire, Conques, Vézelay, Albi, Moissac, Toulouse, Iguácel, Loarre, León, Santiago, Sta. Marta de Tera, etc.

33. Cf. Miguel Asín Palacios, *La escatología musulmana en la Divina Comedia,* Madrid, 1919, p. 132 (miser and serpent), 255, n. 1 (miser with purse around neck), 357, 364 (serpent and adulterous woman, serpent and bad mother); also his *Dante y el Islam,*

1927, p. 114 (miser). Asín neglects, however, the possibility that the Moslem and Latin conceptions descend from a common Near Eastern tradition; the *Visio sancti Pauli,* cited in note 29 above, is based on a Greek text older than Islam. See on this point Silverstein, Theodore, *Visio Sancti Pauli* in *Studies and Documents,* ed. by Kirsopp and Silva Lake, IV, London, 1935, pp. 17, 18. Asín refers the Psychostasis in Romanesque and Gothic art to Moslem eschatology, but it is well known that this is a common old Oriental conception, familiar to classical antiquity and the church fathers and represented in mediaeval art since the tenth century (see Perry, M. P., *The Psychostasis in Christian Art,* in *Burlington Magazine,* XXII, 1912–1913, pp. 95–105, 208–218). The fact that the psychostatic angel in the Islamic Last Judgment is Gabriel, whereas Michael is specified in Silos and elsewhere (see note 8 above) in Romanesque art also confirms the Christian and independent character of the version in Silos. What is peculiar in Silos is the direct combat of Michael and the devil, a detail that occurs also in Armenian art (miniature in Sevadjian collection, reproduced by Tchobanian, *La Roseraie d'Arménie,* I, 1918, pl. opp. p. 32) and in an English Romanesque manuscript, British Museum, Harley MS. 624, f. 134 v. [In a miniature of the Last Judgment in Paris, Bibl. nat. gr.74, f. 51v (ed. by H. Omont, *Evangiles avec peintures byzantines du XIe siècle,* Paris, n.d., pl. 41), two black, winged demons contend with the angel who holds the scales.]

34. The term *Mozarabic* is used here, not in the literal sense of Christians in or from Moorish territory, but in the broader sense of the art historians (cf. Gómez-Moreno, M., *Iglesias mozárabes,* Madrid, 1919), to designate the pre-Romanesque Christian arts and culture of León, Castile, and the South of Spain after the Moorish invasion, and works produced outside these regions but showing the qualities or types of the latter. These arts are essentially a development based on Visigothic art and, although they include Moslem elements, are less "Arabic" or Moslem than is often supposed. On the relative paucity of Moslem influences in Castile see Menéndez- Pidal, *Origenes,* p. 504. For examples of Christian-Moslem relations in Silos, see note 188 below.

35. The great period of translation followed the conquest of Toledo in 1085, not because Arabic science for the first time became physically accessible to Spanish Christians, but because of the favorable development of Christian society and culture at that moment. Similarly, the advance in the technique of ivory-carving in the middle and the second-half of the eleventh century, if influenced by Moorish art, depends also on the internal changes in Christian Spain: otherwise how explain the far more primitive technique of the Christian carvings during the tenth and early eleventh centuries when contact with the Moors was certainly very close, as is evident from architecture?

On the special assimilation of Moslem and foreign European luxury in the later eleventh century in Spain, under the stimulus of the new power of the royalty, see Ballesteros, A., *Historia da España,* II, pp. 547–550.

36. For its inscription on gnostic gems, see Schwab, M., *Vocabulaire de l'angélologie,* in *Mémoires de l'Académie des Inscriptions et Belles-Lettres,* X, 1897, p. 392; Cabrol, *Dictionnaire d'archéologie et de liturgie chrétienne,* II, 1, col. 478; for the names Baribas, Thobarrabas and Tobarrabas in magic and gnostic writings, gems and inscriptions, see Delatte, A., *Etudes sur la magie grecque, Bulletin de Correspondance Hellénique,* XXXVIII, 1914, p. 202. Also common as a demonic name in magical papyri is Barbarioth (Preisendanz, K., *et al., Papyri graecae magicae,* I, 1928, p. 71). In later literature, the Barabbas of Matthew xxvii is identified with Antichrist (cf. Isidore, *Allegoriae quaedam scripturae sacrae,* Migne, *Pat. lat.,* LXXXIII, col. 129). Barabio is a devil-name in Piedmontese dialect (cf. *Mélusine,* VI, p. 30). According to Pierre Delancre (*Tableau de l'inconstance des mauvais anges,* Paris 1612, c. VI, disc. 3) sorcerers brought before justice pretend to renounce the devil and call him disdainfully Barrabas (cited by Collin de Plancy, *Dictionnaire des sciences occultes,* 1846, I, p. 178).

37. Cf. the *Pistis Sophia:* "And Adamas the great tyrant . . . began to war without cause against the light" (translated from the Coptic by George Horner, with introduction by F. Legge, 1924, p. 12). I owe this suggestion to Professor S. Eitrem of Oslo, who conceives of the *Ra* as a prefix, as in the angelic names Rathagael, Rabaphael, Raphael, etc. (Professor Louis Ginzberg surmises that it might be from the Hebrew *Ra* = bad). On the Manichean good genius, Adamas, cf. Cumont, F., *Adamas génie manichéen,* in *Philologie et Linguistique, Mélanges offerts à Louis Havet,* Paris 1909, pp. 79–82.

38. The conjunction with Radamas at first suggested that the two names were possibly corruptions of Rhadamanthys and Aiakos, the judges of the Greek underworld, but I have been assured by philologists that such a derivation is improbable (although the idea of a crossing of Rhadamanthys and Adamas to form Radamas might be entertained). Neither Aqimos nor a plausibly related name appears in the extensive list of Semitic demons and angels published by M. Schwab (*op. cit.*). Aqimos recalls Chemosh, the Moabite idol (Numbers xxi, 29; Jeremiah xlviii, 7) identified with Beelfegor by Rabanus in his commentary on Jeremiah; Acham, a demon of Thursday in sorcery (Collin de Plancy, *Dictionnaire infernal*, Brussels, 1845, pp. 14, 161); and Agrimus, the first-born of the demons in Jewish folklore (Louis Ginzberg, *Legends of the Jews*, I, p. 141). My friend, Professor Ralph Marcus, suggests a possible source in Arabic *Aqîm*—childless, barren, especially since Aqimos is the demon of unchastity. [On Rhadamas as possibly the original name of the underworld god Rhadamanthys, see Jessen in Roscher, *Lexikon*, IV, 85.]

39. Achamoth would be known in the Middle Ages through the writings of Tertullian (Migne, *Pat. lat.*, II, cols. 68, 568, 571 ff). [In Beatus's commentary on Rev. 13:18 (lib. VI, 90, 106–108), with reference to the diabolical Beast whose number 666 spells his name, eight names are constructed, in each of which the sum of the letters as numerals equals 666. The final one is ACXYME (in the Beatus Apocalypse of Saint-Sever it is written AXIME). The third name is ANTEMUS, which is interpreted by Beatus as "abstemius," from "a temeto, id est, vino, quasi abstinens a vino"—perhaps an allusion to Islam. For the text and its variants see Sanders, *Beati in Apocalypsin libri XII*, Rome 1930, pp. 499–500). If the sign ꝙ in the inscription AꝙIMOS is the majuscule T in Visigothic script, as now seems to me the more likely reading, the demon Atimos may be connected with the Antemus of the Beatus commentary, though the connection with the form and context of the figure remains obscure. Haimo of Halberstadt, a Carolingian author, in his commentary on the Apocalypse, interprets "Antemos" as "honori contrarius, quod nomen illi bene convenit, qui Antichristus (id est, Christo contrarius) dicitur"—*Pat.lat.* CXVII, col. 1102.]

40. For demonic names in Spanish Early Christian literature, see notes 46 and 47 below. Professor M. Asín Palacios has written me that he has not come upon Radamas or Aqimos in Moslem literature. The physical resemblance of the dark bestial demons in the miniature of Silos to the demons in Moslem painting (cf: Arnold T., *Painting in Islam*, pp. 89, 109; Blochet, E, *Les peintures des manuscrits orientaux de la Bibliothèque nationale*, p. 275 and pls. 27, 29) need not imply a direct connection; these types were common in Christian literary tradition since the early middle ages. (On the character of demons in early Christian and mediaeval literature, see Migne, *Pat. lat.*, Index, II col. 43–50.) There are Mozarabic parallels in the Gerona Beatus (975)—Neuss, W., *Die Apokalypse des hl. Johannes in der altspanischen und altchristlichen Bibel-illustration*, Münster i.W., 1931, II, fig. 36.

41. An evidence of the survival of pagan traditions in Silos in the eleventh century is the account of an antique bronze head of Venus which had belonged to an idol still honored on a neighboring mountain; her sanctuary was destroyed by the abbot Domingo and the bronze head was attached to a votive crown of gold which Domingo placed above the altar of his own church (Férotin, *Histoire*, p. 40, n. 3).

The existence of pagan magical practices in Spain in the eleventh century is well attested by the decrees of councils condemning sorcerers, augury, incantations, etc., especially the councils of Coyanza (1050) and Santiago (1056), and by passages in the poem of the Cid and the versified life of S. Domingo by Berceo (see Menéndez y Pelayo, *História de los heterodoxos españoles*, 2nd ed., Madrid, 1917, III, p. 326 *et passim*).

The new book by Stephen McKenna, *Paganism and Pagan Survivals in Spain*, Washington, D. C., 1939, was not available to me when this article was completed.

42. For evidences of Moslem contacts with Silos, see note 188 below.

43. Cf. the frequently quoted passages of Helinand of Froidement, a writer of the early thirteenth century: "Bononiae codices, Salerni pyxides, Toleti demones, et nusquam mores," and of Rabelais on the "révérend père en diable, Picatris, recteur de la faculté diabologique" at Toledo (*Pantagruel* I, iii, 23). *Ars* or *scientia toletana* has been the name for magic since the twelfth century. On the traditions concerning demonology and

occultism in Toledo see Waxman, S. M., *Chapters on Magic in Spanish literature, Revue Hispanique*, XXXVIII, 1916, pp. 325–366, and Menéndez y Pelayo, *op. cit.*, III, *passim*. Spanish writers of the late eleventh and twelfth century, Pedro Alfonso, a converted Jew, and Gundissalino, include occultism among the liberal arts and sciences (see Thorndike, Lynn, *A History of Magic and Experimental Science*, New York, 1923, II, pp. 72, 79, 80).

44. See Thorndike, *op. cit.*, II.

45. See Menéndez y Pelayo, *op. cit.*, II, *apéndices*, pp. cvii ff. for the texts, and García Villada, Z., *Historia eclesiástica de España*, I, Madrid, 1929, pp. 77 ff.

46. Ep. 75, to Theodora, Migne, *Pat. lat.*, XXII, col. 687: "Et quia haereseos semel fecimus mentionem, qua Lucinius noster dignae eloquentiae tuba praedicari potest? qui spurcissima per Hispanias Basilidis haeresi saeviente, et instar pestis et morbi, totas intra Pyrenaeum et Oceanum vastante provincias, fidei ecclesiasticae tenuit puritatem, nequaquam suscipiens Armagil, Barbelon, Abraxas, Balsamum, et ridiculum Leusiboram, caeteraque magis portenta, quam nomina, quae ad imperitorum et muliercularum animos concitandos, quasi de Hebraicis fontibus hauriunt barbaro simplices quosque terrentes sono; ut quod non intelligunt, plus mirentur."

47. In his *Liber Apologeticus*: "anathema sit qui Saclam, Nebroel, Samael, Belzebuth, Nasobodeum, Beliam, omnesque tales, quia daemones sunt." (*Corpus Script. Eccl. Lat.*, XVIII, p. 17; and Menéndez y Pelayo, *op. cit.* II, *Apéndices*, pp. xv, xxi, xxx). In the same work he repudiates also the demons named by Jerome: "neque Armaziel . . . Mariam, Ioel, Balsamus, Barbelon, deus est." Isidore, however, speaks of him as the pupil of the gnostic, Mark of Memphis, who was a magician and a disciple of Mani (*De viris illustribus* cap. xv, Migne, *Pat. lat.*, LXXXIII, col. 1092). In this he repeats a text of Jerome.

For the opinion that the Liber Apologeticus is not by Priscillian, but by a follower, see Labriolle, P. de, *History and Literature of Christianity from Tertullian to Boethius*, New York, 1925, pp. 308, 309.

48. Cf. the genius Athernoph with only one leg, but two arms and two heads, on a gem in the Cabinet des Médailles (2182); on a similar one-legged figure, on a gem inscribed IAW, the arms are truncated (Kopp, U. F., *Palaeographia Critica*, 1829, IV, p. 220). (On the interest in magical engraved gems in Spain in the Middle Ages, see Thorndike, *op. cit.*, II, p. 857.)

The absence of a member seems to be quite typical in late antique and oriental demonic figures. In a Greek gnostic work of the fifth or sixth century, the Testament of Solomon, there is a demon Abezethibod, having only one wing ("spiritus molestus, alatus, unicam alam habens," Migne, *Pat. gr.*, CXXII, col. 1355, 1356; cf. also Conybeare, *Jewish Quarterly Review*, London, XI 1898/9, p. 44); and in magical literature, a devil, Abyzou, without a breast (and its modern Greek counterpart, Monobyza, Pradel, F., *Griechische und süditalienische Gebete, Beschwörungen und Rezepte des Mittelalters*, Giessen, 1907, p. 339) and a headless demon ("*akephalos daimon*," Delatte, in *Bulletin de Correspondance Hellénique*, XXXVIII, 1914; Hopfner, T., *Griechisch-aegyptischer Offenbarungszauber*, II, 1924, §186 ff.; Preisendanz, K., *Akephalos der kopflose Gott, Beihefte zum "Alte Orient,"* 8, 1926); in a demotic invocation, Osiris is described as having only one foot (Hopfner, *op. cit.*, II, 1924, pp. 130, 131).

For the survival of such conceptions in the Middle Ages, cf. Pradel, *op. cit.*, pp. 339, 346, and Vassiliev, A., *Anecdota Graeco-Byzantina*, I, Moscow 1893, p. 336, for a one-legged demon "monopodarena," the mother of Belzebouel, Sachael, and Zazael. In Nordic mythology the giant goddess, Hel, who presides over the lower world, has a horse with only three feet.

I have not succeeded, however, in finding an exact duplicate of the demon of Silos, with one leg and one arm, in Christian literature or art. The type is nevertheless very widespread. In China and among various primitive peoples rain and moon gods are described as having one leg and one arm (see Hentze, Carl, *Mythes et symboles lunaires*, Antwerp, 1932, pp. 148–154). Such a figure appears also in the so-called Bushman painting in South Africa with apparent reference to magical production of rain (Stow, G. W., and Bleek, D. F., *Rock-Paintings in South Africa*, London, 1930, pl. 67A). Bochart described, after Arabic popular tradition, a half-man, called "nisnan," in Arabia Felix:

"caput scilicet, et collum, et pectus dimidia, venter quoque dimidius, oculus unus, auris una, manus una, pes unus, quo . . . tamen citissime fertur, atque arbores etiam scandit" (*Hierozoïcon,* London 1663, III, p. 845; Leipzig, 1796, III, p. 847). European folklore abounds in giants, ogres, and demons with missing limbs, or with single members, half-men with one eye, one leg, one arm, one tooth, one horn (cf. *Handwörterbuch des deutschen Märchens,* ed. Bolte and Mackensen, I, 1930–33, p. 478; Loomis, Roger S., *Celtic Myth and Arthurian Romance,* New York, 1927, p. 120, 122). All demons are believed to be one-eyed (see the article *"Einäugigkeit,"* in the *Handwörterbuch des deutschen Aberglaubens,* II, pp. 694, 695). In the painting from Silos, the profile form of the devils' heads, which gives effect of a one-eyed being, is perhaps intentionally demonic and malign, since Michael and the sinners are all shown with two eyes. (For a Romanesque parallel, cf. the devil in the relief of Souillac.) In the thirteenth century, the Spanish bishop, Luke of Tuy, said that the Catharists represent the Virgin Mary with the most repulsive features and give her only one eye to express the idea that Christ had humbled himself in choosing for his mother the ugliest of women (Guiraud, J., *Histoire de l'Inquisition au Moyen Age,* I, 1935, p. 165); [for the Latin text see Luke of Tuy, "Adversus Albigensium errores," *Maxima Bibliotheca Veterum Patrum* XX, Lyons, 1677, p. 222.] I do not believe that this is simply a stupid misinterpretation of a profile image, since the profile was common enough in orthodox paintings in the time of Luke of Tuy; but it may express a fanatically conservative judgment of the difference between the frontal view of the Virgin as the traditionally religious, iconic appearance (with its quasi-magical fascination of the spectator, like the frontal form in Oriental art) and the profile or three-quarters view as the more indifferent and secular, therefore the more evil and "modern" one. For the same writer also rejects the three-nail crucifixion, a recent innovation, as Albigensian (much like those who criticize Expressionist painting as "Kulturbolschewismus.") According to Franz Settegast, who cites from the Mabinogion a wild black demonic figure with "but one foot and one eye" (*Das Polyphemmärchen in altfranzösischen Gedichten,* Leipzig, 1917, p. 68, 69), such monstrous half-men are derived from the classic literary accounts of the Orient, especially of India; cf. the "homines, qui 'monocoli' appellantur, singulis cruribus saltuatim currentes" (Aulus Gellius, *Noct. Att.,* lib. ix, cap. 4), reported also by Ctesias, Pliny, Solinus, and Isidore and identified with the Sciapods, who shade themselves from the sun with their one leg. These Sciapods (Pliny, *N. H.,* lib. vii, cap. 2) were often represented in Romanesque art; interesting for Silos is the example in the *mappamundi* which precedes the Beatus manuscript of 1086 in Burgo de Osma. But the overt sense of this figure seems to be purely ethnographic, not demonic; he is shown in a landscape with the sun. The accompanying inscription describing the Sciapod is taken from Isidore, *Etymol.* lib. xi, c. 3 (Migne, *Pat. lat.,* LXXXII, col. 422). The same text appears beside a very similar Sciapod and sun in an English manuscript of the early twelfth century, Bodleian 614, f. 50r (see James, M. R., *The Marvels of the East,* Roxburghe Club, 1929). Another Spanish work possibly related to the demonic type in the Silos Beatus is the double figure of two monsters labelled *"geride marine"* on f. 60 of the Codex Vigilanus, a collection of canons, dated 976, from Albelda (Escorial d. I, 2); two half-figures, each with a horned beast head, one leg and one arm, are joined together.

Nearer to the moral context of the miniature from Silos, and also physically the closest to Aqimos, are the two devils grasping a naked figure (the soul) of a sinner in an English eleventh-century psalter from Bury (Vatican, *Regina lat.* 12, f. 62 v). Each has only one leg, ending in bird's claws; the unclarity of the drawing makes it difficult to decide whether there are two arms; the left demon seems to grasp the sinner with a claw issuing from the region of the belly. The miniature illustrates psalm LI—"quid gloriaris in malitia. . . ." Also related to Aqimos in these respects is the conception of Frau Welt in German art of the fifteenth century. This incarnation of the vices (pride, avarice, unchastity, etc.) is a synthetic, allegorical monster, with one leg (the right) ending in a bird's foot, and the left hand sometimes hacked off (see Stammler, Wolfgang, *Allegorische Studien,* in *Deutsche Vierteljahrschrift für Literaturwissenschaft und Geistesgeschichte,* XVII, pp. 16 ff. and figs. 8–10, pl. V; and Saxl, Fritz, *Aller Tugenden und Laster Abbildung,* in *Festschrift für Julius Schlosser,* 1927, pp. 104 ff.). In Silos the absence of one arm and one leg may pertain to the character of the demon Aqimos as the tormentor of the unchaste couple, as the demon of Luxuria; the missing limbs of the *left* side of his body

suggest castration (on the interpretation of the demon without a part, especially the head-less demon, as a symbol of castration, see Eitrem, S., *Beiträge zur griechischen Religions-geschichte,* II, pp. 47 ff.). They are replaced by two crab's claws, set beside the prominent genitals (the only sexual indications in the four demons), and seizing the sinners in bed. The attachment of aggressive animal parts to a demonic human figure at points other than the extremities is unusual at this time, though common in late Romanesque and Gothic art; for Spanish examples, cf. the miniatures in the manuscripts of the *Cantigas de Sta. Maria* by Alfonso el Sabio in the Escorial library, and for France, cf. Didron, *Christian Iconography,* London, 1886, II, pp. 118 ff. In these works, beast heads grow out of the knees of the devil and a threatening head is attached to the belly. (For such types, see also Deonna, W., in *Revue de l'histoire des religions,* 1914, LXIX, p. 197, and LXX, pp. 126 ff.) The Gothic devil is perhaps ultimately derived from syncretistic images of the Egyptian god, Bes (cf. Hopfner, *op. cit.,* I, fig. 21, p. 214, amulet in Leyden), whose cult spread over the western Mediterranean (Roscher, *Lexikon,* 2, col. 2894/5). The crab's claws, however, seem to be very rare. I have not found another example in mediaeval art. The crab has a demonic sense in classic literature; a crab-demon Karkinar, subject to Beelzebub, is invoked in lecanomancy, and seems to be a decan-demon important in astrology. The crab is also exorcised as a demon of sickness (Boll, *Archiv für Religionswissenschaft,* XII, 1909, pp. 149 ff.; Hopfner, *op. cit.,* II, 1924, pp. 131, 132). In his Apology, in defending himself against the charge that he has practiced magic, Apuleius mentions the crab's claws, "cancrorum furcas," as instruments of magic (*Apologia,* cap. 35; see also Abt, *Die Apologie des Apuleius von Madara und die antike Zauberei,* Giessen, 1908, p. 146). In modern folklore, the crab is often regarded as a demon or the devil himself and as a bringer of bad luck (*Handwörterbuch des deutschen Aberglaubens,* V, 1932–33, pp. 447, 454; Stith Thompson, *Motif-Index of Folk-literature,* IV, 1934, p. 157). Cf. also P. Sébillot, *Le Folk-lore de France,* III, 1906, p. 358, for the belief that he is the devil because of his gripping claws, and p. 355, for the Breton saying: "Dieu a fait le homard et le diable le crabe." The pinching claws of the crab have also made him a symbol of avarice in folk speech ("die Krebse kneipen"—*Handwörterbuch,* V, p. 447). A Roman-esque writer, Petrus Cantor, in comparing the usurer to the serpent and crab, mentions quite other characteristics: "cum itaque summe accrescit aliquid ex dilatione temporis, vel cum poenae adjicitur supra culpam, usura committitur, quae serpenti et cancro compara-tur, quia serpit, et paulatim crescit, ut totum corpus occupet" (*Contra feneratores,* Migne, *Pat. lat.,* CCV, col. 157). In other Romanesque commentaries on the crab as an example of avarice and covetousness (cf. Hugo of St. Victor, *ibid.,* CLXXVII, 109, 110, and Werner, abbot of St. Blasien, *ibid.,* CLVII, 894), the story told of his guile in penetrating the oyster's shell (from the Physiologus *via* Isidore of Seville, *ibid.,* LXXXII, 457) has an apparent erotic sense. For a mediaeval interpretation of the crab as diabolical and as an example of both avarice and sexual perversity, see Berchorius, Petrus, *Reductorium Morale, lib. ix,* cap. 16 (*Opera,* Antwerp, 1609, III, p. 262). Relevant to the claws as tormenting instruments is a drawing in the manuscript of Halitgarius from Moissac, already cited (Fig. 13). The personification of Unchastity is threatened by a monstrous demon with two human arms, a beast head and a squamous single lower limb ending in another beast head; this demon manipulates a pair of pincers with which he catches the foot of *Luxuria.* Such a figure, incidentally, may be a forerunner of the later Frau Welt.

It should be mentioned finally, with reference to the punishment by heat and water in the inscription of the miniature in Silos (see above, p. 41), that the crab's claws are an attribute of water gods, i.e., demons, in Early Christian and mediaeval art; as such they appear on the heads of personifications of the Jordan in the Baptism (mosaic in the Arian baptistery, Ravenna; Benedictional of St. Ethelwold, etc.). Are the crab's claws in Silos a reinterpreted vestige of a water demon, the infernal counterpart of the personified rivers of Paradise? For an example of the latter with hornlike claws on the head, cf. the sculp-tured Geon on an epitaph of the late tenth century in the museum of Auxerre. The rivers of Paradise were equated very early with the four virtues (Gothein, *op. cit.,* p. 441, and Schlee, E., *Die Ikonographie der Paradiesesflüsse,* Leipzig 1937, pp. 30 ff.). In the alterna-tion of heat and cold (that is, fire and water), the cold water is appropriate to the heat of passion, and the fire to the cold of avarice (on the patristic reference to vice as "frigor" see below, note 66). The crab is often a symbol and prophet of rain and water in folklore

(*Handwörterbuch*, V, p. 449). This aspect of the crab-demon Aqimos recalls the old Far-Eastern and African traditions of the one-legged, one-armed demon as a rain and moon god, cited above; in classical astrology, the crab is the "house" of Selene, and presides over the ocean. Since Cancer in mediaeval astrology is a feminine sign, which pertains to water and to variability of weather, being cold in its entirety, but hot when in the North and wet in the South (cf. Abraham ibn Ezra, *The Beginning of Wisdom,* ed. Raphael Levy and F. Cantera, Baltimore, 1939, p. 165, for a twelfth-century Hebrew Toledan text), astrological considerations may have played a part in the conception of the demon with crab's claws who punishes Unchastity and whose victims pass from cold to heat.

49. For an exposition of gnosticism—which is not one system, but a highly varied, eclectic and syncretistic group of systems—see Leisegang, Hans, *Die Gnosis,* 2nd ed., Leipzig, 1936.

50. As in the writings of Hildegard of Bingen (see Leisegang, *op. cit.,* pp. 21 ff.). Liebeschütz has indicated also Manichean elements in her cosmology, though she herself was opposed to the neo-Manichean heresies (*Das allegorische Weltbild der heiligen Hildegard von Bingen,* in *Studien der Bibliothek Warburg,* Bd. 16, Leipzig 1930, pp. 68 ff.).

51. The whole question of the mode of transmission of presumably Manichean and gnostic ideas to the heretical movements and to visionary literature of the Middle Ages is obscure; the articles cited must be read with caution. Cf. Alphandéry, *Traces de manichéisme dans le moyen-âge latin,* in *Revue d'histoire et de philosophie religieuse,* 1929, pp. 451–467; Aničkov, E., *Les survivances manichéennes en pays slave et en occident,* in *Revue des Etudes Slaves,* VIII, 1928, pp. 202–225; Grondijs, L. H., *De iconographie van den Dubbelen Logos,* II, in *Mededeelingen der koninklijke Akademie van Wetenschappen, Afdeeling Letterkunde, deel 80, serie B,* Amsterdam pp. 183–257. For an exposition of the neo-Manichean or Catharist doctrines and their gnostic elements, see Guiraud, *op. cit.,* I, pp. 35–77 [see also Borst, A., *Die Katharer,* Stuttgart, 1953].

52. For gnostic survivals in mediaeval formulas of exorcism, see Pradel, *Griechische und süditalienische Gebete, Beschwörungen und Rezepte des Mittelalters* (*Religionsgeschichtliche Versuche und Vorarbeiten,* Bd. 3, Heft 3), Giessen, 1907, p. 384 and *passim.*

53. See R. Wünsch, *Sethianische Verfluchungstafeln aus Rom,* Leipzig 1898, pp. 74 ff.

54. Cf. Cagnat and Chapot, *Manuel d'archéologie romaine,* II, 1920, pp. 197 ff. and figs. 449–452. A mosaic example is reproduced by Cumont, F., *Les religions orientales dans le paganisme romain,* 4e éd., 1929, pl. XV, 1.

55. Cf. the invocation of Partenion, Caristellum, Bubastes and Artemisia in an eleventh-century magical text from Maria-Laach in Bonn (Heim, R., *Incantamenta magica graeca-latina,* Leipzig 1892, p. 554). The tradition of four demons in Hell, like the four archangels in Heaven, is common to old Oriental, Jewish, Christian, and Moslem belief; cf. Daniel, vii, 2–7, the Apocalypses of Enoch and Moses, the Sibylline oracles, etc.; Perdrizet, P., *L'archange Ouriel,* in *Recueil d'Etudes, Seminarium Kondakovianum,* Prague, II, 1928, pp. 241–276; Winkler, H. A., *Siegel und Charaktere in der muhammedanischen Zauberei,* in *Studien zur Geschichte und Kultur des islamischen Orients,* Heft VII, 1930, p. 97; the Latin *Visio Sancti Pauli*—"et vidi . . . currentes cum festinacione quatuor angeli maligni et demiserunt eum in flumine igneo"—James, M. R., *op. cit.,* p. 30, and Silverstein, T., *op. cit.,* p. 121, n. 57, on the patristic tradition of four fires in Hell, specific for four vices. The quatrefoil form of Hell in the miniature from Silos corresponds to the quatrefoil Heaven in a drawing of Abraham with the souls of the blessed in Vatican Regina lat. 12 (f. 72), an English manuscript of the eleventh century. Here the inscription reads: "locus refrigerii qui est sinus Abrahe."

56. On the power of the name in magical invocations, see Montgomery, J. A. *Aramaic Incantation texts from Nippur,* University of Pennsylvania, The Museum, Publications of the Babylonian section, Philadelphia, III, 1913, pp. 57 ff. with bibliography; Hopfner, *op. cit.,* II, 1924, *passim;* Origen, *Contra Celsum,* I, 24 ff., V, 45 ff. for a classic statement; and note 46 above. In the miniature of Silos, observe the formal similarity of the four names, Barrabas, Radamas, etc.; they are all three-syllabled and satisfy the rhythmic requirements of incantation. On this aspect of magical language, see Doutté, E., *Magie et religion dans l'Afrique du Nord,* Alger, 1909, pp. 104 ff.

57. Cf. the text of Jerome (Epist. LXXV) cited in note 46 above; Montgomery, *op.*

cit., pp. 81, 82; Hopfner, *op. cit.*, I, 1921, pp. 58, 59, § 249; Audollent, A., *Defixionum Tabellae,* Paris 1904, pp. xlvii, lxiii, lxv; Heim, R., *op. cit.*, p. 559, for a twelfth-century example in a magic formula ("Abarabarbarica borboncabradubrabarasaba"). In his *Miracle de Théophile,* Rutebeuf has the sorcerer, Salatin, call the devil thus: "Bagabi laca bachabé Lamac cabri achababé." Such words are intended not merely as names of demons, but as general sounds of magic invocation which suggest through their very unintelligibility the intercourse with occult regions. Toward 1100 such pseudo-Hebraic babbling was already assimilated, perhaps in conscious parody, to the subverbal sounds of mutism. In a poem by William of Aquitaine the hero, who pretends to be dumb, says: "Babariol, Babarian, Babarian" (in another version, "Tarrababart, Marrababelio riben, Saramahart")—Jeanroy, A., *Les chansons de Guillaume IX Duc d'Aquitaine,* Paris, 1927, pp. 10, 35.

58. See Montgomery, *op. cit.,* pp. 42, 43, 54, 56, 85. On the pointed instruments in magic, see article *Defixio* by Kuhnert, in Pauly-Wissowa, *Realencyklopädie.* The inscription in the miniature, with the repeated *"transibunt"* (see above, p. 41), resembles the magical formulae which call upon an evil spirit or enemy to *pass* from one element to another; cf. Gollancz, H., *The Book of Protection, being a collection of charms,* London, 1912, p. xxxiii.

59. See Audollent, *op. cit.*

60. See above, note 48.

61. *Ibid.*

62. There are also vernacular or vulgar Latin details in the longer inscriptions: e.g., *ad calore* and *ab aqas* (for *aquas*). On this characteristic confusion of the ablative and the accusative and on the dropping of final m in the vulgar Latin of Spain, see Carnoy, A., *Le latin d'Espagne d'après les inscriptions,* 2nd ed., Brussels, 1906, pp. 199 ff., 267 ff. See also note 70 below.

63. It should be observed also that the circular arrangement of the letters has a magical function in amulets, papyri, etc. Cf. the inscribed magic bowls reproduced by Pognon, H., *Inscriptions mandaïtes des coupes de Khouabir,* Paris, 1898, 1899.

64. The word *coronas* is written out above the elders' heads, each letter corresponding to a single crown.

65. See the Index of Sanders' edition of Beatus. But the Vulgate original (Job xxiv, 19) was read in the Mozarabic liturgy of Silos during Easter week, when the Apocalypse was an important lection. See the *Liber Comicus* (ed. Morin, 1893, p. 143) of Silos—Paris, Bibl. Nat., nouv. acq. lat. 2171, a manuscript given to the abbey in 1067.

66. The reference to heat and cold in Job xxiv, 19, had, however, a moral sense to some mediaeval commentators, following Gregory the Great, vice being a frigidity of the soul—"idcirco iniquitas frigori comparatur, quia peccantis mentem torpore constringit" (*Moralia in Job,* Migne, *Pat. lat.,* LXXV, 1160). In a commentary on Job formerly attributed to Jerome the heat and cold are given a completely eschatological meaning— "quasi duas gehennas sanctus Job dicere mihi videtur, ignis et frigoris, per quas diabolus, hereticus, et homo impius commutetur . . ." (*ibid.,* XXVI, 725). This interpretation was apparently influenced by pre-Christian conceptions of punishment (cf. Enoch, xiv, 13, 14; c, 9–13). The torment by heat and cold is known in mediaeval Jewish literature (see Landau, M., *Hölle und Fegfeuer in Volksglaube, Dichtung und Kirchenlehre* Heidelberg, 1909, p. 160 and Ginzberg, L., *Legends of the Jews,* V, p. 418), in Buddhism (see Becker, E. J., *Mediaeval Visions of Heaven and Hell,* Baltimore, 1899, p. 10) and in late classic works (Dieterich, A., *Nekyia,* p. 202). In gnostic writings, the sinful soul or the murderer is described as passing from a region of cold and snow to a region of fire (*Pistis Sophia,* translated by Horner, G., pp. 162, 196; Schmidt, Carl, *Gnostische Schriften in koptischen Sprache aus dem Codex Brucianus,* Leipzig, 1892, pp. 411, 412). In the *Visio sancti Pauli,* a work of the fourth century A.D., there are in Hell not only two regions, one of heat and one of cold, and two rivers, one fiery, the other cold (cf. the classic Pyriphlegethon and Kokytos which were described as hot and cold streams—see Roscher, *Lexikon, s. v.* Kokytos), but the despoilers of widows and orphans are subject *simultaneously* to both heat and cold, "et ignis urebat unam partem, altera frigescebat" (Silverstein, T., *op. cit.,* pp. 53, 154). The specific alternation of heat and cold, the perpetual motion prescribed in

Silos, seems to be a later conception. Bede, who paraphrases the passage of "Jerome" in his commentary on Luke xiii, 128, describes just such a movement in his account of the vision of purgatory by the monk Dricthelm, "unum latus flammis ferventibus nimium terribile, alterum furenti grandine ac frigore nivium . . . non minus intolerabile" (*Historia eccle-siastica*, lib. V, cap. 12, ed. Plummer, I, p. 305). When the souls could no longer stand the heat, they jumped into the cold; and finding no comfort there, they jumped back into the flames, precisely as in the inscription of Silos. This vision of Dricthelm was often copied separately in the Middle Ages (Plummer, II, 295), and was available to the monks of Silos; Paris, Bibl. nat. nouv. acq. lat. 235, an eleventh-century manuscript from Silos in Visigothic script, includes a *Beati Dricthelmi monaci vita* on ff. 207–214 (see Delisle, *Mélanges de paléographie et de bibliographie*, Paris 1880, p. 74). The alternation of heat and cold is common in visions of the lower world since the eighth century (see Becker, *op. cit.*, p. 58 ff.; St. John D. Seymour, *Irish Visions of the Otherworld*, London, 1930, pp. 87, 126, 130; Caesarius of Heisterbach, *Dialogus Miraculorum*, XII, 23, in *Broadway Mediaeval Translations*, II, p. 311; the politically tendentious vision of the priest Bernold who saw forty-one bishops "per vices nimio frigore horribiliter cum fletu et stridore den-tium tremulantes, et per vices calore nimio aestuantes"—Migne, *Pat. lat.*, CXXV, 1115 ff.—a vision admittedly based on older writings, including Bede's). However, the illustra-tion of this torment is very rare in mediaeval art; besides the miniature of Silos I know only a marginal drawing in an English eleventh century manuscript in the Vatican, Reg. lat. 12, f. 71 v. It is a scene of purgatory, and shows one nude figure in the flames and two in water; one holds a chest labelled *opera iustitiae;* still another nude soul is being taken up by the Lord (?). The drawing illustrates psalm 65, lines 9 to 12: "transivimus per ignem et aquam et eduxisti nos in refrigerium." The drawings in this manuscript are of extraordinary importance for both mediaeval art and literature.

The dual and polar character of this punishment has interesting parallels in cosmologi-cal schemes. The alternation of heat and cold recalls Oriental conceptions of the move-ment of the sun through alternating zones or seasons of hot and cold and of the reversal of the seasons—hot winters and cold summers—at the end of the world (Liebeschütz, *op. cit.*, pp. 74, 75, 125); in the visions of Hildegard of Bingen, which show remarkable affinities with such conceptions ("pessimae penae habundant, ita ut ibi in estate frigus in hieme vero ardor . . . existant"—*ibid.*, p. 120, n. 1), the souls in Hell are grouped in diag-onally opposed symmetrical zones of fire and water (*ibid.*, pl. VI). In one Oriental cos-mogony, apparently Persian, the sun deity first creates fire and snow, the twin matters of punishment in our miniature (see Reitzenstein, *Poimandres*, p. 280). This dualism also appears in the Talmudic conception of Michael as the angel of snow and Gabriel, of fire (see Lueken, W., *Michael*, Göttingen, 1898, p. 55); their rôles are reversed in a Christian mediaeval text published by Pradel (*op. cit.*, p. 20, 309). The action of opposite elements is often invoked in magical incantations, cf. Virgil, *Ecl.* VIII, 79 (limus ut hic durescit et haec ut cera tabescit), and *Kalevala* V, 301–372 (cited by Lehmann, A., *Aberglaube und Zauberei*, ed. 1925, p. 108—on fire and cold).

For the alternation of heat and cold as a demonic torment there was also a scriptural precedent in Matthew xvii, 15 and Mark ix, 22, in the story of the possessed youth whose evil spirit "eum in ignem et in aquam misit ut eum perderet" (see note 18 above). The punishment in Hell was perhaps a projection of the experience of fever as well as of a dualistic cosmological scheme of opposed elements. Christianity knew, in fact, a demon of fever; cf. a Byzantine charm cited by Reitzenstein, *Poimandres*, p. 19, and see also the charms and amulets against "the hot and cold fevers," and "fever-heat and fever-frost," published by Gollancz, H., *op. cit.*, p. xlii, xliii, and Preisendanz, *Papyri graecae magicae*, II, 1931, pp. 192, 193.

There is a curious transference of the dualism of snow and fire in a vision described by Peter of Compostela (ed. Soto, p. 112—see note 18 above): "Quotiescunque autem frater aliquis mortis debitum ex(s)olvebat, eius animam in ipsa spiritus exalacione nunc quasi frustrum nivis, nunc quasi rotam ignis visibiliter ad celum videbat conscendere."

67. When Brendan's fellow monks encounter a tempest of snow and hail and say "Numquid pena infernalis est major isto frigore?", Brendan answers: "Audite, fratres, id quod dicam vobis. In navigationibus meis quodam die audivimus in pelago fletum et planctum magnum, ita quod horruit spiritus cuiusque nostrum. Et navigavimus ad locum

ei proprinquum, scire volentes flendi causam. Et ecce vidimus os maris apertum, et in eo conspeximus petram unam, super quam erat vox illa lugubris et miserabilis. Mare enim undique super petram ascendebat, et ab oriente fluctus igneos, ab occidente vero fluctus glaciales et intolerabilis frigoris emittebat. Et sic verificatum est verbum Iob, quod in suppliciis ibunt ab aquis nivium ad calorem nimium." When questioned, the voice says: "Iudas Scariothis ego sum, proditor Christi, et usque ad diem magni iudicii hic expecto resurrectionem" (*Vitae Sanctorum Hiberniae,* ed. Ch. Plummer, Oxford, 1910, I, p. 147). On Judas as the symbol of avarice, see note 23 above.

68. It is listed as no. 80 in a thirteenth-century catalogue of the library of Silos (see Delisle, *Mélanges,* p. 106). See also note 66 above, on the *Vita Dricthelmi* in Silos. There are other similarities in the art of Silos to insular literature and art; they constitute a complex problem which requires a special study.

69. However, the linking of the two torments with avarice and unchastity is not found in this text and is uncommon in the literature on Hell and Purgatory. But it appears already in a passage of Isidore of Seville, commenting on Matthew xvii: 15 (the story of the possessed youth, cited in notes 18 and 66 above), "ille qui saepe nunc in ignem nunc in aquam cadebat, mundum significat. Ignis autem inflammantem cupiditatem, aqua carnis voluptatem demonstrat, in quibus semper arreptus quotidiano lapsu praecipitatur" (Migne, *Pat. lat.,* LXXXIII, col. 121). [The reverse matching appears in a sermon of Alain de Lille: "In hoc inferno alternantur pene, quia transitus fit de calore luxuriae at algorem avaritie." See M.-Th.d'Alverny, "Variations sur un thème de Virgile dans un sermon d'Alain de Lille," *Mélanges d'archéologie et d'histoire offerts à André Piganiol,* ed. R. Chevallier, Paris, 1966, p. 1525.]

70. Even the confusion of ablative and accusative in the inscription, which is typical of vulgar Latin (see above, note 62), has a formal value in this incantatory scheme: *ad calore* corresponds to *a calore,* and *ab aqas* to *ad aquas,* like the *nivium* and *nimium.*

71. On the use of a Bible passage in magic and incantation as a powerful sacred text, cf. Montgomery, *op. cit.,* pp. 62, 63; Blau, L., *Das altjüdische Zauberwesen,* Strassburg, 1898, pp. 68, 84; Heim, R., *op. cit.,* p. 520. On the inexactness of such quotations, see Montgomery, *op. cit.,* pp. 63, 64, and Blau, *op. cit.,* p. 110, who considers it intentional. For Job in magical invocations, see Pradel, *op. cit.,* p. 62. The book of Job was of first importance for mediaeval eschatology; it is used several times in the Apocalypse of Peter, the oldest Christian vision of the afterworld (second century A.D., cf. James, M. R., *The Apocryphal New Testament,* p. 509, n. 1); in the *Visio Sancti Pauli,* Paul meets Job (*ibid.,* p. 552) and converses with him. The commentary of Gregory on Job (the *Moralia*) was one of the chief readings in the monasteries of the eleventh and twelfth centuries, to judge by old catalogues, surviving manuscripts, and citations. There was a copy in the library of Silos (see Delisle, *op. cit.,* p. 107, no. 101). When the Augustinian canons of the cathedral of Pamplona made a pact of alliance with the monks of Conques in 1092, Peter d'Andouque, the French bishop of Pamplona, sent to Conques as a token a copy of the *Moralia on Job* (see Saroïhandy, in *Homenaje . . . de R. Menéndez Pidal,* II, p. 272).

72. The reversal presumably prevented the countermagical breaking of the incantation. For examples, see Blau, *op. cit.,* pp. 85, 147; Montgomery, *op. cit.,* p. 63; Wünsch, *op. cit.,* no. 4; Audollent, *op. cit.,* p. xlvi, p. 408. For reversals in modern Spanish incantations and folk magic, see A. de Ll. Roza de Ampudia, *Del Folklore Asturiano, mitos, supersticiones, costumbres,* Madrid, 1922; Ismael del Pan, *Folklore Toledano,* I, 1932, p. 94, 95; and on the region of Burgos, Domingo Herqueta y Martin, *Folklore Burgalés,* Burgos 1934 (not available to me first-hand).

73. The rotating pattern was possibly influenced by the wheel of torment so often described in Christian visions of Hell. Cf. a Priscillanist fragment of the eighth or ninth century: "angelo tartarucho cum virgis ferreis precutientis rotam volvitur in gyru et flumine tres" (de Bruyne, *Revue bénédictine,* XXIV, 1907, pp. 323, 324); and the *Visio Sancti Pauli:* "locus inferni . . . in quo est rota ignea habens mille orbitas, . . . mille vicibus in uno die ab angelo tartareo percussa et in unaquaque vice mille anime cruciantur" (from a later text published by Meyer, P., *Romania,* XXIV, 1895, p. 366). See also Silverstein, *op. cit.,* pp. 76, 77 and notes 62–80, pp. 122, 123, on this theme.

However, the particular wheel form of the composition and action in Silos is more than iconographic and presupposes stylistic norms of the Romanesque period. The impor-

tance of the wheel in Villard de Honnecourt's album suggests that it would be worth inquiring into the relation of dynamic wheel schematisms in mediaeval art to the technology of the later Middle Ages.

Cumont has shown that the Manichaean and Babylonian conception of a cosmic wheel with twelve pots for drawing souls to heaven ("quae per hanc spheram vertitur hauriens animas morientium") was derived from the similar mechanism of the great wheels on the Euphrates and Tigris which raised water for irrigation (see Cumont, *La roue à puiser les âmes,* in *Revue de l'histoire des religions,* LXXII, 1915, pp. 384–388.)

74. See Liebeschütz, *op. cit.,* pl. VI. The damned are in four fields, two of flame, two of water, arranged a, b, above, and b, a, below, i.e., chiasmically. Further, the punishment by heat takes place in the winter, by cold in the summer. It is interesting that Hildegard in paraphrasing the passage Job xxiv, 19 in her account of the Last Judgment, preserves its traditional sense as a nature metaphor: "Sicque judicio finito . . . omne quod caducum et transitorium est dilabitur, nec amplius apparebit, velut nix esse desinit quae a calore solis liquescit" (Migne, *Pat. lat.* CXCVII, col. 728).

75. It is painted in the blank space at the lower right of f. 86 after the *Storia quattuor animalia* (*sic*) (Beatus lib. III, on Rev. iv: 6), by the same hand as the figure of John on f. 82v, and is undoubtedly before 1109.

76. For a jongleur with a knife, cf. the texts cited by R. Menéndez Pidal, *Poesía juglaresca y juglares,* Madrid, 1924, p. 30, especially the description in the *Gran Conquista de Ultramar* "andaban juglares con muchas maneras de instrumentos de alegrías: los unos cantaban e los otros esgremían con cuchillos e con espadas." There is an initial with a musician and a knife juggler in the Cîteaux manuscript of the *Moralia in Job,* dated 1111, Dijon MS. 168–170 (Oursel, *La Miniature à Cîteaux. pl. XXVI).* The bird in the miniature of Silos may have been suggested by actual association or by the trick of jongleurs of imitating the song of birds, "volucrum exprimere cantilenas" (Pidal, *op. cit.,* pp. 32, n. 3 and 51, n. 1). But the bird and figure are also a typical Romanesque drôlerie in the ornament of manuscripts and architecture during the eleventh and twelfth centuries. Examples occur in a Limoges troper, Paris, Bibl. Nat., lat. 1121 (Gautier, L., *Histoire de la poésie liturgique, Les tropes,* Paris, 1886, p. 113), in a south French grammatical treatise in the Laurentian library (MS. 90 Sup. 13 I, f. 84), on capitals in Moissac, Talmont (Charente-Inférieure), Vertheuil (Brutails, *Les églises romanes de la Gironde,* fig. 269), and in the cloister of Silos (P. J. Pérez de Urbel, *El claustro de Silos,* p. 83), etc.

77. Musicians appear on the portals of Morlaas (Porter, *op. cit.,* ill. 461), Varaize (*ibid.,* 1001), Bordeaux (*ibid.,* 920), Aulnay (*ibid.,* 979), Parthenay (*ibid.,* 1048), Oloron, etc. In Soria and Santiago, in Spain, they are placed radially on the voussoirs as in southern France. For the association of dancers and acrobats with musicians, cf. the portal of Foussais (Porter, ill. 1062) and an apse lunette of St. Vivien, Gironde (*ibid.,* ill. 1086); and with musician-elders, cf. a capital from St. Georges-de-Boscherville in the Musée des Antiquités in Rouen. For the frequency of such figures in the region of Saintonge, see Dangibeaud, in *Bulletin archéologique,* 1910, pp. 56, 57.

78. There are examples in Paris, Bibl. Nat., lat. 796 (Montieramey), lat. 1118 (Limoges) and in London, British Museum, Harley 4951 (Toulouse) (Fig. 18). See Gautier, L., *op. cit., passim,* for other reproductions, and the detailed article by Gougaud, L., *La danse dans les églises,* in *Revue d'histoire ecclésiastique,* XV, 1914, pp. 5–22, 229–245, especially p. 242 on Spain. Although the people and even the clergy often danced in the churches, the church authority, according to Gougaud, never favored or encouraged the introduction of the dance into the churches (p. 7). Significant for this secular aspect of religious art are the opening verses of the vernacular *Song of Saint Foy,* composed in Languedoc in the eleventh century. I quote from the translation by P. Alfaric and E. Hoepffner:

> J'ouïs un chant qui est beau en danse
> Qui était sur un sujet espagnol.
> Tout le pays basque et l'Aragon
> Et la contrée des Gascons
> Savent quel est ce chant
> Et si bien vrai en est le sujet.

(*La Chanson de Sainte Foy*, Paris, 1926—*Publications de la Faculté des Lettres de l'Université de Strasbourg*, Fasc. 32, 33, vol. II, pp. 83, 85).

79. See note 77. In a sense this is also the context of the jongleurs in the miniature of Silos, since they are painted beside Rev. iv: 6 ff. which deals with the twenty-four elders and the four beasts.

80. See Faral, E., *Les jongleurs en France*, Paris, 1910, pp. 93 ff. The association appears constantly in Romanesque imagery. On the facade of Civray, for example, the following subjects are juxtaposed: Samson and the lion, Samson and Delilah, David harping and Saul; twelve elders, sixteen musician angels, the wise and foolish virgins, etc. On the later portal of the refectory of Pamplona cathedral there are carved fighting men and beasts, Samson and the lion, and figures of musicians. Similarly in the Bible of Stephen Harding in Dijon, David and the musicians are shown enclosed by battlements and fighting soldiers. Cf. also a Romanesque miniature in a breviary from Montieramey, Bibl. nat., lat. 796, fol. 235, in which an acrobat, a dancer, musicians, hornblowers, etc., accompany Christ in majesty, set under an elaborate domed structure (Leroquais, *Les breviaires manuscrits des bibliothèques publiques de France*, 1934, *Planches*, pl. X).

The musical instrument has also the value of a completely personal object, especially for the cultivated members of the lower classes, and is the symbol of the free, spontaneous soul in both secular life (the vagrant jongleur and student) and religion (the heretical monk). Cf. the beautiful sentence of Joachim of Flora (in Apoc. 183 a2) placed by Paul Sabatier on the title page of his *Vie de S. François d'Assise:* "Qui vere monachus est nihil reputat esse suum nisi citharam" ("The true monk regards nothing as his own except his guitar").

81. Porter, *op. cit.*, ill. 668. It is possible that the choice of this subject was influenced by the liturgy and related to the themes from the Passion and Resurrection of Christ on the piers. A poetic version of Rev. iv, v, which describes the elders, was sung in the Mozarabic church on the first Sabbath after Easter (Migne, *Pat. lat.*, LXXXVI, col. 637, 638).

The only other early capital with complete human figures shows a grotesque combat of confronted naked men wielding axes and seated backwards on monstrous adossed animals. Similar groups appear in the initials of the contemporary Bible of Limoges (Paris, Bibl. Nat., lat. 8) and on capitals in Vertheuil in the Gironde (see note 76) and in Cunault in the Loire country (see *Bulletin monumental*, 1935, p. 76, fig. 4). The theme of the individual naked figure seated backwards on an animal probably is derived from classic art. Cf. the fifth century coins of Mendé and a dish of late classic style from Perm in the Hermitage (Smirnow, *Argenterie orientale*, pl. LIX).

82. In *Gazette des beaux-arts*, XCVII, 1906, p. 34.

83. The elders are also beardless in the Carolingian manuscripts of the Apocalypse in Trier, Cambrai, Valenciennes, and Paris.

84. The portals of Moissac, Chartres, etc.

85. The manuscript from Saint-Sever, now Bibl. Nat., lat. 8878 (f. 121v, 122)—reproduced by Mâle, *op. cit.*, fig. 2. On one page, f. 199, the elders are beardless, but also without the usual attributes, and in other respects, close to the Mozarabic original. The elders are also bearded in the drawing in Auxerre, attributed by Mâle to the South of France and to the influence of the Mozarabic manuscripts, but probably executed in Tours and entirely independent of Mozarabic art, as I will show elsewhere. [See "Two Romanesque Drawings in Auxerre and Some Iconographic Problems," *Studies in Art and Literature for Belle da Costa Greene*, Princeton, 1954, pp. 331–349, reprinted here pp. 306ff. and Figs. 1, 3.]

86. Also distinct from the form in the Silos Beatus is the perfume bottle on the capital; it is more like the bottles represented in Aulnay and in the Roda Bible.

87. It is worth recalling here that "saltimbanque" and "banker" have a common etymological origin in the "bank" or bench of the fairs.

88. This opposition of an inner and outer world, considered spiritually and materially, is indicated apropos of the closed doors in a sermon on the Doubting Thomas by Radulphus Ardens, a South French preacher of the twelfth century—"Congregabantur autem discipuli omnes sero domi simul, et clausis januis propter metum Judaeorum, et de Domino loquebantur, et eum suspirabant. Nos quoque, fratres mei, postquam per diuturnam actionem ad negotia exteriora exierimus, sero per contemplationem ad nosmetipsos

redeamus, et intra nosmetipsos nos colligamus, ut quid corrigendum sit in nobis . . . Debent etiam fores cordis nostri esse clausae propter insidias daemonum . . ." (Migne, *Pat. lat.,* CLV, 1869, 1870).

The spiritual significance of the crenelated, inhabited frame is confirmed by a Romanesque miniature in the Eadwine psalter from Canterbury, illustrating the first Psalm. The *impius* is personified by a king (*superbia*) sitting with legs crossed under a crenelated arched structure with heads above the turrets and flanked by soldiers and a devil; while the just man sits under a typically sacral architecture, a trefoil arch without crenelations, and is accompanied by angels. See James, M. R., *The Canterbury Psalter,* 1935, f. 5v.

89. Cf. also J. Puig y Cadafalch, *Le premier art roman,* Paris, 1928, pl. V.

90. As in the image of Toledo in the Codex Aemilianensis, f. 129v, in the Escorial.

91. In the Roda Bible—Paris, Bibl. Nat. lat. 6, vol. III, f. 97—the crenelated wall with surmounting figures encloses the royal banquet in the Book of Esther (Neuss, *Katalanische Bibelillustration,* 1922, fig. 120) and is therefore an illustration of the text rather than a free marginal invention. It is in the same *secular* sense that soldiers and musicians are shown above the battlements in Romanesque miniatures of the enthroned David and Solomon in the Dijon Bible of Stephen Harding, in a German Bible of 1148 in the British Museum (Harley 2804, f. 33), etc. They are like the figures blowing horns in the scene of David dancing before the Ark of Covenant in the relief on the portal of Ripoll (Neuss, *ibid.,* fig. 25). Cf. also the late Romanesque relief in Silos representing Domingo rescuing Christian prisoners from the Moors, for figures in the towers (Porter, *Spanish Romanesque Sculpture,* II, pl. 97).

Porter, *op. cit.,* I, p. 45, mistakenly identified the inhabited secular frame in Silos with the more general type of architectural canopy frame. The same error is repeated by Gómez-Moreno (*El arte románico,* p. 167) who identifies the frame of the relief with the considerably later architectural frame of the enamel frontal from Silos, which has indeed crenelations, but no figures, and corresponds to the canopies over isolated figures in Romanesque art of the middle and second half of the twelfth century.

92. See *Trésors des bibliothèques de France,* I, 1926, pl. opp. p. 136. The same motif appears in the Bible of Souvigny in Moulins, a Burgundian work of the later twelfth century.

A possible anticipation of the Romanesque type are the sculptured cross fragments at Hoddam and Heysham, attributed to the ninth century (Collingwood, W. G., *Northumbrian Crosses of the Pre-Norman Age,* 1927, figs. 88, 89); but it is not clear whether the figures in the enframement are secular or religious and illustrate an incident in the life of the main personage.

93. See Boinet, *L'illustration du cartulaire du Mont-Saint-Michel,* in the *Bibliothèque de l'Ecole des Chartes,* LXX, 1909, pp. 335–343, fig. 1. Cf. also a drawing of the Annunciation in Paris, Bibl. Nat., lat. 1654, from St.-Maur-des-Fossés.

94. Goldschmidt, *Elfenbeinskulpturen,* IV, pl. IV, no. 14; Hauttmann, *Die Kunst des frühen Mittelalters,* p. 336.

95. In Sta. Maria in Uncastillo (Zaragoza)—see Porter, *Spanish Romanesque Sculpture,* 1928, II, pl. 154. This remarkable iconographic similarity was pointed out to me by Miss Helen Franc of the staff of the Morgan Library. It is perhaps relevant to the problem of diffusion that Uncastillo belonged to a French seigneur (see Boissonade, *Du nouveau sur la chanson de Roland,* 1923, p. 60).

96. See in *The Art Bulletin,* XIII, 1931, p. 528, fig. 140 [reprinted here p. 231, Fig. 140]. A figure blowing a horn is also represented on the city walls on the capital of the Martyrdom of Lawrence in the cloister. Cf. also a capital from Moutier–St.-Jean in the Fogg Museum in Cambridge, with a figure on top of the city blowing a horn in the scene of Christ and the Pilgrims. On the other hand, the figures blowing horns on the south transept portal of Santiago are angels of the Last Judgment.

97. Porter, *op. cit.,* 1923, ill. 469 (Doubting Thomas), 471 (Last Supper).

98. Cf. Lasteyrie, R. de, *L'architecture religieuse en France á l'époque romane,* second ed., 1929, figs. 427, 428, 478, 479. The southernmost example I know was on the church of Moirax (Lot-et-Garonne) near Agen (see *Revue de l'art chrétien,* 1910, p. 279). Note also a capital from La Sauve with the story of John the Baptist, in the Musée Lapi-

daire of Bordeaux, for a representation of a building with just such scales. They occur also at Foussais on the relief by G. Audebert of the Feast in the House of Simon (Porter, *op. cit.,* ill. 1063). The presence of this form on the architectural frame of the great enamel altar-frontal from Silos, now in Burgos, is undoubtedly a Limousin feature—cf. the same motif on the *châsse* of Ambazac (Rupin, *L'oeuvre de Limoges,* Paris, 1890, I, fig. 208, pl. XIX). For different explanations of the use of these inverted flat scales, see de Lasteyrie, *op. cit.,* p. 405 and Enlart, C., *Manuel d'archéologie française,* 1919, I, p. 367.

99. Notably in Toro, Zamora, and Salamanca. See Lampérez, *Historia de la arquitectura cristiana en España,* Madrid, 1908, I, fig. 246; Ricardo Garcia Guereta, *La Torre del Gallo,* in *Arquitectura,* IV, 1922, pp. 129–136. For other Spanish examples and their relation to South French buildings, see Torres-Balbas, L., *Los cimborios de Zamora, Salamanca y Toro,* in *Arquitectura,* IV, 1922, pp. 137–153, and Hersey, C. K., *The Salamantine Lanterns, their Origins and Development,* Cambridge, Mass., 1937.

100. See Férotin, *op. cit.,* p. 359—"tiene un cruzero grande y muy bueno, y en este y en todo lo demas es bien semejante a la iglesia mayor vieja de Salamanca." This is obviously a lay judgment, and not a reliable evidence.

101. There are examples of such scales in scattered representations of buildings in Belgian, English, and German miniatures, but they are not concentrated regionally or reproduced plastically as in Silos and in southwest France. These roof scales should be distinguished from the nonconstructive surface motif of imbricated scaly leaves, common in Romanesque and earlier art, and from the geometrical scale ornament of Early Christian screens and balustrades (cf. Venturi, A., *Storia dell' arte italiana,* I, figs. 407, 411, 412, 415, etc.). I do not insist on this detail, but I cite it as a confirmatory, rather than in itself conclusive, indication of the connections between Silos and southern France.

102. Goldschmidt, *op. cit.,* I, pl. XXI, no. 45—an ivory of Reims style in Weimar.

103. For a similar connection cf. a miniature in a manuscript of the Crónica Troyana, c. 1350, in the Escorial, which shows a walled city with musicians and watchmen behind the crenelations (Menéndez Pidal, *Juglares,* p. 71).

104. See his *Autobiography* (*Broadway Mediaeval Translations*), London, 1925, p. 126, and the Latin text, ed. by Bourgin, L., Paris, 1907, p. 125 (lib. II, cap. vi).

105. On the belfry in municipal life, see the classic work of Luchaire, A., *Les communes françaises à l'époque des Capétiens directs,* Paris, 1890, p. 106; on the Jacquemards and the town musicians, see Blavignac, J.-D. *La Cloche,* Geneva, 1877, pp. 56–58, 385, 393, 408 ff., Chapuis A., and Gélis, E., *Le monde des automates, Etude historique et technique,* Paris, 1928, 2 vols., and Davidsohn, R., *Geschichte von Florenz,* IV, 1, Berlin, 1922, pp. 174 ff. On the crenelated city wall or gate as the emblem of the town, especially in southern France, see Roman, J., *Manuel de sigillographie française,* 1912, pp. 319, 320, and Blanchet and Dieudonné, *Manuel de numismatique française,* II, figs. 40–43. [Two watchmen blowing horns are represented on the Porte de la Grosse Cloche on the seal of Bordeaux, 1297—Roman, J., *op. cit.,* p. 134.]

The automatic Jacquemards of the churches and the town belfries are especially interesting for the worldly tendencies within Gothic art. These mechanical figures secularize the highest spaces of religious and civic architecture: the sounds of the elevated bell which radiate through the entire space of the town and announce the church before it is visible, these sounds are now revealed as material products of human effort, of the townspeople themselves in their mechanized simulacra.

106. They anticipate the typically bourgeois theme of seventeenth-century painting, the figure looking out of the window (Dou, Murillo, etc.). They must be distinguished from the corresponding figures on the classical city gate, like the Porta Marzia in Perugia (late Etruscan?), which are apparently guardian divinities, not citizens.

Dr. Julius Held has called my attention to a related conception in the church of St. Marien in Mühlhausen in the 1360s, life-size figures of the Emperor Charles IV and the queen carved on the parapet of the south transept (Pinder, W., *Die deutsche Plastik des 14. Jahrhunderts,* 1925, pls. 87, 88). In describing these sculptures (*ibid.,* p. 65), Prof. Pinder recognizes the civic political function of the figures in their setting and their direct spatial relation to the spectator; but in observing the precocious aesthetic effects, he labels the idea "baroque" because of the elimination of "aesthetic boundaries" between the sculpture and the spectator.

107. Menéndez Pidal, *Juglares,* pp. 59, 60. [Cf. also in the poem of the Albigensian Crusade, in the account of the rebuilding of the walls of Toulouse: "trompettes et tambours on entend résonner" (*La Croisade contre les Albigeois, Epopée Nationale,* tr. Mary Lafon, Paris, 1868, pp. 254, 278.)]

108. Menéndez Pidal, *op. cit.,* p. 60, n. 3.

109. London, British Museum Add. MS. 30853—"non oportet cristianos ad nubtias euntes ballare vel saltare . . . Qui in saltatione femineum habitum gestiunt et monstruose fingunt et malas et arcum et palam et his similia exercent, 1 annum peniteat" (Menéndez Pidal, R., *Origenes del español,* Madrid, 1929, p. 23). The penitential probably goes back to a text of the eighth or ninth century; there are similar passages in the *Poenitentiale Vigilanum* (before 976).

The conception of the jongleurs as pagan is expressed in the Beatus manuscript of Facundo (1047) in the miniature representing the worshippers of Nebuchadnezzar's statue as jongleurs, including figures with horns and cymbals (illustrated in Menéndez Pidal, *Juglares,* p. 315); the same conception appears in the Silos Beatus, folio 229 (Fig. 26).

110. Vergara, S. de, *Vida y Milagros de el Thaumaturgo Español, Santo Domingo Manso* . . . Madrid, 1736, p. 420; Menéndez Pidal, *op. cit.,* pp. 39, 40.

111. Menéndez Pidal, *ibid.,* pp. 42 ff., and Rokseth, Y., *Les femmes musiciennes du XIIe au XIVe siècle,* in *Romania,* LXI, 1935, pp. 464–480. In some Prudentius manuscripts the enticements of Luxuria are illustrated by female musicians and a dancing woman, like the Salome of Romanesque art (Stettiner, *op. cit.,* pls. 4, 22).

112. On dancing in the churches see note 78 above. Music and dancing could be justified by the example of David; cf. the verses of Baudri de Bourgueil:

"Organa, cantica, cymbala, tympana, carmina, sistra,
Psalterium, citharae, saltusque David spoliati,
Et rota mystica sunt cultusque dei speciosus."

(Abrahams, Phyllis, *Les oeuvres poétiques de Baudri de Bourgueil, Paris,* 1926, p. 361.)

Cf. also the miniatures of Alfonso's *Cantigas,* in which figures of musicians and jongleurs accompany scenes from the life of the Virgin within a walled enclosure, Menéndez Pidal, *op. cit.,* p. 455. In Silos the Gothic paintings of the ceilings of the cloister galleries include profane figures. It is even possible that the presence of the jongleurs in the relief reflects the secular entertainments during Easter week. In mediaeval art the figure blowing a horn is often a symbol of jubilation. For an early example, cf. the Corbie psalter of the ninth century, Amiens, Bibl. Mun., MS. 18, psalms 99, 130.

113. Already in the early twelfth century, St. Bernard, who denounced *drôlerie* in art, likened his Cistercians to jongleurs. "In the eyes of worldly people we have the air of performing *tours de force.* All that they desire we flee, and what they flee we desire, like those jongleurs and dancers who, head down and feet up in an inhuman fashion, stand or walk on their hands and attract the eyes of everyone" (*Ep.* 87, no. 12, Migne *Pat. lat.,* CLXXXII, col. 217).

114. As in Sahagún in 1116 where the tanners, the shoemakers, and the jongleurs were the chief insurgents (Menéndez Pidal, *op. cit.,* p. 328). This is especially interesting for our study since the *fuero* of the town of Silos at this period was a duplicate of that of Sahagún. See below, note 130. S. Gili Gaya has discovered the name of a jongleur as a witness of a contract in 1062 in Huesca; see *Revista de filología española,* XIV, 1927, p. 274. On the payment of the jongleurs, their corporations, their regulation by the towns, see Menéndez Pidal, *op. cit.,* pp. 85 ff. On the middle class origin of most of the early jongleurs in southern France, see Jones, W. P., in *Publications of the Modern Language Association,* XLVI, 1931, pp. 307–311.

115. See Vossler, K., *Der Troubadour Marcabru und die Anfänge des gekünstelten Stiles,* in *Sitzungsberichte der kgl. bayerischen Akademie d. Wissenschaften. philos.-philol. u. hist. Klasse,* 1913; Jeanroy, A., *La première génération des troubadors,* in *Romania,* LVI, 1930, pp. 481–525.

116. Cf. *trobar clus, cobert, escur, sotil,* etc. and other terms cited by Vossler (*op. cit.*) from the poets' descriptions of their own styles. Marcabru speaks of the "entangled words" of the troubadors; Bernard Marti "interlaces the words" (*entrebescar los motz*); Raimbaut d'Orange writes "I pensively interlace rare, somber, and colored words" (cf.

Jeanroy, *op. cit.*, pp. 498 ff.). William of Aquitaine also speaks of his interlaced verses (poem VI, 7). Cf. these poetic practices with Aquitaine sculptures in Moissac, Souillac, etc. which employ chiasmic symmetry, interlaced figures and draperies (trumeau of Souillac), figures in X, etc. I have analyzed these forms in detail in an article on Souillac in *Mediaeval Studies in Memory of Arthur Kingsley Porter*, Cambridge, Mass. 1939, pp. 359 ff. [reprinted here pp. 102 ff.].

117. "Qu'ieu ai nom 'maiestre certa'." (poem VI, 36, ed. Jeanroy, p. 15). In the same poem he speaks of his verses as being of "good color," and as issuing from his "atelier" *(obrador)*; his art is his *"mestier."*

118. Cf. Jeanroy, in *Romania*, LVI, 1930, p .482, n. 2— "Il est remarquable que les réalistes sont des jongleurs, c'est à dire des hommes de fort basse extraction; les plus anciens poètes courtois, Jaufré Rudel, Rambaut d'Orange, comme au reste Guillaume IX, appartiennent au contraire à la plus haute noblesse: ce n'est donc pas le hasard qui avait déterminé les attitudes que nous leur voyons prendre."

119. In the second third of the twelfth century there is an opposed tendency to expand a religious scene into the margins, as in the sculptures of the archivolts around a tympanum. This may be regarded as a religious counter-assimilation of the expanded world of experience; it is the starting-point of early Gothic Catholic universality and system.

120. John xx, 29. Cf. the sermon by Radulfus Ardens: "Beati, inquit, qui me non viderunt et crediderunt . . . Sed his verbis ostenditur quoniam majoris meriti est fides quae sine sensus experientia credit quam ea quae per experientiam credit." (Migne, *Pat. lat.*, CLV, 1869).

121. II Corinthians v, 7.

122. An exegetist might say: the doubting Thomas, who must see in order to believe, is the burgher or city man, whose dwelling and sensory inclinations are shown in the frame of the sculpture.

At this period relics and miracles are already judged on the basis of first-hand experience, and the writers of lives of saints are compelled to acknowledge criticism, if only in prefatory statements avowing their own critical attitude. Thus the author of the *Miracles of St. Gilles* (c. 1120) says he will report only miracles he has seen or known through reliable witnesses (*Mon. Germ. Hist. Sc.* XII, 1856, pp. 316 ff.) and the anonymous writer of the *Historia Silense*—ed. Santos Coco, F., Madrid, 1921 (a work usually identified with Silos—but this is now questioned by Gómez-Moreno—see note 195 below) says: "experimenta magis quam opinione didicimus" (p. 11), and "stupenda loquor ab hiis tamen qui interfuere prolata" (p. 84). The abbot Guibert of Nogent wrote at this time a treatise (*De Pignoribus Sanctorum*) criticizing the naive acceptance of relics, in which he asserts of a saint: "antequam ergo eum deprecer, necesse est ut de veritate sanctitatis ejus altercer" and "quem sanctum nescit cum quis orat, peccat" (Migne, *Pat. lat.*, CLVI, 607 ff.) H. Delehaye, the foremost of modern critical hagiographers, has called Guibert "un véritable phénomène, en avance sur son temps de plusieurs siècles" (*Sanctus, essai sur le culte des saints dans l'antiquité*, Brussels, 1927, pp. 202, 203). But such merely theoretical avowals did not entail a real criticism of the evidence for miracles or a change in the manner of narrating the lives of saints, since the hagiographical type of legend was a compelling model and limited the new critical attitude, as H. Günter has pointed out (*Die christliche Legende des Abendlandes*, Heidelberg 1910, pp. 184 ff.). But it remains significant how frequent the critical statements become after the eleventh century, in response to the empirical tendencies of the thinking of the time.

123. The frequent conception of the town, and especially the fortified town, as female and as the subject of conquest, in folklore, literature, and everyday speech raises the question whether in Silos the more explicit representation of the city walls with the opened doors and with the male and female musicians (who accompany both the wedding and the triumphal entry into a town), bearing contrasted instruments—the men blowing horns, the women beating on tambours—was part of a richly charged sexual image in the psychoanalytic sense (See Otto Rank's paper, *"Um Städte Werben, Beitrag zur Symbolik in der Dichtung,"* in his book *Der Künstler,* fourth ed. 1925, pp. 158–170). It would be related then to 1) the aggressive and intimate physical aspect of Thomas's contact with the open wound of Christ, which corresponds also to the primitive conception of knowledge by

touch and grasp—cf. its counterpart in the Coptic legend of the midwife with the withered arm at the Nativity, testing the virginity of Mary; 2) the mediaeval Christian symbolism of the closed door (*porta clausa*) as the Virgin (who is often placed above a closed door in images of the Pentecost—cf. Brit. Mus., Lansdowne MS. 383). On the corresponding symbolism in pagan literature see H. de la Ville de Mirmont, *Le "Paraklausithyron" dans la littérature latine*, in *Philologie et Linguistique, Mélanges Havet*, 1909, pp. 573–592. In an illustrated thirteenth-century manuscript of the *Cantigas de Sta. Maria* (Escorial T.I. 1, f. 177), a clerk in love with a girl pleads with her in vain; she stands at the door of the city. In Cistercian manuscripts of the late twelfth and early thirteenth century of Conrad of Hirsau's *Speculum Virginum* (Troyes, Bibl. mun. 252, f. 58v from Clairvaux, Berlin, Staatsbibl. lat. 73, from Igny), the wise and foolish virgins are grouped on the two sides of a towerlike, gabled building (Paradise) under the figure of Christ, with one door at the left opened for the wise virgins and a door at the right closed for the foolish. (See Morel-Payen, Lucien, *Les plus beaux manuscrits . . . de la Bibliothèque de Troyes,* Troyes, 1935, pl. XVIII, no. 70.) The door may therefore relate to Christ as well as to the Virgin Mary. In Silos the extraordinary posture of Christ's rigidly raised arm, the position of the hair and head of Christ, also seem to indicate a sexual connotation. The specific gestures of Christ and Thomas in Silos are not usual in mediaeval art; on the contrary, in Spanish Romanesque sculpture in Huesca and Santillana del Mar (see Porter, *Pilgrimage Roads,* ill. 533, 866) Thomas does not even try to touch Christ's wound and Christ is the more active figure. (In the Avila Bible, however, on f. 325, Thomas and a second apostle hold up Christ's gigantic arm as Thomas touches the wound.) The doctrinal requirements of the theme hardly account for the diversity of postures of Christ and Thomas in the various examples, so that psychological and social considerations become relevant in explaining the different conceptions. Sometimes Christ does not even expose his body; he is completely clothed and Thomas merely touches his outstretched hand (Paris, Bibl. nat., lat. 9448, from Prüm). There are works in which only the bust of Christ is shown (Troia Exultet roll). In the English psalter, Brit. Mus., Nero C IV, both arms are extended to form a cross and are supported by two apostles. Also interesting for Thomas's action is the passage from II Corinthians (12:7) inscribed on Paul's scroll in Silos: "ne magnitudo revelationum me extollat." It is only the first part of a sentence which continues: "datus est mihi stimulus carnis . . ."—the thorn in the flesh and the buffetings of Satan.

The elements of sexual fantasy suggested here are not incompatible with the religious context. Not only does the Bible refer to the wall and towers as feminine metaphors (cf. *Song of Solomon,* chap. 8, *Revelations,* chap. 17, on Babylon as the scarlet woman) and mediaeval commentators describe the facade and towers of the church as symbols of the Virgin, but in popular tales, especially in Italy in the fourteenth century, phrases like "ponere lo papa a Roma" and "pontificem in urbem intromittere" are familiar sexual terms. But we do not have to leave Romanesque Spain in order to justify the posing of these questions before the relief of Thomas in Silos. The verses on the virgin birth by Peter of Compostela, a conservative, strongly antisecular churchman of the twelfth century, show clearly enough the feminine context of the Doubting Thomas:

"Ut propiis solis radiis lux vitra subintat,
Sic uterum rector superum mox virgins intrat.
Ut dominus clausis foribus loca discipulorum
Ingreditur, sic rex oritur de matre bonorum."

(Soto, *op. cit.* [full reference n. 18 above], p. 122). The psychoanalytic investigation of the sculpture would not necessarily exclude or contradict the social interpretation given above, since the sexual symbolism and content depend also on relations and objects—the city, the instruments, the new values of the religious subject—which are historically and socially conditioned; and even the individual motivations of the sculptor are conceivably shaped by the circumstances of his time. Thus the presence of these implicit sexual meanings—if they are indeed such—in the particular scene of the Doubting Thomas would be less likely before the Romanesque period; they presuppose to some extent the conflicts and that secular tendency which arise mainly with the burgher class and the growth of cities, and those very oppositions of faith and experience, ascetic repression and sensual enjoyment, expressed in the more overt meanings of the Doubting Thomas and the musicians in the city-frame.

124. In the *mappamundi* of the Beatus of Silos (f. 39v, 40r), unlike the corresponding page in the Romanesque Beatus of Saint-Sever or in the Liber Floridus of Saint-Omer (an encyclopedic and Apocalyptic work of the early twelfth century which includes a chapter —f. 49v in the manuscript in Ghent—*de mundi civitatibus*), there are no indications of towns and cities, only of provinces. In this respect, the Beatus of Silos agrees with the older Mozarabic versions. There were indeed towns and trade in the tenth century in Christian Spain, especially in León, as Sanchez-Albornoz rightly insists (see his *Estampas de la vida en León durante el siglo X,* Madrid, 1926, p. 26, n. 44), but they had hardly the political, social, and cultural importance that they acquired after the growth in the eleventh and twelfth centuries.

125. For this change, see Ballesteros, A., *Historia de España,* Barcelona, 1920, II, chaps. III, IV, VI Menéndez Pidal, R., *La España del Cid,* 2 vols., Madrid, 1929. The most important source book for this period remains T. Muñoz y Romero, *Colección de fueros municipales,* Madrid, 1847. The profound cultural effects of these economic, political, and social changes may be judged from the changes in so stable a field as language. The philologist R. Menéndez Pidal, who groups the various material factors as "political," writes of this period: "En esta época, la mas crítica de todas las reseñadas, el mapa lingüístico de España sufre un cambio fundamental. Este cambio del mapa lingüístico es parejo del gran cambio que sufre el mapa político entre 1050 y 1100; no hay otros cincuenta años en la historia de España que presenten tantas mudanzas de Estados como esta segund mitad del siglo XI . . . Estos grandes trastornos políticos influyen decisivamente en los movimientos de expansión de los antiguos dialectos" (*Orígenes del español,* Madrid, 1929, p. 540).

126. On these colonists, see Boissonade, P., *Du nouveau sur la chanson de Roland,* Paris 1923, pp. 65 ff.; Menéndez Pidal, R., *Juglares,* p. 327. On the rights of colonists in the new towns, see Keller, Robert von, *Freiheitsgarantien für Person und Eigentum im Mittelalter* (*Deutschrechtliche Beiträge,* XIV, 1), Heidelberg, 1933, pp. 64 ff., 141, 150 ff.

127. Férotin, M., *Recueil des chartes de l'abbaye de Silos,* Paris, 1897, p. 388 ("puerta de Varrio Gascones," document of 1338), p. 460 ("Varrio de Varri Gascones"—1407). It is possible that these Gascons included Navarrese (Vascones) settlers, but later documents referring to a French mayor in Silos (see note 133 below) establish the fact that there was a French colony in Silos.

128. See Serrano, *op. cit.,* II, pp. 15, 16, 212 ff., 260, 261. In the *"Votos de San Millán,"* a privilege attributed to Fernán González and dated 934 (but really of the twelfth century), requiring all the towns and villages of the region of Navarre and Castile surrounding the abbey of San Millán to give the latter what they had in greatest abundance, Burgos, Lerma, Bureba, and Silos are made to pay in *coin,* others in kind or manufactures (Serrano, II, p. 276).

129. On trade and pilgrimages, see note 209 below.

130. A town already existed in Silos in the middle of the eleventh century (see Férotin, *Histoire,* p. 74, n. 1) and there is even mention of a town council in an act of 1067 (Férotin, *Recueil,* p. 18); but there seems to have been no *fuero* or royal charter of privileges before at least 1085. In 1126, in a charter of S. Frutos, a dependency of Silos, the king, Alfonso VII, speaks of the *fuero* of S. Frutos as following the *fuero* of Silos and S. Facundo of Sahagún given by his grandfather, Alfonso VI. Since the *fuero* of Sahagún was given in 1085, and since it is described as identical with that of Silos ("secundum forum burgi Sancti Dominici et Sancti Facundi . . ."), it is possible that the *fuero* of Silos also dates from about 1085 (see Férotin, *Recueil,* p. 60). In another charter, of 1126 (*ibid.,* p. 56), the *fuero* is of "Sancti Dominici vel Sancti Facundi." Serrano (*op. cit.,* I, p. 329, n. 1) has recently questioned the date of 1085 and would place the *fuero* of Sahagún somewhat earlier, since it was confirmed by Simeon, bishop of Burgos, who died in 1082.

131. Férotin, *op. cit.,* p. 30.

132. *Ibid.,* pp. 63 ff., pp. 123 ff.

133. "Maiorini Sancti Dominici sint duo, unus castellanus et alter francus"—1209 (*ibid.,* p. 123; cf. also pp. 163, 413). An identical provision appears in a charter of Sahagún, dated 1152 (Muñoz, *op. cit.,* p. 310). Mayer, E., (*Historia de las instituciones sociales y políticas de España y Portugal durante los siglos V a XIV,* Madrid, 1925, pp. 55–58)

asserts that "franco" or "francus" need not mean French, but simply a city dweller or a person exempt from certain obligations. However, the context in the documents of Silos and Sahagún is plainly ethnic, since "francus" is distinguished from "castellanus." A document of 1175, concerning a conflict between the abbeys of Silos and Arlanza, is signed by one Ioannes Francus from Silos (Férotin, p. 100). The inscription *O*(biit) *Magister Robert*(us) *et uxor ei*(us) *Cecilia* on the southwest pier of the cloister under the later relief of the Annunciation also suggests a French origin.

134. Notably in Sahagún, a center of the French Cluniacs and the model of the institutions of other newly established towns in Spain. (T. Muñoz y Romero, *Fueros francos: Les communes françaises en Espagne et en Portugal pendant le moyen âge*, Madrid, 1867, was not available to me.)

135. The inscription has disappeared, but was recorded by Férotin (*Histoire*, p. 11, n. 1) who evidently saw the original. There was a second inscription ERA MCXVIII (1080) SUMSIT INICIUM HANC OPERA(m), of which L. Huidobro Serra has published a slightly variant reading based on other records (*Boletin de la Comision provincial de monumentos históricos y artisticos de Burgos*, III, 1924, p. 203). A chronicle of Arlanza by Juan de Pereda (1563) dates the completion of the church in 1081. See Gómez-Moreno, *op. cit.,* 1934, pp. 93, 94, for still another reading. The relations of Silos and Arlanza at this period were very close. Charters of Arlanza of 1065 and 1092 were signed by abbots of Silos (see Serrano, L., *Cartulario de San Pedro de Arlanza*, Madrid, 1925, pp. 138, 166, 164).

136. *Loc. cit.*

137. See L'abbé Baurein, *Variétés Bordeloises*, Bordeaux, 1876, II, p. 290 (Jeanne Osten); III, p. 227 (Arnaud Austen), p. 231 (Pierre Austen); IV, 178 (Guilhemna Austen). These are all mediaeval. Note also an Austennus vicedominus in a document of 836 in Narbonne (Vic and Vaisette, *Histoire de Languedoc*, II, col. 195 of the charters); Ostense, bishop of Sarlat in Perigord (Chevalier, *Repertoire, Bio-Bibliographie*, II, p. 3443); Ostiens of Viviers (*ibid.*); etc. On the other hand, there is no Osten or related name in the indices of the collections of documents of Burgos and Arlanza published by Serrano (*op. cit.*).

138. He died in 1068. He played an important part in the Spanish Church in the period of establishment of Roman Catholic power. See Chevalier, *op. cit.,* I, p. 389. His successor was named Willelmus (*Gallia christiana*, I, col. 981).

139. Archives Municipales de Bordeaux, *Livre des Bouillons*, Bordeaux, 1867, pp. 475 ff.

140. See Meyer, Paul, *Girart de Roussillon*, Paris, 1884, p. 76, note. The copy in Silos had been transcribed by a magister Vitalis of Saint-Sever, a canon of Saint-Severin in Bordeaux. The relationship of the Spanish churches of the second half of the eleventh century to those of the Gironde is a problem still to be investigated.

141. See Keller, Robert von, *op. cit.,* pp. 64, 141, 150.

142. See Bloch, Marc, *Les caractères originaux de l'histoire rurale française*, Oslo, 1931, p. 14; but I doubt his theory that the *défrichement* in southern France was delayed because of the colonization of Spain by natives of southern France.

143. This was already recognized in the seventeenth century by Marca, P. de, *Histoire de Béarn*, nouv. éd., 1894, I, pp. 412, 413, II, p. 56.

144. Ballesteros, *op. cit.,* II, pp. 547, 548, has observed the development of luxury, especially in costume, under Alfonso VI, and has contrasted the sumptuousness of his court with the simplicity of his father's (Fernando). Note in the Silos Beatus (Fig. 9) the richly ornamented costume of the jongleur.

145. These in turn promote the antiaristocratic and unfeudal estimation of men by their capacities rather than by their class origin. Pope Gregory VII in 1081 advised the Castilian king, Alfonso, to select for the archiepiscopal office an able man of humble blood; the church, like the pagan Roman republic, judged men by their virtues of mind and body rather than by the nobility of their families. "Neque vero te pigeat aut pudeat extraneum forte, vel humilis sanguinis virum, dummodo idoneus sit, ad ecclesiae tuae regimen, quod proprie bonos exoptat, adscire; cum Romana res publica, ut paganorum tempore, sic et sub Christianitatis titulis inde maxime, Deo favente, excreverit, quod non tamen generis aut patriae nobilitatem, quam animi et corporis virtutes perpendendas adju-

dicavit" (Migne, *Pat. lat.*, CXLVIII, col. 605, 606). From the same viewpoint the Waldensians drew the more radical conclusion that priestliness is not given by ordination but by virtue, that any good man can administer the sacraments and preach. Gregory himself was described as "vir de plebe" by a contemporary; according to legend, he was the son of a goatherd (see *Fliche, La reforme grégorienne*, I, p. 375, n. 1).

146. Characteristic in this respect is the minute rendering of Peter's fingernails in the Doubting Thomas or of Christ's navel in the Descent from the Cross, scenes of great pathos in which the faces are practically expressionless.

147. Cf. the related treatment of the figure of St. James on the colonnette of S. Pelayo in Santiago—Porter, *Romanesque Sculpture of the Pilgrimage Roads*, ill. 705.

148. Cf. also the Christ in Majesty above saints in a miniature of the Mozarabic psalter from Silos in the library of Nogent-sur-Marne (Seine) MS. 2, published by W. M. Whitehill, *A Mozarabic Psalter from Santo Domingo de Silos*, in *Speculum*, IV, 1929, pp. 461–468, pl. III, opp. p. 466.

149. Cf. the Silos Beatus, f. 111, 151v, 152.

150. As on the column of Trajan.

151. For other variations of the same ultimately classic arrangement in mediaeval sculpture, cf. the tympanum of the north portal of the west facade of Fidenza and the scenes of Paradise and Hell on the tympanum of the Last Judgment in Bourges Cathedral. Such works indicate the possibility that the arrangement entered Silos from a foreign (perhaps French) rather than native Mozarabic source.

152. Cf. the relation in Ripoll where the sculptures of the facade show precisely this overlapping of superposed figures (though far less regularly aligned than in Silos), in contrast to miniatures of the Farfa Bible, from which the conception of several of these sculptures is derived. In the manuscript the upper rows of figures in a crowd are without feet. See Neuss, *Die Katalanische Bibelillustration*, 1922, figs. 1, 25.

153. Paris, Bibl. Nat., lat. 8878, f. 217v (John writing). Cf. also the seated Lord on f. 26v and the angel below, and the Lord on f. 4 (Neuss, *op. cit.*, fig. 47). John on f. 77v is remarkably like Thomas in the relief in Silos. The effort of some scholars, especially Lefebvre Des Noëttes, to assign the Beatus of St.-Sever to the twelfth century is entirely groundless: not a single bit of evidence has been offered and the palaeographic authority for this opinion has remained anonymous. See *Gazette des Beaux-Arts*, pér. 6, I, 1929, p. 97, and the comments of R. S. Loomis in *Speculum*, XIII, 1938, p. 227.

154. Observe also that while the general structure of superposed rows in an architectural frame implies a horizontal-vertical grouping of elements, the superposed heads actually form diagonal, not vertical lines; the horizontal of the lower row of figures—the only complete ones in the relief—is broken asymmetrically by the figure of Christ.

155. The typical centralized arrangement with the superhuman Christ is illustrated by the Byzantine mosaics of St. Luke's in Phocis, of Daphni and S. Marco.

For a corresponding transformation in the Beatus manuscripts, cf. the paintings of Daniel and the Lions in the Mozarabic versions with the Beatus of St.-Sever (Neuss, *op. cit.*, pl. 17).

156. See note 9 above.

157. As in the early Beatus in the Pierpont Morgan Library (MS. 644, f. 9), where the figure rests his elbow on a support. On these postures in ancient art, see Tikkanen, J., *Die Beinstellungen in der Kunstgeschichte*, Helsingfors, 1912 (reprint from the *Acta Societatis Scientiarum Fennicae*, XLII).

158. This manuscript of Jerome on Jeremiah is not explicitly mentioned in the Moissac catalogue of this period (Delisle, *La Cabinet des manuscrits de la Bibliothèque Nationale*, 1874, II, pp. 440, 441); but no. 5 is a "Jerome"; 12, a Jerome on Ezechiel; 15, a Jerome on Isaiah; there is also a Jerome on Daniel. Delisle includes MS. 1822 as from Moissac, but with a (?); it is very close in style, however, to MS. 1656 A, which is undoubtedly from Moissac, and also MS. 52 from Moissac. A figure very similar to ours appears in a miniature in the Bible of St. Martial of Limoges (Bibl. Nat., lat. 8, vol. II, f. 254v), heading Paul's epistle to the Thessalonicans, at the left of the scene; his legs are like Michael's in the Silos Beatus.

159. For other examples of the same form, cf. the miniature from Saint-Sever reproduced in our Fig. 30, the arm of the angel in the relief of the Three Maries in Silos

(Fig. 28), the tympanum of La Charité-sur-Loire (Porter, *Pilgrimage Roads*, ill. 115), miniatures of Limoges—Paris, Bibl. Nat., lat. 8, vol. I, f. 52, II, f. 254v, etc.; lat. 9438 (Lauer, *Les enluminures romanes*, pl. LIV)—and Tours (Bibl. Municipale, MS. 321, f. 3), etc.

160. The figure holding the beast to form an initial P may be found also in a Roman breviary from Silos in the British Museum (Add. MS. 30849, f. 1). This page seems to have been inserted, however, from a missal. There is a related ornament of the P in a Catalonian manuscript, Paris, Bibl. Nat., lat. 794, and in a manuscript from Ripoll in the Vatican, lat. 5730 (see Albareda, A. M., *Catalonia monastica*, I, 1927, fig. 2, p. 82). Cf. also the initial in a manuscript from San Millán de la Cogolla, reproduced by Gómez-Moreno, *op. cit.*, pl. XV, 4. The style is evidently based on South French miniatures. See also note 76 above.

161. It is reproduced by Pérez de Urbel, J., *op. cit.*, p. 121 and by Férotin, *Histoire*, pl. X. The close connection between the manuscripts of Moissac and Spanish art of the late eleventh and early twelfth century is evident in the similarity of the little figure grasping the P in a missal from Sahagún (Bordona, J. D., *Spanish Illuminated Manuscripts*, I, pl. 51 A) and the corresponding figure in two manuscripts of Moissac (Paris, Bibl. Nat., lat. 52, f. 1 and 1656A, f. 16).

162. There is an example in a Spanish sculpture in the collection of Mrs. Arthur Kingsley Porter (Porter, *Spanish Romanesque Sculpture*, I, pl. 59, II, pl. 120); cf. also Rupin, *L'oeuvre de Limoges*, Paris, 1890, II, p. 425, for an example on a Limousin *châsse*. On the general subject of the inscriptions on the scroll of Paul, see Dobschütz, E. von, *Der Apostel Paulus*, II, *Seine Stellung in der Kunst*, Halle, 1928, p. 60 and n. 85.

163. For the text of the Mozarabic lectionary of Silos (Paris, Bibl. Nat., nouv. acq., lat. 2171) see Morin, G., *Liber Comicus*, Maredsous, 1893, p. 457 (Epistolary index); also Férotin, M., *Liber Ordinum*, p. 557 (index.).

164. See Férotin, M., *Le Liber Mozarabicus Sacramentorum* (*Monumenta Ecclesiae Liturgica*, VI), Paris, 1912, p. 353 (Missa in diem Scōrum Petri et Pauli); Migne, *Pat. lat.*, LXXXV, p. 178 (Mozarabic liturgy); and Morin, *op. cit.*, p. 223 (in dominico de octabas paschae).

165. For the choice of this passage in the Roman rite see the article, *Epîtres*, by G. Godu in Cabrol, *Dictionnaire d'archéologie chrétienne et de liturgie*, V, I, col. 288, no. 177. That it was also sung in the Roman rite of Silos on June 30 is proved by the text of the Roman breviary of Silos, written at the end of the eleventh century, British Museum, Add. MS. 30849, f. 257. This has been kindly verified for me by Mr. Francis Wormald of the staff of the British Museum. [For this antiphon in the liturgy of Cluny in the 1080s, see the *Consuetudines Udalrici*, Migne, *P.L.* CXLIX, 682.]

166. The date of the official substitution of the Roman for the Visigothic or Mozarabic rite in the kingdom of Castile is variously given as 1078, 1079, 1080, 1085, 1089, and 1090 in the literature on Spanish history. It is evident from letters of Pope Gregory VII to King Alfonso of Castile and Bishop Simeon of Burgos that the new rite, propagated since 1074, was not yet officially adopted in 1079 (see Migne, *Pat. lat.*, CXLVIII, col. 339, 340, 448, 449, 549–551); but in a letter of 1080 (or 1081), Gregory thanks Alfonso for having finally established the rite in all Spain (*ibid.*, col. 604–606; "noverit excellentia tua, dilectissime, illud unum admodum nobis, imo clementiae divinae, placere, quod in ecclesiis regni tui matris omnium sanctae Romanae Ecclesiae ordinem recipi, et ex antiquo more celebrari effeceris."). A charter of Alfonso to the abbey of Sahagún, dated May 1080 by Fita (*El concilio nacional de Burgos en 1080*, in *Boletín de la Real Academia de la Historia*, XLIX, 1906, pp. 316–319, 351–356), also speaks of the introduction of the Roman rite. From the content of this charter, Fita infers a date of March 22, 1080 for the council of Burgos which officially abrogated the old rite; Florez, the editor of *España Sagrada*, had misdated this council in 1085. More recently, the abbot of Silos, Luciana Serrano, has read the date as 1081, adjusting the year to the Roman indiction. (*El Obispado de Burgos*, 1935, I, p. 306).

167. Cf. *Antiphonale du B. Hartker*, in *Paléographie musicale*, 2e série, I, 1900, pp. 285–291. The same text also throws a light on the introduction of Paul in the scene of the Doubting Thomas, for the song goes on to describe the great saint Paul as one "qui et

meruit thronum duodecimum possidere" (cf. Roulin, *Revue de l'art chrétien*, LIX, 1909, p. 367). In the eleventh century a hymn, "Sanctus claviger Petrus et magnus Paulus," and another, "Sanctus Petrus et magnus Paulus," are sung in southern France in Moissac, Limoges, etc. See Daux, C., *Tropaire-Prosaire de l'abbaye Saint-Martin de Montauriol*, Paris, 1901, pp. 159, 160 (really from Moissac), and Paris, Bibl. Nat., lat. 1338, f. 61, lat. 1120, f. 124v, etc. (from Limoges).

168. See Férotin, *op. cit.*, p. 353, and Migne, *Pat. lat.*, LXXXV, col. 766.

169. *Prologus libri II* (ed. Sanders II, p. 114); British Museum, Add. MS. 11695, f. 38. It follows a commentary on the twelve apostles and the significance of their names. Peter is Cephas, as head of the apostles, etc. Paul is included as an apostle. In the Silos manuscript, *superius* is written *supervus* (for *superbus*), a meaningful lapse found in other Beatus manuscripts. The same text appears in Isidore's *Etymologies* (lib. VII, cap. ix, *de apostolis*—Migne, *Pat. lat.*, LXXXII, col. 288).

170. See note 166 above. Since the "Magnus Sanctus Paulus" occurs also in the Pentecost, one of the oldest of the pier reliefs in Silos, the whole series of six reliefs may be dated after 1081. On the slight possibility that the Roman rite was already introduced in Silos a few years before 1081, see note 200 below.

171. Cf. the inscription under Cain and Abel on the facade of Modena Cathedral—"Hic premit, hic port(at), gemit hic, nimis iste laborat." Cf. this with an inscription in the Bible of Floreffe (British Museum, Add. MS. 17738)—"Prima gemit, plorat, dolet et patiendo laborat"; Otranto pavement mosaic of Hell—"Hic stat, hic ad ardua vadit, at iste cadit"; Musée de Cluny, enamel plaque from Hildesheim, Crucifixion, twelfth century— "Hec parit, hic credit, obit hic, fugit hec, hic obedit"; Erlangen, Gumpert Bible (Swarzenski, *Salzburger Malerei*, pl. XLIX, fig. 150), Baptism of Cornelius—"Hic docet, hic credit, baptismum suadet, obedit."

[The verse "REX OBIT . . . CARUS DOLET IMPIUS ORAT" is inscribed on a relief of the Descent from the Cross on the tympanum of the cathedral of Ribe, an old commercial center and port in Denmark. It was made under Bishop Thure (1114–1134). See Erik Fischer, "Note on a possible relation between Silos and the cathedral of Ribe," *Classica et Mediaevalia, Revue Danoise de Philologie et d'Histoire*, IX, 1948, 216–230, and M. Mackeprang, *Tydske Granitportalen*, Copenhagen, 1945, pp. 160ff.

In an Italian sacramentary of the early twelfth century in Florence (Biblioteca Riccardiana, ms. 299, f.106v) an inscription below a drawing of the Crucifixion reads: "Rex obit, hec plorat, karus dolet, impius orat." Here a priest kneels in prayer at Christ's feet. For the drawing and the inscription see Adalbert Ebner, *Missale Romanum im Mittelalter. Iter Italicum*, Freiburg im Br., 1896, fig. 4, pp. 50–51. The drawing is reproduced also by E. B. Garrison, *Studies in the History of Medieval Italian Painting, Florence*, 1957, vol. III, p. 109, fig. 122.

Still another variant of the same verse appears in a fragment of a commentary on the Apocalypse inserted at the end of a thirteenth-century manuscript of Bruno of Asti, *Expositio in Apocalypsin* in the Madrid Biblioteca Nacional ms. 4319 (no. 171 in the *Catálogo de Códices Latinos*, 1935, I, Biblicos). The rhymed verses on the passion of Christ, preceding the commentary, include the line: "rex obit, hec plorat, carus luget, ipsius (*sic* for "impius") horat." It was perhaps taken from an inscription on an image of the Crucifixion or the Descent from the Cross with a praying figure at the foot of the cross.]

172. *De inventione sanctae crucis*, Migne, *Pat. lat.*, CLXXI, 1315. Cf. also col. 1290, 1305, 1309 for other examples by Hildebertus, and col. 1727, by Marbodus. Such leonines are also common in Germany in the eleventh century; cf. especially the tituli by Ekkehard IV of Mainz (see note 179 below). And we may cite as an exceptional Carolingian anticipation Theodulfus' line, "Hic sedet, hic sedit, hic it, et ille redit" (Migne, *Pat. lat.*, CV, col. 336 C).

173. *Ars Amatoria*, I, 124. I owe this reference to Professor E. K. Rand.

174. See his *Einleitung in die lateinische Philologie des Mittelalters*, Munich, 1911, I, p. 113.

175. Lehmann, Paul, *Pseudo-antike Literatur des Mittelalters* (*Studien der Bibliothek Warburg*, 13), Leipzig-Berlin, 1927.

176. Cf. Migne, *Pat. lat.*, CLXXI, col. 1387, 1390, 1427, attributed to Hildebertus in

Migne, but to Petrus Riga by recent scholars (Hauréau, B., in *Notices et extraits des manuscripts de la Bibl. Nationale et autres bibl.*, XXVIII, 2, 1878, pp. 289–448).

177. Hic Genetrix Joseph Christus
 Cernit deponit deportat
 Natum doctorem crucem
 Nicodemus amicus
 abstrahit hic flet
 clavos tristis amicum.

(Migne, *Pat. lat.*, CLXXI, col. 1282, no. 13). Note also on the same page the verse on the Nativity:

Preco Puella Deus Grex Pastor Stella Sabaeus
fert parit irrotat stupet audit ducit adorat.

178. On the epitaph of Domingo see Férotin, 1897, p. 295 and n. 1. Cf. the verse form with the contemporary Spanish epitaph of Sancho, who died in 1072, by a monk of the abbey of Oña:

"Sanctius, forma Paris et ferox Hector in armis,
Clauditur hac tumba jam factus Pulvis et umbra"

(Menéndez Pidal, R., *La España del Cid, I, p. 207*). These classical references already suggest the influence of the new post-Mozarabic culture, parallel to the French. For the corresponding leonine epitaph form of the same period, cf. the epitaph of the Pole, Boleslas Chrobry: "Hic iacet in tumba princeps gloriosa columba"—written about 1075 (David, Pierre, *L'épitaphe de Boleslas Chrobry, Etudes historiques et littéraires sur la Pologne médiévale*, Paris, 1928). The leonines in the epitaph of Munio in the cloister of Silos (P. Pérez de Urbel, *op. cit.*, pp. 238, 239) are probably after 1100. The same is true of the inscription of Gonzalvus (*ibid.*, p. 235), which includes two verses of St. Anselm, in letters of the twelfth century.

179. Cf. the epitaph of Eulogius by Alvarus, a Cordovan poet of the ninth century: Eulogius, lumen dulce per saecula nomen (Migne, *Pat. lat.*, CXV, col. 722). It should be observed, however, that true leonine rhymes appear sporadically in the writings of Alvarus and Dracontius (cf. J. A. de los Rios, *Historia*, II, pp. 111, 315).

Another inscription in the cloister of Silos, the speech of the angel to the Maries, on the arched frame of the relief of the Maries at the Tomb—"Nil formidetis, vivit deus, ecce videtis"—agrees in form with the inscription of the Descent from the Cross rather than of the epitaph of Domingo. It resembles also the speech of the angel to Elizabeth in the tituli of Ekkehard IV for the paintings of Mainz—"Ne timeas, vates! Ego sum Gabrihel, age grates!" (Schlosser, *Quellenbuch zur Kunstgeschichte des abendländischen Mittelalters*, Vienna, 1896, p. 173, 576). The speech of the angel to the three Maries appears also in a miniature in a Mozarabic manuscript from Silos, Paris, Bibl. Nat., nouv. acq., lat. 2176 p. 265 (reproduced in *The Art Bulletin*, X, 1928, p. 353 and Gómez-Moreno, *op. cit.*, 1934, pl. X). But we cannot therefore infer that the verse is also Mozarabic; for the miniature in question was added to the manuscript in the mid-twelfth century—contrary to Gómez-Moreno, *ibid.*, p. 18, who mistakenly attributes it to the eleventh century as the work of a pupil of Stephen Garsia of Saint-Sever. The inscription is in a French hand of the twelfth century, unlike the Visigothic hand of the text of the manuscript. The verse was probably taken directly from the cloister sculpture of the same subject.

180. The intersecting letters, however, as in the US of "Nazarenus" in the Doubting Thomas and in the Descent from the Cross, seem to be un-Mozarabic; they are common in French majuscule writing of the eleventh and twelfth centuries.

181. It appears in Spain in the seventh century (Huebner, *Inscriptiones Hispaniae christianae*, no. 142), but is so rare in the Visigothic manuscripts and inscriptions of the tenth and eleventh centuries that the examples in the cloister—considering their date and their context—may be derived from contemporary Romanesque art, where the form is common.

182. See Porter, *Pilgrimage Roads*, ill. 705, 706, 707, and *Spanish Romanesque Sculpture*, I, pl. 59. It is found also on an ambulatory capital in Santiago toward 1080 (*tempore . . .*) and in Iguácel in 1972, but is no longer used on the colophon page of the *Diurno* of 1055 in Santiago (Férotin, *Le Liber Mozarabicus Sacramentorum*, Paris, 1912, pl. VIII), which is already Romanesque in its figure style. It is found, however, in the Silos Beatus

(fol. 2). A common origin in late classic cursive writing explains the use of a similar t in French Merovingian inscriptions (Orléans).

183. As in ADAM in the Descent from the Cross (Fig. 1) and in the epitaph of Domingo (Fig. 32). The triangular notched appendages of the O and V in these inscriptions are also typically Visigothic; they occur in the inscription of the chalice of Domingo.

184. In the Beatus, f. 273; in the manuscript in Nogent-sur-Marne (Whitehill, *op. cit.*, pl. II); etc. Cf. also a manuscript from S. Millán, dated 992, reproduced by García Villada, Z., *Paleografía española*, Madrid, 1923, pl. XXVI. Monsieur Gaillard is therefore mistaken when he says (in *Bulletin monumental*, 1932, p. 58) that this form of M is unknown before an advanced period of the twelfth century, and cites its presence in the sculptures of Silos as an argument for a late dating. The common uncial M (without the descending middle leg) is also known in pre-Romanesque Spanish inscriptions; cf. Gómez-Moreno, *Iglesias mozárabes*, 1919, pl. 131.

185. Notably the B, M, G, T, d in the epitaph of Domingo (Pérez de Urbel, *op. cit.*, p. 121), the h in hic and hec on the frame of the Descent from the Cross (Fig. 1) and the d and m of Adam at the bottom of the same relief.

186. By Paul Deschamps in *Bulletin monumental*, 1923, p. 350. His reasoning is accepted by Georges Gaillard, *ibid.*, 1932, p. 58, and in *Gazette des beaux-arts*, LXXI, 1929, p. 342. Monsieur Deschamps has himself reproduced an example of such foliate letters in an inscription of 1126 in Vienne (in *Bulletin monumental*, 1929, fig. 33, x, d).

187. Gómez-Moreno, *op. cit.*, pl. 131. Letters with palmettoid growths occur also in the Silos Beatus (f. 4, 4v) and in the Beatus of Facundo (f. 6v), a work of 1047. It is interesting to observe the recurrence of this detail in the Visigothic type of the cover of the *Archivo español de arte y arqueologia*.

188. On this point see my remarks in *The Art Bulletin*, XII, 1930, pp. 108, 109.

It should be added in support of this hypothesis that the history of Silos is unusually rich in contacts with Islam in the eleventh century. Silos was situated in the region of Christian-Moslem warfare and acquired as a result of the Christian expeditions against the Moors several of their villages. The miraculous powers of St. Domingo were especially operative in freeing Spaniards from the Moors; hence the numerous votive chains on the tomb of the saint. His biographer tells of a Moorish convert to Christianity living as a monk in the abbey. The earliest surviving Latin manuscript in paper, a material introduced into western Europe by the Arabs, is precisely a Mozarabic breviary of the mid-eleventh century in the library of Silos (MS. 6). The magnificent Moorish ivory-box of 1026, now in Burgos, comes from the treasure of Silos; in the twelfth century an enamel plaque with a representation of St. Domingo between two angels was set in one side. Not only is the Arabic inscription on this box of the florid cufic type, but an altar-frontal of the late twelfth century, still preserved in the abbey of Silos, is decorated by a prominent cufic inscription.

189. Porter, *Spanish Romanesque Sculpture*, I, pl. 46. The foliate forms in the B and P are not clear in this reproduction, but I have verified them in the original sculpture in Madrid. Gómez-Moreno (*El arte románico español*, 1934, p. 161) attributes this relief to the later twelfth century, "su estilo corresponde al siglo XII avanzado," but I cannot see its contemporaneity with works like the Virgin of Solsona or the relief of the Virgin and child in Santillana del Mar (Porter, *Pilgrimage Roads*, ill. 867).

190. García Villada, Z., *op. cit.*, p. 88, rejects this tradition, and denies that such a council was ever held; but see Menéndez Pidal, R., *La España del Cid*, I, p. 280, n. 1, for the evidence, including the account in the Tudense chronicle. For the corresponding change in musical notation from Visigothic to Aquitainian neumes, see Dom Gregori M. Sunyol, *Introduccío a la paleografía musical gregoriana*, Montserrat, 1925, pp. 70, 71, 164, 199, 212, 213; and R. P. Casiano Rojo, *The Gregorian Antiphonary of Silos and the Spanish Melody of the Lamentations*, in *Speculum*, V, 1930, pp. 306 ff.

191. Férotin, *Histoire*, pp. 262, 263.

192. Férotin, *Recueil*, pp. 41–43 (Husillos, 1088); Menéndez Pidal, *op. cit.*, II, pp. 867, 868 (Burgos, 1080).

193. Obituary entries of the death of monks (?) in 1102 and 1108 in the Silos manuscript, Paris, Bibl. Nat., nouv. acq., lat. 2169, f. 385, are still in Visigothic script (Férotin, *Histoire*, p. 297, n. 2). See also García Villada, Z., *op. cit.*, pl. XLVI (1144), (1162). A

thoroughgoing change in script was not fundamental or urgent in 1090, since no relationship between groups was *directly* and immediately affected by the formal character of script. The Cid still signed his name in a Visigothic hand in 1097 (Menéndez-Pidal, R. *op. cit.*, II, p. 590), but also in Arabic (*ibid.*, p. 611). The change in script was a secondary adjustment, more important in the liturgical books than elsewhere. Hence the cultural "lag" here is no maladjustment. Many who favored the new political regime did not sympathize with the ecclesiastical or cultural changes.

194. It was begun not long before 1091 (see note 2), but the belated use of the old script is attested by the Visigothic hand of the colophons of that year and of 1109.

195. Grimaldus, a monk of Silos and biographer of Domingo, who wrote a little after 1090, makes no allusion to this change. The autograph manuscript of his Latin life of the saint was written in Visigothic script—see Andrés, P. Alfonso, *Notable manuscrito de los tres primeros hagiógrafos de Santo Domingo de Silos*, in *Boletín de la Real Academia Española*, Madrid 1917, p. 18 of the off-print. If the so-called Silos Chronicle (*Historia Silense*) were indeed by a monk of Silos, its violent anti-French sentiment would be significant here; but the Silos origin is questionable—see Gómez-Moreno, *Introducción a la Historia Silense*, Madrid, 1921. The recent effort of P. Justo Pérez de Urbel (*Los monjes españoles en la edad media*, Madrid, 1933–34, II, p. 475) to reestablish the Silos origin of this chronicle is unconvincing.

196. Cf. British Museum, Add. MS. 30849, f. 2–4v (Mayeul and Odo); Paris, Bibl. Nat., nouv. acq., lat. 2194, f. 2, 5, 56, 74v (Mayeul and Odilo). It is possible that these manuscripts were not written in Silos, though used in the monastery; they include masses of S. Domingo, however. The thirteenth-century chronicler of Tuy refers to Domingo as *S. Dominicus Cluniacensis Ordinis Abbas de Silos* (Florez, *España sagrada*, XXVII, 1824, p. 231). P. Justo Pérez de Urbel has called attention to the fact that Cluniac titles replaced the native ones in the abbey of Silos in the late eleventh century; the miniaturist Peter of Silos calls himself *prior* instead of *prepositus*, and the titles *grandprior, prior claustral, subprior, camerario,* etc. occur in the documents of the abbey (*Los monjes españoles en la edad media*, Madrid, 1934, II, p. 434). One should not infer from these Cluniac elements in Silos a direct cultural or artistic relation with Burgundy, since the agents of Cluniac penetration in Spain were mainly monks from southern France, from Agen, Moissac, Périgueux, etc.

197. These are difficult to evaluate with reference to connections of Silos and southern France in the late eleventh century, since they already appear in Mozarabic manuscripts; for example, Saturninus of Toulouse and the feast of his translation, which were long established in the region of Navarre, occur in Paris, Bibl. Nat., nouv. acq., lat. 2169 (Silos manuscript of 1072), in nouv. acq. lat. 2171, (which was in Silos in 1067), British Museum, Add. MS. 30845 (Silos, tenth or early eleventh century), which includes on f. 150 a drawing of the saint; Add. MS. 30851, f. 114 (Mozarabic psalter from Silos), hymn in *diem Sancti Saturnini*. Nouv. acq. lat. 2171 includes the feasts of Victor of Marseilles and Caprasius of Agen; *ibid.* 2176, the feast of Mary Magdalene, which arose in France in the eleventh century; nouv. acq. lat. 2170 and 2194 have the feast of Saint Martial of Limoges; but all of these might have reached Silos before the middle of the eleventh century.

On the other hand, in the new Easter liturgy of Silos after the introduction of the Roman rite, the *quem quaeritis* trope is literally the one recited in France at this time, possibly under the influence of the tradition of Limoges which was the great center of trope composition. Cf. British Museum, Add. MS. 30848, f. 125v, and 30850, f. 106; and see Lange, Carl, *Die lateinischen Osterfeiern*, Munich, 1887, pp. 24, 25, and Gautier, L., *Histoire de la poésie liturgique au moyen âge. Les Tropes*, Paris, 1886, pp. 85 ff.

I am not referring to the presence of a sacramentary of the tenth or eleventh century from Aurillac in the library of Silos as evidence of liturgical relations between Silos and southern France at this period, since the manuscript was still in France in the thirteenth century. See Delisle, L., *Mémoire sur les anciens sacramentaires*, in *Mémoires de l'Académie des Inscriptions et Belles-Lettres*, XXXII, 1886, pp. 223, 224.

198. This event is recorded in a contemporary note in a manuscript of Silos, Paris, Bibl. Nat., nouv. acq., lat. 2169, f. 37 bis verso. See also Férotin, *Histoire*, p. 72, n. 3.

199. See the inscription of S. Frutos reproduced by Férotin, *op. cit.*, pl. X (also pp. 218, 297) and in *Arquitectura,* Madrid, VI, 1924, pl. opp. p. 2. Another priory of Silos, S. Maria in Duero, was consecrated by the same archbishop Bernard in 1088; this event was recorded beside the consecration of the church of Silos (note 198).

200. It is just possible that the new rite was adopted in Silos before 1081 (though after 1071, the date of its adoption in Aragon), since in British Museum, Add. MS. 30850, a manuscript of the Roman liturgy in Visigothic script, the feast of Domingo who died in 1073 and was already a saint in 1076, is an *added* feast. But this addition might well have been made after 1081.

201. In a bull issued by a council of Husillos in 1088, the signature of Fortunius, abbot of Silos, heads all the abbots, including those of Arlanza, Sahagún, Oña, and Cardeña (Férotin, *Recueil*, p. 43).

202. See Férotin, *Histoire,* pp. 54–62. Notes on the contemporary campaigns of Alfonso and Sancho appear in a manuscript of Silos, Paris, Bibl. Nat., nouv. acq., lat 2171 (*ibid.,* p. 274).

203. See Férotin, *Recueil,* pp. 15, 18, 23, 29, 31, 32, etc.

204. See Férotin, *Histoire,* pp. 54–56. Domingo was an ambassador of Fernando to Garcia of Navarre in 1054 and took part in the assembly held in Burgos in 1071 for the partition of Galicia. In 1097 his successor, Fortunio, accompanied the Emperor Alfonso on a military campaign.

205. The new rite was considered in a synod of 1077 and in a council of 1080 or 1081 held in Burgos, the seat of the diocese to which Silos belonged.

206. See Férotin, *Histoire*, p. 55n., and pp. 59, 60 for a miracle of Domingo at León on this occasion.

207. Silos was already called the abbey *Sancti Dominici* in a charter of 1076 (Férotin, *Recueil,* pp. 24, 25), but the older name recurs in charters of the next twenty-five years. It is not until early in the twelfth century that the new name is fixed.

208. See Férotin, *Histoire,* pp. 44, 45, 52, 53, and Vergara, *op. cit.,* pp. 360, 402. For a representation of the early thirteenth century in Silos showing Domingo as the rescuer of chained Christian captives, see Porter, *Spanish Romanesque Sculpture,* II, pl. 97. Domingo also protected by miraculous means the crops of the abbey and of neighboring farmers from the depredations of a robber nobleman.

209. On S. Domingo de la Calzada (died 1109), see *Acta Sanctorum,* May III, p. 166 ff. He was visited by Domingo of Silos who recommended the energetic hermit to his followers. Like Domingo of Silos, he rescued Christians from Moorish prisons; he was intimate with the papal legate in Spain. Lesmes (died 1097)—*A.S.,* January III, pp. 671 ff.— was a monk of La Chaise-Dieu in France, called to Spain by Queen Constance, and given a priory in Burgos, near Silos. Inigo, abbot of Oña—*A.S.,* June I, pp. 11 ff.—also rescued Christian prisoners; but he is especially important for his organization of the agricultural work of the monastery and his expansion of its property. The socially progressive character of the monastic enterprises of road-building, hospices, and protection of pilgrims is rooted in the association of pilgrimage with trade; on this connection (common to Christianity and Islam), see Kulischer, J., *Allgemeine Wirtschaftsgeschichte des Mittelalters und der Neuzeit,* I, 1928, pp. 91, 92.

Significant also is the introduction of the cult of Saint Nicholas in Castile during this period; an altar was dedicated to him in Silos in 1088 and in the cathedral of Burgos in 1092, soon after the translation of his relics from Myra to Bari (1087) when the Turks invaded the south of Asia Minor (see Serrano, *El Obispado de Burgos,* Madrid, 1935, I, p. 339, 345). The new cult of Nicholas throughout western Europe seems to have been linked with the recent growth of commerce: he was the patron saint of merchants and travelers at sea, and also of prisoners of war.

It is interesting to observe in this connection that even the apostle James (Santiago) was transformed in the eleventh century into an aggressive figure of the time. In the *Historia Silense* is described the vision of a poor Greek pilgrim who, having denied that St. James was a knight or ever rode a horse, was confronted, while praying at night in the portico of the basilica, by the saint himself mounted on a magnificent white horse of which the radiance illuminated the portico (See Gómez-Moreno, M., *Introducción a la*

Historia Silense, Madrid, 1921, p. cxxiii). This conception of James as a knight and a rider saint (unfamiliar to the Greek pilgrim of the time of Fernando I) is paralleled by the contemporary elevation of St. Martin from a pedestrian to a cavalier.

210. Undoubtedly as a projection of modern conflicts between Spanish monarchist landholders and certain strata of the middle class.

211. Feudal relationships and the rivalries of the Christian kingdoms made it possible, and even necessary, that Christians sometimes support the Moors against other Christians. In 1063, Castile fought on the side of the Moors of Saragossa against the Aragonese, since the ruler of Saragossa was a vassal of Castile (cf. Menéndez Pidal, R., *La España del Cid*, I, p. 145). Even the national epic hero of the Spaniards, the Cid, fought on the side of the Moors; and it is by his Moorish name, Sidi, that he has passed into history and Western literature.

On the other hand, the Christian rulers were opposed by the native Christians in the newly conquered lands. According to a lost chronicle of Pedro of León, cited by Sandoval for the year 1106, Alfonso VI feared the Mozarabs on the frontiers more than the Moslems and deported them to Africa. See Fernández y González, *Estado social y político de los mudéjares de Castilla,* Madrid, 1866, p. 57.

212. "Robertus, Simonis Magi imitator factus, quanta potuit malignitatis astutia adversus beati Petri auctoritatem non timuit insurgere, et centum milia hominum, qui laboris nostri diligentia ad viam veritatis redire coeperant, per suggestionem suam in pristinum errorem reducere" (Migne, *Pat. lat.*, CXLVIII, col. 575, 576).

213. See the letter of Alfonso to Hugo, abbot of Cluny: "De Romano autem officio, quod tua iussione accepimus, sciatis nostram terram admodum desolatam esse, unde vestram deprecor Paternitatem, quatenus faciatis ut Domnus Papa nobis suum mittat Cardinalem, videlicet Domnum Giraldum, ut ea quae sunt emendenda emendet, et ea quae sunt corrigenda corrigat" (D'Achery, L., *Spicilegium*, III, 408). See also Hefele, *Conciliengeschichte*, second ed., V. 1886, p. 174, for the opposition to the new rite from 1070 to 1090.

214. On the introduction of the Roman rite see Florez, *España Sagrada*, XXVI, 1771, pp. 153–157, and III, p. 311. The duel and the trial by fire are recounted in the chronicle of the archbishop Roderick of Toledo (died 1247) and in the earlier chronicle of Maillezais. The story may be legendary, but is relevant nonetheless, since it records the conflict of interests. When the Roman rite was adopted, everyone wept and said: "Quo volunt reges, vadunt leges." Roderick also reports an uprising of the people and the soldiers.

215. The presence of Paul in the reliefs of the Ascension, Pentecost and Doubting Thomas, discussed above, pp. 47, 58, may also have a bearing on the national sentiment and the resistance to Rome. For he is not merely included in scenes where he does not belong historically, but he is set above Peter by his greater proximity to Christ and by the inscription *Magnus Sanctus Paulus*. In the second half of the eleventh century the relations of Peter and Paul in imagery had already become problematic, and Peter Damian wrote a treatise (*de picturis principum apostolorum*, Migne, *Pat. lat.*, CXLV, col. 589 ff.) to account for the discrepant positions theologically. I suppose it was the efforts of Gregory VII to unify and centralize the church through the authority of Rome that made such questions especially urgent. The traveler to Rome could see in the great basilicas venerable mosaics in which Paul had the place of honor beside Christ (Sta. Pudenziana, SS. Cosmas and Damian); in Cluniac painting of Italianate style, contemporary with the reliefs of Silos, it is this tradition again which is followed (apse of Berzé-la-Ville). Peter Damian explains that when Peter is at Christ's right, his primacy among the apostles is honored; but that when Paul is placed there, it is to symbolize the latter's descent from the tribe of Benjamin (the *filius dextrae*), or the contemplative life, as distinguished from the active which is expressed by the left side (*ibid.,* col. 593: "quamquam et hoc non a mysterio vacet, quod B. Petrus Dominici lateris sinistram tenet. Per illum siquidem activa vita signatur. Et sicut contemplativa via per dexteram, sic actualis exprimitur per sinistram"). Since the right side is the more spiritual, it could also be argued that Paul is superior to Peter in that he pertains to Christ's spiritual period, after the Resurrection, whereas Peter is of the earthly period. (For the recent literature on this question and on the meaning of left and right in mediaeval art, see Sauer, J., *Symbolik des Kirchengebäudes und seiner Ausstattung in der Auffassung des Mittelalters,* 2nd ed.,

Freiburg im Br., 1924, pp. 96 ff. and 391.) But in Silos it is not so much a question of orientation as of absolute proximity to Christ and, more than that, of an historically unwarranted participation of Paul in three scenes from the life of Christ. Is it possible that the importance given to Paul here expresses the claims of an independent national church or tradition?

Paul was regarded in Spain as the apostle to the Spaniards, since he spoke in Romans xv, 24 of a voyage to Spain, "whensoever I take my journey into Spain, I will come to you." There was no evidence that Paul really visited the country (the Early Christian texts of Pope Clement, the Muratorian Canon, the *Actus Petri cum Simone,* Jerome and Isidore, which speak of this visit, are not convincing, for they all appear to be based on the statement in Romans; but see García Villada, Z., *Historia eclesiástica de España,* Madrid, I, 1929, pp. 105–146, for a contrary conclusion); but it was argued that since he spoke of coming, he must have come: "sant Pablo, porque como ese mismo apostol escriviese a los Romanos que pasiaran por ellos o vernian a las Espanas, asi aya venido en cuerpo," for an apostle can't lie, "que as verdad, no pudo mentir" (*Crónica de España* by Luke of Tuy, a thirteenth-century bishop, ed. Puyol, Madrid 1926, p. 4). By placing Paul above Peter in the reliefs of Silos, the independence and worth of the native Spanish church are presumably affirmed against the aspersions of Pope Gregory VII. The latter, in demanding the abolition of the Mozarabic liturgy, had asserted that Spanish Christianity, Roman in origin, had become corrupt through Arianism, through later heresies, and through the centuries of Moslem rule (see his letter to Alfonso of Castile' and Sancho of Aragon and their bishops in 1074—Migne, *Pat. lat.,* CXLVIII, col. 339, 340). Although an investigation of Mozarabic service books held in Rome under the preceding pope, Alexander II, had confirmed the orthodoxy of the native Spanish liturgy—the books were judged "bene catholici et omni haeretica pravitate mundi" (Férotin, *Liber Ordinum,* p. xix)—Gregory continued to insist on the heretical character of the Mozarabic rite (citing "suggerentibus religiosis viris,"—letter of 1081, Migne, *loc. cit.,* col. 605). Moreover, he regarded Spain as a possession of the See of Peter; and in a letter of 1073 to the French nobles who were going to Spain to fight the infidels, he gave the crusaders the right to lands taken from the Moslems, on condition they recognize that they have them "ex parte sancti Petri" (*ibid.,* col. 289). In a subsequent letter he maintained that the kingdom of Spain from old times had belonged to the See of Peter ("regnum Hispaniae ex antiquis constitutionibus beato Petro et sanctae Romanae Ecclesiae in jus et proprietatem esse traditum"—letter of 1077 to rulers and nobles of Spain, *ibid.,* col. 484–487); and in conflicts between papal authority and Spanish rulers or individuals, he denounced their opposition or recalcitrance as an act against Saint Peter himself. Of the French monk, Robert, who had led a popular rebellion in Sahagún against the new Roman liturgy, he wrote to Hugo, abbot of Cluny: "Robertus, Simonis Magi imitator factus, quanta potuit malignitatis astutia adversus beati Petri auctoritatem non timuit insurgere . . ." (*ibid.,* col. 575, 576); and after this rebel had been removed and the king had adopted the line of Rome, Gregory warned Alfonso that if he relapsed, "nos . . . beati Petri gladium super te evaginare cogamur" (*ibid.,* col. 577). In another letter, of 1079, the pope informs Alfonso that "God has subjected all the principates and powers of the earth to Saint Peter, the chief of the apostles in faith and devotion," and recommends piety and humility to the king (*ibid.,* col. 549, 550). "In order that our exhortation be impressed more deeply in your heart, we have sent you a little golden key in which is contained a relic of the chains of the blessed Peter" (*ibid.*). Such a gift was especially appropriate for a Spanish ruler because of the miraculous unchaining of Christian prisoners of the Moors, but for this miracle Spaniards appealed to their new national saints (see note 209 above).

The unusual importance given to Paul in the sculptures of Silos, in a region where the cult of Paul was relatively slight—according to Serrano (*op. cit.,* II, p. 390) there was only one church dedicated to Paul in the entire diocese of Burgos—this recalls the corresponding reaction against Peter during the Protestant Reformation and in the heresies of the Early Christian period and the Middle Ages. The Manicheans and their Paulician successors (the name Paulician, however, may not refer to the apostle) placed the highest value on the epistles and regarded themselves as disciples of Paul (see Alfaric, P., *Les écritures manichéennes,* Paris 1918, I, pp. 21, 49, 71, 101; II, pp. 162, 168 and Guiraud, J., *Histoire de l'inquisition,* I, pp. 156, 157; note also that the heretic Priscillian wrote a

résumé of the doctrine of Paul—García Villada, Z., *op. cit.*, I, 2, pp. 102, 103). On the other hand, in the struggle against heresy in the twelfth century, Peter becomes the guiding saint; cf. the story told by Robert of Torigny, about 1152, of a young Gascon girl who remained for days speechless and without breath, and revealed, when she came to, that Peter had taught her the orthodox faith; whereupon she converted several heretics (Guiraud, *op. cit.*, p. 23). The prominence of Paul in the relief of Silos has no apparent heretical sense, but as a possible reaction against Rome corresponds to a similar elevation of Paul in other places and times. The Catharism of Italy and southern France seems to have reached Spain (Catalonia ?) early in the eleventh century; Raoul Glaber speaks of heretics passing from Sardinia to Spain; but I have found no evidence of such movements in the region of Silos in our period. Yet the introduction of Paul in the reliefs of the cloister, his elevation above Peter, and the inscribed text reminding the spectator of Paul's humility, all these would have a bearing on the tense relations between Rome and the native Spanish church in the period of 1070 to 1090. However, by 1118 such a motive could hardly have operated in Silos, which had been so friendly a protégé of the Castilian kings during the crucial period of change. For in 1118 the abbey of Silos, to escape the exactions and pressure of the bishops of Burgos who claimed administrative jurisdiction over the abbeys of their diocese, obtained the privilege of direct protection by the See of Rome and became the property of Saint Peter, like so many monasteries in France and Spain (see Férotin, *Histoire*, p. 80, and Serrano, *op. cit.*, II, pp. 370, 371).

If this hypothesis concerning the figure of Saint Paul in the relief of Doubting Thomas is correct, then the sculptures may be dated more precisely between two termini, after 1080 or 1081—the year of the introduction of the new rite (which provided the inscribed texts, but which was also the occasion of resistance to Roman authority and the reaffirming of native traditions)—and before 1118, the year of the submission of Silos to Saint Peter. And the latter limit may be pushed back still further to the first decade of the twelfth century, since the period 1109 to 1120, according to its latest historian, L. Serrano (*op. cit.*, I, pp. 380 ff., II, p. 439), was very unfavorable for construction in Castile. There was civil war between the kingdoms of Aragon and Castile; commerce was interrupted and agriculture declined. Although Silos was one of the wealthiest abbeys in Spain and received great donations during the later eleventh century, the cloister was left unfinished for several decades after two galleries and the beginning of a third had been built. The west and south lower galleries are admittedly of a later style than the east and the north. The political and economic difficulties of the period 1109 to 1120 would account for the interruption of the work.

216. The thirteenth-century chronicle of Alfonso el Sabio reports that the old Spanish rite was also preserved in some monasteries: "Et maguer que en algunos monesterios guardaron yaquanto tiempo despues el (sc. officio) de Espanna, et el traslado del salterio aun oy se reza en algunas de las eglesias cathedrales et en los monesterios mayores: per al commun, el de Francia anda por toda la tierra, et aquel usan al comun en la scriptura de las letras et en ell officio" (*Prìmera crónica general de España,* ed. R. Menéndez Pidal, I, Madrid, 1916, p. 543).

217. See note 193 above. Dates of documents are still given in the Spanish Era throughout the twelfth century; but in Silos, both the Era and the date A.D. appear in records of consecrations of Silos and a priory in 1088 and 1089 (Paris, Bibl. Nat. nouv. acq., lat. 2169, f. 37 bis verso—Férotin, *Histoire,* pp. 72, n. 3 and 215, n. 3). The same double dating appears in a document of the council of Husillos, near Silos, in 1088 (Férotin, *Recueil,* pp. 41–43), which was attended by Fortunius.

218. Of possible significance for the independent monastic valuation of the manuscript is the fact that an important charter of the abbot Peter (1158), regarding the allotment of the revenues of the abbey—a matter of conflict between monks and abbots, finally settled after the intervention of the archbishop of Toledo—was copied in the Beatus manuscript (f. 267 v) at the same time. For the text and circumstances, see Férotin, *Histoire*, pp. 85, 266, n. 1, and *Recueil*, pp. 91–93.

Significant also for the attitude of the monks, as distinguished from the abbots who faithfully supported the kings, is the note on Alfonso's accession to power, written in a Visigothic hand on a blank leaf of a manuscript of Silos (Paris, Bibl. nat., nouv. acq. lat.

2171, f. 21). Alfonso is accused of the murder of his brother Sancho, the preceding ruler, who had killed his brother, Garcia. See Menéndez-Pidal, R., *op. cit.*, I, p. 218 for a facsimile of this text, and II, p. 736, for a transcription. The note was probably written soon after Alfonso came to the throne.

219. On the elaborate forms of Mozarabic colophons, see Domínguez Bordona, J. *Ex libris Mozárabes*, in *Archivo español de arte y arqueologia*, XXXII, 1935, pp. 153–163.

220. See f. 276—*ob onorem Sancti Sebastiani abbati Fortunio librum Munnio presbiter titulabit hoc*. See note 207 above, on the vocable of the abbey after 1076.

221. This is evident from the account of Domingo's mission in Silos given by his biographer Grimaldus, who knew him in person. See Férotin, *Histoire*, pp. 24, 25, 37, 38.

222. But already in the 1040s and '50s the transition to Romanesque forms is evident in miniatures of manuscripts like the Beatus of Facundo (1047), the charter of S. María at Nájera (1054), the *Diurno* of Sancha (1055)—Gómez-Moreno, *El arte románico español*, 1934, pl. I–VI. The underlying Mozarabic tradition is still unmistakable in these works.

223. On this, see P. Justo Pérez de Urbel, *Los monjes españoles*, II, pp. 444 ff.

The Sculptures of Souillac

(1939)

THE sculptures now preserved in the inner west wall of the abbey church of Souillac (Fig. 1) are the fragments of a larger whole which we can no longer reconstruct. The largest of these (Fig. 2)—the relief of the story of Theophilus—is still intact,[1] though possibly removed from its original architectural field. It is so irregular in design that we are led to suppose at first that this relief, too, has been subject to a later reconstruction and loosely transformed. The parts seem as oddly fitted to each other as the whole to its modern field. If Porter could admire its inner composition, another writer has spoken of its mediocre architectural design.[2] The expected Romanesque adherence to an embracing architectural frame is violated throughout the work. But a more detailed analysis will show that the apparently "accidental" design is a deeply coherent arrangement, even systematic in a sense, and similar to other mediaeval works. In the course of this analysis, I shall indicate the existence of a type of mediaeval design which has received little attention from investigators, though important for a correct account of mediaeval art.

I

The main relief is composed of nine slabs in three stepped horizontal rows of three (Fig. 3). This sustained three-part scheme is analogous to the divisions of the objects, the zones, and the content of the sculpture. The story of Theophilus, which includes three actors—the *vidame*, the devil, and the Virgin—is recounted in three episodes.[2a] There are also three angels issuing from the trefoil arch, and the great central field is

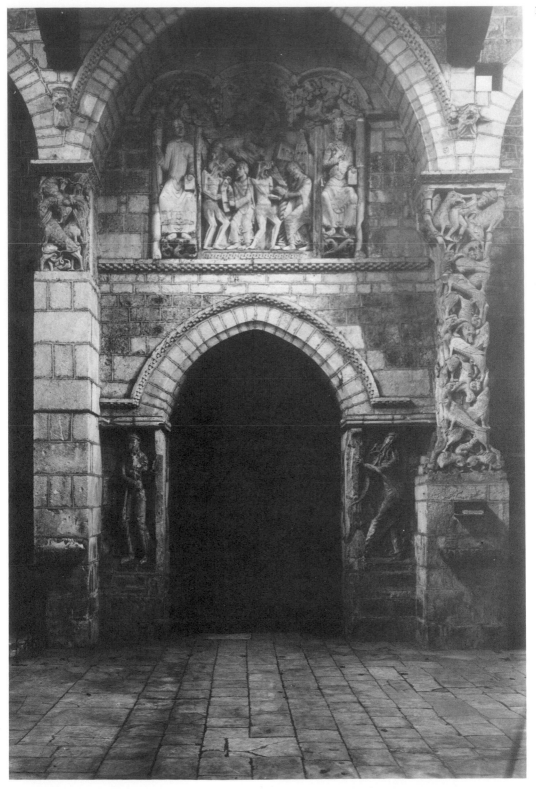

Fig. 1. Souillac, Abbey Church: West Wall. *Kunstgesch. Seminar Marburg*

2

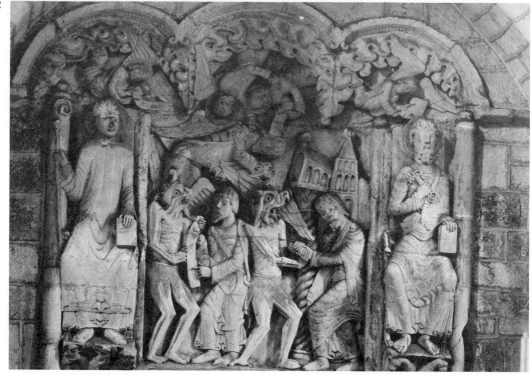

Fig. 2. Souillac: Story of Theophilus. *Kunstgesch. Seminar Marburg*

Fig. 2a. Souillac: The Devil and
Theophilus: The Contract. *Kunstgesch.
Seminar Marburg*

Fig. 2b. Souillac: The Devil and
Theophilus: The Agreement.
Kunstgesch. Seminar Marburg

2a

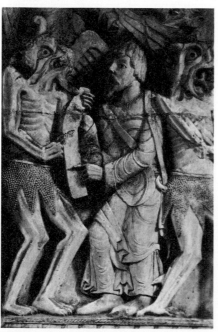

2b

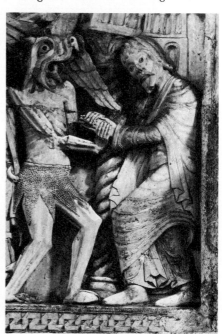

flanked by two saints. But the actual fields of the masonry do not correspond strictly to the figures applied to them. The horizontal joints of the central slabs cross the breasts and arms of Theophilus and the devil, and the joints of the slabs at the sides intersect the legs of the abbot Benedict and the thighs of Peter (Fig. 2).

On the other hand, the extremities of the figures are relatively independent of the larger frame. The four heads of the devil and the sinner in the central field are unframed and unconnected with the salient elements of the adjoining fields. The heads of Benedict and Peter are similarly unenclosed. And if we observe the feet of these six figures, we encounter again a conception of the field and the frame as an unarchitectural mosaic or marquetry.

In this relation of the masonry and the carving, as in many other respects, the relief of Souillac agrees with the sculptures of Moissac;[3] the common stylistic types are bound up with common technical devices. But in Souillac, even more than in Moissac, the lack of a strict accord between the composition of the sculpture and the composition of the material field corresponds to the nature of the sculptural composition. Within the latter, too, there is a discrepancy between the frame of the whole and the enclosed elements.

The trefoil arch above the scene is designed as a symmetrical structure embracing a field with a corresponding symmetrical three-part form. Yet the axes of the two symmetrical sets do not correspond. The central arch segment is indeed placed directly above the central scene. But the two pairs of Theophilus and the devil are unequal in breadth; the right is broader than the left, so that the vertical compositional axis is a little to the left of the geometrical axis of the field. More important are the inequalities of the segments of the trefoil arch. The left one extends considerably beyond the figure of Benedict below, whereas the right is tangent to the frame of Peter. This inequality is sustained by the fine differences in the curvature of the flanking segmental arches and by the variant levels of the two terminal points of the central arch. The frame thus appears to be modeled on a freehand drawing of a frame, and is not a typical constructed shape; it is an eccentric, irregular, flattened trefoil without a supporting form. The central arch is above the irregular, uncentralized composition of the central field, and the flanking, irregular arch segments are above the rigid, stabilized figures of Benedict and Peter. The seated frontal saints are placed at the sides, and the middle field is occupied by the more active and uncentered profile figures. This arrangement departs from the usual conception of an arched Romanesque field, as in Moissac and Chartres, where the central area is occupied by a stable, even rigid, frontal figure and the sides by more active ones in profile. In Souillac the central turbulent figures are even reduced in size; the flanking, detached Peter and

Benedict are the largest in the whole relief. But their rigid axes find no prolongation or conclusion in the segments above them, for the central axes of the latter are diagonal and converge toward the main field. And even if we should isolate a vertical axis in the area spanned by each lateral segment, it would not coincide with the axis of the seated figure below. In fact, the sculptor has marked such an axis in the symmetrical convergence of the voluted ornament on the crowns of the segmental arches. On the right it is far to the left of Peter's axis; on the left, it is slightly to the right of Benedict's.

II

I shall call this discrepant relationship of corresponding parts "discoordinate." By discoordination I mean a grouping or division such that corresponding sets of elements include parts, relations, or properties which negate that correspondence. A simple example of a discoordinate design is a vertical figure in a horizontal rectangle or a horizontal figure in a vertical rectangle.[4] The frame corresponds to the figure in its rectangular form, but its major axis is opposed to the major axis of the enclosed figure. Such arrangements are not "errors" of taste or artistic judgment; they occur in works of high quality in the Middle Ages and must be seen in detail to be understood.

Consider the grouping of the figures directly under the trefoil arch in Souillac. Each segment includes a descending angel; but these angels, instead of tieing the three members of the frame to the corresponding fields below, contradict this implied coordination. The left angel descends diagonally toward the central rather than the lateral field; the diagonal of his wings points downward to Theophilus, and his extended scroll completes the chain in repeating the direction of his arm and the curve of the wing of the descending angel of the central field. He is completely detached in gesture and movement from Benedict below, although their adjacent forms are plastically similar, with an analogous roundness and salience.[5]

We should expect—given the symmetry of the arched frame and the fields below—that the angel emerging from under the right segment would be turned to the left as the symmetrical counterpart of the first angel. On the contrary, he descends to the right and poses a book above the head of Peter, repeating the movement of the left angel, but also negating the latter's relation to Benedict, the corresponding seated figure. The diagonal slope of his wings, exactly as in the left angel, confirms the unsymmetrical repetition of the figures. Thus we have within a symmetrical group a left-to-right movement, instead of a convergence of counterpart elements (Fig. 4). The three-part structure of the upper zone of the

relief is therefore discoordinate with respect to the three-part structure of the lower zone, a discoordination already implied in the relation of the arched frame to the field below.

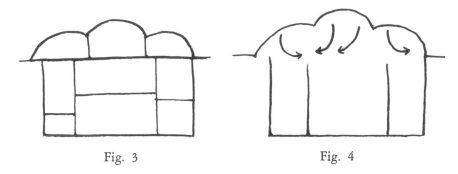

Fig. 3　　　　　　　　　　　　　Fig. 4

A similar relation may be found in the cloud forms and the trefoil, but it is less significant than the relation of the two lateral angels to the central pair of descending figures, the Virgin and the third angel. This pair may be seen in two ways: moving diagonally to the left in opposition to the flanking twin pair of angels, who move diagonally to the right, or as two figures, of which the right is the symmetrical counterpart of the adjacent right angel and the left is the counterpart of the left angel. I believe that the first is the more significant and pregnant view of the whole, especially since the central figures, embraced by the dominant arch segment, are tied to each other by shape and meaning. But in either view the static symmetry of the centralized three-part scheme is destroyed and a violent opposition created within the heart of the larger symmetrical structure. Just as the lateral components of the symmetrical series are re-peats rather than counterparts and thus introduce a left-to-right movement in a symmetrical group, so the central figures are repeats, not counter-parts, but introduce a lateral movement in the opposite direction.[6] Even the subordinate structure isolated in the second way of seeing the group has a similar character; for then two new axes are produced at the meet-ing of the arch segments (Fig. 4). At the right, the angel moving right-ward and the Virgin moving leftward form a *diverging* symmetrical pair with respect to the juncture of their two segments; while on the other side the two descending angels form a second (though less rigorous) pair *converging* to each other. The two individually balanced pairs are not counterparts of each other; they are simply juxtaposed, even overlapping, structures, one convergent, the other divergent, but made up of roughly similar elements.

The reference to the junctions of the segments as alternative axial points is confirmed by the divergent spiral or voluted tips at these junc-

tions. Moreover, the fine voluted ornament of the trefoil segments is designed symmetrically with respect to both the crowns of the arches and the junctions. And in the cloud forms we can observe within the seemingly unordered, freely improvised lines differentiated pairs of volutes, convergent at the issuing point of the left angel, divergent above the central angel, and parallel above the Virgin and the right angel.

If the two outer angels were converging counterparts rather than parallel figures directed to the right, there would result a predominance of movements to the left, since three of the four figures would have that direction. We can see then how the present discoordinate arrangement is a necessary balanced scheme; but its balance depends on the negation of the usual order of the symmetrical three-part scheme of central and flanking elements implied in the trefoil frame. It corresponds to those single Romanesque figures with arms turned one way, head and legs the other way, like the Joseph in Souillac (Fig. 5). In the Isaiah (Fig. 6) the crossed symmetrical legs and the arms are turned to the left, and the central dominant mass of the head to the right. In the upper group of the angels and Mary a movement is balanced, not by a directly confronting mass, but by elements on both sides, as by a larger active milieu. The central figures move in one way; their *surrounding* attendants all move in the opposite way. The extension of the trefoil at the left may be regarded as an adjustment of the contrast of these directions.

It is possible to discover other schemes within the four upper figures, more clearly symmetrical than the grouping described above. But these newer groupings are also tied to the larger discoordinate scheme. Thus we can see the left arms of the central angel and the Virgin, plus the head of the angel, as a convex arched form opposed to the concave loops of the bodies of the lateral angels, and the three curves as a symmetrical counterpart scheme corresponding to the trefoil above (Fig. 7). But within this scheme the four heads create a discoordinate structure; the heads of the central pair are considerably to the left of the main axis of the relief, the heads of the outer angels are shifted as markedly to the right.

Fig. 7

III

The peculiarities of the four upper figures and their relations to the enclosing forms recur in the flanking saints (Figs. 9, 10). How Benedict is

placed centrally below his arched segment and Peter eccentrically below the other has already been observed. This asymmetry reappears within the narrower field of each saint in the enclosing shafts, which are of unequal height; it corresponds to the asymmetry of the arch above. But these inequalities are ordered in a counterpart sense, forming a larger symmetrical frame, *a-á, á-a*, like the trefoil as a whole (Fig. 8). The enclosed

Fig. 8

saints, however, are disposed like the two lateral angels, as repeated rather than counterpart elements, and thereby contradict—though to a lesser degree—the order of their frames. Thus each holds a book in the left hand and an appropriate symbol in the right. The common position of the books and the identity of form, even to the placing of the clasp, create a pronounced rightward deviation from the axis of the whole relief, opposed to the leftward extension of the trefoil above. But the common diagonal inclination of the crozier and keys produces a countermovement to the left. This movement is also upward because of the diagonal relation of the levels of the two attributes. In opposition to these repeated forms, the right arms, which would maintain a common form if they agreed with the system of repeats, are flexed as symmetrical counterpart shapes, the arm of Benedict being turned outward, of Peter, inward.

In truth, the two figures are thoroughly differentiated and contrasted in detail, contrary to the larger correspondences described. In Peter the diagonal of the right arm is repeated in the band across the breast and shoulder, opposed in turn by the huge keys. In accord with this X-scheme the draperies of the torso and the legs are zigzag, pervasively diagonal and symmetrical, like the legs and feet. But in Benedict a more compact, placid, cubical form is created, with primary vertical and horizontal accents and with prolonged lines. Hence the elongated crozier, the book, the vertical folds of the garment, the clear horizontal edges, the inward

turn of the crozier and the left hand. The silhouette is less richly indented than Peter's, the mass less skeletalized; hence the relaxed quality of Benedict in contrast to the tension and rigidity of Peter. Both figures seem to hold identical books, but the book of Peter rests only partly on his diagonal thigh. It projects beyond the body, while Benedict's book is held firmly on the foreshortened thigh. The difference in conception may be verified finally in the hands and feet. Peter's left hand is turned slightly away from the body, Benedict's, inward. Peter's feet are bare and clawlike, with multiplied diagonal forms which resemble the clawed feet of his throne; Benedict wears shoes which form a simpler, broader, more stable mass. The distinction between the beardless and bearded faces is a feature in this sustained contrast.

Even the beasts under the feet of the two figures maintain the formal oppositions above them. Under Peter two dragons are crossed in an X, biting each other's tails; the wing of the left dragon points diagonally upward, the parallel wing of the right, inversely downward. Under Benedict a more compact, rounded, serpentine monster is deployed horizontally across the field in three coilings (Fig. 11). From the summits of the coils issue three grotesque human figures which form a roughly symmetrical, centralized group in horizontal alignment, like the three groups of pleats at the edge of Benedict's robe. But the two left figures, torsos of devils, are isolated as an independent pair with converging wings and corresponding ribs, inwardly and outwardly symmetrical. The axis of this pair coincides with the juncture of the two left coils from which the demons emerge. These coils, however, are neither symmetrical counterparts nor repetitions of each other; one is the inverse rather than reverse of the other. The outer left coil has as its veiled counterpart the third coil at the extreme right; but the magnificent head issuing from the latter is turned to the right like the first figure, rather than to the left as its proper counterpart. Thus the scheme of the angels of the upper trefoil field, with the rightward turn of the outer figures and the leftward of the inner angel, is repeated below at the feet of Benedict. But whereas in the trefoil the leftward movement of a central pair is balanced by the rightward movement of surrounding figures, here a symmetrical pair at the left is balanced by the accented rightward direction and magnitude of a single head at the right. In distinction from the upper group which surmounts the entire centralized field of the sculpture, the lower group is simply a lateral element and is adjusted to its restricted marginal place below by the predominance of the lateral head. In the double scale of this head and the two little demons, the sculptor reproduces the contrast of the figures of the central field and the great lateral saints. Further, this large head maintains the direction of the serpent's body (which corresponds to

the order of the diabolical scenes in the central field), in opposition to the twisted head of the serpent below. These two heads are turned divergently, unlike the two confronted demons at the left; and, also unlike the latter, they are superposed vertically rather than set horizontally beside each other. Finally, this large head reembodies within the fantastic bifurcation of the beard the inner oppositions of the two demons.

Because these groups of monstrous beasts under the ledges supporting Benedict and Peter are so small and so minor an element in the whole, they reveal to us all the more deeply in their minute distinctions and powerful fantasy and in the pervasive contrast of corresponding parts the sculptor's independence of an *a priori* architectural form and his conscious method of design, with its virtuosity in variation and intricate juggling of symmetrical schemes.

I V

Let us turn now to the central field (Fig. 2). The relative frequency of the protagonists suggests a schematized hierarchical grouping. Theophilus appears three times, the devil twice, the Virgin once. But these numerical relations are hardly disposed in a symbolic sense and play little part in the actual composition. The system of repeated and contrasted pairs is more crucial for the structure of the whole. Below, the devil first offers the contract to Theophilus; then, at the right, the same group is repeated, but the devil grasps Theophilus by the hands to make him his liege man. The simple succession from left to right, the repetition of the broad structure of the first scene in the second, corresponds to the grouping of the outer angels above; and this correspondence is accented by the parallelism of the devil's and the angels' wings. The two scenes produce a chiasmic symmetry, with Theophilus and the devil back to back in the center of the field, and the devil and Theophilus face to face at the sides of the field. The order of the inner divergent pair is reversed in the outer pair, and through this device the opposition of man and devil is varied and sustained. Reading the group as *a, b, a', b'*, we can isolate four symmetrical pairs, *a–b, a'–b', b–a', a–b'*, in every one of which appear the opposed Theophilus and the devil. If for the sake of a larger symmetry of the two scenes the sculptor had grouped the figures, *a, b, b', a'*, the second scene would be the counterpart of the first, but the opposition of Theophilus and the devil would then be less pervasive.[7] The symmetrical pairs, *a–b, b–b', a–a' b'–a'*, include only two in which the protagonists are opposed, *a–b, b'–a'*. This alternative system is evoked, however, in one detail of the present arrangement, the relation of the arms. In the left group the devil's arm is raised higher, Theophilus', lower; in the right group

this order is reversed, so that an *a–b, b–a* scheme results. In the actual design the chiasmic form is maintained throughout the two groups by the mimetic play of the diverging and converging limbs in energetic diagonal schemes of which the linear elements are diffused in the ribs, the zigzag, hairy waistband, and the wings of the devil, and in the draperies of Theophilus.

With a passionate feeling for the expressive pantomime, the sculptor has varied the two pairs according to the meanings of the episodes, the left showing a more relaxed and compact confrontation of the figures, like the adjoining Benedict, and the right, a more tense and vehement combination, like Peter (Figs. 2a, 2b). These qualities appear in the relations of hands and heads as well as in the major limbs, and finally in the spiral-cable column between the figures at the right. The column, of which the diagonal coils move upward toward Theophilus, concentrates the aggressive energy of the devil's forward movement in a single intermediate member, expanding also the motif of the diagonally grasping hands. The devil's wings are diagonal in both episodes and point downward to Theophilus, but while in the left scene the inner wing passes behind Theophilus as an embracing form and is obscured, it is pointed fixedly like a sword in uninterrupted movement toward Theophilus at the right. In both groups there is a sustained correspondence of lines down to the smallest details, but the form is different in each scene according to the underlying content of the figures. Yet transcending these differences is a common movement that pervades the relief, without culminating, however, in a central or surmounting object. Observe, for example, how the two heads are turned to each other in the left group, how the intervening wing bridges their forms, but, originating in the devil, maintains a dominant left-to-right movement; and how, in the second group, the whole physiognomy of the devil has changed with the turn of the head, assuming a more predacious character by an astonishing conversion of the features into flamboyant, centrifugal, tentacular curves, related to the forms of the clouds above. This inventiveness and energy of expression is maintained in the adjacent elements which unite the devil's and the *vidame*'s heads. The lines of the devil's jaw and snout flow into the curves of the capital surmounting the column, and thus to the bowed, not opposed, head of Theophilus. In the first group, the figures are linked by a continuous convex curve; in the second, which represents not only agreement but an asserted possession and submission, the heads are united by an undulating curve with a central concavity, a curve issuing from the monstrous active snout of the devil.

The sculptor's conception of contrast as both a principle of arrangement and a quality of antagonistic or divided objects appears also in the rendering of the devil's feet. They are different in the two episodes, as if

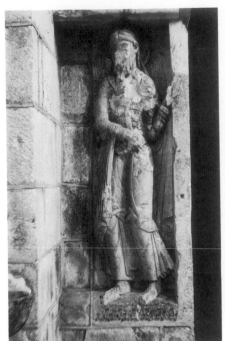

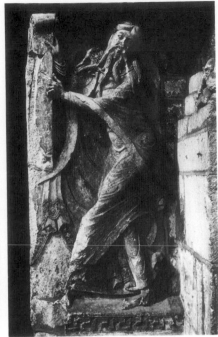

Fig. 5. Souillac: Joseph. *Kunstgesch. Seminar Marburg*

Fig. 6. Souillac: Isaiah. *Kunstgesch. Seminar Marburg*

Fig. 9. Souillac: St. Benedict. *Kunstgesch. Seminar Marburg*

Fig. 10. Souillac: St. Peter. *Kunstgesch. Seminar Marburg*

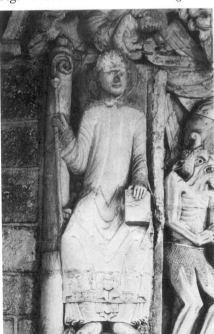

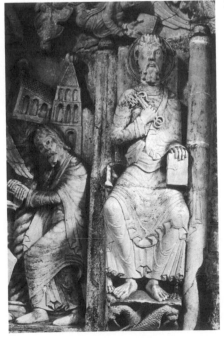

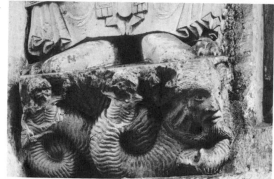

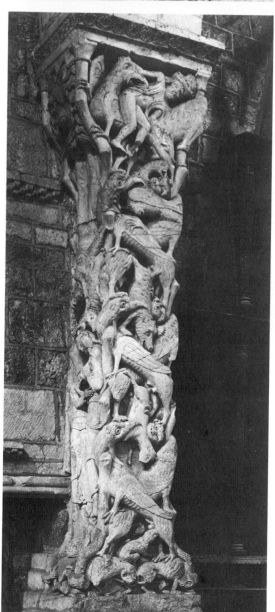

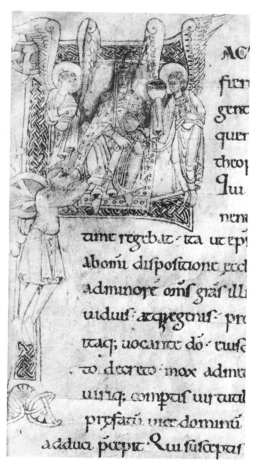

to indicate a development in the devil who changes in the course of the action. At first he has the clawed feet of a predacious quadruped; then the feet are distinguished from each other: the right is clawed like a bird's, the left is a cloven hoof. This inner change corresponds to the contrast of Benedict's and Peter's feet which has already been observed; but the internal asymmetry of the devil in the second scene is a progressive revelation of the demon, a final emergence of his lowest nature and ugliness, as in the changing shape of his head.

For the solution of the drama, which includes a third act—the repentance of Theophilus and miraculous intervention of Mary—the sculptor had to introduce the new figures in a sequence which breaks with the established order of episodes. The final scene is not placed at the extreme right to continue the left-to-right movement of the story, but above the left scene in an ambiguous temporal relation to the others. Theophilus is prostrate above the first scene, but the church in which he prays (according to the legend) is above the second, and is in part an element of the latter. The image, however, is more than a succession of incidents to be identified by the spectator; their arrangement depends on devices of expressive composition applied according to the artist's judgment of the significant content of the story. For the mediaeval spectator the reconstruction of the sequence of moments was a simple matter which flowed from his understanding of the objects. The religious and dramatic values, the inner gradations of action, were more important; and it was from these that the artist derived his liberty of arrangement. The third incident with its transcendent persons had to be placed above; as a culminating moment it was centralized and elevated to the zone of angels. But it is not a dominant theme for the sculptor. Its elevation and centrality, as will be shown later, are more conventional than expressive.

It is more difficult to describe this region of the sculpture than any other, not merely because it is more irregular or complex in arrangement but because the third figure of Theophilus, as a mediating element between the upper and lower zones, belongs at the same time to so many distinct configurations.

Thus the recumbent sleeping Theophilus is balanced in his own horizontal field by the masses of the adjoining church, with its attached vertical and slightly inclined horizontal blocks, and may be seen together with them as the base of the apical pair of the Virgin and angel. But he is also the counterpart of the second Theophilus swung through an arc of 90°. The two figures, with their corresponding heads, arms, and thighs, are symmetrical with respect to a diagonal line bisecting the left building and tangent to the devil's snout (Fig. 12). The divergent wings of the devil have a related symmetry; and if the right wing is above the arm of the second Theophilus, and the left wing below the arm of his counter-

part, the variation corresponds to the interplay of the mantle and the arm in the two figures. At the right, Theophilus' left arm issues from under the mantle; in the upper figure the corresponding right arm extends above the mantle.

Fig. 12

Finally, the praying Theophilus is tied to the lower band of figures. He emerges directly from behind the first devil and the raised wing of the second; no border or frame divides the upper from the lower band. By this interception of the legs Theophilus is bound to the movement of the figures below. His body appears to be an arched form spanning the first and the second devil and surmounting the first Theophilus, as if the latter were a central figure. The two devils are bound in turn by the embracing mass of the penitent, just as the wing in the first scene connects the heads of the devil and Theophilus. The right leg of the penitent prolongs the right arm and torso of the first devil, and the right arm of the former parallels the right arm of the second devil. The rear wing of each devil rises to the body of the penitent. The leftmost wing meets the descending wing of the central angel, and thus the uppermost and lowest groups are brought into contact. But this is a minor contact beside the more decisive mediation of the penitent's right arm which resembles the general form of the bent limbs below. It corresponds also to the arms of the upper lateral angels, and belongs to the same scale of arched forms as the arms of the central angel and the Virgin. The common obtuse angle

of these rhythmically distributed arms in the three zones of the relief distinguishes them as elements of a single scheme, separate from the acutely flexed arms of Peter and Benedict.

The correspondence of the penitent figure and the buildings before him has also a mediating character. The upward-tending, emergent mass of the figure is opposed by the upward-tending and emergent buildings at the right. They form the only directly confronting symmetrical pair on the axis of the large field. The devil and Theophilus below are divergent, back to back; the angel and the Virgin above are turned in one direction. But the relation of figure and building is approximately, not strictly, symmetrical, and then only with respect to an axis considerably to the right of the main axis of the relief. The axis of the three superposed pairs is therefore roughly zigzag in form, like the contact of the central adossed pair of Theophilus and the devil. The rightward movement of the penitent Theophilus, who reaches across the axis of the field and is prolonged by the ascending scheme of knobs on the buildings and the throne of Peter at the right, is opposed to the asymmetrical leftward turn of the Virgin and angel above, but repeats the rightward disposition of the lateral angels and the order of the scenes below. The meander ornament under the central field is also directed to the right.

Thus the interwoven contrasts and discoordinate relations of the trefoil and the upper row of suspended figures are continuous finally with the middle and lower zones of the relief. The three episodes become a single differentiated action of three groups.

V

Although we are uncertain whether the figures of Isaiah and Joseph (Figs. 5, 6) were originally placed below the relief of Theophilus, as they are today, their coherence with the latter appears in numerous correspondences. They are paired symmetrically with respect to the doorway; Joseph's head is turned to the left, Isaiah's to the right, and their arms, in similar opposition to the heads, are extended in counterpart patterns to the doorway. But in contrast to these symmetrical relations the legs are all turned in the same leftward direction; and this contrast, which resembles the systematic discoordinate oppositions of the relief above, is maintained in the opposed rightward movement of the meandering ribbons under their feet. Thus the arms of Joseph are directed like the devil's, and the arms of Isaiah like the sinner's; but if the general direction of the upper pair is from left to right, in the lower pair it is from right to left. The counterpart of Isaiah's scroll appears, however, in the hands of the devil at the left.

The two figures are tied still more intimately to the large relief in

their fine inner differences which correspond to the contrasted elements above. Both are internally asymmetrical and mobile, with head turned one way, arms or feet the other way; but Isaiah is the more skeletal, angular, and tense, like Peter and the devil; Joseph, the more stable, compact, and relaxed, like Benedict and Theophilus. Isaiah is similar in these respects, as well as in energy of movement, to the group of Theophilus and the devil at the right. Even the swirling diagonal edge of Isaiah's robe that encircles the right leg reappears in the second Theophilus. The latter's posture and drapery agree in other details with Isaiah's; his head, however, is bent submissively, in contrast to the independent turn of the announcing prophet's. On the other side, Joseph's body is like Theophilus' at the left, but his arms correspond to the devil's rather than the *vidame's*. The former's scroll reappears, however, in Isaiah's hands, not Joseph's. Finally, the separate but counterpart symmetrical gestures of the two figures below reenact the transacting gestures of the devil and the sinner at the left.

If we accept Joseph and Isaiah as parts of a larger scheme including the relief of Theophilus—and I think this is justified by the intimate correspondences, which imply a purposive connection—then we have an added evidence of the formal method of the sculptor. The procedure of discoordinate pairing, of repetitions in counterpart elements, of oppositions in repeated units, recurs in the two figures below. Yet they are no duplicate of any of the pairs above, but form a distinct variation of the common theme of the paired figures. They are flanking elements like the two seated saints above, and are also active like Theophilus and the devil; parallel, however, rather than opposed in their motion, like the upper lateral angels. But more essential, each is divided internally in his motion unlike any of the figures above, and thereby resumes within himself as an isolated single being the contrasting structures which pervade the larger groups and the work as a whole.

VI

This internal contrast reappears in the fabulous trumeau (Fig. 13). Here it is raised to a higher power in paired figures which are not merely confronted, like Isaiah and Joseph, but diagonally crossed. The motif underlying the frantic confusion of struggling, devouring, intertwining figures is the repeated pair of crossed beasts with a common victim. Their bodies diverge, but their heads are turned back to face each other. Isolate this chiasmic unit and the whole will emerge ordered and clear. Tie it, however, to its architectural frame—the parallel columns around which the beasts twist their necks—and the whole will appear inextricably involved (Fig. 14).

A remarkable intrigue animates these opposed predacious beasts. They are of different species, the one a monstrous quadruped with the wings and head of a bird, the other a kind of Romanesque lion. Their foreparts are mounted on each other's backs, but their bodies are turned in opposite directions, as if awaiting other prey. Then reversing the divergent movements of their bodies, they turn their heads and find a common prey behind their crossed backs.

Fig. 14

Even this paradoxical return is obstructed and indirect. The necks are twisted around constricting colonnettes. The violence is therefore devious, improvised, and constrained; the weak victim is caught between the opposed monsters, like the latter between the slender colonnettes. In their common enlacement of the colonnettes, the monsters are distinguished again; the outer one twists his neck around the obstacle from within, the other, from without. The contrast of the two upper victims, with bent, resisting forms, to the lower ones, with rigid bodies, and the repetition within these pairs, also recall the formal method of the large relief.

In the diagonal crisscross and knotted forms, the functional, structural lines of the trumeau are completely obscured. There is no sustained vertical element in the design. On the contrary, if the two lower victims are vertical, they are unstable, unresisting figures, held momentarily in place between the jaws of the monsters. And if the colonnettes are conceived as quasi-structural members which appear to support the impost above and

hence the whole mass carried by the trumeau, we are shown this function in the very process of its disturbance by the action of more powerful, non-architectural forces. The vertical colonnettes are bent inward at four levels by the lateral pull or tension of the excited beasts; the latters' force, greater than the architectural load, deforms the supporting colonnettes. Another pull, and the whole structure will topple down into a shapeless heap.

The sculpture is therefore an undemountable form. We cannot isolate the figures without disrupting the architecture. The contorted animals must first be unwound from their frame; and the frame will change its shape, it will return to a vertical, when the figures are removed.[8]

The pattern of the trumeau is not simply a network of abstract, ornamental lines to which the figures have been submitted. The beasts are twisted, entangled, and unbalanced by their own rapacious energy. Every motion issues naturalistically from its opposite. The intensity of the beasts, their almost supernatural vehemence, lies in the deforming oppositions generated by impulsive movements. In his divided posture the beast acquires a human complexity and inwardness, a suggestion of conflicting motives, like a Christian with his double nature. The diagonal crisscross pattern, the interlaced scheme, and the scalloped verticals are the inspired devices of this tense, congested struggle. They are material aspects of the beasts, or physical elements like the sagging colonnettes, real situations of tension, instability, obstruction, and entanglement, even if repeated in the sense of ornament. The beast is not unstable because fitted into a diagonal scheme; he is presented diagonally because the sculptor wishes an unstable figure. This realism of design corresponds to the powerful reality of representation in the animals, and to the rich variety in the repeated units, which transcends the norms of ornament.[9]

VII

The relation of the content of the large relief to the formal characteristics and method of design analyzed above is more difficult to state, since we must refer to meanings which are hardly as explicit to us as the forms of the sculpture. To approach this relation fruitfully we must begin, I think, not with the episodic details of the story of Theophilus, but with the broader, even formal aspects of the story.[10]

We have already observed that in contrast to such works as the tympana of Moissac and Chartres, and, in fact, to most monumental mediaeval sculptures, the theme in Souillac is so disposed that the religiously inferior figures (Theophilus and the devil) occupy the central field, and the Virgin, angels, and saints, the peripheral fields. The center consists, moreover, of the mobile, episodic figures, and the sides, of the stable, hier-

archically elevated figures. The contingent, the temporal, and inferior are centralized in Souillac; the stationary and elevated are marginal. As a result, the chief formal devices for showing transcendent objects—namely, magnitude, stability, centrality, and elevation—are unconnected here. The figures grow smaller as they approach the crown of the field.[11] This suggests compositions of the later Renaissance, like El Greco's Burial of Count Orgaz; but the contraction of forms in Souillac is without perspective value. It creates no optical illusion of distance and transcendence. No figure in the lower zone looks upward or toward a central object. There is, in fact, no fully central object, only an implicit axis, the junction of two figures who stand back to back. And correspondingly, in the upper zone, the religiously transcendent figure of the Virgin is shown, not enlarged and enthroned, but reduced, unstable, descending, and suspended from an angel's arms. The flanking angels, far from constituting a symmetrical retinue, are directed toward the right, rather than toward the center. With the two enthroned figures at the sides, the normal hierarchical relations become merely accessory and conventional. Finally, it is the heavenly figures, the Virgin and the angels, who are incomplete, being intercepted by the frame.

These aspects of the larger form may therefore be seen as a conception of the content, a devaluation of absolute transcendence. In the episodic trinity of the man, the devil, and the Virgin, the central figure is not the Virgin, but the apostate-penitent, Theophilus.[12]

A similar relation governs the content of the trumeau. If themes of violence and conflict are represented on the sides, they are the more restrained, human, and religious motifs. (On the right, three superposed pairs of embracing and wrestling figures of an old man and a youth; on the left, Abraham about to sacrifice his son, and an angel descending with a ram to stay the hand of the patriarch.)[13] The more violent struggles of the monsters are applied to the broader frontal face, and it is the latter which are most intricately articulated and most capable of divided movements. But within the dominant outer groups the central element is always the weakest figure, the helpless prey caught between the powerful beasts. As on the great relief of Theophilus, the traditional values of centrality and symmetry have been inverted. In Oriental and Romanesque art, the heraldic beasts paired beside a central object are protecting or adoring figures; here they destroy the inferior prey. The adossed beasts who turn their heads are like the familiar apocalyptic escorts of the enthroned Christ in Majesty in Carolingian and Romanesque art. On the trumeau of Souillac they become predacious monsters devouring the immobilized central victim.[14]

This devaluation of the central and the immobile and of the absolute hierarchical order is already present in the meanings of the sculpture of

Theophilus, in the positive concern with the religious and moral struggles of a single lay individual. The sense of the story of Theophilus is much richer than appears from the simple moral of salvation through Mary. In its twelfth-century form[15] we can distinguish the following contemporary interests and motives:

1. The secular concern with position and wealth in the very bosom of the church, the church being one of the great feudal powers, a corporate landholder with a functional stratification of rank. The *vidame*, Theophilus, the lay administrator of the church funds,[16] has declined the office of bishop through humility. But once he is removed from his own office by the new bishop, he is deeply distressed and attempts to recover his old position. The presence of Peter and Benedict[17] at the sides of the relief pertains to the administrative, ecclesiastical context of the affair: Benedict is the great abbot, Peter, the first bishop. I know of no other image of Theophilus in which this context of authority is emphasized through the figures of the two saints.

2. The apostasy or heresy of Theophilus. To regain his position, he renounces Christ and the Virgin and accepts the devil as his lord. The intermediary is a Jew. The legend probably originated in Asia Minor[18] during the early Christian period at a moment of heresies and controversies over the nature of Mary as the mother of God. But in the twelfth century the apostasy of Theophilus, his adherence to the devil, had a local significance in southern France, the classic region of mediaeval "Manichaean" heresy which regarded the church as a creation of Satan.[19] A grievance of the heretics against the church was the sinfulness of its great wealth and offices; they demanded a religion compatible with the ideals of poverty and a pure devotion.

3. The acquisition of rank through a written charter, feudal in nature, whereby the individual obtains a privilege or benefit by conceding something in turn to a seigneur and by becoming his vassal. The signing of the charter plays an important part in the story in the literary versions of the Romanesque period.[20] In Souillac the feudal moment is enacted ceremonially in the gesture of feudal homage; the devil takes the hands of Theophilus between his own.[21]

4. The conception of the feudal contract as a fatal trap. The vassel sells himself; he is in the power of the seigneur. This aspect of the feudal relation I suppose was significant in Souillac because of the secular lords of the churches and abbeys in the diocese of Cahors, to which Souillac belonged. The cathedral of Cahors and the abbeys of Moissac and Beaulieu, among others, were continually disturbed in the late eleventh and early twelfth century by the claims of nobles of the region, the so-called "secular-abbots," on whom they had once relied for protection in return for feudal concessions.[22]

5. The rescue of the vassal through the intervention, not of God, but the Virgin, i.e., the powerful lady who is superior to the seigneur-devil; she is also the patroness of the abbey of Souillac. In the Middle Ages, the queen or noblewoman could intercede for a guilty person and was regarded as an especially influential protector of the suppliant.[23]

6. The intercession of Mary is personally solicited in this story, outside the normal channels of administered liturgy; but it is effectively won only in the church and through a canonical penance of forty days. Hence the church satisfies through this legend the popular demands, so crucial to the protestants of the twelfth and later centuries, for an individual, unmediated relation to God and for an inexpensive piety. But it encloses them within the physical framework of the organized, orthodox religion.

7. Salvation, finally, by a material device, through return of the contract, a salvation in this world and by everyday juridical means. The devil has no power over Theophilus when the latter has regained the document with his signature.[24] Neither the confession nor the death of the penitent, which follows soon after, appears in the relief.

Of all these possible meanings and interests, only certain ones were essential to the designers of the relief. The chief moments in the sculpture are the contract, the submission to the devil as seigneur, and the liberation from the contract through the Virgin's aid. But these episodes are enclosed by figures of church authority, Benedict and Peter, and by the mediating angels.

The subject of the great relief is therefore not the supervening Christ-Savior, dogmatically centralized and elevated, but an individual rescued from the devil, from apostasy, from material, feudal difficulties and his own corruption within the political body of the church, through the direct intervention of the mother of Christ, opposed as a woman to the loathsome male devil. Theophilus is a layman, whose pact with the devil and change of fortune have an essentially secular nucleus,[25] comparable to the later adventure of Faust. The antitheses of rank and privation, of the devil and the Virgin, of apostasy and repentance, create a psychological depth—the counterpart of a world of developing secular activity and freedom, more complex than the closed field of Christian piety represented in the dogmatic images of the majestic Christ on Romanesque portals. In the themes of individual salvation and intercession, the relief of Souillac anticipates the Gothic tympana of the Last Judgment in which the Christian spectator could identify himself and his fellows. It goes far beyond these, however, since the judgment of Theophilus is isolated from the Resurrection of the dead and the divinity of the crucified Christ; the incident is localized on this earth as the dramatic vicissitude of a single intriguing individual. But the fortunes of this individual at every point depend on his relations to the feudal church.

VIII

The school of the diocese of Cahors (or the region of Quercy and southeast Limousin), to which the sculptures of Souillac, Moissac, and Beaulieu belong, shows a remarkable evolution of themes within the short period of fifteen years between about 1115 and 1130. Each of these portals is a highly original or, at least, untraditional work: we know no earlier example of a tympanum or painting with the *crowned* Christ among the seated elders, as in Moissac; no earlier Last Judgment with the naked torso and outstretched arms of Christ, as in Beaulieu; and no prior image of the story of Theophilus.[26] If we consider merely the broad external aspect of the iconography, the familiar names like the Last Judgment, the Vision of Christ and the Elders, the Legend of Theophilus and the Virgin, by which these sculptures are designated in the books, we shall hardly see more than a superficial relation between them. But if we observe the fuller range and connection of subjects within each portal, common themes and a continuous growth will be evident, and the local peculiarity and originality of the school will seem even greater.

In Moissac the dominating scene is already secular and realistic in tendency. The enthroned royal Christ—whom the natives have identified with Clovis (*Reclobis*), the legendary founder of the abbey—is surrounded by a court of lesser kings with an independent mobility of posture, with luxurious costume and the instruments of courtly entertainment. The hierarchical relations of Roman Christianity, the temporal claims of the church, are presented here in terms of the most advanced conceptions of centralized feudal power possible at that moment. The scenes below, which form uncentralized, episodic groups, display an even greater iconographic realism. They pertain to history and morality—the domestic, maternal moments of the Christian legend, the punishment of Avarice and Unchastity by the monstrous devils, and the banquet of Dives and the reward of the beggar Lazarus in heaven.

In Beaulieu[27] the moral, individual reference is developed further. The royal Christ becomes the resurrected, crucified figure, with naked torso and tensely outstretched arms, surrounded by the material instruments of the Passion. His absolute formal centrality is compromised by the competing cross held behind him at the side by two angels; and throughout the tympanum the apostles and resurrected figures are grouped as independent gesticulating pairs detached from the central Christ. The hierarchical stratification of Moissac disappears under the intercepted zones and overlapping figures—signs of a contingent, unconfined activity of single individuals. The historical themes of the porch of Moissac are lacking; but the tormented figures of Avarice and Unchastity reappear beside new themes of moral conflict and divine intervention.

Whereas Moissac shows only the sin as an accomplished fact in the reliefs of Avarice and Unchastity punished by the devil, Beaulieu adds the psychological episodes of the Temptation of Christ by the demon. And whereas in Moissac the contrast of torture and bliss is absolute and still located in the afterlife, in Beaulieu the sculptor creates also a transitive scene of divine intervention; he represents the angel bringing Habakkuk to Daniel, who sits unharmed among the lions.

In Souillac these marginal human aspects of Beaulieu and Moissac become central. The subject is the individual sinner, his temptation, intrigue, and repentance, his psychological torment and deliverance within this world. Theophilus confronts the devil twice, like Christ in the Temptation; he is rescued by the Virgin, who is brought by an angel, like Habakkuk to Daniel in Beaulieu, and like the ram to Isaac in Abraham's Sacrifice on the trumeau of Souillac. The fear of violent destruction, which is embodied in the mythical story of Daniel in the lion's den, is evoked in Souillac directly and with overwhelming power by the monstrous beasts actually devouring their victims.

The iconographic development disengaged above from these three portals does not correspond strictly to the temporal order of the works, but to three stages which are evident in the school at different rather than successive moments within a short period of time. The dates of the portals are uncertain; but it is commonly admitted today that the tympanum of Moissac is the oldest of the three, and Beaulieu the most recent. The reliefs below the tympanum of Moissac seem to me to be later than those of Souillac, and contemporary with, or a little later than, Beaulieu.[28] But whatever the exact dates of the sculptures, we may consider their subjects as expressions of new religious and secular interests current in this region during the first third of the twelfth century.

The portal of Moissac, with its incipient realism, is still tied to the dogmatic, centralized iconographic types of earlier mediaeval art; the tympanum of Beaulieu points to Gothic iconography; but the relief of Souillac looks even farther forward and anticipates in some respects the Renaissance and the end of the Middle Ages. In every one of these, however, there is a moralistic reference to the Christian individual. The spiritual conceptions have a secular axis; they embody the most recent attitude of the church to questions and demands posed under a changing feudalism by the people of the towns and by critical elements within the church. If the majesty of Christ is pictured concretely in Moissac as a royal structure in a feudal world of small, individual vassal-rulers, the moral subjects betray the concern with individual activity outside the confines of traditional Christian piety—Avarice being the accumulation of wealth by the burghers, and Unchastity the libertinism of the towns and the new aristocratic culture. In denouncing these vices and in repre-

senting Christ as a king of kings, as the ideal apex of temporal powers, the church was not only asserting its superiority to the feudal lords,[29] but was also defending itself against the charges of the heretics and burgher critics—especially numerous in southern France—who deplored its wealth and demanded a humble Christianity, a church restricted to its spiritual sphere.

In Beaulieu the Last Judgment becomes increasingly concrete. It portrays the humanity of the judging Christ and assigns a prominent place to the individual sinners and the blessed and to their actual emergence from the tomb. If the wealthy abbey of Moissac in a spirit of counterreform condemned the avaricious burgher and recommended poverty and charity in the person of the beggar Lazarus, Souillac pictured the quasi-simoniac official as an un-Christian apostate, but finally a repentant sinner, saved by the indulgent Virgin after his prolonged prayer in the church. In Beaulieu we see on one side of the porch Christ refusing the devil's offer of the riches of the world, on the other, Daniel protected from the lions and nourished in the den by the miraculously transported Habakkuk, the type of the priest who administers communion.

Thus the church glorifies poverty as a Christian virtue and admits a personal relation to a higher being, the mother of God; at the same time, answering those who deny the value of the Eucharist, it represents individual salvation, physical and spiritual, as finally dependent on the instrumentality of the church. The themes of Daniel, the Temptation of Christ, and the Last Judgment were known long before in art, and Theophilus, Avarice, and Unchastity in literature. But in the face of new conditions the church does not simply reaffirm its older doctrines. It presents new versions or rearrangements which isolate the aspects of these themes relevant to its mediating function, its power, and its interests in the changing society of which the church is a sensitive part. In Souillac the individual ecclesiastic moral episode replaces the symbolic, hierarchical Christ as a central theme. The protagonist is a secular functionary of the church.[30]

The accompanying stylistic changes cannot be deduced simply from the new content of religious art. They are shaped finally in a wider field of social and cultural conditions, although certain of the formal peculiarities of the sculpture of Souillac are solutions of a problem of religious representation posed uniquely in Souillac. The decentralizing episodic forms and discoordinate schemes, the antithetic mobility of the figures, the concreteness and energy of presentation, in contrast to the traditional centralized, symbolic designs, presuppose the broader conception of the active, morally divided individual, at once Christian and secular, whose struggles are resolved in the religious legends of the church. The social and economic development which indirectly evoked the new programs of

imagery in the church also promoted the freedom of the sculptor and sug-
gested to him within the framework of spiritualistic and ascetic concep-
tions more naturalistic forms, a more articulated and flexible composi-
tion, to satisfy the new norms of lay experience. Throughout his work the
sculptor displays in the intricate design and variety of detail an indepen-
dent virtuosity of manipulation, beyond the needs of traditional, symbolic
imagery. (In this he resembles the vernacular lyric poets of the time
whose freedom as artist-craftsmen, affirmed in numerous comments on
their own art, depends also on their service in the entertainment of the
feudal nobility.) The specialized autonomy of the sculptor as an artisan
entrusted with great enterprises by the church appears not only in the
prominence of original carved ornament beside the religious subjects, but
in the tendency of the sculptor to transform this ornament into images of
action and daily life abounding in realistic detail. Even if it is possible
that the beasts of the pillar of Souillac were already interpreted as Christian
symbols in the twelfth century, it is hardly likely that they were designed
as such from the very first. The fear of violence or the respect for aggressive
force which was usually sublimated in mythical themes of divine protection,
like Daniel in the lions' den, or of the heroism of a religious figure, like
Samson, is here embodied directly in a nonreligious fantasy of rapacious
beasts. The very existence of the trumeau implies that sculpture has begun
to emerge as an independent spectacle on the margins of religious art, as
a wonderful imaginative workmanship addressed to secular fantasy. But
this fantasy is governed by the content and material levels of social experi-
ence. The trumeau is a passionate *drôlerie*, brutal and realistic in detail, an
elaboration of themes of impulsive and overwhelming physical force, cor-
responding to the role of violence at this point in the history of feudal
society. They are like the dreams of animal combat which foretell the fero-
cious human battles in the contemporary *chansons de geste*.

The secular tendency evident in the sculpture of Souillac within the
framework of the church issued from a moment in social development
which was apparently very brief. We lack the documents to reconstruct
the formative factors in Souillac itself. The local peculiarities of the his-
tory of neither Souillac[31] nor the region[32] are sufficiently clear. And the
economic and social movement of Quercy during this period has yet to be
described from a viewpoint broad enough to permit us to grasp directly
the interplay of classes, institutions, traditions, and culture, and to
account for the differences between the local art and that of other regions.
We know simply that in the later eleventh and early twelfth century,
after a long period of restricted agricultural economy and anarchic feudal
struggles, this region experienced an intense economic development. The
growing communes acquired vernacular written codes of municipal law;
and the monasteries themselves, which had accumulated great landed

properties and moved beyond the sphere of merely local interests, were affected in some measure by the rise of the towns and the burgher class, profiting by the growth of trade and amassing wealth from their tolls, rents, and agricultural enterprises. The strength of the local nobility declined, while the power of the abbeys became broader and more centralized, sustained by Cluny, the bishops and popes, and sometimes by the towns. The abbeys of Moissac, Souillac, and Beaulieu were all situated on important streams and derived from their feudal rights over the river traffic and the fishing a considerable income and influence over the towns.[33] The abbey of Souillac was the feudal seigneur of the town, to which she owed a part of her revenues, but was herself undisturbed by the rival feudal powers—unlike Moissac, where the townsmen achieved a high degree of municipal independence early in the twelfth century, and the secular "cavalier-abbots" intervened for a time in the affairs of the monastery. With their many dependent priories (some over a hundred miles away), their cultivated lands, projects of reclamation and construction, and constant jurisdictional disputes, these great abbeys, as administrative centers of an expanding corporate power, promoted the practical attitudes, the calculations, and the everyday realism familiar to the merchants of the time. The abbots of Moissac were respected for their sagacity and leadership in temporal affairs.

The fact that so many of the great churches of the region, including the cathedral of Cahors, were built in the beginning of the twelfth century long before the cathedrals of the North, is itself a sign of the material expansion in Quercy at this moment. And the very character of the Romanesque churches of Souillac, Moissac, and Cahors, as single-aisled domed buildings, untraditional in plan and method of construction,[34] also points to the force of novel conditions. However original and peculiar to Aquitaine are the complete buildings, the conception of the unit bay with dome, pendentives, and salient piers was borrowed directly from the art of a distant eastern region with which the West had just renewed commercial and political relations after a great victorious crusade. Instead of the prolonged vista focused on the choir and altar, instead of the succession of nave bays flanked by the subordinate aisles, these churches present a shorter series of independent, self-contained domical bays to which the choir is added as a subordinate terminal niche. When we enter the nave, we are not drawn to the distant sacred space of the apse by the endless rhythmical procession of arches and supports, but each of the two or three gigantic bays appears to us a complete individual with its own domical focus. The domed churches are a sharp deviation from the historical line leading from Romanesque to Gothic architecture and foreshadow late mediaeval, Renaissance, and Protestant churches. The broad proportions of these novel buildings, their diffuse, undramatic lighting, the

explicitness and accented materiality of the prismatic and concave forms are secular in suggestion. Nothing in Romanesque architecture is more remote from the Gothic cathedrals which inspire, through their steep proportions, their hierarchical subdivisions, their mysterious contrasts of light and dark and network of ascending and receding lines, apprehensions of an intangible, pervasive but transcendent order everywhere reaching out to subdue and absorb the individual. The domed churches are clear in form and unmystical in expression, especially in the spaces of the nave reserved for the congregation. The nave is amplified and liberated from the compulsive apsidal focus, just as the monumental design of Theophilus dethrones the absolutized Christ.

We cannot pursue here the similarities in the development of the architecture and the sculpture of the region. The parallelism is quite general and limited to aspects in which common factors operate; for the two arts have their special functions and conditions at this moment and therefore respond differently to the great historical changes of the time. The forms of the domed churches of Aquitaine have been explained, together with the three-aisled churches, as a *direct* reflection of the heretical movements of southern France.[35] But no evidence connects the particular buildings directly with the heretics, and it is in a region outside the main centers of heresy in Languedoc that the domed churches arise. The secular attitudes expressed in the heresies were not limited, however, to the new religious sects; the latter were themselves the result of special circumstances in the opposition to the church. The secular tendencies which under some conditions promoted the heresies were part of a more general development of society of which the effects appear also in political forms like the communes, in new moral ideas, in vernacular literature and science—in that whole complex of worldly interests which is sometimes called the proto-renaissance. The paganism of this culture does not exclude the ascetic ideals of the heretics, just as the later Protestantism with its puritan virtues is an aggressive middle-class religious counterpart of the humanism of an aristocratic culture. The domed architecture of Aquitaine was affected, like the living church itself, by the social and economic conditions which were also the fruitful ground of antiecclesiastical, puritan, heretical beliefs. It illustrates how the church, despite its claim to an independent spiritual sphere, by virtue of its real dependence on earthly conditions adopted an architecture more adequate to sentiments of secular freedom. In the relief of Theophilus in Souillac the elements of the conflict between the older ecclesiastical claims and the new social relations are mythically transposed and resolved in a compromise form which entails, however, a new individual framework of Christian piety. Not in Souillac alone but throughout Romanesque art can be observed in varying degree a dual character of realism and abstraction, of secularity and

dogma, rooted in the historical development and social oppositions of the time.

NOTES

1. Mâle (*L'Art religieux du XIIe siècle en France*, Paris, 1922, p. 434, n. 1) says of these blocks: "quelques-unes de ces pièces doivent nous manquer." But it is sufficient to observe the continuity and perfect connection of carved forms across the joints, especially the wing and right arm of the central descending angel and also the Virgin's scroll, to conclude that no piece is missing from the relief of Theophilus.

2. Cf. A. Ramé (*Gazette archéologique*, 1885, p. 231), "son mérite d'architecte est des plus contestables."

2a. For the story of Theophilus, see above, pp. 118–119.

3. See my analysis in *Art Bulletin*, XIII (1931), pp. 468, 469, 493, 499, n. 127 (reprinted pp. 203, 204, 231, 262, n. 127 below).

4. Like the symbol of Luke in the Book of Durrow. See K. Pfister, *Irische Buchmalerei* (1927), Pl. 22.

5. In this analysis I have omitted reference to plastic qualities, to relations of modeling, relief, and surface, in order to isolate more sharply the compositional or inner "topographical" relations of the sculpture.

6. For a related conception of paired figures in Moissac, see *Art Bulletin*, XIII (1931), p. 473 (reprinted p. 207 below).

7. The actual grouping was perhaps influenced by the idea that the devil's proper place is always at the left, as the evil and sinister side; but in the three scenes of the Temptation of Christ in Beaulieu, the devil appears twice at the right, with Christ at the left.

8. The flexibility of the colonnettes recalls in the scalloped forms the "unarchitectural" disposition of the trefoil frame of the relief of Theophilus. It is related, however, to the common practice of the builders of Quercy and Limousin, who prolonged the tenuous colonnettes of their portals and windows as a torus of the spanning archivolt, often without an intermediate impost, so that the continuity of colonnette and curved torus is accentuated. (See Enlart, *Manuel d'archéologie française, Architecture religieuse, 2e éd.*, 1919, I, pp. 353, 396; and R. Fage, in *Bulletin archéologique*, 1920, pp. 378 ff.) It was the same builders who gave a cusped or scalloped form to the jambs of a portal and the engaged colonnettes—examples at Moissac, La Souterraine, Noailles, Vigeois, etc. (see Fage, *loc. cit.*, p. 382).

9. The realistic aspect of the represented animals was recognized by Viollet-le-Duc (*Dictionnaire raisonné de l'architecture*, Paris, 1854–1869, VIII, p. 197), who, at the same time, compared the underlying design with the interlaced, deformed animals of the Cross page of the Lindisfarne Gospels (*ibid.*, p. 186, Fig. 33). I cannot deal here with the relationships of Souillac to northern and eastern art indicated by Viollet-le-Duc, and observed also on the iconographic side by Arthur Kingsley Porter (*The Crosses and Culture of Ireland*, New Haven, 1931, pp. 126, 127). In my own view, these relations—which I should have to qualify—are not the result of a direct influence of a distant art on Souillac, but of a long tradition or of descent from a common source. The crossed animals of Souillac are an old oriental theme which is fairly common in Quercy and other parts of southwestern France, appearing in manuscripts of Limoges (Paris, Bibl. nat. lat. 8 and lat. 254) and Toulouse (British Museum, Harley MS. 4951), and in capitals in Saint-Savin, Monsempron, Carennac, Moissac, etc. The motif is related to the figures with legs crossed in X, and even to the uncommon theme of the crossed columns (St. Amand-de-Boixe). Mâle (*op. cit.*, p. 19), in comparing the trumeau with an ornament of the tenth century in the Limoges Bible, Paris Bibl. nat. lat. 5, which lacks precisely the crossed form and the intertwining of animals with their enframing bands, has overlooked not only the northern examples but also the true parallels of such animal and band interlace in South French manuscripts of the late eleventh and twelfth century—Bibl. nat. lat. 7, 254, 2154, 5056, etc.

10. I have already referred to meanings in the formal analysis in so far as our judgment of "directions" and movements depends on our interpretation of the action of the figures.

11. This diminution is further accentuated by the greater distance of the upper figures from the spectator. It is also worth observing that the central arch segment of the trefoil frame appears to be the most shallow and the smallest, though the spans of all three are identical.

12. The exact opposite of this formal conception of a sculpture dedicated to the Virgin is the south portal of the west facade of Chartres, where the axes of both tympanum and lintel correspond rigidly to the Virgin and Child.

It may be asked whether the sculpture of Theophilus was not perhaps an accessory relief beside a larger, more emphatically centralized sculpture of Christ or the Virgin in glory, like the accessory moral and narrative reliefs in Moissac and Beaulieu. I lack the data for a reconstruction of the original arrangement of the portal; but judging by the dimensions of the porch and of the sculptures and by their relation to the other portals of the same school (Moissac, Beaulieu, Cahors), it seems to me highly improbable that the sculpture of Theophilus was a subordinate pendant or flanking relief. But even if it were only a secondary relief, the characters described would still be significant. In other versions, of a still smaller scale or lesser rank in a whole, the theme is centralized and dominated by the Virgin. Cf. Fig. 15 of this article, and a miniature of the early thirteenth century by Conrad von Scheyern in Munich Clm. 17401 (Boeckler, *Jahrbuch für Kunstwissenschaft*, I, 1923, pl. 25).

13. Reproduced by A. K. Porter, *Romanesque Sculpture of the Pilgrimage Roads* (1923), ill. 350–352.

14. It should be observed further that the theme of Abraham and Isaac, which is not only a symbol of salvation and of the Crucifixion but has also the value of an instance of submission to authority, Abraham preparing to sacrifice his son at God's command and Isaac submitting to his father—this theme is parodied on the opposite side of the trumeau by images of conflict between a youth and an old man, wrestling pairs who resemble Abraham and Isaac. Some writers (cf. Porter, *Crosses and Culture of Ireland*, pp. 126, 127) have identified them as Jacob wrestling with the angel. This is doubtful for the following reasons. The pair is shown three times, but in no case with attributes consistent with the distinction of Jacob and the angel. They are both naked to the waist, and neither has wings. Nor is there reference to Jacob's thigh, weakened by the angel's blow, as told in *Genesis* XXXIII: 25 and illustrated in Trani. It has been supposed that the praying gesture of the boy in the upper zone indicates the blessing of Jacob by the angel; but why should this bearded angel clutch Jacob by the hair, as in the scene of Abraham and Isaac on the other side? In the middle zone, the tail of a monster on the front of the trumeau is wound tightly around the necks of the wrestlers. This is evidently a *drôlerie*, and the intriguing contrast of the wallet hanging from the boy's belt and the key from the old man's seems to confirm this interpretation. From the viewpoint of the formal peculiarity of the sculptures of Souillac we might even hazard the guess that the wallet and key pertain to an episodic intrigue formed like the sculptural pattern, wallet and key being complementary opposites, each incomplete in itself, like the wrestling, interlocked figures. In Beaulieu, too, a young and an old man are juxtaposed as caryatids on the trumeau of the portal. Playful fantasies of force and conflict underlie the conception in Souillac, rather than a theological idea. If anything, it is a countertheological idea. The parody or secular inversion of the Abraham-Isaac theme in these wrestling figures in Souillac corresponds to the marginal inversion of the Daniel theme on the impost of a capital in the cloister of Moissac (*Art Bulletin*, XIII, 1931, p. 334; Rupin, *L'Abbaye et les cloîtres de Moissac*, Paris, 1897, pp. 293, 294 [reproduced in Fig. 79 of Chap. 4]). [I refer to the same subject in an article to be reprinted in Vol. II—"The Angel with the Ram in Abraham's Sacrifice: a Parallel in Western and Islamic art," *Ars Islamica*, X, 1943, pp. 134, 147, esp. pp. 144–145. See also *Words and Pictures*, The Hague—Paris, 1973, p. 15, n. 9, n. 10, n. 92.] There a little figure, no prophet or saint, but a droll layman, strangles two giant birds with his arms, pulls the tail of one lion and stabs another in the jaws with a comical bravado and irreverent self-confidence which deflates the theme below of Daniel protected by God from the lions. [Three pairs of fighting men—old and young—with long-

beaked birds biting the outermost figures are represented on a canon table of the twelfth-century Bible in the library of Bourges (Ms. 3, f. 306v).]

15. For a summary of the history of the story, with a bibliography of the numerous vernacular versions, see Karl Plenzat, *Die Theophiluslegende in den Dichtungen des Mittelalters* (Germanische Studien, Heft 43, Berlin, 1926), the edition of Rutebeuf, *Le Miracle de Théophile,* by Grace Frank (Champion, Paris, 1925), pp. iv–x, and Ramé, *loc. cit.,* pp. 228, 229. For Latin versions of the Romanesque period (eleventh and twelfth centuries), see the sermon of Fulbert of Chartres, Migne, *P.L.,* v. 141, col. 323, 324; the chronicle of Sigebert, *ibid.,* v. 160, col. 102; the poem *Historia Theophili Metrica,* attributed to Marbodus, *ibid.,* v. 171, col. 1593 ff.; Honorius of "Autun," *ibid.,* v. 172, col. 992–994. When this article was in press, I learned of Alfred C. Fryer's "Theophilus, the Penitent, as Represented in Art," *Archaeological Journal,* XCII (1936), pp. 287–333. E. Faligan, "Des formes iconographiques de la légende de Théophile," *Revue des traditions populaires,* v (1890), pp. 1–14, lists several versions of the thirteenth century, but ignores Souillac.

16. On the *vidame* (Latin, *vicedominus*) see A. Luchaire, *Manuel des institutions françaises (Période des Capétiens directs),* Paris, 1892, pp. 288, 289. The *vidame* was appointed by the bishop to exercise episcopal jurisdiction in certain temporal matters, to look after the property of the church, to represent the bishop in the feudal courts, to protect the episcopal palace, etc. It was often a hereditary office, with a *seigneurie* consisting of a house in the city and a piece of land. In some literary versions, Theophilus is a merchant or layman and is prompted by a desire for wealth (cf. Plenzat, *op. cit.,* pp. 43, 231).

17. The identity of this figure is not altogether certain. It is unlikely that it represents St. Stephen (as Porter supposed), in spite of the prominent dalmatic, the maniple, and the youthful face. The crozier excludes a deacon; it is more properly the attribute of a bishop or abbot, who are sometimes shown, as here, with dalmatic and maniple and without chasuble and mitre. The omission of the chasuble in the relief may have been a formal necessity, the V-shape being unsuited to the design at this point.

What particular saintly abbot or bishop was represented is difficult to decide. The following come into question: St. Eligius (Eloi), bishop of Noyon, who was mistakenly regarded as the founder of the abbey (see *Gallia Christiana,* I, p. 179) and whose feast and translation were celebrated in Souillac (but it is unknown whether this tradition and cult existed already in the twelfth century); St. Gerald, abbot of Aurillac, founder of the abbey of Aurillac to which the monastery of Souillac belonged, and the donor of the site of Souillac to this abbey (909); finally, St. Benedict, the founder of the order itself. Benedict is represented on the portal of Moissac, but without the crozier. He holds the latter on a capital in St. Benoît-sur-Loire (Porter, *Pilgrimage Roads,* ill. 1420) and in other Romanesque works. Of these three possibilities, Benedict seems the most plausible counterpart to Peter, and I provisionally assign his name to the figure.

18. In the literary versions Theophilus is described as a *vidame* of the church of Adana in Cilicia in the sixth century. The Latin accounts can be traced in part to a Greek version by one Eutychianos who pretends to be an eyewitness.

19. On the heresies in southern France, see I. von Döllinger, *Beiträge zur Sektengeschichte des Mittelalters,* I (Munich, 1890), and G. Guiraud, *Histoire de l'Inquisition au Moyen Age,* I (Paris, 1935).

20. See the Latin texts cited in n. 15 above.

21. On this ceremony, see Luchaire, *op. cit.,* p. 185. In Gothic art, Theophilus kneels before the devil. In the Greek text, Theophilus is kissed by the devil, as in the ceremony of homage in the Byzantine court. This detail is omitted in the early Latin translation (Plenzat, *op. cit.,* p. 18, n. 13).

22. On these *abbates-milites* in Moissac and Beaulieu, see A. Lagrèze-Fossat, *Etudes historiques sur Moissac,* I (Paris, 1870), pp. 115–142, and M. Deloche, *Cartulaire de l'abbaye de Beaulieu en Limousin (Collection de documents inédits sur l'histoire de France),* Paris, 1859, pp. xix ff.

23. On the analogy of the noblewoman as intercessor, see the mediaeval text cited by Coulton, *Five Centuries of Religion,* I, 140. In France the conception of the Virgin as the interceding queen of heaven was undoubtedly conditioned by the important administrative and even judicial role of the queen in the French monarchy.

24. Cf. the version by Fulbert of Chartres: "She (Mary) consoled the grieving man, promising him indulgence: and that he should not doubt her promise, she tore the charter from the devil and returned it to the captive as a token of his liberty. When, upon awakening, he found it on his breast, what joy he felt, with what pious feeling he uttered sounds of exultation and confession!" (Migne, *P.L.,* v. 141, col. 323, 324.)

25. This sense of Theophilus is indicated in the representation of the story in a wheel of fortune in the de Brailles psalter in the Fitzwilliam Museum, Cambridge. See Fryer, *op. cit.,* pl. IX, opp. p. 300.

26. A drawing of the Last Judgment in Pembroke College (Cambridge) MS. 120, in which Christ is shown with naked breast and arms extended diagonally downward, seems to be of the same period as the sculpture of Beaulieu.

Mr. Charles Niver has called my attention to a drawing of Theophilus in Paris, Bibl. Nat. MS. Latin 11750, f. 51, a manuscript of the mid-eleventh century from St. Germain-des-Prés, and has kindly permitted me to reproduce it in this article (Fig. 15). But here we see only the figure of Theophilus imploring the Virgin seated between angels; the compact with the devil is not represented. The real subject of the drawing is the Virgin, who is elevated, centralized, and enthroned, and retains her hierarchical majesty.

27. Reproduced by A. K. Porter, *Romanesque Sculpture of the Pilgrimage Roads,* ill. 409–420.

28. I date the tympanum of Moissac about 1115, the sculptures of Souillac about 1115–1120, the porch of Moissac, including the jamb figures of Isaiah and Peter, about 1120–1130, and Beaulieu about 1125–1130. The reasons are too complex to be presented here.

29. Such an image of the supreme king expressed also the monarchical sympathies of the church, the centralized monarchical state being the necessary political counterpart of the expanding centralized church and its ally in the common struggle against the local feudal nobility.

30. It is not a theme issuing from the "people"; its popularity, as M. Mâle has observed, is due to the importance given to the story by the church, which introduced it into the liturgy as early as the eleventh century. It is worth citing here the observation of Plenzat (*op. cit.,* p. 236) that none of the vernacular versions of the legend is by a nobleman; they were all written by poets from the clergy or the lower classes, and abound in secular-pagan elements. In several of the poems, the Virgin is relatively unimportant and the action terminates, as in Souillac, with the return of the contract.

31. The book of Abbé P. Pons, *Souillac et ses environs* (Souillac, 1923) summarizes the scanty older literature on this period; see p. 205 for a bibliography of manuscripts and printed literature.

32. The chief work remains the first volume of Guillaume Lacoste, *Histoire générale de la province de Quercy* (Cahors, 1883). For the history of Moissac and Beaulieu, see n. 22 above.

33. The wealth of the merchants of Souillac during the Middle Ages seems to have issued from their monopoly of the salt trade in Corrèze, Auvergne, and part of Quercy. They shipped timber to Bordeaux by way of the Dordogne and brought back salt in exchange. See Pons, *op. cit.,* p. 11.

34. On these buildings see Raymond Rey, *La Cathédrale de Cahors et les origines de l'architecture à coupoles d'Aquitaine* (Paris, 1925). On pp. 194 ff. he attributes the domed church of Moissac (of which only the lower nave walls, narthex, and porch survive) to the period of 1150 to 1180. This attribution rests largely on an equivocal document concerning the attendance of the bishop of Oloron at the dedication of the church of Moissac in 1180, but is not supported by the detailed comparative study of the moldings and ornament. The church is more likely of the first third of the twelfth century. Excavations have shown that the foundations of the preceding Romanesque church (mid-eleventh century) did not extend as far as the present narthex and porch, which are no later than the first third of the twelfth century. The west wall of the nave, which masks the narthex and tower, was erected only soon after, and so soon after, that the courses of the upper north side could coincide with the western part of the adjoining nave wall which was progressing toward the narthex at this time. The moldings of the porch, the narthex, the exterior of the tower, and the windows of the nave are very similar, and in some details identical.

The same atelier produced the capitals of the nave windows, various modillions of the tower of Moissac and capitals and modillions of the domed church of Cahors, which M. Rey attributes to the first quarter of the century. (On pp. 162, 163 he assigns to the same period the domed church of Souillac which in some respects is more developed toward the later types than either Moissac or Cahors.) It is therefore highly unlikely that the similar construction in Moissac belongs to the second half of the century, and is fifty or more years later than its own narthex. More relevant to the date of construction than the reference of 1180 is the papal bull of 1132 which granted forty days' indulgence to those who visited Moissac on the feast of the dedication of its church (Lagrèze-Fossat, *op. cit.*, III, pp. 234-235).

35. Notably by Felix Witting, *Westfranzösische Kuppelkirchen* (Strassburg, 1904).

131

The Romanesque Sculpture of Moissac

(1931)

I

INTRODUCTION[1]

THE study here undertaken is of the style of the sculptures of the cloister, the portal, and the porch of Moissac.

A catalogue of the sculptures and a description of each face of every capital in the cloister is desirable but cannot be given here. Such a description would almost double the length of this work. A plan of the cloister with an index to the subjects of the capitals has been given instead (Fig. 2). This, with the photographs reproduced, provides a fair though not complete view of the contents of the cloister. For a more detailed description the reader is referred to the books of Rupin and Lagrèze-Fossat, which lack, however, adequate illustration and a systematic discussion of style or iconography.

In the present work, the postures, costumes, expressions, space, perspective, and grouping of the figures have been described, not to show the immaturity of the sculptors in the process of representation, but to demonstrate that their departures from natural shapes have a common character which is intimately bound up with the harmonious formal structure of the works. I have tried to show also how with certain changes in the observation of nature apparent in the later works, the artistic character is modified.

In the description of formal relations I do not pretend to find the nature of the beauty of the work or its cause, but I have tried to illustrate by them my sense of the character of the whole and the relevance of the parts to it. These relations occur in apparently simple capitals in larger number than is suggested by analysis. To carry analysis further would

require a wearisome restatement and numerous complications of expression not favorable to simple exposition. The few instances given suffice, I think, to illustrate a pervasive character evident at once to sympathetic perception. The particular problem in description was to show a connection between the treatments of various elements employed by the sculptors—to show that the use of line corresponds to the handling of relief, or that the seemingly confused or arbitrary space is a correlate of the design, and that both of these are equally characteristic features of the inherent style.

I find the essence of the style in the archaic representation of forms, designed in restless but well-coordinated opposition, with a pronounced tendency towards realism. Archaic representation implies an unplastic relief of parallel planes, concentric surfaces and movements parallel to the background, the limitation of horizontal planes, the vertical projection of spatial themes, the schematic reduction of natural shapes, their generalized aspect, and the ornamental abstraction or regular succession of repeated elements. In the dominant restlessness are implied unstable postures, energetic movements, diagonal and zigzag lines, and the complication of surfaces by overlapping and contrasted forms, which sometimes compromise the order and clarity inherent in the archaic method. In the movement of arbitrarily abstracted intricate lines, the style is allied with Northern art of the early Middle Ages; in its later search for coordinated asymmetries within larger symmetrical themes it is nearer to the early Baroque of Italy. The realistic tendency, evident in the marked changes in representation in the short interval of thirty years between the cloister and the porch, appears at each moment in the detailed rendering of the draperies, the parts of the body and accessory objects, and in the variety sought in repeated figures.

The earliest sculptures are flatter and more uniform in their surfaces. They are often symmetrical, attached to the wall, and bound up in their design with the architectural frame or surface. Their forms are stylized and their parts more distinct.

In the later works the figures are more plastic and include varied planes. Independent of architecture and bound together in less rigorously symmetrical schemes, they stand before the wall in a limited but greater space. The whole is more intricate and more intensely expressive.

These contrasts are not absolute but relative to the character of the earliest works. Compared to a Gothic or more recent style, the second Romanesque art of Moissac might be described in terms nearer to the first. In the same sense, the first already possesses characteristics of the second, but in a lesser degree and in a somewhat different relation to the whole.

Throughout this work I am employing the term "archaic," not simply with the literal sense of ancient, primitive, or historically initial or antecedent, but as a designation of a formal character in early arts, which has been well described by Emanuel Löwy.[2] In his study of early Greek art he observed a generalized rendering of distinct parts, the parallelism of relief planes, the subordination of modeling to descriptive contours, and other traits which he found also in primitive styles, and explained as characteristics of memory imagery. Although the psychological explanation is not satisfactory and the definition of the features overlooks their positive aesthetic qualities, the description is valuable for the interpretation of mediaeval as well as classic art.

This conception of an archaic style must be qualified and extended in several ways. The archaic characters may be purely conventional formulas (repeating a traditional archaic style), without an immediate origin in the peculiarities of memory or a conceptual reconstruction of a visual whole. In a similar way, they may be aesthetically or morally valued aspects of an early style, consciously imitated by a later artist. In such archaistic works the retrospective character is betrayed by the unconscious and inconsistent participation of the later (often impressionistic) style within the simpler forms.

We must observe also the frequent recurrence, not *survival*, of archaism whenever the untrained or culturally provincial reproduce nature or complex arts or fashion their own symbols; and, on a higher level, when a complex art acquires a new element of representation, like perspective, chiaroscuro, or foreshortening. Thus the earliest formulated examples of parallel perspective in Italian art have the rigidity, simplicity, symmetry, and explicit ornamental articulation of archaic frontal statues, in contrast to the unarchaic complexity of the figures enclosed in this space. In the same sense, in the earliest use of strong chiaroscuro there is a schematic structure of illumination, a distinct division of light from shadow, as in a primitive cosmogony. The archaic nature of the early examples of these elements in highly developed arts is evidenced by the spontaneous reversion to their forms in still later provincial and naive copies of the more recent unarchaic developed forms of perspective and chiaroscuro. The popular ex-votos of the eighteenth and nineteenth centuries often show a perspective and chiaroscuro with the stylistic marks of more skillful earlier art.

Archaic characters are not historical in a chronological sense, except where there is an unilinear development toward more natural forms. The archaic work is conditioned not only by the process of reconstructing part by part the whole of a natural object in imagination, but also by a pre-existing artistic representation of it, with fixed characters that are more or

less archaic and by the expressive effects required of the specific profane or religious content. The typology of early Greek art is to some degree independent of the archaic process of designing the types, some of which have been borrowed from Egyptian and Near Eastern arts and have probably influenced the formal result. In a similar way the archaic mediaeval sculptures begin with an inherited repertoire of figure types and iconographic groups of complicated character and also with a preexistent ornament of extreme complexity. These were the forms which had to be reconstructed for plastic representation; the product, though archaic, was necessarily distinct from the classic archaism. Just as the Greek predilection for simple, clearly composed, isolated wholes dominated even the more realistic phases of classic art, the Northern European fantasy of intricate, irregular, tense, involved movements complicated to some degree the most archaic, seemingly clear and simple products of early mediaeval art.

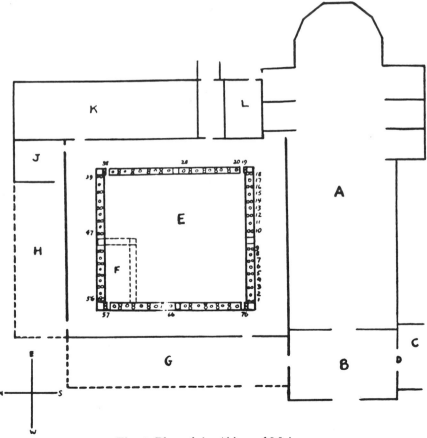

Fig. 2. Plan of the Abbey of Moissac

A, Gothic church of the 15th century with remains of Romanesque nave walls (c. 1115-1130); B, narthex (c. 1115); C, porch (c. 1115-1130); D, tympanum (before 1115); E, cloister (completed in 1100); F, lavatorium (destroyed); G, chapel and dormitory (destroyed); H, refectory (destroyed); J, kitchen; K, Gothic chapterhouse; L, sacristy.

Subjects of the capitals and pier sculptures:

S. W. pier: Bartholomew, Matthew (Figs. 9, 10, 17, 18).

South gallery: I, Martyrdom of John the Baptist (Fig. 21); 2, birds in trees; 3, Babylonia Magna; 4, birds; 5, Nebuchadnezzar as a beast (Figs. 22, 23); 6, Martyrdom of Stephen (Figs. 24, 25); 7, foliage; 8, David and his musicians (Fig. 26); 9, Jerusalem Sancta; unsculptured pier; 10, Chaining of the devil, Og and Magog (Figs. 27, 28); 11, symbols of the evangelists (Figs. 29, 30); 12, Miracles of Christ; the Centurion of Caphernaum and the Canaanite woman (Figs. 31, 33); 13, the Good Samaritan (Fig. 34); 14, Temptation of Christ (Figs. 32, 35); 15, Vision of John the Evangelist (Figs. 36-38); 16, Transfiguration (Figs. 39, 40); 17, Deliverance of Peter (Figs. 41, 42); 18, Baptism (Fig. 43).

S. E. pier: Paul, Peter (Figs. 5, 6, 15, 16).

East gallery: 19, Samson and the lion, Samson with the jaw bone (Fig. 44); 20, Martyrdom of Peter and Paul (Figs. 45, 46); 21, foliage; 22, Adam and Eve; Temptation, Expulsion, Labors (Figs. 47-49); 23, foliage; 24, Martyrdom of Laurence (Figs. 50, 51); 25, Washing of Feet (Figs. 52, 53); 26, foliage; 27, Lazarus and Dives (Figs. 54, 55); 28, dragons; pier: Abbot Durand (1047-1072) (Figs. 4, 20); 29, dragons and figures; 30, Wedding at Cana (Figs. 56, 57); 31, foliage; 32, Adoration of the Magi (Figs. 58, 59), Massacre of the Innocents (Figs. 59, 60); 33, foliage; 34, foliage; 35, Martyrdom of Saturninus (Figs. 61-63); 36, foliage; 37, Martyrdom of Fructuósus, Eulogius, and Augurius (Figs. 64-67); 38, Annunciation and Visitation (Figs. 68, 69).

N. E. pier: James, John (Figs. 7, 8, 19).

North gallery: 39, Michael Fighting the Dragon (Fig. 70); 40, birds; 41, foliage; 42, Miracle of Benedict (Figs. 71, 72); 43, birds; 44, Miracle of Peter (Fig. 73); 45, foliage; 46, angels (Fig. 74); 47, Calling of the Apostles (Figs. 75-77); 48, Daniel in the Lions' Den, Habbakuk (Figs. 78, 79); 49, Crusaders before Jerusalem (Figs. 80, 81); 50, foliage; 51, four evangelists with symbolic beast heads; 52, birds; 53, Three Hebrews in the Fiery Furnace (Fig. 82); 54, Martin and the Beggar, Miracle of Martin (Fig. 83); 55, foliage; 56, Christ and the Samaritan Woman.

N. W. pier: Andrew, Philip (Figs. 11, 12).

West gallery: 57, Sacrifice of Isaac (Fig. 84); 58, angels with the cross (Fig. 85); 59, foliage; 60, birds; 61, Daniel in the Lions' Den (Fig. 87), Annunciation to the Shepherds (Fig. 86); 62, foliage; 63, grotesque bowmen; 64, Raising of Lazarus (Fig. 88); 65, foliage; 66, dragons and figures; pier: inscription of 1100 (Fig. 3), Simon (Figs. 13, 14); 67, Anointing of David (Fig. 89); 68, foliage; 69, birds and beasts; 70, foliage; 71, Beatitudes (Fig. 90); 72, lions and figures; 73, Cain and Abel (Fig. 91); 74, foliage; 75, Ascension of Alexander; 76, David and Goliath.

S O M E F A C T S F R O M T H E H I S T O R Y O F T H E A B B E Y

The town of Moissac is situated on the Garonne river, about a mile south of its confluence with the Tarn, in the department of Tarn-et-Garonne. It lies in a strategic position, a crossing point of many roads, some of which were called in mediaeval times "cami-Moyssagues."[3] Traces of Roman habitation survive in classic columns, coins, and fragments of masonry discovered in the town and its surrounding country.[4] The great abbey to which Moissac owes its celebrity was not founded until the middle of the seventh century.[5] A popular tradition has dignified the event by ascribing the foundation to Clovis who was impelled to this act by a dream and divine guidance.[6] Even in the last century the gigantic figure of Christ on the tympanum was called Reclobis by the natives.

The monastery arose under auspicious circumstances, for the diocese of Cahors, to which Moissac then belonged, was ruled by Desiderius, a bishop renowned for both austere living and artistic enterprise.[7] Toward the end of the century the wealth of the abbey was greatly increased by a donation of lands, serfs, and churches by a local nobleman, Nizezius.[8] In the next generations, however, it was a victim of the Saracenic invasion. The church was burned and the surrounding country devastated. Rebuilt in the early ninth century with the aid of Louis the Debonnaire, the abbey suffered a similar disaster at the hands of the Huns and Normans. The reconstructed church was damaged in 1030 by the fall of the roof, and in 1042 by a fire which attacked the whole town. In this period the monastery was harassed by predacious noblemen and the lack of internal discipline. Its abbot, Aymeric de Peyrac, wrote in his chronicle of Moissac (c. 1400) that it had become a "robbers' cave," when Odilo, the abbot of Cluny, passing through Moissac in 1047, effected its submission to Cluny, then the most powerful monastery in Christendom.[9] He placed at the head of Moissac one of his own monks, Durand of Bredon (in Auvergne), under whose administration it acquired great wealth and prestige. Durand consecrated a new church in 1063[10] and extended his architectural enterprise to the whole region; Aymeric could write that where the boar once roamed the woods now stand churches because of Durand's labors. He was not only abbot of the monastery but also bishop of Toulouse nearby, and upon his death was venerated as a saint by the monks of Moissac. Under the rule of his successor, Hunaud (1072–1085), the monastery acquired vast properties, but was continually embroiled in ecclesiastic controversies and in conflicts with the local nobility.[11] Anquêtil, who followed him, could not ascend his seat without a conflict with a malicious monk. In despair, the usurper set fire to the town; and it was only after a prolonged struggle and papal intervention that Anquêtil's place was finally assured.[12] It is to Anquêtil that we owe the cloister and

the sculptures of the tympanum, according to Aymeric's chronicle.[13] But these constructions of Anquêtil were no novelty in Moissac, for works, now destroyed, have been attributed to Hunaud before him,[14] and Durand's architectural energies are well known. Roger (1115–1131) constructed a new church, domed like those of Souillac and Cahors, and probably added the sculptures of the porch.[15]

This century, immediately following the submission to Cluny, was the happiest in the history of the abbey. It controlled lands and priories as far as Roussillon, Catalonia, and Perigord.[16] In the Cluniac order the abbot of Moissac was second only to the abbot of Cluny himself.[17] Yet the literary and musical productions of this period are few in number. Except for a brief chronicle, a few hymns, and some mediocre verses, the writings of the monks of Moissac were simply copies of earlier works.[18] No monk of the abbey achieved distinction in theology or letters. But in the manuscripts copied in Moissac in the eleventh and twelfth centuries may be found beautiful ornament and miniatures, of which some are related in style to the contemporary sculptures of Aquitaine.[19]

The next century was less favorable to the security of the abbey. In 1188 a fire consumed the greater part of the town which was soon after besieged and taken by the English.[20] And in the subsequent Albigensian crusade the monastery was attacked by the heretics and beset by depressing ecclesiastical and political difficulties.[21] The abbot, Bertrand de Montaigu (1260–1293), repaired some of the damaged buildings, including the cloister of Anquêtil, which he furnished with its present brick arches in the style of the thirteenth century.[22] But in the wars that followed the abbey was again ruined. The church itself was probably subject to great violence, since its upper walls and vaults and its entire sanctuary had to be reconstructed in the fifteenth century.[23]

In 1625 the abbey was secularized and thereafter fell into neglect. The National Assembly, in 1790, suppressed it completely. The church and the cloister were placed on sale; and the latter, purchased by a patriotic citizen, was offered to the town which exposed the building to unworthy uses. The garrison stationed there during the first empire damaged the sculptures and ruined the ancient enameled tile pavements. At one time a saltpeter factory was installed in the surrounding buildings. More recently, as a classified *monument historique,* the cloister and church have received official protection. In the middle of the last century parts of the abbey were restored, but the sculptures were happily left untouched by the architects of the government.[24]

Since the Middle Ages, the history and arts of the abbey have been the subjects of inquiry and comment. In the late fourteenth century its abbot, Aymeric, in writing his chronicle of Moissac, noted the artistic enterprise of his predecessors and expressed his sense of the great beauty of the

Romanesque works. The portal he called *"pulcherrimum, et subtillissimi operis constructum."*[25] He added that the trumeau and the fountain (now destroyed) were reputed so wonderful that they were considered miraculous rather than human works.[26] Aymeric was one of the first of a long line of monastic archaeologists. Not content with the testimony of written documents he made inferences as to the authorship and dates of works from their artistic or physical character. Thus he attributed the unsigned inscription of the dedication of the church of Durand (1063) to Anquêtil, who was not abbot until almost thirty years after, because of the stylistic similarity to the inscription of 1100, placed by Anquêtil in the cloister.[27] On a visit to the priory of Cénac in Perigord, he was struck by the resemblance of its sculptures to those at home in Moissac.[28] He explained them as due to the same patron, Anquêtil, and cited the form of the church as well as written documents in evidence of the common authorship. At other times he was fantastic in his explanations and caused confusion because of his credulity and whimsical statements.

What travelers and artists of the Renaissance thought of the sculptures we do not know.[29] In the seventeenth century scholars, mainly of the Benedictine order, collected the documents pertaining to the mediaeval history of the abbey.[30] De Foulhiac, a learned canon of the cathedral of Cahors, copied numerous charters of Moissac and wrote on the antiquities of Quercy, the region to which Moissac belonged.[31] His still unpublished manuscripts are preserved in the library of Cahors. The monks of St.-Maur, Martène and Durand, who searched all France for documents to form a new edition of the *Gallia Christiana,* and in their *Voyage Littéraire* (1714) described many mediaeval buildings of Aquitaine, did not visit Moissac. The library of the abbey had been brought to Paris about fifty years before.[32] In the later eighteenth century an actor, Beaumenil, on an archaeological mission, made drawings of classical antiquities in Moissac, but paid little attention to the Romanesque works.[33] Dumège, a pioneer in the study of the ancient arts of southern France, wrote a description of the abbey and recounted its history in 1823, in an unpublished manuscript of which copies are preserved in Moissac and Montauban.[34] It was not until the second quarter of the last century, during the romantic movement in literature and painting, that the sculptures of Moissac acquired some celebrity. In his voluminous *Voyages Romantiques,* published in 1834, Baron Taylor devoted a whole chapter to the abbey, describing its sculptures with a new interest.[35] He drew plans of the cloister and the whole monastic complex and reproduced several details of its architecture. Another learned traveler, Jules Marion, gave a more precise idea of the history of the abbey in an account of a journey in the south of France published in 1849 and 1852.[36] He was the first to utilize the chronicle of Aymeric. In the *Dictionnaire raisonné de l'architecture,* published shortly afterward by Viollet-le-Duc, who had been

engaged in the official restorations of the abbey church and cloister, numerous references were made to their construction and decoration.[37] In 1870, 1871, and 1874, a native of Moissac, Lagrèze-Fossat, published a detailed account of the history and arts of the abbey in three volumes.[38] It was unillustrated, and in its iconographic and archaeological discussion suffered from unfamiliarity with other Romanesque works. Other archaeologists of the region—Mignot, Pottier, Dugué, Mommeja,[39] etc.— brought to light details which they reported in the journals of departmental societies. In 1897 appeared Rupin's monograph which offered the first illustrated comprehensive view of the history, documents, and art of the abbey, but was limited by the use of drawings and by the lack of a sound comparative method and analysis of style.[40] In 1901 the Congrès Archéologique of France met in Agen, near Moissac, and devoted some time to the investigation of the architecture of the abbey church.[41] In the following year excavations were made in the nave of the church to discover the plan of the building consecrated by Durand in 1063. Partly because of the infirmity of Monsieur Dugué, the conservator of the cloister, the excavations were never completed, and the results have remained unpublished to this day.[42] In the past twenty-five years the sculptures of Moissac have held a prominent place in discussions of French Romanesque art, but except for the researches of Mâle,[43] Deschamps,[44] and Porter,[45] little has been added to the knowledge acquired in the last century.[46] Deschamps has defined more precisely the relations of the earliest sculptures of the cloister to those of Toulouse, while Porter has shown the extension of similar styles throughout Spain and France and has proposed novel theories to explain the forms at Moissac. In the celebrated work of Mâle on the art of the twelfth century, the sculptures of Moissac are the first to be described. They are for Mâle the initial and unsurpassed masterpieces of mediaeval sculpture, the very inception of the modern tradition of plastic art, and the most striking evidences of his theory of the manuscript sources of Romanesque figure carving in stone. The influence of manuscript drawings on sculptures had long been recognized; it was not until recently that this notion was formulated more precisely. In America, Morey of Princeton had, before Mâle, distinguished the styles of Romanesque works, including Moissac, by manuscript traditions.[47] In Mâle's work the parallels between sculpture and illumination are more often those of iconography.[47a]

THE PIER RELIEFS OF THE CLOISTER

Of the mediaeval abbey of Moissac there survive today the Romanesque cloister, built in 1100; a church on its south side, constructed in the fifteenth century, incorporating the lower walls of the Romanesque church; the tower and porch which preceded the latter on the west; and

several conventual buildings to the north and east of the cloister (Fig. 2).[48]

A glance at Figs. 1 and 2 will show the reader the rectangular plan of the cloister, the disposition of its arcades with alternately single and twin colonnettes, and the brick piers with grayish marble facings at the ends and center of each arcade.[49]

On the sides of the four corner piers, facing the galleries, are coupled the almost life-size figures[50] of Peter and Paul (southeast), James and John (northeast), Philip and Andrew (northwest), Bartholomew and Matthew (southwest) (Figs. 5–12). Simon stands on the outer side of the central pier of the west gallery, facing the garden of the cloister (Fig. 13).[51] On the inner side of the same pier is the inscription that records the building of the cloister (Fig. 3); and on the corresponding side of the central pier of the east gallery, in front of the old chapter house of the abbey, is represented the abbot Durand (1047–1072) (Fig. 4). All these figures are framed by columns, and by arches inscribed with their names.

The rigidity of their postures and their impassive faces, the subdued relief of the hardly emerging figures placed on the shadowy sides of the piers, their isolation at the ends of the galleries, and their architectural frames suggest an archaic funerary art of ceremonious types.

The figures are so slight in relief they appear to be drawings rather than sculptures. This impression is confirmed by the forms of the figures, clearly outlined against the wall, with their features and costumes sharply delineated in simple geometric shapes. The unmodeled bodies are lost beneath the garments which determine the surface design. The costumes are laid out almost flat upon the background and incised with lines in concentric and radial sets like seams or moldings rather than true folds. The different layers of dress lie one upon the other in parallel planes. When folds reach the contour of the figure they stop short, only rarely altering the outline which was conceived before the folds.

It might be supposed from a brief inspection of the piers that the suppression of relief was due to the thinness of the slabs—these are no more than two inches thick—and that an obvious calculation restrained the sculptor. The same hand carving the nearby capitals produced heads and bodies almost completely detached from the stone.

But the character of the relief is not explained by the material alone. The slight projection of the figures was perhaps influenced by the nature of the slab; but the limited modeling and shell-like layering of surfaces are independent of it, and may even have favored the use of so thin a slab. With a thicker stone the figures might have been more salient; they would have been no more detached from the wall, and surely no more complex in surface.

In Durand (Fig. 4) the reduced relief, like the symmetry of details, is

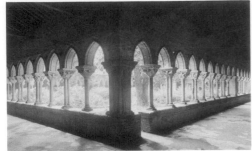

Fig. 1. Moissac: View of the Cloister (southeast)

Fig. 3. Moissac, Cloister; Pier Inscription of the Date of the Cloister (1100)

Fig. 4. Moissac, Cloister; Pier Sculpture: The Abbot Durand (1047–1072)

Fig. 5. Moissac, Cloister; Pier Sculpture: St. Paul

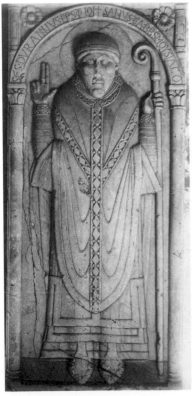
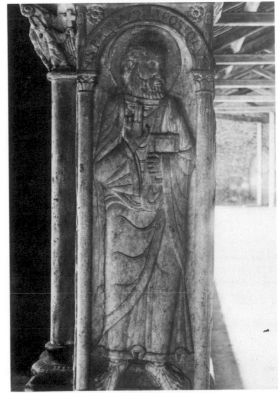

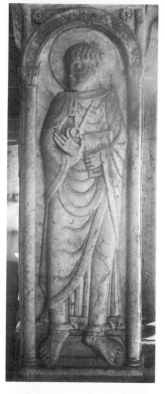

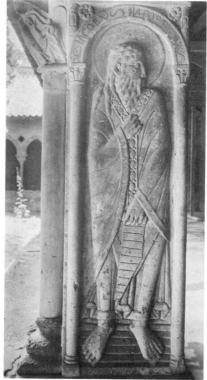

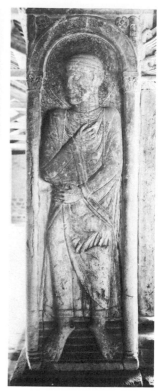

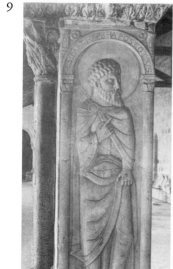

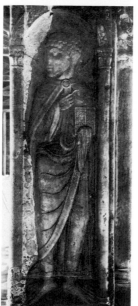

Fig. 6. Moissac, Cloister; Pier
Sculpture: St. Peter

Fig. 7. Moissac, Cloister; Pier
Sculpture: St. James

Fig. 8. Moissac, Cloister; Pier
Sculpture: St. John

Fig. 9. Moissac, Cloister; Pier
Sculpture: St. Bartholomew

Fig. 10. Moissac, Cloister; Pier
Sculpture: St. Matthew

an essential element of the expressive immobility of the whole. This figure, the only one that is entirely frontal and raises a hand in blessing, is of a commemorative type which retained for a long time an analogous flatness and incised forms.

The relatively greater projection of the figures on the capitals is due to their far smaller size; for size is an important factor in the relief of Romanesque figures. Small sculptures are not simply reduced replicas of large ones; in the adaptations of common types to a new scale, their proportions are modified, the relative thickness of folds increased, and the modeling considerably affected. The more complex architecture of the capitals, with the salient astragal, volutes, and consoles (Figs. 21 ff.), required as strong an accent of the carved forms, whereas the apostles decorated simple rectangular slabs. The apparently high relief of the small figures on the capitals by the master of the piers includes no greater differentiation of planes or richer modeling.

The reduced relief and simple surfaces are also correlates of the geometrical forms and the linear mode of representation evident throughout the piers. Despite the long tradition of preceding arts, these sculptures share with archaic sculptures of other times a specific manner of conceiving forms.

The body of an apostle is seen in front view, but the head in near profile, and the eye which should gaze to the side is carved as if beholding us. The feet are not firmly planted on the ground, but hang from the body at a marked angle to each other. The thin slab does not determine this trait. On the capitals, where the astragal provides a ledge for feet to stand on, some figures preserve an identical suspension. The movements of the limbs are parallel to the plane of the background. The hands are relieved flat against the bodies, with the palm or the back of the hand fully expanded. The arms are distorted, never foreshortened, and the bent leg is accordingly rendered in profile. The articulation of the body is subordinate to the system of parallel and concentric lines which define the costume. Only at the legs is an understructure of modeled surface intimated, and then only in the most schematic fashion, by a slight convexity of the garment. The folds are rendered as if permanent attributes of the dress, as purely decorative lines, though once suggested by a bodily conformation. They are spun to and fro across the body in regular, concentric, and parallel lines produced by a single incision, or by a double incision which creates a slight ridge, by polygonal patterns of fixed form, and by long vertical moldings parallel to the legs. The folds are curved as if determined by the hollows and salient surfaces of an underlying body. This body is not rendered.

The living details are schematized in the same manner. The head is a diagram of its separate features. The flow of facial surface is extremely

gentle; prominences are suppressed and transitions smoothed. Each hair is rendered separately, and bunches of hair or locks form regular spiral, wavy, or imbricated units that are repeated in parallel succession.[52] The eyebrow is a precise arched line, without relief, formed by the meeting of two surfaces.

The eye itself is an arbitrary composition, a regular object of distinct parts, in simple relation, none encroaching on the next. The lids are treated as two equal, separate members without junction or overlapping. They form an ellipsoid figure of which the upper arc is sometimes of larger radius than the lower, contrary to nature. In some figures (Figs. 17–20) the eyeball is a smooth unmarked surface with no indication of iris or pupil. In others (Figs. 14–16) an incised circle defines the iris. The inner corner of the eye is not observed at all.

The mouth shows an equal simplicity. The fine breaks and curves, the hollows and prominences which determine expression and distinguish individuals, are hardly remarked. A common formula is employed here. The two lips are equal and quite similar. Their parting line is straight or very slightly curved, but sharply drawn. In the beardless head of Matthew (Fig. 18) we can judge with what assurance these distortions and simplified forms were produced and how expressive so abstracted a face may be.

A difference of expression is obtained by a slight change in the line between the lips. Drawn perfectly horizontal—Bartholomew (Fig. 17), James (Fig. 19)—the impassivity of the other features is heightened. But in Peter (Fig. 16) it is an ascending line which makes him smile, and in Paul (Fig. 15) a descending line which combines with the three schematic wrinkles of the brow, the slightly diagonal axis of the eye, and the wavy lines of the hair and beard to express a disturbance, preoccupation, and energy that accord well with Paul's own words.

A Romanesque tradition describes Durand as given to jesting, a sin for which he was reproved by the abbot of Cluny and punished after death.[53] The mouth of his effigy has been so damaged that it is difficult to say whether its present expression of malicious amusement is a portrait or an accident of time (Fig. 20). A well-marked line joins the nose and the deep corners of the mouth. The line of the mouth is delicately curved and reveals a search for characterization within the limits of symmetry and patterned geometrical surface.

The drapery forms are as schematic as the eyes and hair. The lower horizontal edge of the tunics of these figures is broken in places by a small unit, usually pentagonal in outline, which represents the lower end of the fluting formed at the base of a vertical fold, or the pleating of a horizontal border (Figs. 5 ff.). In its actual shape it corresponds to nothing in the structure of drapery, unless we presume that a wind from below has

stirred the garment at certain points into this strange schematic fold, and that another force has flattened it against the body. In the reliefs of James (Fig. 7), Paul (Fig. 5), and Peter (Fig. 6) it appears three times at regular intervals, like an ornament applied to the lower border of the tunic.

We are not surprised to find such forms on figures whose feet hang and whose eyes stare at us even when the face is turned in profile, and whose hands can perform only those gestures which permit us to see their full surface. The elevation or vertical projection of the fold derives from the same habit of mind that gives to objects incompletely apprehended in nature an unmistakable completeness in images. The fold is freed of the accidents of bodily movement and currents which make drapery an unstable system of lines, and is designed instead as a rigid geometrical element. Rather than evoking the free and sporadic appearance of nature, it is further limited, when multiplied, to a few symmetrically arrayed lines.

Similar observations may be made of hands and feet, of the structure of the whole body, and even of the ornaments of the reliefs, the rosettes of the spandrels, and the foliage of the little capitals.

We must not conclude, like some Greek archaeologists, that material difficulties have determined these peculiarities and that every shape is a compromise of will with a refractory object and inexperience. On the contrary, the material is a fine Pyrenees marble, and the tools were evidently adapted to the most delicate cutting. Only a slight examination of the surfaces will reveal with what care these figures were executed and how thoroughly the sculptor commanded his style. This is observable in two features of the work—the uniformity of execution of repeated elements, and the elegance and variety of detail. The double fold appears a hundred times in these figures, and always with the same thickness and decisive regularity. The forms have been methodically produced; they are not a happy collusion of *naïveté* and a noble model.

The archaism of these works differs from that of early Greek sculptures in an important respect. The pier reliefs contain clear traces of an older, more advanced art: beside the schematic reductions of natural forms there are more complex derivatives of classic naturalistic styles. The profile head is not simply the abstracted contour of a line drawing, as in early Greek reliefs, but is slightly turned to reveal a second eye. This eye is actually foreshortened; it is smaller than the other, and intersects the background wall. It differs from a truly foreshortened eye in its regular form. On Simon's head (Fig. 14), which has been turned to a nearly three-quarters view, the profile of the jaw is inconsistent with that turn; it illustrates the domination of a more complex material by an archaic method.[54]

This presentation of the less visible parts of the profile face is to be distinguished from the rendering of the profile head completely in the

round on some capitals of the cloister. There no foreshortening is implied, since with the relatively higher relief the entire head could be modeled. The inner eye does not intersect the background wall, nor is there an inconsistent relation of the two sides of the face.

Traces of an unarchaic model are present also in the posture of St. Philip (Fig. 12). Although his feet are suspended as if no ground existed for their support and are parted symmetrically, their point of junction is off the axis of the figure. A line drawn from the sternum to the heels is diagonal and not strictly vertical, as we would expect. This irregularity is balanced by the greater extension of draperies at the right than at the left. The prototype must have been a figure seen in three-quarter's view, less rigid than the cloister sculpture.

A more remarkable evidence of originally spatial and plastic proto-types are the pedestals and stairs under the feet of some figures. These pedestals are trapezoidal in shape; they represent foreshortened rectan-gles, horizontal planes projected vertically in the course of centuries, but retain inconsistently the converging sides. The feet of James (Fig. 7) and of John (Fig. 8) stand on several steps at one time, as if the horizontal bands were a background of the figure and not stairs perpendicular to the wall.

The unarchaic character of the sculptor's prototypes appears also in the costumes of the figures. Whereas the artist seeks distinct forms, a clear patterning and a legible succession of planes, the garments show a complex overlapping and even ambiguity of surfaces. On the figure of Peter (Fig. 6) the end of the mantle on the right shoulder is not continuous with any other piece of clothing; we are at a loss to explain it. The overlapping of drapery at his right ankle is also not clear. Similar inconsistencies occur in the costume of John (Fig. 8); his tunic is covered at the left ankle by the mantle, yet is represented behind the mantle on the background of the relief. The triangular tip of James's chasuble (Fig. 7) is lost in the tunic.[55]

It is already apparent from the description of the small polygonal folds at the lower edges of the tunics that they were simplified versions, not of folds observed in nature, but of a more plastic expanded form in older art. Classic sculpture had provided the prototypes in the fluttering garments of active figures; these reappear in the stiff immobile apostles in rigid form.[56]

The folds of lambent double curvature across the legs of some figures presuppose a modeling of the body to which they correspond; but this modeling does not exist in the sculptures of the cloister. The form here is vestigial. It betrays its character not only in the association with flat, barely modeled surfaces, but in its actual hardness and sharpness, its doubled line, its uniformity, its pointed termination. These are archaic modifications of an originally fluent fold which moved across a more plastic surface.

11

13

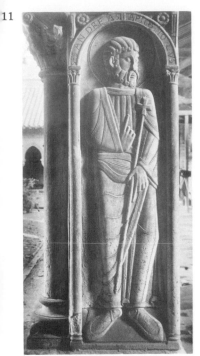
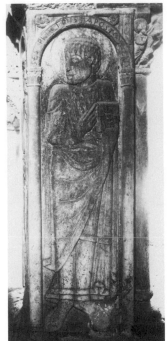
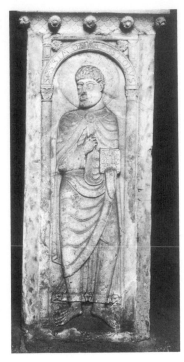

14

Fig. 11. Moissac, Cloister; Pier
Sculpture: St. Andrew

Fig. 12. Moissac, Cloister; Pier
Sculpture: St. Philip

Fig. 13. Moissac, Cloister; Pier
Sculpture: St. Simon

Fig. 14. Moissac, Cloister; Pier
Sculpture: Head of St. Simon

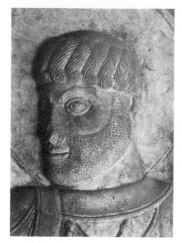

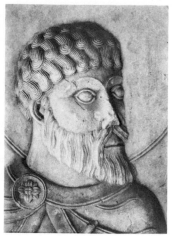

Fig. 15. Moissac, Cloister; Detail of Pier Sculpture: Head of St. Paul

Fig. 16. Moissac, Cloister; Detail of Pier Sculpture: Head of St. Peter

Fig. 17. Moissac, Cloister; Detail of Pier Sculpture: Head of St. Bartholomew

Fig. 18. Moissac, Cloister; Detail of Pier Sculpture: Head of St. Matthew

Fig. 19. Moissac, Cloister; Detail of Pier Sculpture: Head of St. James

Fig. 20. Moissac, Cloister; Detail of Pier Sculpture: Head of Abbot Durand

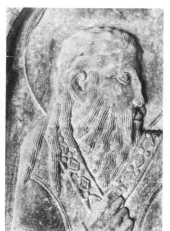

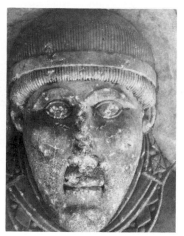

The sculptor has evidently reproduced older works of a less archaic character, and accepted their complex modeled and foreshortened forms as a matter for schematic reduction in terms of his own linear style. The plausibility of the folds as representations was less important to him than their decorative coherence and clarity as single, isolated rhythmic lines. The apostles as traditional figures received a traditional dress, not subject to verification except in older monuments. In the portrait of Durand, however, the contemporary costume had a symbolic value and was scrupulously drawn, to the last detail. Yet in this figure of the abbot the faithfully rendered forms produce an effect of overlapping and ornamental involvement analogous to the arbitrarily designed garments of the apostles. It is evident that the definiteness of details as single elementary shapes, which governs the archaic process of representation, does not itself determine the character of the whole. We must ask whether the complication of these archaic reliefs is due merely to the reduction of models of ultimately unarchaic, illusionistic character; or whether complex elements of the latter were retained in the process of reduction—which we must suppose took place over a period of several centuries—because of the taste of the reducing artist for a restless and more intricate play of lines. The question may be put in another way: Did a specific method of design and expressive end favor the selection of elements and larger patterns of a complexity exceeding that of the common method of representation?

Before I proceed in the analysis of the design of the reliefs, I shall describe two important kinds of variation in their forms—first, the distinction of individuals by varying details of costume and of face, as well as posture; second, the development evident in the successive renderings of the same element.

The quasi-ornamental rendering of forms shows a realistic bias. If the folds are limited to a few elementary shapes, these are arranged in fresh combinations from figure to figure. The study of the hair alone will reveal the search for variety: in Matthew (Fig. 18) a pattern of hexagonal imbrications, each with parallel vertical lines; in Andrew (Fig. 11) and Peter (Fig. 16), an array of locks ending in small spirals; in Bartholomew, overlaid series of locks with similar spirals (Fig. 17); in Simon, James, and Paul (Fig. 15), long, wavy striations that escape the common regularity; in Philip (Fig. 12) a band of zigzags between the two lower rows of imbricated tufts; and in John (Fig. 8) a row of diagonal hairs emerging from under the ribbed cap. In all these forms, however, there is a common thought. All of them avoid the disordered and accidental in hair and abstract its uniformity of structure; they render its curly, straight, or wavy character by a parallel striation of similar locks or tufts. The forms representing the different kinds of hair remain equally regular and ornamental.

A similar variety is evident in the costumes and accessories of the

figures. John alone has a cap; Peter and Paul are sandaled, Durand and Philip wear shoes; the others are barefoot. Some carry closed books, Matthew and Simon have open inscribed volumes, James a scroll, Andrew a cross. Even the pedestals of the figures are varied. Under John and James the horizontal bands suggest a staircase, while beneath the others has been carved a quadrangular plaque.

This diversity is not iconographic—a rendering of attributes of the apostles—except in a few details like the cross of Andrew and the inscription of Matthew's book. It is more probably a character of the style, and accords with an unmistakable tendency toward individualizing representation evident also in slight anatomic variations, some introduced perhaps in the course of the work from figure to figure.

The forms of the human body and its costume are not equally accessible to the archaic method of representation. The artist who did not observe the human eye correctly and misproportioned the arms and legs and head was very careful to represent the stitching in the shoes of St. Andrew (Fig. 11) and each separate hair of his beard. For hairs and stitching are regular, repeated, simple shapes, whereas an eye is asymmetrical, and the proportions of the limbs are unique, unmarked on the body, and not susceptible to a precise ornamental construction.

It is conceivable that these larger or more complex parts of the figure should be subject in time to a canonical definition as precise and regular as the simpler elements. Such a regulation and schematic control are familiar to us from Egyptian art.

But in the cloister piers the proportions and details of the figure are not rigorously fixed; and we may perceive within the ten reliefs evidence of observation newly made in the course of work. This is hardly apparent in the modeling of the body, which is everywhere minimized. But proportions change. Bartholomew and Durand are exceedingly short; their heads are little more than one-fifth their total height. In other apostles the heads are one-sixth, and in Peter and Paul approach one-seventh the height of the figure.

The greater breadth of the relief perhaps accounts for the squat proportions of Durand. He stands under a segmental arch instead of the semicircle of the others. Not all the figures are compactly fitted in their frames. Philip, John, and James raise and narrow their shoulders as if to pass through a close archway.

The extreme shortness of the arms of Bartholomew, which recurs in Andrew and Peter, is corrected in Matthew and James.

It is difficult to decide whether these variations proceed from a closer attention to nature or from varying models. The rendering of the iris in Peter, Paul, and Simon might suggest a fresh observation by the sculptor, were it not that the iris appears in Toulouse[57] in earlier sculptures, less

naturalistic than the works in Moissac, and is absent from later sculptures that are even more detailed and veracious in rendering the figure.[58]

But in the representation of the ear, we can follow a development which parallels that of early Greek art.[59] In Peter, Matthew, Simon, and Durand, it is small and set too high; in Bartholomew (and Simon) it is more accurately placed, but still too small; in James, however, it is so well observed that, except for the rest of the figure, it might seem by another sculptor. Shapes as well as proportion and position are developed; the parts of the ear become more clearly differentiated.

The variation of the size and shape of the three polygonal folds of the lower edges of Peter's tunic (Fig. 6) reveals a similar tendency. On Andrew's garment (Fig. 11) a diagonal doubled line is incised on the corresponding border to mark the turned-up or folded edge. The ornament of beads and lozenges, common to the costume of James and Durand, is more plastic in the former. In the case of Durand the lozenges are quite flat; in James they are convex and enclose a central jewel.

That these variations indicate a tendency in one direction is impossible to demonstrate by a study of the figures in their original succession in time; for it is not known in what order the figures were carved; and any order inferred from the variation of a single feature, like eyes, proportions, or inscriptions, is contradicted by study of another. The greatest number of uncial characters appears in the inscription of Bartholomew, who is one of the shortest of the apostles and has been considered the most archaic.[60] Except in the relief of Simon, the capitals of the framing colonnettes are of identical form. An exceptional base molding occurs in this relief, and also in the relief of Bartholomew. A more searching observation of the sculptures might perhaps enable one to determine an order of carving; but this would be complicated by the problem of deciding how many hands were at work and to what extent the variety is due, not to a development in time, but to different sculptors working together. The figure of Simon, I shall try to show later, was not carved by the same artist as the other apostles.[61] I have been unable to distinguish other hands on the piers since the variety is so considerable in small details, and the large effect so uniform. The sculptures were probably carved within a brief period in which development could hardly be considerable. Differences of design were varieties of the same conception or method; the progressing tendency toward more realistic art is inferred from details rather than the whole.

One may suppose that these details are sporadic deviations from a common type without any significance for future local styles. Yet their resemblance to a later more naturalistic art which maintains for a while the archaic conventions of the cloister permits us to assert that the style was not fixed and that the tendency of variation was toward the forms of

later styles. It is conceivable that figures might grow more squat or their eyes more slanted; but the existence of five or six representations of ears which approximate in varying degree to the natural form makes it unlikely that the most natural was the first and that the cruder and deformed types were developed from it. Such a conclusion would run counter to the uniform technical skill of the reliefs; it would overlook also the association of the natural type with slightly later arts in which the forms show a corresponding character.

There are differences in the design of the figures which are even more difficult to interpret. It is enough to observe that this design already presents many of the features of subsequent Romanesque art, though the figures themselves are so flat and so much more schematically conceived than the works of the twelfth century.

The reliefs of each corner pier were not composed as separate slabs, but as intimately related pairs of figures. The apostles on the adjoining panels of the same pier face each other and sometimes reflect in their costumes, gestures, and linear schemes the artist's wish to accent an architectural unity. The pedestals and feet of the two apostles are identical; and on each pier some distinctive elements of dress or posture distinguish the two figures from those on the other piers.

The unity of the figures on one pier is itself archaic in that it is achieved by the duplication of forms. The complexity of their design is limited by the method of representation which admits only simple shapes, isolates the parts of an object as definite entities in the whole, and converts minor variations of a surface into ornamental markings.[62]

This design, however, is already so asymmetrical and intricate and so nicely contrived, that the primitive conventions observed above constitute not the initial stages of an art, but a practiced archaism with a heritage of more realistic models from an unarchaic style. In several of the figures we note a less obvious ordering of details, unornamental combinations so arbitrarily accented that we can hardly doubt the deliberate aim. The sleeves of John form a continuous curve (Fig. 8) which is repeated in the long diagonal fold below. In the figure of James beside him (Fig. 7) the intricacy of the lines makes it difficult to distinguish the arbitrary or premeditated elements from the rhythmical character which emerges spontaneously in the execution of an artistic project. The arms, fingers, collar, mantle border, scroll, and feet form a series of rigorously coherent, but unobtrusively related diagonal lines, asymmetrical in scheme, unequally accented, and without the appearance of an imposed design. The incised curves of the mantle folds are subordinate to them. Horizontal lines of the suspended scroll repeat the steps of the pedestal, and several vertical folds and contours are emphasized in contrast and also as parallels to the columnar frame.

Neither the coherence nor intricacy of forms is a sufficient characterization of the design of these works. These qualities, like the peculiarities of representation isolated before, may be found in the arts of other times and places. The figures possess a distinctive Romanesque character which may be illustrated by analysis of several details.

Peter (Fig. 6) holds between his forefinger and the tip of his thumb two great keys which overlap slightly and then diverge. In accord with the conceptual process which governs the representation of forms in these reliefs, the two fingers are laid out flat in the same plane as the others, despite the physical impossibility of flexing the joints in this manner. In the same way, the circular handles of the keys are made to overlap so that each may be visible. The two keys are separated for the same reason, though the resulting relation of fingers and keys is strained and disturbing. This anatomically difficult gesture entails also an improbable twisting of the wrist.

Such distortion was not produced for clarity alone. On the contrary, the sculptor has enclosed these forms within a complicated whorl of concentric and radial lines, of which the two fingers and the rings of the keys appear to constitute the vortex.

The gestures add a note of animation and diagonal movement in the forms of the figures. The artistic effect of a single figure is obtained not only by the main contours and the larger folds of the garment, but by numerous curved lines, freely invented, inscribed on the surface of the body. These radiating lines are strongly contrasted; some folds have a wavy curvature, while others are in a forceful opposition to straight lines.[63]

This restless effect appears also in the contours of the figures. With all the elaboration of drapery lines the contours remain simple, but are nevertheless in accord with the patterning of the enclosed lines and limbs. They are asymmetrical, avoiding duplication of one side of the body by the other. They are formed by straight lines, with only occasional curves, and hardly suggest the flowing contours of the body. The normal attenuation of the waist and legs and the greater breadth of the shoulders are not observed. Even though these angular and harsh outlines are rarely modified by draperies which pass across the body, they are complicated by other means—by the jutting edges of the mantle and the triangular bits of drapery that emerge from behind the figure (Figs. 6, 7, 9, 12, 13). There is produced in consequence a secondary contour which in its zigzag inequalities contrasts with the neighboring architectural frame. The interruption of the lower horizontal edge of the garments by the polygonal patterned folds described before contributes to the same end.

Even in the figure of Durand, who is represented with a deliberated precision, as if by compass and ruler, and whose neat, almost mechanical

symmetry suggests an indifference to expression, the forms are not in ideal repose or clarity. The abbot is carved on the broadest of the nine reliefs, but his posture is extraordinarily strained. Standing like him, and enacting the same gestures, we would feel ourselves cramped, enclosed, and without firm support. The artist who reproduced with devotion the insignia of Durand's authority did not maintain in the smaller elements the ritual gravity inherent in the static architectural design of the whole. The details, though quite regular and schematic, break up the figure into numerous parts with contrasted axes.

At the very bottom are two vertical shoes of curved outline, bordered by a restless scalloped design, in contrast to the horizontal band of the ground. Then follows a series of overlapping surfaces, bounded by horizontal bands of unequal length. They include incised and sculptured perpendiculars, differently spaced on each surface, and so arranged that no continuity of verticals appears, but an endless interception of ornamental lines and overlapping of planes. The incised verticals (like the lower sides of the costume) tend toward the axis of the figure as they ascend; another triangle is implied in the relation of the two stoles to the small bit of the central band of the dalmatic visible below the tip of the orfrey. In contrast to the straight lines and perpendiculars of the alb, the tunic, and the stole, four triangular figures with curved hypotenuse are cut out symmetrically on the dalmatic by the descending chasuble.

The latter is dominated by a prominent vertical band enriched with jewels, forming the axis of the figure, like an everted spine. This orfrey divides the chasuble into two equal parts; their symmetry is sustained in the scrupulous correspondence of minor elements of the two sides. But these elements are so designed that the chasuble, viewed from top to bottom rather than from left to right, yields a perpetual contrast of lines and areas. Its lower boundary is ellipsoid, and recalls the shoes; its upper edge is a more complex form, with delicate ogee lines on the shoulders, rising to the ears and then returning to the chin in an opposed curve. Folds incised on the lower part of the chasuble form two sets of tangent asymmetrical loops, radiating from the orfrey like ribs from the spine. A more powerful contrast to the lower edge of the chasuble is provided by the rigid, diagonal jeweled bands, which meet near a point from which the loops descend.[64] The areas cut out on the breast between the orfrey, the shoulders, and the collar, with their elegant contrast of curves and straight lines, are typical of the whole in their restless angularity. Within these areas are incised other curves complementary to the loops of the lower chasuble, reversing their direction, and dividing the breast and shoulder into dissimilar but beautifully related areas. The subdivision of narrow angles, the radiation of these curves from the meeting point of contrasting diagonals, the interception of other lines which proceed to the

same point (like the lower edges of the sleeves), and the groups of diago-
nal lines at the elbows—all these confer an additional restlessness on the
central portion of the figure. From this area of zigzag and diagonal move-
ments we are brought back to a vertical-horizontal scheme by the erect
arms, with simple folds perpendicular to the limbs. The surmounting
hands resume the same scheme, but include the diagonal in an ingenious
way. On the right hand the extended thumb parallels the sleeve and con-
nects the architectural design of the hand with the sloping shoulder and
with the diagonals and incised curves of the breast. Its direction is
repeated by the other thumb, which bridges the crozier and the shoulder.
This duplication is asymmetrical; but a more general symmetry is partly
maintained by it. The force of the inward spiral curve of the crozier is
countered by the outward turn of the thumb. The fingers are bent hori-
zontally about the staff in another contrast to the same spiral curve. Anal-
ysis of the details of the hands and the crozier will reveal a most refined
balancing of asymmetrical parts by inequality of interval, opposition of
directions, and minute variations of relief.

The uppermost part of the figure, which is apparently simple and
quite regular, includes the contrasts, encroachments, and interruptions of
forms observed in the rest of the relief. This is clear in the banding of the
collar with its overlapping folds and ornament and crescent shapes; in the
halo which disappears under the arch and is broken by the spiral head of
the crozier; and in the contrasts of the lines and surfaces of Durand's
head, of the tonsured crown, the vertical hairs, the fillet, the arched eye-
brows of double curvature, and the unusually long face, proportioned
somewhat like the chasuble below.

I have tried to illustrate by this analysis of details a character of the
whole. The reading of the separate parts in succession does violence to
the simultaneous coherence of the object, but it enables us to follow the
design of the work more easily, and to perceive in the complex adjust-
ment of apparently simple parts their peculiarly involved and con-
trasted character in a whole which at first sight seems a bare archaic
description.

A similar character may be found in the inscriptions of the piers. In
the record of the consecration of the cloister (Fig. 3) the letters are
closely packed, tangent to the frame and crossed or enclosed by each
other. Even in the lower lines, which have larger letters, and where the
artist could have spaced more broadly, he has preferred to crowd them,
and to design them tangent to the frame. Where he is able to separate let-
ters clearly he has chosen to accentuate their angularity and sharpness by
triangular notches placed between them. The reason the border is
pinched inwardly at the angles and center of the lines may be found in
the same character of the style. The artist could not accept two lines in

clear unmodified parallelism; to animate the frame, to bring it nearer to the enclosed forms, he indented the border, anticipating Baroque frames.

The style may be grasped further by comparison of the Roman letters of the inscription with the corresponding classic forms. They are less regularly spaced, less uniformly proportioned than the latter; the verticals of letters like T, N, I, and L are not strictly parallel.[65] On the arches of the pier reliefs the sequence of letters is continually varied, and several different patterns are contrived from the inscriptions. The letter S is sometimes laid on its side.

The inscription of Durand's name and titles is even more obviously designed like the draperies of the figure. The spacing of the letters is rhythmical but irregular and complicated. The two Ns of DURANNUS are crossed in an exciting zigzag, and other letters intersect in monogram-like combinations. That the artist sought these effects and was not merely constrained by the narrowness of the surface and the length of the inscription is evident from the great variety in the amplitude of the letters, the irregularity of spacing of forms which in their individual details are cut with an obvious decisiveness, and from such peculiarities as the horizontal line passing through the BB of ABB(a)S, as a contraction of the word. Since it signified the omission of an A it might more plausibly have been placed above the second B and the S, instead of extending from the first A into the second B. The whole inscription is angular, crowded, intricate; the interruption of the text within a word (TOLO-SANUS) at the crown of the arch distinguishes this Romanesque work from a classic inscription. Not only is an untextual element of religious character—a cross—introduced within a word, but the harmonious span of a curved line is thereby broken at its midpoint. We are reminded of the prominent keystones of Baroque arches, and of the aesthetic effect of the pointed construction.[66]

The design of the arcades of the galleries betrays an analogous conception (Fig. 1). The arches are not supported by a succession of uniform members, which we might expect from the uniformity of arches, but by columns alternately single and twin, and by occasional piers of prismatic form. This alternation lightens the arcade, diversifies the procession, introduces an element of recurrent contrast in what is otherwise a perfectly simple sequence, and makes of each bay an asymmetrical structure. For the arch springs on one side from a single capital and column, on the other from a twin combination; while in the adjoining bay this design is reversed. There results theoretically a larger symmetrical unit of two bays, bounded by single or twin columns; but this larger unit is not fixed and is hardly perceptible, since it is not embraced by a larger discharging arch or molding.[67]

I think it is apparent from this analysis that the intricacy and contrast

of forms are not due merely to the survival of older complex elements in an archaic art; the latter is essentially devoted to such effects and produces them even in figures like the abbot Durand, whose costume and posture are significant mediaeval inventions. The symmetry of this relief is as fanciful as the less regular and traditional asymmetry of the apostles. Characteristics like the clear and generalized views of head, shoulders, and limbs, with their familiar archaic forms, are affected also by the dominant expressive bias of the style. Hence, perhaps, the retention of certain unarchaic features, like the remote eye of a profile head, and the frontal feet, suspended in a zigzag pattern.

It is also clear from the architectural context of the figures, their common material, their similarities in style, posture, frames, and ornament, that they are the product of a single enterprise and an already developed stable practice. The fact that in so restricted a project, under apparently uniform conditions of material and skill, variations of forms appear, with an unmistakable tendency toward more naturalistic and complex forms, is significant for the rapid development of western sculpture in the first half of the twelfth century. The variation is the more remarkable when we recall how stiff are the figures, how regular and formula-bound the representation of certain details.

THE CLOISTER CAPITALS

The arcades, which are reinforced at the ends and in the middle of each gallery by the piers of rectangular section, are supported by slender monolithic colonnettes, alternately single and twin (Fig. 1). On the east and west sides there are twenty arches, and on the others eighteen. The pointed arches are reconstructions of the thirteenth century, but spring from stone capitals, all of evident Romanesque origin. These capitals are seventy-six in number, alternately single and twin like the colonnettes which support them. Those surmounting the corner colonnettes are engaged to the piers, and are cut in half vertically (Fig. 69). At one time two smaller arcades stood in the northwest corner of the cloister as enclosures of the fountain and the lavatorium of the monks.[68] They were of the same structure as the arcades of the galleries and were decorated like these by sculptured capitals. But the marble basin has disappeared, the arcades have been dismantled, the capitals scattered; and only the springing voussoirs of the arches which touched the gallery arcades have been left as traces of the original structure. Several colonnettes, as well as one capital and two impost blocks, are now preserved in the Belbèze collection in Moissac. They are of the same style as the capitals and imposts of the north gallery.[69]

Each capital, whether single or double, is composed of two parts, an

inverted truncated pyramid and a rectangular impost block. Unlike clas-
sic art, the astragal is the base molding of the capital rather than the
crown of the column. The capitals are with few exceptions circular in
plan at the astragal, rectangular above at the impost. The transition from
one form to the other is effected by an almost insensible flattening of the
conical surface until the block assumes the section of a pyramid. (On sev-
eral capitals the lower section is square or hexagonal, but the astragal
remains circular.) By the salient relief of figures projecting from the ideal
geometrical surface and by the structure of volutes and consoles, the
change in section becomes imperceptible and the shape of the capital
eludes a simple description.

The dimensions of the capitals vary according to their single or twin
character; but in each class of capital they are nearly uniform. Excep-
tional dimensions appear in the twin capitals of the west gallery (Fig. 86)
which received also the arches of the destroyed lavatorium. Their broader
bases are at once intelligible.[70]

In the design of the capitals it is difficult to discover a fixed system of
proportions, since the initial blocks of the sculptor, probably quarried or
rough-hewn in uniform dimensions, were trimmed unequally in the proc-
ess of sculpture, and the original proportions altered. But several approxi-
mate ratios may be inferred from the measurements of the entire group,
despite the occasional deviations. On the twin capitals the height of the
drum is equal to the combined diameters of the two astragals (.30 to .32
plus); the upper breadth of the impost on its longer side is twice the
height of the drum. This might be stated also: the diameter of the capital
at the astragal is doubled in the height of the capital, quadrupled in the
upper breadth of the impost. It is about equal to the height of the
impost. The proportion of the heights of upper and lower impost bands
is about that of the lower and upper breadth of a twin capital on its
broader sides (.32: .50 and .065: .09, or .06: .10).

Of the visible surfaces of the impost—the upper, a horizontal band,
and the lower, beveled—it is the second that receives the richer and more
deeply carved ornament. The upper is covered with imbrications, in very
low, almost shadowless relief, of many patterns; or is inscribed, or striped
horizontally, or given a decoration of flat lambrequins, triangles, lozenges,
beads, arcatures, disks, and intersecting semicircles. These separate geo-
metrical motifs are repeated in horizontal succession, tangent, or at regu-
lar intervals. On only a few imposts is a scheme of two alternating motifs
employed, and these are usually very simple, like lozenge and bead, disk
and dart, etc.

On the lower surface of the impost, however, a magnificent decoration
of animal and plant forms is applied. Placed between the nonliving, geo-
metric ornament of the upper surface and the human figures of the capi-

tal proper, it seems that, naively or by design, distinctions of vitality or importance have been rendered by distinctions of relief and of architecture. I shall not stop here to analyze this decoration, which deserves a separate study.

The drum of the capital retains several classic members. Two volutes form an upper frame of the figured scenes on each face. Usually they do not meet at the center but are interrupted by a triangle inscribed between them to form a zigzag. In the Miracle of Cana a central pair of volutes copies purer classical models (Figs. 56, 57). The central console block is likewise an ancient survival. Here its form is elaborated. No less than twelve different shapes may be counted, ranging from simple rectangular blocks, with one beveled surface, to finely curved consoles, not susceptible to an obvious geometrical description. The most elaborate and varied forms appear in the south gallery, the simplest in the east. The astragals too receive different ornaments. The greater number are plain torus moldings, but several are cabled, and many have an ornament of lozenge-nets, ovals, imbrications, and horizontal strings, like the upper impost band. As on the consoles, the richest forms appear in the south gallery where astragal decorations are most common.

The surfaces of the capitals, below the volutes and consoles, are covered with human and animal figures or with foliate patterns. The latter are evident adaptations of the forms of the Corinthian capital; but on a few capitals palmettes rather than acanthus forms are employed, and the separate units are enclosed in scrolls in a manner unknown on the classic capital. The animals are mainly birds or lions confronted or adossed in simple heraldic groups. On several capitals human figures are placed between such animals or dragons. Stylistically, the animal and human forms on these capitals are not unlike those on the historiated ones. They are grouped somewhat more simply, but the anatomical structure, the contours, the modeling, the details of the features are quite similar to those of the narrative figures. Even the symmetrical grouping and the ornamental devices of these capitals recur in some of the religious compositions.

On the historiated capitals the figures are set on a neutral curved surface, in a relief which, though very low when measured in its absolute projection, is high in proportion to the size of the capitals and the figures. The scenes are spread out on all four faces of the capital; but we shall see that an effort was made to achieve pictorial unity by limiting separate incidents to a single face, and by framing the figures by the volutes and buildings carved at the angles. On several capitals of the east and west galleries (Figs. 45, 52, 53–57, 65, 86) inscriptions are incised, sometimes with scattered letters, on the background surfaces between the figures. In the south and north galleries this practice is less common; it is

only on the capitals of most primitive style that the background is treated in this way. On the more skillfully carved works the inscriptions are placed on the impost block or are incised on the capital itself in vertical and horizontal alignment. On no capitals of the cloister are the inscriptions more vagrant and decomposed than on those which show the greatest simplicity in the composition of the figures and a striving for symmetrical, decorative grouping of the episodes.

These inscriptions usually name the figures represented. Sometimes even the animals are accompanied by their names or initials (Fig. 86). On several capitals, not only the names of the actors but their actual speech is reproduced. On the capital of Cain and Abel, the Lord's question and Cain's reply are both incised on the common background. The abbreviated texts of the Beatitudes accompany the figures that personify these sentences (Fig. 90). Occasionally, as on the capitals narrating the miracle of St. Martin (Fig. 83) and the fall of Nebuchadnezzar (Fig. 22), whole lines from the illustrated text are copied on the imposts above the figures. The latter practice is a more refined device than the others. In the use of the inscriptions, as in the carving of the figures, may be observed various stages of archaism. The naming of the figures on the adjacent surface is a naive method known also in ancient art; the placing of a text above the scene is an advanced development.

* * *

When the sculptor of Moissac wished to represent the story of Adam and Eve he did not isolate a single incident from the Biblical text, but carved on the same surface the Temptation, the Lord's Reproach, the Expulsion, and the Earthly Labors of the pair. Adam appears four times in this one relief; we are asked to view the figures in a sequence in time as well as space, and to read them as we read the text they illustrate (Fig. 47–49).

The same primitive continuity of narrative appears on most of the figured capitals of the cloister.

Since the entire surface of a capital could not be seen at one glance, it was admirably fitted for the continuous method of narrative sculpture. By limitation of the field visible at the same time, it escaped the inconsistency of several moments presented as simultaneous; in this respect it resembled the papyrus or parchment roll of ancient art and the columns of triumph on which successive scenes were deployed on a winding surface.

And like the ancient sculptors, who imposed a more complex dramatic unity on the separate incidents of the narrative sequence, the artists of Moissac practiced also those foreshortenings of episode which reveal the most action through the fewest gestures or figures. On the capital of the

Martyrdom of John the Baptist, the martyr's head appears on the banquet table, while the figure of Salome at the right, with one hand raised, refers to another moment of the story (Fig. 21). The Expulsion of Adam and Eve likewise combines two incidents. On the south face the angel expels from Paradise two figures clad in the skins of beasts. Eve at the left grasps the branch of a tree projecting from the west face, where Adam reappears with a pruning tool. The Magi proceed from a building labeled Jerusalem and march to the Virgin and Child who are seated before Bethlehem; behind the first structure is enthroned Herod, ordering the Massacre of the Innocents, which takes place before him. The scene is framed at the right by the same tower of Bethlehem (Figs. 58–60).

The continuous illustration of connected episodes in Moissac cannot be identified, however, with the classic or primitive process from which it differs in a peculiar manner. Whereas the continuity of representation on a column of triumph or a picture book like the Joshua Roll is maintained by a formal treatment which mingles the figures and backgrounds of successive episodes, so that the movement proceeds without interruption in a single direction, in Moissac four surfaces are demarcated on a capital and as many incidents are usually represented.[71] Here the continuous method is modified by the architectural isolation of scenes, further accented by the decorative unity of each surface. Each face of a capital is often bounded by single figures or buildings which frame the scene; the centralizing of action or design by the arrangement of elements about an apparent midpoint or axis confirms the discontinuity.

This difference from classical continuous illustration appears also in the variable and indeterminate direction of the story. Not only are scenes rendered as static symbolic arrangements or as architectural decorations, but incidents on adjacent sides of a capital may have no apparent connection.[72]

On the same capital the Magi approach the Virgin from the right (Fig. 58), while the Massacre of the Innocents proceeds from Herod seated at the left (Figs. 59, 60). The narrative order of the Adam and Eve capital is from right to left, of the Annunciation and Visitation, left to right (Figs. 68, 69); and in a scene like the Martyrdom of John (Fig. 21) the condensed narrative makes it difficult to judge whether the beheading at the right implies a movement from right to left or the reverse.[73] Without indication of an end or starting point there cannot be a legible order or direction in scenes placed on the four sides of a pyramid. In the Temptation of Christ (Figs. 32, 35) each of the four incidents is isolated; and by no possible interpretation of gestures can we infer the textual order of the incidents. The feeding of Christ by the angels, which terminates the action in the Gospels, is in fact placed here between the second and third temptations (Fig. 35).

Each scene is usually so self-contained in composition that only before

a few capitals, which will be considered later, have we an impulse to shift our position the better to grasp the sense or structure of a group.

Even when two incidents appear upon the same face of a capital they are so designed that a single decorative composition emerges; the two actions diverge from a common axis (Figs. 50, 59). This is not the succession of movements characteristic of continuous illustration.

This peculiarity of the narrative method in Moissac is an essential feature of the style; hence the analysis of its elements and the distinction from other types of continuous illustration are instructive.

It seems to be occasioned by the architecture of the capital, which is crowned by a rectangular member. The impost commands a separate attention to the figures under each of its sides, and these are consequently treated as closed fields.

Such an explanation is incomplete, however. The rectangularity of the impost was itself designed by the sculptor; its clear, sharply defined surfaces, its geometric ornament in low relief, indicate to us that the shape of the impost was not an anterior condition that determined the grouping of the figures but was conceived as an element of the whole like the figures themselves, and shared with them a common archaic character.

The pointed arches and ornament of Gothic picture frames will clarify this relation. The irregular forms within the pictures are not determined by these boundaries; both are specifically Gothic creations. The analogy of frame and enclosed forms (as in the Romanesque works) is a common mediaeval feature.

The compact grouping of figures under a single side of an impost is not merely meant to define limits of action or space; it is also decorative and approaches in the pervasiveness of its often symmetrical design the quality of pure ornament. The trapezoidal shape of the surface, with the broader side above, like a blazon, contributes to its heraldic effect. A scene has thus a double aspect: it is a religious illustration, and like the foliate and animal ornament of other capitals it is an abstract architectural design. Even the most literal representations have this decorative character; the formal distinction between narrative illustration and decoration is inapplicable here, though some capitals with fewer figures have a more obvious ornamental design than others.

In the early Romanesque ornament of Moissac the motif is designed as an ideal example of the simplest and most general relations evident in the actual object represented. The petals of a flower are strictly assimilated to a radial structure, and the repetition of the flower itself constitutes a regular series of which the elements are equivalent. The more complex details are submitted to a similar process. The curling of the petals is uniform in relief and may be defined in geometrical terms. The asymmetrical plant forms in scrolls are no less regular. Their unequal lobes constitute an ideal helicoid pattern.

21

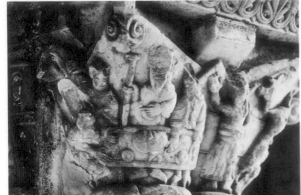

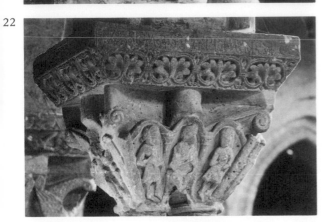

22

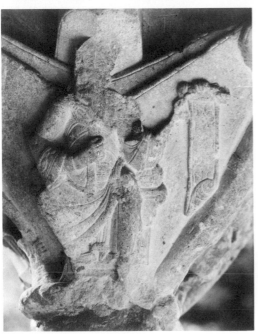

23

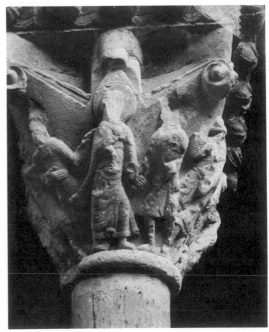

24

Fig. 21. Moissac, Cloister; Capital of South Gallery: Feast of Herod; Martyrdom of John the Baptist

Fig. 22. Moissac, Cloister; Capital of South Gallery: Daniel Interpreting the Dream of Nebuchadnezzar

Fig. 23. Moissac, Cloister; Capital of South Gallery: Nebuchadnezzar

Fig. 24. Moissac, Cloister; Capital of South Gallery: Arrest of Stephen

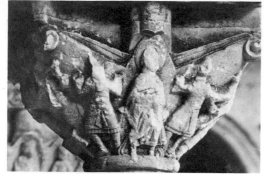

25

Fig. 25. Moissac, Cloister; Capital of
South Gallery: Stephen Preaching

Fig. 26. Moissac, Cloister; Capital of
South Gallery: David's Musicians,
Ethan and Idithun

Fig. 27. Moissac, Cloister; Capital of
South Gallery: The Chaining
of the Devil

Fig. 28. Moissac, Cloister; Capital of
South Gallery: Golias (the Devil),
Og, and Magog

Fig. 29. Moissac, Cloister; Capital of
South Gallery: Symbols of the
Evangelists—the Eagle of John

Fig. 30. Moissac, Cloister; Capital of
South Gallery: Symbols of the
Evangelists—the Man of Matthew

26

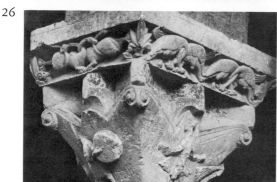

27

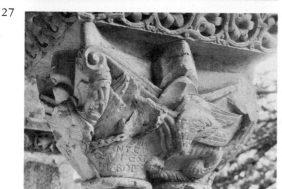

28

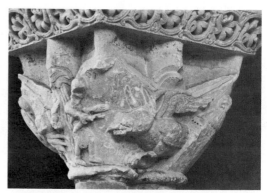

29

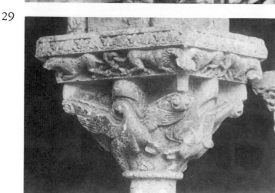

30

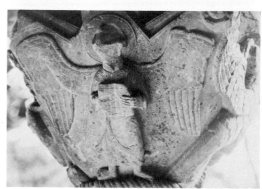

In the same way the grouping of figures in religious themes often reproduces the most general relations of objects. Figures with the same function are often parallel and similar in gesture. The simplicity of the shapes of the figures is maintained in their combinations.

But this archaic rendering of narrative or drama is only one factor in the decorative character of the whole. Besides this conceptual simplicity there is the apparent assimilation of the objects to the architecture of the capital and the style of ornament. The architecture of the capital is not an external element which imposes itself on the illustration and determines its form, but, as I remarked of the impost, it is itself a conception analogous to the ornament and the figures. It has a similar archaism and a similar expressiveness. Its pronounced diagonals, its symmetry, its accented contrast of surfaces, its centralized zigzag frame and volutes, all these are correlates of the figure style.

The inverted trapezoidal field of each side of the capital demanded either distortion and seeming instability of corner figures or ingenious accommodations. The sculptor sacrificed plausibility to decoration. In the capital of Adam and Eve the edicule representing the gate of Paradise (Fig. 49) is inclined at an angle more precarious than that of any leaning tower.[74] The figure of Eve at the other end also follows the sloping profile of the capital; and on the north face, the Lord and the tree are composed diagonally (Fig. 48). This is true of most of the figures and objects placed under the volutes of the cloister capitals. Regarded from the side, these figures appear vertical and stable; but the rest of the capital is thereby distorted. It is obvious that the sculptor usually planned the capital as a series of four separate surfaces, and adapted the composition to the trapezoidal shape (regardless of a probably unacknowledged conflict with natural appearances) while exploring its decorative and expressive possibilities.

The sculptural field is bounded not only by the diagonal sides of the inverted trapezoid, but by an even more unusual upper frame. For the figures must be fitted under the zigzag formed by the volute bands and a triangle of which the apex touches the central console. This upper frame appears on all four sides of most of the capitals. It is a survival of the Corinthian capital and illustrates the preservation of no longer relevant parts of a parent form even when the artistic character of the offspring is altogether different from its ancestor's. The central triangle is a flattened angularized version of the central leaf of the upper row of acanthus of a rough-hewn Corinthian capital. In the capitals of the Three Hebrews (Fig. 82), St. Benedict (Figs. 71, 72), St. Martin (Fig. 83), and the Crusaders before Jerusalem (Fig. 81), the original leaf appears between the volute bands with its curved tip and axial ridge. There is reason to believe that this was not an unnoticed survival or merely traditional routine. For on the capitals representing Adam and Eve and the Martyrdom

of St. Laurence (Figs. 50, 51), the central console is modeled in the form of a rough-hewn acanthus leaf. And in the Wedding of Cana (Fig. 56), where the usual triangle is absent, it is replaced by a pair of central volutes as in the true Corinthian capital. The free use of the volutes, the simplified curved leaf form and its flattened triangular derivative as equivalent motifs on the same part of the capital, shows that the sculptors were aware of their original structural sense, and that whoever employed the triangle knew of its more plastic source. Where neither leaf, nor triangle, nor central volutes appear (Annunciation to Shepherds, Fig. 86; St. Saturninus, Fig. 61; Washing of Feet, Fig. 53, etc.) their place is always occupied by a central object—a head, tower, or plant form—so that the symmetry of the upper frame and of the capital as a whole is not disturbed.

The zigzag frame is not an ordinary diagonal motif or a regular zigzag. The greater breadth of the two outer lines, the variety of angles, the distinction of an inner triangle, the termination by spiral volutes—all these constitute a symmetrical centralized structure, unlike the endless zigzag of pure ornament.

On the broader surfaces of the twin capitals the central triangle of the upper frame has an evident similarity to the junction of the lower parts. At this junction there is usually a triangular concavity. The zigzag frame provides also a transition from the sloping sides of the capital to the diagonal profile of the beveled band of the impost. It gives a greater elegance to the form of the capital by its vertical and diagonal directions and spiral endings. As a restless angular form crowning figures in action this frame participates in the expression of the sculptured forms and confirms a quality of the design already observed in the piers. Like the sloping sides of the capital it precludes a classic tectonic structure in the composition. Set in this architecture of the capital, the figure is tilted, not vertical and horizontal.

<p style="text-align:center">* * *</p>

Where the subject provided only two or three figures, or suggested a central theme and two equal accessories, the artist was frankly decorative. In the Annunciation to the Shepherds (left of Fig. 87), the two goats confronting the central plant hardly seem part of a narrative theme, and are indistinguishable in design from the purely ornamental animal figures. It is true that this face of the capital has been inscribed to suggest a relation to the story; but even the inscription is an ornament, and is arranged symmetrically. The word "cabras" is incised behind each goat, and on the right side is written backwards, with the letters reversed, ᴀЯ8ᴀƆ. This is not illiteracy, as has been supposed, but the result of an artistic intention.[75] On the central console block another inscription (SISVA— for SILVA) designates a palm between the goats as a forest. On the

adjoining face of the same capital, a similar heraldic design represents Daniel between the lions (Fig. 87). Here too, the rampant animals are adossed, heads turned to each other, next to the central seated prophet with symmetrically orant hands. The inscriptions are likewise distributed in parallel ornamental schemes. As in textile patterns, the interspaces between the figures are filled, though here with letters.[76]

Even on capitals without such animals the artist has contrived human figures as schematically grouped as the animals in ornamental combinations. On a capital like the Adoration of the Cross a symmetrical arrangement was inevitable; two angels stand beside a central cross. But on the east and west faces of the same capital an isolated figure of an angel has been more arbitrarily bent to a decorative pattern from which results an angelic radiance (Fig. 85). He stands with outstretched arms in the center of the field between the great wings of the adjoining angels of the other sides of the capital. His own wings are spread out in diagonal lines repeating the volutes of the frame; his mantle forms a semicircle in contrast tó these straight lines, and repeats the curves of the wings of the adjoining angels. The legs of these figures constitute a powerful diagonal frame below, while minor curves of drapery on the central figure repeat and diffuse these tangent arcs throughout his body.

This axial mass is not a rigid center of the theme, but is itself twisted and turned to produce within the heart of the design an energetic asymmetry, which includes the circular movements of the larger outer forms. The head is turned to the right, the feet to the left; the diagonal of the torso is opposed to that of the left leg, so that a zigzag results from the movements of the limbs, which is accented by the jeweled band across the breast and the diagonal edge of the tunic across the legs. An additional contrast is produced by the asymmetrical nimbus. The whole figure is cast in a stiff *contrapposto,* in which we can detect, however, a symmetrical organization from top to bottom in the contrasted directions of the head and feet, the torso and legs.

In the east gallery, on the capital of the Martyrdom of Peter and Paul, an angel carries the nude souls of the two saints in his arms (Fig. 46). He stands in the very middle of the field, his head and halo on the central console, his wings outstretched to form a background of the relief and a frame. The little figures are identical in gesture and position; their arms diverge in loops from the angel's breast as his wings spread out from behind his head. The legs of the martyrs emerge from a widening pit, wedged in the narrow base of the field between the sides of the triangular frame.

The souls of the three Spanish martyrs (Fig. 67) are similarly grouped. They are enclosed, standing and orant, in one mandorla, between two angels. The hand of God appears on the console on the upper point of the jeweled glory.[77]

Such a centralized design occurs also in the Martyrdom of St. Saturninus (Fig. 63). In the scenes from the life of St. Martin the figure of Christ holds the divided mantle between two angels. In these works the marked symmetry is not merely a conventional device of composition; it penetrates the smaller elements of design, and controls gestures, contours, and accessories to such a degree that the whole may be analyzed with ease.

In the hagiographic scenes, especially, the formalizing of gesture, composition, and small details of drapery, so that the whole appears prearranged, permanent, and hierarchic, has an air of liturgical seriousness. Here the order implied in symmetry has religious as well as artistic significance.

This centralized design is also apparent in the architectural representations. Where a building occupies the face of a capital it is placed in the middle and flanked by towers or other paired structures. Sometimes the building is a narrow tower in the middle of the field, separating two groups of figures that are usually disposed parallel to each other in gesture or movement (Figs. 50, 59).

In the examples of symmetrical composition cited above, the subject is essentially static and implies no dominant movement across the surface of the capital. There are other capitals in which episodes rather than symbols or hieratic groups have been submitted to a similar conception. In the representation of the wise man (possibly Daniel) interpreting the dream of Nebuchadnezzar (Fig. 22), the central position of the king is not merely official; it is an iconographic correlate of a design in which the symmetry has been maintained by numerous accessories. The three figures are framed by three arches; the axis is confirmed in the arched contour of the console; and the king sits with legs crossed symmetrically in the very middle of the field.

On the capital of the Martyrdom of Stephen, the saint preaching to the Jews is placed in the center of the surface on a seat with diagonal legs which repeat the triangle above his halo (Fig. 25). The trefoil edge of the console is a further means of centralizing the action. Two figures who menace the saint stand at his sides with arms raised in similar diagonal gestures. Also, in the adjoining scene of Stephen led by his accusers, he stands in the center of the field (Fig. 24); if he faces the right, the symmetry of the whole is maintained by the flanking figures, who are slightly differentiated to balance the inequality produced by the direction of Stephen's movement. How intently the sculptor was preoccupied with closed compositions of clear and finely sustained symmetry we may see in the arbitrary extension of Stephen's mantle, flying to the left and forming a diagonal mass and a movement which correspond to the extended arm on the other side.

In the Massacre of the Innocents (Fig. 60) two mothers with infants in their arms are placed in the middle of the field and are so designed

31

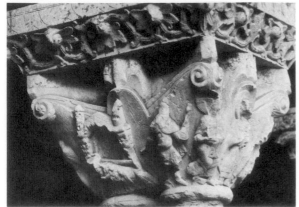

32

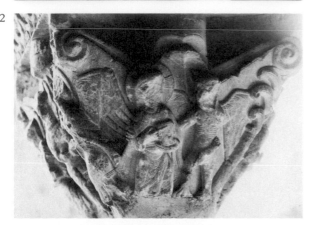

Fig. 31. Moissac, Cloister; Capital of South Gallery: Christ and the Centurion of Caphernaum

Fig. 32. Moissac, Cloister; Capital of South Gallery: Temptation of Christ

Fig. 33. Moissac, Cloister; Capital of South Gallery: Christ and the Canaanite Woman—Apostles

Fig. 34. Moissac, Cloister; Capital of South Gallery: The Good Samaritan Pays the Innkeeper

33

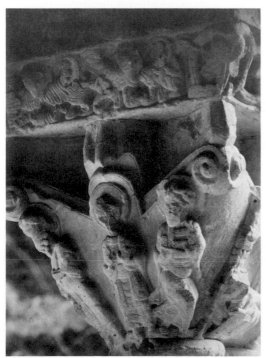

34

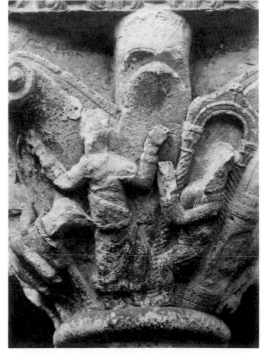

35

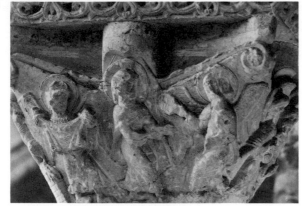

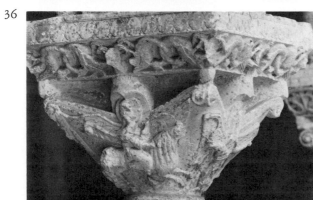

36

Fig. 35. Moissac, Cloister; Capital of South Gallery: Christ Served by Angels after the Temptation

Fig. 36. Moissac, Cloister; Capital of South Gallery: The Vision of John —Apocalyptic Rider

Fig. 37. Moissac, Cloister; Capital of South Gallery: The Vision of John

Fig. 38. Moissac, Cloister; Capital of South Gallery: The Vision of John —the Angel with the Sickle

37

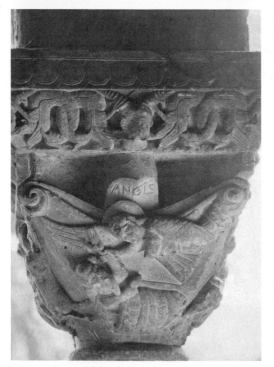

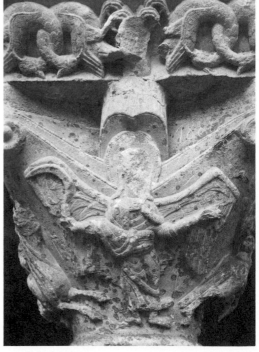

38

with their children that they constitute a perfectly symmetrical group. This conception is all the more significant for the primacy of a decorative end in representation because the symmetry is maintained at the sides of this group by two soldiers who belong to different moments of the action. The soldier at the left faces Herod, who is seated on the western surface of the capital and commands him to massacre the children. The soldier at the right faces the eastern side of the capital on which are superposed the murdered children and their detached limbs. Elements of three actions are combined in a single centralized static group.

The crusaders before Jerusalem (Fig. 81) are not represented in procession, but are grouped in twos in symmetrical adaptation to the field. Each bears a great spear or axe in his extended arm, parallel to the diagonal edge of the capital.

In the scene of the Calling of the Apostles, Christ stands between the waves with arms extended symmetrically; his arms and shoulders parallel the zigzag frame of the capital, while groups of fishes, arbitrarily introduced beside him, form a lower diagonal frame (Fig. 77). In the adjoining scenes of the fishermen almost every detail has been subjected to a preconceived symmetry (Figs. 75,76). The waves despite their continuity are made to diverge from the center of the capital like two undulating wings; the net is suspended from the exact midpoint of the boat; and two volutes spring from within the boat to meet directly beneath the central console. The symmetry is beautifully sustained by the clear and uniform succession of relief surfaces. I feel that the trefoil section of the console (Fig. 75) was thoughtfully designed so that the entire scene might culminate in a symmetrical object with a salient central mass between analogous forms in lower relief. Its convexity provides a necessary contrast to the concave center of the lower portion of the field.

The subordination of narrative to architectural design is apparent in a remarkable detail of the Adoration of the Magi (Fig. 58). Two great petaled flowers are carved on the volute bands near the spiral ends. They are symmetrically placed and seem a purely ornamental addition to the theme. But an inscription next to each flower tells us that they are stars; they are labeled OR to designate the eastern star followed by the wise men. The repetition of the star can only illustrate its double appearance to the men, and its movement before them as they marched to Bethlehem. ("And, lo, the star which they saw in the east, went before them, till it came and stood over where the young child was." Matthew, ii, 9.) The textual recurrence in time has been converted into a static ornament, and even the star itself has become a flower.

But not all the capitals are composed so obviously. There are some which are regular in grouping, but a prominent central theme is avoided. The Miracle of Cana (Fig. 57) is in this respect most remarkable and subtle. In the middle of the field is the hand of Christ, hardly apparent,

bearing a short horizontal magic stick; under it, the three jars of water, symmetrically grouped, and above it, an open symmetrical book held out by the apostle to the left. Above the book are two immense central tangent volutes in high relief, like the corresponding jars below and the heads of the figures. The volutes are crowned by five tonguelike processes, arranged to parallel the three jars and the two adjoining figures. The diagonal bands of the central volutes form the sides of an equilateral triangle of which the base is the horizontal molding behind the jars. Together they invert the shape of the whole capital and frame the miraculous symbolic center theme. The edges of the mantles of Christ and the opposite apostle prolong the volute diagonal to the bottom of the capital, while above, the haloes and the outer volute spirals carry the central volute motif across the upper part of the capital.[78] Further observation of this mutilated relief will reveal more correspondences of line, spacing, and mass that confirm our initial impression of the orderliness of its structure and its perfection of simple rhythmical form.

In the wedding scene on the same capital (Fig. 56) the figures are aligned in obvious succession, but monotony is avoided by a division into two groups, separated only at the upper and lower frame by pairs of central volutes, and by the variation of parts like the hands, the feet, and the dishes. A fine touch is the extension of the table before only five figures; the sixth stands at the right and is the only diner whose entire figure is visible. A further asymmetry is created by the intrusion of the bride's tunic among the equal feet, ranged under the table like so many architectural supports.

Although the table seems to extend across the whole capital its center is not on the axis, but to the left, under the third figure (from the left) who encroaches more upon the table than any of the other diners. If the symmetry of the whole is modified by this isolation of five figures within the large series, the outer four of these, in turn, are placed symmetrically beside the third figure. The four diners at the ends of the table are disposed in equal groups of two by their common gestures and occupation with the food, and by the parallel incised folds of the tablecloth. The position of the bread on the table, in the middle of the capital rather than of the table, and the grouping of the feet below (as well as of the heads and volutes) assure the dominance of the main symmetry of six figures rather than of the five. But the symmetry of the latter is an effective disguise which gives a movement and variety to a simple, regular series without disturbing either its symmetry or its effect of casual, unforced placing. It is interesting to observe how unique is each figure, how different the amplitude of the separate masses, and the overlapping of bodies, arms, and hands.

In the Adoration of the Magi the sculptor's problem was to relate an

enthroned Virgin and Child to three Magi in procession (Fig. 58). Although he followed the "Hellenistic" tradition which placed the sacred group at one end, he preserved the monumental frontality of ancient Eastern prototypes in setting the Virgin and Christ under the left volute unattentive to the three kings.

The composition is so simple and unpretentious that its solution of the problem will appear only on close scrutiny. The sculptor has managed to wrest a symmetrical scheme from an apparently unsusceptible subject by dividing the four units (the Virgin and Christ are one) into two groups, each set in one of the halves of the twin capital. He has made the first Magus, who adjoins the Virgin, smaller than his fellows. The two stars, already mentioned, are placed symmetrically on the volute bands above the figures. Lest the sharp line between the two halves of the capital be too striking a division, it is crossed by the salient mantle end of the second Magus. The garments of all three are thus blown forward, forming jutting triangles. With the raised arms of the Magi, carrying gifts, and the advancing legs, this mantle edge participates in a strong vertical zigzag movement, parallel in the three figures and opposed to their horizontal procession. By this means the predominantly vertical and triangular character of the Virgin theme is brought into relation with the horizontal order of the other three units. The flying drapery above her head is in this respect also significant.

Groupings of an asymmetrical or uncentralized character are not uncommon in the cloister. Although the presence of unlike objects in the story—man and beast, figures standing, seated, and recumbent, or characters in subordinate relation—does not conflict with and even suggests an ornamental grouping in some works (Daniel, Shepherds and Goats, Crucifixion of Peter, etc.), the subject could not be bent to such a scheme, or would not be treated in this manner, by an artist of more complex style. This is especially true of the work of the sculptor of the south gallery (Figs. 26–42). In his capitals the more complicated asymmetrical conceptions sometimes include an approximate symmetry. Even among the more archaic capitals, beside the striving for symmetry and regular alignment, less schematic structures appear. But they are usually more compact, massive, and enclosed than those of the south gallery capitals and display simpler lines and rhythms. We have seen in the Miracle of Cana how the sculptor has modified the general symmetrical design in varying the equality of parts and the smaller details of drapery, gesture, and accessories.

On the capital of the Anointing of David (Fig. 89) the gestures of the figures, the horn of Samuel, and the mantle of David have been disposed to form simple curves, with a clear rhythmical alternation of concave and convex lines, as in arabesque patterns. The turn of the horn has an

obvious relation to the arbitrarily extended and curved mantle of David. That this arrangement was deliberate seems evident from an unusual asymmetry in the framing volute bands: the central triangle, above David's head, is irregular in uniting the curve of the horn with the left volute. The contours of the figures are so simple that the ideal geometrical framework of the relief coincides with forms of the figures, as in the capitals with foliate ornament.

On this capital the curvilinear scheme, which has also an illustrative value, producing an intense and active union of the two figures corresponding to the episode, is concentrated in the center of the field. A related design is sometimes spread across an entire surface. We see this in the figure of the apocalyptic dragon in the south gallery and in the scenes from the lives of Benedict and Martin in the north. In the latter, Martin and the horse together are a preponderant mass (Fig. 83); the beggar is in posture and form so unlike the saint and the horse that the unity of the relief appears all the more remarkable. The sculptor has connected the two figures by a series of curves extending across the upper half of the field—curves formed by the great wing of an angel brought over from an adjoining face, by the raised arms of Martin and the beggar, and by the concentric loops of the garment held between them. Related curves are abstracted from the beggar's ribs and skirt and from the body of the horse.

Even in the ordinarily asymmetrical theme of the Sacrifice of Isaac (Fig. 84) the sculptor has centralized the figure of the boy. If the whole is not strictly symmetrical, it is organized with respect to a symmetrical zigzag and diagonal frame. But unlike the Anointing of David the whole is decidedly angular, with many sharp oppositions which transmit the quality of the episode itself. An angel behind Isaac corresponds to the figure of Abraham; the contours of his zigzag wings resemble the volute bands, the central triangle, and the gestures and knife of the patriarch. Isaac sits on a triangular heap of stones, and his own body is a structure of diagonal lines.

On the capital of the Deliverance of Peter (Fig. 42) three men with great pointed shields stand under the polylobed Moorish archway that symbolizes the prison. The symmetry here is inevitable; but the angel and Peter on the adjoining face lend themselves less readily to such repetition. Whereas Peter is chained and bent, the angel soars down from the clouds under the volute, almost horizontally extended. In the beautiful design of his outspread wings, the halo, and the movement of head and arms, he forms a linear sequence opposing, diffusing, and repeating the contours of Peter below. The curves of both figures are contrasted with similar straight diagonals of towers and walls and the volutes of the capital itself. The relief of the figures and the buildings also participates actively in the design. Nowhere else in the cloister is the surface of a capital so com-

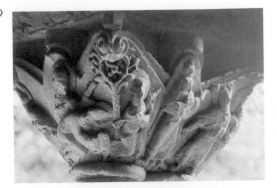

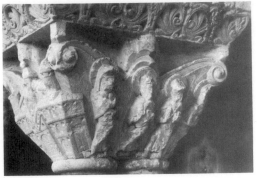

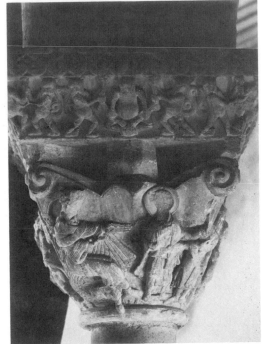

Fig. 39. Moissac, Cloister; Capital of
South Gallery: Transfiguration
of Christ

Fig. 40. Moissac, Cloister; Capital of
South Gallery: Descent from
the Mountain

Fig. 41. Moissac, Cloister; Capital of
South Gallery: Peter before Herod

Fig. 42. Moissac, Cloister; Capital of
South Gallery: Liberation of Peter

Fig. 43. Moissac, Cloister; Capital at
Corner of South Gallery: Baptism
of Christ

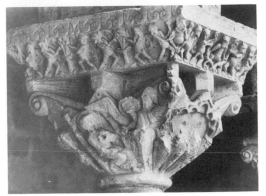

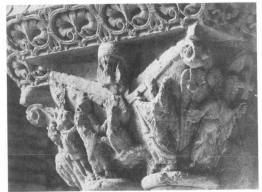

44

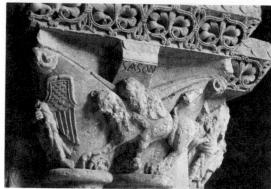

45

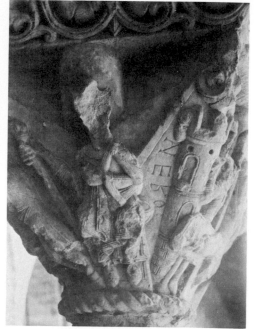

46

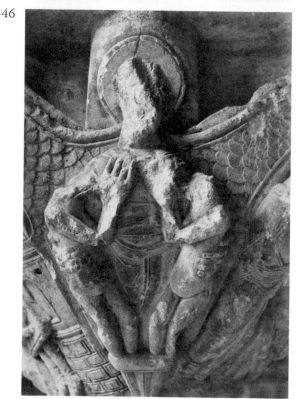

Fig. 44. Moissac, Cloister; Capital at Corner of East Gallery: Samson and the Lion

Fig. 45. Moissac, Cloister; Capital of East Gallery: Martyrdom of Peter and Paul—Nero

Fig. 46. Moissac, Cloister; Capital of East Gallery: Angel with Souls of Peter and Paul

Fig. 47. Moissac, Cloister; Capital of East Gallery: Temptation of Adam and Eve

47

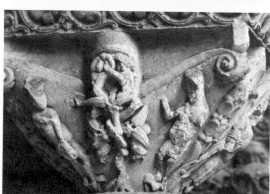

pletely covered by as varied lines and planes, or is the play of forms so concentrated and rich. The building of the adjacent side of the capital encroaches upon this side. Its corner is not under the volute but so far within the scene of Peter and the angel that it connects the former's foot with the angel's sleeve, and marks the meeting of two plane surfaces that break up the ordinary neutrality of the background and contrast with the rounded forms of the two figures.

In the Appearance of the Angel to John, also in the south gallery (Fig. 37), we see a similar rhythmic grouping of two asymmetrically superposed figures. John reclines on an unsupported bed suspended on the wall; the angel, emerging as before from under the volute, grasps his arms. The rear wing of the angel is carried across the capital to the other volute. Examining the upper contour of this figure we discover that it is a continuous line of disguised symmetrical character. Its highest point is the angel's head beneath the console, from each side of which extend wing forms of subtly varied contour prolonged to the volute spirals. Likewise below, the arms of the angel are nicely duplicated by the pleated folds of his hanging mantle on the right; and the opposed left arm of John finds its symmetrical counterpart in a diagonal molding along the outer edge of the same mantle. In this scene the apparent network of intricate, freely rhythmical shapes includes a larger though not instantly apparent, symmetrical structure. The grouping of the heads and arms of the two figures, if regarded with respect to a diagonal axis, will reveal itself as a simple scheme of two equal opposed heads separated by a triangle of which the base is formed by their united outer arms, and the sides by the opposed inner ones. As a completing touch (which helps establish the symmetry of the scene) this triangle is crowned by another of which the apex is the left volute; the sides are the angel's wing and the diagonal wall of John's chamber (only barely visible in the photograph). The sculptor has won a symmetrical disposition from the whole group by the extension of the angel's wings, the centralizing of his head, the incision in low relief of two side walls rising to the volutes, and by the prolongation of John's coverlet to form a simple base. Where the story contradicted this regularity of design, as in the opposition of the two figures, he has shaped the resistant elements into another symmetrical group, but with respect to a diagonal axis parallel to the inclination of their heads and the left volute band. To unite these three systems of horizontal, vertical, and diagonal axes he has multiplied certain folds and extended the wings so that a harmonious interpenetration results. Thus the volute bands are prolonged in the distorted right arm of the angel and the falling mantle-edge, while, in the space between, trapezoids and triangles are inscribed to duplicate the structure of the capital and to link objects more intensely than is possible by gesture alone.[79]

In the east gallery, on a capital of which some actors are aligned in

simple repetition—the Washing of the Feet—the figures of different pose share in a beautiful play of line and of the masses of body and limbs (Figs. 52, 53). The first impression of the utter awkwardness and lack of skill of this sculptor, produced by the squatness of the apostles, their thick folds and homely bodies, yields to a perception of the nicety of his feeling for linear rhythm and massing. As in the Vision of John, the work of a far more skilled sculptor, the diagonals of the joined arms of Christ and Peter intervene between the heads, and the contours of the bodies bring apparently casual movements into intimate plastic relation.

It would take too long to inquire into the structure of each scene in the cloister. Those analyzed above have been summarized rather than read thoroughly. And no two capitals are identical in design. The symmetry is of variable shapes and combinations, while within the skeleton of axial structure are developed less simple but as rhythmical articulations.

I have considered so far mainly those scenes which form closed compositions corresponding to a single trapezoidal field of a capital. In several sculptures a scene is not isolated by means of figures or objects placed at the sides of the field, and the action is expanded across two or three faces of the capital. But even in such works the single surfaces retain their compositional unity; the figures are so contrived that if each face of the capital were isolated and the figures cut off at the ideal frame of the trapezoid, the resulting design would be balanced and complete, despite the incompleteness of illustration.[80]

In the Martyrdom of Laurence the angels who cense and fan the body of the saint, lying on the central grill (Fig. 51), extend in symmetrical correspondence across the upper part of the capital. Their wings correspond too and help frame the scene; but the bodies of the angels actually emerge from the volutes of the adjoining faces. In the same way the symmetrical bellows beside the grill are held by executioners represented on adjacent sides of the capital.

On the capital of the Three Hebrews in the Fiery Furnace (Fig. 82) the action, extending around the entire capital, forms separate structures as symmetrical and decorative as the most rigorously designed animal ornaments. The Hebrews stand in the *corners* under the volutes, with arms outstretched—one arm on each side of the capital. The center of the field is occupied by flames—symmetrical wavy processes, like gigantic vegetation. The orant arms of the Hebrews parallel the waves and complete the ornament of flames. But these arms, considered from the corner of the capital, form a symmetrical enclosure of the figure and a zigzag movement in contrast to the volutes. Even the costumes of the figures reflect this conception in the zigzag ends of the tunics, a reminiscence of Oriental costume traditional in this scene. When we regard the figures in relation to the frame we understand why the Hebrews were not placed in the center of the field under the consoles.

In these two works the unenclosed narrative was easily submitted to symmetrical designs. But in some subjects the action has a dominant direction which could not be bent to so formalized an arrangement. On a capital of the south gallery, devoted to the apocalyptic Chaining of the Dragon (Fig. 27), the monster is led by an angel who emerges from under the volute of one side and extends across the adjacent surface of the capital, up to a building which occupies its far end. That the single surfaces were considered as compositional units, despite the obvious direction and continuity of the scene, is apparent from the position of the dragon who occupies almost the whole of one field, and from the extension of the garment and wings of the angel to complete the design of a field in which he himself does not participate. By this extension the unity of episode is furthered, insofar as the angel who is turned away from the dragon is thereby connected with him. It is possible that the illustrative significance affected the design, for the dragon is placed asymmetrically in the field to admit this extension of wings and clothing, and his tail is coiled upward to form a mass corresponding to these parts of the angel and a movement parallel to them. Despite the asymmetry of the beast he is placed so that his prominent bulk occupies the center of the field; in the correspondences of the angel and the monster's tail there is an evident symmetry. Even within the latter's body an analogous correspondence has been contrived in the assimilation of his large head and the lower wing.

The conception of the surfaces of the capital as isolated fields with enclosed designs seems to be contradicted by such expanded episodic themes as the Good Samaritan (Fig. 34) and the Transfiguration (Figs. 39, 40). In the latter the conception differs from the traditional type in that the three apostles are grouped on one side of Christ, the two prophets on the other. The rare theme of the Descent from the Mountain is also represented (Fig. 40). In the first scene the three apostles, who are placed on two sides of the capital, move in one direction. By dividing them so that two are on the south face and the third is on the east next to Christ, the sculptor was able to enclose each face of the capital and yet retain the effect of a narrative composition with a single marked direction. On the south face a palm tree placed under the volute arrests the forward movement of the two apostles; while a third figure at the other end of the same face, belonging to another scene (the Descent from the Mountain) and moving in the opposite direction, balances the first group. We see on this side of the capital elements of two distinct episodes combined without intelligible relation, yet perfectly coordinated as relief compositions. Here the archaic clarity pertains less to meanings than to forms.

If the figure of Christ in the Transfiguration is not isolated between the two prophets, as in the imposing traditional images of the subject, he retains, nevertheless, a central position between one apostle and one

prophet. The second prophet, under the volute, is balanced by the palm tree already described. Christ faces the right, like the apostle beside him; but this strong direction is countered by the opposite movement of the prophets and the vigorous diagonal extension of the arm of the first prophet.

Even in the Descent from the Mountain (Fig. 40), in which four figures proceed in the same direction, the sculptor has cast the whole group into a balanced pattern. One apostle has been placed in the exact center of the field under the console; on one side he is flanked by Christ and a building (the tabernacles of Peter), on the other by two apostles. If they all walk toward the left, the upper body of Christ is turned back to regard the apostles, and two figures make gestures of the hand opposed to the direction of their march.

It is in the same spirit that this sculptor, in the beautiful figure of the Apocalyptic rider (Fig. 36), has opposed the lion's movement by the angel's flying mantle and the extended wing behind him to form a closed composition.

It is apparent, too, that in capitals of the south gallery and in several of the north the composition of single faces is not so deliberately enclosed as on the other capitals; the horizontal direction of narrative is more pronounced even if finally submitted to a balanced scheme. The corner figures or objects sometimes participate in two actions on these capitals. In the Healing of the Centurion's Servant, Christ stands under the volute; his body is turned toward the figures on one side of the capital, his head toward the centurion on the other (Fig. 31).

This obvious continuity of action is not, as one might suppose, a more primitive stage of representation, a sort of pictographic procession of elements. On the contrary, the rendering of action in these capitals is more subtle and complicated than in the firmly enclosed static groups. In the latter, the figures usually maintain a single direction in their gestures and bodily movement. When such figures confront each other, they are often completely determined by this relation, while in the south gallery a figure points in one direction and looks in another.[81] In conversation he may indicate the subject or reference by an equivocal posture which symbolizes his attention to two objects. The centurion imploring Christ points at the same time to his servant who lies in bed behind him (Fig. 31); and Christ, as I have already observed, has an analogous complexity of gesture. The whole body is animated by a contrast of movements which in its repeated and uniform application recalls the mannered *contrapposto* of the sixteenth century as well as the later Romanesque style of southern France.

That the narrative composition described above is a more complex type than the first, and yet distinct from the simple narrative continuity

of the more primitive arts, is confirmed by the striking tendency toward asymmetrical composition in the capitals of the south gallery. The symmetrical elements of such scenes as the Angel appearing to John (Fig. 37) are hardly as explicit as in the capitals of martyrdom. Even in themes inherently suited to a symmetrical form the sculptor has willfully diverted certain elements to create a more intricate balance than was ordinarily attained in the cloister.

On the capital of the Four Symbols of the Evangelists (Fig. 30) the human figure lends himself readily to a central position under the console block. The head is inscribed in the usual triangle between the volutes, and the disproportionately great wings are extended to fill the surface. The opened book in his hands is placed at the very center of his torso, marking the axis of the body. But the garment of the lower body is blown by the wind and extends unequally across his legs, so that the right contour has a marked triangular salience, while the left is an unbroken line. This disturbance of the equality of two parts similar in function and shape in a scheme otherwise rigidly symmetrical has an obvious motivation. On another side of the same capital (Fig. 29) the eagle is carved in profile rather than in the heraldic frontality we might expect. This is one of the finest conceptions in Romanesque art; it is at the same time monumentally grand and delicate. The nimbed head set under the console is turned away from the direction of the body, between great wings of undulating contour that carry the curve of head and neck across the capital to the spiral volutes. The body forms a graceful reversed S, covered by fine imbrications in very low relief. The feathers of wings and body are rendered by different scale, tongue, curved-dart, and banded patterns. The right leg has been mutilated, but it is clear from the fragments that the powerful mass of the tail at the left was balanced by the two unequal legs. To this relief the impost ornament is especially adapted. The upper band of palmettes in low relief (the only palmette-ornamented upper impost band in the cloister) is carved like the ornamental wings and other feathery surfaces of the eagle, while the lower group of symmetrically adossed lions with knotted tails above the eagle's head has a plastic energy and movement completely in accord with the symbolic bird. They parallel beautifully the outstretched wings.

Of all the sculptors of the cloister the master of the south gallery capitals (Figs. 26–42) was the boldest in his groupings and undertook the most difficult problems. He, more than any of the others, sought asymmetry even where the subject permitted a simpler arrangement, and delighted in elaborating the draperies of a figure to enrich its surface, its contours, and movement.[82] In the scene of Peter before Herod (Fig. 41) the latter is so majestically enthroned, the articulation of the figure is so complex, that in the composition he takes up half the field; two standing

figures are required to balance his great mass. The extended arms and legs form a strong scaffolding together with the flying folds at the ankle. The arc of the rich, beaded rosette medallion which serves as a throne repeats the arch behind his head—a fragment of architecture that signifies an interior—and is further echoed in the central festooning between the volute bands and Peter's nimbus. The figure is modeled and built in several layers, and behind the high relief of the body with its enveloping costume are the less salient flat surfaces of these accessories and of suspended draperies, the mantle with radiating folds under Herod's left arm.

The archaic features noted in this description cannot be said to arise from the need to reproduce complicated natural forms with an inadequate technique or limited knowledge of the forms. For the purely ornamental capitals show similar conceptions even in details not borrowed directly from nature. The foliate capitals of Corinthian type are subdivided into blocks of salient leaves; but on each of these blocks are cut separate leaves detached from each other, and without organic correspondence to the main salient mass. What in the classic prototype was a large curled leaf is in Moissac an assembly of several leaves each distinguished from its neighbor. In the classic capital the adjoining leaves overlapped so that the whole wrapping of foliage was luxuriant and free; but in Moissac the masses are isolated, their forms distinct, and the ornamental geometric structure more obvious. The single lobes of a leaf have the same relation to the leaf that the latter has to the salient mass, and this mass to the whole capital. The ornament is not free, sporadic, natural, but strictly organized with an apparent structure that dominates every turn and interval.[83] Nowhere in Moissac is the Roman Corinthian capital reproduced as faithfully as in Burgundy and Provence.

The decorative character of the figured compositions has been overlooked by French scholars who have conceded it in plant and animal capitals, where it is obvious. There the absence of iconographic significance, the traditional employment of such motifs as ornament, and the unmistakable simplicity and order of their schemes elicited instant recognition of the decorative conception. But the more complex design of the figures has not been understood because the arbitrariness of the groupings and the frequent distortion are opposed to the methods of later realistic art, and are judged to be products of inexperience and naiveté. Yet the rare figures mingled with some of the animals, and the few animal groups on the historiated capitals should have pointed to the fundamental unity of the narrative and decorative art. Monsieur Deschamps, who has studied the cloister *in situ*, nevertheless writes: *"c'est seulement aux frises stylisées, aux motifs purement décoratifs dont la composition se répète et demande moins d'invention, que nos sculpteurs ont su donner une réelle beauté. Mais quand il s'agit de composer, de grouper une scène autour de la corbeille d'un chapiteau, comme alors on voit leur inexpérience!"*[84]

In the constant coordination of gestures, movement, and contours with the volute bands of the capital and the triangle carved at their junction under the center console we see again how the abstract design is a primary consideration. For these are elements foreign to reality, survivals of the Corinthian capital which has been cleared of its foliage to make place for narrative figures; it is significant for the style of the capitals that this upper frame is a zigzag, symmetrical structure. In more realistic Romanesque and Gothic works, in which geometric design is less rigorously pursued, the figures are not coordinated with such accessories (and are often surmounted by an even more irregular frame). On the figured capitals of the porch of Moissac there are no volutes, consoles, or triangular central borders.

※ ※ ※

Having observed the abstract character of the design of these capitals, in which all figures and accessories are contrived in simple rhythmical forms, sometimes approaching the schematic patterning of pure ornament, we are not surprised that the backgrounds are neutral, and that the sacred stories are presented through actors in no particular space or environment, as in primitive pictographic writing. Locality is indicated only when it is an essential element of the legend, traditionally cited, or an accessory that gives meaning to figures otherwise undistinguished. The gate of Paradise is thus introduced (Fig. 49), the city of Bethlehem set between the Adoration of the Magi and the Massacre of the Innocents, and Jerusalem represented in the scene of the Crusaders (Fig. 80). But these cities are not a background against which the figures are placed. They do not cover the drum of the capital as their size would demand. They are separate items of narrative as small as the figures or only a little larger, and are often only parts of a building or city—a tower, a house or wall—abbreviated to signify a greater whole.

Interiors are barely conceived by the artist. For an interior implies an enwalled hollow that effaces the background and introduces an extended third dimension. The sculptors of the cloister think in terms of separately aligned solid objects united by a common narrative context and an ornamental design rather than by their enclosure in a common deep space in nature. In banquet scenes like the Feast of Herod (Fig. 21) and the Marriage at Cana (Fig. 56), and in the group of Dives and Lazarus (Fig. 54), there is no definition of the limits of an action which must have taken place within a house. The only indication of an interior space is an arched frame or horizontal banding present behind figures in several capitals. It appears in the Banquet of Herod, the Annunciation (Figs. 68, 69), and the Miracle of Cana (Fig. 57) but hardly evokes a distinct space or locality.[85]

The spacelessness of the narrative scenes is more radical than one

would suppose from a first glance at the capitals. For the figures are often lively, well articulated, bulky, and abound in natural details; they seduce us into a belief in the reality of their whole setting and interrelation. But we observe soon that if they are set against no interior or exterior wall, even a supporting ground is absent, and finally that the conception of a definite horizontal plane is foreign to the early sculptors of Moissac.

The figures do not usually stand on a ground plane perpendicular to themselves. Most often the feet are carved upon the same vertical surface of the drum as the rest of the body, so that the figures appear suspended. Only rarely is the projecting astragal utilized as a ground plane; and when this is done, as in the Marriage of Cana, it is not on the upper horizontal side of the astragal that the feet are placed, but on its vertical surface, so that the feet are still presented as hanging.[86]

This lack of horizontal planes is also evident in the representation of chairs and tables. In the banquet scenes (Figs. 21, 54, 56) the upper surface of a table is parallel to the background and the figures, yet dishes and food are carved resting upon it. This projection of horizontal surfaces upon a vertical plane is consistently applied; even the seats and cushions are erected behind figures rather than beneath them (Virgin, in the Adoration of Magi, Fig. 58; Daniel, Figs. 78, 87; Abraham and Lazarus, Fig. 55).[87]

Where the sculptor wishes to indicate that two figures are in depth one behind the other, he superposes them, or at least some of their limbs. In the Raising of Lazarus the method recalls old Oriental zoned perspective. The two women who kneel before Christ (Fig. 88, right) are placed one above the other, and the upper seem to float in the air.[88] Likewise, in the Annunciation to the Shepherds (Fig. 86) three animals are superposed, without overlapping. In the capital of the Magi the foreparts of three horses emerge from the central tower which an inscription tells us is Jerusalem. The tower is so small that it could not possibly contain the concealed parts of the animals. They are set one above the other; the most distant is the highest, and his legs are suspended in the middle of the capital on no perceivable ground.

The figures, as jointed bodies capable of movement in three dimensions, are subject to related deformations. The horizontal plane formed by the lap and thighs of a seated person is ignored and the legs are extended in profile (Abraham and Lazarus, Fig. 55; Daniel, Fig. 78; Apostles in the Washing of the Feet, etc.). In the frontal Virgin and Child of the Adoration (Fig. 58), this process is especially evident. The seat of the Virgin, as well as the cushion, is a vertical plane; the Child is applied parallel to the lower body of the Virgin, whose legs do not project to provide a seat for him, and his own legs, also without a lap, are in profile. Sometimes, as in the banquet scenes, a table conceals the suppos-

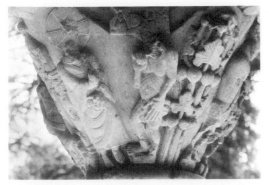

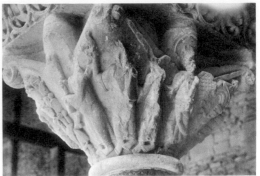

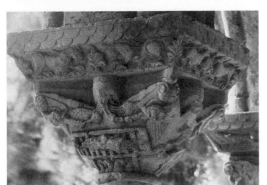

Fig. 48. Moissac, Cloister; Capital of
East Gallery: Adam before the Lord

Fig. 49. Moissac, Cloister; Capital of
East Gallery: Expulsion of Adam
and Eve; Adam Pruning a Tree

Fig. 50. Moissac, Cloister; Capital of
East Gallery: Martyrdom of St.
Laurence

Fig. 51. Moissac, Cloister; Capital of
East Gallery: St. Laurence on the Grill

Fig. 52. Moissac, Cloister; Capital of
East Gallery: The Washing of Feet

Fig. 53. Moissac, Cloister; Capital of
East Gallery: The Washing of Feet
—Apostles

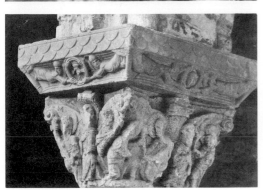

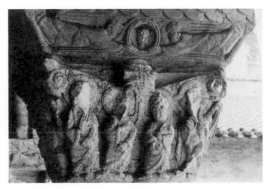

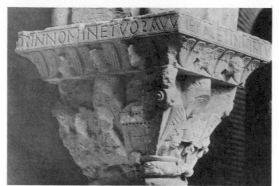

56

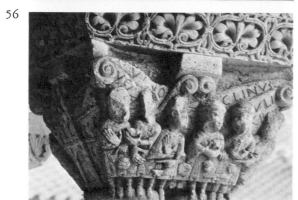

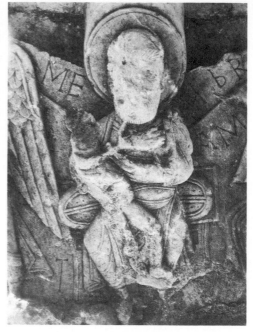

Fig. 54. Moissac, Cloister; Capital of
East Gallery: Lazarus and Dives

Fig. 55. Moissac, Cloister; Capital of
East Gallery: Lazarus in Abraham's
Bosom

Fig. 56. Moissac, Cloister; Capital of
East Gallery: Marriage at Cana

57

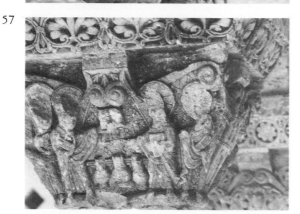

Fig. 57. Moissac, Cloister; Capital of
East Gallery: Miracle of Cana

Fig. 58. Moissac, Cloister; Capital of
East Gallery: Adoration of the Magi

58

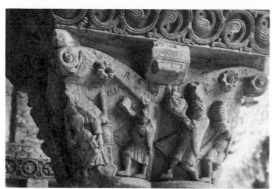

edly extended legs of the seated figures (Figs. 21, 56). The rear leg of Herod, who is seated in profile, is carved above the front one instead of behind it, as in the superposed horses on the same capital (Fig. 59).

The gesturing hands are also drawn parallel to the surface of the capital rather than perpendicular or diagonal to it. The limbs are pressed close to the wall or the body; and in this uniform striving for clarity in the itemized legible representation of separate parts, the profiles of extended limbs are preferred to less distinct views. If the feet in some capitals hang vertically, in others a standing figure has both feet in strict profile and parted at a straight angle to each other (Virgin of Annunciation, Fig. 69). The vertical frontal feet permit a view of their full unforeshortened form. But this is possible even in profile. Adam before the reproachful Lord stands with feet in profile and with their entire upper surface clearly visible, as if the soles were planted on the wall itself (Fig. 48). The hands, too, as in the pier reliefs, are limited to those gestures which least obscure their complete form. They are most often carved flat against the background, with little or no foreshortening.

It would be wrong to suppose that all conception of depth is lacking. There is no enclosed space, no sharp contrast of ground, foreground, and background, and there are no movements in depth as free as those on the vertical pictorial surface. But by differences of relief, by the modeling of bodies and the occasional overlapping of parts, limited effects of three-dimensional space are produced.

By the salience of the figures from the background and the uniform projection of the astragal as a ledge around the surface, a narrow stage is created for the action. The overhanging console and impost suggest the same depth above. The relatively high relief of the figures—for they are very small and quite salient—admits a contrast of light and dark and a layering of several surfaces on the capital. The figure is enveloped by shells of drapery which constitute distinct surfaces; in places they are extended across the background in a series of planes between the figure and the wall. On capitals of the south gallery such drapes are enriched by pleats and undercutting, and the interval between the foreground and background is bridged by numerous surfaces. The latter are usually parallel to each other, but in some cases, as in the seated figure of Daniel in the north gallery (Fig. 78), they are contrasted in section—concave opposed to convex—with the suggestion of a more considerable depth. A few figures are even partly detached from the background, as if there were a space behind them, but these are exceptional (Fig. 91). Thy remain significant, however, as a variation anticipating later art.

Another source of spatial suggestion is the overlapping of figures and objects. Such encroachment of parts may be seen in the capital of the Miracle of St. Benedict (Fig. 71); figures stand behind rather than beside the

recumbent person. In the Liberation of Peter (Fig. 42) and in other capi-
tals of the south gallery such overlapping is especially pronounced, and is
not merely an unavoidable consequence of the theme or the restricted sur-
face, but seems to be a predilection of an artist with a more complex style
than the others. In the Miracle of Peter, on a capital of the north gallery
(Fig. 73), by a sculptor of especially refined style, the Beautiful Gate of
Jerusalem is represented behind the figure of the lame man as an actual
background. This implies a spatial conception of relief more advanced
than in the other capitals. But this innovation is treated in an archaic
manner, for the building is parallel to the figure and the surface of the
capital, and the relation of figure and architecture is not confirmed by a
ground plane common to the two. Here again we find an anticipation of
later art, associated with precocious lettering and a more complex asym-
metrical composition than appears on the other capitals of the cloister.

There occur also occasional movements perpendicular or diagonal to
the background, notably in the south gallery. The arms of Christ in the
Temptation (Fig. 32), of the symbol of Matthew (Fig. 30), and of the
figure of Asaph in the capital of David's Musicians are more boldly fore-
shortened. On a capital engaged to the northeast pier—of St. Michael
fighting the dragon—a central orant figure stands with left leg flexed in a
manner unusual in the cloister (Fig. 70). It reminds us of the relaxed legs
of classical statues. The effectiveness of such movements is limited since
they are so rare and isolated; no accessories prolong them or help to fix the
spatial relation more precisely.

Sometimes a figure is so related to architecture that we infer unseen
spaces. On the capital of the Magi (Fig. 59) the three horses emerge from
a tower. An innkeeper stands in a doorway in the parable of the Good
Samaritan (Fig. 34). The apocalyptic monster, Golias (Fig. 28), issues
from a building so high in relief that the doorway is carved in the thick-
ness of the building, i.e., on a plane perpendicular to the background.

But a linear perspective is unknown. There is no attempt to represent
a depth more extensive than the actual thickness of the relief; and if the
narrow lair of the monster Golias is rendered in depth, it is by means of
an approximation to sculpture in the round rather than by foreshorten-
ing or atmospheric devices. The treatment of architecture, which is so
abundantly represented on the capitals of this cloister that a treatise on
Romanesque construction might be illustrated by them, shows this
clearly. When whole buildings are introduced they are placed beside the
figures rather than behind them. Houses and figures are of about the
same height, and are usually set on the same plane in equal salience
(Figs. 62, 71, 80, etc.).

Only one broad face of a building is shown in its entirety and is paral-
lel to the background plane. Plunging or angular viewpoints are avoided;

but by an adjustment which is characteristic of this art, with its concept of completeness, the roof is as visible to us as the lower doorway. The buildings—religious, domestic, and civil—are minutely observed and detailed. The profiles of arch moldings, the jointed masonry, and even the small parts of door bolts are rendered. But the more evident plan is usually distorted because of the lack of foreshortening and broad planes perpendicular to each other. Such neighboring surfaces are set at an angle approaching 180 degrees, as in the drawings of children, primitives, and self-taught moderns who indicate the adjoining sides of a building as if on one plane.[89] And as in such drawings, we observe in the representations of Jerusalem (Fig. 80) and of Cana (Fig. 56) three sides of a rectangular structure at the same time. It is this deformation that gives these buildings the appearance of a polygonal plan. The sculptor wished to present as many sides as possible, but to retain the angularity proper to them.

The upper stories or towers are often set back as if in real space, but hardly in effective proportion to the actual recession of such members. In the treatment of such details and of the sides of these buildings we can grasp the conceptual character of the space world of these capitals. The buildings are essentially facades, elevations rendered in exceedingly low relief. The sides are narrow walls which disappear into the background of the capital without foreshortening or indication of the actual depth of the structure. The building appears to be a wall applied to the surface or emerging from the impenetrable interior of the capital.

The high relief convinces us of the bulk and projection of figures, but not of their full detachment from the background surface of the capital or their penetration into it. Relief and background are not entirely distinct. The latter cannot be considered a wall before which the figures move as on a stage (although this is already intimated on a few capitals of the south gallery); the movements are strictly parallel to the background, as if they were bound to it in some way. The apparent indefiniteness of the space arises from the lack of horizontal planes and a distinct ground. We cannot identify it with either the restricted but definite platform of Gothic reliefs and paintings, or the boundless but undifferentiated space of expressive, religious import evoked in Early Christian and Byzantine art. Since the background is simply the surface of the object on which the figures are represented and is not itself a representation, it has no symbolic value, like the uniform gold or blue background of figures in a mosaic. It is genuinely neutral, as in the early Greek reliefs which combine a similar architectonic-decorative parallelism of surfaces with a design of analogous simplicity and a related manner of conceiving natural forms part by part in their most general aspect.

The material character of this background is evidenced in its broken

upper surface of volutes, consoles, and central triangles. These are parts of the object decorated (the capital), rather than represented spatial elements. The fact that they enter decisively into the design does not change this character, since the design is decorative and includes the surfaces and shapes of the decorated object.

But this succession of layered surfaces between the impost and astragal itself constitutes a spatial system. The console emerges from a greater depth than the volutes and is often carved in several planes, including surfaces at an angle to the capital. The volute bands are molded in two planes, while the triangle between them is sometimes modeled. Hence the head of Nebuchadnezzar (Fig. 23) under the console seems to advance from a remoter space. It is placed in front of three overlapping surfaces, one of which—the console—is subdivided into two angular planes and projects from a deeper wall. The figure, because of the relief and the considerable succession of parts—the arms, sleeves, body, cushion, and seat— seems to sit before a wall rather than emerge from it. The diagonal surface of the console also suggests a freer shaping of the space of the whole.[90] The spatial element here is not simply a representation but a decorative contrivance, and is significant for the later elaboration of the sculptured frame as a space-building factor. But the indenting and projections of the upper part of the capital by volutes and consoles are essentially foreign to the narrative aim, which seems to call for a clear and consistent delimitation of the field of the figures, whereas on these capitals that field is irregular and layered and in several places the figures cross the volutes or the consoles. Such frames are not inconsistent, however, with a lively expression of action for which the representation is coordinated in its lines and masses with frequently trespassed irregular boundaries, independent of nature or the subject.

Thus the effect of these modeled, massive figures and accessories remains that of an arbitrary assemblage of separate signs which to a great degree accord in appearance with their specific reference. But a more extended activity in depth through bodily movement is denied them. They are like shadows cast on a wall, or the repeated units of an ornamental frieze. Although they represent incidents of which the actors and accessories are drawn from a real world, it is another logic of space and movement that governs them.

These characteristics of the space and perspective of the Moissac cloister are interesting not only in themselves and because of their intimate connection with certain aesthetic results, but also because some of them appear in other civilizations and times remote from eleventh-century Languedoc, and precede the development of three-dimensional representation in more recent art. The approach to an imaginary space in art as extended as that of our actual world was a slow process, without the sudden pro-

59

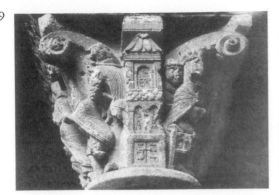

60

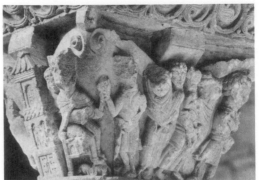

61

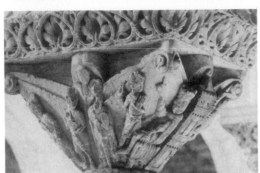

62

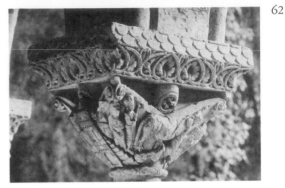

63

Fig. 59. Moissac, Cloister; Capital of
East Gallery: Journey of the Magi
from Jerusalem; Herod Orders
the Massacre of the Innocents

Fig. 60. Moissac, Cloister; Capital of
East Gallery: Massacre of the Innocents

Fig. 61. Moissac, Cloister; Capital of
East Gallery: Martyrdom of
St. Saturninus—the Accusation
of the Saint

Fig. 62. Moissac, Cloister; Capital of
East Gallery: St. Saturninus Dragged
by the Bull

Fig. 63. Moissac, Cloister; Capital of
East Gallery: The Soul of
St. Saturninus in Glory

64

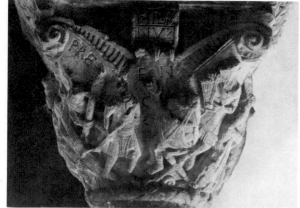

Fig. 64. Moissac, Cloister; Capital of
East Gallery: Martyrdom of the Three
Spanish Saints—the Prefect Emilianus

Fig. 65. Moissac, Cloister; Capital of
East Gallery: The Three Spanish Saints,
Augurius, Fructuosus, and Eulogius

Fig. 66. Moissac, Cloister; Capital of
East Gallery: The Three Spanish
Saints in Flames

Fig. 67. Moissac, Cloister; Capital of
East Gallery: The Souls of the Three
Spanish Saints in Glory

65

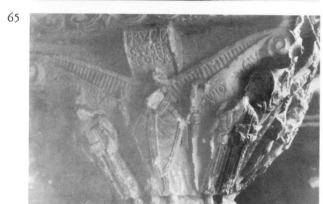

67

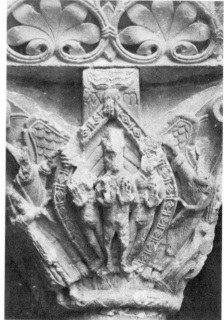

66

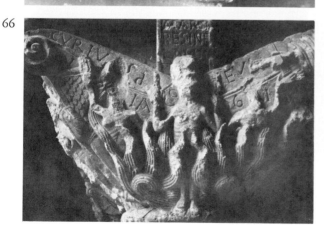

pulsion that might result from the intrusion, in pictorial imagination, of our everyday habitual awareness of how distant objects differ from near and how a varying sunlight affects the appearance of familiar forms. The artistic conception involves a positive process which represents objects to suit an existing style and an immediate decorative end. It is from the elements already represented that a constructed space will begin to emerge in the next generation of Languedoc sculptors. There will be no radical revision of the style to accommodate a newly apprehended concept; but the overlapping, modeling, and embryonic perspective will yield a slightly more plausible penetration of depth, as proportions become less arbitrary, and the movement and modeling of figures call for a clearer definition of ground, foreground, and background.

It is significant that in this group of capitals, executed in a short period, the spatial features described are not uniform; they show small variations which point to later art, just as do the details of representation in the cloister piers. This fact throws light not only on the history of forms but on their character as well, for we learn from it that the forms or processes were not absolutely stable. The diversity may indicate the cooperation of artists of different ages, but there is presupposed, in that case, a developing style. Even on the same capital, however, we can observe the primitive vertical projection of members and a more advanced procedure. The innovations do not imply a consistent revision of the whole style.

THE FIGURES OF THE CLOISTER CAPITALS

In an earlier chapter were described the figures of apostles placed singly on large flat surfaces. We turned then to smaller sculptures of which the groupings of figures were considered. Now we may ask: Are the individual figures of the capitals similar to those of the piers? How are they affected by the smaller scale, a different material, and another technique of cutting? How are they influenced by the narrative content of the capitals? Does the greater variety of forms in the more numerous capitals indicate a development in time or the presence of several sculptors of differing skill or tradition?

On some capitals there are figures which in posture and in the design of their garments are almost precise replicas of the apostles on the adjacent piers. Such is the angel at the left of the Sacrifice of Isaac (Fig. 84). St. Michael in the north gallery and a figure of St. John on the nearby capital, representing a miracle of Peter, also recall the apostles (Fig. 73). The diagonal line of the mantle, extending from the ankle to the waist, is as common on the capitals as on the piers. As on the latter, concentric folds, incised and doubled, issue from this diagonal line. On the capital

may also be seen the contrast of the uncovered side of the tunic, with its vertical leg folds, and the broad striated surface of the mantle. The peculiar curved incision at the exposed knee, the little patterned break of the lower horizontal edge, the slinglike enclosure of the arm in imitation of classic art, and the parallel torso folds, all these occur on the capitals.[91]

But because of the smaller size of the figures an equal delicacy was not so readily achieved. The interval between two grooves of a fold seems clumsy on the capitals, refined on the larger piers. The common details, especially of folds and features, stand out much more prominently in the smaller works. This is not due to a difference of skill, but to the nature of the tools and surfaces. In Chartres, also, the transfer of the forms of the jamb figures on the west portal to the capitals above them entailed a similar change.

The same depth of relief cutting on the piers and on the capitals is clearly of different significance because of the size of the figures. The salience of two or three inches of a figure only eight to twelve inches high is massive and suggests an almost total emergence from the wall; but on one of the apostles, almost five feet tall, the effect is of scant relief, if not of drawing. The difference is especially evident in the treatment of the head. Even when turned in profile, the head on the capital is rendered in its full mass, like sculpture in the round; when seen from the side, it presents a full face to the spectator. But for the actual modeling of the head, the relatively higher relief is of less consequence. These smaller figures do not manifest a more developed study of the head structure than do the figures on the piers.[92] On the contrary, as we should expect, the delicacy of facial surface and the fine detail of the features, possible on the larger heads of the apostles, are reduced on most of the capitals.

It is only on some capitals of the south gallery (Figs. 26–42) that the smaller scale does not result in a relatively thickened reproduction of the forms of the apostles. The folds are as delicate as on the latter, and insofar as a greater variety of forms appears in them, it may be said that on these capitals the work is even more refined than on the piers. The chiseling of the ordinary stone produces here transitions and undercutting not attempted on the larger marble slabs of the piers. The coincidence of this novel technique with a more complex design and space and with forms anticipating later Romanesque styles indicates that materials or tools alone cannot account for the difference from the other works of the cloister; an artist, influenced by other traditions, more "modern" in his time, and more ambitious, was at work here.

On the other hand, in some capitals, like the Washing of Feet (Figs. 52, 53), the forms of the pier reliefs are immobilized, simplified and thickened even more than on the capitals first discussed. The capital itself is more massive, broader at the base, than the others. The eyes of the

figures bulge enormously; their hands and feet are immense; the few lines of drapery seem to swathe the figures which are exceedingly squat. The apostles on this capital are only three heads in height. If the capitals of the south gallery seem the work of an artist other than the master of the pier reliefs because of more highly differentiated forms, this capital seems the work of still another by virtue of its distinct simplicity and more pronounced archaism.

That squatness appears surprising to us until we recall other primitive arts which present an equally unhuman canon. Even classic art, which at one time placed so great a value upon height as a mark of strength and dignity, in its last phases reduced the figures to stunted pygmies, far from human, much more from heroic, proportions. Such are the men carved in the early fourth century on the Arch of Constantine to celebrate the victories of an emperor; such also are the saints and Biblical figures on some Christian sarcophagi.

The shepherds in the west gallery (Fig. 86), the figures on the accompanying capitals that represent the Raising of Lazarus and the Anointing of David (Figs. 88, 89), are not much taller. Even on the capitals carved with greater skill the head remains unusually large. In the desire to indicate all that is essential to the structure of the head which already figures so largely in the conception of a man, the sculptor has given it a disproportionate physical prominence. The torso and legs, covered by draperies, are defined by fewer details. If we regard only the parts of the body below the shoulders of the nude Spanish martyrs (Fig. 67), their proportions will appear normal, though marked by forms which have been arbitrarily simplified. But if we include the heads, then the figures will appear stunted and deformed.

In the capitals the heads of children and adults are of one size. This is not a gross error of representation, when the proportions of the whole body are considered. In the Massacre of the Innocents (Fig. 60) the adults are only three or four heads in height, and the children, two. Also the heads of women and men are not distinguished in mass, except where a beard gives the male head a greater surface. Their bodies too are of one size. We cannot regard these proportions as absolutes since the isocephalism of primitive relief plays an important role in determining size. The heads of seated and standing figures are usually on the same level. The seated figures therefore seem more naturalistically proportioned (Fig. 41). Sometimes, perhaps in avoidance of the odd proportions of legs and head inevitable in a seated figure whose head is on the same level as that of a standing figure, the feet are made to hang like a baby's. But actually, where the narrative calls for subordination, the figures are not of equal height. So the baptized Christ (Fig. 43) is sunk into the water up to his breast; his head is below John's. The same observation may be made of

Isaac in the sacrifice (Fig. 84), of Abel attacked by Cain, and of a servant at Herod's feast (Fig. 21).

These peculiarities of proportion occur also in the capitals of the south gallery, which are in other respects more refined in detail and more natural than the adjoining capitals. The standing figure never attains a height of more than five heads.

Like the apostles of the piers, the figures on the capitals are disposed by the artist to yield as clear views as possible of their important parts— head, hands, and feet—despite the consequent distortion. The figures of Adam and the Lord (Fig. 48) are good examples of this archaic conception and are especially worth a closer observation because of their contrasted dress and nudity. Both heads have been destroyed. Enough of the necks and the contours of the heads is preserved to assure us that the heads were in profile, facing each other as the narrative demanded. Yet the shoulders of both are strictly frontal as in Egyptian drawing and relief; likewise the torsos, except that in Adam the nudity permits us to see the abdomen, of which the sculptor has wished to suggest the roundness by a curved contour. This distortion of the abdomen of a frontal torso, in order to represent its profile, appears in many other figures of the cloister, even in the clothed. If we do not observe it on the Lord it is because the abdomen is covered by his hand.

But once the groin is reached the artist abandons the frontality of his figure, for his legs are best seen in profile. The nakedness here betrays a process less evident in the clothed figures. Adam's hand and leaf conceal a junction difficult to realize in a figure so arbitrarily twisted. If his legs are in profile, how can we see both of them unless one is advanced? And, as in Assyrian art, it is the remote leg that is brought forward. To render the right foot behind the left, they are superposed; but the big toe of the left foot, the lower one, overlaps a toe of the right—a naive version of the concealment of one by the other in our vision of a profile figure in nature. Both feet are laid out on the surface of the capital as if seen from above or planted on a wall.

The Lord's left (rear) leg is also bent so that it may be seen in profile. Both feet are suspended in parallel rather than divergent diagonals and are exposed in their full unforeshortened mass.

If we examine now the proportioning of the various parts we shall conclude that here too is at work a process of abstraction, fractioning, and addition such as has arbitrarily twisted the axes of the body. The hands of Adam are enormous. The open, extended left hand lies across the whole length of the thigh. The closed right fist is longer than the breast. The proportions of head and body have been noted before. Here they are exposed in the naked figure in which the drapery, essentially subordinate to our conception of man's body and in itself undifferentiated in scale by

fixed units (as of limbs, torso, etc.), does not conceal from us the sculptor's conception of the whole figure. In simple recollection of the nude body the shoulders are distinct from the breast. The sculptor has therefore given shoulders and breast equal prominence, with great exaggeration of the former, but has not indicated the clavicle. But from breast to foot the body is proportioned as in the most common type of West European man. Were it not for the hands, the shoulders, and the head, we would feel no excessive disproportion.

The sculptor's conception is not of a characteristic body contour, but of the combined shapes of separate limbs and large masses, like the abdomen. These he represents in a simple form which admits no specific muscles or bony structure and no subtle indentations of surface and outline. Although the hands and head are grossly enlarged, the body axis distorted, and the stance of the figure so improbable, care is taken to represent the navel and nipples, which appear as decorative surface elements. The obvious pattern of the ribs could hardly have escaped an artist so devoted to decorative abstraction. They have a skeletal prominence in a body of which the other bones are not even suggested. Following the costal margin as a guide, the sculptor arbitrarily arranged them in a chevron pattern, with the sternum at the apex, in reversal of the true direction. The ascending curve of the ribs toward the back is not observed, perhaps because of the more complex form; such an observation implies foreshortening and attention to planes perpendicular to the main body surface, both foreign to this sculptor.

The broad surfaces of the chest and abdomen are flat or curved slightly, without abrupt transitions. Arms and legs are simple rounded members with no apparent articulation at the joints. The meeting of limbs is a simple angle of the contour, a slight break or incision of the surface, precisely as in the jointless hands. In the left leg of Adam the rear profile is suavely curved in recognition of an obvious musculature which is not otherwise indicated. The surface of a male body is therefore hardly different from that of a female; we must see them clothed in order to distinguish them. The distinction is, in fact, difficult in the scene of the Temptation (Fig. 47). Only the longer hair of the right figure permits us to call it Eve. We see more clearly here the confusion of front and profile of the abdomen, the prominence of the head and hands, the lack of muscular differentiation, the contrast of profile legs and head with the frontal shoulders. The sexless nude souls of Peter and Paul (Fig. 46) in the same gallery are remarkably like Adam and Eve.

Not all nude figures are treated in this manner. The exceptional symmetry and frontal position of Durand, which were explained by his episcopal and monastic rank and by the commemorative nature of the relief, occur in many nude figures on the capitals. Sometimes they are motivated

by religious meanings, as in the nude soul of the martyred Saturninus who stands alone in the mandorla on a background of two convergent sets of radial lines (Fig. 63). Were it not for the extremities, the body would have the normal human proportions. It is precisely designed, in perfect symmetry; the hands are extended alike, and both sides of the figure are identical in their delicately curved contours. The ribs are patterned, unlike Adam's, in well-observed concentric lines.

On the neighboring capital of the Spanish martyrs, the mandorla is filled by the three nude orant souls (Fig. 67). The limited surface has required the squeezing of the lateral figures into narrow corners, the slight turn of their bodies, and the overlapping of the inner sides of those two martyrs by the central soul. In the soft unmodeled bodies with rounded limbs the ribs are coarsely incised, and even the clavicle is rendered by a thick ridge at the base of the neck, converging to the sternum.

Another symmetrical standing nude appears on an ornamental carving in the west gallery, grasping the wings of two dragons. The motif is repeated on all four faces of the capital. Although by the same hand, the figures are not identically proportioned and modeled. The ribs, ridged in one, are faintly incised in another. But all have a common pose and a similar beauty of line and surface.

Besides these figures there are nude demons (Fig. 72), the half-dressed beggar in the capital of St. Martin (Fig. 83), and a partly nude personification of a Beatitude in the west gallery. The profile position of the devil who receives the offering of Cain is unusual in the cloister (Fig. 91).[93] It governs the whole figure and not merely the legs and head. The shoulders are perpendicular to the surface of the capital. The contour of the back of the neck and the head has been carefully noted, while the ribs, in relief, are not the symmetrical structures of the other capitals, but the well-observed forms of the side of the body. Unfortunately, the lower limbs of this demon, who approaches human shape more closely than the human figures of the cloister, are badly mutilated; we cannot tell how the sculptor made the transition from human to animal form plausible. Unlike the figure of Adam, the demon has the outer leg advanced, almost completely detached from the background. This double departure from archaic methods perhaps explains its destruction. The undercut and detached outer arms of both Cain and the demon have also been destroyed.

The unusual forms observed in this capital are not isolated details of the style, but elements of an increasing refinement apparent in the technique, proportions, folds, and movements, and even the inscriptions. The wheat offered by Cain is placed on the altar under the console, each blade finely rendered and the whole forming a column and capital, reminiscent of the ancient Egyptian. In the persistent symmetry of the group, the

squatness of the figures, the large heads (but tiny feet), and the common drapery conventions, we see that the exceptional details of this sculpture are not intrusions of another style but developments from the more archaic forms of the cloister. The demon who tempts Christ in the south gallery (Fig. 32), on a capital which shows forms of drapery genuinely new in the cloister, is more archaic than the demon before Cain. Here, too, the frontality of the upper body persists.

Besides these standing nude figures there are others in less common positions. In the parable of Dives, Lazarus is stretched out horizontally across two sides of the capital, forming an arc of ninety degrees in plan (Fig. 54). He furnishes a remarkable instance of the arbitrary space of the world of these capitals. Though obviously recumbent, he is carved lying on the vertical surface rather than on the astragal only a trifle below him. His body is presented frontally, as if seen directly from above, the whole torso unforeshortened. The upper body is long and slender, the legs almost nonexistent in their shortness. As in the representation of tables in the cloister capitals, the horizontal surface of the recumbent figure has been projected vertically.

<p style="text-align:center">* * *</p>

In the study of the piers we observed that the heads of the apostles were individual conceptions, like portraits, although so uniform in their surfaces. In the case of Durand, a Cluniac tradition (that speaks of his jesting nature) has been cited to confirm the accuracy of the equivocal expression in his likeness. Yet this is surely the stiffest of the figures, the most schematically constructed and ornamental.

The smaller scale of the capitals hardly admitted such fine distinction of personalities. The head of St. John the Evangelist in the south gallery (Fig. 37) is an exception, and less surprising when the more elaborate detail of other figures in this gallery is considered.

The impassivity of the apostles is an expression proper to their hieratic positions and gestures. But the absence of facial expression in scenes of violence like the Martyrdoms, the Massacre of the Innocents, and the Entry of the Crusaders into Jerusalem is especially remarkable. When we recall the contemporary anonymous historian's account of this last event (Fig. 81), in which religious fervor followed an unrestrained brutality that made Tancred weep, and when we remember also the enthusiasm of the convocations, the impassivity of the scene is astonishing. Such "serenity" is not limited to the early art of Greece, but is a common archaic feature. The expression of the faces on the capitals is neutral rather than impassive. There is a total absence of facial expression beyond the smile of the little demon (?) behind Herod in the Massacre of the Innocents (Fig. 59). The representation of a momentary feeling is foreign to this

art which proceeds from the more stable or general appearance of individual objects.

Expressiveness is achieved by other means. Either symbolical gestures, movements, and attributes communicate their feelings and characters, or the design of the work, the zigzag or calmer organization of forms, sometimes expresses the quality of an episode or situation. The latter is most evident in the hieratic groups of saints and angels, in which symmetry and centralized design confer the effect of a ritual moment and a dogmatic finality on the representation. This result is of course not separable from specific attributes like haloes and mandorlas and from gestures that symbolize exaltation or prayer.

On the capital of the Martyrdom of the three Spanish saints, Fructuosus, Augurius, and Eulogius, the composition of each of the four scenes has a distinct expressive character. First they stand in their ecclesiastic robes in ceremonious postures, strictly frontal (Fig. 65); then they appear in the flames, nude and orant, in a beautiful symmetrical design of wavy flames, maintained in their own gestures (Fig. 66). Despite the horrible theme there is no sense of violent engagement of the figures and the fire, but a common upward movement, as of flowers emerging from a thick base of stems and long curved foliage. The adjoining scene of the prefect Emilianus commanding the execution has a more genuinely broken, exciting form, with many angles and strong oppositions throughout the field (Fig. 64). The official sits on an X-shaped chair, before a musician with a triangular instrument. The former's garment is divided by folds into several triangles. His arm extends diagonally across the middle of the surface, and ends in a pointing finger. Three leaves curled over the tip of the central triangle of the frame produce a more insistent zigzag above. The contour of the musician provides another zigzag line, which is paralleled in the forms of two men at the left who stir the flames with diagonal rods. To increase this effect of sustained diagonal contrasts the sculptor has broken the volute bands by numerous short diagonal lines, saw-toothed in section. Even the astragal has a prominent pattern of intersecting diagonal strands. On the fourth side of the capital (Fig. 67), the souls of the three nude martyrs are enclosed in the middle of the field by a jeweled mandorla held above by the hand of God and at the sides by two angels. By the greater mass of the central figure, by lines concentric with the mandorla incised behind the saints, by the related forms of the angels and their wings, and by the four hands of the saints placed palm outward across the middle of the field, the composition acquires a more definite centrality and seems to focus on the glory of the martyrs.

Such coordination of expressive form and content is not everywhere apparent. It throws some light on Romanesque methods of design and

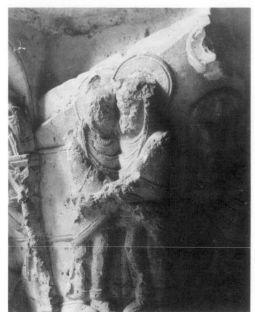

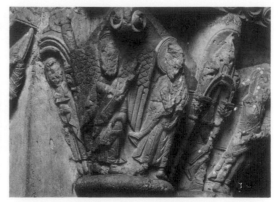

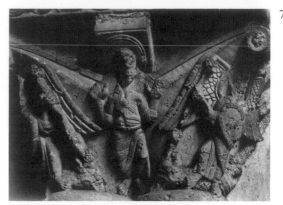

Fig. 68. Moissac, Cloister; Capital at Corner of East Gallery: The Visitation

Fig. 69. Moissac, Cloister; Capital at Corner of East Gallery: The Annunciation

Fig. 70. Moissac, Cloister; Capital at Corner of North Gallery: St. Michael and the Dragon

Fig. 71. Moissac, Cloister; Capital of North Gallery: Miracle of St. Benedict

Fig. 72. Moissac, Cloister; Capital of North Gallery: Miracle of St. Benedict —Monk Tempted by Demon

73

74

Fig. 73. Moissac, Cloister; Capital of North Gallery: Peter Heals the Lame Man at the Beautiful Gate

Fig. 74. Moissac, Cloister; Capital of North Gallery: The Angel Gabriel

Fig. 75. Moissac, Cloister; Capital of North Gallery: The Calling of the Apostles—the Apostles Fishing

Fig. 76. Moissac, Cloister; Capital of North Gallery: The Calling of the Apostles

Fig. 77. Moissac, Cloister; Capital of North Gallery: The Calling of the Apostles—Christ

75

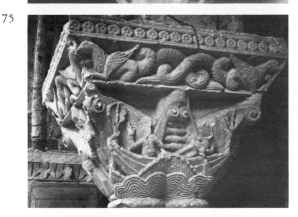

77

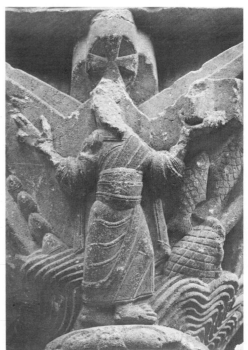

76

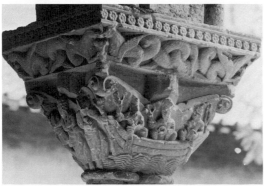

independence of purely material factors, like the shape of a field, and the traditional iconographic data. On no two sides of this capital of the Spanish martyrs do we find identical frames. The upper zigzag is modified to accord with a conception of the whole surface; sometimes the volute bands are striated, sometimes the central triangle is omitted or topped by foliage.

The individual gestures are very few in number and thoroughly conventional. Most frequently, the hand is extended, either pointing or palm outward, as a symbol of acknowledgment, prayer, surprise, or speech. The orant arms of the three Hebrews and the three Spanish martyrs are a deliberately applied symbol of the cross as well as a gesture (and in the Romanesque period, artistic symbol) of prayer. In the figure of Durand, the hand is raised stiffly in an emphatic gesture of commanding speech which has become the static sign of his spiritual authority. In some figures the legs are crossed, but the meaning of this posture is not clear (Figs. 53, 64, 76). It is the stance of a possessed figure in a miniature of the late eleventh century from Monte Cassino, but is more frequently found at this time in sacred figures. In Romanesque art it is an expressive formal device, an unstable, untectonic posture with parallels even in architecture, a strained movement and inward tension.[93a] In the cloister, it is still a convention without intensity.

On the more archaic capitals of the cloister each figure is engaged with a single object and refers to only one other figure in his gesture or movement. But on the capitals of the south gallery (and the north) the use of gesture is more complex. The sculptors were too archaic to link the action of figures by the glance of the eye; but through the positions of hands and heads they achieved a similar connection. I have already observed that in the Healing of the Centurion's Servant (Fig. 31), the centurion (facing Christ, who stands at the right) extends one hand to the left, pointing to the servant in bed, and addresses Christ by raising the right hand before him. Christ is turned to the right, away from the supplicating figure, but his head is directed to the centurion. There is created by these contrasting motions (the bent legs of Christ are an additional element of contrast) a complicated intercourse, in which the double preoccupation of each figure—the centurion's with his servant and with Christ, Christ's with the centurion and the apostles—is adequately expressed.[94]

On the capital of Nebuchadnezzar (Fig. 22) the figure who stands at the right is turned away from the king, though facing him; his opposed arms point in opposite directions. An analogous complexity may be observed in the king himself, whose arms are contrasted in gesture, the head turned, and even the legs crossed. The double gesture is not merely

designed to represent a more complex interaction, but is an element of a style which promotes contrasts and movement. It constitutes an expressive form as well as an expressive symbol.

DRAPERY

The drapery forms of the capitals include all that were observed on the sculptures of the piers. The schematic incised radial, concentric, and elliptical folds, the doubled lines, the patterned breaks of the horizontal edges, all appear on the smaller figures. The difference in scale modifies the proportion of the fold to the whole figure, so that on an analogous apostle on a capital the drapery lines are fewer and the folds are considerably thickened. One detail of Romanesque costume unknown on the piers is a commonplace on the figures of the capitals who wear contemporary dress. This is the vertical slit on the collar of the tunic at the sternum. On the capitals of the south gallery the jeweled ornament, carved on the borders of the garment of Durand and James, becomes an element of style and is applied on angels, kings, and lay figures of lesser rank. The peculiar definition of the folds of the lower abdomen by an ovoid figure with an incised horizontal axis, which occurs on several of the apostles on the piers, is often repeated on the smaller figures of the capitals. But on the latter this form is part of a larger system of folds which includes concentric bands drawn across the torso. These bands are less visible on the piers, perhaps because of the mantles which conceal the torso folds of the apostles, or because of the traditional ancient costume worn by the latter.

It is significant of the latent realism of this style that the costume of the figures on the capitals is minutely differentiated and offers a great variety of types. For not only apostles, but all kinds of secular figures—kings, soldiers, executioners, shepherds, musicians, servants, women, and children—and many religious types—saints, angels, martyrs, bishops, prophets, monks, and priests—appear on these sculptures in distinct dress.

In one large group of capitals, including those of the north and west galleries—with the exception of those engaged to the piers and the capital representing the Annunciation to the Shepherds (Figs. 86, 87)—and three western capitals of the south gallery (Nebuchadnezzar, Stephen, and Babylon, Figs. 22–25), the forms of drapery are precisely those of the pier reliefs, without the addition of elements unknown in the latter. The differences are mainly of scale and costume. Even the figures in movement are governed by the same isolation of folds, clear contours, incised lines, and the close fitting of the garment to the actual contours of the body. The unmodeled clothes cover the figure like a shell. Except for the familiar pentagonal pattern on the lower edge, the outlines are usually simple and unbroken. It is only by exception that a slightly

greater prominence is given in a few instances to hanging or flaring parts of the costume.

On the capitals of the east gallery and those engaged to the piers, the forms described above persist, but are accompanied by others with different principles of drapery composition. Thus the plain diagonal of the mantle is broken by zigzag pleats, and the contour of the garment, ordinarily fitted to the body, is sometimes expanded by flying ends of drapery. On Nero's legs in the martyrdom of Peter and Paul (Fig. 45) the falling mantle cascades in pleats unknown on the piers. In addition to the common concentric incised lines a chevron system is employed to organize the folds on the body surface. The horizontal edge of the tunic of the angel who expels Adam and Eve (Fig. 49) is broken by a continuous wave pattern. But these new elements of drapery design are less refined in execution than the more usual forms of the north gallery. More often they are coarser and thicker, heavily ridged or grooved, and associated with figures of squat proportions.

A more striking and pervasive departure from the drapery types of the piers occurs in the ten historiated capitals of the eastern part of the south gallery (Figs. 26–42). They differ from the other capitals in the greater richness of dress, in the complexity of folds, in the breaking of contours by the zigzag and meandering edges of pleats, in the multiplied overlapping folds, in the free use of flying and blown ends, in the more plastic surfaces of cloth, in the undercutting of the lower edge of the garment, and in the more refined treatment of those features of the other style which persist in the new. In these capitals we see conventions of drapery pattern common in the developed Romanesque style of the twelfth century.

The garment is less closely fitted to the body. It is not limited to the simple rectangular mass, adorned with radial and concentric lines, but is arbitrarily broken at the edges into lively patterns. A line recalling the Vitruvian scroll or "running dog" terminates the pleats on some figures. It approaches the meander in the reduction of the curves to straight or only slightly curved lines forming alternately obtuse and acute angles. It is a highly developed, late archaic form of which the relation to the far simpler folds of the east gallery will be more clearly grasped if we observe the parallel contrast in early Greek art of the vases of Euphronius and a late black-figured work. The few pleatings of the east gallery form simple zigzag contours, without the complexity of a meander or a scroll. Their surfaces are perfectly flat, just as their terminations are simple curves or unvaried straight lines. The pleating itself is broadly spaced and limited to three or four planes at the most.

The sculptor of the south gallery does not simply abstract from the normal pleating of unarranged folds an effect of parallel or radial band-

ing and a lively scroll contour. The mantle or tunic is blown in different directions to generate such forms outside the boundaries of the body. The mantle of Herod (Fig. 41), hanging from his arm, is extended diagonally across the background and ornamented by a fine pattern of double incised radial lines, a few modeled pleats, and a wavy scroll contour. This extension of the mantle is not designed for such effects alone; it serves also to unite two parts of a composition otherwise unbalanced, and opposes a similar jutting of the mantle of Peter beside it. It suggests a comparison with the similarly extended mantles of the Magi (Fig. 58). The latter are plain and unbroken by multiplied folds.

The sculptor has yet other devices for accenting the movements of figures by the lines of their garments. At the left leg of Herod the tunic is blown far behind to form a curious horizontal process, consisting of a thin upper band, an outer polygonal fold hooded to resemble a dome, a series of small vertical pleats of wavy lower contour, and several concentric sets of incised folds that connect this group with the main body of the garment. The same structure appears on the apocalyptic horseman (Fig. 36), where it is more obviously motivated by the movement of the figure, as in equestrian representations in Greek and Byzantine art. Sometimes a slender end of drapery flies from the back of the figure; sometimes the parallel pleatings on the body are carved in diagonals contrary to the direction of the other folds, as if blown from behind (Og and Magog— Fig. 28).

Another source of complex linear movement and plastic variation is the swathing of the figure in great garments, far exceeding the actual body surface. The dress on most of the capitals is more closely fitted than in the south gallery where the amplitude of costume allows the richest overlapping. On the apocalyptic angel with the sickle (Fig. 38) the outer garment is so large that it must be tucked under the lower tunic at the waist.

The polygonal pattern of the lower horizontal edge persists in these capitals, but is further developed in outline and modeling. It tends toward a more broken, yet more distinct contour, and is more plastically rendered. It terminates a fold no longer rigidly vertical, but irregular, curved, blown, and even triangular. In addition it is so employed in groups of three that the horizontal border becomes even more restless. In the Christ of the Transfiguration (Fig. 39) two such folds are directly superposed, like two vertical symmetrical zigzags united at the top by a horizontal line. This is a more complex form which appears frequently in later Romanesque art.

Even the banded folds of the torso are elaborated. They are not simply doubled by parallel incisions, but in some cases (Healing of the Centurion's servant and the Canaanite girl—Figs. 31, 33) each fold of the torso is accompanied by two such incisions.

It would be a mistake to suppose that in these capitals the draperies alone were enriched without a development of other features. Though very primitive forms persist here, their sculptor undertakes more complex compositions than any of his fellows. His surfaces are carved with greater variety. He employs jeweled ornament in a profusion that suggests the later and more monumental tympanum. His buildings are distinguished among all those represented in the cloister by their refined detail and by exotic types like the Moorish portal of the Deliverance of Peter. Archivolts, though so tiny, are delicately molded, as in actual structures of the period. The impost blocks of these capitals are the most remarkable in the cloister; they include rare figure motifs drawn from foreign art, like the dog or wolf-headed men and the putti in scrolls, and plant forms unknown elsewhere in the cloister. Details like the hair and beard, which retain the patterned dispositions of the other capitals and the piers, are more plastically rendered (Fig. 33). In the discussion of design and space the slightly more complex groupings of this master have already been noted. If the sculptor of the north gallery in his most developed work employs undercutting and detaches limbs from the background, he never models folds even as slightly as this artist, nor chisels underneath the ends of drapery to lift them from the surface behind.

THE MASTERS OF THE CLOISTER

In the discussion of the pier reliefs I inquired if there were any evidences of change of style during the course of a long enterprise. It was observed that proportions vary from a squat to a taller canon and that certain refinements of detail visible in some figures are absent from others. But it was impossible to affirm with certainty that these differences mark a development. For they are not coordinated, but sporadic; and the more sophisticated or skilled forms appear side by side with others of more archaic character. Yet even these variations are significant. They indicate at least one source of new forms in the striving to individualize figures that are identical in decorative function and architectural position and belong to the same iconographic program; and another source in the greater skill and assuredness that results from a long project in which the same problem—an almost life-size figure—is undertaken at least ten times.

The figure of Simon (Figs. 13, 14) seemed sufficiently unlike the others to provoke inquiry into the possibility of an independent authorship. His head at first sight appears uglier than the others. His jaw has a pronounced salience; the lips are pursed in a novel manner, while the three-quarters turn of the head is a boldness unparalleled in any of the apostles. Other details confirm the difference. No eyes are so large as

Simon's; none but Peter and Paul (Figs. 15, 16) possess a similarly incised iris. In Peter and Paul, the incision is less prominent. The draperies of this exceptional apostle repeat the forms of the others, but in a more insistent and schematic manner. Almost the entire surface of his body is spun with closely grouped concentric and parallel lines. The curves have a uniform waviness less accentuated in the others. The fold of the left knee is thick, prominent, and unexpected. Likewise, the lower curve of the abdominal ellipse, common to most of the figures of the cloister, is raised in an unusual relief. Simon is further remarkable as the one apostle who copies closely the forms of another. We have only to compare him with the figure of Matthew (Figs. 10, 18) to realize that they are not the works of the same hand. The open inscribed book of Matthew has some significance in the portrait of an evangelist; the inscription reproduces the initials of the opening words of his gospel. But in the representation of Simon such an open inscribed book departs from the traditional iconography and implies a confusion of types. The script of Simon's text (CANANEUS) is coarser than Matthew's; in accord with the accentuation of the repeated lines of the garment, the ruled lines of the book, omitted in the book of Matthew, are here incised.

A single detail confirms the notion of a separate authorship of the figure of Simon. It is the design of the capitals of his columnar frame. These are unique among all the capitals represented on the pier reliefs in the zigzag line connecting the volutes, as on the historiated capitals of the cloister. They are unique also in that the two capitals are unlike and that their ornament includes motifs found on none of the other piers. One is a central palmette flanked by large acanthus leaves which emerge from its lower lobes. This ornament appears on imposts of the cloister as well as on a capital of the east gallery.

The relief of Simon is not very distinct from the others. The differences are perceptible in small details and in that general effect of a whole figure, which is difficult to define except by minute comparisons. Simon is more restless than his fellows. He is not firmly planted on the ground but is weighted on the toes. The symmetrical bending of the knees contributes to this effect of impermanence and expectancy in his position.

In the capitals of the cloister a broad distinction of styles has already been indicated in the contrast of the drapery forms, as well as in the differences in design and representation; but a more precise distinction of individual hands among all the sculptures of the cloister is difficult to establish because of the variations within any group and the unique effect produced in certain of the subjects. Since work continued for a considerable time, the development of the style and a possible mutual influence of the sculptors upon each other might account for the variety observed.

In the south gallery, however, the ten eastern capitals (Figs. 26–42) form a homogeneous group with peculiarities of drapery form, technique, ornament, and design that appear in no other capitals. This was apparent throughout the discussion of the style of the cloister sculptures. The master of these capitals is not the author of the pier reliefs, for although conventions of the latter are still employed by him, his own unusual forms are unknown on the piers. Which capitals were carved by the pier master is not certain because all the other capitals reproduce his forms. But they do this with varying skill and artistic result, so that several hands may be inferred. I believe that among the unengaged capitals of the north gallery (Figs. 71–83) and in a few of the west and south may be identified the works of the pier master. Those of the west are the Angels bearing the Cross (Fig. 85), the Beatitudes (Fig. 90), the Ascension of Alexander, Cain and Abel (Fig. 91); of the south, Nebuchadnezzar (Figs. 22, 23), Babylon, and the Martyrdom of Stephen (Figs. 24, 25). With these may be included most of the adjoining capitals with animal, plant, and figure ornament.

In the capitals listed may be observed all the details of the piers rendered with identical precision, though they are of a different scale. Especially in the north gallery, a figure like the Christ calling the apostles (Fig. 77) is evidently of the same artistic family as the apostles on the piers. The fine surface finish of these capitals also distinguishes them from the closely related capitals engaged to the piers and from those of the east gallery. In the capitals of the pier master little or no addition is made to the repertoire of drapery forms used on the piers, other than the banding of the torso and those elements which belong to contemporary dress. His themes are broadly spaced and clear, the movements of the figures restrained, their bodies more rounded, and the details more sharply cut than on the capitals engaged to the piers, or in the east gallery. A comparison of the Three Hebrews in the Furnace (Fig. 82) with the analogous Spanish saints in the east gallery (Fig. 66), and of Daniel between the lions in the north Gallery (Fig. 78) with the more archaic Daniel by another master in the west (Fig. 87), will establish these characteristics of the master. They are reflected in the inscriptions, which are placed on the horizontal bands of the impost or, if cut within the capital itself, are more clearly and regularly aligned than in the east gallery. On the capital of Martin dividing his cloak an inscription is incised on the sword (Fig. 83). But there are at least two, if not more, alphabets on the capitals of this group (Figs. 71–83). The inscriptions were added by different hands: or the single sculptor possessed the versatility and habit of scribes who in the books of the period composed titles and headings in several manners.[95] The resemblance of the figures on the capital of the Three

Hebrews to those on the capitals of Benedict and Martin is so great that the remarkable difference in their inscriptions cannot be a criterion of different authorship of the capitals.

Two capitals in the west gallery—with the Raising of Lazarus (Fig. 88) and the Anointing of David (Fig. 89)—might be early works of the pier master. They are somewhat cruder in finish and simpler in design than the capitals of the north gallery but have very similar shapes. They point also to the capitals engaged to the piers (Figs. 43, 44) which, though by one hand, display a variety that indicates a developing style.

Related to the engaged capitals are those of the east gallery (Figs. 45–67) and the Shepherds in the south (Figs. 86, 87), which present a distinct epigraphic style, with larger, more angular letters than the south or north capitals. But the Shepherds and some sculptures in the east gallery—the Washing of Feet (Figs. 52, 53), Lazarus and Dives (Figs. 54, 55), Cana (Figs 56, 57), the Magi (Figs. 58, 59, 60), and the three Spanish saints (Figs. 64–67)—are so much more archaic in the canon of the figure, the large head and squat body, the compact compositions, the heavy folds, and extremely schematic forms that one must ask if they are not the works of a fourth hand. Similar figures exist beside the more usual type on engaged capitals (Baptism, Fig. 43). Even in the works of the pier master and the south gallery there is a similar range in proportions and style of drapery. The more archaic works may be earlier carvings of the sculptor who did the other capitals of the east gallery and the engaged columns. One fact, however, seems to point to a distinct authorship of this more archaic group. The letters of the inscriptions are not uniformly aligned but strewn in diagonals and verticals on the surface of the capital between the figures. The eight engaged capitals are uninscribed except for the SAMSON which is placed, not on the field of sculpture, but on the console above it. The decomposed diagonal inscriptions occur on the Shepherds, the Martyrdom of the Three Spanish Saints, and Peter and Paul (Fig. 45), as well as on the five capitals listed above. The figure of the king in the Martyrdom of Saturninus (Fig. 61) appears to be by the same hand as Herod in the Massacre (Fig. 59) and Emilianus in the three Spanish Saints (Fig. 64), and Saul on the engaged capital of David and Goliath. Within this large group of the eastern gallery and the engaged capitals there is a stylistic span in which I have perhaps failed to distinguish two or even three different hands. I am still uncertain whether the pier capitals are to be grouped with those of the east gallery, or whether the Adam and Eve (Figs. 47–49) and the Martyrdom of Laurence (Figs. 50, 51) belong with the others. The identity of the nude figures of Adam and Eve with the nude souls of Peter and Paul points to a common authorship. But other details of these two capitals are less obviously similar.

The capitals engaged to the piers might be considered the works of the pier master, were it not that the forms used by the sculptor of the north and west galleries are even closer to those of the apostles, and that common novelties like the lifted mantle of the high priest in the Miracle of Peter and a figure at the Feast of Herod (Fig. 21) are more neatly and skillfully rendered in the first than in the second. Besides, on the pier capitals occur several details of drapery, chevron incisions, zigzag ends, and flying folds of a heavy flattened character unknown in either the pier reliefs or the capitals of the north gallery, and far less developed than in the south.

The intrusion in the west gallery of a capital like the Shepherds may be explained in the light of two of its peculiarities. It is of greater width, by four centimeters, than any other capital of this gallery. It received not only the weight of the gallery arches but also of the bay of the lavatorium arcade which began at this point, and has left traces of its haunch and spring above the impost of this capital. Hence it may be supposed that this capital belongs to another moment in the architectural enterprise, being either a slightly earlier reemployed capital or the work of a hand introduced in the course of this new construction. A similar departure from the normal width of the capitals occurs in the Washing of Feet (Figs. 52, 53), a capital of a more friable material than the others, and with unusually compact figures and simple, forceful execution.

To which of the masters of the cloister the figure of Simon (Fig. 13) is due I cannot decide. It is surely not the work of the sculptor of the south gallery, but in the remaining capitals there are no figures sufficiently like Simon to suggest a common hand. A little head projecting from the tower beside Nero in the Martyrdom of Peter and Paul (Fig. 45) has a similar appearance. The other figures of this capital, however, are distinct from the apostle. The existence of a capital in the east gallery with the exceptional foliate forms of the relief of Simon also points to one of the hands of the east gallery.

In the cloister the evident differences between the capitals of the east gallery and those of the south are not due to an internal development during the course of work, or even to a gradual transformation of the first style during a longer time. The two groups are contemporary, and even the stylistically intermediate group of the pier master (north gallery) is of the same period. I should not say "intermediate," for this word presupposes a logical or historical order of development which is contradicted by closer observation. For if the capitals of the north gallery (B) are more refined and more naturalistic than those of the east (A), and less developed in drapery forms and ornament than the capitals of the south (C), their compositions and space are as complex as C's, and their inscriptions, in fact, more modern. Noteworthy is the presence on the crudest capitals

in the east gallery of the zigzag folds and projecting ends of drapery, unknown in B. In the possession of these forms the most archaic capitals intimate a subsequent development, unannounced in B. It may be, however, that they are copied from the style of C, and that far from being an antecedent of C, the capitals of A are an adaptation of C to an earlier manner. But this seems unlikely to me because of the specific character of the broken draperies in A; they presuppose only the simpler pleatings of C and show no trace of the more developed forms even in a coarsened or reduced version.

If we observe within a given group certain variations from one capital to another, they may be interpreted as the stages of a personal development. But these variations within a group are less radical than the differences between the groups as wholes. We can infer a common preoccupation with more naturalistic forms, but it would not account for the striking stylistic differences between the groups and the presence of divergent stylistic tendencies. In the north gallery the draperies are rarely the source of expression or movement; we find more animated draperies and episodic lively compositions in the eastern capitals, which are, however, the most remote from the south gallery in design and naturalism. In the latter, the most novel forms, even if associated with a more complex whole and more complex details, do not imply a uniform transformation of every feature of an earlier practice. Those forms which promote linear movement and intensified peripheral rhythms along the contours are the most radically developed; side by side with the more elongated and naturalistic figures and the finer draperies persist the primitive conventions of stance and the most marked deformations. The feet are still separated at a straight angle or are suspended vertically without support, while the earlier fractioned representation of parts appears in such enormities as the right arm of the demon who embraces Christ in the scene of the Temptation (Fig. 32). It is as long as his own body from head to foot. In this group the change of style appears at first as the result of a simple addition of new motifs to the common stock of forms rather than in a central quality that pervasively modifies every detail from within. The old are not completely modified by the intrusive combinations, but exist beside them in the very same figures. This is evident in some imposts where the common palmette acquires a more plastic character in the south gallery by the simple ridging or curling of a lobe, or by the sheathing of a stem, the plant otherwise remaining the same. But beside this gradual change, which reflects a plastic tendency in the complication of surfaces and also a search for more intricate and more numerous lines, we recognize the novel motifs of ornament employed by the same sculptor beside the slightly altered palmette. Their richness corresponds to the complexity imposed on the latter; they include in another context the

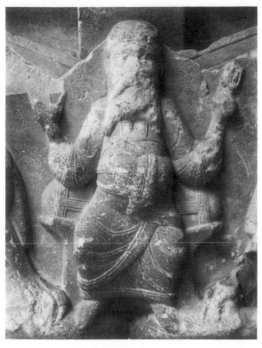

Fig. 78. Moissac, Cloister; Capital of North Gallery: Daniel—Detail of Fig. 79

Fig. 79. Moissac, Cloister; Capital of North Gallery: Daniel in the Lions' Den

Fig. 80. Moissac, Cloister; Capital of North Gallery: The Crusaders —Angel before Jerusalem

Fig. 81. Moissac, Cloister; Capital of North Gallery: The Crusaders

Fig. 82. Moissac, Cloister; Capital of North Gallery: The Three Hebrews in the Fiery Furnace

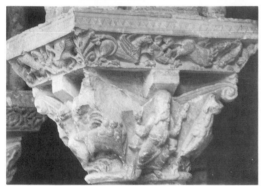

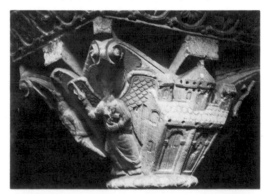

80

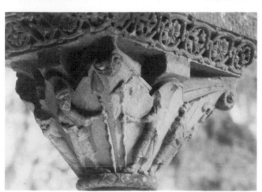

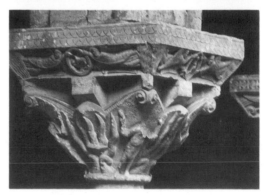

82

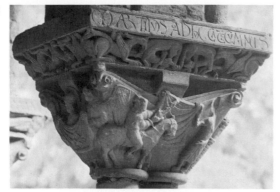

83

Fig. 83. Moissac, Cloister; Capital of North Gallery: St. Martin Dividing his Mantle

Fig. 84. Moissac, Cloister; Capital of West Gallery: Sacrifice of Isaac

Fig. 85. Moissac, Cloister; Capital of West Gallery: Angels with the Cross

Fig. 86. Moissac, Cloister; Capital of West Gallery: Annunciation to the Shepherds

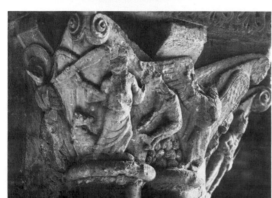

84

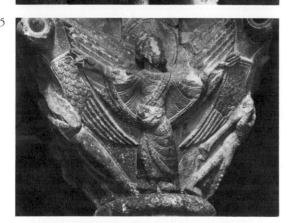

85

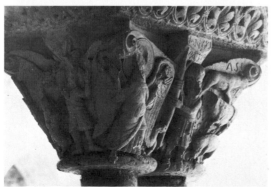

86

ridging, sheathing, and curling introduced in the palmette. We are led to suppose that the larger change in the common types is not simply an internal development but has been produced by the intrusion or observation of another style. What forms resulted from the more self-contained development of the original types can be seen in the north gallery, which lacks precisely the novel drapery forms and rich surfaces of the south, although it often goes beyond the latter in the naturalistic postures, proportions, and design of the figures.

The masters of the south and east galleries (especially of the Wedding of Cana and the Washing of Feet), though contemporary, represent nonetheless two poles of a development within the local Romanesque art. In the second we observe in the clearest manner, on capitals of more massive, almost rectangular block form, a style of compact, immobile figures, grouped in ornamental sequences or antithetic schemes, as simple as the structure of the figures themselves. The contours and surfaces of these squat, bulging figures are often only slightly differentiated; they are conceived descriptively as a naively realistic, itemized composition of isolated, geometrically formed parts. In the south gallery, on the other hand, an effect of freer movement is achieved by a proliferation of radial and meandering lines of drapery, by taller, more slender figures with an increased flexibility of posture, by asymmetrical, open compositions and a higher differentiation of surfaces, whereby the originally inert volumes, attached to the wall, are converted into slightly more articulated, more plastic structures that suggest an incipient liberation from the background in an implied if inconsistently framed space. Beside this artist, the other appears to be a carver of ornamental capitals of birds, beasts, and plants, who is also called upon to execute figured groups; while the first seems primarily a figure sculptor, who imposes on the ornamental portions of the capitals the individualized complexity of living objects. His astragals are not merely ornamented; they become representations of jeweled, banded, cordlike objects. In his series of ten capitals, unlike those by the other masters, there is not one purely decorative sculpture. But his progressive naturalism goes hand in hand with the disengagement of line from a primitive inert massiveness and a simplified descriptive usage in a composition of discrete elements. Thus the two opposed characterizations of Romanesque style—as of architectonic, rigorously coordinated, weighty, symmetrical, culminating masses, and as a less plastic system of multiplied, contrasted lines—may both be verified in the sculptures of the cloister. But in the capitals of the south gallery, this second character, already evident within the most archaic capitals, is intensified, and anticipates the later tympanum of Moissac.

It is important to observe that at the very beginning of the modern tradition of sculpture there is already great freedom and divergence from

a common method in the same project, and that the variations are not uniformly directed. This freedom corresponds to the variety of subject matter and the motifs of ornament, unlike the stereotypes and limited range in other traditions. The basic unity of the whole is apparent when we compare it with works of another region, like Burgundy. The uniform structure of the capitals is its clearest expression.

A N o t e o n T e c h n i q u e

There are no capitals in an unfinished state at Moissac which would permit us to study the method of carving. Hence it must be inferred from the completed works and by comparison with contemporaneous unfinished capitals in the same region. Luckily such a capital, from the cloister of the cathedral of Saint-Étienne, is preserved in the Musée des Augustins at Toulouse (Fig. 128). It shows four figures blocked out and partially modeled, probably intended to represent the foolish virgins, since the wise virgins have been carved on the other side. The cutting is sufficiently advanced to enable us to judge the composition of the figures, their relative mass, the directions of the main lines, and the gestures. But no features are visible. The heads are simple eggs, the hair, broad unstriated surfaces in high relief. It is remarkable that the shoes have been carried further than other parts of the figures, perhaps because of their simple shape. It may be supposed from this capital that at Moissac the sculptor drew upon the smoothed block of the stone the broad outlines of the figures and cut away the intervals between them to establish their full salience. The figure was not completed part by part, but, as far as can be judged from this capital in Toulouse and another in the Archaeological Museum of Nevers, the capital was chiseled as a whole, stage by stage, except for the final details. The background was smoothed early in the work. In this method are implied a clear contrast of salient masses and hollows and a preconception of the capital as a decorative, plastic whole.

The sculptor employed chisels and drills. I have observed no traces of a saw in Moissac and Toulouse, as in the earliest Greek sculptures. The forms of the chisels are difficult to determine, since the finished surfaces of the capitals have been smoothed with a finer tool. But it is evident from the capital in Toulouse that a broad-edged chisel was employed in the preliminary (really the actual) labor, since the planes demarcated in the rough-hewn figures are so broad and sharply cut. Besides the chisels, pointed instruments must have been used; several kinds of delicate and coarse grooving, striation, and incision are visible. Some of these may have been accomplished with a narrow chisel, some with a gouge. The drill had a limited application. Traces of its use appear mainly in the ornament and in the cutting of apertures in the buildings rendered on the capitals. Unlike the sculptors of Cuxa, Elne, and the eastern part of

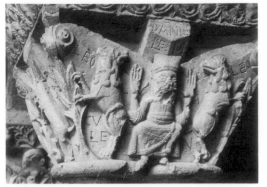

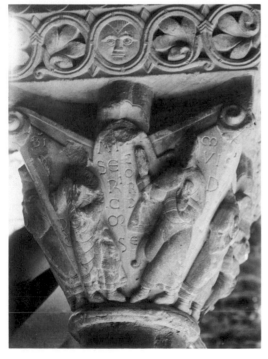

Fig. 87. Moissac, Cloister; Capital of
West Gallery: Daniel in the
Lions' Den

Fig. 88. Moissac, Cloister; Capital of
West Gallery: The Raising of Lazarus

Fig. 89. Moissac, Cloister; Capital of
West Gallery: The Anointing of David

Fig. 90. Moissac, Cloister; Capital of
West Gallery: The Beatitudes

Fig. 91. Moissac, Cloister; Capital of
West Gallery: The Offering of Cain

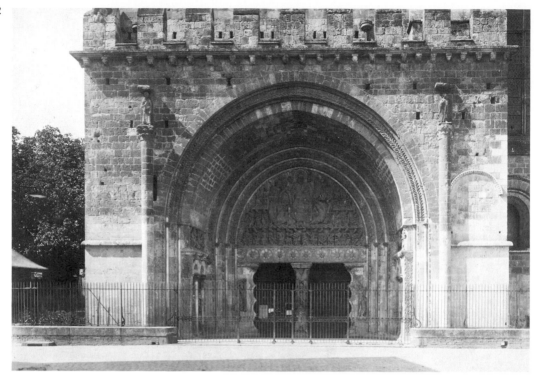

Fig. 92. Moissac, Church: South Porch of Narthex

Fig. 93. Moissac, Church: Tympanum of South Porch

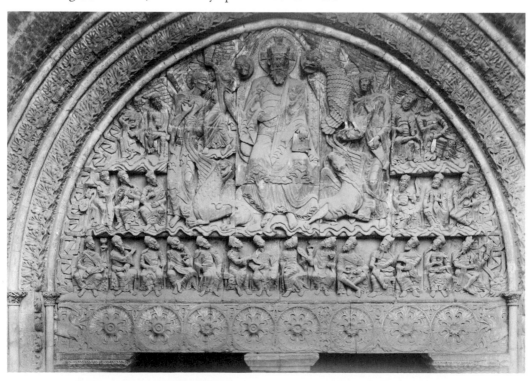

Languedoc who retained the late classic practice of drilling details of eyes, mouth, and other parts of the body, the atelier of Moissac employed the drill to represent hollows of circular section. It is possible, however, that it was applied also in undercutting of heads and limbs of some of the figures and animals. Such undercutting is exceptional in the cloister, but more common in later works of the region. The practice of undercutting is evidenced in the missing parts of figures, in the loss of heads and limbs that left no scar on the background from which they were in part detached. On the capitals of the south gallery, the contours of drapery are in places lifted slightly from the background, and the heads in high relief, while not free from the wall, touch it at only a single point.

The effect of the various materials—the marble and limestone—upon the sculptor's labor and conceptions is beyond my competence to judge. It is incorrect to reason as does Monsiur Rey[96] that the "progress" of Romanesque sculpture follows the substitution of white calcareous stone for marble, which is less easy to cut, or that the archaism of certain sculptures is simply the result of refractory materials. He cites early Greek sculpture as an example of the consequences of different materials, "poros" and marble, on style. Yet in Greece it is precisely the softer poros which preceded the marble. Had he observed more closely the sculptures of Moissac, of which he has written, he would have seen that in the same calcareous stone is carved a great diversity of figures and that the few marble imposts are neither more nor less crudely decorated than the simple limestone. Not only the most primitive capitals in the cloister (the Shepherds, Cana, Washing of Feet) are in the latter material, but also the most highly developed in design, realism, technique, and complexity of ornament—those of the south gallery. The marble pier reliefs stand between them; but on the later porch the most delicate carving appears on the marble reliefs of the Visitation and Unchastity.

For many years it has been asked whether Romanesque capitals were carved in place, from the scaffolding, or in the workshop prior to elevation on the column. For the conditions of labor are manifestly different in the two methods. In the first the sculptor is not as free to manipulate the capital. In the second, however, he lacks the direct vision of its relation to the column, walls, and adjacent moldings. According to most students, Gothic sculptures were all carved in the atelier and set in the walls and arches afterwards, while in the Romanesque period both practices are observable. Labor on the scaffold supposedly explains the lack of delicacy in some Romanesque works. Placed high above the ground the sculptor had less ease and assurance in his labor and undertook fewer refinements. This, however, is uncertain, for a skillful sculptor, accustomed to scaffold conditions, was less limited by them. What is called crude is sometimes a willful simplification, or an early work of a powerful plastic sensibility. The inference of sculpture *après* and *avant la pose* is made

from the relation of the carving to the wall in which it is fitted. If a capi-
tal engaged to a wall is carved on all its sides despite its partial conceal-
ment, it is apparently an atelier rather than scaffold product. But the per-
fectly adapted capital may as well be an atelier as a scaffold sculpture, for
the specifications and context could have been readily anticipated. The
determination of the method has more often been a subject of controver-
sies over dating rather than of strict technical inquiry. To justify dating
of sculptures later than the known consecration or completion of the
building, it has been argued that the capitals were carved long after they
had been set up rough-hewn on the columns; while those who defended a
precocious dating of sculptures in a building constructed over a long
period of years invoked the theory of a sculpture *avant la pose* to corrob-
orate an attribution to a time when construction had barely started.

In Moissac the capitals are on columns so low that a scaffolding was
probably never employed. On the capital of the Annunciation engaged to
the northeast pier (Fig. 69), the servant is cut at the left in order to fit
the vertical surface of the pier. This would not have happened if the capi-
tal had been carved *in situ*, for then the sculptor would have adapted the
figure to the narrow space. It is possible, on the other hand, that this cut-
ting is due to the later reconstruction in the thirteenth century when the
pointed arches were erected. Vöge[97] supposed that the earliest Roman-
esque sculptures, and especially those of southern France, were carved in
place, but there are several capitals in Toulouse, on the portals of St.-Ser-
nin and of St. Pierre-des-Cuisines (a priory of Moissac), of which the
faces turned to the jambs are sculptured like the others. They were there-
fore carved before their erection on the columns. It is certain also that the
earliest capitals of the cloister of Silos, which date from the end of the
eleventh century, were not carved in place, since in the clusters of five
capitals at the midpoints of the arcades the central capital is as minutely
carved as the others, although hardly accessible to a chisel between the
four supporting columns.

II

THE TYMPANUM

The first Romanesque art of Moissac appears in numerous capitals, some
decorated with religious subjects. Larger reliefs are of single figures. The
whole recalls an illuminated Bible in which the miniatures of each book are

preceded by a full-page figure of the author. Initials are fancifully wrought with beasts and flowers as on some of the capitals.

In the tympanum of the south portal (Figs. 92, 93) the sculpture of Moissac becomes truly monumental. It is placed above the level of the eye, and is so large as to dominate the entire entrance. It is a gigantic semi-circular relief, five meters and sixty-eight centimeters in diameter, framed by a slightly pointed archivolt in three orders. Its great mass is supported by a magnificently ornamented lintel, a sculptured trumeau, and two doorposts of cusped profile, on which are carved figures of Peter and the prophet Isaiah. The portal is sheltered by a salient barrel-vaulted porch, decorated on its lower inner walls with reliefs representing incidents from the Infancy of Christ, the story of Lazarus and Dives, and the Punishment of Avarice and Unchastity. On the exterior of this porch, which is attached to the south wall of the western tower of the church, the figures of the abbot Roger (1115–1131) and St. Benedict (?) have been set above engaged columns.

In its grouping and concentration of sculpture the porch is comparable in enterprise to an arch of triumph. The tympanum alone is a work of architecture, for twenty-eight blocks of stone were brought together to form its surface. That so shortly after the reemergence of figure carving in stone such great monuments were attempted testifies to the rapidity of development and the unhampered ambitions of monastic builders in the presence of new means and new powers.

On the tympanum, about a central group of a gigantic crowned Christ enthroned in majesty with the four symbols of the evangelists and two seraphim, are placed the four-and-twenty elders bearing chalices and various stringed instruments (Figs. 93–106). These verses of the fourth and fifth chapters of the Apocalyptic vision of John are almost literally rendered:

> Revelations iv, 2 . . . and behold, a throne was set in heaven, and one sat on the throne.
>
> 3. And he that sat was to look upon like a jasper and a sardine stone; and there was a rainbow round about the throne, in sight like to an emerald.
>
> 4. And round about the throne were four and twenty seats; and upon the seats I saw four and twenty elders sitting, clothed in white raiment; and they had on their heads crowns of gold. . . .
>
> 6. And before the throne there was a sea of glass like unto crystal: and in the midst of the throne, and round about the throne, were four beasts full of eyes before and behind.
>
> 7. And the first beast was like a lion, and the second beast like a calf, and the third beast had a face as a man, and the fourth beast was like a flying eagle. . . .

v, i. And I saw in the right hand of him that sat on the throne a book written within and on the back side, sealed with seven seals.

8. . . . and four and twenty elders . . . , having every one of them harps, and golden vials full of odors, which are the prayers of the saints. . . .

The tympanum does not render a specific line of the Apocalyptic text but a characteristic and impressive moment of the vision. It omits the "lightnings and thunderings and voices" and the "seven lamps of fire burning before the throne"; and though the elders are given instruments and phials, they do not kneel before the lamb, as in the verse which describes them, "having every one of them harps and golden vials full of odors, which are the prayers of the saints." The two angels with scrolls are likewise abstracted from their immediate context (Rev. v, 2, mentions one angel, and v, 11, "ten thousand times ten thousand, and thousands of thousands"), and with their six wings are the seraphim of Isaiah's vision (Isaiah vi, 2), not John's. Unlike the text of Revelation, Christ blesses with his right hand and holds the sealed book in his left, while the four beasts, whose evangelistic symbolism is absent from John, are given the books a later tradition ascribed to them. The crown and cross nimbus of Christ are also additions to the original vision. The symbols have not the six wings or the many eyes a literal rendering would demand (Rev. iv, 8), but only two wings, in departure from both John and Ezekiel. Their arrangement about the throne follows the order of the heads of Ezekiel's tetramorph rather than the text of John.

With all these modifications of the vision, the tympanum is yet wonderfully in accord with it. A simple hierarchical conception of the Apocalyptic numbers is expressed in its design. The central and largest figure is the one God; next in magnitude are the two seraphim; then follow the four symbolic beasts, and smallest and most removed from Christ are the twenty-four elders in three rows. The symbolic beauty of this conception, which is unique in the iconography of the theme, will be apparent from a confrontation with some ancient traditional version like the great mosaic of St. Paul's in Rome.[98] Here only the bust of Christ is represented in a large medallion, above tiny angels; the symbols fly in a vast heaven beside him, while the elders, grouped in two unequal rows of twelve, are tall figures, as large as the object of their veneration.

Beside this theological contrast of magnitude and number, the abstract elements of design, the symmetry, and the proliferation of energetically opposed animated lines reinforce the vision, and the numerous details of terrestrial ornament and distinctions, unmentioned in the text, contribute to the reality of heavenly splendor. The meander ribbon, issuing from the jaws of monsters, bounds the whole vision and is lost under

the wings of the seraphim and symbols, like the heaven of a primitive cosmogony.

The attribution of repose to only one figure in the whole tympanum, the seated Christ, who is placed in the center of the field, and the surrounding of this dominating center with large figures in energetic movement, are conceived in the spirit of Apocalyptic imagery. The directing of the heads of the numerous little elders toward the central figure of Christ produces an effect of peripheral waves reaching out to the corners of the tympanum. Ten of the elders sit with legs crossed; the others acquire a similar animation by the contrasts of limbs and instruments. The wavy lines of the sea of glass, the meandering ribbon under the archivolt, and the dense, serried feathers of the many wings contribute further to the restlessness of the whole. The focus is maintained throughout, and all the details seem to revolve about Christ. Even the sea of glass halts for a moment before his feet; the amplitude of the wave is noticeably greater here in acknowledgment of the common center.

The thirty-one figures are distributed symmetrically in contrasting directions. In the center is the vertical Christ; around him the circle of symbolic beasts flanked by the two seraphim; and beside and below them, in horizontal bands, are the seated elders. The zoning of the latter parallels the lintel so that the frieze of rosettes seems a part of the figure composition, and a great cross is thereby created of the vertical Christ and the trumeau, and these bands of elders and the lintel. The side doorposts further prolong the verticals of the seraphim and oppose the horizontal bands above by their contrasting divisions; while their scalloped contours flank the trumeau just as the similar curves of the symbols accost the central figure of Christ.

This architectural composition is stressed by the distinct isolation of all the elements. The elders are grouped as separate individuals in clear alignment. The encroachment of one figure on another is only peripheral and never obscures the second. The high relief of the wavy borders of the horizontal zones provides a definite boundary of the groups of elders; and the difference of scale between Christ, the symbols, and the seraphim creates an equally effective segregation.

The distribution of the figures and the zoning of groups of elders do not correspond strictly to any underlying architectural divisions. The appearance of molded frames between the bands of elders is a sculptured contrivance rather than an actual jointing. Likewise, the central group of Christ and the symbols is independent of the structure of the tympanum and is composed on several slabs on which figures have been carved without much attention to the joints. It was inevitable that these should to some extent correspond to the figures, but the latter are not determined by them. Whatever appearance of architectonic order the tympanum pro-

duces is the result of an independent design which has a decorative regu-
larity and a symmetry to a large extent self-evolved. This conception of
tympanum design must be distinguished from that of Chartres and of
Gothic portals, in which each group corresponds to an architectural divi-
sion of the registers of the lintel and the upper lunette. It accords with
the latter only insofar as the use of numerous slabs, as in a mosaic compo-
sition, imposed some system or economy on the sculptor and demanded
that he avoid as far as possible the extension of one figure on two slabs.
Hence the smaller elders are carved singly or in groups of two on single
blocks of stone; but the larger Christ and the adjoining figures are cut by
the joints of several slabs. Compare this with Chartres where each vous-
soir has its own figure or complete ornament and the main figures of the
tympana, like Christ and the Virgin, are carved on single blocks of stone.

Within the symmetrical design and simple arrangement of its numer-
ous parts, the tympanum includes irregularities which are manifestly
planned, but not apparent without close examination. These irregulari-
ties are not the small variations inevitable in human workmanship, to
which in reaction against the machine one attributes an inherent aes-
thetic worth, but decided deviations from an expected sequence or a can-
onical geometric form. They produce expressive contrasts and exciting
interruptions in accord with the restless animation of the tympanum as a
whole. Thus the repeated wavy lines below the uppermost band of elders
are not only discontinuous; they are not strictly parallel. The even
number of figures on the lowest zone and the symmetry of the whole tym-
panum precluded an elder directly beneath Christ. Such a figure would
have detracted from the exclusive centrality of the latter and given too
great a prominence to the vertical axis in a primarily radial and concen-
tric scheme. Yet the sculptor, with a fine feeling for the exigency of the
design, and in avoidance of a static precision, has arranged the heads of
the four elders beneath Christ in an asymmetrical series, so that one is
nearer to the axis than the other (Figs. 93, 104). The parallel rather than
divergent diagonals of the instruments confirm this asymmetry and pro-
duce a contrast of directions within the group of four.

This deviation from the expected symmetry is as artfully sustained in
the lintel, where there is likewise no single central unit but a juncture of
rosettes at a point to the left of the axis of the tympanum and the central
division of the row of elders. The slight preponderance of the right side
of the lintel is perhaps designed to balance the arm of Christ extended at
the left. But the shifting of the axes is a corollary of a more general move-
ment in the design of the whole.

Just as the ten rosettes are not aligned with equal intervals, the heads
of the elders show a similar casualness in their arrangement, which
appears rhythmical and necessary when more closely observed. If we

number as 1 to 8 (from left to right) the separate slabs on which the lower zone of elders is carved, we see that the head of the inner figure of 4 is farther from the axis than the opposed head on 5; and in consequence the interval between the two heads on 4 is less than on 5; the inner head of 3 is, in contrasting interval, farther from the axis than the corresponding head on 6, and its distance from its mate is less than in 6. On each side there is one interposition of a chalice in a wide interval. But these two chalices are not symmetrical; one is in the extreme left block, the other in the fifth, near the center of the whole zone. If the bosses of the heads are considered single plastic units of equal magnitude and salience, and the chalices, minor masses, then the pattern of bump and hollow is hardly as regular as the general orderliness of the tympanum would lead us to expect. On the zone above there are two groups of three elders (Figs. 98, 99). On the left they are arranged: two, large interval, one; on the right the three are separated by two large intervals.

In the symmetrical central group of Christ, the symbols, and the seraphim the dynamic character of the coordination is especially apparent. The seven heads form an elliptical figure of horizontal major axis in contrast to the dominant vertical Christ and in closer accord with the shape of the tympanum. The wings of the lion have been turned upward to connect his head with the left seraph, a modification of the symmetry of the two lower beasts, which adds wonderfully to their energetic movement. In contrast to the flexed arm of the left seraph, the left arm of the other seraph is designed to complete the ellipse of the heads. The implied figure is not really an ellipse, but a less regular form, since the heads of the seraphim are nearer to the upper than to the lower symbols. The bull's head is higher than the lion's, the eagle's higher than the man's, and in consequence these four heads determine diagonal, not vertical or horizontal lines. The glances of the lower beasts are not directed toward Christ, but in powerful intensification of the movement of the geometrically ordered tympanum trace a great X with the crossing point beneath the convergent symmetrical beard of Christ. There is an obvious multiplication of parallel diagonals, like the horns and wing of the bull and the wavy lines on his back, which accent the same intersecting scheme. It is further complicated by the diagonal draperies on the body of Christ.

Even Christ (Fig. 94), the one strictly frontal figure on the tympanum, is asymmetrical in the benedictional gesture of his raised right hand, in the contrasting arrangement of the folds of the two shoulders, and in the great sweep of drapery at the left ankle, unduplicated on the right. This drapery is the immediate counterpart of the arched back of the bull, from which it seems to diverge, and opposes in its curve the right arm of Christ and the enveloping folds. By means of these diagonally contrasted elements, the figure of Christ, though solidly enthroned, acquires some of

the animation of the surrounding forms. There is also an element of strain or inner tension due to the sloping thighs and legs, which form a zigzag line with the diverging feet. The inclined throne, as a plane diagonal to the common wall, is a corresponding motif in relief.

How deliberately such forms were sought and turned to the common end appears in the tail of the bull (Fig. 96), which sweeps upward with the lower edge of Christ's robe and with the long fold that issues from under the jeweled edge of the mantle (and also with the bull's hind leg and his back, and even the sea of glass) and then suddenly drops, diverging in four radial, curved locks, like the fan-shaped folds to the left. The lion's tail describes an analogous curve; but the symmetry of these tails is disturbed by the rhythmical opposition of the ends, the one pointing upward, the other down (Fig. 97). Such intensity of linear design is sustained throughout, and collaborates with oppositions of relief to stir the more rigid geometrical framework of the whole. We have only to examine a small portion of relief, like the hind leg and flank of the lion, to perceive the excited, vigorous movement of the well-ordered forms. The symmetry and zoning appear for a moment as elements of the vision, or simple devices of order in architectural design, rather than an essential pervasive scheme.

It is characteristic of the style that the individual figures cannot be reduced to a banded or symmetrical design like the tympanum itself. This is sufficiently clear in the animals, in the symbol of Matthew, and in the elongated zigzag postures of the seraphim. Even the smaller elders are as complex in design. Though the heads are fixed on a common point, the bodies have a wonderfully varied and independent life which maintains the movement of the tympanum in every block. There are no two elders who sit alike or whose garments are similarly arranged. The patterned zigzags of falling draperies are continually varied and attest to the ingenious fancy of the sculptor. The heads, also, show this in their tilted poses, in the diversity of hair, beards, and crowns. The instruments and chalices furnish additional motifs capable of as great variety though similarly shaped; raised or lowered, held horizontally or diagonally, in the right or left hand, they form essential parts of unique conceptions of each figure. Those who are seated at the outer edge and touch upon the archivolt have an additional source of rhythmic complexity in a thick ribbon framing the tympanum. Its irregular beaded meander is in lower relief than the figures which at times overlap it, but it moves with them and their sharp angles of limb and instrument are contrived to parallel its winding form.

A study of the two elders seated opposite each other in the upper zone adjoining the seraphim (Figs. 98, 99) will reveal much of the sculptor's intention and his method of design. They are symmetrical with respect to the figure of Christ and are unusual among the figures of the tympanum

in that their postures are so similar despite the constant variation of the corresponding units of the two sides of the relief. They are seated in repose, with the right leg placed across the left in an impossible horizontality. In both figures the left leg is perfectly straight, in evident architectural contrast to the supported limb. This post and lintel construction is maintained by the vertical instruments of the two elders, and by the lines of the torsos and draperies. The arms too preserve as straight a line as possible and, if slightly curved, do not cross the torso. The heads alone offer a prominent contrast to this rectangular scaffolding, for they are turned to the figure of Christ between them.

The repetition of the crossing of legs is an asymmetrical motif, for the same leg is crossed in the two figures, instead of the parts corresponding in a symmetrical composition. If both instruments are held stiffly vertical, one is suspended from the horizontal limb, the other is raised above it. The left figure bears a chalice in his left hand, the other elder, with his right, draws a bow across the erect viol. The right elder has a short beard that forms a broad fringe across his jaw; the left elder's beard is long and stringy, with locks falling upon the breast and shoulders. The crowns, too, are contrasted—round in the one, polygonal in the other. There are also effective differences in costume and the disposition of the folds which are apparent in the photographs and require little comment. I must mention, however, those apparently descriptive details of the two figures which reconcile these differences and attach the divergent forms to the common framework. Such are the curved lines of the mantle of the left elder, enclosing the banded folds of the breast, and the straight lines of the same garment falling from the right leg behind the suspended instrument. In the other figure the same function is fulfilled by the viol and the curved bow, now damaged, which produce a similar play of curves across the torso, and the vertical fall of drapery from the horizontal leg, accented by a jeweled border, in counterpart to the suspended instrument of the other figure. A close study of the movements of the figures, the wings, and the folds, which as representations of real objects are strange and quaintly elaborate, reveals in them an impassioned logicality of decorative directions. Each line reechoes or answers its neighbor, and the mutual interest of these figures in the vision is corroborated in the relation of their smallest lines.[99]

The symmetry of these two figures is restless, though they are not in motion and express no inner disturbance; their forms have been designed in sustained opposition. Even in those elders who are ostensibly moved by the vision of God and sit uneasily or cross their legs, the effect of animation is primarily an imaginative contrivance of the sculptor, and issues more from the fantastic but coordinated play of lines than from the observation of excited human movements in nature.

The *contrapposto* observed in several capitals of the cloister is raised

to a higher power on the tympanum by the forceful contrast of more numerous elements. The wonderful elders seated at the edges of the tympanum will illustrate this clearly (Figs. 100, 101). In these figures the movement of the head toward Christ is opposed by the arms or legs, as if the whole figure did not participate in the vision and the eyes were suddenly distracted from another object. Yet by these opposed movements, the expressiveness of the tympanum is considerably heightened and the excitement of the center transmitted to the corners. The gesture that binds the elders to Christ is in fact part of an independent zigzag or *contrapposto* scheme. In the lower right figure (Fig. 100) the arms and thighs are carried to the right in contrast to the head, but the instrument is raised in opposition to this movement and the left leg crossed with a similar intention. By a radical distortion of the ankle the right foot is turned to form a diagonal converging toward the left. The beard is prolonged as a braided band parallel to the viol, the left leg, and the right foot. This Romanesque *contrapposto* is distinguished from the spiral torsion of Renaissance art in that (among other things) the pliable parts of the body—the torso and neck—preserve an independent rigidity, the larger form is zigzag rather than curved, the opposed movements are usually in planes parallel to the background, and the contrasted elements are divided or terminated by intricate, winding, and broken lines. In the Romanesque works the balance is largely unplastic, linear. It is no equilibrium of masses but a balance of directions in a single plane which is not designed to effect an ultimate repose. Instead of a redistribution of masses by which the body is relaxed, the sculptor has designed a scheme of opposed movements by which the limbs are uniformly strained. In the two seraphim (Figs. 96, 97) the parallel bending of the legs balances the turn of the head, but this balance is a tense, restless posture that cannot be maintained. The knees are strained and the legs fixed in a movement away from the rest of the figure. In the elder at the extreme right of the middle row (Fig. 101) the crossed feet form an unstable, unsupporting mass. In the corresponding figure on the left the instrument is suspended diagonally, outside the main body mass. Observe how even in such small details as the position of the hand grasping the chalice, the sculptor has sometimes chosen an arbitrary and difficult articulation. In the middle zone of the left side of the tympanum (Fig. 98) the second elder holds the cup suspended between two fingers, not at the base but at the upper bowl. The elder at the extreme right of the same zone (Fig. 101) has twisted his arm in order to grasp the chalice with the thumb outward.

On the tympanum the body is only one element in the equilibrium of the figure. It is part of a larger scheme in which the drapery and instruments have a considerable role. In the outer elder of the upper left zone the body is bent diagonally from left to right, and the draperies suspended from his left arm and the parallel instrument, now destroyed,

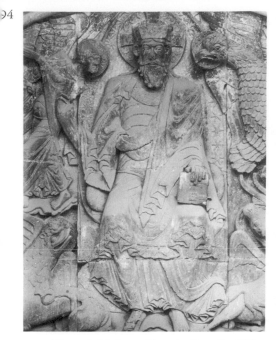

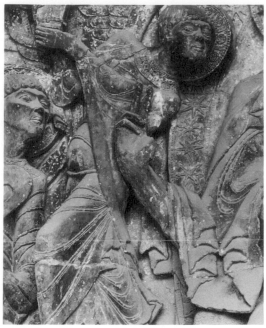

Fig. 94. Moissac, Church; Detail of Tympanum: Christ and the Four Symbols

Fig. 95. Moissac, Church; Detail of Tympanum: Symbol of Matthew

Fig. 96. Moissac, Church; Detail of Tympanum: Symbols of John and Luke; the Right Seraph

Fig. 97. Moissac, Church; Detail of Tympanum: Symbols of Matthew and Mark; the Left Seraph

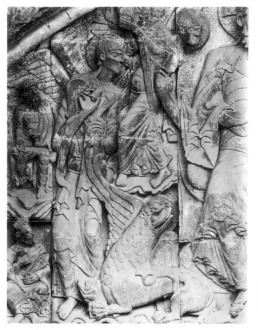

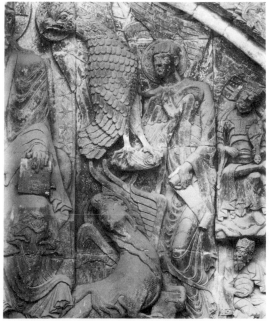

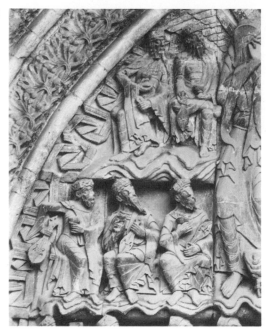 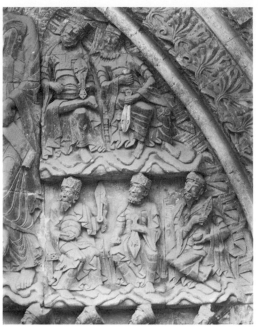

Fig. 98. Moissac, Church; Detail of Tympanum: Elders of Upper Left Rows

Fig. 99. Moissac, Church; Detail of Tympanum: Elders of Upper Right Rows

Fig. 100. Moissac, Church; Detail of Tympanum: Elder at Right End of Lowest Row

Fig. 101. Moissac, Church; Detail of Tympanum: Elder at Right End of Middle Row

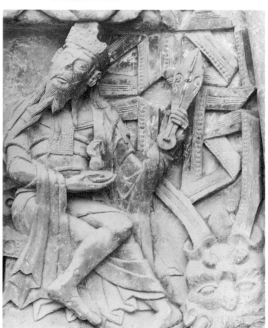 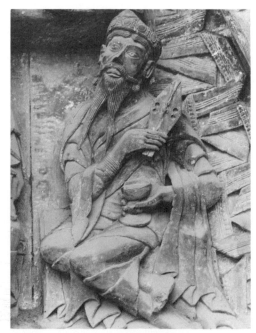

maintain the balance of the figure (Fig. 98). But even with this coordination of lines the result is less a stabilized structure of parts than a restless crossing of lines. I have already mentioned the extended instruments of other elders (Fig. 100) which, in balancing the turn of the head and legs, create an additional strain. The very overlapping of the meandering ribbon by those figures (Figs. 100, 101) is a reflection of the same character of the style. Where such external lines do not enter to oppose or play with the body forms, the edges of the garment are broken in meandering pleats that produce a similar effect. The body is rarely isolated as a closed, self-balanced mass, but is usually a complex angular structure in a more intricate system of moving lines.

Even this dominant structure is subordinate to a linear surface design, despite its high relief and apparent plastic strength. There are numerous planes diagonal or perpendicular to the background, but they are limited to the individual figures and are never prolonged to modify the spatial form of the whole. They are not conceived as directions proceeding from the outer surface of the tympanum toward the background, but as the indispensable outward projection of a figure placed against a wall. We shall grasp this character of the figure more clearly when we have examined the space of the tympanum as a whole.

The Apocalyptic vision is rendered on the tympanum rather than in it. The space of the literary conception is compressed into the architectural limits defined by the enclosing arch of the relief and the impenetrable Romanesque wall. The sculptor does not attempt to suggest an expanse wider than the portal or deeper than the thickness of the stone. If the elders and symbols circle about Christ, it is in one plane; they can step neither behind nor before him.[100] They are on the stones placed above or beside, none more salient than the other, to form a sculptured wall.

This archaic equality of projection is essential to the formal unity and the architectural setting, and is hardly perceived as a contradiction of the vision. Yet, just as the symmetry of the whole includes so great asymmetry in the members, the apparently flat surface composition unites figures that are all so deeply cut as to constitute separate free statues in the round. Regarded from the side, the elders seem an array of men seated on a narrow ledge, rather than applied or engraved upon a wall (Fig. 103). The heads of some of them are even detached from the background, the necks undercut, and the arms and instruments free, except at one or two points. This new boldness in carving accounts in part for the destruction of projecting members and accessories.

But the contrast of figure and neutral background is so regular and organized that the seated elder, a statue in the round, with fully articulated, asymmetrical body, appears as a "motif," a unit repeated with decorative effect, as in the cloister capitals.

Each figure occupies a little less than the full depth demanded by his

position. But since behind each elder we see a common wall and since no two overlap, the represented space appears to be limited to the depth of the elders' seats. The variety of movement achieved within this narrow space confirms its actuality. Yet the subordination of this movement to a whole composed primarily in line, in which each elder is a unit of a large surface design, provokes our attention before the individual spaces described above.

For how arbitrary are the seating of the elders and the structure of the whole vision! The figures are superposed on narrow ledges so that those below can see only the heels of those above, and the central object is only barely visible to the elders. In the Roman mosaic of the vision in S. Paolo *fuori le mura* the elders are ranged in two rows of which the upper figures are partly concealed by the lower and appear to be behind them. But within the more extended depth of the earlier work there is an even less realistic coordination; for if the figures are turned toward Christ, their heads face the spectator. In Moissac, they are all turned to behold Christ, but they can hardly see him for lack of space to turn in and a plausible viewpoint.

In this respect the tympanum is archaic like the cloister capitals on which the figures are also of relatively high relief, even if less boldly undercut. Whatever overlapping of figures appears in the tympanum is limited to their extremities, so that no one is in lower relief than another. The wings of the lion and bull cover parts of the seraphim's legs, but the bodies of the latter are as salient as the beasts', and no greater depth is effected by the overlapping.

Even the platforms on which the figures are placed are not strictly horizontal planes but sloping surfaces, analogous to the astragals of the cloister. Their projection is, of course, more considerable, like a narrow stage, but still not enough to permit the full extension of the thighs of a seated figure. The thigh is therefore seen in profile or is placed at an acute angle to the wall. But in the few figures whose legs are extended at right angles to the wall, the thighs are necessarily foreshortened, precisely as in the exceptions on the cloister capitals and as in contemporary drawings. The sculptor has tried to give the legs of Christ their full extension by inclining the lap as if the figure were seated on a sloping surface or were drawing his legs underneath the throne. A similar distortion is practiced on the sloping upper surface of some of the elders' chairs (Figs. 99, 104). We recognize in it the survival of the more archaic vertical planes of the chairs and tables of the cloister.

Though their heads are turned at various angles the figures retain a characteristic axis which reveals the underlying archaism of the whole conception. In only one figure are the shoulders not strictly frontal (Fig. 104). It is true that they cross their legs and extend their arms. But these

movements are uniformly restrained and do not modify the simple block of the whole. They suggest in no way the penetration of the background wall, or a complete freedom of gesture. In no figure is the axis of the torso a curved line.

In the one elder whose shoulders are perpendicular to the background, the torso stiffly sustains this position (Fig. 104). The transition from the upper to lower body is therefore unreal. We may observe here how the more sophisticated conceptions of movement, when they appear in an archaic art, are transformed into schematic representations as arbitrary as the most primitive rendering of a figure at rest. The limbs are treated as separate units and combined in disregard of the complex torsion of connecting parts, which makes these movements possible.

That the movements of such figures were conceived as on a flat surface appears from the extension of the instruments and from the distorted positions adopted in order to cross the legs and turn the body in parallel planes (Figs. 100, 101). If they generate no spatial design despite their twisted and restless postures, their limited movements in depth are nevertheless essential to the quality of the tympanum as a whole. The tympanum is so densely filled with irregular solids that hardly a smooth clear surface is visible in the entire work. The endless complication of radial and zigzag lines is paralleled to some extent by the play of projecting limbs. The cross-section of the tympanum at any level is of an extreme complexity and offers analogies to the overlapping and involvement of shorter lines in plane. How deliberately this circulation of forms within the limited depth of the relief was designed may be seen in the outer garment of the elder in the lower right corner of the tympanum (Fig. 100). It passes behind the right shoulder, under the upper arm, across the forearm and right thigh, and behind the left foot. It is coiled in depth and interlaced with the body like the fantastic beard of the same figure. In the elder above him (Fig. 101) the mantle issues from behind the back through a triangle formed by the flexed arm, as though a knot, and falls behind the right foot which, by a similar design, is twisted around the left leg.

There are several figures in whom the contrast of limbs, though still subordinate to a linear surface design, implies the emergence of a more plastic and spatial relief. It is apparent in the two elders at the left end of the middle row, whose legs are turned toward each other (Fig. 98). In the outer figure the overlapping of the arms, the instrument, and the winding ribbon produces an active recession of forms in space, which is confirmed by the diagonal projection of the right thigh and the inclination of the head and crown. The mantle asserts its spatial character in its inclination from the projecting knee to the right shoulder and in its draping of the left arm.

Yet even in these figures the contrasting limbs are designed primarily on a common surface as directions or lines to which the necessary realization of the individual form of each part gave a more spatial character. The diagonal projection of the legs in both elders was first conceived as a diagonal movement in plane. The shoulders and torso remain parallel to the background and the feet are brought forward to the same plane, though the thighs are at a marked angle to the surface. It is noteworthy that in no instance is a leg bent sharply backward in depth, but in many figures it is inclined diagonally, parallel to the surface (Fig. 96).[101]

The figure of the angel symbolizing Matthew includes the typical distortions resulting from the embodiment of intense movement, designed in a single plane, in figures carved in the round, with an archaic bias toward distinctness, generalized representation, and parallel planes (Fig. 95). His pose suggests a body placed in depth perpendicular or diagonal to the surface of the tympanum; in fact, the prominence of his belly with its rounded contour is clearly that of a figure in profile. Likewise, the outline of his left shoulder, which has been foreshortened, belongs to a profile position. But if we regard the other shoulder we shall see that it does not extend into the wall in the expected direction; it is parallel to the background like the shoulders of Christ and the seated elders. The whole figure is in consequence distorted; but from this arbitrary twisting results a greater energy of movement. The limbs appear to be all the less constrained. These positions are not really impossible, but they are achieved in actuality only with effort, and are precariously sustained. Such also is the crossing of the angel's legs. The feet are brought to the same plane of the foreground instead of standing one behind the other. We perceive this as the necessary accompaniment of the twisting of the shoulders and the crossing of the arms. The head and hands are opposed above, like the two feet below, as the terminations of the diagonals of a great X which underlies this figure. The extended arm of Christ adds another diagonal to the whole scheme. In accord with this intensity of gesture, the contours of the figure are wavy and zigzag. We have only to follow the outline of the upper part of the figure, the lifted book, the arm, shoulder, and head, and compare it with that of the left side—of the projecting leg, the belly, and the mantle edge—to see that the effect of energy and movement inheres not in the posture alone, but in the play of body and drapery contours as well. The shapes of adjacent objects also contribute to this movement of a single figure. The extended arm of Christ has already been mentioned; observe too the feathers of the wing above the angel's head, the nimbus, and the curved line of the starred mandorla which rises from behind it.

We see from this analysis that the distortion of the body arises more from a linear design than from plastic considerations. To cross the limbs so energetically as to produce an X and a related zigzag silhouette and

maintain at the same time the clearer and more characteristic views of the parts of the body required an inconsistency in the natural articulation, which hardly deterred a sculptor to whom the form of the whole body was a pliable expressive aggregate of separate limbs.

The persistence of an archaic system of forms is apparent in the inconsistent directions of the glance and the turn of the head. Because of the universal attraction to Christ we interpret each eye as directed toward him. But in most of the elders, and especially those at the ends, the inclination of the head has only a symbolic and compositional reference to Christ. The eyeballs themselves are perfectly smooth or show an iris or pupil incised at the center of the eye. If the glance were prolonged as a line perpendicular to the horizontal axis of the eyeballs, it would fall in most cases, not on the figure of Christ, but outside the tympanum, far before him.

This apparent contradiction of the intended glance and the turn of the head is a modern reading foreign to the Romanesque sculptor. The composition was designed as if in one plane and the turn of the head represents a movement on the surface of the tympanum, and not in a depth unformulated and unimagined by the sculptor. The figures appear to us isolated, freely moving three-dimensional objects, but although they are such in substance, they were not entirely such in the conception of the artist. The glance was for him not a direction in three-dimensional space but, like other large movements, an implicit line on the plane surface of the image. A strictly frontal figure like Christ can therefore have no glance; it would presuppose a space outside the image. To determine the intended glance of the Romanesque figures of the tympanum, we should draw lines in the plane of the latter, prolonging the horizontal axis of the eyes. They would then converge approximately to the head of Christ.

If the sculptor admitted the necessary profile views of the heads of the elders directly beneath Christ (Fig. 104), it was not simply because this turn alone was plausible, or more consistent with a spaceless conception than another posture, like that of the shepherds in Byzantine and Gothic art who look up frontally to see the angels. It is motivated also by the dynamic (and, in a sense, kinematic) concentration on Christ achieved by a progressively effected coincidence of the posture and the glance; it conforms to the central position of these heads beneath Christ and their symmetrical pairing below his divergent feet. Since the gaze of a figure is defined by the prolongation of the horizontal axis of the eye, or a line in the plane of the tympanum perpendicular to the vertical axis of the face, a head directly beneath Christ could see him only if turned in a horizontal profile.[102]

In a later sculpture of the same magnitude, the outermost figures would be turned in the sharpest profile and the more central individuals

would maintain a three-quarter or frontal position. For since the heads are carved in the round, the spectator from his central viewpoint would see the peripheral profile heads in three-quarters, unless the profile were emphasized. In Moissac, however, each figure is carved as if seen from a point directly opposite and is bound to the whole by a linear and surface, not spatial, design. The insistent representation of twenty-four profiles would have been repugnant to a sculptor devoted to a fuller rendering of parts, and would have, besides, overaccented the subordination to Christ in a field of which each corner has its varied, distinctive form. Such a pro-filing would also have produced in each figure a movement in depth and commanded either a profile body, in contradiction of the primarily paral-lel relief planes of the whole, or a stark uniform contrast of the profile head and frontal body.

The profile heads of several elders in the lowest zone show the consid-erable elasticity of the style. They indicate that the imaginative sculptor was not rigidly committed to a set archaic method but, as in the capitals of the cloister, could apply more developed forms (perhaps invented in the course of work). This is confirmed by the diversity of eye forms in the elders, which include a range from the most archaic smooth, unincised, inexpressive eyeball to an eye in which the iris is a concavity slightly off both axes of the eyeball. In several elders (Fig. 101) this concavity be-comes, because of the inclination of the head, the locus of an active glance, like the more impressionistically modeled eyes of a later art. Only its lack of a consistent spatial relation to the figure of Christ forbids us to identify this conception of the eye with a naturalistic rendering of a glance. Naturalistic details and individuals were sooner created than naturalistic groups.

A marked development in representation is apparent in other parts of the figure beside the eye, and corresponds to the greater complexity of relief and linear design in the tympanum as compared with the cloister capitals. The proportions are still arbitrary, ranging from the superhu-man height of Christ and the angels to the dwarfed figures of some of the elders, but they imply a freer choice and a greater knowledge of actual shapes than in the earlier works. For the heads are no longer the prepon-derant mass that was observed in the cloister; if the elders appear so short, it is partly because of hierarchical distinctions in the proportioning of the various types of figures on the tympanum, partly because of the exi-gencies of spacing. The larger scale of the whole permitted a greater relief and a more detailed rendering of familiar forms.

The structure of the limbs emerges more clearly from underneath the drapery than in the cloister, though still simplified. The swelling of the calf, the contour of the ankle and foot, are finely observed (Fig. 100) and utilized as important lines of the composition of a figure. The jointing

has become looser, so that less distortion results from the movements of hand and foot, and the fingers are bent with greater freedom. No hand in the cloister reveals such precise observation as the left hand of Christ, clasping the book (Fig. 94). On the right wrist are faint traces of a ridging that correspond to the tendon structure, unobserved in the cloister. Instead of the few conventional positions of the hand admitted in the cloister, the sculptor has produced a great variety, including some distorted hands of unarchaic complexity. The feet likewise show a more refined observation and increased knowledge. Less mobile than the hands, they were sooner copied with an effect of complete accuracy.

The greatest verity was sought in the reproduction of surface ornament, such as the jeweled borders of the garments, the cabochons of the crowns, and the embroidered rosettes of the cushion and cloth behind the figure of Christ. These are of an incredible minuteness and fidelity, in contrast to the broad chiseling of the other surfaces. Such exactitude was already visible in the earlier works of the cloister and it is not surprising in an art which reduces organic forms to regular decorative patterns. In reproducing this ornament the sculptor was engaged not so much in the imitation of nature as in the repetition of a familiar ornamental motif in stone.

The musical instruments are an excellent example of this kind of realistic representation which is simply the reproduction of an object, itself a work of contemporary art. The sculptor fashioned the instrument in stone in its actual dimension and detail, as did the original craftsman in wood. It offered no problem of adjustment to scale or perspective, for it was carved in the round and sometimes even detached from the background. The stone was sufficiently thick to permit a full reproduction without need of foreshortening. The forms were easy to render, since they too were essentially Romanesque creations. From these sculptured artifacts it is possible to reconstruct precisely the instrumentation of the period. Not only have the surfaces been carefully copied, but the strings are noted separately, and in one case a bow has been introduced. Such literalness is nevertheless not unartistic. The position of the instruments, their angles with respect to the seated and variously turned figures, are finely determined. But even the instruments themselves are beautiful and we must concede an aesthetic intention in the precise reproduction of shapes so graceful.

In the modeling of the larger body masses, like the torso and legs, the sculptor reduced the natural variety of surface articulation to a few broad planes. Such is the construction of the figure of Christ, who is divided into several sharply contrasted surfaces, all quite flat, on which numerous folds are inscribed. The richness of surface is primarily linear rather than plastic. Even the rounding of the legs and the hollow of the lap are

sacrificed to this impressive architectural severity of the figure. A single broad plane defines the upper legs and lap, another joins the lower legs, in disregard of the concave surface that ordinarily appears between them on so close-fitting a garment.

Of this quadrature of the body structure, the beautiful elder who sits at the extreme left in the middle row is a powerful example (Fig. 98). The thigh and leg have become prismatic blocks; their planes are contrasted like those of the crown of the elder and the sides of his stringed instrument.

The heads of the figures are squared in the manner of archaic Greek sculpture. The contrast of the planes of brow and eyes, of the sides of the nose, of cheeks and jaws, is so sharp that the stereotomic character of the work is brought into striking relief. The head has the appearance of quarried stone and the features seem hewn rather than chiseled. This vigorous construction of the head accents the symmetry of the features. On a wall less sheltered from the sun these heads would invite a more interesting light and shade with abrupt transitions and clearly outlined shadows. The division of planes accords with the conception of drawing, which delineates geometrically correct features, arches the brows high above the eyes, and isolates the parts distinctly to ensure perfect clarity.

Not the head alone but the more complex structure of crown, head, and beard constitutes the sculptured unit. These are united as the separate parts of a building in three dimensions, three superposed storeys, each unlike the other, with clear lines of demarcation. The addition of crown and beard suggests a wonderful variety of plastic combinations. In each head the disposition of hair and crown has a characteristic plan that is uniquely related to the facial structure.

On the crowns, the small cabochons and filigree motifs form an applied surface ornament which rarely modifies the structure or contour of the crown. But the beards are in themselves ornamental patterns, formed by the repetition and symmetrical grouping of locks and curls and the parallel striation of individual hairs, as in the more primitive figures of the cloister piers. But on the tympanum, the sculptor, freer in the use of radial and wavy lines, has produced more varied combinations in the effort to singularize the hair and beard of each of the twenty-four elders. The rich variety of beard and hair seems deliberately cultivated, like the arbitrary breaks and pleatings of the garments and their jeweled borders, rather than a simple imitation of contemporary manners. The elaborateness of the hair recalls classic descriptions of the customs of the Germanic peoples and the earlier Celts.[103] But it is doubtful that the finely combed long hair, beards, and moustaches of the Romanesque tympanum are simply imitations of a historical practice. The braiding of the hair and beard of one elder (Fig. 100) is known earlier in Irish art[104] and in Romanesque sculptures in Toulouse,[105] Saint-Antonin,[106] Verona,[107]

Silos,[108] and Chartres,[109] and León.[110] But these examples are so exceptional that we must regard the form, whether found in life or in art, as an artistic motif, an assimilation of the wavy, mingled strands of hair to a familiar mediaeval ornament. This is especially apparent in the Irish examples which are associated with borders of intricate interlaced bands. Likewise, the spiral locks of the beard of Christ recall the palmette designs of imposts in the cloister. The use of braided and more pronounced radial patterns on the tympanum, as distinguished from the simpler though equally ornamental hair forms of the cloister, corresponds to the heightened linear complexity and movement in the former.

Even though the features have been much more closely observed in the tympanum, the absence of facial expression is almost as marked here as in the cloister. The various combinations of hair do not conceal from us the uniform impersonality of the elders. The emotion of the figures in an apocalyptic experience is hardly indicated by their features. Except for the smile of the Matthew symbol and the left seraph, the heads are altogether impassive. It is remarkable that this peculiar smile should alone among all possible expressions of the face precede the others in both Romanesque and archaic Greek sculpture. The classical archaeologists have sometimes questioned the meaning of this expression and have even doubted that it was designed to represent a smile. But in Moissac it is probably a sign of beatitude or joy before God; in later scenes of the Last Judgment it appears in unmistakable emphasis on the faces of the blessed.[111]

I do not believe that it is simply a religious expression, just as it would be wrong to explain the impassivity of the elders as a consciously constructed image of their dignified attention to Christ or of their changeless nature. The presence of this smile in archaic Greek sculpture and in early arts in China and Central America, which otherwise maintained a common impassivity, calls for another, if only complementary, explanation. The more usual absence of facial expression is readily intelligible in the archaic context of plastically simple forms which are compounded of the stable characteristic aspects of objects. That the smile does occur in Moissac is less strange when we observe its limitation to a few figures and its schematic form. It is a simple curvature of the mouth rather than the revision of the whole face in emotion. Is the smile perhaps the archaic type of all facial expression, the most generalized and contagious form of facial excitement? And is the happiness of the angels in Moissac a theological motif congenial to a sculptor who for the first time was preoccupied with the representation of feeling, just as in later art incidents of extreme suffering are a chosen matter for realistic reproduction? When the wounded soldiers of Aegina grimace with pain, the mouth is turned upward as in the contrary archaic smile.

For the expressive effect of the whole tympanum the introduction of

special meanings in the faces of so many little figures would have been a superfluous and distracting effort. We have seen that the common excitement is transmitted in a much more subtle and striking manner by more abstract means. Of these, the elaboration of drapery forms deserves a special description. From the inanimate garments the sculptor derived more numerous and more intricate patterns of movement than from the human figure. In the design of the tympanum the figures are indeed skeletons which without their draperies would possess some articulation but hardly their present intensity.

The complication of drapery forms was inevitable in an expressive linear style which had for its chief subject matter the clothed human figure, and which was associated with an ornament of traditional linear complexity. In an art that rarely represented facial expressions, limited gesture to a few conventional movements, and conceived nude forms only in rare religious contexts, the greatest possibilities of expression, of surface enrichment, and of linear design lay in the garment. The most complex drapery forms, the most freely meandering movement of folds, are significantly found in those schools of Romanesque art which also display their dynamic goal in the extraordinary elongation of the figures and their unstable postures. But in Auvergne and Tuscany, where the garments cling more closely to the figure and are less intricate, the figures appear squat and lethargic.

The rendering of a fluent, mobile element like drapery hardly seems upon first thought a likely task of an art as archaic as the sculpture of Moissac. But the process which simplifies the nude body and selects clear positions and regular monumental groupings also orders the succession of folds in parallel or concentric surfaces. If these retain, in spite of the archaic treatment, the mobile quality of actual garments and, in fact, an even more extreme activity, it is because the processes of representation are in this style subordinate to an essentially dynamic expressive end. In the following analysis, we shall see that the drapery forms of the tympanum are unplastic linear abstractions of a geometric character, and that the great freedom and energy of movement spring from the arbitrary combination of simple stereotypes, in many ways unlike the forms of actual folds.

In the drapery of a Gothic or more recent sculpture, single folds are inseparable from the whole; they are more plastic than the Romanesque and mingle in such a way that whatever their patterning and linear organization they are perceived at once as parts of a common structure. We can trace no groove without observing the influence of neighboring forms on its expansion and movement; its origin is usually indefinite or vague. On the early Romanesque figures, folds may be more readily isolated, despite their apparent complexity. The entire pleating of the lower

edges constitutes a system independent of the upper portion, while the single grooves on the torso and legs are separate, unplastic elements attached to the garment like the buttons or fringes on a modern dress. The drapery resembles in this respect the forms of the figure itself. Just as eyes, nose, and lips are separate elements compounded to form the whole, so the folds are distinguishable entities on the costume, no matter how involved and contrasted.[112] This point, which seems obvious, is worth making since it confirms the pervasive character of the processes of representation and the style, whether occupied with animate or inanimate things.

The costume of the tympanum figures consists of the following pieces: a long, undecorated undergarment that falls to the ankles, a tunic reaching to a point just below the knees, usually bordered at the collar and lower edge with jewelry, and a simple mantle, only rarely buckled. Not one figure wears shoes. All but the two seraphim and the symbols are crowned. The crowns are not of one form, but round, square, polygonal, and are adorned with a variety of lozenge and simple foliate patterns. The elders are variously clothed; some wear all three garments, others only two, and on several we can detect but one robe. The ornaments also vary, both in their distribution on the collars and other borders and in the motifs employed. The system of design is uniform and traditional. It consists of the repetition, in alignment, of one motif or of two in alternation. The lozenge and the rosette are most common, while the simple bead or pearl is the usual filling of the interspaces. The high relief of some lozenges, the circumscribed circles, the carving of facets on both lozenge and circular units, point to the imitation of actual cabochons. Filigree appears in the beaded borders of some rosettes and in the beads attached to long, fine filaments.

The variety of costume is especially interesting since it is not commanded by distinctions of rank. It is an arbitrary choice which reflects at the same time a realistic predilection for diversity and a style that multiplies oppositions. It is in turn a source of textural variations and formal contrasts.

In the figures of the tympanum we are hardly aware of distinct robes, but of numberless pleats, folds, borders, broken edges, and overlapping planes of cloth, at first difficult to disengage. There are no clearly exposed, undivided surfaces on the garments. But this seeming chaos of drapery includes only a few types of pleats and breaks. These are arbitrary schematizations of actual folds multiplied, without exact reference to an existing model, for enrichment of sculptural surface and line.

On the tympanum the bare incised line common in the most primitive arts is exceptional and subordinate. It appears on the sleeves of some of the elders as a decorated border or as a means of rendering a particular

texture, sometimes as a faint wrinkle at the elbow joint. Its ornamental function is apparent also in the figures of Christ and the Matthew symbol as a line accompanying a more plastic or salient parallel fold.

Instead, the doubled line already described in the reliefs and capitals of the cloister is more commonly used. It is limited, however, to the figure of Christ, the seraphim, and the symbol of Matthew. Sometimes it is repeated in simple concentric loops or radial curves, as on the arms of the seraphim; sometimes two sets of such lines, proceeding from opposite sides of a limb or garment, interlock in alternation. This device was familiar in later classic art; it arose from the stylization of the great, deep-grooved folds of a suspended classical garment. It occurs, for example, on the Victories of the podium of the Arch of Constantine and on numerous figures in the province of Gaul.[113] But in Moissac, the classic subordination of these lines has been carried still further; they are only superficial markings of the surface of the figures; their repetition forms a secondary ornament beside the more powerful lines of the legs and torso.

The figures are swathed in their tunics as if bandaged by rolls of heavy cloth. The torsos are divided by concentric or parallel lines formed by the contours of these superposed bands. A similar banding covers the arms and legs, but here the lines are often radial. The garment is of so thick a cloth that the outline of a limb is stopped or broken by the succession of overlapping bands. On the central figures of the tympanum a finely incised line accompanies such folds. On the thigh of the Matthew symbol this incision is doubled. The alternate interlocking of two systems of adjacent concentric folds, such as occurs in the double folds, is also applied to these prominent lines between the legs of the right seraph.

The forms described so far determine for the most part curved lines and concentric groups. They are the forms of draperies fixed to the body and inscribed on its surface, and hence limited to simple lines, whether curved or straight. They are not among the more effective devices of movement employed on the tympanum, but their restless character is evident in two peculiarities of their application. They are designed perpendicular to the axis of the limb which they cover, and hence in contrast to its larger form. We shall grasp this effect more readily if we imagine a column banded with horizontal rings instead of flutings parallel to its axis. Imagine the corresponding Greek figures with the folds of their garments, not falling in easy verticals, but grooved horizontally about their bodies. In the second place, by the overlapping of such bands of cloth in concentric shells, the large simplified expanse of the leg or torso becomes broken and incomplete, like a telescoped object. The surface loses its definiteness and, though barely modeled, is perceived as a composite of numerous minor surfaces. An animated plastic effect is achieved here with

a minimum of relief. The device remains archaic in the similarity of these bands and in their regular succession.

These folds are too subordinate to the human figure to have suggested possibilities of more intense linear interplay to a sculptor little concerned with anatomical detail and plastic variety. But wherever the garment is only partly attached to the figure and at least one of its ends hangs freely, the design acquires a remarkable richness from the elaboration of the consequent broken contour. Yet the independence of anatomical constraint does not imply an unrestrained fancy. On the contrary, the units of a hanging bit of drapery are singularly conventional and limited to as few basic forms as the ornament of prehistoric pottery. But these elements occur in such a variety of combinations that the poverty of motif is hardly apparent.

Suspended drapery never falls here as one broad mass. It is subdivided by numerous parallel or radial pleats, all equally flat. The pleats are pressed so close to each other that no arris confronts the spectator. But in contradiction of this piling up of flat, almost parallel layers, their lower contours form larger angles than their superimposed surfaces, as if the edge of the garment were diagonal rather than horizontal.

This is an archaic device, analogous to the vertical surfaces of the tables and seats represented on the cloister capitals and the peculiar polygonal ends of the garments of the apostles. The lower edges are clearly exposed as if they were parts of a system of pleats forming angles of forty-five degrees. We have seen this same convention in the cloister—sometimes, as in the east gallery, it was even more arbitrarily applied. It is also familiar in the early sculptures of Greece and China.[114]

In this contour the artist reveals the full expansion of folds, of which the main surface is partly concealed, and makes the overlapping of drapery perfectly clear. The edge is defined by ascending and descending, less frequently horizontal, sequences of meandering and zigzag lines. The rhythmic movement of well-distributed, alternately advancing and receding lines, unequally accented by relief and shadow, is heightened by the play of the verticals they terminate. The simplest zigzag is of perfectly straight lines, all diagonal. The angle ranges from ninety degrees to very acute openings.

Often the pleating is more dense and intricate; the tucked surface is brought far under the outer layer, and meander patterns of extremely narrow interval are produced by the lower edges. Not content with the simple regularity of the common zigzag, the sculptor breaks each of its lines in two, forming an inner obtuse angle, as if the pleats were folded in the middle. Although the pleat remains as flat as before, its broken lower contour suggests an equally broken surface. But it is primarily an enrich-

ment of line that is sought in this device, although the more complex form might well have been suggested by real garments.

Beside these fan-shaped pleatings, a symmetrical form analogous to the peculiar polygonal patterning of the lower edge of the costume in the cloister is often employed on the tympanum. It may be defined as a symmetrical system of pleats of which the lower contours ascend diagonally to the central fold. The folds between Christ's legs are a clear example of this form. The border of his outer tunic has been disposed to produce two such groups of zigzags.

In several elders such contours are independent of lengthy pleats but terminate a small bell-like structure at the ankle, attached to the main body of the garment by a thin pleat or even a knot (Fig. 105–left).

At Christ's left ankle such a fold is monstrously expanded without a clear motivation by the form of the garment or the movement of the figure. The long wavy fold that attaches the fanlike pleats to the tunic is difficult to explain as a feature of an actual costume. This stem appears to be a ribbon or loose end of clothing projecting from an invisible undergarment. It is based on a more intelligible model, of which the parts have been combined without reference to their original relation. In classic and Carolingian art, on garments rendered as if blown by the wind, a long diagonal fold terminated in a domical structure that flew behind.[115] The diagonal was the index of the swiftness of the movement; the smaller its angle with the ground the greater the velocity and the current which produced the fold at its end. The figure of Christ bearing a long cross in the canon-tables of the Gospels of Saint-Médard-de-Soissons is a clear illustration of the original type.[116] In Moissac the connection of the terminal structure with the central part of the tunic has been misunderstood. It is attached to the end of the garment, yet the copied diagonal fold is added to connect the blown portion with the unmoved central part to which neither belongs.

There is another inconsistent but effective detail in the drapery of Christ which is a traditional survival of an ancient, misunderstood form. A hanging fold across the torso, passing under the drapery of the right arm, is a remnant of the sash formed in late classic art by the disposition of the mantle across the waist and abdomen. In classic figures the folds that covered the right arm emerged from under this sash as on the tympanum. The Christ of the mosaic of Santa Pudenziana in Rome is an example of the prototype of the Romanesque figure.[117] Here the mantle thrown across the body is no slight suspended band but a broad sash that covers the undertunic. As in Moissac the earlier Christ of the mosaic is enthroned and extends his right hand in a similar benediction. Although the original function of this bit of drapery has been lost in the sculpture, the artist has distinguished it clearly from the adjoining folds. He has

accented its continuity with the extended arm in the interception of the opposed concentric, convex lines of the torso, and hence its anaxial or eccentric correspondence to the symmetrical curves of the lion and the bull. By these oppositions the axial figure of Christ in the center of the encircling group becomes even more unstable, more active.

The simplicity of the linear devices described above has its counterpart in the modeling or relief of the garments. The obvious definiteness of the single contours, which is called by a just metaphor, "geometrical," is matched by the relative regularity of the larger surfaces. The garment envelops the body closely without plastic self-assertion. The multiplied pleats do not alter the surface of the limbs but determine a slightly thicker shell at certain points. If the drapery modifies the underlying body structure at all, it is by a simplification which shapes one broad plane across the legs to cover the hollow ordinarily between them. On this plane the folds are superposed, each quite flat, or incised. Where the folds hang or fall outside the figure they are attached to a chair or background wall or form a surface parallel to the latter. Even in those pleats which are slightly diagonal to the wall, as at the left ankle of Christ, the separate surfaces are flat, and there is little or no contrast with curved forms, and no irregular flow. The profiles or sections of folds illustrate the archaic character of the relief. The development of relief is measured not by the absolute depth of cutting but by the depth represented and by the variety of section of boss and hollow. In the tympanum the relief is less the result of varied modeling or shaping of surfaces than of the superposition of similar enveloping layers on a projecting mass. The extension of limbs carries with it the salience of the garment and its suspended folds; but these are themselves unarticulated and show no tensions or movement in a third dimension independent of the structure beneath them. The effect is of great massy surfaces with intricately cut boundaries and a network of lines.

A departure from the vigorous application of this conception appears in the shallow fluting of some vertical folds, and in the corrugation of broad surfaces, like the torso, by grooves zigzag in section. But the stylized form of these departures shows how well established is the linear rather than plastic conception of drapery. Even in the few folds of curved rather than zigzag or meander contour, the surfaces retain the simplicity of the others. The relief of the garments is essentially no different from that of a pressed pleated ribbon. This is the more evident in the figures seated near the frame adjoining the fine meander border.

Hence the draperies invite little contrast of light and shade except along contours. We are reminded of the plastic character of the undraped primitive figure. The contours of drapery at Moissac are often undercut, lifted above the background, but the raised surfaces are barely articulated

in a third dimension. The drapery design, so far as modeling is concerned, is therefore in no opposition to the principles governing the high relief and vigorous salience of the bodies. When it covers them, the drapery is a simple shell, richly adorned by concentric or radial lines, and where it leaves the bodies it forms in turn a flat mass in a low relief.

The multiplying of layered surfaces, however unplastic, remains a striking feature of the relief of the tympanum. It suggests the unsuccessful effort to achieve a varied plastic form by the addition of unplastic elements, like theoretical unextended points arrayed to form a line. But this is not really the function of such an accumulation of layers of relief. Its evident effect has already been observed in the description of the ringlike folds of the legs and torso, which produce a busy contrast of lines and an activation of the larger surface. By the overlapping of pleats a similar, if not more broken, restless surface is produced despite the flatness of the whole. The larger planes seem to be covered by irregular shreds, like the surface of an object intricately wrapped innumerable times.

The ornamented borders of the garments are important parts of the drapery design. They provide a surface roughened, pitted, minutely grooved and bossed, in contrast to the smoother parts of the garment. Originally these jeweled bands were painted, like the rest of the tympanum, and this contrast of textures must have been reinforced by color. How the drapery design was affected by the polychromy we can no longer say, for no large tympanum has preserved its original color intact. At Conques, where the fading color is still visible, the tones are so blond and light, so delicate, that they are little more than a vague ornament; perhaps no plastic accentuation was intended, and no strong pattern results. I think it is not improbable that on the tympanum of Moissac the crowns and all other metallic details were gilded; that the undergarments and mantles were distinguished by sharply contrasting tones; that the background itself was painted and entered more prominently into the design.

The prominence of the jeweled detail indicates the primitive character of the art, not because a barbaric taste for richness is reflected, but because the effect of a colorful or rich relief is demanded from applied surface ornament more than from plastic variation. In the later art it is by furrowing deeply and chiseling the body and the garments to yield an endless play of boss and hollow that a diversified surface is obtained. The use of jeweled detail in broad flat bands is in a sense antiplastic. This is apparent in Byzantine painting in figures of monarchs and angels who are laden with richly ornamented garments. The modeling of the limbs and folds, which is common in other figures, even in the same works, is less pronounced.

It is clear from this survey of the details of drapery on the tympanum that although they include all the elements of drapery form present in

the cloister they are closest as a group to the capitals of the south gallery. In the latter were observed the same proliferation of folds, the swathing of the body in numerous pleats, and the jeweled detail. The edges of garments are often broken into meandering lines like those of the tympanum. Like the latter, they are predominantly angular and sometimes extend beyond the outlines of the body as if blown by the wind. In the elders, the incised double fold is rarely employed although it appears on the garments of the taller figures of the tympanum. The chief differences between the drapery style of the portal and that of the south gallery are in the relation of the unit or small detail to the whole figure and in the richness of effect. On the tympanum the cutting of the folds is more vigorous and powerful; the contours are more vivacious and irregular, and the whole surface is more diversified by the pleating than on the capitals. The banding of the torso is never as prominent on the latter as on the tympanum. The extension of this concentric banding to the legs does not occur in the cloister.

* * *

A few words, finally, on the animals which are carved no less beautifully than the human figures. Taken down from the tympanum, and viewed separately (Figs. 96, 97), these three beasts would be regarded as supreme masterpieces of animal representation, comparable to certain archaic Greek and Chinese sculptures. The lion and the bull are a single conception. For such a combination of elasticity and power in animal bodies we must turn to the monstrous lions discovered in Southern China by the Ségalen Mission.[118] So intense is their concentration on the figure of Christ that the twist of the head seems to motivate the entire body; the legs are reduced to puny projections.

The sculpturing of the bodies shows the same contrast of broad chiseling and closely observed detail as the human figures. It is especially clear in the heads which are rendered in a powerful and original manner, unlike any familiar beasts. The lion's head was an especial delight to the artist, who lavished on it an obsessive attention in his effort to make the imagined beast more credible by the amount of recognizable detail. The eye has been carved with greater care than that of any human figure; the iris has been incised, the corners of the eye deepened, and the lids clearly demarcated. In a like manner, the muzzle and brows have been painstakingly detailed. I have already mentioned the grand movements of the tails and wings of the animals. The eagle alone is inactive, but the contrasted directions of his head and body create an effect of tension, increased by the tight clutching of his scroll which is wound spirally. The carving of the imbricated feathers is of a subtle perfection in its variation of the same unit by the simplest means.

The position of the eagle involves an extreme twisting of his head, for both head and body are in profile but turned in opposite directions. This fact is not admitted by the sculptor, who has represented the difficult movement without indication of strain or distortion. Is the contrast of the eagle's head and body an intended parallel to the corresponding man-symbol of Matthew, who is subject to a similar torsion? Their contours have a related upper and lower projection toward Christ and a similar intervening hollow. But even the lion has been shaped into an analogous construction: the head is violently turned, contrary to the movement of the body, while a large wing rises from his neck, extended like the arms and book of the Matthew symbol.

The Lintel

The tympanum rests on a great lintel with a decoration no less radiant than the figures above. It is 5.68 meters long and .76 wide, and is composed of three horizontal slabs of Pyrenees marble, reinforced in the rear by other slabs to sustain the huge mass of the tympanum. On its outer surface is carved a frieze of ten rosettes encircled by a cable which issues from the jaws of curly-snouted monsters at the two ends (Figs. 93, 105, 106).[119] The three blocks are not of identical size or shape and are so cut that the symmetrical inner jointings are stepped to ensure a more secure fitting and a better distribution of the weight.[120]

The unit rosette motif consists of eight leaves of acanthus form radiating from a central circular knob or petaled flower. Except in two instances, the leaves are symmetrically disposed with respect to the axes of the slab. The leaf is not the familiar soft or spiky classic form, but a peculiar stylized version that approaches in some details the conventionalized palmette. A radial five-lobed structure, with curled or arched lower lobes, rises from a symmetrical two-lobed stalk as from a vase. On each side the two inferior lobes of the leaf are tangent to those of the neighboring leaves and, together with them, enclose two eyelets as in the classic Corinthian capital—the inner, tall, ovoid, and deep-cut; the outer, broad, crescent, and shallow. Each lobe is bisected by a ridge or vein issuing radially from the central axial ridge of the whole leaf. The lobes are otherwise smooth and regular and, with the exception of the curled ones, symmetrical and tonguelike in shape.

In the triangular surfaces between the large rosettes are also carved acanthus leaves. But these are stylized to resemble trilobed half-palmettes or the profile acanthus of late Roman rinceaux. They are grouped, four in a triangle, and issue from an acanthus wrapping at its base, like a great plant with four waving leaves. Two leaves diverge horizontally, the others vertically, in a symmetrical pattern.

At the tangent point of two rosettes the encircling cable passes through a narrow sheath. But the sixth, seventh, and eighth rosettes (counting from left to right) are not tangent. They are separated by mascarons—chinless monsters like the Chinese Tao-Tieh—through whose heads the cable moves. Between the sixth and seventh the interspace is large enough to permit the insertion of a heavy fruit-and-blossom motif common in Quercy and Limousin.[121]

The effect of this beautiful frieze is one of intense and sustained movement because of the recurrent radiation. Not only the main rosette motif but the subordinate fillings of the interspaces are composed radially. The simple alignment of the rosettes in horizontal order contrasts with the richness of small centrifugal details. Even these, when observed closely, form the elements of simpler circular schemes. For the design is not only of the repeated rosettes and their prominent central knobs; the hollows between the lobes produce flowerlike patterns. Thus each rosette is a system of concentric circular motifs issuing in widening ripples from the petaled knob. The diffusion of the larger structure in small details gives the whole a liveliness and sculptural richness akin to the tympanum above. And as in the figure sculpture, the apparent regularity of the whole is modified in places by delicate departures from the expected spacing and forms. The even number of rosettes, the variety of knob structure, petaled in five rosettes and simply ridged concentrically in three, the inequalities of interspacing, the anaxial position of two rosettes,[122] the unequal projection of the monsters at the ends, the spiral grooving of the cable of the three left rosettes and the smooth surface on the others—all these are not accidents of hand labor, but designed, since the variations of the left side are balanced by contrasts on the right, while the common details are too finely executed to permit a judgment of negligence or incompleteness.

More remarkable than the linear design and division of the lintel is the character of its relief. Each rosette is a concave surface, like a shallow circular dish set within a wall. The leaves are curved in depth, and the central knob is flush with the flat outer surface of the frieze. Examined more closely, the rosette is not the dish, but its decoration in extremely low relief. Such a style of carving is unique. It cannot be compared directly with the imitation of a wall encrusted with faience dishes, like the facade of the town hall of Saint-Antonin, near Moissac. Such a wall is itself uncarved, while in Moissac the interspaces are also ornamented, and the central knob is flush with them. The outer plane of the lintel is subordinate to the concave themes. In ordinary relief the chief motif is salient from the uniform background plane or is contrasted with the dark shapes of deeply cut interspaces. Sometimes two (or more) patterns of unequal salience constitute the ornament on a common background, but

both are flat or parallel in plane. In Moissac the distinction between fore-ground and background is abolished by the concave modeling of the frieze. We seem to look into the negative mold of a more salient band. By these concavities is achieved a plastic effect with the least assertion of relief. Compare this method with the relief of the tympanum on which the figures, almost detached from the wall, have only a superficially modeled surface. They are alike in the contrast of the relief of the larger units with the subordinate flat details. But the lintel is foreign to the style of the tym-panum. Even as a mold of a more obvious convex form, the lintel is not analogous to the reliefs above or to the ornament that frames the tym-panum. The dense expanded foliate forms in the lowest possible relief, as well as the repeated concavity, itself shallow, seem to be inconsistent with the massive projection of the figures. The thick vegetation of the archi-volt is a more evident decorative analogue of the tympanum relief.

The lintel is an un-Romanesque element in the portal, yet is appar-ently in place and participates in the design of the whole. It might even be said that its un-Romanesque features are essential to its accord with the whole, and that its discrepant relief is a contribution to an energeti-cally contrasted animated scheme. A more positive and direct congruence in the radial design has already been observed; the concavities serve the same end in promoting a movement between the central knob and the circumference of each rosette.

A lintel of flat rosettes would be insignificant beneath the tympanum; not only would a plastic accent be lacking, but the radial design of the leaves would be lost in the dense all-over patterning of the band. A lintel of convex giant rosettes would be plastically intrusive beneath the row of seated elders and disturb the iconographic hierarchy of the portal. The radial leaves would be less effectively centrifugal, as in an inverted flower. Granted the pattern of rosettes, the existing relief seems most proper to the forms of the tympanum. It is, in fact, anticipated on the latter in the great diversity of rosette ornaments embroidered on the garments of the figures.

When we examine the undersurface of the lintel (Fig. 102) we under-stand more readily the un-Romanesque character of the main design. For this lower surface, which has been frequently cited but never reproduced, is carved with an earlier ornament and betrays in its style a hand of the seventh century A.D. It consists of a narrow band of acanthus and vine rin-ceaux, bordered by geometric spiral scrolls, the whole so low in relief and of such delicate execution that its details are barely visible. The vine pattern occupies the two eastern blocks, the acanthus, the western. Anglès was mistaken in writing that the three blocks did not always belong together because of the difference in the ornament of the lower surface.[123] For the three bands are of identical breadth and their borders

agree perfectly. If on one band the vine replaces the acanthus, their styles are identical. It is only the abrupt transition from one to the other that justifies the inference that although originally parts of one frieze, they have been reemployed with the omission of an intermediate strip.

The lintel consists of reemployed ancient blocks of which the original style of ornament has been maintained not only in the decorated surfaces preserved, but in those more recently carved. A similar block in the museum of Cahors, undoubtedly of the early Christian-Merovingian period, also includes such rosettes; they are derived, like those of Moissac, from ancient Roman types.[124] The retrospective copying of ancient art might have been inferred without knowledge of the models from the character of the ornament itself, which in relief and motif is un-Romanesque and distinct from the surrounding capitals and moldings.

The lintel has a more general interest for the interpretation of historic arts. It is often supposed that the unity of a work—and the tympanum and lintel are a single work—requires the formal analogy of its parts, and that only those foreign elements are incorporated in a style which are exactly congruent with the rest. But the lintel, which is obviously in harmony with the tympanum, displays quite different principles of relief. There is no question that the art of the seventh century is in style distinct from the Romanesque, yet in this work the close imitation of the earlier style, reproduced with a precision that has misled scholars to suppose the whole work an ancient piece,[125] is compatible with the surrounding Romanesque forms. We learn from this example that the analogy of elements in a work of art is not necessarily pervasive or complete, and that stylistically unlike forms may coexist within a coherent whole. The relations between forms are more crucial and determinative than the form elements themselves. Hence the possible absorption of features from the most remote arts in the Romanesque, without the effect of an eclectic or unintegrated style. The judgment of unintegration is of imperfectly coordinated, not of anomalous, elements.

I must mention, however—if merely to exclude the argument that the lintel is in its entire decoration a reemployed work—the distinctly Romanesque details in its carving. If the carving were ancient, its coherence with the Romanesque tympanum would be even more surprising, and would lead us to suspect an enormous extrapolation in the theory that unity or the quality of work inheres in all its details because of the absolutely integrated thought or perception of its maker. We have only to place the two corner beasts beside the lower symbolic animals of the vision to see that they are decidedly Romanesque in type, although flattened to accord with the subtle relief of the lintel. The disproportionately small legs, and the flat thighs pressed close to the body, recur in them; while the deeply sunken eyes and prominent frontal ridges are precisely

as in the lion of St. Mark. But there is even better evidence that the same hand carved tympanum and lintel. The monstrous head in the lower left corner of the tympanum (Fig. 93), from whose jaws issues the meander ribbon, is an almost exact replica, in both shape and function, of the head of the left monster of the lintel. Both have the peculiar curled snouts that suggest the elephant. Nor can it be said in possible reply that the tympanum master copied the already existent lintel in carving such details, for they are unknown in this form in earlier art, though ultimately based on ancient traditions. There are still other indications of the unity of the two works. The two mascaron heads serving as interspaces reproduce exactly the head on the lower right of the tympanum (Fig. 100). They reappear also in the narthex on a console block and are carved on the intricately ornamented outer jambs of the south porch. The fruit and blossoms issuing from the jaws of the left mascaron of the lintel have their exact parallels in sculptures at Beaulieu, Souillac, Cahors, and Martel, all products of the school which produced the portal of Moissac.

There are also elementary considerations of design that refute the argument. The ornament of the ends is perfectly adapted to its position. The repeated rosettes and knobs are like the elders aligned on the zone above, while the density of the carved ornament, filling the surface completely, and its circular, radial design recall the central group of the tympanum. The lintel is conceived in such harmony with the tympanum that they must have been planned as parts of one scheme of decoration.

THE RELIEFS OF THE PORCH

As on the cloister capitals we observed the style of the pier reliefs in a narrative context, so the corresponding manner of the later sculptors of Moissac is visible in the reliefs of the inner walls of the porch (Figs. 107–122).

Their style has long been recognized as more recent than that of the tympanum, but the differences are such that the two works cannot be far apart in date. The sculptures of the jambs and trumeau which sustain the tympanum belong to the same period as the porch.

On the east wall are scenes from the Infancy of Christ; on the west, the parable of Lazarus and Dives and the punishment of Avarice and Female Unchastity. Little capitals with figures, tormented in the flames by demons or attacked by monsters, paraphrase the Last Judgment (Fig. 125). On the east jamb which supports the lintel is carved Isaiah with a scroll prophesying the virgin birth. On the corresponding west jamb, near the reliefs of the parable and the punishments, is Peter, the patron of the abbey, with the keys of heaven. The intermediate trumeau is sculptured

102

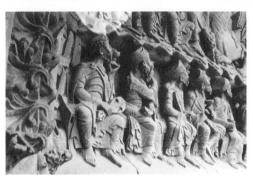

103

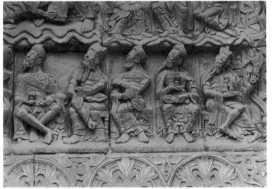

104

Fig. 102. Moissac, Church; Detail of
Lintel: Under-surface of Lintel

Fig. 103. Moissac, Church; Detail of
Tympanum: Elders of Bottom Row

Fig. 104. Moissac, Church; Detail of
Tympanum: Elders of Bottom Row

Fig. 105. Moissac, Church; Detail of
Tympanum: Elders of Lowest Row

Fig. 106. Moissac, Church; Detail of
Tympanum: Elders of Lowest Row

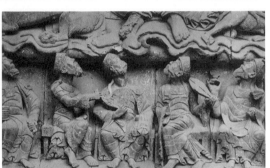

105

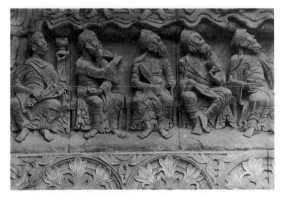

106

107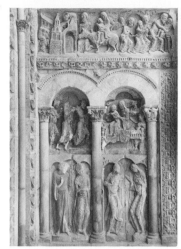

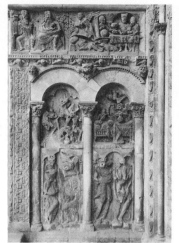

109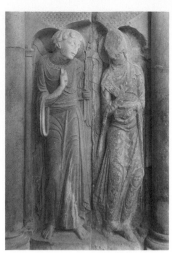

110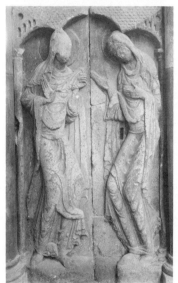

Fig. 107. Moissac, Church; Sculptures on East Inner Wall of Porch

Fig. 108. Moissac, Church; Sculptures on West Inner Wall of Porch

Fig. 109. Moissac, Church; Detail of East Wall of Porch: Annunciation

Fig. 110. Moissac, Church; Detail of East Wall of Porch: Visitation

Fig. 111. Moissac, Church; Detail of East Wall of Porch: Adoration of the Magi—the Magi

111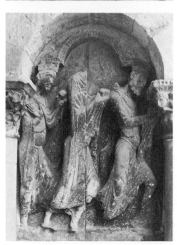

with two unnimbed figures of uncertain name. The western figure is bald
and has a wrinkled brow like Paul in the cloister and in reliefs at Silos
and Arles. The other bears a scroll instead of a book and is probably a
prophet, corresponding to Isaiah, like the similar figures in Lombard
churches.

The abbot, Roger (1115–1131), is represented on the exterior south
wall of the porch, high up on an engaged column (Fig. 137). Another
figure, in monastic dress—possibly St. Benedict—stands on a similar
column on the other side of the arch (Fig. 135). On the crenellations
above the porch are enwalled two figures blowing horns, like watchmen
of the fortified church (Fig. 140). The cornice beneath them, crowning
the porch, is carried by sculptured modillions of which several are
modern restorations.

The reliefs of the porch are not arranged in simple alignment or
superposition, but a special architecture, independent of the structure of
the wall, is applied to it to frame the reliefs (Figs. 107, 108). They agree
in this respect with the sculptures of Poitou, Angoumois, and Saintonge,
which are similarly set under arcatures applied to the surface of the wall.
But they differ from them in the extension of one scene (the Magi)
under two arches, and the superposition of two under a single arch. The
independence of architecture and sculpture was already seen in the tym-
panum, which is composed of separate blocks applied to the wall, and
offers no strict correspondence of figures and blocks as in Gothic
portals.[126] The designer of the porch not only disregards the character of
the wall in the applied members, but even the latter in the distribution
of the sculptures among them.[127] This is hardly the unity of structure
and decoration which a doctrinaire aesthetic theory has judged to be the
essential character of mediaeval architecture, in contrast to Renaissance
and Baroque styles. Actually, the grouping of architectural elements on
these walls is nearer to the Baroque in principle, and we might number
the Romanesque among the early styles in which investigation detects
analogies to Baroque art.

The columns framing the superposed reliefs have the character of a
giant order enclosing two rows of minor arches and colonnettes. In
Romanesque churches, like Saint-Sernin in Toulouse, the bays of the nave
have a related elevation, with great shafts rising to the base molding of
the barrel vault and enclosing two superposed arches. But in Moissac the
columns themselves carry a dominant arch, and the vault springs from a
tall frieze placed above it like an attic storey.

The paneling of the inner walls of the porch is designed in a free,
asymmetrical manner. The arched fields are framed on one side (south)
by vertical bands of richly carved ornament; on the other, by the slender
colonnettes of the portal which are noticeably taller than the carved

bands; and above, by large friezes sculptured with narrative scenes. There is no podium below. Not only is the frame of the arched fields varied on all four sides, but the internal divisions of the fields are not maintained or acknowledged in the bounding areas by either moldings or ornament. The surface of the inner walls of the porch appears therefore crowded and irregular; the axis of the symmetrical sculptured panels does not coincide with the central axis of the entire wall; and no common background is visible behind this accumulation of sculptures, friezes, and frames.

The arbitrariness of the architecture may be illustrated by the following details. The arches are bordered by a semicircular molding strip, intercepted at the sides by the outer jambs of the portal and the vertical friezes that terminate the walls of the porch. A cornice surmounts the arches, although a horizontal frieze is placed above it. It rests on the busts of caryatids with uplifted hands, while in the spandrels of the arches are carved salient heads in imitation of water spouts or modillions, here functionless. To lend some architectural character to the subdivision of the arcatures into upper and lower panels, trefoils resting on slender, barely visible colonnettes are inscribed within the semicircular arches.

The moldings are not continuous with those of the tympanum. The barrel vault of the porch springs from the torus above the upper horizontal friezes, at a level higher than the capitals of the tympanum archivolt, while the cornice beneath the friezes is higher than the crown moldings of the trumeau and the supporting walls of the portal. Except for the base moldings common to the portal and the walls of the porch, the horizontal lines of the two are discontinuous. At Beaulieu the horizontals of porch and portal coincide; but the porch of Cahors is in this respect disposed more like that of Moissac. Although the porch and tympanum of Moissac are not contemporary, it is doubtful that the discontinuity proceeds from the difference of time alone or even serves to indicate the fact. The alternation of horizontals is too well sustained to be accidental.

The asymmetry of the architecture of the side walls, in shifting the axis toward the portal, subordinates their sculptures to the tympanum and relates them more closely to the figures of the jambs. Had the column stood in the axis of the wall, it would have imposed a corresponding center on the crowning frieze, which is by its very nature, with its horizontal sequence of narrative themes, an unsymmetrical member. It would have given the inner walls of the porch an isolated, self-sufficient, centralized character inconsistent with the religious and plastic priority of the tympanum.

The salient cornice diminishes the apparent height of the sculptured surface and thereby subordinates it again to the tympanum which, by the same device, produces an impression of still greater height. The isolation

of a frieze above the reliefs of the side walls corresponds to the clear horizontal bands of the elders and the rosettes, and its contrast with the vertical panels below maintains the contrast of the elders and lintel with the trumeau and jambs of the portal.

The superposed friezes also offer to our perception of static forces a more solid support than a pair of arches on tall slender colonnettes. By a similar calculation the arches are of rectangular section and unmolded, in active contrast to the richness of surface carving everywhere apparent. If the architectural framework of the reliefs is a free composition imposed on the wall, its design is well adapted to the sculptural whole of the porch and portal and is consistent in character.

The sculptures of each side of the porch do not unite to form one great relief like the tympanum; nor are the main contours distinct enough to determine a single scheme dominating the whole. But we shall see presently that an effort was made to surmount the barriers of separate subject matter and architectural frames by a common movement and related forms.

The reliefs diminish in height in ascending order. At the same time they broaden, so that the middle panels, which are united into a single large field either by the subject (Adoration of the Magi) or the common design (the Death of Dives and his Punishment), mediate between the tall vertical panels below and the single horizontal friezes above. The arches within the scenes of the Presentation, the idols of Heliopolis, and the banquet of Dives unite the horizontal friezes more intimately with the arcaded reliefs below.

The reliefs, moreover, are not on the same plane. The lowest figures (Annunciation, Visitation, Luxuria) stand under trefoiled arches which form the edges of a sloping roof structure. On the eastern reliefs this roof is realistically rendered with carved slate or tile imbrications.[128]

The panels above are set more deeply under the large arches and the flat, molded trefoils. We can more readily appreciate this recession in observing the relation of the roof above the figure of Unchastity to the ground plane of the scene of Dives' death above it.

With this diminution in the height of the ascending reliefs their figures change in proportions. The most elongated and slender are in the lower panels, the squattest, in the upper horizontal scenes.[129] On the east wall this gradation of scale corresponds to the narrative order of incidents. For the lowest scenes are the earliest (Annunciation and Visitation) and those of the upper frieze the last of the cycle (Flight into Egypt). On the west wall, however, the story of Lazarus and Dives begins on the frieze above and terminates below in the central panels. On the lowest band are represented the Punishment of Avarice and Unchastity.

Whether this contrast in the order of incidents is a stylistic correlate of an asymmetrical architecture and restless animated figures or the conse-

quence of an iconographic program is difficult to decide.[130] The episodic parable of Lazarus and Dives could hardly be fitted into the two lowest panels which were reserved for twin pairs of opposed elongated figures. There are other contrasts and irregularities in the sequence of action that suggest an aimlessness of composition surprising in Romanesque art. But analysis will reveal an underlying order and purpose.

In the horizontal frieze of the east wall the episodes of the Presentation in the Temple and the Flight into Egypt seem to form a continuous narrative (Figs. 107, 117–119). But these scenes do not move in a single direction; if we attempted, without knowledge of the texts represented, to determine the order of events and the relation of certain figures to each other we would be very much puzzled. The Presentation, the first in order of time, moves from left to right; but the Flight moves in the opposite direction. At the extreme left of the panel is the city of Heliopolis with its falling idols. The successive incidents diverge from a common center; and with a perfect adroitness in dramatic arrangement the artist has placed between the two scenes a figure common to them and pointing in both directions. This is Joseph, who lags behind the procession in the temple, and turns his head in response to an angel who urges him to flee to Egypt (Fig. 119). The position of the angel is itself noteworthy. The curve of his suspended body unites the two episodes. Of his symmetrical wings, one points toward Egypt, the other toward Jerusalem, and each occupies another slab of the frieze.[131] The center implied in this division of the scenes is to the right of the column below and does not correspond to the midpoint of the frieze. But the direction of the Flight is opposed to that of the Magi below, and the Presentation is in corresponding opposition to the Holy Family. This chiasmic symmetry of separate groups is a typical mediaeval pattern, especially evident in ornament and color.

In reliefs of the Magi, the Annunciation and Visitation below this frieze (Figs. 109–112), the order of scenes is unequivocally from left to right as in western script. But on the west wall the direction is reversed. The banquet of Dives is represented at the right; the beggar lies at the left, is carried to heaven by an angel, and reposes in the bosom of Abraham at the end of the frieze (Figs. 108, 120, 121). In the central panels, the death of the rich man is at the right and his subsequent punishment at the left (Figs. 115, 116). In the lowest reliefs, of Unchastity and Avarice, which have no narrative connection, a sequence cannot be abstracted; but the scenes, together, form a symmetrical pair.

The contrast of the iconographic sequence on the two walls is, in an architectural sense, a symmetrical form. It is occasioned by the common relation of both walls to the portal; we shall grasp it more clearly if we imagine an open book in which the words of the right page run from left to right, and those of the left page from right to left.

The sequences described are not always in the dominant directions of the forms. The horizontals are primarily narrative, textual; the design of the larger reliefs of the porch is still close to the most archaic works of the cloister in the symmetry and isolation of scenes and even conflicts with the general succession in some details. Such a symmetry was inevitable in the Annunciation and the Visitation, or in the figures of Unchastity and the demon (Fig. 114). In the adjoining mutilated relief of the miser and the beggar, a devil, perched on the shoulders of the seated miser, prolongs the mass at the right in symmetrical opposition to the standing beggar (Fig. 113).

On the other hand, it should be observed that the legs of the demon and the unchaste woman, who form a balanced symmetrical group, have a common movement toward the right (north) in contrast to the narrative succession of scenes on the wall. By this means, perhaps, the pair is opposed to the Punishment of Avarice, in which the only moving figure, the beggar, is turned to the left (south). But on the relief of the Annunciation on the east wall (Fig. 109) both figures move toward the right (south), in contrast to the corresponding demon and the unchaste woman and in accord with the narrative sequence from left to right. In these panels the opposition of the turned heads and gestures modifies the simple parallelism of the movements of the limbs. It is apparent that the textual order of episodes does not determine uniquely the directions and order of forms but, as in the cloister, a more fundamental style of expression and design controls the distribution of scenes.

On the east wall the Adoration of the Magi (Figs. 111, 112) is divided into two equal parts by the central column and the similar arches. A repeated wavy vertical contour unites the figures of the two groups. The Magi are not simply three equal figures in alignment, but the central is the tallest and stands under the highest lobe of the common trefoil, so that even here there is a distinction of central, axial, and lateral despite the direction of the Magi's movement and their common significance. In the Holy Family the Virgin is centralized, and the inequality of the Child and Joseph compensated by the introduction of the ox's head at the right.

The symmetry of such groups is primarily architectural or decorative; it has little expressive purpose as in the tympanum and certain capitals of the cloister. It is a means of ordering a group, but does not impose a rigid form or correspondence on every detail. In this respect the later sculptures of Moissac approach Gothic composition. In the opposite reliefs of the death and punishment of Dives (Figs. 115, 116) a similar underlying formality of grouping may be observed in the agitated and varied movements of men and demons. But this formality is less apparent here than in the cloister or the tympanum. A more complex disorder is organized. The separate groups are extraordinarily restless and correspond in their

zigzag and wavy movements to the asymmetrical, irregular architecture and to the highly emotional and dramatic conception of the subjects. Whole incidents are presented with a genrelike familiarity, and imaginative symbolical groups, like the punishments of vices, have the concreteness and mobility of an actual episode.

We can no longer judge of the character of the Annunciation which had been mutilated and was restored by a modern sculptor without understanding of Romanesque style; but in the Visitation is preserved for us a magnificent pantomime unparalleled in Romanesque representations of the scene (Fig. 110). Instead of the usual embrace of the two women, in which a sculptor of the cloister found a pattern of rigid lines, like the letter M (Fig. 68), or the traditional type of Elizabeth and Mary standing calmly separated in simple contemplation of each other, the sculptor of the porch has, by deep sympathy and by exploiting the dramatic force of every flection of the body, composed a new scene in which the emotion of the meeting and mutual revelation is expressed in both the gestures and the strange elongated zigzags of the pregnant women. This deliberate staccato rhythm is refined by numerous delicate lines formed by draperies of such thinness that the women appear most tenderly clothed and their bodies spiritual. One raises the edge of her veil or shawl to disclose a single breast in sign of motherhood; the left breast is covered by the hand turned palm outward in communication. The other woman inclines her head and indicates through the delicate cloth the swelling breast and nipple. The hands of both are thin and bony and the slender wrists are striated with the ridges of tendons.

Despite the mutilation of the faces, which probably had little expression, the feelings are adequately symbolized in the gestures and the structure of the bodies. Yet the simple zigzag of the limbs is not uniquely determined by the narrative; it carries also an expression independent of the meaning of the figures and common to scenes that represent other subjects.

What could be more remote from that maternal pair than the punishment of Unchastity? The figure of the loose woman tortured by toads and serpents (Fig. 114) has the posture of the Virgin of the Annunciation, and the horrible demon who pursues her repeats the gestures and flections of the left figure of the Visitation. But the legs of the demon parallel the legs of the woman as if they marched in a common procession. It is the elements of design and the typical forms that are the same in the two scenes. The wholes are different; and in the wholes are expressed the specific character of each subject, but with a common accent which is that of the entire portal and is imposed on no matter what incident or figure.

The death of the rich man is an enclosed picture in a modern sense, with a literal reproduction of the deathbed (Fig. 116). The haggard

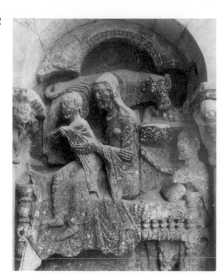

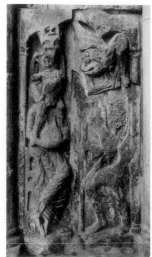

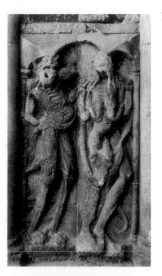

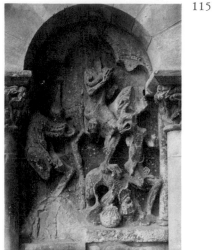

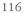

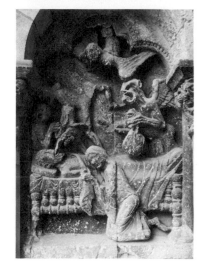

Fig. 112. Moissac, Church; Detail of
East Wall of Porch: Adoration of
the Magi—Holy Family, Ox, and Ass

Fig. 113. Moissac, Church; Detail of
West Wall of Porch: The Punishment
of Avarice

Fig. 114. Moissac, Church; Detail of
West Wall of Porch: The Punishment
of Unchastity

Fig. 115. Moissac, Church; Detail of
West Wall of Porch: Hell Scene—
Punishment of Avarice and Unchastity

Fig. 116. Moissac, Church; Detail of
West Wall of Porch: Death of Dives

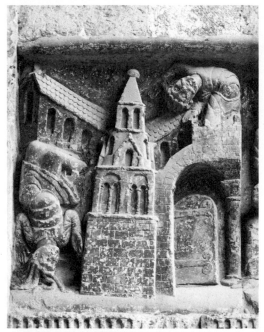

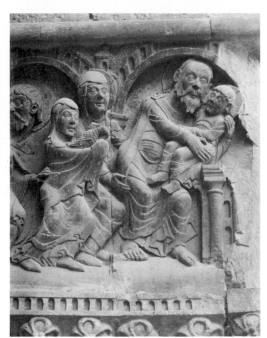

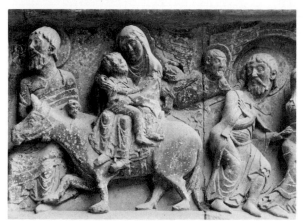

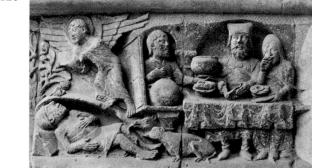

Fig. 117. Moissac, Church; Detail of
East Wall of Porch: Fall of the Idols
of Heliopolis

Fig. 118: Moissac, Church; Detail of
East Wall of Porch: Presentation
in the Temple

Fig. 119. Moissac, Church; Detail of
East Wall of Porch: Annunciation
to Joseph and Flight into Egypt

Fig. 120. Moissac, Church; Detail of
West Wall of Porch: Lazarus and
Dives

Dives is thinner, more bony than at his banquet table—his head resting on an inclined pillow, his scrawny breast uncovered, the body under a pleated blanket. His mourning wife kneels at the bedside just as the beggar Lazarus lay beside the table. The demons who descend to take his soul are described with an atrocious veracity. In the adjoining panel (Fig. 115) they trample on his fallen body weighted by the moneybag, and ride on a miserable woman with hanging breasts who emerges from the background in the middle of the field. By the almost chaotic, salient, curved and angular, swarming masses throughout this sculpture, the ferocity and turbulence of the story are wonderfully expressed. But the effect inheres also in the completeness and detailed—even accurate—articulation of the monstrous demons. The extraordinary reality of these horrible, fantastic figures with animal parts—yet assimilated to a human structure—matches the unexpected precision with which the sculptors of the porch have represented on the capitals and modillions various morbid and deformed human heads. In the spandrel above the western reliefs (Fig. 124) is a leering old woman, with open, toothless mouth, stringy neck muscles and flying, disarranged hair. Her eyes are barely open, as in extreme old age; her tongue lies weakly in the bottom of her mouth. Another head is of a goitrous woman grimacing in half-witted complacence (Fig. 108–right).

These human types are not required by the iconographic program and must therefore express an individual interest and initiative of the sculptor. But they are so common in French Romanesque art, especially in the decoration of modillions (Figs. 138–140), that they can hardly be ascribed to the curiosity of a single sculptor and must embody a common perception. They seem especially strange in an art which, in its monumental religious compositions, applies generalized forms and abstract geometrical combinations. Regarded in the light of the monstrous in other primitive arts, this contrast of abstraction and realism is less surprising. The process of abstraction in Romanesque art includes an audacious distortion of ideal and symbolic figures for expressive ends; in the exact representation of monstrous, already deformed human heads, energy of expression was directly attained. The extremes of realism and abstraction have a common arbitrariness. The marginal position of the deformed heads in the decoration of a wall reflects their independence of an ideal or symbolic beauty. They are individuals who, in themselves, constitute the form of a "servile" architectural member—a corbel or modillion—which is a repeated minor element of construction, while the tympanum is a unique monument within the monument, an image of heaven erected above the entrance to the church.

The fantasy of Romanesque sculptors was more prolific in the creation of types of evil and violence than of beatitude. On the capital from which spring the two western arches we may see the demonic and human

combined in a religious theme (Fig. 125). The punishment of the
damned is represented here. I suppose it is the association of this capital
with the other scenes of punishment that led de Lasteyrie to describe the
sculptures of the portal as a Last Judgment. A nude man and woman
with bowed, repentant, suffering heads are tied by a rope held by an
appalling devil. His whole body, from head to claws, is covered with thick
scales. He has the curled snout of the monster on the lintel and a long,
corrugated tongue which licks the tail of another nude demon. The latter
is smooth-skinned but no less frightful in the knotted muscles, the tail
ending in a serpent's head, and his own wolfish head in forked bristling
hairs. He devours the left arm of a woman. In all these minutely rendered
demons and human figures the forms and surfaces contribute to a
common agitation. They resemble in this respect the composition of more
ideal figures.

<center>* * *</center>

In the sculptures of the porch the construction of space undergoes a
marked change from the methods of the cloister. Not only is space deep-
ened by the overlapping of figures and by great differences of relief, but
horizontal planes and architectural accessories are employed to realize
this more extended depth. The upper surfaces of the beds of the Virgin
and the dying rich man are rendered as horizontal planes (Figs. 112,
116). Only in the table of the feasting scene (Fig. 120) and in the pillow
of Dives does a slight inclination recall the earlier archaic distortion. The
feet of standing figures are more firmly planted on the deep base molding
of each panel (but the slightly sloping surface of some of these bases [Fig.
114] indicates the persistence of the earlier conception). In the Adoration
of the Magi, a column which separates the Magi from the Virgin and
Christ stands in front of the field of relief rather than in it, while the
main arches and subordinate trefoils, in lower relief than the figures,
define a foreground and background architecture in space (Figs. 111,
112).

The cloister capital with the same subject (Fig. 58) enables us to
study the change in representation in this short period. In the porch the
space has been deepened by the addition of Joseph and the animals, with
their overlapping masses and higher relief. The proportions of human
beings and beasts are still arbitrary. The small size of the ox cannot be
attributed to the sculptor's desire to suggest a great depth by a perspective
diminution. Something of the superposed arrangement of the Magi's
horses on the cloister capital survives in the placing of the ox and ass
above the figures, although the traditional image of the Nativity assigned
to them a similar position. The ox standing without support contradicts
the framework of ground and background in the rest of the relief. Of the
ass, the head alone is rendered; and this head is visible only if we view

the sculpture from the left—it is carved in the spring of the arch and is partly concealed by the projecting capital.[132] This denial of the architectural frame makes the latter a part of the scene, but so inexplicable a part in its contradiction of the spatial unity that we must regard the penetration of the frame by the ass as an iconographic and technical expedient and as a correlate of the arbitrary, irregular architecture and the naive realism of the whole, rather than as an approach to an open, more extended image space. But this pecularity is worth noting, for it is by such exigencies that more consistent spatial forms are later suggested.

More significant are the numerous overlappings that lead us in well-ordered sequence to the background. At the bottom of the relief are the legs of the Child, the bed cover, a fragment of the underlying sheet, the bed itself, and finally between these and the wall, the legs of Joseph and his seat. In the upper half the depth is more vigorously indicated; the body of the ox extends behind the Virgin and Christ, while his head is sharply turned, almost *en face,* and brought forward to a more prominent plane. The great thickness of the relief slab[133] permits a deep modeling of the profile torso and head of figures which are practically detached from the background, as on the tympanum. The left arm of Joseph, which was extended to reach the Virgin's elbow, was completely freed from the wall and has been broken. In the tympanum, however, such consistent choice of the profile of a torso is almost entirely lacking. It is limited there to one or two elders.

The representation of profiles is still archaic in that it depends on a thick slab which admits a carving of the farther side of the head in the round. The profile is not a perspective projection but the side of a head carved like a statue, with the whole face quite visible. The sculptor wishes to reproduce, as far as possible, the entire surface of an object, and to render his work intelligible from several points of view. Hence the lower parts of the body are nowhere in strict profile. The two legs are not permitted to overlap completely as in a perfectly profiled figure in nature. The axes of the legs deviate from the torso to produce a distinct view of each limb. The shoulders of the Magi are not perpendicular to the background as the strict profile of their heads and their movement would suggest, but are turned at an angle. Otherwise it would be necessary to foreshorten in order to compress the breadth of the shoulders within the narrower depth of relief; and foreshortening is still undeveloped in these early sculptures. The haloes are always carved flat against the wall and set behind the heads of the figures as if carried on the farther shoulder or applied to the concealed side of the face—a convention that persists up to the early Renaissance period. In a similar way, suspended or flying draperies covering no part of the figure are never represented perpendicular to the wall, but are expanded on a plane parallel to it.

These observations concerning the relief of the Magi apply equally to

the others. In the death of Dives we see a similar arrangement of figures in front of and behind a bed (Fig. 116). Only here the pictorial unity is better established, for the group is self-contained and independent of the adjoining relief of the punishment. The kneeling wife before the bed and the horizontal plane of the reclining Dives are as effective in creating depth as the corresponding group on the opposite wall. The interception of the lower bodies of the demons by the bed, of the wings of one demon by the right frame, of the angel by clouds and the lobes of the trefoil arch, suggests a further space behind these figures. In the adjacent relief (Fig. 115) the nude bust of the unchaste woman emerges from the wall like a console ornament without indication of the rest of the figure. In the feast of Dives (Fig. 120) only the upper body of the servant is seen under an archway, while the body of the Virgin in the Presentation is partly obscured by Anna(?) and Simeon (Fig. 118).

With all these approaches to a construction of space, it is nevertheless clear that the concept of a unified three-dimensional space in which figures act, bend, cross, and meet is foreign to the sculptor. This is obvious in the upper horizontal reliefs in which figures far from each other in time and place are grouped together as if in one scene. The continuous method does not preclude the organization of a consistent common space, as is apparent from Roman and Renaissance landscapes. But in Moissac the figures move before—or, rather, across—a changing background; on the same band we see Heliopolis and Jerusalem, or the interior of Dives' house and the tree of Paradise. If the feet of the recumbent Lazarus and the dogs who lick his wounds are in the house of Dives, the beggar's head is already under the tree of Paradise (Fig. 108).

Even within a single scene, like the Banquet of Dives, despite the common architecture, each figure moves in a private space not consistently related to the larger planes of the whole (Fig. 120). The servant, who seems to emerge from behind the table, is, with respect to the arch, nearer to us than Dives, whom he serves. This composite character of the whole space—the independent construction of each figure in depth—is better illustrated in the Presentation of Christ in the Temple (Fig. 118). Simeon and Joseph are carved under arches, while the two women stand in front of the arches in a foreground plane. But so far is the sculptor from a conception of the space as distinct in shape, like any receptacle, that he has contradicted the implied order of planes for plastic fullness. One arm of the Virgin extends from behind Simeon who, with respect to the common architectural background, is behind the Virgin. By an even more remarkable reversal the nearest figure is the shortest, and the most distant one, Simeon, the tallest. This reversed perspective is to be distinguished from that of ancient Oriental and Early Christian art which sometimes placed large figures above or behind the smaller ones and

aimed thereby to render concrete the differences in power or significance. In those earlier arts the reversal had spatial meaning because the position in an upper part of a scene denoted distance as well as a superior importance. In Moissac the difference of height is not hierarchal or only a perspective device; as already observed, it is a consistent element in an art which promotes contrasts in the effort to realize effects of movement and expression of excited energies. When we follow the rhythmical undulations of the contours of the figures in the scene discussed we arrive at the different heads without surprise at their inequality; its arbitrariness is dissolved in the pervasive movement to which the whole has been submitted.

Small details of the architecture reveal further the character of the style. The two arches of the Presentation are of unequal span, and are not rendered with the same completness. The larger arch, at the right, is carried by capitals, while the other has no visible supports. The construction is lost behind the figures, and even where an unsculptured surface might admit some indication of a column or base (as between the feet of Simeon and the Virgin), it is not represented. In the spandrels a central turret is flanked by two rectangular buildings which ramp along the arches. Their windows are slightly tilted, as if voussoirs of the turning arches. But more interesting is the interception of the buildings by the upper frame of the relief. The buildings seem to disappear under the heavy molding and to pass beyond. That this was designed rather than simply the incidental result of material constraints is evident from the successive shortening of the windows as they approach the frame and the adaptation of the whole group of buildings and the larger arches to the narrow surface under the frame. The intersection has an obvious spatial effect but it is also part of an untectonic composition in which such contrasts and overlappings are striking features.

In the single enclosed scenes, on the other hand, the architectural frames provide indications of foreground and background and define the limits of action. Various movements and overlappings confirm the depth therein created. But a consistent construction is lacking. In the relief of the Magi the animals are incredibly placed, while the ground plane does not accord in its depth with the space suggested above it. The same contradiction appears in the Death of Dives. The depth is not uniformly realized and the space lacks a clear configuration.

An approach to an enclosed or uniform space is evident in several details. The trefoil arches of the lower panels are not flat, but salient in plan, and support a gabled roof of three sloping sides which converge toward the vertical axis of the panel. The figures beneath seem to stand under a sloping canopy. A similar but more significant touch appears on the right side of the feast of Dives (Fig. 120) in the chamfered vertical border converging toward the scene. Had another such wall been placed

on the left, the whole interior would have been clearly defined and a sym-
metrical boxlike space, a uniformly deep receptacle of the other masses,
would have resulted. But this solution, which implies a conception of
space as an ideal regular form and artistic means, was not to come until
much later, in the Gothic period.

Foreshortening is likewise more apparent than actual. The horizontal
and vertical planes perpendicular to the wall are reproduced in their full
depth rather than foreshortened. Lines converging toward a central point
in the background are unknown. It was possible to arrange the folds of
the bed so that they produced an effect of recession by means of their
lines alone. But this was not admitted by the sculptor, though a matter
of everyday observation. In the roof frame of the Visitation the conver-
gence of the gable walls is contradicted by the absence of foreshortening in
the receding windows. It is obvious that the sculptor conceived of all
planes as equally distinct relief surfaces. Just as he turned to the side and
carved the less visible surface of a head as if it were a statue in the round,
he rendered with equal fidelity to fact, rather than perspective vision, the
sides of buildings. In the city of Heliopolis (Fig. 117) which by its scale is
a symbol of a city rather than a true background of the idols, the doorway
(so small that the figures even by stooping could not enter it) is carved
on a vertical plane perpendicular to the background and is invisible
except to the approaching family. It is cut in the thickness of the relief.
In the house of Dives a similar surface is slightly inclined, so that it
appears foreshortened to the spectator, although carved without fore-
shortening (Fig. 120).

That the sculptor had some awareness of linear perspective is evident
in his treatment of the left building of Heliopolis (Fig. 117). Having
observed the convergence of the roof and ground lines of such structures,
he has rendered the walls, windows, and roof as inclining toward the
ground and has shown another side of the building at a much less obtuse
angle than appears in the buildings of the cloister. But his representation is
so far from accurate that we think of the inclination as the result less of a
recession into depth than of a peculiar diagonal ground. Besides, the pro-
portioning of the idols takes away all suggestion of verity from the
perspective of the architecture.

Still another means of creating the effect of space is approached by the
sculptor. To confirm the full solidity of the Magi's bodies, of which some
parts are invisible, the inner sides of their mantles, that envelop these
parts are extended in very low relief across the background wall, so that
they cast no shadow (Fig. 111). In the same way the star of the Magi
(unlike the star in the cloister) is a barely visible petaled form on the tre-
foil arch above the Child (Fig. 112), while on the opposite wall the tree
of Paradise (Figs. 108, 120) is carved in very slight relief as if far behind

the figures. In these three examples the minimizing of relief is not occasioned by the thinness of the object alone or by other overlapping surfaces, but an attempt is made to suggest a distant plane or location by a limited salience and modeling.

The image of Heliopolis includes an extraordinary representation of an interior (Fig. 117). In many mediaeval and even early Renaissance paintings the front wall of a house is removed so that we may follow the action as if from within. In Moissac by a more complex dissection of the building, the anterior column and voussoirs of an arch seen in profile have been omitted, as in a cross-section in modern architectural drawing.

We may conclude from this study of the representation of groups of figures in Moissac that neither in the most archaic capitals of the cloister nor in the more elaborate and fully realized figures of the porch is there a clear abstraction of an enclosing space in which the figures move. But there is, on the other hand, an approach to the separate elements of such a space, manifest in the more realistic rendering of individual figures. The space as a whole is never presupposed as in later art, and we cannot, therefore, explain the various distortions and illogicalities of the works in Moissac as tentative solutions of a difficult problem or the attempts by an inferior culture to represent a complex idea. Actually, the idea of a regular, cubical space in art is very simple, but it is remote from the style of this period which coordinates separate figures in surface arabesques of intricate design. The subject matter demanded a grouping in depth, which was furthered by a growing skill in representation. But the depth resulted from the piece-meal construction of separate figures and accessories one by one. Most important for the later development is the gradual formation of horizontal planes and the construction of architectural frames so salient that the relief seems enclosed and its figures more deeply set within. Beyond such devices the depth is achieved, not by foreshortening, but by a scale reproduction of the actual mass of the object.

* * *

In the construction and surface of this mass the sculptures of the porch have been developed beyond the tympanum in the direction already intimated in the change from the styles of the cloister to that of the tympanum. The figures are still more detached from the background and are more plastic, not merely in the sense that their relief is higher, but that the bodies are more richly molded and the surfaces of drapery more deeply and complexly grooved. The figures stand, bend, and turn more freely within their narrow space. If they are still limited by a rigid conception of the axes, they are nevertheless much freer than in the cloister and tympanum.

The change is not uniform or equally evident in all the sculptures of the porch, for two distinct hands were at work here. The growth beyond the style of the tympanum is more evident in the large reliefs than in the horizontal friezes. The latter are the works of another master with a distinct character, apparent not only in the forms and design of his panels but in the very type and expression of his figures. The individual heads and drapery forms reproduce with a considerable fidelity motifs of the tympanum. The patriarch Abraham (Fig. 121) has the long beard and the flowing locks of Christ, and like him is seated frontally on a great cushioned throne (Fig. 94). His halo is richly jeweled, and the lower edges of his garment are broken by two flaring fanlike pleatings, as on the figure of Christ. The angels' heads are close replicas of the symbol of Matthew. The ass of the Flight (Fig. 107) is short-legged like the lion and the bull (Figs. 96, 97). The details of drapery are too obviously like those of the elders to require an extensive comparison. But the following differences may be noted. The multiplying of pleats and breaks is less elaborate in the friezes than in the tympanum and far less imaginative in line. The lower folds of Christ and Abraham illustrate the difference very clearly. With the exception of two examples, on the leg of the Infant in the Presentation, the doubled fold is absent from the upper zone of reliefs. But this fold was only infrequently applied on the tympanum itself, and mainly on the taller figures. There is one detail of costume that is unknown in the earlier work. The collars of Dives (Fig. 120) and the Infant Christ in the Flight into Egypt (Fig. 119) are fastened under the chin and folded at the sides to form lapels.

The modeling of the heads and the bodies, though apparently as on the tympanum, produces softer, more rounded surfaces and lacks the sharp meeting of planes which accents the quadrature of surfaces in the earlier sculpture (Fig. 122).

In the scene of the Presentation the heads are carved with a characteristic expression of feeling that does not appear in the reliefs below. The brows are lifted high, the eyes are wide open and the mouth turned at the corners in a faint smile. In the head of Joseph the effect is one of anxiety, in the others, of joy (Figs. 118, 122). In all of them the resemblance to the eager Matthew symbol of the tympanum is evident. The bent legs of the figures and the curved or zigzag contours increase the effect of excitement. The opposite relief of Lazarus and Dives is calmer and the figures are less animated. There the vertical and horizontal scaffolding of the design accords with the placidity of facial expression (Fig. 120). It is only in the group of the recumbent Lazarus and the angel, which departs from the regular scheme of the adjoining figures in its diagonal lines, that we find something of the gesture and facial movement of the Presentation.

The shortness of these figures is not an obvious pecularity of the style

as one might suppose from the contrast with the elongated Magi and Virgin below. A similar difference of proportions appears in the lower row of elders and the seraphim under similar conditions of design within a single work. The sculptors have in each case freely adapted the figures to the height of the relief. A similar duality in canons of proportions of small and large figures has been demonstrated in other schools of French Romanesque sculpture by Laran.[134] But in the upper friezes of the porch the figures are short not merely because of the scale and the narrow horizontal field; they have clumsier, heavier bodies than the corresponding elders. The squatness of the figures pertains also to the domestic and genre realism of the sculptor, just as the elongation of Christ and the seraphim on the tympanum has a religious dignity, formally accentuated in a style of intense, imaginative linear movement. In the scenes of banqueting on the capitals of the cloister no figure is represented actually eating, with food at the mouth, like the rich wife in the upper frieze of the porch (Fig. 120). She recalls Germanic art of the later Middle Ages.[135] Nor is Lazarus in the cloister (Fig. 54) so unmistakably a dying beggar as the clumsy, sore-covered figure in the porch.[136]

The master of the larger porch reliefs was a more skillful and original artist. He derives as obviously as his associate from the art of the tympanum master. But he has modified the style of the latter much more freely. His figures are even more slender and elongated, their garments are of thinner stuff, the folds arranged in more novel combinations, the heads modeled in greater detail. There is likewise in the work of this master a greater freedom in the movements of the figures. A comparison of the two figures of the Visitation with the two seraphim of the vision, who are so similar in pose, will make clear the difference between the style of the tympanum and its development on the porch. The marble material of the Visitation may be a factor in the greater delicacy of its surfaces; but this is something I cannot decide. Whereas in the tympanum all folds are lines inscribed on flat or broad, smoothly rounded surfaces, and regular pleatings are repeated in simple ornamental schemes, more plastic forms appear on these figures of the porch. The sleeves of the two women are casual, ungeometric pouches, broken by irregular folds. The section varies from fold to fold and is curved rather than rectilinear. Also, the concentric alternating lap folds which copy those of the right seraph are incised on a deeper concave surface. The double-incised forms are applied as on the tympanum, but are less insistently concentric and pronounced. The zigzag and meander contours of drapery, while they repeat the forms of the tympanum, are smaller in proportion to the whole figure, and in places, as at the lower edges of a garment, are more closely serried. On the abdomens of the two figures are small rippling grooves that appear also on Joseph and Simeon in the Pre-

sentation (Fig. 118). They are unknown on the tympanum, but are sug-
gested there by a more prominent and vigorous furrowing of the belly
folds of the upper elder next to the right seraph (Figs. 96, 99).

Another detail of the style of the tympanum that is more extensively
used on the porch is the flying, fanlike fold attached to a long curved
stem, as at the left leg of Christ (Fig. 94). On the porch it appears in the
garments of the Magi, flattened against the wall, and on Isaiah, Peter,
and Elizabeth (Figs. 131,129, 110). In the last the lower edge of the tunic
is broken by a smooth domical fold with patterned, zigzag opening, as in
several of the elders. But it differs from the latters' in the position
between the feet and in the detachment from a stem.

Of one fold on the later figures there is no intimation in the tym-
panum. On the right leg of Peter (Fig. 129) and the left of Isaiah (Fig.
131), above the knee, are incised two lines forming an angle of forty-five
degrees. On Isaiah's leg it is repeated to form a chevron pattern. The
same convention occurs also on the three Magi (Fig. 111).

The modeling of the figures refines and elaborates the forms of the
tympanum. This is especially apparent in the hands, which are more deli-
cate, and in the wrists, of which the tendons are indicated by slight stria-
tions. The vigorous and clearly blocked-out forms of the vision are
replaced by more delicate and flowing surfaces. Compare the head of
Peter (Fig. 123) with that of any figure on the tympanum and the greater
search for surface variety and movement in the details of the first will be
evident. The sculptor has renounced the elaborate locks and beards of the
tympanum; but while retaining the archaic system of parallel striations
and repeated locks of hair, he has introduced more curved lines. The
moustache is not formed as before by hairs parallel to its long contours,
but by spiral strands. Spiral and crocket ends appear already in the tym-
panum, but in the porch they are more common and less regular.

In the nude figure of the unchaste woman (Fig. 114) we may judge of
the change in the sculpture of Moissac since the carving of the cloister
capitals. The expressive contrast of the movements of her head and legs
has already been noted on the capitals. But if the earlier sculptors chose
to shorten the figure, the later artist has increased elongation to inhuman
proportions. He has extended his observation to numerous details which
escaped his predecessor, and created a nude female figure so elaborate in
contour and surface beside the simpler nudes of the cloister, and so unfor-
gettably expressive, that were it not in its present context we should not
readily judge it to be a work of the early twelfth century. A similar nude
figure of Luxuria at Charlieu also seems strangely precocious at this time
in its massive articulation and fluent contours. In Moissac the Roman-
esque character is evident in the thoroughly symmetrical torso of the
twisted figure, her parallel raised hands and pendant breasts, and the reg-

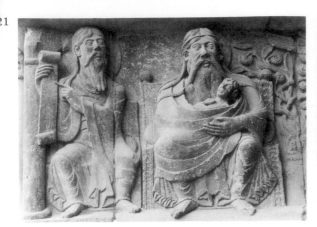

Fig. 121. Moissac, Church; Detail of
West Wall of Porch: Lazarus in
Abraham's Bosom

Fig. 122. Moissac, Church; Detail of
East Wall of Porch: Mary and Anna
(Detail of Fig. 118)

Fig. 123. Moissac, Church; Detail of
West Jamb of Portal: Head of
St. Peter (Detail of Fig. 129)

Fig. 124. Moissac, Church; Detail of
West Wall of Porch: Corbel in Form
of Old Woman's Head

Fig. 125. Moissac, Church; Detail of
West Wall of Porch: Capital with
Hell Scene

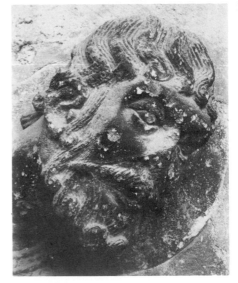

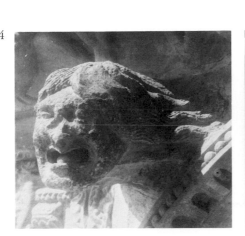

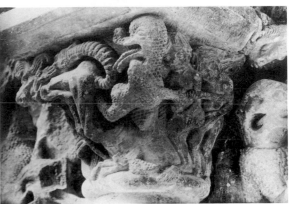

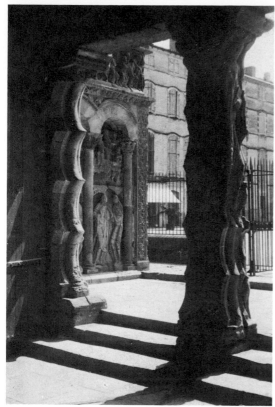

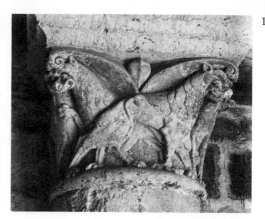

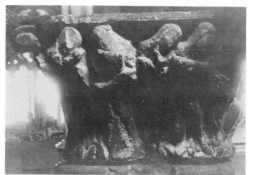

Fig. 126. Moissac, Church; Detail of
Narthex: View from Interior of
Narthex

Fig. 127. Moissac, Church; Detail of
Narthex: Capital of Narthex

Fig. 128. Toulouse, Musée des
Augustins: Romanesque Capital

Fig. 129. Moissac, Church; Detail of
Portal: St. Peter on West Jamb

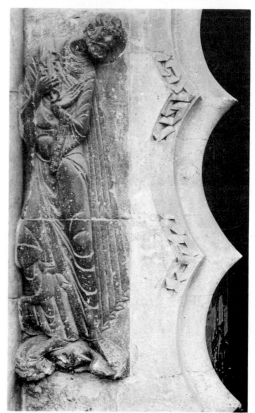

ular design of the suckling serpents. At the base of this vigorous plastic structure, the toad who devours her sexual parts is enclosed by her thighs and the hanging bodies of the serpents, which unite with the torso to form a beautiful symmetrical scheme of fluent lines and bosses. The head is mutilated, but enough remains for us to observe that the sculptor produced features appropriate to the theme and achieved an extraordinary realism. The inclined head and wavy locks spread out on the breast and shoulders are in themselves an impressive sculpture.

THE DOORPOSTS

The hand of the same master appears also in the figures of Peter and Isaiah on the walls that support the tympanum (Figs. 129, 131). They are of almost identical size but are placed at unequal distances from the ground and from the scalloped edges of the jambs. Peter is higher than Isaiah and not so close to the door. This inequality is consistent with the unequal breadth of the jambs and of the two doorways; it entails an irregular, asymmetrical relation of the figures to the adjoining cusps. That these irregularities were designed is evident from the measurements of the figures and the surrounding architecture. For the left jamb and doorway are together equal to the right jamb and doorway, which are respectively smaller and larger than the corresponding parts on the other side.[136a] There can be no question, then, considering the precise equality of the two halves of the portal and the identical structure of the halves, that the alternating variations were preconceived, and were features of style rather than accidents of work.

The extremities of the figures correspond to no moldings or prominent architectural divisions. They are thoroughly unarchitectural applications, independent of the structure of the wall. There are, however, in the contours of the two figures analogies to the scalloped profile of the jambs, but these contours are conceived as contrasting lines and are subordinate to diagonal schemes. It is characteristic of the style that the contour of Peter's right side, which is a symmetrical counterpart, not repetition, of the scalloped jamb, should be attached to a vertical colonnette. In one sense the architecture may be considered subordinate to the sculpture, since the abnormal profile of the jamb is justified by the movement of the figure rather than the latter by the jamb.[137] The aesthetic effect and specific religious expression presuppose this autonomy of the plastic. On the west portal of Chartres the elongation of the ancestors of Christ is a human paraphrase of slender architectural verticals though not determined by them; in Moissac, the elongated Peter is an unstable figure without an axis or a frame.

This Peter is an ascetic hardly expressive of the Roman authority

embodied in his name. The lion on which he treads is barely observable beneath his feet. The keys are sculptured to form the letters of his monogram, but the tapering left hand is raised palm outward beside it in more humble deference and in contrasting diagonal movement. His left leg is a harsh diagonal of unexpected rigidity, accented by the hanging mantle folds that seem ruled mechanically on the stone. The head, almost wrenched from the shoulders in its marked inclination toward the doorway, forms a contrasting diagonal, while both movements are resumed in the zigzag of the bent right leg on the other side. This opposition of limbs is the underlying motif that makes the figure so intensely expressive. The extreme slenderness of Peter, the tenuous, insecurely balanced figure, the striving of the parts in different directions, the head one way, the legs another, the hands and arms in similar disarray, are all relevant to one idea, apparent in the head itself. But the head (Fig. 123) shows less of the gauntness and ascetic nature, the painfully achieved, almost reluctant, spiritual submission that we sense in the whole. And it may be said that here the expression of character is lodged primarily in the forms.

Comparison of the saint and the left seraph on the tympanum (Fig. 97) will make clearer the nature of the forms of Peter which contribute to his powerful expressiveness. In the seraph the similar gestures and elongations are of quite different effect, for contrast is not so thoroughly sustained. His bent legs are parallel to each other. In Peter the right is bent, the left is extended stiffly in the opposite direction, and the feet are parted in further contrast, while in the seraph only one foot is carved, so that less opposition of line is possible. The lion's book and paws at this point only parallel the legs of the seraph and prolong their movement. The wings of the beast sweep across the field, connecting the lines of the seraph's body with other figures. But Peter is isolated, independent of others who might diminish the forcefulness of his own gestures, or reduce them to parts of a larger scheme. In the seraph there is a dominant inclination or turn of the figure toward Christ; but in Peter two directions struggle for dominance, the head and upper body toward the doorway or axis of the portal, the legs away from it. A long pleat flies from between the legs and issues in a suspended fold, outside the body contour, on the column that bounds the movement of the figure on the left. The tilt of Peter's head, as already observed, is sharp and agonized as if the muscles of the neck were stretched by this gesture. The head looks down rather than directly beyond like the seraph's.[138]

The difference between the two conceptions may be illustrated in the surfaces of the figures. In the seraph the limbs are equally salient. In Peter this simple treatment of the relief is changed only slightly, but with great effect. The section of the seraph's body is at almost all levels a symmetrical contour; in Peter it is more bulging or convex, in some places at

the left, in others at the right. The knees are not in equal relief. Even the lion under Peter's feet projects farther at the left than the right. The greatest recession toward the background is at the waist. A similar effect appears on the angel of Matthew in the tympanum.

In the Isaiah, on the other jamb, the forms are essentially the same. But the contrasting directions of the head and legs are the simple Romanesque formula of the cloister and the porch, without the inspired accentuation in Peter. Isaiah's legs are turned toward the reliefs of the porch which fulfill the prophecy inscribed on his scroll; but his head is turned away from the scroll and these reliefs. The internal contrast is not an expression of a conflict within the man, but a purely formal conception that we have already observed in other contexts, with an expressive force independent of the prophet-subject. In Isaiah the suspended scroll is a vertical band that indicates the axis from which this less animated figure bends. Perhaps the precise iconographic content, evident in the large inscription and the nearby associated themes of the Virgin limited the movement of the figure. In Souillac the marvellous Isaiah, carved by a sculptor of the same school, carries a great scroll inscribed only with his name. Perhaps it was in subordination to Peter, the patron of Moissac, that the prophet was restrained and his movement limited to a conventional form. The unequal breadth of the two jambs and the balanced inequality of the doorways imply the difference or contrast of the corresponding figures.

In the miniature figures of Peter and Paul surmounting the vertical bands of plants and birds on the beveled jambs framing the outer eastern colonnette, the contrast is more explicit and quaint (Fig. 136). In chiasmic opposition to the larger Peter of the left doorpost and Paul on the west side of the trumeau, the little Paul is seated on the left jamb, while Peter sits inverted on the right. I have been taught that such small anomalies of design were a superstitious concession to the evil eye which detested nothing so much as a perfect craftsman. But in this instance contrast has become a rule, and in the literal inversion of the patron saint, who was martyred on the cross upside down, the assistant sculptor has appeased the devil and carried to a perfect but comic conclusion the conscious formulation of his master's style.[139]

THE TRUMEAU

I have not described the trumeau after the lintel, despite their architectural connection, because its sculpture is not a part of the original design. That a trumeau always stood here is evident from the structure of the tympanum and the lintel; but that the present one was sculptured at the same time as the stones above is less likely. Its carving is probably

even later than the figures of the jambs and the side walls of the porch. The divergence from the rest of the portal may be seen not only in the style of its figured and animal decoration, but in the moldings and foliate ornament as well.

The section of the side jambs is fifty-three centimeters in depth, of the trumeau, forty-nine. Their profiles also differ (Fig. 126). In both trumeau and jambs a festooned, or lobed, colonnette is engaged to the sides facing the entrance-ways. On the trumeau it is segmental, and set between angular prismatic moldings that form a zigzag interrupted by the central colonnette; on the jambs it is of semicircular section and is placed on a flat band with outer chamfers. The trumeau has five scallops on each side, the jambs but four.[140] Their base moldings are also different.[141] The original impost of the trumeau has been replaced in recent times by an uncarved block of limestone unlike the marble of the block below. The capitals of the engaged colonnettes have been preserved and show a structure and foliate ornament resembling the capitals of the Romanesque windows of the church and several of the adjoining tower, but in contrast to the deeply undercut plant and animal forms of the other capitals of the porch and the portal.

The trumeau was already singled out for special admiration in the fourteenth century. The abbot Aymeric de Peyrac then wrote that this stone and the marble font of the cloister (now destroyed) were "reputed the most beautiful, and the most subtly wrought, and were said to have been brought here with great cost and labor and even supposed to have been made miraculously rather than by a man, especially a simple abbot."[142]

It is a marble monolith, 3.52 meters high and about .72 wide. On its outer face are carved three superposed couples of crossed animals (Fig. 130). They are lion and lioness, contrary to the common description of them as male alone. The outer animal is always a lioness, alternating in direction from pair to pair. The beasts are mounted on each other's haunches, while their tails, distinguished by a smooth carrotlike termination in the female and by a similar form with a pebbled surface and a hooked end and lobed calyx envelope in the male, are interlaced between them on a background of acanthus rosettes.

On the sides of the trumeau are the elongated figures of Paul and a bearded prophet, engaged to curved colonnettes which terminate in a palmette capital on one side and an acanthus capital on the other (Figs. 132–134). The prophet stands with legs crossed, Paul with a simpler bending of the limbs. They are compressed within the narrow frame formed by the fore and rear parts of the animals and the back of the pillar, festooned like the jambs beside it. A series of imbricated semicircular scales, which Aymeric thought was the signature of the abbot Ansquitilius (1085–1115), decorates the back.

The sculptures are unarchitectural in effect, and betray no effort to accent the static function of the pillar. But this indifference to physical structure is consistent with the form of the trumeau, since the latter has itself been designed without regard to the expression of its function and even contradicts it. It contains hardly a vertical line. Its contours are scalloped both in elevation and plan; the colonnettes of its narrow sides are curved behind the figures engaged to them. The diagonal crossing of the lions throws the plastic accent on recurrent heads and legs along the broken edges of the trumeau. The vertical axis becomes plastically subordinate, even neutral, with the addition of circular rosettes behind the beasts. The placing of the figures, on the less visible narrow sides, is also significant of the unarchitectonic character of the style. But the positive energy and movement of the tympanum and porch, which imply these willful asymmetries, these irregular forms and contrasts of the trumeau, are less apparent in the latter.

Mâle has remarked of the animals that they are more Assyrian than the Assyrian lions themselves.[143] They are inferior copies of the symbol of Mark on the tympanum. They have the same peculiar muzzles, worried brows, short legs, and conventionalized locks of hair but lack the energy and powerful modeling of their original. Their caterpillar bodies are surcharged with the repeated ornamental details which formed a simple fringe in the tympanum. In this fantastic, though not untraditional rearrangement of the usual portal lions, they have lost their ferocity. The threat of their animal bodies is diminished by their repeated pairing and crossing, the knotting of their tails, and the attachment to disks of foliage. The force of the diagonal movement of the beasts has been dissipated into a simple pattern and neutralized in their vertical succession. Lions are more effectively crossed on a capital of the narthex where the contours of the beasts are sharply isolated and intersect in rigorous correspondence with the enclosing volutes (Fig. 127).

The rosettes carved on the outer surface of the pillar, as backgrounds of the crossed animals, are weak imitations of the forms of the lintel. The interspaces have been left bare, the cable omitted, the central knob treated like a button without the crispness or variety of the original, and the leaves themselves have been reduced to smaller, softer patterns, consisting of five spoon-grooved lobes. The eyelets are no longer effective in the design.

In the figures of the trumeau there is an analogous dilution of the powerful forms of the tympanum. They are even more slender than the figures of the porch, but their elongation is no longer a support of intense diagonal contrasts. It is an elegant proportion in figures whose movements are languid, almost indolent, versions of their prototypes.[144] A similar change is evident in the smoothly undulating surfaces of the heads

and beards and the boneless hands (Fig. 133). The draperies have the thinness of certain Renaissance costumes. The doubled fold has been abandoned for more plastic, delicate forms.[145]

If the figures are not adapted to a caryatid function or designed in columnar forms, they are hardly troubled by the jagged, constraining structure in which they have been embedded. In neither figure does the compression between cusped edges and lions correspond to an inward involvement or sustained constriction and conflict of forms, or even the abstraction of vertical themes. They recall certain kings with legs crossed, engaged to the columns of St.-Denis and Chartres, more than their own prototypes in Aquitaine. Only the unarchitectural design of the trumeau has concealed this similarity.

THE ABBOT ROGER AND "ST. BENEDICT"

These two figures, placed high upon the capitals of columns engaged to the south wall of the porch, are themselves independent of the latter (Figs. 135, 137). They are not carved in the wall or even in a salient block which forms an essential part of it, as we might suppose from the engagement of the column, but are almost detached in high relief on a thick slab set into the wall subsequent to the construction. The background is, in fact, cut (like a flat pilaster) in slight salience from the wall. This separate relief background illustrates at the same time the independence of architecture already analyzed in the sculptures below, and also the persistence of an earlier method of relief even in figures which by their salience suggest a complete detachment from the background. The two figures exist in a space more emphatically defined than any we have seen below. Their feet are firmly planted on a deep, horizontal ground and are exaggerated in mass and flatness, as if to underline the newly achieved stance in space. On the trumeau, the feet of the prophet (Fig. 132) are still suspended in the archaic manner of the cloister, and on the jamb, Isaiah stands upon a sloping ledge (Fig. 131). Another horizontal surface confirms the depth of the figures on the columns; it is the slab above their heads, which was probably designed to protect them but serves also to mark the depth or projection of the stage on which they stand. In the description of the capitals of the cloister an analogous effect was observed in the projecting console above the head of Nebuchadnezzar (Fig. 23); but there the salience was slight and the corresponding ground plane still undeveloped.

The postures of the two figures also imply a development of spatial forms. By their religious office and significance they are bound to a frontal position and an ideal repose, like the abbot Durand in the cloister

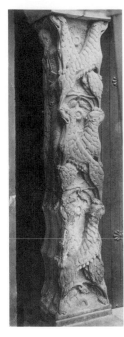

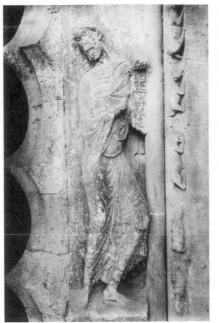

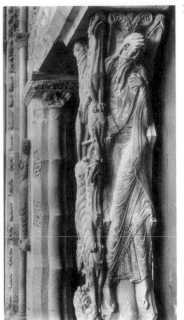

Fig. 130. Moissac, Church; Detail of Portal: Trumeau

Fig. 131. Moissac, Church; Detail of Portal: Isaiah on East Jamb

Fig. 132. Moissac, Church; Detail of Trumeau: A Prophet

Fig. 133. Moissac, Church; Detail of Trumeau: Head of St. Paul

Fig. 134. Moissac, Church; Detail of Trumeau: St. Paul

Fig. 135. Moissac, Church; Detail of Exterior of Porch: St. Benedict (?) on West Column

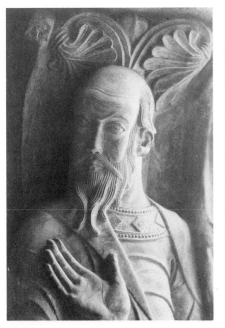

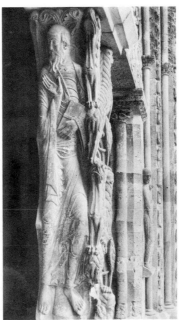

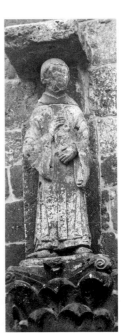

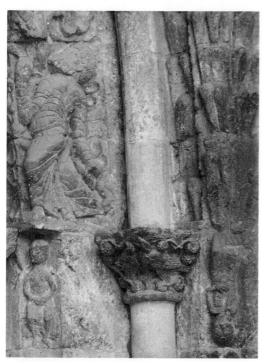

Fig. 136. Moissac, Church; Detail of Portal: Peter and Paul below Spring of Archivolt of Tympanum

Fig. 137. Moissac, Church; Detail of Exterior of Porch: Abbot Roger (1115–1131) on East Column

Fig. 138. Moissac, Church; Detail of Exterior: Modillions of West Tower

Fig. 139. Moissac, Church; Detail of Exterior: Modillions of West Tower

Fig. 140. Moissac, Church; Detail of Exterior: Cornice and Crenellations of South Wall of South Porch

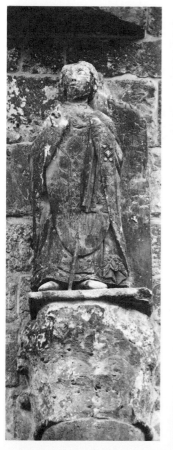

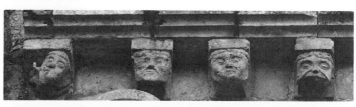

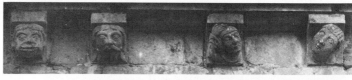

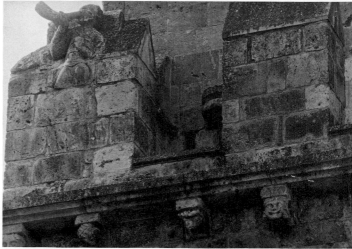

(Fig. 4); but the abbot Roger looks up to the left and the head and shoulders of St. Benedict are turned toward the right, although their glance has no perceptible object. If we compare them with the opposed apostles on a single pier of the cloister (Figs. 5, 6) whose heads are turned to each other, we see that the more recent figures are less bound to the wall and that their arms, if parallel to the wall, are less constrained by this archaic procedure. The immobility of the two men contrasts with the figures of the tympanum, as if by this liberation of the mass all the energy of line had been sacrificed. But this iconlike immobility is distinct from the stiffness of the apostles in the cloister, which was an unnatural, imposed rigidity, whereas Benedict stands humbly with an ascetic quietude and detachment and the physically mediocre Roger, in his massive pyramidal costume, has an air of energy and assertion. They are portraits of contemporary monastic figures of the contemplative and active life.

The dominance of the mass of the figures is a further development of the style of the porch. Instead of a complicated course of pleatings at the edges of the costume, the sculptor has accented the larger, plastic undulation of the mass of the garment about the legs. In Benedict the folds are simpler, softer, more natural forms; the sleeves are deeply hollowed to expose the ends of an inner garment. The contours of both figures have been simplified and rounded to produce a clearer, more definite solid.

Despite this simplification and immobility, the characters of the earlier style persist to some degree in the two figures. Roger is placed to the left of the slab rather than in the exact center like Durand, and his name, BEA(tu)S ROT(g)ERIUS ABBAS, is inscribed at the right. If he wears the symmetrical costume of an abbot, it is no longer disposed in its ideal or typical order but is stirred by an accidental asymmetry of the parts. The turn of the abbot's head is contrary to the inclination of his staff. The authoritative hand is not rigidly parallel to the background like his predecessor's but is bent back in a more natural gesture. The ascending diagonal lines of his costume are crossed by other angular forms. Large, vigorous pleats are placed asymmetrically on the lower edge. In Roger we see a realistic asymmetry imposed on an iconographically symmetrical object, as in Durand an inherent symmetry was reproduced with an effect of intricate abstract ornament.

Benedict is a slightly taller, more slender figure than Roger, but no more closely related to the earlier reliefs of the porch. The two figures are so different in expression that it is difficult at first to see their common authorship. This difference attests the development of the style in which one could conceive such individual interpretations of a historical and an almost contemporary figure.

There are no figures below quite like them, but their forms suggest either a later work of the master of the horizontal friezes of the porch or

of a sculptor closely related to him. The more recent date is evident in purely material details like the relation of the slabs of these figures to the surrounding wall, as well as in the plastic development of the figures. The modeling and perspective of the hands and sleeves of Benedict is of a naturalism beyond that of the lower porch reliefs. The inscription beside Roger has larger, rounder, more plastic letters than the inscription of Isaiah (Fig. 131). The forms of A and R are especially noteworthy in their approach to early Gothic majuscules.

NOTES

1. This work is the first part of a doctor's dissertation accepted by the Faculty of Philosophy of Columbia University in May, 1929 and published in *The Art Bulletin* in 1931. I have made many changes in the original text, but with only slight alteration of the conclusions.

I have profited by the generosity of Professor Porter, who opened his great collection of photographs to me, and by the criticism of Professor Morey. I have been aided also by the facilities and courtesy of the Frick Reference Library, the Pierpont Morgan Library, and the Avery and Fine Arts Libraries of Columbia University.

I owe an especial debt to the late Monsieur Jules Momméja of Moissac, who taught me much concerning the traditions of the region, and to the late Monsieur Dugué, the keeper of the cloister of Moissac, who in his very old age and infirmity took the trouble to instruct me. He permitted me to study the unpublished plans of the excavations of the church, made in 1902.

The photographs of Moissac reproduced in this study are with a few exceptions the work of Professor Richard Hamann and his students of the Kunsthistorisches Institut of the University of Marburg. I thank Professor Hamann for his kindness in allowing me to reproduce them, and for other courtesies to me during the writing of this work. I recommend his wonderful collection to all students of mediaeval art.

I must thank, finally, the Carnegie Corporation of New York, which supported my graduate studies at Columbia University, and enabled me by its grant of a fellowship in 1926–1927 to travel for sixteen months in Europe and the Near East.

2. Emanuel Löwy, *The Rendering of Nature in Greek Art*. English translation, London, Duckworth, 1907.

3. Devals, *Les voies antiques du departement de Tarn-et-Garonne*, in *Bulletin Archéologique de la Soc. Archéol. de Tarn-et Garonne*, Montauban, 1872, p. 360, n.

4. Dumège, *Antiquités de la ville de Moissac* (manuscript copy in the Hotel-de-Ville of Moissac), 1823, pp. I ff., 127 ff., 140 ff. See also *Bull. Archéol. de la Soc. Archéol. de Tarn-et-Garonne,* LI, 1925, pp. 140, 141, for a report of the discovery of Roman bricks of the year 76 B.C. under an old house in Moissac. The presence of Roman remains was observed by the abbot Aymeric de Peyrac in his chronicle, written c. 1400 (Paris, Bibl. Nat. ms. latin 4991-A, f. 154 r, col. I)—*Denique in multis locis harum parcium in agris et viis publicis apparent antiqua pavimenta que faciunt intersigna villarum antiquarum et penitus destructarum.* . . .

5. A. Lagrèze-Fossat, *Études historiques sur Moissac*, Paris, Dumoulin, III, 1874, pp. 8 ff. and 495–498, and E. Rupin, *L'Abbaye et les cloîtres de Moissac*, Paris, Picard, 1897, pp. 21–25, for a *résumé* of the evidence concerning the period of foundation and the various local legends which pertain to it.

6. Rupin, *loc. cit.*

7. *La Vie de St. Didier, Évêque de Cahors* (630–655), edited by Poupardin, Paris, Picard, 1900, pp. 22 ff. This biography was written in the late eighth or early ninth century by a monk of Cahors who utilized a source contemporary with the saint. One of the manuscripts comes from Moissac (Bibl. Nat. lat. 17002).

8. Rupin, *op. cit.*, pp. 28, 29.

9. On these disasters and the submission to Cluny, see Rupin, *op. cit.*, pp. 31–50.

10. An inscription of the period, now enwalled in the choir of the church, records the event. Rupin, *op. cit.*, pp. 50–52, and fig. 5.

11. Rupin, *op. cit.*, pp. 57–62.

12. *Ibid.*, pp. 62, 63.

13. Paris, Bibl. Nat. ms. latin 4991-A, f. 160vo., col. I. The text is published by Rupin, *op. cit.*, p. 66, n. 2 and by V. Mortet, *Recueil de textes relatifs à l'histoire de l'architecture en France au moyen-âge. XIe-XIIe siècles*, Paris, Picard, 1911, pp. 146–148. The construction of the cloister by Anquêtil is also indicated by an inscription of the year 1100 in the cloister. For a photograph see Fig. 3.

14. Rupin, *op. cit.*, p. 350, and Mortet, op. cit., p. 147. Aymeric mentions a "very subtle and beautiful figure in the shrine in the chapel of the church" made for Hunaud, and similar works in the priory of Layrac, near Agen, which belonged to Moissac.

15. Rupin, *op. cit.*, pp. 70–75. The portrait of Roger is sculptured on the exterior of the south porch (see below, Fig. 137). The evidence for the attribution of the domed church to Roger will be presented in the concluding chapter. [See the article on Souillac, n. 34, pp. 129–130 above, on the date of the church.]

16. Rupin, *op. cit.*, pp. 181 ff., has listed the property of the abbey, and reproduced a map (opposite p. 181) showing the distribution of its priories and lands.

17. *Millénaire de Cluny*, Macon, 1910, II, pp. 30, 31, and Pignot, *Histoire de l' ordre de Cluny*, II, pp. 190 ff.

18. G. M. Dreves, *Hymnarius Moissiacensis. Das Hymnar der Abtei Moissac im 10. Jahrhundert nach einer Handschrift der Rossiana. Analecta Hymnica Medii Aevi*, II, Leipzig, 1888, and C. Daux, *L'Hymnaire de l'abbaye de Moissac aux X-XI ss.*, Montauban, 1899.

The remnants of the mediaeval library of Moissac were brought to Paris in the seventeenth century by Foucault, and are now preserved in the Bibliothèque Nationale. They are mainly religious texts. For their history and content, and for ancient catalogues of the library of Moissac, see L. Delisle, *Le Cabinet des Manuscrits*, I, pp. 457–459, 518–524.

19. They were called to the attention of scholars by Delisle more than forty-five years ago, but have never been published as a group.

20. Rupin, *op. cit.*, pp. 82, 83.

21. *Ibid*, pp. 86 ff.

22. *Ibid*, pp. 107, 354 ff.

23. *Ibid*, p. 345.

24. Except for the angel of the Annunciation on the south porch and several modillions. On the fortunes of the abbey building in the nineteenth century, see Lagrèze-Fossat, *op. cit.*, III, pp. 266–268.

25. Rupin, *op. cit.*, p. 66, n. 2, and Mortet, *op. cit.*, pp. 147, 148.

26. *Ibid*

27. He writes, "*Credo quod ipse (Asquilinus) fecerit scribi etiam in lapide et de eisdem litteris consecrationis monasterii facte de tempore domini Durandi abbatis.*" See Mortet, *op. cit.*, p. 148.

28. Mortet, *op. cit.*, pp. 146, 147.

29. Léon Godefroy, a canon of the church of St. Martin in Montpézat (Tarn-et-Garonne), visited Moissac about 1645. He observed numerous relics in the treasure, including the body of St. Cyprian. Mosaics covered the entire floor of the church. He paid little attention to the portal and said of the cloister that it was "*fort beau ayant de larges galeries et le préau environné d'un rebord . . . colonnes d'un marbre bastard . . . et des statues qui représentent les Apostres. Si ces pièces sont mal faites il faut pardonner à la grossièreté du temps qui ne possédoit pas l'art de la sculpture au point qu'on fait à present.*" He observed also a fountain in one corner of the cloister. See Louis Batcave, *Voyages de Léon Godefroy en Gascogne, Bigorre et Béarn (1644–1646)*, in *Études Historiques et Religieuses du diocèse de Bayonne*, Pau, VIII, 1899, pp. 28, 29, 73, 74.

30. *Gallia Christiana*, 1st ed., 1656, IV, pp. 678–680; 2nd ed., 1715, I, pp. 157–172.

31. Rupin, *op. cit.*, p. 6.

32. Delisle, *op. cit.*

33. F. Pottier, in *Bull. de la Soc. Archéol. de Tarn-et-Garonne*, 1888, p. 67.

34. *Antiquités de la Ville de Moissac,* 1823. The copy in Moissac is kept in the archives of the Hôtel-de-Ville.

35. Nodier, Taylor, and de Cailleux, *Voyages pittoresques et romantiques dans l'ancienne France, Languedoc I, partie 2,* Paris, 1834.

36. Jules Marion, *L'abbaye de Moissac,* in *Bibliothèque de l'Ecole des Chartes,* 3e série, I, 1849, pp. 89–147, and in the same journal, *Notes d'un voyage archéologique dans le sudouest de la France.* 1852, pp. 58–120.

37. Paris, 1854-1869, III, pp. 283-285; VII, pp. 289–293, etc.

38. *Études Historiques sur Moissac,* Paris, Dumoulin, 3 volumes, 1870, 1872, 1874. The archaeological study is in the third volume.

39. J. Mignot, *Recherches sur la chapelle de St. Julien,* in *Bull. de la Soc. Archéol. de Tarn-et-Garonne,* IX, 1881, pp. 81–100; and *Recherches sur les constructions carlovingiennes à Moissac, ibid,* XI, 1883, pp. 97–105. Henry Calhiat, *Le tombeau de Saint Raymond à Moissac, ibid,* I, 1869, pp. 113–117. Chadruc de Crazannes, *Lettre sur une inscription commémorative de la dédicace de l'église des Bénédictins de Moissac,* in *Bulletin Monumental,* VIII, 1852, pp. 17–31, and *Lettre sur une inscription du cloître de Moissac, ibid,* IX, 1853, pp. 390–397. Francis Pottier, *L'abbaye de St.-Pierre à Moissac,* in *Album des Monuments et de l'Art Ancien du Midi de la France,* Toulouse, Privat, 1893–1897, I, pp. 49–63. Jules Momméja, *Mosaïques du Moyen-Age et Carrelages émaillés de l'abbaye de Moissac,* in *Bulletin Archéologique,* Paris, 1894, pp. 189–206. Viré, Chenet, and Lemozi, *Fouilles exécutées dans le sous-sol de Moissac en 1914 et 1915,* in *Bull. de la Soc. Archéol. de Tarn-et-Garonne,* XLV, 1915, pp. 137–153. *Addendum et rectification, ibid,* pp. 154–158. For the excavations of 1930, conducted by M. Viré, see the report in the *Comptes Rendus de l'Académie des Inscriptions et Belles-Lettres,* 1930, pp. 360, 361.

40. *L'abbaye et les cloîtres de Moissac,* Paris, Picard, 1897. Mention is made of an illustrated work by J. M. Bouchard, *Monographie de l'église et du cloître de Saint-Pierre de Moissac,* Moissac, 1875, but it has been inaccessible to me.

41. *Congrès Archéologique de France,* Paris, Picard, 1902, pp. 303–310 (by Brutails). The congress of 1865 also visited Moissac and reported the discovery of fragments of another cloister. See Rupin, *op. cit.,* p. 200, and Lagrèze-Fossat, *op. cit.,* III, pp. 107, 108.

42. There is a brief report in the *Bulletin Archéologique,* Paris, 1903, p. li.

43. *L'art religieux du XIIe siècle en France,* Paris, Colin, 1922, and *Les influences arabes dans l'art roman,* in *Revue des Deux Mondes,* Nov. 15, 1923, pp. 311–343.

44. *Notes sur la sculpture romane en Languedoc et dans le nord de l'Espagne,* in *Bulletin Monumental,* 1923, pp. 305–351; *L'autel roman de Saint-Sernin de Toulouse et les sculpteurs du cloître de Moissac,* in *Bulletin Archéol.,* Paris, 1923, pp. 239–250, pls. XIX–XXVII; *Les débuts de la sculpture romane en Languedoc et en Bourgogne,* in *Revue Archéologique,* Paris 5e série, XIX, 1924, pp. 163–173; *Notes sur la sculpture romane en Bourgogne,* in *Gazette des Beaux-Arts,* 5e période, VI, 1922, pp. 61–80.

45. *Romanesque Sculpture of the Pilgrimage Roads,* Boston, Marshall Jones, 1923, 10 volumes; *Spain or Toulouse? and other Questions,* in *Art Bulletin,* VII, 1924, pp. 1–25; *Leonesque Romanesque and Southern France, ibid,* VIII, 1926, pp. 235–250.

46. The sculptures of Moissac have been discussed also by Wilhelm Vöge, *Die Anfänge des monumentalen Stiles im Mittelalter,* Strassburg, Heitz, 1894; Albert Marignan, *Histoire de la sculpture en Languedoc du XIIe-XIIe siècle,* Paris, Bouillon, 1902; Gabriel Fleury, *Études sur les portails imagés du XIIe siècle,* Mamers, 1904; André Michel, in his *Histoire de l'Art,* I, 2e partie, Paris, Colin, 1905, pp. 589–629 (*La sculpture romane*); Jean Laran, *Recherches sur les proportions dans la statuaire française du XIIe siècle,* in *Revue Archéologique,* 1907, pp. 436–450; 1908, pp. 331–358; 1909, pp. 75–93, 216–249; Auguste Anglès, *L'abbaye de Moissac,* Paris, Laurens, 1910; Robert de Lasteyrie, *L'architecture religieuse en France à l'époque romane,* Paris, Picard, 1912, pp. 640 ff.; Ernst Buschbeck, *Der Portico de la Gloria von Santiago de Compostella,* Wien, 1919, pp. 24 ff.; J. Jahn, *Kompositionsgesetze französischer Reliefplastik im 12. und 13. Jahrhundert,* 1922, pp. 11–16; Alfred Salmony, *Europa-Ostasien, religiöse Skulpturen,* Potsdam, Kiepenheuer, 1922; Raymond Rey, *La cathédrale de Cahors et les origines de l'architecture à coupoles d'Aquitaine,* Paris, Laurens, 1925, *Les vieilles églises fortifiées du Midi de la France,* Paris, Laurens, 1925, and *Quelques survivances antiques dans la sculpture romane méridionale,* in *Gazette des Beaux-Arts,* 5e période, XVIII, 1928, pp. 173–191.

47. Charles Rufus Morey, *The Sources of Romanesque Sculpture*, in *Art Bulletin*, II, 1919, pp. 10–16; *Romanesque Sculpture,* Princeton, 1920; *The sources of Mediaeval Style,* in *Art Bulletin,* VII, 1924, pp. 35–50.

[47a. On Mâle's ideas concerning Moissac see my article: "Two Romanesque Drawings in Auxerre and some iconographic problems," *Studies in Art and Literature for Belle da Costa Greene*, Princeton, 1954, pp. 331–349, reprinted in the present volume, pp. 306 ff.]

48. For the appearance of the buildings prior to the restorations, see the lithographs and engravings in Nodier, Taylor, and de Cailleux, *op. cit.*, I, partie 2, 1834, pl. 65, and Rupin, *op. cit.,* pp. 199, 200, figs. 34, 35. In the early nineteenth century the galleries were covered by wooden barrel vaults, and several capitals and columns in the west and north galleries were then replaced or enclosed by piers of rectangular section. These must have been later substitutions which were removed in the 1840s by the French restorers of the cloister. The present columns and capitals are contemporary with the others. In only one of them (number 61) is there an exceptional form—a greater breadth of the astragal and thicker columns—which may be explained by the fact that the arch of the lavatorium sprang from this very capital. See below, n. 68.

49. Except the central pier of the south gallery which is a monolith of reddish marble. Lagrèze-Fossat, *op. cit.,* III, p. 259, has mistakenly described all the piers as monoliths. The revetment is a thin hollowed marble case with two or three unjointed sides. The fourth side is stuccoed or faced with a thin slab of marble (central western pier, Fig. 13).

50. The height of the piers, without their imposts and podia, ranges from 1.57 m. to 1.60. The angle piers are not quite square in section, and vary in breadth from .49 m. (St. John, Fig. 8) to .53 (St. Paul, Fig. 5). The central pier of the east gallery (abbot Durand, Fig. 4) is .72 m. wide on its east and west faces, and .52 m. deep. The central north pier (unsculptured) is .66 m. by .51 m., the central west, with the inscription (Fig. 3) and St. Simon (Fig. 13), is .69 m. by .52; but the relief of Simon, set in the broader side, is only .51 m. wide. The thickness of the slabs is no more than .04 to .05 m. (in those piers of which the narrow edge of a slab is exposed). On the southwest and northwest piers the slabs were too narrow to cover the sides on which are sculptured Philip and Matthew (Fig. 10); extremely slender pieces were added to complete the revetment. In the relief of Philip (Fig. 12) a vertical joint runs along the right column and cuts the arch. His mantle has been designed parallel to this line, and never crosses it; and a wide interval has been left between the O and L of APOSTOLUS in the inscription to avoid crossing this same joint.

51. The figure of Simon (Fig. 13) was for many years enwalled in the exterior of the south porch of the church, where it was seen by Dumège (before 1823) and the authors of the *Voyages pittoresques et romantiques* (before 1834). It was restored to its present position by Viollet-le-Duc or his assistant, Olivier, during the restorations of the 1840s. It is not certain that it is now in its original place, but it undoubtedly belonged to the cloister. That all the apostles were once represented cannot be inferred from the structure of the piers. The central southern pier is intact. Of the two remaining piers with blank faces, the central northern has, on its south side, a brick filling up to the very edge of the impost. Unless this is a more recent change it would exclude the application of a slab to its one bare surface. The same holds true of the central eastern pier (Durand), for the marble encloses the two narrow sides completely, and there is no place on the broader (west) side with exposed brick surface for a marble slab. Hence it must be concluded that only nine apostles (including Paul) were originally represented on the piers. Others were perhaps carved on the corner pier of the destroyed lavatorium or fountain enclosure (see below, n. 68), and on the supports of some adjacent monastic structure. It is possible, however, that narrower slabs (c. 51 m.), of the same dimensions as those of the corner piers, were once inserted on these broader faces (.66 m., .72 m.) of the central piers. The relief of Simon (.51 m.) is narrower than that of Durand (.72 m.).

52. For similar treatment of hair in archaic Greek sculpture, see Lechat, *Au musée de l'acropole d'Athènes,* Paris, 1903, fig. 5 (p. 99), fig. 7 (p. 125), fig. 33 (p. 343).

53. After his death he appeared in a dream to a monk of Cluny, with his mouth swollen with saliva and unable to speak. Six monks had to maintain a vigil of absolute silence in order to redeem him. See Migne, Patr. lat. CLIX, col. 873, 901, 913.

54. There is a similar distortion in drawings in the Gospels of Matilda of Tuscany, an

Italian manuscript contemporary with the cloister. It is now in the Pierpont Morgan Library. See *Gospels of Matilda Countess of Tuscany,* 1055–1115, with an Introduction by Sir George Warner. Privately printed, Roxburghe Club, 1917, pl. XXIV.

55. The costume of Bartholomew (Figs. 9 and 17) is also misunderstood. Note the misplaced buckle and the false mantle on the right shoulder. With his left hand he holds up the bottom of his tunic—a common gesture in the capitals—which covers still another tunic. The diagonal of the outer tunic is obviously classical, and the gesture of the saint appears to be a rationalization of that diagonal. The lower edges of the costume of Philip (Fig. 12) are also arbitrary and unclear.

56. Cf. the Amazon Hippolyta in the relief from Martres-Tolosanes, near Toulouse— Ésperandieu, *Recueil général des bas-reliefs de la Gaule romaine,* II, fig. 5, p. 37.

57. As on the capitals of the south transept portal of Saint-Sernin in Toulouse, dated before 1093.

58. The tympanum of the aisle portal of Saint-Sernin. The smooth unincised eye occurs also at Chartres—Houvet, *Cathédrale de Chartres, Portail Royal,* pl. 28.

59. Cf. W. Deonna, *Les "Apollons Archaïques,"* Geneva, 1909, p. 24, n. 2. The oblique axis of the eyes of Paul, Simon, Andrew, and John is also a feature of archaic Greek art.

60. Note especially the forms of B, R T, h, and O, as well as the sign of contraction, with its central handle; and the use of superposed circular dots instead of triangular notches.

61. See below, p. 191.

62. I have considered above only the linear design. But these sculptures were originally painted, and their effect depended also on the color which distinguished areas, accented parts, and possibly determined patterns not suggested by the carving we see today. Traces of color—pinkish and greenish tints—are still visible on the apostles. But they are so faint and fragmentary that little can be inferred from them as to the original scheme of painting. They seem to have been clearer seventy years ago when the figures were described by Viollet-le-Duc (*Dictionnaire,* VIII, p. 111).

63. If we follow the courses of the concentric folds incised in clear sets on the mantle of Peter, on his arms, and on the torso between the arms, we shall observe that they form three distinct sets of intercepted lines, detached from each other.

64. The lozenge ornament of the enriched portions of the costume is also significant in its zigzag and unstable units. A sculptor of more classic style would have used beads or another circular motif.

65. The frequency of angular letters is also characteristic.

66. Cf. also with the inscription recording the completion of the cloister in 1100 (Fig. 3). It begins with several lines of small letters, close-packed, linked, crossed, and nested in unpredictable groupings, and ends with a series of large, regularly spaced letters in four uniform rows of repeated initials in sets of three: V.V.V./M.D.M./R.R.R./F.F.F.—a remarkable contrast of script styles.

[These enigmatic letters, which have engaged the curiosity of local antiquarians who mistakenly read them in vertical sequence (see Rupin, *op. cit.,* p. 315), are a variant of an inscription of mysterious alliterative initials often found in manuscripts since the ninth century and interpreted there as a prophecy of the fall of Rome. In some instances the decipherment is attributed to Bede. V.V.V. is read as Venit Victor Validus or Victor Vitalis Veniet, M.M.M. as Monitus Monumentum Mortuus (sic), R.R.R. as Rex Romanorum Ruit, F.F.F. as Ferro Frigore Fame. On this mediaeval puzzle, which seems to have arisen from the effort to decipher an inscription on a Roman monument, see the instructive article by Karl-August Wirth "Überlieferung und Illustration eines mittelalterlichen Anekdotenstoffes," *Münchner Jahrbuch der bildenden Kunst,* XII, 1961, pp. 46–64, including on pp. 54–55 and in notes 75, 76 interesting observations by Professor Bernhard Bischoff. The inscription in Moissac has been overlooked in the writings on this subject.]

67. The variation in the size of the capitals—some single capitals having a greater vertical dimension—indicated by Taylor and Rupin (Rupin, *op. cit.,* Fig. 38) is sporadic rather than systematic. It appears in only a few capitals. But the single columns, with a few exceptions, have a greater diameter than the twin (.165 m., .13 m.).

68. The existence of the lavatorium is inferred from the traces of arches above the cen-

tral pier of the north gallery and the fifth capital from the northwest pier in the west gallery—both arches springing toward the garden of the cloister. Since a fountain once stood in this northwest corner of the cloister the inference seems even better founded. Lenoir, in his *Architecture Monastique,* Paris, 1856, p. 312, fig. 469, reproduced an engraving of the marble basin of the fountain, after an "old drawing" of which he unfortunately did not state the provenance. That this fountain was an elaborate, perhaps richly sculptured construction, is implied in the description by the abbot Aymeric de Peyrac (c. 1400), *"quidem lapis fontis marmoreus et lapis medius portalis* [the trumeau], *inter ceteros lapides harum precium, reputantur pulcherrima magnitudine et subtilli artifficio fuisse constructi, et cum magnis sumptibus asportati et labore"* (*Chronicle,* f. 160 vo., col. I, Rupin, p. 66, n. 2). He attributed both works to the abbot Anquêtil (1085–1115), who built the cloister. The fountain was observed in the seventeenth century by a traveler, Leon Godefroy (see note 29 above). A fountain with an arcaded enclosure of the late Romanesque period exists in the cloister of San Zeno in Verona (A. Kingsley Porter, *Lombard Architecture,* IV, pl. 234, 4).

Lagrèze-Fossat, *op. cit.,* III, p. 265, has denied the existence of such an enclosure in Moissac, especially since the traces of the arches are in the same brick as the arches of the cloister and belong to the later thirteenth century. He states that excavation has revealed no trace of the foundations and suggests that a lavatorium enclosure was undertaken in the thirteenth century but never completed. He overlooked the exceptional breadth of the lower part of the capital of the west gallery (Annunciation to the Shepherds and Daniel between the lions, Figs. 86, 87), which received the spring of this lavatorium arch, and also the existence in Moissac of a series of capitals and colonnettes of the same material and dimensions as those of the cloister. They are now in the Belbèze estate, which is on the grounds of the monastery. The Belbèze family occupies the old palace of the abbots of Moissac. The slight foundation required for such an arcade might have been removed with the arcades themselves, especially since the garden of the cloister was cultivated, and in the nineteenth century served as the dumping ground of a saltpeter establishment.

69. Rupin, *op. cit.,* fig. 37, reproduces, after Nodier and Taylor, a view of what has been called both the *petit* and *grand cloître*—a galleried enclosure that occupied the site of the Petit Seminaire of Moissac. Its pointed arches of simple rectangular section were carried by twin tangent colonnettes. It is difficult to judge from the old lithograph the date of this building; it is presumably a Gothic construction. Fragments of this cloister were observed by the archaeological congress which visited Moissac in 1865 (Rupin, *op. cit.,* p. 200, Lagrèze-Fossat, *op. cit.,* III, p. 107). They consisted of the remains of a single bay with unsculptured capitals and two marble columns engaged to a pier.

70. The combined diameters of the astragals are a little more than .41 m., whereas on most of the twin capitals their breadth ranges from .32 to .36. A similar proportion appears in the Adoration of the Magi (Fig. 58) and an ornamented capital in the west gallery—the fourth from the south pier—of which the breadth of the astragal on the longer sides is .40 m.

71. The same figure rarely appears twice on a single side of a capital. An exception is the Virgin in the Annunciation and Visitation (Figs. 68, 69).

72. This variant of the continuous method in mediaeval art was overlooked by Dagobert Frey in his excellent *Gotik und Renaissance,* 1930, in which he distinguishes early mediaeval space and representation as successive and those of the Renaissance as simultaneous. He has identified the order of the represented objects (content) with the order of the design, although these may be distinct.

73. Interesting for the freely composed rather than strictly narrative successive character of Romanesque illustration is the grouping of incidents on the tympanum of Bourg-Argental (Porter, *Romanesque Sculpture of the Pilgrimage Roads,* 1923, ill. 1150), where the scenes are ordered from right to left, but the figures within these scenes move from left to right.

74. Cf. also the diagonal sides of the building in Cana (Fig. 56). In Lazarus and Dives (Fig. 55) the corner tower cuts the adjacent building diagonally.

75. In the Washing of Feet (Fig. 52) the name of Peter is incised in his nimbus from

right to left. It is the symmetrical counterpart of the name of Christ who kneels before him at the left. The reversal of direction produces a pairing of names analogous to the grouping of the two figures. I mention here, as of possible significance to those who might seek an iconographic interpretation of this reversal, the existence of a retrograde inscription to St. Peter in the lapidary museum of Béziers in Languedoc (J. D., *L'Histoire de Béziers racontée par ses pierres—Catalogue du Musée Lapidaire*, Béziers, Barthe, 1912, pl. XXIV, fig. 1). See also note 82 below. The inscription of Nero in the martyrdom of Paul (Fig. 45) is also reversed; it corresponds to the scepter on the left side.

76. The decomposition of words in the most archaic capitals of the cloister corresponds to the decorative distortion or realignment of the separate abstracted elements of an object. The word as an incised composite whole, of which the elements could be freely rearranged to make new words, had, perhaps, no rigid axis to an archaic artist; its elements, the letters, stood in no fixed relation to the whole, and could be arranged freely, except where a specific combination (the monogram of Christ) had a symbolic value.

Another archaism in the inscriptions of the cloister is the reversal of N and S even in normal inscriptions—a practice common in the writing of children and the newly literate. It is also characteristic of the archaic indeterminacy of the form of S and N, which have two diagonal axes—one explicit, the other implied—that in the reversed inscription, mentioned above, the final S has been detached from the word and written in its normal direction between the two goats, and that in the reversed inscription of Nero (Fig. 45) only the N remains normal.

77. Note the lotuslike plant on which the saints and angels repose—a remarkable parallel to Chinese Buddhist sculptures which also present such groupings of figures on a mandorla-shaped surface.

78. A head inserted between the two apostles at the left balances the accent on the figures of Christ and the Virgin at the right.

79. The ornament of the impost also participates in this conception, though so remote from it in content. Despite its involvement and interlaced birds, the ornament of the lower band is divided symmetrically. The birds diverge from a central mascaron of which they grasp the divergent horns as the angel grasps the hands of John.

80. There is an especially subtle example in the Martyrdom of Saturninus (Figs. 61, 62). Here the design of adjacent faces is related by common diagonal directions.

81. Note, however, the contrast of gesture and head in the figures before the king in the capital of the martyrdom of St. Saturninus (Fig. 61) in the east gallery.

82. When this master of the south gallery reversed an inscription in the capital of David and the Musicians, it was not designed to produce the simple decorative symmetry of the archaic capitals of the cloister, but a more intricate opposition. For words in the normal direction are placed directly underneath the reversed names. Thus in the inscription ASAPH CVm LIRA, the first two words are incised from right to left, the third from left to right immediately below. In the inscription EMAN CVM ROTA, EMan is reversed and the following words are written below in the normal order. Is the reversal in this instance possibly influenced by the wish to imitate the direction of Hebrew letters? It is unlikely, even though the conception of this subject is based on the preface to the psalter. In a Latin manuscript of the same period, a miniaturist of Moissac reproduced a Hebrew inscription on the scroll of Jeremiah (Bibl. Nat. lat. 1822).

83. In the density of the whole, in the multiplying of small contrasting elements and the movement of diagonal lines and surfaces, the foliate capitals share the Romanesque character analyzed in the pier reliefs.

84. *Bulletin Archéologique,* Paris, 1923, p. 247.

85. A more complex banding occurs in the south gallery in the Vision of John (Fig. 37).

86. There are exceptions, even in the very archaic capitals, like the Adoration of the Magi (Fig. 58). It is characteristic of such figures that their stance is very light, and that their feet are parallel, not normal to the background (Figs. 61, 96).

In the capital of Adam and Eve (Fig. 48) Adam and the Lord stand on little sloping pedestals, remnants of a separate private ground or hillock from late classical and early mediaeval art. They are the clearest sign of the absence of a general concept or abstraction of a common ground plane in these sculptures.

87. In the Washing of Feet (Fig. 53, extreme left, east face) no seats at all are represented behind the figures. The application of the vertical projection described above to human figures may be seen in the capitals of Lazarus and Dives (Fig. 54), St. Lawrence (Fig. 51), and Benedict (Fig. 71) in representations of recumbent bodies.

88. In the capitals of the three Marys at the Tomb in Issoire, the three soldiers are similarly superposed, but in alternating directions.

89. This is especially clear in the representation of the innkeeper in the doorway on the capital of the Good Samaritan (Fig. 34).

90. A related succession of surfaces, with a similar archaic parallelism, appears in the Chaining of the Dragon (Fig. 27).

91. Several figures in the east gallery hold up the edges of their tunics or mantles like Bartholomew (Figs. 48, 53). In the Washing of Feet (Fig. 53) James has the melon cap of the apostle John on the northeast pier (Fig. 8).

92. But in some capitals, portions of the head invisible to the spectator are carved in detail (Nero, Fig. 45).

93. The angel who takes the soul of Paul at his martyrdom (not reproduced) is also represented in profile. Cf. also the seated Christ washing the feet of Peter (Fig. 52).

93a. [See "From Mozarabic to Romanesque in Silos," p. 57 above.]

94. On the same capital an apostle is placed between Christ and the Canaanite woman; the conversation thereby becomes indirect and more complicated. For the use of a more developed type of gesturing figure in the east gallery, cf. Fig. 61, of the martyrdom of Saturninus. This is one of the most refined capitals in the east gallery.

95. The inscription of the impost of Nebuchadnezzar (Fig. 22) includes the crossed and enclosed letters of the inscription of 1100 (Fig. 3).

96. Raymond Rey, *La cathédrale de Cahors,* Paris, Laurens, 1925, pp. 120 ff.

97. Wilhelm Vöge, *Die Anfänge des monumentalen Stiles im Mittelalter,* Strassburg, 1894, pp. 267 ff. (270, n. 5, on Moissac).

98. A. Venturi, *Storia dell' arte italiana,* I, fig. 79.

99. A similar analysis could be made of the two adjoining elders at the ends of the upper row.

100. The text describes the elders as seated in a circle about Christ—*in circuitu sedis.* This spatial conception, which was observed by mediaeval commentators and interpreted mystically, has been projected vertically on the wall of the tympanum.

101. There is a slight bending of the legs of the seraphim.

102. For an analogous turn of the head in a figure looking directly upwards, see Lauer, *Les enluminures romanes de la Bibliothèque Nationale,* Paris, 1926, pl. XXXII—a miniature of the mid-eleventh century from St.-Germain-des-Prés (Bibl. Nat. lat. 11550).

103. Barrière-Flavy, *Les arts industriels des peuples barbares de la Gaule,* Toulouse, Privat, 1901, I, pp. 75–80. The native Celt-Iberic population are often beardless in the Roman reliefs—cf. Déchelette, *Manuel d'archéologie préhistorique,* II, *Archéologie celtique ou protohistorique,* pt. 3, Paris, 1914, p. 1582; and Ésperandieu, *Recueil des bas-reliefs de la Gaule romaine,* 9 vols., 1907–1928, *passim.*

104. Cf. Saint-Gall ms. 51—Beissel, *Geschichte der Evangelienbücher,* Freiburg i. Br., 1906, fig. 33. For examples in Irish sculpture, see H. S. Crawford, *Handbook of Carved Ornament from Irish Monuments of the Christian Period,* Dublin, 1926, pl. L.

105. Porter, *Romanesque Sculpture of the Pilgrimage Roads,* Boston, 1923, ills. 434, 435.

106. *Ibid,* fig. 359.

107. R. Hamann, *Deutsche und französische Kunst im Mittelalter,* I, 1923, fig. 107. A similar treatment of the hair in a figure in the Duomo of Ferrara—*ibid,* fig. 104.

108. Porter, *Spanish Romanesque Sculpture,* New York, 1928, I, pl. 35.

109. E. Houvet, *La cathédrale de Chartres, Portail Royal,* pls. 18, 26.

110. Porter, *Romanesque Sculpture of the Pilgrimage Roads,* ill. 697. There is an example in S. Clemente, Santiago—a figure of a prophet in the style of Master Mateo.

111. As in the Last Judgment of the portal of Bourges cathedral. In the legend of Turkill, the hero, passing through Paradise, observed that "Adam was smiling with one eye and weeping with the other; smiling at the thought of those of his descendants who

would find eternal life, and weeping at the thought of those destined to damnation." (From M. P. Asin, *Islam and the Divine Comedy*, London, 1926, p. 200.)

112. In the early Romanesque sculptures of Moissac the folds are primarily pleats, in later art, creases.

113. Ésperandieu, *Recueil*, II, p. 309, no. 411.

114. Lechat, *Au musée de l'acropole d'Athènes*, Paris, 1903, fig. 29; K. With, *Die asiatische Plastik*, pl. 27.

115. Reinach, *Repertoire de reliefs Grecs et Romains*, Paris, 1909, I, pp. 223, 224 (Phigaleia); Ésperandieu, *Recueil*, IV, p. 201.

116. A. Boinet, *La miniature carolingienne*, Paris, 1913, pl. 20.

117. Van Berchem and Clouzot, *Mosaïques chrétiennes*, Geneva, 1924, fig. 66.

118. O. Siren, *La sculpture chinoise de Ve au XIVe siècle*, Van Oest, Paris and Brussels, 1925, pls. 3–11.

119. The two outer rosettes are cut unequally by the edges of the lintel.

120. This stepping is perhaps also a stylistic bias in the technique. Its practice in Islamic art (joggled lintels) may throw light on the practice in France.

121. In Beaulieu, Martel, Souillac, Cahors and the manuscripts of Limoges.

122. The fourth and seventh from the left.

123. *L'abbaye de Moissac*, Paris, Laurens, 1910, pp. 28, 29.

124. I have discussed the history of the lintel and the relation of its ornament to earlier arts in a paper read at the meeting of the College Art Association in December, 1928, and summarized in *Parnassus* I, 3, March, 1929, pp. 22, 23.

125. Cf. Rupin, *op. cit.*, p. 331.

126. The second Magus is cut vertically by the joint of two vertical slabs (Fig. 111). The reliefs were carved and set in place before the enclosing architecture was erected. This is a variation of the usual method, which has been little noticed in discussions of the techniques of sculpture *avant* and *après la pose*. The hand of the first Magus is obscured by the central capital, and on the adjoining relief (Fig. 112) the head of the ass projects into the haunch of the arch, which has been specially cut to admit this head.

In the capitals of the porch, in distinction from those of the cloister, there is no longer a limiting structure of volutes, consoles, and central triangular frame (Fig. 125). Their carving constitutes a circular relief, without division into four distinct fields, and is so deeply cut that the background is hardly apparent and the figures cannot be regarded as a *decoration* of the capital.

127. Even the arcaded bays of the side walls are not strictly symmetrical or regular, but are deliberately designed to produce an alternation of unequal parts (Figs. 107, 108). On the east wall, the south bay is the broader, on the west wall, the north. Each bay is divided into four slabs, two above and two below—but slabs of unequal breadth, arranged in symmetrical alternation.

128. These scales led de Lasteyrie to suppose that the slabs were reemployed lids of Early Christian sarcophagi. But in this he was mistaken, for not only do their dimensions disagree with those of the early sarcophagi of the region, but the units are also considerably smaller than in the latter. In their tonguelike rather than semicircular form they resemble the scaly slats on the gables of Aquitaine churches. The imbrications are carved on only four of the twelve slanting surfaces above the trefoils, and in one case (the Visitation) they adjoin the representation of arched windows and oculi. These show clearly enough that the imbricated ornament is designed to represent a rooftop and is not a remnant of the original decoration of a reemployed slab.

129. The great contrast in the sizes of the different figures of the same relief in Romanesque sculpture (Moissac, Vézelay, Autun) is an analogy in surface composition to the Baroque exaggeration of perspective diminutions and the frequent placing of a large figure in the immediate foreground and a very small one behind him. Such Baroque contrasts are not merely the result of a scientific perspective, but are designed to produce a strong and immediate opposition of adjacent objects and a precipitate movement in space. [I was not aware, when I wrote this, of the already current characterization of sixteenth-century works with these features as "Mannerist."]

130. In the sculptures of the facade of Ripoll, in Catalonia, the scenes move from left to right in superposed rows until the uppermost, where the direction is reversed.

131. Each of the four slabs of the frieze is designed as a balanced relief. The joint which divides the angel's body falls along the ass's tail, but although this is the central jointing of the frieze, the true vertical mid-line corresponds to the back of the mounted Virgin.

132. See note 126 above. The head is carved *in the slab,* which projects into the space enclosed by the arch, and also into the arch.

133. More than fifteen centimeters. Cf. the four or five centimeters of the reliefs of the cloister.

134. Laran (*Revue Archéologique,* 1907, pp. 436–450; 1908, pp. 331–358; 1909, pp. 75–93, 216–249) showed by the application of statistical anthropometric method to the study of the proportions of a large number of Romanesque figures that within any school of French Romanesque sculpture there exist two sets of proportions, one for large figures and another for small. He verified the apparent stylistic homogeneity of certain distinct groups (Languedoc, Burgundy, Auvergne) in showing that this homogeneity varied with the mean deviation of the proportions of the figures included in the group. His measurements of Moissac are not reliable for statistical treatment however, since of the more than two hundred figures of the cloister and the fifty or more of the portal we are not told which were selected for comparison. The elders of the tympanum and the figures of the cloister capitals are included as small figures and their proportions averaged, although this smallness is relative and the elders are three to four times as large as those of the capitals. Factors of time and individual style were also neglected by Laran who averaged, as of one school, the regional works of different style and period. But these errors of method, while they may discredit the tabulation for Languedoc, are less apparent in the treatment of other regions. Measurement of all the capitals in Moissac would probably confirm Laran's general conclusions, although it might alter his specific figures.

135. Cf. the figures of the apostles in the sculpture of the Last Supper in the cathedral of Naumburg (c. 1245?), reproduced by Panofsky, *Deutsche Plastik des XI. bis dem XIII. Jahrhundert,* pl. 93.

136. Note especially his leper's bell on the porch.

136a. The measurements above the base moldings are: left jamb, .87 m.; left doorway, 1.61 m.; trumeau, .72 m.; right doorway, 1.67 m.; right jamb, .81 m. The height of Peter is 1.54 m. (including the lion at his feet), of Isaiah, with his larger pedestal, 1.66 m., and the breadths of their slabs, respectively .46 m. and .43 m.

137. The scalloping of the jambs, which appears in other churches of southwestern France, should be distinguished from the polylobed arches of Romanesque and Islamic art. For while the individual scallops of the latter have a clear analogy to the arched form of the whole, the scalloping of the jambs produces a line in active contrast to the rigid verticals of the jambs. It is a distinctly more restless, broken form, which classicist taste has found reprehensible in mediaeval art. By the application of such scalloping to a jamb beside a trumeau (less prominently scalloped in Moissac) the doorway becomes an asymmetrical architectural unit without the appearance of static support inherent in the common lintel-and-post construction. On the contrary, the doorposts in Moissac are animated members of which the movement is accented by the pleated ribbon meandering on the inner edges (Fig. 129). The slender colonnettes engaged to these narrow sides of the jambs are also lobed and broken, in contradiction of the nature of the columnar member.

138. The strong, square cutting of the seraph's head reappears in Peter (Fig. 123), but in the latter the chief facial planes meet in a line parallel to the elongated axis of the head and not perpendicular to it, as on the tympanum. Peter's hair is wavy and restless and falls low upon the brow in the manner of the cloister and tympanum.

139. A French writer discovered in the succession of ascending animals on these jambs —fish, bird, quadruped, and St. Peter—a Romanesque anticipation of the theory of evolution. See the *Bulletin de l'Association Française pour l'Avancement des Sciences et Arts de Montauban,* 1902.

140. The scallops increase in span as they ascend. This produces a more dynamic succession and at the same time a more harmonious transition to the lintel. Note also that the scalloping is in contrast to the circular rosettes of the trumeau rather than concentric with them.

141. The colonnettes of the doorposts have a flatter, deeper scotia than those of the trumeau.

142. ". . . *quidem lapis fontis marmoreus et lapis medius portalis, inter ceteros lapides harum precium, reputantur pulcherrima magnitudine et subtilli artifficio fuisse constructi, et cum magnis sumptibus asportati et labore; ymo pocius extimantur miraculose ibidem fuisse [constructi], quod opere hominis, maxime unius simplicis abbatis."* Chronicle, f. 160 vo., col. 1, Rupin, *op. cit.*, p. 66, n. 2. On the marble font, see above, note 68.

143. Aymeric called them leopards, and observed the existence of a similar sculptured beast on the portal of a priory of Moissac in Cénac (near Périgueux), built by the abbot Anquêtil (1085–1115). The church survives, but without trace of such a sculpture. That it was a lion to the sculptor and not a leopard appears from the close resemblance to the lion of Mark in the tympanum. The identification of these two species in the Middle Ages is well illustrated in a manuscript of the twelfth century from La Charité (diocese of Bésançon) now in the British Museum (Add. Ms. 15603); on f. 113 vo. marginal drawings of two very similar beasts are labeled *leo* and *lipar*. The text of Aymeric reads . . . *"perlegi fundacionem dicti prioratus* [Cénac] *per scripturas antiquas, et reperi quod ipse Asquilinus, seu ejus contemplacione et procuracione et secundum formam operis ecclesie patet, quod ipse fecerit quia de similibus operis et sculturis videtur esse artifficiatum, et in portali dicte ecclesie de Senaco est quidem leopardus, sicut in portali ecclesie Moyssiacy sculpatus."* Chronicle, f. 159, vo., col. 2, f. 160 ro, col. 1, (cited by Rupin, *op cit.*, p. 69, n. 9). [The nave and the portal of the church at Cénac have been rebuilt in the nineteenth century. The historiated capitals of the old choir show the same structure of volutes, console, and impost as those of the Moissac cloister.]

144. Paul has the posture of the seraphim of the tympanum; the prophet is similar to the Isaiah in Souillac, and more remotely to the angel of Matthew in the tympanum.

[145. These figures perhaps owe much of their dryness to a recutting in the nineteenth century.]

On Geometrical Schematism in Romanesque Art

(1932)

THE new book of Jurgis Baltrušaitis (*La Stylistique Ornementale dans la Sculpture Romane*)[1] is the first French work on mediaeval art that deals systematically with problems of form. For this reason alone it appears as an object of striking originality in the French literature of art and has received the warmest praise from French critics. Marcel Aubert, the leader of the French school of mediaeval archaeologists, has concluded that it is the final (as well as first) word on the style of Romanesque sculptured ornament. The book has, in fact, an exhaustive appearance, and is not only a theoretical and speculative effort in aesthetics, but also an admirable collection of concrete examples of Romanesque sculpture; over nine hundred specimens are reproduced, including numerous capitals, many of which are little known.

I

The basic idea of Baltrušaitis is that Romanesque form is determined by the union of two antagonistic elements—the objects given by the content, with their own natural shapes and canons of proportion, and an antecedent geometric form or schema. The imposition of the schema on the object destroys the natural form and produces the distorted, even disordered appearance of Romanesque figures. But careful study of the sculpture reveals an inner geometric ordonnance and structure conferred by the primary schematic principle. B. distinguishes several types of schema. The first, and most characteristic, is that which is imposed by the frame, for the frame is a generating, ordering principle; another is derived from a basic ornamental germ, a little plant, which is the secret of

a whole tympanum. There is also the palmette that shapes a great variety of motifs, even sirens and crucifixions, and may actually beget the subject itself. The crocket capital is described as a geometrical, architectonic type of which the mathematical, physical lines of force determine the ornament, the composition of scenes, and expressive effects. B. thus accounts for the expressive distortions in Romanesque sculpture as the resultant of an iconographic material and a primary geometrical form imposed on it. The distortion cannot be carried too far, since the sculptor is human and does not wish to deform his fellow creatures. He therefore practices various evasions. He deploys the object-form so that it can be fitted into the mathematical scheme without loss of its essential humanity. But to do this he must introduce new accessories and gestures, and so modify the content of the work.

The author believes that he has solved in this way the "fundamental paradox" of Romanesque art, the "paradoxical contradiction between the sculpture and the architecture, between the abandon of the one and the rigor of the other, the moving disorder of the decoration and the permanent order of the building." The underlying order of the sculpture is imposed by the surrounding architecture. "The frame is not a passive element. It acts on the composition of the relief. It organizes it. It incorporates it into the structure." "The sculptor is not only a maker of images, he is a mathematician concerned with measure."

II

The problem, I believe, is neither well posed nor well answered. At the root of both the statement and the solution lies the tacit, unanalyzed identification of the stable with the ordered and of the disordered with the mobile. B. has assumed that a misproportioned natural form is necessarily mobile and disordered, as if an image of a man five heads tall cannot be as ordered or stable or simple as the image of a man seven heads tall. Because he uses "unnatural," "distorted," and "disordered" as equivalent, interchangeable concepts, he imagines that he has explained a "disorder" when he has traced a "distortion."

In truth, his standpoint is unclear and shifts during the course of analysis. For in the beginning the paradoxical conflict was not between the natural shape and the architectural form, but between the finished synthesis and the architecture. The disorder was aesthetic, not biological. But in the course of explanation he has undertaken to show, not why the figures are disorganized, but why they are unnatural.

Another crucial assumption is that the formal structure of a work of art is a definite separable entity within it (like the academic idea of "composition" in rectangles, circles, or triangles), a fixed geometrical schema or configuration, rather than a unique, pervasively sustained

organization of the whole, in which schemas may be only single, often simplified, abstracted aspects, like the symmetry of the human body. For B. this schematic form has no individual properties or qualities other than such stylistically neutral characteristics as order and simplicity; but it is always prior to the content and the whole, as the framework of a wooden house precedes and limits the walls and spaces.

The content or meaning of the work of art is therefore an inert, characterless material, without an active role in the final result, a material that is stamped with the schema. B. assumes a definitely envisaged object —envisaged naturalistically by the artist, and then schematized according to one or another principle, just as certain modern decorators submit a typical figure to ornamental curves, to "stylization." Why the imposition of a schema on an unexpressive natural material (granted that such a material existed in a canonical natural form) should produce an unstable, exuberant, disordered image is never shown. It is all the more remarkable since a simple, ordered architecture is believed to be the source of the schema. In Renaissance art figures are frequently adapted to schematic compositions without the effects presumed by B. in Romanesque art. Tectonic lines may be traced in the naturalistic art of the Greeks. The unstable, disordered image is eloquently presented as a necessary result, but the necessity is neither analyzed nor demonstrated by the author.

The reader will recognize the mechanically Platonic character of this theory. The schemas are the transcending, prior, mathematical, form-giving ideas. In contrast to the disorder and mobility of the particular object, they are permanent, ordered, and stable; they alight on the object from the purer, more abstract realm of architecture. The artist is a mathematician who gives the proper number or schema, who stamps things with a mysterious, uniform, preexistent seal. More, he is a speculative, dialectical mathematician, playing with his pure forms and creating new contents by imprinting his forms on any given subject and reshaping it. Starting from a palmettoid design, he makes a siren; the siren becomes a crucifixion; but sirens and crucifixion all bear the key palmettoid form.

B. believes, however, that he is explaining not only the formal structure of Romanesque art, but also the factors which underlie the process of its creation and the growth of new types. He applies then the concept of dialectic, since new forms originate for him in the resolved opposition of schemas and natural shapes. Each solution becomes in turn a schema to be impressed on or incorporated in a still newer content. This dialectic adds a further contradiction to the mechanical union of form and content, for the disordered resultant becomes in some magical way the ordering stable schema of the succeeding work. Yet we are told at the same time that the process is uniform and the schemas permanent.

We could not discover from this dialectic how a new style arose, or

how Romanesque art ever changed at all. It is not an explanation of an active historical process, nor is it, strictly speaking, a dialectical method in the sense of Hegel or Marx. It does not expose the possible latent internal conditions of formal development as Riegl did in calling attention to oppositions within a style which rendered the style unstable and hence suggested fresh changes and solutions. Its principle of change is nowhere verified in a concrete historical sequence nor is there here an empirical consideration of social, religious, technical, or psychological sources of change in the conception or application of works of art; the factor of historical time has been eliminated, as we shall see in the chapters on ornament. A crucial weakness of B.'s dialectic lies in the inactive, neutral role of content in the formation of the work of art; it allows for no interaction between the meanings and shapes; the schemas remain primary and permanent. It is therefore an artificial or schematic dialectic which ignores the meanings of the works, the purpose of the art in Romanesque society and religion, the willed expressive aspects of the forms and meanings (which were created as wholes and not as combinations of antagonistic forms and subjects), and fails to explain the known historical development of Romanesque art. The subject matter, the represented objects, which are stamped with the geometrical schemas, are considered wholly passive, without significance or value to the artist. The expressive qualities are merely the by-products of distortion by the frame, and sometimes they are even generated by the frame.

From such a dialectic we could hardly deduce the richness and variety of Romanesque art. We could not grasp through it the unclassical principle of variation, whereby two adjacent capitals, of identical architectural function and shape, have altogether different ornament. We could not understand why Romanesque capitals and archivolts, in contrast to the classic, should have their characteristic exuberance of animal and human life. For if submission to a uniform architectural system governed by simple geometrical relations determined the uniformity and regularity of classic architectural ornament, why does the stable, well-ordered Romanesque architecture produce the varied, seemingly disordered forms when its lines are impressed on human and animal figures? Is it because the conception of the subjects, the content selected for each capital, is different? But if the variation from capital to capital is occasioned by a principle exterior to the architecture supposedly governing the individual sculptured form, why not consider the apparent variety, the movement, "the disorder" within the individual work as a related aesthetic?

B.'s conception of Romanesque architectural styles and their principles of composition is itself problematic as a basis for his theory of underlying schematic forms. No one who has studied the development of Romanesque architecture from earlier types and compared it with Roman, Byzan-

tine, and Islamic forms will accept as adequate the description of the Romanesque as rigorous, simple, and ordered. (This is a characterization that some critics make of all "good" buildings.) Beside a classic building a Romanesque church appears highly complex and abounds in discoordinate, incommensurable, and elusive relations of form, and in dynamic qualities overlooked by B. The existence of series of individually sculptured capitals, of prominent facade sculpture, or a rich system of unconstructive arcatures would alone lead us to question his statement of the problem. A facade, like that of Notre-Dame-la-Grande in Poitiers or of the cathedral of Angoulême, as an architectural whole, is not in opposition to the enclosed sculptured forms; and the plastic character of piers and moldings and arches, of surfaces and masses, is not fundamentally different from the evident character of surfaces and masses in Romanesque sculpture. If there are oppositions of sculpture and architecture, it is in a sense that contradicts the thesis of B. On many portals (cf. Carennac and Moissac), the inner divisions, the frames and paneling of the sculpture, do not correspond to the actual jointing or composition of the masonry, and appear as arbitrary, pseudoarchitectural elements imposed on the field. On the portal of Vézelay (see our Fig. 3) the figure on the trumeau projects upward beyond the trumeau. The figure above him on the lintel projects beyond the lintel. And the great central figure of Christ not only "violates" the axis of the portal, but breaks through the outlines of the tympanum frame and commands it to detour around his projecting head. Here the frame is repeatedly "violated" by an eruptive sculptural form. A zigzag figure, like the saint Peter on the porch of Moissac, seems to contradict the vertical form of the jamb to which he is attached; but that jamb is itself scalloped in contradiction of the tectonic form. On the adjoining vertical trumeau the decoration consists of crossed diagonal beasts, irreducible to a constructive scheme. But the vertical trumeau itself has no explicit vertical lines. The architecture thus exhibits anomalous qualties very similar to those of the sculpture, and these qualities are achieved in both by decided contrasts. We cannot always speak of architecture contradicting sculpture; internal oppositions *within* both sculpture and architecture are characteristic of the two arts in the Romanesque period and are sustained by further oppositions of the sculpture to the architecture. Here is no paradox, but an example of a pervasive mode of design characteristic of Romanesque, just as another mode is characteristic of Greek. This relation is especially evident in the initial ornament of Romanesque manuscripts. The structure of the initial, far from limiting or determining the forms of its ornament, is often violated by it, or is itself extravagantly deformed and obscured as a letter.

If there is a sense to B.'s paradox, it may be found within the architecture itself in the practice of imposing an untectonic ornament or decora-

tion on a constructive member. Thus the ribs of Romanesque and early Gothic buildings are often decorated with a zigzag band in contrast to the actual form of the member; or a grotesque figure in strained posture squats at the springing of an arch or rib, as if he were burdened with a great weight. This independent, tense vitality, imposed on simpler, less expressive elements, illustrates perhaps a "contradiction" of architecture by sculpture. But the contrast here is not so much of order and disorder, simplicity and luxury, but of constructive and physiognomic forms. This, however, is not what B. means by the "paradox" of Romanesque art. For just as the zigzag of the ornament is not occasioned by its frame and the forces of the arch, the squatting figure usually exceeds the tension of the natural strains of his simulated function. He is a characterful whole with an individual life irreducible to a simple geometrical form.

Even if we accepted the notion of a paradoxical contradiction, it would not be resolved by B.'s approach. Specific examples of his solution will be discussed later. Here it may be said that the discovery of an ordered framework underneath the "disordered" sculpture does not explain the disorder, or even the order of the whole, or, what is more important, the highly organized character of the "disordered" object. Our experience before a Romanesque portal like Vézelay or Autun is not of a disordered work or of one in which an order can be discovered *despite* (B.'s word, p. 20) its actual appearance, but of a purposeful, deeply ordered, decoratively coherent object. It is restless and endlessly animated in details, yet these qualities are not opposed to order. The richness and pervasive character of the movement should, on the contrary, imply that the work is outwardly organized in detail; otherwise the movement would appear dissipated, incomplete, aimless.

When, therefore, B. says that *despite* the outward disorder of a Romanesque tympanum there is an underlying ordered scheme, one might reply that because of an underlying "disordered" scheme the tympanum has a "disordered" appearance, or that because of an underlying orderly scheme, it has an outward appearance of order. A sound method would not struggle to show that *underneath* the apparent "disorder" of Autun there is a "rigorous" ordered scheme, but would indicate by what forms an expressive effect of disorder is produced, how the different elements collaborate toward this effect, how it pervades the whole in its lines, its surfaces, masses, gestures, meanings, and even technique. A clear sign that B.'s method is inadequate is the frequent discrepancy between his discovered schemas and the actual decorative coherence and expressive character of the objects. His schemas are *a posteriori* extrapolated diagrams traced on the sculptures; they are rarely verified in our direct experience or in a careful analysis.

The error of B. is that having perceived the organized aspect of a

Romanesque work, he does not set about to describe that aspect, but reduces it to mechanically operative components like frame and content, schema and subject, of which the first acts upon the second to produce the final work. His law or principle is thus a hidden component form within the work which determines the whole, as in astrological systems. His paradox springs from the failure to analyze his impression of simplicity and order in the architecture and of complexity and disorder in the sculpture. It is also by disregarding the differences between these two arts, and especially the content and purpose of the sculpture, that he could astonish himself by his presumed paradox.

He has limited the analysis of sculpture to lines alone, neglecting the masses and surfaces. The qualities of spaces and modeling, the relief, the expressive values of the combinations and juxtapositions, are practically ignored. This partiality for the schematic-linear in Romanesque sculpture is reflected in the numerous drawings of capitals made by the author. They are unshaded line drawings, with little reference to masses, areas, or plastic effects. B. tends to reduce details like the human eye to single shadow lines or circles, to combine eye and nose in a single curve, to omit one eye in a three-quarters face, and to practice numerous prettified simplifications which are the outcome of a schematic, abbreviated modern style of drawing, and which falsify the archaic aspects of Romanesque representation.[2]

But let us turn to the author's actual demonstrations where we shall see in his own analyses the consequences of his theory.

III

In the first chapter he presents the "law of the frame." In Romanesque sculpture the frame, by which he means the architectural boundary of a sculptured surface, like the archivolt of a tympanum, or the rectangular border of a lintel, is the generating principle of the enclosed relief. "It does not merely restrict the movements of the silhouettes, but directs them. It attracts them, it distributes them in the whole, it fixes their proportions and their equilibrium (p. 7). . . . It dominates the sculptural composition from within as well as from without by imposing on the relief the structure and economy of the frame" (p. 12).[3]

How does B. demonstrate this formative power of the frame? He shows us 1) a rectangular lintel with repeated standing figures of identical height and posture (Arles); 2) a pentagonal lintel with figures graded accordingly (Mozat). In neither of these lintels do we perceive a conflict between the architecture and the sculpture or its subject; nor does B. refer to such a contradiction at this point. But it would be easy to find lintels in which the figures are not grouped according to the lines of the

frame. On the *pontile* of Modena, the apostles of the Last Supper are arrayed like an ornament in strict uniformity, but the central figure of Christ rises outside the common frame. Likewise in Meillers (de Lastey-rie, *L'architecture . . . romane*, fig. 672), the lintel is pentagonal, but the uniform apostles are aligned in a simple rectangular band under an arcade, independent of the peaked form of the enclosing frame. Yet the central Christ is so enlarged as to break through the peak of the pentagon and to determine a special gable of steeper pitch than that which covers the apostles. A scholar could with the same cogency as B. show by an impressive series of examples that Romanesque sculpture is independent of its frame, that one of its distinctive traits is the violation of the frame or the enclosing form.

B. is aware that all sculptures are not readily reducible to their frames. He therefore introduces the concept of a "hidden frame"—an invisible boundary. He shows 3) a pentagonal grouping of figures, but without a visible pentagonal frame, and assumes that here a concealed frame is operating, a frame erased after the work was done; 4) another "hidden frame," this time triangular, in the diagonally opposed wings of two angels in a semicircular tympanum (Fig. 13). This nonexistent, "hidden frame" is compared with the actual triangular gable of 5) St.-Gabriel in Provence, but B. fails to note that the latter encloses a *rectangular relief* with independent vertical figures, set under arches, nor does he explain why the first "frame" should be concealed. Then in 6) the tympanum of Conques he arbitrarily constructs arched lines around the figures in hell in order to justify the influence of an imaginary frame. But this "frame" does not correspond to the figures even in B's drawing, and would not prove the determination of their forms by a frame even if the latter were a real molding and enclosed the figures rigorously or neatly. For it would be, in that case, not the architectural frame of the tympanum, but a nonconstructive, iconographic component of the image, like the figures themselves, and therefore, according to B.'s law, a product of the general frame of the tympanum.

In citing the tympanum of Conques, he has called our attention to a work to which his theories are certainly inapplicable. For the large effect of the tympanum is panoramic, the field being divided into broad zones with long processions of almost inert figures who seem to come from beyond the frame. In the left part of the lintel, in the scene of Paradise, where arches are really *represented* and not "concealed," the stable figures enclosed by them are quite ordered and symmetrical, and of a compositional form altogether different from the figures in the adjoining turbulent scene of hell. If we did not know the meaning of the two scenes we could not grasp the reason for the formal and expressive contrasts—the sacral, architectural setting of the one and the unenclosed, dense grouping of the other.

Finally, B. explains 7) the tympanum of Autun by a schema of lines which have nothing to do with the frame, but which he calls a frame because their supposed function in organizing the work or in forming it is *like* that of his first example of a frame. He has thus identified "frame" as the accented architectural boundary of a sculptured field with "frame" as an implicit skeleton or framework. He does not even try to connect this imaginary schema of the figures with the shape of the field or the archivolt. On the contrary, he has misdrawn the tympanum to include the lintel within a semicircular archivolt, when, in fact, the semicircle does not comprise the lintel. But more important is his disregard of the character of that lintel which is rectangular, like the frieze of Arles, cited in 1), yet encloses figures that are irreducible to the formal and expressive qualities of those at Arles, despite the identity of the subjects as well as of the frames of these two lintels.

The "law of the frame" is the limited and insufficiently analyzed observation that in some Romanesque works particular elements of the frame—one of its lines or the whole outline—are paralleled by particular elements of the image framed. But from this observation to the statement that the image in general is *determined* by the frame, that the frame is the source of its order and its form, is a leap into a groundless void. B. does not see that the frame is a constituent of the whole, like the object framed, and that both are affected by so many conditions that a unique determination of the one by the other—and especially of the major by the minor—is improbable. His "law" is not supported by systematic study. He does not analyze the plastic and spatial relations of frame and image, but only linear surface relations. He would have seen otherwise that frame and image have variable relations and interactions, that they are not determined by each other, but often are determined together. And if he had studied also Romanesque miniatures and initials, the relation would not have appeared so simple to him. There are initials of which the frame is indeed affected by the letter insofar as the frame is drawn after the letter has been completed and is designed to follow all the projections and accidents of the initial ornament. There is also a type of frame which is designed after the initial, but designed so that the initial will appear to break through the frame and violate its enclosing function. Where a letter is strictly enclosed by a simple geometrical border and repeats elements of its structure, we must ask whether this accord does not arise from a primary conception, a desired quality, which determines the forms of both frame and letter and their relations to each other, rather than from a submission of the letter to an *a priori* frame. B. tacitly assumes that the frame is prior and independent because it is part of the architecture, although the plastic development of the portal archivolts is undoubtedly parallel, not prior, to the development of sculpture. To compare a Romanesque and a Gothic frame, a Burgundian and an Aqui-

tainian frame, is to see that the Romanesque frame is often subject to the same (or a similar) aesthetic intention as the enclosed carvings. The celebrated Peter of Moissac is not bent because of the adjoining scalloped jamb. The latter is as arbitrary as the figure. They are common products of one style; and their coordination is not a one-sided submission of the figure to the architecture, but a uniform, restless, unstable treatment of adjacent forms—the one contradicting the tectonic of the human figure, the other contradicting the tectonic of the jamb.

Like other writers B. speaks (pp. 38, 39) of the long vertical figures of Chartres as determined by the columns to which they are attached or by an elongated frame. In doing so he overlooks the column figures with legs crossed, who could not be explained by his theory. But if we assume that the rigid vertical posture existed prior to the column, or at least was independent of it, then we can understand better the application of figures with crossed legs on the same series of columns. For the crossing of legs in Romanesque art is a tense, unstable posture (just as it is a posture of relaxation in Greek art), and therefore accords with the constrained, suspended forms of the rigid figures. On the portal of Avallon in Burgundy the unsculptured column next to the columnar figure is grooved diagonally in such a way that the column itself appears twisted and strained. Thus the natural tectonic of the figure is "violated" by its rigid immobile form, the tectonic of the column by the winding, diagonal ornament.

The appearance of constraint in columnar figures is a primary idea, and not just the result of submission to a column's axis. The conformity of a figure to a column is not explained by the compulsion of the column, for though in all Romanesque schools there are analogies of figures to their surroundings, the columnar figure occurs only in certain ones and only at a certain time. There are many possible adaptations of a figure to a column, and hence the character of the figure in Chartres is explained, not by the column but by an aesthetic that underlies both the form of the column and the character of the figure attached to it. The Greek adapted a figure to a column by a relaxed, well-supported stance; the Romanesque artist by a rigid, even tense pose or by an acrobatic posture. The Greek figure was complete in himself or clearly enframed, whereas the Romanesque figure was suspended or embedded in the architectural member. While the frame in Greek art tends to be a distinct enclosure, in mediaeval art it is an inhabited environment or milieu which often coalesces with its contents and is even subordinated to them, as a means of enhancing their dominance or quality of expansive energy.

Even if the examples chosen by B. to support his theory conformed to it, we would still have to conclude that the "law" is not general, for it admits numerous and imposing exceptions. According to the author himself, the greatest works of Romanesque art follow another principle. The

tympana of Vézelay, Moissac, Autun, Charlieu, and Chartres are inde-
pendent of their frames; their forms are an expansion of a little flower or
other plant which is represented nearby, usually on the archivolt, and
provides a key for the ultimate "decipherment of the mystery of Roman-
esque art in the twentieth century." In every example of such a key
discussed by B., the form of the original is distorted in his drawing or
analysis, and arbitrary interpretations are imposed on the form. He deals
with artistic wholes but he is able to sacrifice large sections of a tym-
panum or relief in order to fit it into his scheme, which he then presents
as the principle of the *whole*.[4] So in reducing the pier relief of the
Women at the Tomb in Santo Domingo de Silos to a palmette (Fig. 721),
he omits the upper half of the relief and overaccents the diagonal lines of
the sleeping soldiers at the sides. But these forms cannot be grasped with-
out the figures of the angel and the three women and the enclosing arch
and the diagonal tombstone. In the tympanum of Neuilly-en-Donjon
(Fig. 723) he omits the first Magus, who is inseparably bound with the
Virgin and Christ, and draws a column in his place; he omits also the
figures on the two beasts and thus loses the anaxial spacing of the origi-
nal, which contradicts his symmetrical palmette.

　　To demonstrate the analogies with the nuclear ornament, he lops off a
hand here, an arm there, and introduces dotted lines to connect parts and
to match the imagined generating form. Even the basic plant motif is dis-
torted in his astute reproductions (Figs. 729, 731, 732, 733, 736, etc.). To
explain the North tympanum of the Royal Portal of Chartres, he
abstracts from the archivolt of the central door a motif of a head between
two foliate stems, which he misdraws in his Fig 733b, oversimplifying it,
omitting several constituent leaves; and to produce a resemblance of this
motif to the tympanum of the Ascension, he also misdraws the latter,
accenting in thicker, darker lines the clouds and the lower wings of the
two angels, retracing much more faintly the legs of the angels, and omit-
ting altogether the upper terminations of the rising wings, which are frag-
mentary today but originally converged toward the crown of the tym-
panum and Christ's head and formed a mandorla around Christ—a
design irreconcilable with B.'s foliate model. The arbitrariness of his
method is evident enough in its mutilation of the whole, in its imposed
accents and in its omissions. But in Chartres, especially, he betrays its
inadequacy in omitting the upper register of the lintel, with the descend-
ing angels. Their symmetrical system of suspended loops and returning
curves is an integral part of the design of the tympanum. But this register
cannot be assimilated to B.'s key nuclear pattern or to the "law of the
frame."

　　He could reduce the tympanum of Moissac to a palmette of the archi-
volt by misdrawing both the tympanum and the palmette, by limiting

analysis to the central group of Christ, the symbols, and the two angels minus their legs, minus the wings of the lion and bull and other details, and by darkening the shallow cuts and lightening the deep ones. "Everything converges toward a center accentuated by the depression which separates the knees of Christ." This depression is strongly marked in the drawing, but does not exist in the sculpture; the surface is quite flat here. It is curious that although he speaks of the group as radiating from and about Christ, he overlooks the predominantly radial and concentric rosettes, grouped horizontally on the lintel, as foliate analogues of the pattern of the tympanum.

Fig. 1 Fig. 2

The concluding analysis of the tympanum of Vézelay is equally inadequate. 1) The schema of the whole is derived from the archivolt ornament which is described and reproduced in such a way as to destroy its true plastic character and structure. In his drawing (Fig. 746—see our Fig. 2) the scalloped edge of the plant is presented as the zigzag outline of a nuclear surface, whereas we experience it in the work itself as the inner edge of an enclosing convex surface. The hollow thus becomes the dominant positive element, and the essential lines of the convex surface are lost in B.'s drawing (cf. his Fig. 746 with Porée, *L'Abbaye de Vézelay*, Paris, 1927, p. 45—see our Fig. 1). But since his first outline is the inner contour of a curled plant and depends on the lobing of a convex surface, the omission of the other lines is a misunderstanding of the form. He does accent, however, two divergent arcs at the base of the plant, which correspond to nothing essential or prominent in the schematized tympanum.

2) The analysis of the tympanum is limited to the portion of the field that encloses Christ and the apostles (see our Fig. 3). The lintel, the eight panels that complete the tympanum, the signs of the zodiac, the labors of the months, and the indispensable trumeau are left out. Were

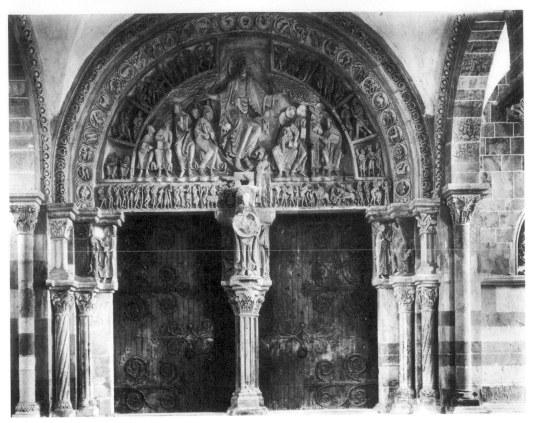

Fig. 3. Vézelay: Central Portal.
Kunstgesch. Seminar Marburg

these included in his inaccurate diagram, he could not have constructed his elaborate network of diagonal lines which correspond to so little in the actual work. He not only ignores the parts already mentioned, but such essential elements as the rays, the clouds, the zigzag posture of Christ, and the figures at Christ's left foot have no place in the schema. Not even the remarkable and highly original division of the tympanum, with the opening at the center for Christ's head, has a role in B.'s design. But even if he had devised a geometric scheme which corresponded more closely to the composition of the tympanum, we could hardly accept it as an adequate model of the structure and expressive effect of the whole. For it would not include such striking and original aspects as the eruptive movements of figures across the frames along the vertical axis of the portal; the gradation of the scale of units in the concentric bands of the frame, increasing toward Christ; the deliberate discontinuity and incommensurability of the adjacent panels; the undulation and corrugated surfaces of the lintel; and the relation of the contours of the bodies to the arbitrary eddying lines of the draperies.[5] These are essential devices in the immediate effect of the whole, but they are hardly reducible to a single geometric schema. Such a schema would be the tympanum itself.

An important defect of B.'s analysis, and one which is a consequence of his method, is the neglect of the direction of the head and the glance of the figure in the structure and expressiveness of the whole. In the tympanum of Fleury the opposed glances of the upper and lower evangelists create an active movement; and in Moissac, where the radial concentration of the elders' heads on Christ is opposed in its centripetal diagonal pattern by the vertical and horizontal banding of the zones and the larger figures, an effect of excitement and tension is produced throughout. This tension is in turn developed in the contrast between the direction of the glance and the posture of individual figures. There is hardly a Romanesque tympanum in which the contrast of bodily directions and glances is as striking and as essential for the expressive quality of the sculpture as in Vézelay, yet it is completely ignored by B. Thus Christ who looks forward and extends both arms symmetrically is turned below, in an unmotivated manner, to one side. We could not grasp the part played by this turn in the movement of the whole unless we observed the directions of the heads of all the apostles at the left, as well as of Christ's head. Yet in a diagram of the sculptured lines of the tympanum these directions would not be drawn.

The schemas traced by B. on various tympana of the twelfth century are like the geometric forms traced by Villard de Honnecourt on already completed figures. These figures were not designed according to a schema, but the artist inscribed the schemas subsequently on his figures. The schemas are not so much the sources of the form or even its generalized for-

mula as they are analyses of drawings, *post factum* abstractions of their shapes in simpler diagrams. It is significant that they appear on individual figures or isolated groups of figures, never on a complete, enclosed composition. Professor Focillon,[6] the teacher of Dr. Baltrušaitis, has wished to see more than such diagrams in the triangles of Villard, and has supposed that Villard preserved a Romanesque tradition of basic geometrical schemas, despite the unRomanesque character of his art. This is a supposition unwarranted by the contents of Villard's album; even his architectural drawings show no preliminary generating form. It is in the Renaissance, not in the Middle Ages, that we find such an ideal function assigned to an *a priori* geometrical scheme.[7]

IV

The most valuable and original part of this work is the analysis of ornament that follows the study of tympanum composition. B. has investigated here not only the structure of ornamental types but also their mode of development. Here too the analysis is limited to linear elements of design, and the concrete individual form is simplified in terms of a preconception about an underlying schematic form. Little if anything is said of the plastic qualities of Romanesque sculptured ornament, although this aspect of ornament should be considered in a work that treats Romanesque sculpture in its architectural context and that tries to uncover principles of development in art.

At the base of *all* Romanesque ornament he finds three or four simple palmette motifs that are derived from an initial form by synthesis of its elements. The whole of Romanesque ornament is presented as the result of the combination of several fixed elements, existing from the very beginning. The growth of ornament is therefore a purely synthetic matter, without interplay of elements, without a propulsion from ideas or conditions or interests that transcend ornament as such. This limitation is not only methodological; for if B. says of the ornament: "It is only the principles of their combination, their mechanism, that we aimed to establish," he adds immediately: "Once the prototypes are fixed, the whole system develops rigorously, without the intervention of unforeseen principles" (p. 66), thus affirming his belief in the historical reality and effectiveness of this "rigorous" development.

Just as the figured sculpture is determined by the frame, the ornamental motifs are determined by the "geometry" of the building; the ornament *explains* the construction (p. 71); it is profoundly tectonic (p. 72), in fact, a graph of static architectural forces. Yet he discovers as the basis of Romanesque ornament, underlying all plant and animal decoration as a "master curve" ("courbe maîtresse"), the wavy, untectonic rinceau.

This rinceau form is not analyzed carefully or distinguished from the classical rinceau. He dissects it in order to generate by recombination of its elements the full variety of Romanesque plant and animal ornament. By one mode of recombination palmettes are formed, and through a series of substitutions these become animals in confronted and adossed groups. The postures of the animals, their convulsive movements, are simply the consequences of the basic schematic curves which preceded them. Monsters are ornamental creations begotten by the union of actual beasts with a preexisting mathematical form. B. admits that these monsters often have a legendary history and have existed prior to the "master curves," but he considers such historical facts irrelevant to the scope of his work.[8] He does not ask whether the convulsive movement of a Romanesque beast is expressively of the same order as a spiral curve and would necessarily result from such a curve in any art.[9] In his thought the psychological process whereby themes of ornament are assimilated to each other is identical with the historical genesis of the style. He presents no evidence that the different ideal forms he assumes in the development of a motif are historical successive stages; his genetic theories are pure constructions, *a priori* arrangements by the author.

To illustrate the "dialectic" of the development of ornament he has ingeniously shown a relief in Metz of a fish-siren with tail ending in crossed palmettes beside a typical Romanesque palmette. But this is no example of a dialectical process since there is no conflict or opposition to begin with. The *analogy* of siren and palmette is inconceivable without the prior motif of the siren holding the two divergent ends of her tail. The explanation of B. is unclear; he does not show us the antithetic siren form which was combined with the supposed palmette to produce the result at Metz. His originating process is a kind of Platonic mechanism in which the palmette as the ideal form alights on shapeless content and palmettizes it everywhere. The ornamental curves are fixed forever—"an armature of a kaleidoscope of mirages." Unfortunately he has ignored the

earlier history of these armatures and mirages, or he would have found ancient versions of the symmetrical fish-siren.[10]

But the dialectical process goes further. Just as the palmette enclosed in an inverted heart-shaped frame *produces* the siren holding the ends of her forked tail arched above her head, the latter in turn is imposed on a hundred new subjects. All animals paired beside a central figure are interpreted as the transformed tails of the siren framing the latter—all such groups, including Daniel and the Lions, the Ascension of Alexander, even a centralized set of three figures (p. 128) like the Crucifixion.

Why the artist, who must represent the Crucifixion or Daniel between the Lions, should conceive of these episodes as siren-shaped is never asked, much less explained. The truth is that it is not the episode that resembles a siren, but a typical artistic form or version of the story. Only in a tradition in which Daniel between the Lions is a centralized symmetrical emblem could an artist perceive the analogy to the palmette form. But in that case (granted that the artist perceived that analogy), can we speak of a dialectical opposition of the palmette form and the iconographic type, and can we explain the form of the image in terms of such an opposition? If the association of the two is due to an aesthetic analogy, then we can hardly invoke a dialectical principle to explain the changes in schemas or in style, for these schemas are of a common style.

Although B. claims that he is discussing the "process" of formation, the "physiology of stylistic growth," he has little to say of the process by which sirens grow out of palmettes and Crucifixions out of sirens. He is content to summarize it in a single sentence—"The technique of these transformations remains at bottom always the same; it operates by the increase, by the complication of elements." Yet in his exposition of these changes we see no principle of growth, only iconographic substitutions. The same schematic structure is embodied in successive motifs. Discussing the crocket capital he writes, "It is always the same figure, inscribed in the same place on the capital, that changes its name, its mask, its clothes, and renews its role" (p. 222); and in citing various subjects which are cast into the schematic mold or are even produced by the latter, he writes, "Thus the silhouettes do not change, they keep their place on the block of the capital and it is only in varying the details of the costume and of the gestures, and introducing accessories that the artist renovates the iconography without changing the structure" (p. 223). Structure, then, is a definite schematic form, not a pervasively organized system of the whole, as if a composition of a Raphael and a follower were identical since a common triangular scheme underlies both works. B. seems to think that there are three or four typical geometric forms into which are cast the ornamentally congruent subjects, as if one should say of Renaissance art that its compositions are based on a triangle in which are set the Holy

Family, a rectangle in which the artist fits the Last Supper, etc. He conceives of "schema" as an explicit preexisting abstract form, independent of the represented objects, and as in every sense prior to content. So too on the relation of subject and frame, he attributes the "embracing" type of the Visitation in Romanesque art to the narrowness of the central surface of a capital (Fig. 575). Although he admits an influence of the content (". . . required not only by the intensity of the feeling, but also by the strictness of the frame"), he believes that it is the narrow frame that begot this iconographic conception, for he has added in a footnote (p. 225): "this observation doubtless permits one to give their true sense to the remarks of E. Mâle on the double type of the Visitation"; and then to prove his indifference to the religious content—already evidenced by several errors of identification—he incorrectly summarizes Mâle: "the one [type] grave and solemn, of Oriental origin, and keeping the two women at some distance from each other, the second of a more dramatic sentiment, uniting the Virgin and St. Anne [sic] and proper to the Occident."

Actually, Mâle calls the first type Hellenic and the second, Oriental, and shows that they are equally common in the Latin West. It is apparent that both types can be fitted into a narrow or a broad space; in fact, examples can be cited in Romanesque art of the "embracing" type of Visitation on the broader surface—not in the central vertical field isolated by B.—and of the "detached" type on a narrow surface (cf. the capital in the cloister of Moissac—an embrace on a broad surface—with the relief on the porch of Moissac—detached figures on a long vertical panel). The expressive characters of Mâle's early Christian types are not the Romanesque ones, however, for the gestures and the styles have changed.

Yet B. writes that "the narrow frame favors embraces; the frame formed by columns imposes well-balanced attitudes; the arcaded frame determines violent gestures" (p. 227). He assumes a formative compulsion in the frame which forces the artist's hand and mind, dictating both the shapes and the sense.[11]

This mechanical formalism has a counterpart in the author's general attitude to iconography and history. He subordinates the first almost completely to schematic forms—as if the subject types and the meanings of a religious art were dictated by ornament and schematic frames imposed by architecture—and misinterprets even obvious subjects.[12] These are not just errors of identification, for in some cases his disregard of the meaning of a sculpture has allowed him to infer an incorrect formal explanation. The gigantic leg of the Sciapod (Saint-Parizé-le-Châtel, Fig. 829) is considered purely ornamental, without reference to the fact that this is a fixed attribute of the well-known exotic monster, his distinctive mark; on the contrary, the author writes: "The figure loses something of his indi-

viduality; he deviates from his canonical type in order to conform to another order" (p. 100). This order is the order of the palmette.[13] B. also derives from pure ornament certain groups of which the symmetrical form is rooted in mediaeval iconographic conceptions, like the Ascension of Alexander, Luxuria and the Demons, and the traditional figure between monsters. The subjects are not even mentioned. A surprising instance is the analysis of the Crucifixion on a capital from St. Pons-de-Thomières, a Crucifixion which he has already derived from a siren. He asserts that the four figures beside the Crucifixion are the products of an ornamental doubling, a logical complication; they are, in fact, the traditional figures of Longinus and Stephaton and the censing angels. On p. 225 he attributes the tight embrace of John (sic) and Christ in the Descent from the Cross and of Christ and Judas in the Betrayal to the schematic narrow central vertical band of the capitals, even though these are traditional expressive motifs which had appeared earlier in manuscripts and wall paintings without this constraining band.

With that indifference to the meanings in Romanesque art goes also a superiority to historical method. Although he has informed the reader at the beginning of the book that he is not concerned with the *history* of forms, but only with their style, he does not refrain from drawing conclusions about the origin of forms and the processes of stylistic development. His aesthetic theory implies for him a view of the necessary genesis of types and motives. Hence he writes (pp. 178, 179): "It is thanks to this stability of the ordonnance that one can follow the continuity of their creative effort, that one can reestablish the laws of their succession and their heredity, and discern all the steps of the invention that produced them. . . . In arranging several reliefs one beside the other, we could see appear first a head, then shoulders, trunk, and legs. These are the stages of the genesis of a being. The figure hidden within the block is progressively disengaged and liberated. . . . We could have unrolled the same film in another direction and seen, with the same sharpness, the progressive absorption of a living body by the impersonal structure of the crocket, seen how man or beast, at first independent and free, bends under the architectural will and petrifies. . . . But the direction of this movement matters very little, it is the movement itself that we must follow, the play of abstract forms, etc. . . ." He wishes to seize "the logic of their rapports, and explain several mysteries of their aspects. This method has permitted us to discover the active source which transforms and unites them."

He concludes this page with a further discussion of the reversibility of development in which he maintains that both historical interpretations—abstract to figured and figured to abstract—are equally valid; what matters most is the kinematic continuity of development. It is not clear

whether he is referring to an actual or a possible *historical* development or to ways of ordering and classifying works of art in time. But since he prides himself on having discovered the laws of their "succession and heredity," we must assume that he believes that these laws are reversible and that the direction of an organic or historical process does not matter. His mechanical view of history betrays the same conception of a determining *a priori* form and a passive content as his analyses of individual works of art.

The method of B. recalls the instruction in certain American art schools, based on the Hambidge system of "dynamic symmetry." Students are taught to divide the surface of a picture by diagonals and perpendiculars, and to fit the subject—figures, still-life, or landscape—into the resulting areas, or along these lines. With this system, the history of art has been reinterpreted to show the Hambidgian, mathematical basis of masterpieces, as if Classic, Renaissance and Modern art were alike in compositional principle. It is fortunate that we have no Romanesque texts to lend credibility to such a method as B.'s. For if a theologian had told us that all forms were triangles, rectangles, and palmettes, one would be tempted to identify the structure of Romanesque art with this formula. But how little such formulations penetrate into the nature of an art we can judge from the schematic application of Cézanne's statement on spheres, cones, and cylinders to his pictures. It is from the aesthetic milieu surrounding the practice of Cubism which certain critics rationalized in terms of Cézanne's misquoted dictum and endowed with the prestige of a mathematical method and content, that is derived the approach of B. It is a work emerging from the ultimately Platonic studio aesthetic of recent times and the passionate feeling for primitive art. B.'s method is an example of the verbally formulated, rather than real, "Kunstwollen," of French post-Impressionism and Cubism. To make Romanesque a modern art, or an art in modern terms, he has reduced content to a passive role, and has identified form with geometrical schematisms and with architecture—an abstract art. But this passivity of content has today become problematic. The condition and interests which promoted an analytic geometrical style no longer exist. We detect all the more readily the inadequacy of an interpretation like B.'s, which gives no formative role to the functions and meanings of a public religious art and which explains the choice of expressive effects solely by a geometrical coincidence.

Notes

1. Paris, Leroux, 1931.
2. Compare his drawing of the portal of Ely (Fig. 60) with the photograph in Hauttmann, *Die Kunst des frühen Mittelalters*, p. 585.
3. "Il ne limite pas seulement, il dirige les mouvements des silhouettes. Il les attire, il

les répartit dans l'ensemble, il fixe leurs proportions et leur équilibre [p. 7]. . . . Il domine la composition sculpturale de l'intérieur aussi bien que de l'extérieur, en lui imposant sa structure et son économie" (p. 12).

4. In an earlier chapter (pp. 28, 29), in order to demonstrate his principle of a concealed frame in a relief in Arles (Fig. 48), he must ignore the animal on the base of the composition, although it supports the whole group of figures above it.

5. Overlooked also is the shifting of the groundline of the figures in the radial fields on the margin of the tympanum. In the two lower fields on each side the figures stand on the radial lines, in the upper fields they move on the arch itself. This unusual device for maintaining the erect stance of figures through a subtle discontinuous rotation of their axes in contrast to the regular rotation of the radial fields (a device that binds those figures to the varied movements of figures at the sides and center of the tympanum) has its counterpart in a correspondingly graded irregularity in the filling of those fields with figures. The circular medallions of the archivolt, through their formal similarity to the circular disk in the arms of John the Baptist on the trumeau and also to his head and halo, contribute to the multicentered aspect of the larger whole of the portal. It is pertinent to observe here—since all this concerns a portal in which the frame is so pronounced a part of the composition—that Baltrušaitis ignores the relation of the frame to the enclosed sculptures in precisely those works which he assumes were organized according to a schema.

6. *L'Art des Sculpteurs Romans*, Paris, 1931, pp. 219 ff.

7. Cf. Leonardo Olschki, "Der geometrische Geist in Literatur und Kunst," *Deutsche Vierteljahrschrift für Literaturwissenschaft und Geistesgeschichte*, VIII, 1930, pp. 516 ff. He comments on Villard's schemas that they are "neither the expression of an artistic vision nor ideal built-in forms, but simply a means to a didactic picturing of an accidental outer symmetry."

8. His analysis of the structure of Romanesque ornament would have gained significantly in value had he compared Romanesque, pre-Romanesque, and Islamic works, and through common motifs in which appear similar relationships of ornament to a border or frame and to centralized and wavy geometrical schemes.

9. He writes on p. 151 that an animal is represented twisted in order to form an S; one could also say that it is shaped like an S in order to appear twisted.

10. For prototypes, cf. an Etruscan capital reproduced by Ducati, *Storia dell' arte etrusca*, Florence, 1927, II, Fig. 452, and the stucco figure in the apse of the underground basilica of the Porta Maggiore in Rome, reproduced by J. Carcopino, *La basilique pythagoricienne de la Porte Majeure*, Paris, 1927, pl. XXIV. A Hindu version is illustrated by A. K. Coomaraswamy in *Art Bulletin*, IX, 1929, p. 220. For Old Oriental and Greek analogues, cf. A. Roes, "Protomés doubles et têtes d'animaux géminées," *Revue Archéologique*, Mai-Juin 1932, pp. 197 ff.

Toward the end of the book (p. 347), Baltrušaitis admits that the siren existed before Romanesque art; but he maintains that its vogue in that art was due to its ornamental form. He does not give himself the trouble, however, of reconciling this admission with his account of the genesis of the siren form from the Romanesque schema.

11. One could say on the contrary that the compact embracing postures account for the choice of a narrow field, the broadly spaced postures for a wider rectangular one, vehement gestures for an irregular or broken frame.

12. On p. 229 he describes the Marriage at Cana on a capital in the cloister of Moissac (Fig. 700) as a Last Supper and identifies two of the guests at the table precisely as Christ and John who are not represented on this capital in the scene of the wedding feast.

13. A similar mistake occurs on p. 42 where B. explains the arched bodies of the falling idols of Heliopolis (Fig. 98) in Moissac as due to an invisible arched frame.

A Relief in Rodez and the Beginnings of Romanesque Sculpture in Southern France

(1963)

THE figure of Christ in the archaeological museum of Rodez (Fig. 1) has puzzled me greatly ever since I saw it as a student in 1926. This small marble relief, less than two feet high,[1] recalls on first view the great Romanesque sculptures of Burgundy and southern France. Yet where in that art do we see a Christ against such a background, with this tiny head set directly on the shoulders, and these delicate asymmetric and foreshortened limbs? Not in the region of Rodez, where the outstanding Romanesque work is the tympanum of Conques (Fig. 2). There the figure of Christ is massive, four-square, and commanding, with an administrative gesture, like a semaphore directing the traffic of the Day of Judgment; his robe is a thick shell around the bulk of the immense underlying body.[2] The earlier Christ of the tomb of Bégon III (†1107) in Conques, less monumental and closer to the size of the Rodez relief, has even simpler drapery forms, and points to the style of the tympanum.[3] The Christ of Rodez seems completely *dépaysé* when set among the stone sculptures of the twelfth century in its own region.

Certain works in Burgundy are nearer to it in their slender figures and layered rhythmic folds. From the concentric lines of these folds one might conceive a common ancestry of the Rodez relief, the capitals of the choir of Cluny, and the tympana of Vézelay. But the Rodez Christ does not sit comfortably in the familiar sequence of Burgundian Romanesque works; we cannot find a place for its folds in that series of developing drapery forms. These works share with the tympanum of Conques, but not with the Rodez Christ, an essential power of relief. In its refined graphic and painterly style, the Rodez plaque is foreign in spirit to the vigorous con-

quest of modeling that marks the sculpture of the early twelfth century in France, to which several scholars have assigned it.[4]

Is its exceptional character due perhaps to the thinness of the material —the slab of marble only three inches thick—that limits the depth of cutting? And also to the special context of the altar to which it probably belonged, with an old tradition of *repoussé* metal relief and flat geometric ornament?

I do not know a work of the first half of the twelfth century from the school of Burgundy made under these conditions. On the altar at Avenas, the figures are cut more deeply and with a simpler, larger rhythm of the folds and limbs.[5] And where a Romanesque artist undertakes to decorate a marble altar plaque with a Christ in Majesty, as at St.-Guilhem-le-Désert, not far from Rodez, the whole conception is different technically as well as in style.[6] In this work of 1138, the Christ with symmetrical legs is a typical figure of the twelfth century; and though the use of color through incrustation may recall the traces of inlay at Rodez,[7] it is more frankly a graphic work, a flat silhouette with incised inner details, a line drawing on stone, nearer in its schemas and elements to the forms in miniatures and enamels of the same period.

If we cannot find a style like that of the Rodez Christ in French art of the twelfth century, it must be admitted that the few remains of stone carving from the century before in the same regions yield no convincing parallels. They are generally works of bulky mass with a sparse development of surface lines. Their rude powerful shapes have a more primitive aspect, like the imagery itself with its frequent types of human and animal force.[8]

The Rodez relief might be a dated work, however, if we could trust a document of a kind that is usually regarded as strong evidence. The relief was part of an altar of which the table still exists,[9] and bears an inscription naming the Bishop Deusdedit as the one who had it made (Fig. 3).[10] According to the records of the church of Rodez, there were three bishops of that name; it is to the third, who ruled from 961 to 1004, that students have credited the altar.[11] The ornament of the table is very similar to that of marble altars at Quarante (Hérault) and Gerona, which, on independent grounds, are placed in the late tenth or early eleventh century.[12] Identical in type and moldings and made of the same marble, they were produced, according to Paul Deschamps, at the quarries of St.-Pons-de-Thomières near Montpellier, the center of that industry in the tenth and eleventh centuries.[13]

In Rodez the underside of the altar table and the inner sides of the supporting columns (now preserved in the local museum) contain grooves for an altar frontal of the same thickness as our plaque.[14] The original height of the plaque, inferred from the diameter of the lower circle on which Christ sits, agrees with the height of the columns and cap-

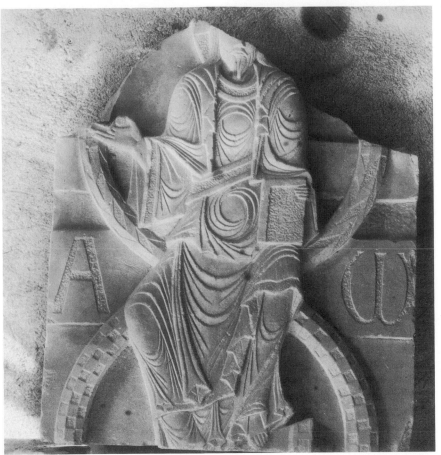

Fig. 1. Rodez: Christ in Majesty
(relief). *By permission of the
Musée Fenaille*

Fig. 2. Conques, Ste.-Foy, Tympanum
of West Portal: Christ (detail of
Last Judgment)

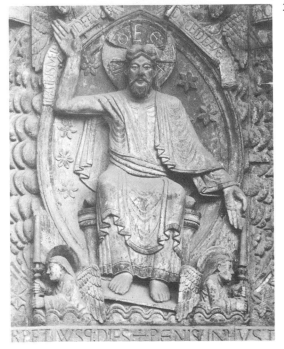

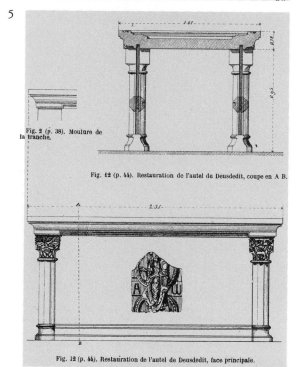

Fig. 2 (p. 38). Moulure de la tranche.

Fig. 12 (p. 44). Restauration de l'autel de Deusdedit, coupe en A B.

Fig. 12 (p. 44). Restauration de l'autel de Deusdedit, face principale.

Fig. 3. Rodez Cathedral: Engraving (19th c.) of the Altar of Deusdedit

Fig. 4. Rodez: Detail of the Altar of Deusdedit (after Bousquet)

Fig. 5. Reconstruction by the Abbé Vialettes of the Altar of Deusdedit

Fig. 6. Rodez: Capitals from the Altar of Deusdedit. *By permission of the Musée Fenaille*

Fig. 7. Limoges, St.-Martial: Detail of Troper; Paris, Ms. Lat. 1121, f. 34. *By permission of the Bibliothèque Nationale*

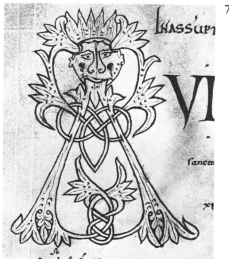

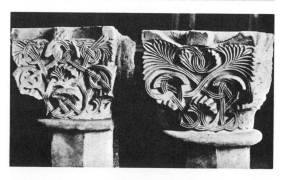

itals (Fig. 5).[15] The plaque is said to be of the same marble as the columns, capitals, and table,[16] but this I have been unable to verify.

The agreement in physical detail does not, of course, exclude the possibility that the relief, together with the capitals and columns, was cut and fitted to the altar table at a later time.

Recently the Abbé Bousquet of Rodez, accepting the original unity of table and frontal, has supposed that the whole was made in the third quarter of the eleventh century for a bishop, Peter Béranger, who was later removed from office because of his crimes. To erase his memory, the succeeding bishop, toward 1075 or later, replaced the original inscription by one attributing the altar to a Deusdedit who had rebuilt the Cathedral in the tenth century.[17] No evidence from the form of the inscription or the ornament of the table or from its history is offered in support of this conjecture, and the problem of relating the relief to the art of the third quarter of the century is not even posed.[18]

Study of the ornament of the altar table points rather to an earlier date. This ornament (Fig. 4) has been derived by several scholars from Mozarabic and Moorish art of the tenth and early eleventh century.[19] In this judgment they have ignored the Carolingian parallels of the inclined plants and the twisted and crossed stems,[20] as well as the greater resemblance to initials in South French manuscripts of the period around 1000.[21] The artist applied these motifs in a technique that goes back to the carving of foliage in low flat relief on the marble sarcophagi of the sixth century in the same region—at Rodez, Narbonne, and Toulouse.[22] The tradition of fine marble work still existed there in the late ninth century. A Life of St. Theodard, Bishop of Narbonne (†893) speaks of the beauty of the carvings of the marble altar and throne in his church.[23] I can imagine this art only as a reflex and continuation of Carolingian style. And the same may be supposed of the no longer existing work in marble for the choir and altar of the Cathedral of Clermont—executed about 950 by Adelelmus, a sculptor described in a text of the late tenth century as a great artist in stone and gold.[24] His work, which included statues of the apostles, the crucified Christ, and the Virgin and Child, was ordered by the Bishop Stephen II who, as Abbot of Conques at the same time, donated the famous gold statue of St. Foy.

The capitals, too, of the Rodez altar (Fig. 6) have been compared with Moorish works.[25] Their bulky form—a cubical block on an inverted conical segment—does resemble certain capitals of the tenth and eleventh centuries in Spain, but this architectural type, of compact vaselike profile, is known still earlier in Carolingian and Lombard art.[26] It is not necessary to look outside France for the models of the capitals in Rodez.

Their ornament, however, is of another style than the carving of the table. It is a striped interlace, three-ply or double-grooved like the knotted bands on the stone plaques of the ninth century; but unlike these, a

foliate growth issues inorganically from the broad edges of the bands or at the crotch of a branching of stems, as well as from the ends. The form may be described in another way: the stem thickens into a leaf at a turn or loop or branching. These fanlike, serrated leaves are distinct from the lobed forms on the table. One can find analogies in Moslem art, but there the bands and foliage are of a different type.[27] Although I cannot point with certainty to older examples in stone,[28] the ornament of these capitals is of a kind that appears often in the manuscripts of Moissac and Limoges in the first half of the eleventh century (Fig. 7).[29]

In sculpture, capitals with identical forms may be seen on the north transept portal of the Abbey Church in nearby Conques (Fig. 8).[30] This portal is not dated, but as the oldest door in a church that was begun about 1040 under the Abbot Odolricus (1031–1065), of the same sandstone and molding profiles and other ornament found in the east end of the church, which was built in the first campaign, it may be safely placed in the 1040s or 1050s.[31]

This type of capital was already being developed in the preceding decades. Capitals in S. Pere de Roda in Catalonia (Fig. 9), a church consecrated in 1022 and perhaps begun in the last quarter of the tenth century, show a simpler, coarser version of the same forms.[32]

In the manuscripts, the history of this foliate interlace can be followed from the Carolingian period onward.[33] But the specific form that we see in Rodez and Conques does not seem to occur before about 1000.[34]

If capitals and relief belong to the same project of a rebuilding or completion of the altar of Deusdedit, they may be dated through the evidence of the capitals of Conques and the manuscripts of Moissac and Limoges in the second quarter of the eleventh century, if not a little before.

Although I hesitate to compare the qualities of a figure sculpture with those of foliate and interlace ornament, I see a common style in these capitals and the relief. The ornament is graphic, slender, and precise, like the forms of Christ. A rhythm similar to the latter's appears in the play of clustered lines and in the flicker of the small dark background areas reserved behind the banded pattern. The striped stems lie against the body of the capital like a close-fitting vestment of openwork threads, and the emerging leaves hold to the plane of the interlaced bands. The structure of this ornament resembles the paired concentric and radial lines on the folds of the figure; capitals and figure are by artists of one school, if not by the same hand. Compare in particular the leaves and grooved stems with the radial lines on the folds below the waist. The image of Christ and the capitals harmonize fully as parts of a single whole.

Let us turn now to the figure of Christ and consider its forms in themselves; they are amazingly subtle in conception and artistic quality.

Among the surviving stone sculptures of the early Middle Ages, the Christ of Rodez is unique in the treatment of relief as a field of lines and textures. It is finished in three kinds of surface: smooth on the slight convexities of the figure and on the planes of the background; grooved, ridged, and stepped on the layered folds of the costume; finely roughened on the book, the A and W, the halo, the footstool, and the bands of the collar, right sleeve, and waist. The same granular effect marks alternate squares of the borders of the footstool and lower circle, as well as the lozenges of the mandorla. Here the pitted surface is bounded by smooth fillets, squares, or lozenges in higher relief. By this device the artist has produced a difference of "value," the neighboring surface being of another grain and brightness. The recessed parts were once filled with a colored substance more luminous than the painted marble. The difference between outer and inner layers of relief was then more pronounced than today and the contrasts of color were more evident.

The relief owes much of its interest to the variation of flat and rounded surface. The alternately advancing and receding bands of the background make straight horizontal lines of shadow; the convex layered surface of the body is broken up by multiplied curved folds. These are edges of planes, sets of rhythmical lines, sharply cut yet graded, like the black and white of a pen drawing with thinner and thicker strokes.

Though exceptional in sculpture, this contrast of the vertical figure with the intermittent banded ground is common in Carolingian, Ottonian, and Mozarabic painting, where the field is divided into horizontal zones of distinct color.[35] Observe also that the inscribed A and W are not lapidary but painted forms; they lack the serifs and V section that we expect in a stonecutter's letters.

We see, then, how deeply this sculpture is imbued with the qualities of a painter's and a draftsman's art.[36] A goldsmith's, too, for the artists in luminous metal varied the figures and ground by wafering, stamping, and modeling the surface.[37]

Another finesse, more of structure than of surface, livens the composition in many small differences. In the upper half, the folds, cut in symmetrical groups, accent the symmetry of the strictly frontal upper body; below the waist is an equally marked asymmetry of the folds and limbs. The opposed upper and lower schemes become one through the diffusion of similar short arcs, regular yet nicely varied. They are united by the circles of halo, mandorla, and heaven, and also by the convex ovals reserved on the arms, breast, abdomen, and knees. On the large framing circles, however, the contrasts are inverted: the rectangular ornament is on the heaven seat, the unstable angular lozenges are on the mandorla above.

There is also in this dense field of curved lines a grid of horizontals

and verticals that gives a constructed aspect to the whole. The bands of the background are opposed to the many verticals in the figure, not only the straight edges of the sleeve and book, but the sets of round folds placed one above the other on the main axis of the body and bounded by straight lines.

The cutting is admirably crisp throughout, tracing clean shadows and precise silhouettes in the whorl of complex folds. The nicety of variation, the sensitive adjustment of responding forms in figure and background and along the edges, repay close attention. Follow in particular, in the central vertical section of the body from head to foot, the changing shapes of the larger parts and the shifting axes of the curves on the abdomen—inspired deviations that give life to the whole. This is clearly the work of an artist of high originality, completely master of his forms.

By these and still other means is conveyed a contemplative mood, constrained, passive, ritualistic, and imaginative. Our attention is fixed not so much on the organic body of Christ as on a fanciful surface bound to the shapes of symbolic attributes. The immobilized figure, with little salience and modeling, is veiled by a web of concentric lines. The exposed human parts are slight, the outer veil and artifice rich and endless in detail. The body is a torso without distinct limbs, an almost shapeless mass animated by the folds alone. In its profuse pleating, this complex costume of four robes seems to be a wrapping or unwrapping of an inert underlying ground that is all layered surface. The folds, too, are not felt as forms issuing from a natural state of the garment and body; their multiplicity or sparseness, their straightness or curves, have little to do with the weight and substance of actual robes. The drapery lines are as much a property of the subtle matter of the relief, the marble as a sum of abstracted layers or planes.

If the folds form series, centered or axial with respect to the convexities of the body beneath, these schemes are no less clearly assimilated to the theological symbols: the circles of heaven and glory, the halo, the wafer, the book, and the footstool. Like the lines on the garments, the halo and the figure-8 mandorla are not closed circles. Intercepted by the body, they are symmetrical segments, or, more precisely, spiral segments in complementary patterns. Only the wafer is rendered as a complete form.

Note, besides, that Christ is not enthroned in power, but is suspended without chair or cushion in the twin circles—larger, more solid versions of the lines of his own garment. The hands and foot are without force; the hand holding the book is the tiniest hand that I can remember in mediaeval art. The right hand is held out gently, neither to command nor to bless. Between two delicate fingertips it encloses and displays the eucharistic host, the symbol and vestment of the miraculously present,

metabolized body of Christ. Fingers and host are a nucleus of this body in form as well as meaning. We may see them together as a paradigm of the pattern of circle and tangent lines in its veiling surface, as if the body of Christ were made up of countless units such as the hand and host.

From this description of the Rodez relief, it becomes clear, I think, why the relief resists comparison with the Romanesque sculptures of the twelfth century. Beside this spiritualized figure, the monumental Christ-figures of the portals seem grossly naturalistic.

On the other hand, certain of its features remind us strongly of Carolingian art. In the conception of the subject, the Christ of Rodez has an evident affinity with the miniature painting of Christ in Majesty in the First Bible of Charles the Bald (Fig. 10),[38] a work of the school of Tours, dated about 845. The figure-8 mandorla, the little disk in Christ's hand, and the strict frontal posture with V-shaped foreshortened asymmetrical legs are clear signs of a historical connection between the two works. If the older figure lacks some details of the relief—the diagonal foot rest, the extended right arm, and the position of the fingers—these elements may be found in other French Carolingian works, as in the Christ figures of the Codex Aureus in Munich[39] and of the Bible of S. Paolo fuori le mura.[40] We are certain that the sculpture of Rodez in its detailed iconographic conception descends from a type current in France in the ninth century.[41]

What interests us even more—the artistic conception—also depends on Carolingian art. I shall not trace here the sources of single motifs, which is easy enough to do. I wish, rather, to bring out some larger ideas of form common to the relief and to certain Carolingian works.

In the same manuscript painting (Fig. 10), the drapery lines, following broadly the natural lay of the garment and the structure of the body, have been shaped as a large formal scheme. At the center there issue from a great spiral—strictly speaking, a whorl of spiral segments[42]—two sets of centrifugal folds. It is a pattern familiar in Hiberno-Saxon art (though the later example may be an independent reinvention). These inward-curving diagonals, tangent to the spiral and joining it to opposite ends of the figure, are contrasted with the axis of the rigid upper body, but accord with the bent legs and the sides of the lozenge frame; the round form is repeated in the wafer, in Christ's nimbus, mandorla, and heavenly seat, and in the medallions of the four prophets. Through the diverging lines of the mantle, the abdomen appears as a rotating center of the entire composition.[43] It competes with Christ's head and is the core of the linear framework of the whole.

Three features of Carolingian art, important for later styles, are found in this painting. 1) The human figure has been embedded in and assimilated

to the enclosing elements and symbols that form together a schematic geometrical whole.[44] 2) The upper part of the body is strictly frontal and symmetrical, the lower body is markedly asymmetrical—an unclassic but typical Carolingian and early mediaeval form. 3) And within this figure, which retains much of classic organic detail, the finespun drapery, while adapted to the larger system of geometric forms, has also its own dynamic effect within the rigid framework, and is often more pronounced than the bodily structure itself. If the limbs are constrained, the folds of the costume have become a more active vehicle of expression, largely through the involuted lines, and have assumed in a stable mechanical scheme something of the natural mobility of the limbs. By centering this movement at the navel, the artist has endowed the figure with a fascinating primitive quality strange to classical art but cultivated often in the Middle Ages when rotation or other intense movement had to be rendered.[45] What appears as an abstract form—the circle, the lozenge—is also an attribute to Christ, a part of the religious meaning of the whole; and what belongs to familiar reality—the human body, the costume—is cast in analogous regular schemes.

Without assuming a direct connection of the Rodez figure with this paticular Carolingian Christ, their kinship in form seems to me as evident as the iconographic similarity. But the differences are no less significant.

Instead of a central core with rotating lines, the sculptured Christ has several such schemes in symmetrical pairs. The formal nucleus of the Carolingian body has been replicated throughout the sculptured figure (just as the figure-8 mandorla has become two distinct circles). Yet something of the underlying organic form is maintained and even expressed in these lines. They enclose or define by their curves on a slightly modeled, almost flat surface what in the older art would have been a pronounced convex form. They divide the body into many parts, each with its isolated pattern of drapery lines.

In this process the Rodez Christ has lost much of the antique modeling still preserved in Carolingian metal and ivory sculpture. It does not yet show, however, the archaic massiveness of the early Romanesque, though the modeling is primitive in its simple rounding and contrasts.

The articulation through lines, I must add, is not just a later variant of a Touronian style. It depends on another Carolingian type found particularly in miniatures from the court scriptorium in Aachen, where the lines of the costume, more vagrant and broken, bring out the underlying body form. Already in the ancient art that was the model of the Carolingian sculptors and painters, we can distinguish broadly two polar types in the draping of the figure: one accents the many salient parts of the body, shaping each as a smooth convex surface bounded by the ridges of folds; the other, more common in Hellenistic and Roman art, defines the

8

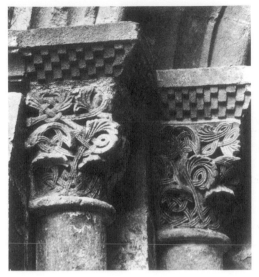
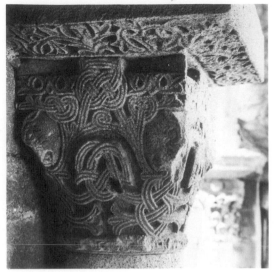

Fig. 8. Conques, Ste.-Foy: Capitals of North Transept Portal

Fig. 9. S. Pere de Roda (Catalonia): Capital. *By permission of Ampliaciones y Reproducciones Mas*

Fig. 10. First Bible of Charles the Bald: Christ in Glory, Evangelists, Symbols, and Prophets; Paris, Ms. Lat. 1, f. 330v. *By permission of the Bibliothèque Nationale*

Fig. 11. Dialectic and Rhetoric of Albinus: Christ in Majesty with Symbols. Zentralbibliothek Zürich, Ms. C. 80, f. 83

0

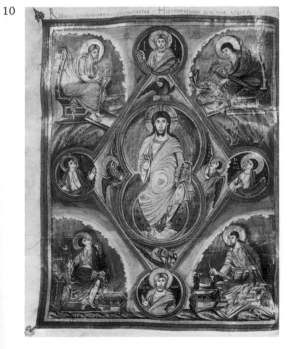
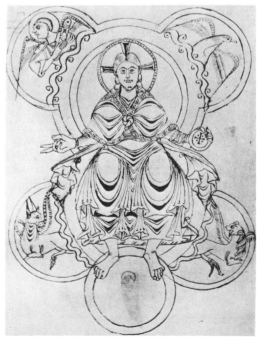

Fig. 12. Bede on the Apocalypse, etc.: Christ between Angels; Einsiedeln, Stiftsbibliothek, Ms. 176, p. 6

Fig. 13. Detail of Halitgarius on the Vices and Virtues, from Moissac; Paris, Ms. Lat. 2077, f. 164v.
By permission of the Bibliothèque Nationale

garment as a whole by a large enveloping form with closely repeated con-
verging or diverging folds that join far separated points, often by diago-
nal lines. (There were, of course, in both classic and mediaeval art, mixed
and intermediate types, of which the Tours miniature is an example.) In
Romanesque art both types survive, and both are converted into legible
schemes, more explicit and regular than in Carolingian art.

From the tenth century, which is a time of revival and reworking of
Carolingian forms in Germany and England, we have many figures that
resemble the Rodez Christ in detail as well as in broad type. The Christ
of Tours was copied then by the miniature painters of western Germany
who preserved the characteristic central whorl and the analogy of the
human forms to theological emblems.[46] In both Ottonian and Anglo-
Saxon art we find also the taste for close-spun concentric and spiral folds.
If the Rodez figure looks more schematized, more advanced toward that
regular play of bounded, clustered lines which is for many students a
defining feature of Romanesque art, one can point to works of the tenth
century which are even more schematic than the Rodez Christ. In a draw-
ing from St. Gall (Zurich, Stadtbibliothek, MS C. 80, fol. 83), the rounded
lines of the folds are like the circles of the halo, host, and medallions
(Fig. 11).[47] Here we observe in a less refined style that peculiar construc-
tion of the body and the surrounding emblems as a coherent system of
analogous forms. In its schematic aspect and symmetry, this drawing
seems more Romanesque than the relief; at least it corresponds better to
modern descriptions, surely inadequate, of the Romanesque as a style of
strictly schematized forms.

Still another example, interesting for the pre-Romanesque roots of the
relief of Rodez, is a drawing from Einsiedeln (Fig. 12) in which the more
complex types of folds have been reduced to distinct sets that remind us
of the forms in Rodez.[48]

So little has come down of figure representation of the tenth century
from southern France that we cannot confront the Rodez Christ with
equally complex and accomplished native work of that time. The remains
are chiefly of initials or drawings with highly simplified forms.[49] From
the first third of the eleventh century, however, there are drawings of a
related character. In a manuscript from Moissac (Paris, Bibliothèque
Nationale, MS Latin 2077) with illustrations of the Vices and Virtues, the
pendrawn figures are designed with regular lines and pleats that may be
set beside those of Rodez as works of a common school or region (Fig.
13).[50] This community of forms will be more evident if we compare both
works with the art of the late tenth and early eleventh century in the
north of France or even in neighboring Burgundy.

In other manuscripts from southern France, written at Limoges[51] and
Clermont[52] in the late tenth and early eleventh century, there are traces

of such a style in simplified forms with regular hooped and concentric folds or complementary spiral segments marking the convexities of the body (Fig. 14). That a more complex treatment existed we may suppose not only from the Moissac manuscript, but from the parallel practice in Burgundy. A drawing from Dijon of the second quarter of the century (Paris, Bibliothèque Nationale, MS Latin 11624, fol. 22)[53] shows a surprisingly rich pleating and spinning of the lines of costume; it depends on the post-Carolingian art of the North and perhaps descends, like the similar drawing in the Ottonian art of Fulda, from works of the Carolingian court school (Fig. 15).

A small detail confirms the connection of the relief with the art of southern France in the early eleventh century. In the manuscript from Moissac, the figure of Castitas (Fig. 16) holds a palm branch between two fingers of a horizontally outstretched hand as the Rodez Christ holds the sacred host. The same conception of the ostensive gesture occurs also in a drawing from Clermont of the late tenth century.[54]

Finally, I recall to the reader that in the same manuscript of Moissac there appears the design of interlaced bands with foliate edges and fillings which we see on the capitals of the Rodez altar.[55] In the manuscript, this ornament is already more intricate than at Rodez. Its history is not known, but one can point to examples from the early eleventh century in other manuscripts of Moissac and Limoges.[56]

From these works we may surmise that the drawings and ornament of the Moissac manuscript were not exceptional forms, but belonged to a broader post-Carolingian tradition with distinct local features. There are several interesting evidences of the penetration of Carolingian art in the south of France and in Spain during this time in works that share with the Rodez Christ some unusual traits of iconography or form.

A painting in the Beatus Commentary on the Apocalypse in Gerona, a Mozarabic work of 975, permits us to suppose that the type of Christ in the Bible of Charles the Bald and the Rodez relief existed in southern France in the second half of the tenth century. The Christ on fol. 2 (Fig. 17) is clearly an intrusion from a Northern source. This prefatory page does not belong to the original stock of Beatus illustrations, and betrays in several features its connection with art across the Pyrenees. The great lozenge, the 8-shaped mandorla, and the four lunettes with the symbols of the Evangelists remind one strongly of the page in the Bible of Charles the Bald (Fig. 10). Not only the gesture of Christ with the sacramental wafer held ostensively in the right hand between the thumb and the third finger, but the peculiar turning of the heads of the beasts, comes from France. The scroll assigned uniquely to the eagle—a detail that Emile Mâle mistakenly thought was a Spanish invention copied from a Beatus manuscript by the sculptor of the tympanum of Moissac—is a French Car-

14

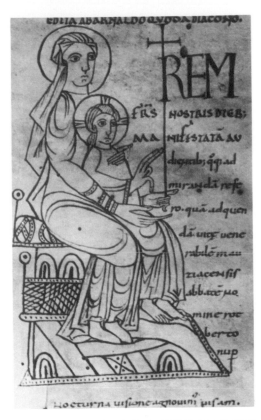

Fig. 14. Minor Works of Gregory of
Tours: Virgin and Child; Ms. 145,
f. 130v. *By permission of the
Bibliothèque Municipale et
Universitaire, Clermont-Ferrand*

Fig. 15. Detail from the Works of
Ambrose; Paris, Ms. Lat. 11624, f. 22.
*By permission of the Bibliothèque
Nationale*

Fig. 16. Detail of Halitgarius on the
Vices and Virtues, from Moissac;
Paris, Ms. Lat. 2077, f. 173.
*By permission of the Bibliothèque
Nationale*

15

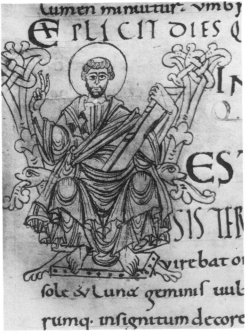

16

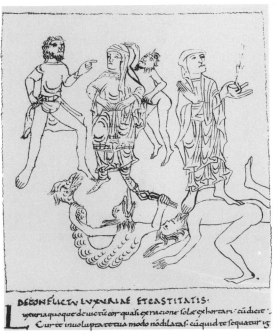

17

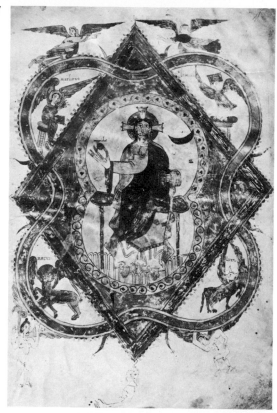

Fig. 17. Beatus Commentary on the Apocalypse: Christ in Majesty with Symbols of the Evangelists. Gerona, Cathedral Treasure, f. 2

Fig. 18. St.-Genis-des-Fontaines: Detail of Lintel. *By permission of Ampliaciones y Reproducciones Mas*

18

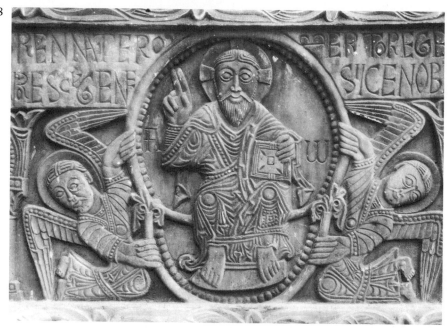

Fig. 19. St.-Genis-des-Fontaines:
Detail of Lintel. *By permission of
Ampliaciones y Reproducciones Mas*

Fig. 20. Marseilles, Musée Borély:
Tomb of the Abbot Isarn

Fig. 21. Cluny (Saône-et-Loire),
Capital from Ambulatory of the
Abbey: Fourth Tone of Plain Song.
By permission of the Musée Ochier

21

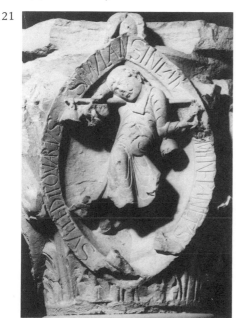

olingian motif found especially in Tours.[57] Like some modern scholars, the Iberian artist has not understood the original meaning of the disk in Christ's hand[58]—for the eucharistic controversy of the Carolingian theologians seems to have had little echo in Spain[59]—and he has labeled it *mundus*.[60] That the painter had before him a French work of the tenth rather than the ninth century is hard to say; but if such Carolingian models were known in the tenth century in Mozarabic Spain, they were undoubtedly available then in southern France.[61]

From the first quarter of the eleventh century there is another sign of Carolingian tradition in one of the oldest pieces of dated stone sculpture in the neighboring region: the lintel of St.-Genis-des-Fontaines (Pyrénées-Orìentales), which was executed in 1020-21 (Figs. 18, 19). The central figure of Christ blessing and the accompanying saints and angels, however primitive in aspect, reflect, in the variety and complication of surface lines and the node-like centers with spiral elements, the dependence on a Carolingian style like that behind the Christ of Rodez.[62] We cannot regard these vermiculated forms of St.-Genis as inventions of the provincial, though gifted, sculptor; we assume rather that there existed in his milieu a more refined art with these elements. The technique of carving in the flat with V-grooved lines recalls contemporary Moorish work, as well as the pre-Carolingian ornamented plaques.[63] But one should not overlook the presence here of layered surfaces of drapery as well as incised lines—distinct features that resemble the devices of the Rodez sculptor and point to both Carolingian and early Romanesque art. At St.-André-de-Sorède and Arles-sur-Tech nearby, there are reliefs of the same period which agree in other details with the Rodez Christ,[64] though they are simpler and less accomplished works.

All these sculptors from the province of Roussillon are often classed as Catalonian, and the horseshoe arches make this view seem plausible. But Roussillon and Catalonia had close relations then with the South French world, and retained old ties with the post-Carolingian kingdom in the North. In the eleventh-century Catalonian Bibles of Roda and Ripoll, which show clear links with Early Christian art, there are also many figures of French Carolingian type, including the Lord in the 8-shaped mandorla with the eucharistic host.[65] The inscription of the lintel of St.-Genis gives the date of the work as the twenty-fourth year of the reign of King Robert of France. The Count of Barcelona was a vassal of the King of France, and the Bishops of Rodez and Narbonne were important figures in the ecclesiastical life of Catalonia and Roussillon.

I turn finally to the great tombstone of the Abbot Isarn (†1048) from St.-Victor in Marseilles (Fig. 20). The engraved lines at the shoulders and breast and the modeled folds at the feet are patterned in a dense scheme related to the Christ of Rodez.[66] Compared to the latter, this powerful

gisant gives the impression of a figure from a capital of the time, immensely enlarged. The whole is at once more primitive in the reductive simplicity of lines and more advanced toward the Romanesque in the starkness of relief. For what seems to have been a revived task inspired by ancient example—the funerary portrait—the sculptor found his model for the folds not in the Early Christian sarcophagi so abundant in Marseilles, which had excited Isarn when he came as a young monk to the Abbey of St.-Victor from his native region of Toulouse,[67] but in manuscript drawings[68] or in the stone and metal reliefs of altars and other church furniture of the first half of the century.[69] His art, with its symmetry of lines, is already more sculptural and regular, more in the path of Romanesque monumental form, than the Christ of Rodez, and makes more credible the latter's early date.

I shall not in this paper go into the consequences of the proposed redating of the Rodez relief for the history of Romanesque art in southern France. But I wish to remark in conclusion on its bearing upon the old problem of the Cluny capitals.

The existence of an art like that of the Rodez relief by the middle of the eleventh century revives the question of the date and sources of the Cluny sculptures. The lines on the body of the Fourth Tone at Cluny (Fig. 21) are later variants of the forms of the Rodez Christ and its Carolingian ancestors.[70] On the belly is an incised spiral fold; above and below, on the breast and lap, are concentric curves in diverging sets. What has been a single connected motif in the Tours Bible, and is repeated in Rodez in smaller units, breaks up at Cluny into discontinuous sets of rhythmic lines, each set belonging to another section of the body. But while the form at Cluny seems more primitive in this separation of parts, the body is more natural through the modeling and the suppleness of posture—the free turning and movement of the whole figure, a Romanesque *contrapposto*. The strong relief of this figure and the deep undercutting depend on an intervening growth of the plasticity of the capital, outside this tradition of drawing and in accord with the changing architecture. I do not suppose that a continuous series of stone sculptures leads directly from the Rodez Christ to the capitals of Cluny—they may be separate branches of a common development, although the close relations of Cluny, Auvergne, and Rouergue in the eleventh century suggest the possibility of more direct connections.[71] From the few remains of what must have been rather limited programs of stone carving, it appears that at a certain point in the growth of relief sculpture late in the eleventh century, the complex drawing of the Carolingian type, until then confined in sculpture to figures for the altar in gold and marble, was applied for the first time to the architectural capital which earlier in the century had generally been the task not of specialized sculptors but of stone-

cutters, sometimes highly imaginative and gifted, who created figures of a primitive bulk and sparse surface detail. I cannot imagine that the goldsmiths who produced the altar frontals and book covers for the great churches of the Royal Domain toward 1000 practiced as archaic an art as the capitals of St.-Germain-des-Prés or Fleury (though we recognize in these capitals some details borrowed from the graphic style of the manuscripts, and though, for the special requirements of reliquary images in the round, the goldsmith might aim at a symmetry and compactness adequate to the majesty of the sacred figure).

The early dating of the Rodez relief—a work of high sensitivity and skill—would make more intelligible the creation of the marble capitals of Cluny in the period of 1088 to 1095, to which Arthur Kingsley Porter had the insight and courage to assign them.[72] What had made his view so hard to accept—namely, the lack of a native ancestry, which Porter proposed to fill by distant Byzantine models[73]—is overcome if we recognize in the Rodez Christ a product of the preceding period in a line of developing art. The master of Cluny, working in marble, builds on the forms of refined marble altar sculpture of the first half of the eleventh century, rather than on the figured capitals of that time. It may be, too, that a tradition of sculpture in marble existed in Cluny itself in the first half of the century when the Abbot Odilo, who ruled from 994 to 1049, built a cloister of marble, *mirabiliter decoratum,* with material brought from the South.[74] The sculptor of the Cluny capitals fuses the living tradition of complex drawing in the precious arts of the altar with the steadily advancing plasticity of the architectural stone carvers whom he surpasses in boldness of undercutting. And he renews the vestiges of classical art in his Carolingian heritage of line by assimilating freshly the rich forms of the Roman Corinthian capital, with its abundant light and shadow in the curling and depth of the leaves, and by setting among them equally modeled figures of a delicate grace of movement.[75]

NOTES

1. It is 42 cm. wide, 50 cm. high, and 7.5 cm. thick.

2. This applies also to the relief of Christ in the church of St.-Georges-de-Camboulas near Rodez, which is clearly a provincial sculptor's copy of the Christ of Conques and not, as L. Bousquet (*La Cathédrale pré-Gothique de Rodez,* Rodez, 1948, p. 157, pl. XIX) supposes, an early twelfth-century model of the tympanum of Conques originally on the portal of the Rodez cathedral. His view is accepted by Christoph Bernoulli, *Die Skulpturen der Abtei Conques-en-Rouergue,* Basel, 1956, p. 65. The style of drawing in the objects of the early twelfth century in the treasure of Conques is closer to the contemporary art of Moissac, Albi, and Limoges.

3. Arthur Kingsley Porter, *Romanesque Sculpture of the Pilgrimage Roads,* Boston, 1923, IV, ill. 387.

4. Raymond Rey, "Quelques Survivances antiques dans la Sculpture romane méridionale," *Gazette des Beaux-Arts,* S. 5, XVIII, 1928, p. 191 (the photograph reproduced

there is my own); Paul Deschamps (*French Sculpture of the Romanesque Period. Eleventh and Twelfth Centuries*, New York [1930], pp. 3, 4, 30, pl. 22b) calls it a fragment of a tympanum and dates it "first half of XII century"; R. Hamann-MacLean and J. Verrier (*Frühe Kunst im Westfränkischen Reich*, Leipzig, 1939, p. 17, no. 192 of Notes on the Plates, pl. 208) date it "um 1100." In L. Gischia and Mazenod (with text by J. Verrier), *Les Arts Primitifs français*, Paris, 1953, p. 30, no. 192, the relief is dated in the second quarter of the twelfth century; L. Bousquet ("Rodez; Cathédrale," *Congrès archéologique de France* [session tenue à Figeac, Cahors et Rodez en 1937], Paris, 1938, pp. 360, 376, 377) places it in the first half of the twelfth century.

5. Porter, *op. cit.*, II, ill. 12.

6. *Ibid*, IX, ill. 1300.

7. Traces of glass paste and leaves of gold and silver in the hollows are noted by Bousquet, *La Cathédrale* . . . , p. 143; they had escaped my attention.

8. Yet in the capital from St.-Hilaire in Poitiers, with the beard-pulling fighting men, the spiral and radiating folds of the torso of the left figure are related to the schema on the Rodez Christ; for a good illustration, see Gischia-Mazenod, *op. cit.*, pl. 172. For a survey of the capitals of the eleventh century in France, see Francisco Garcia Romo, "La Escultura románica francese hasta 1090," *Archivo español de Arte*, XXX, 1957, pp. 223–240; XXXII, 1959, pp. 121–141.

9. It is preserved in the Cathedral as the retable of a later altar. See Josef Braun, *Der christliche Altar*, Munich, 1924, I, p. 270 and pl. 43; Bousquet, "Rodez . . . ," pp. 360, 376, 377, and *idem*, *La Cathédrale* . . . , pp. 128ff and pl. XI. For the connection of the relief with the altar, see L. Vialettes, "Autel de Deusdedit, sa Reconstitution, son Epoque," *Mémoires de la Société des Lettres, Sciences et Arts de l'Aveyron*, XV, 1894–99, pp. 37–72.

10. DEUSDEDIT EPISCOPUS INDIGNUS FIERI IUSSIT HANC ARAM.

11. For Deusdedit III, see *Gallia Christiana*, 1715, I, p. 203. One must leave open the possibility that there was a fourth Deusdedit, since there seem to be no documents of the church of Rodez which name the bishop during the first quarter of the eleventh century.

12. For these altars, see Braun, *op. cit.*, I, pp. 270ff, who dates the Gerona altar in the late tenth century, before the repairs of the Cathedral in 1015 to 1038; P. Deschamps, "Tables d'Autel de Marbre exécutées dans le Midi de la France au Xe et au XIe Siècle," *Mélanges d'Histoire du Moyen Age offerts à M. Ferdinand Lot*, Paris, 1925, pp. 137–168; Georges Gaillard (*Premiers Essais de Sculpture monumentale en Catalogne aux Xe et XIe Siècles*, Paris, 1938, pp. 48–50) dates the Rodez altar in the beginning of the eleventh century and the Gerona altar 1017–28. The dating of the Quarante table by the consecration of the church in 982 (Deschamps, "Tables . . . ," p. 146) has been doubted by Bousquet (*La Cathédrale* . . . , p. 148), who refers to M. de Dainville, *Les Eglises romanes du Diocèse de Montpellier*, Montpellier, 1937, fasc. I, for a consecration of the church of Quarante in 1053. (The book by M. de Dainville has not been available to me.) The same type of marble altar table was produced until the end of the eleventh century as is shown by the example in St.-Sernin at Toulouse signed by the sculptor Bernardus Gelduinus; but the ornament here is different and obviously later.

13. "Tables . . . ," pp. 160–162. I learn from Georges Gaillard, who in 1938 accepted Deschamps' attribution of these altars to the Hérault quarries, that the identity of the marble is now questioned and is being studied further.

14. These columns and capitals of the altar are believed to have been brought to the museum, together with the relief, about 1840; see the Abbé Vialettes, *op. cit.*, pp. 39, 40, 42.

15. Since the outer radius of each circle is about 18.25 cm., the height of the original relief could not have been less than 73 cm. If we allow for a free background surface equal to that at the sides of the globe and mandorla (about 6 cm.), the relief would have been about 85 or 86 cm. high. This agrees well with the original height of the altar; the supporting column, capital, and base had a total height of 95 cm. Allowing 10 cm. for the upper and lower borders of the frontal, the relief of Christ, estimated as 85 cm. high, would fit the space neatly. It should be noted that the lower uncarved projections of the four corners of the altar table formed the imposts of the capitals.

16. Cf. Vialettes, *op. cit.,* pp. 42, 55, and Bousquet, *La Cathédrale* . . . , pp. 134, 135. The unity of the material, among other reasons, led the Abbé Vialettes to date the relief in the time of Deusdedit III.

17. *La Cathédrale* . . . , pp. 150ff.

18. Bousquet ("Rodez . . . ," pp. 360ff) compared the relief with the tympana of Autun and Vézelay, and proposed a date in the first half of the twelfth century for the table, the capitals, and the relief. The inscribed name of Deusdedit seemed to him a forgery: "We suspect that the inscription was incised at this time in order to authenticate the relics deposited in the block of the altar."

19. Deschamps, "Tables . . . ," p. 148; J. Puig y Cadafalch, in *Bulletin de la Société nationale des Antiquaires de France,* 1928, pp. 149–152; Gaillard, *op. cit.,* p. 52; Bousquet, *La Cathédrale* . . . , p. 130. Braun (*op. cit.,* I, pp. 270, 271) had already compared the ornament with florid Cufic inscriptions.

20. Both the regular symmetrical plants and the freer forms on the tables of Rodez and Gerona appear in French manuscripts of the ninth century. Cf. H[enri] O[mont], *Peintures et Initiales de la Première Bible de Charles le Chauve. Reproduction des 90 Miniatures du MS. Latin 1 de la Bibliothèque Nationale,* Paris, n.d., pls. IX–XIII, 6, 28, 36, 46, 68. For these and other Touronian examples, see W. Koehler, *Die karolingischen Miniaturen,* I: *Die Schule von Tours,* Berlin, 1930, pls. 2b, 16e, 34e, 43a, 58g, 66d, 83. Cf. also the Drogo Sacramentary (Paris, Bibl. Nat., MS Lat. 9428) in E. A. van Moé, *La Lettre ornée dans les Manuscrits du VIIIe au XIIe Siècle,* Paris, 1943, pl. 77; the Second Bible of Charles the Bald (Paris, Bibl. Nat., MS Lat. 2), in H[enri] O[mont], *Peintures et Initiales de la Seconde Bible de Charles le Chauve,* Paris, n.d., pl. 32; the flabellum of Tournus, in L. E. A. Eitner, "The Flabellum of Tournus," *Art Bulletin: Supplement I,* 1944, pls. I–XIII. Cf. also, the sculptured frieze on the west front of the tower of St.-Germain in Auxerre, in J. Hubert, *L'Art pré-roman,* Paris, 1938, p. 164.

21. From St.-Martial of Limoges: Paris, Bibl. Nat., MS Lat. 5, vol. I, fol. 2, vol. II, fol. 1ᵛ (Bible, second half of tenth century); Paris, Bibl. Nat., MS Lat. 5301 (Lives of Saints, late tenth century), in Van Moé, *op. cit.,* pls. 25, 58, and also fol. 256; Paris, Bibl. Nat., MS Lat. 1118, fol. 132 (Troper, late tenth and early eleventh century); Paris, Bibl. Nat., MS Lat. 1120, fols. 26v, 32, 35 (Troper, early eleventh century); Paris, Bibl. Nat., MS Lat. 5321, fols. 43, 101ᵛ (Lives of Saints, early eleventh century); Paris, Bibl. Nat., MS Lat. 740, fol. 179ᵛ (early eleventh century); Leiden, University Library, MS Voss. 8° 15, fol. 196v (early eleventh century), in G. Thiele, *Der illustrierte lateinische Aesop in der Handschrift des Ademar, Codex Vossianus lat. Oct. 15 fol. 195–205,* Leiden, 1905, pl. IV. From Moissac: Paris, Bibl. Nat., MS Lat. 2989 (early eleventh century). From Auvergne: Clermont-Ferrand, Bibl. Mun., MS 145, fols. 13, 19 (end of tenth century or ca. 1000), and MS 147, fol. 9 (ca. 1000). From the Lyons region: Paris, Bibl. Nat., MS Lat. 2460. More developed and complex ornament of the same foliate type appears in many manuscripts of the first half of the eleventh century from Burgundy, the Loire region, southern France, and Catalonia; cf. Paris, Bibl. Nat., MS Lat. 15176, fols. 73, 192, 195 (Bible from Cluny); Paris, Bibl. Nat., MS Lat. 17333 (Sacramentary from Nevers); Dijon, Bibl. Mun., MS 51, fol. 121; Leiden, University Library, Voss. 38 (Terence manuscript from Angers, see L. W. Jones and C. R. Morey, *The Miniatures of the Manuscripts of Terence,* Princeton [1930], Plates vol., figs. 15, 109, 153, 274): Orléans, Bibl. Mun., MS 44, fol. 62 (tenth century), MS 155, p. 1 (early eleventh century), MS 66, p. 113 (mid-eleventh century); Paris, Bibl. Nat., MSS Lat. 1954, 2385, 14301 (Marseilles); Paris, Bibl. Nat., MS Lat. 6 (the Roda Bible), etc.

The Moorish and Mozarabic forms that have been compared with the ornament of the Rodez and Gerona altars descend from the same Near Eastern Early Christian art as the Carolingian forms, but they are laid out more schematically and lack the luxuriance and freedom of movement characteristic of the Western examples, especially in the tenth and eleventh centuries.

22. See Edmond LeBlant, *Les Sarcophages chrétiens de la Gaule,* Paris 1886, pls. XXII (Rodez), XLI (Toulouse), XLIII, 2, XLVI, 1 (Narbonne); and J. B. Ward Perkins, "The Sculptures of Visigothic France," *Archaeologia,* LXXXVII, 1937, *pls.* XXXIV, 1, XXXV, 2, 3, 5, XXXVI, 5.

23. *. . . ex magno et candidissimo marmore, aram miro sculpturae opere caelatam* and *in circuitu altaris basim marmoream et quibusdam praeeminentibus caelaturis ornatam*; for this text and the inscription dated 890, see J. von Schlosser, *Schriftquellen zur Geschichte der karolingischen Kunst,* Vienna, 1896, pp. 234, 235.

24. The text has been published most recently by May Vieillard-Troiekouroff, "La Cathédrale de Clermont du Ve au XIIIe Siècle," *Cahiers archéologiques,* XI, 1961, pp. 210ff. Also significant for the continued practice of figurative sculpture in the tenth century is the destroyed marble altar table of Montrolieu (near Carcassonne), dated 948–81, with the four symbols of the Evangelists in medallions; it was reproduced by Mabillon, *Annales ordinis Sancti Benedicti,* 1706, III, p. 495, whose engraving has been copied in Hubert, *op. cit.,* p. 151, fig. 171.

25. By Bousquet (*La Cathédrale . . . ,* p. 136) who follows the views of A. Fikry on this type of capital form (*L'Art roman du Puy et les Influences islamiques,* Paris, 1934, pp. 148ff).

26. Cf. capitals at Toscanella (G. T. Rivoira, *Lombardic Architecture,* rev. ed., Oxford, 1933, I, fig. 183), Sta. Maria in Cosmedin, Rome (*ibid.,* fig. 184), S. Satiro, Milan (*ibid.,* fig. 243), S. Leo (*ibid.,* figs. 248–250), Flavigny (Hubert, *op. cit.,* pl. XXXVa), St.-Romain-le-Puy (R. de Lasteyrie, *L'Architecture religieuse en France à l'époque romane,* 2nd ed., Paris, 1929, fig. 142), Tournus (H. Focillon, *L'An mil,* Paris, 1952, pl. VIII), Souillac (G. Cany, "L'Eglise abbatiale Sainte-Marie de Souillac, sa Tour-Porche et sa Nécropole," *Bulletin monumental,* CIX, 1951, p. 393—a capital of the late tenth century). For the parallel development of this type in Ottonian and Romanesque German art, see G. Dehio, *Geschichte der deutschen Kunst,* 3rd ed., 1923, Plates vol. I, figs. 244 (Paderborn, early eleventh century), 251 (Quedlinburg), 265–68 (Brauweiler, etc.).

I cannot verify the reference of Bousquet, *op. cit.,* p. 136, to the profile of base moldings in Cordovan art.

27. Bousquet (*La Cathédrale . . . ,* p. 136) recognizes that the interlace comes out of Carolingian art, but speaks of the 'palmette' on these capitals as an Oriental addition.

28. A plaque with such ornament in the museum at Clermont-Ferrand, said to be from the abbey of St.-Allyre, is attributed to the late tenth century—see Vieillard-Troiekouroff, *op.cit.,* fig. 34 opp. p. 232.

29. From Moissac: Paris, Bibl. Nat., MS Lat. 17002, fol. 168v; Paris, Bibl. Nat., MS Lat. 2077, fols. 38, 45v, 119. From Limoges: Paris, Bibl. Nat., M: Lat. 1121, fol. 2 (possibly end of tenth century), and MSS Lat. 1254 and 909. From Auvergne: Clermont-Ferrand, Bibl. Mun., MS 147, fol. 197 (ca. 1000). In some South French manuscripts, of uncertain place of origin, both types of ornament found in Rodez—of the table and the capitals—occur, cf. Paris, Bibl. Nat., MSS Lat. 2787, 2817 (early eleventh century).

30. This connection had already been noted by Bousquet in 1937 ("Rodez . . . ," p. 148); he believed then that the portal was of the twelfth century. In 1948 (*La Cathédrale . . . ,* pp. 136, 137), when that part of the church of Conques was generally assigned to the middle of the century or the 1040s, he also compared the capitals of Rodez with others at Figeac and Aurillac attributed to the mid-eleventh century. These have similar profiles but are different in style of ornament, lacking the specific foliate structure and patterns of interlace found in both Conques and Rodez. A capital at Nant in Aveyron is closer to our type, but looks like a crude late copy, and is perhaps a modern restoration. Fikry reproduces several of the South French capitals of neighboring types, though not with the same motifs (*op. cit.,* pls. XLI, XLIII, XLVIII). See also Roger Grand, "La Sculpture et l'Architecture romanes à Saint-Géraud d'Aurillac," *Mélanges . . . Martroye* (Sociéte nationale des Antiquaires de France), Paris, 1941, 239–267, pls. X, XI, for capitals at Aurillac attributed to the first third of the eleventh century; they resemble those of Rodez in profile, but have another repertoire of ornament, more advanced perhaps.

31. See Bernoulli, *op. cit.,* p. 28, and for the capitals and portal, pp. 47, 48, 75. When the Abbot Odolricus died in 1065, the building was described as almost finished.

32. See Fikry, *op. cit.,* pl. XLIII, fig. 198; Mildred Byne Stapley, *La Escultura en los capiteles españoles,* Madrid, 1926, pl. 180; J. Gudiol Ricart and J. Antonio Gaya Nuño, *Arquitectura y Escultura románicas* (Ars Hispaniae, V), Madrid, 1948, pp. 17ff and figs. 10, 12. M. Gómez-Moreno, *El Arte arabe español hasta los Almohades, Arte Mozarabe* (Ars Hispaniae, III), Madrid, 1951, pp. 364, 365, dates the chevet in 958.

33. In the first Bible of Charles the Bald (Paris, Bibl. Nat., MS Lat. I) capitals with knotted interlace appear on the Canon Tables beside capitals with foliage (Omont, *op. cit.*, pl. XIV), and in the same manuscript are initials with interlace ending in plant forms (*ibid.*, p. 36). In manuscripts of the Franco-Saxon school, besides the foliate ends of interlace bands, there are buddings or quasi-foliate thickenings along the bands (Paris, Bibl. Nat., MS Lat. 2, see Omont, *op. cit.*, pls. 40, 43, 66, and Van Moé, *op. cit.*, pl. 6; Arras, Bibl. Mun., MS 1045, in A. Boinet, *La Miniature carolingienne*, Paris, 1913, pl. XCIIIa). Cf. also the manuscripts of the so-called Corbie-St.-Denis School (*ibid.*, pls. CXXXIVa, CXXXVIIIC, and A. J. Schardt, *Das Initial*, Berlin, 1938, p. 73); the foliate and budding interlace is very common in the Carolingian manuscripts of St. Gall, see *ibid.*, pp. 79, 81 (Folchart Psalter).

34. Possibly before 1000 is the plaque from St.-Allyre(?) in the Clermont-Ferrand museum (see n. 28 above); the Limoges Troper, Paris, Bibl. Nat., MS Lat. 1121, which is before 1029, might have been written in part, at least, at the end of the tenth century. On the other hand, this type of ornament continues throughout the eleventh century, cf. the manuscripts of Moissac and its school from the middle or the second half of the century: Paris, Bibl. Nat., MSS Lat. 1720 and 2293, and Nouv. Acq. MS Lat. 1871. There is an approach to this ornament in an English manuscript of the end of the tenth century or about 1000, the Bosworth Psalter (British Museum, Add. MS 37517), from Canterbury; see Talbot Rice, *English Art, 871–1100*, Oxford, 1952, pl. 57b.

35. This is not the same aesthetically as the overlapping bands and striped, checkered, and grooved backgrounds that in some Romanesque sculptures determine a single ground plane, cf. Porter, *op. cit.*, VIII, ill. 1274 (capital from St.-Pons) and V, ill. 557 (capital of Cuxa).

An interesting parallel to the Rodez form in painting is the figure of St. Augustine in an Italian manuscript of the early eleventh century in Florence, Bibl. Laur., MS XII, 21; he stands against a ground of alternately dark and light horizontal bands.

36. The flattened perspective schema of the book and footstool also come from painting; cf. the Christ of the First Bible of Charles the Bald (Pl. XV, 10) and of the S. Paolo fuori le mura Bible (Boinet, *op. cit.*, pl. CXXV b).

37. Cf. the Arca of S. Isidoro in León, the gold book cover in Essen, the reliquary of Begon, and the Lantern of St.-Vincent in Conques. On gold and silver altar frontals in France in the ninth and tenth centuries, see Braun, *op. cit.*, II, pp. 87ff.

In Rodez the squares and lozenges on the mandorla and globe, with their traces of incrusted color, recall the polychrome decoration of Romanesque buildings in regions not far from Rodez: Le Velay, southern Auvergne, the Lyonnais, and Hérault. Porter (*Art Bulletin*, VII, 1923, p.12) supposed that such treatment of the building surface came to this part of France from Constantinople; the facade of the Byzantine palace, Tekfour Serai, shows a similar use of color. Mâle (*Art et Artistes du Moyen Age*, 4th ed., Paris, 1947, pp. 56ff) and others (cf. Fikry, *op. cit.*, pp. 229ff) have pointed to Moslem Spain and North Africa as the source. A third possibility has not been sufficiently considered: Carolingian architecture, where such polychromy in simple geometrical patterns was widely used (cf. the Lorsch gateway and the Basse-Oeuvre at Beauvais). Perhaps a native Carolingian tradition, going back to Roman times, was the root of the Romanesque practice and prepared the way, in some instances, for the acceptance of the related Moslem and Byzantine forms in the eleventh century. Whatever the explanation, this kind of colored inlay is rare in sculpture. There is a parallel in a relief in Venice of a Byzantine emperor against a mosaic background; and nearer to Rodez the badly mutilated tympanum on the west transept portal of the Cathedral of Le Puy with a background of colored inlay with a geometrical pattern (Fikry, *op. cit.*, pl. XXXI, fig. 104). For the more specific design of the mandorla and globe in Rodez, with an ornament of lozenges and squares, there are parallels in Western images of Christ in Glory: the Bible in Angers Bibl. Mun. MS 3–4 (Boinet, *op. cit.*, pl. CLII, but eleventh century) and an ivory plaque in Berlin (Hanns Swarzenski, *Monuments of Romanesque Art*, Chicago [1955], pl. 67, fig. 155), also interesting for the iconography and the drapery forms of the Rodez Christ.

38. This has been noted by Bousquet, *La Cathédrale*, p. 140.

39. Boinet, *op. cit.*, pl. CXVIb.

40. Boinet, *op. cit.*, p. CXXVb.

41. The serrated hem above the lap of the Rodez Christ may be derived from the similar motif above the belly in a Carolingian Christ like the figure on the gold cover of the Codex Aureus in Munich; see Swarzenski, *op. cit.*, pl. 10, fig. 20.

42. The form is clearer in Koehler, *op. cit.*, pl. 73. The "spiral circle" occurs already in Early Christian art, and a work like the ivory carving in Berlin, with Christ, Peter, and Paul (W. F. Volbach, *Elfenbeinarbeiten der Spätantike und des frühen Mittelalters*, 2nd ed., Mainz, 1952, no. 137, pl. 42), shows what kind of sixth-century type was the basis, broadly speaking, of the Tours Christ. From the same Early Christian art in the Greek Near East probably descends the spiral circle of the belly in the ninth-century fresco of the dancers at Samarra, which are so Romanesque in appearance (see the collection of plates *Oriental Art*, O, Section IV: *Iranian and Islamic Art* [The University Prints], eds. R. Ettinghausen and E. Schroeder, Newton, Mass., 1941, pl. O-446).

43. For the possible religious or spiritualistic connotations of this centering at the belly in an image of Christ with the eucharistic wafer, cf. the painting by Pacino di Bonaguida, ca. 1345, of the strange communion of the apostles suspended around a central standing Christ from whose navel twelve tubes extend to the lips of the apostles (reproduced by R. Offner, *A Corpus of Florentine Painting*, New York, 1956, Section III, vol. 6, pp. 142ff). One might note also in this connection the contemplative practice of the Byzantine "omphalopsychoi" at Mount Athos (W. Roscher, "Neue Omphalosstudien," *Abhandlungen der philologisch-historischen Klasse der königlich sächsischen Gesellschaft der Wissenschaften*, XXXI, no. 1, Leipzig, 1915, pp. 11, 12). On the primitive idea of the navel as the seat of the soul, see also the fascinating book of R. B. Onians, *The Origins of European Thought About the Body, the Mind, the Soul, the World, Time and Fate*, 2nd ed., Cambridge [England], 1954, pp. 485–490.

44. To avoid confusion with Focillon's idea of a "law of the frame" governing Romanesque composition—an idea that I have criticized elsewhere ("Über den Schematismus in der romanischen Kunst," *Kritische Berichte zur kunstgeschichtlichen Literatur*, Zurich-Leipzig, 1923–33, pp. 1–21 [for the English text, see in this volume, pp. 271ff.])—it should be noted that we are dealing here with an inner "framework," distinct from the rectangle that encloses the entire page, and comparable to the canopy around the ruler in Imperial images. The effect of movement is not the outcome of a submission of bodily forms to a frame, but inheres in an independently conceived form. The Carolingian conception must also be distinguished from a solution like the Imago Hominis of the Echternach Gospels (Paris, Bibl. Nat., MS Lat. 9389); there the figure, reduced in a far-reaching, drastic way to an assembly of ornamental units, is immobilized not only through this reduction, but also by the lines of the frame which advance into the space of the figure and clamp it like a vise. The Insular form is significant for later art as an example of a free treatment of the frame, which is not a fixed conventional enclosure but a flexible form that intrudes into the pictorial field, and is itself no less active and articulated than the objects in the field.

45. For the conception of the figure as a rotating body, with spiral forms, cf. the falling Abel on the bronze doors at Hildesheim and the beautiful drawing of the figure on a wheel in Vatican, MS Reg. Lat. 12, fol. 901 (F. Wormald, *English Drawings of the Tenth and Eleventh Centuries*, London, 1952, pl. 27a). On the Bayeux Embroidery, the comet is drawn as a circle with diverging involuted tangents, like the schema in the Tours Bible.

46. As in two manuscripts of the tenth century from Trier: Koblenz, Staatsarchiv, Cod. 701 (A. Goldschmidt, *German Illumination*, New York, n.d., II, pl. 14a, and C. Nordenfalk in *Acta Archaeologica*, VII, 1937, p. 284, fig. 4); and Paris, Bibl. Nat., MS Nouv. Acq. Lat. 1542 (*ibid.*, p. 285, fig. 5).

47. On this manuscript see Goldschmidt, *op. cit.*, I, pl. 87, and A. Merton, *Die Buchmalerei in St. Gallen*, Leipzig, 1923, pp. 63ff. For a less schematic, more modeled conception in the tenth century, cf. the drawing of Christ in Kassel, MS Theol. fol. 60 (Goldschmidt, *op. cit.*, I, pl. 81). There is also in Kassel a curious example of the nodal and circular motifs of the body and the emblems in a figure of Aesculapius: Landesbibliothek, MS Phys. fol. 10 (*ibid.*, I, pl. 19a, tenth century, perhaps Fulda). Nearer to Rodez geographically and interesting for the many similar elements is the ivory cover in Dôle (Jura) attributed to the tenth century, cf. Goldschmidt, *Die Elfenbeinskulpturen aus der*

Zeit der karolingischen und sächsischen Kaiser, Berlin, 1914, I, pl. XV, nos. 28–30. Cf. also the ivory carving cited above, n. 37, in Berlin.

48. On this manuscript, see E. T. DeWald, "The Art of the Scriptorium of Einsiedeln," *Art Bulletin*, VII, 1925, pp. 85, 86; also pl. LXIV, fig. 36, for another drawing in the same manuscript. Closer to the French Carolingian sources is the painting of Christ in Einsiedeln MS 156 (Gregory on Ezekiel), *ibid.*, pl. LXIII, fig. 29.

49. The drawings of the Evangelists and their symbols on the Canon Tables of the tenth-century Bible from Le Puy (Paris, Bibl. Nat., MS Lat. 4, VOL. II, fols. 135–137) are slight, sketchy copies of a Northern work and have more interest as examples of the persisting Carolingian tradition in the tenth century than as evidences of a new development of a native South French art.

50. A. Katzenellenbogen (*Allegories of the Virtues and Vices in Mediaeval Art*, London, 1939, p. 11) dates the drawings too late, "end of the 11th century." The script seems to me earlier and the ornament is close to Paris, Bibl. Nat., MS Lat. 1121 from Limoges, which is before 1029 and possibly before 1000.

51. Cf. especially the "notebook" in Leiden, University Library, Voss. lat. 8°15, in R. Stettiner, *Die illustrierten Prudentiushandschriften*, Berlin, 1905, Plates vol., pls. 24–29, and especially pls. 27–29.

52. Clermont-Ferrand, Bibl. Mun, MS 145, fols. 6, 77, 130v.

53. It may be dated through the similarity, if not identity, of the handwriting with that of the scribes of Paris, Bibl. Nat., MS Lat. 9518, in which verses name Halinardus, the abbot of St.-Bénigne of Dijon between 1031 and 1046, as the donor of the book.

54. Clermont-Ferrand, Bibl. Mun., MS 145, fol. 77. The identical gesture appears also in an Anglo-Saxon manuscript of the early eleventh century, Cambridge, Trinity College Library, MS B. 10. 4, in E. Millar, *English Illuminated Manuscripts from the Xth to the XIIIth Century*, Paris-Brussels, 1926, pl. 15.

55. On fols. 38, 45v, 119. See also n. 29 above.

56. Cf. Paris, Bibl. Nat., MSS Lat. 1121 (from Limoges) and 17002 (from Moissac); in the latter, this ornament appears beside the types found in Limoges manuscripts of the second half of the tenth century (Paris, Bibl. Nat., MSS Lat. 5 and 5301).

57. For all the above and for references, see my article "Two Romanesque Drawings in Auxerre and Some Iconographic Problems," *Studies in Art and Literature for Belle Da Costa Greene*, Princeton, 1954, pp. 331–349, especially p. 344 on the Gerona manuscript, and p. 338, n. 35. [Reprinted in this volume pp. 314, 322, n. 35.]
In the Gerona Beatus a gold book is at the eagle's head, placed like a square halo, and the object at the eagle's claws may be a cushion, since it rests on the chair. But the confusion of halo and book, scroll and cushions, seems to me to betray the copying of an unfamiliar French model in which the eagle held a scroll in its claws.

58. It was introduced in Carolingian art in the image of Christ in heaven as an affirmation of the real presence, I suppose, after the treatise of Paschasius Radbertus, *De Corpore et Sanguine Domini* (831), just as in the Drogo Sacramentary and later works the figure of Christ was inserted over the dove in the traditional image of the Pentecost to affirm the *filioque* against the doubters.

59. Manuscripts of Paschasius' text on the eucharist must have been extremely rare in Spain to judge by the unique (and not even certain) mention of it among the numerous mediaeval and later catalogues collected by R. Beer, *Handschriftenschätze Spaniens*, Vienna, 1894, p. 455, no. 19, and this in a catalogue of the thirteenth century from Silos, long after the introduction of the French rite and other practices in the Castillian monasteries. On the other hand, a tenth-century copy of the Paschasius text from Le Puy is preserved in Paris, Bibl. Nat., MS Lat. 2855, bound with the famous manuscript of Ildefonsus in Visigothic script, written in 951. The same work of Paschasius was transcribed in the Moissac manuscript, Paris, Bibl. Nat., MS Lat. 2077, fols. 124–140v. That the meaning of the eucharistic sacrament, debated by Paschasius and Ratramnus in the ninth century, was still a controversial issue in the tenth century, appears from the writings of Ratherius, a bishop of Verona in the 950s. He was a native of the Mosan region and had also lived in Provence. See Migne, *Pat. lat.*, CXXXVI, 42, 443A. I must, therefore, modify my statement in the article cited above in n. 57, which would limit the interest in the problem to Berengar's time.

60. The error of treating or interpreting the wafer as the world globe also occurs in southern France on the Lantern of St.-Vincent in Conques and on the tympanum of Bourg-Argental (Loire). But it is also found in a Carolingian manuscript—Paris, Bibl. Nat., MS Lat. 269—which was later preserved in Limoges.

In an article by E. Delaruelle, " 'Le Christ élevant l'Hostie' de la Cathédrale de Rodez, ses Parallèles et son Interprétation," *Congrès de Rodez* (Fédération des Sociétés savantes Languedoc-Méditerrané et Languedoc-Pyrénées), June, 1958, pp. 193–202, an article that I know only through the summary in *Cahiers de la Civilisation médiévale*, IV 1961, p. 93, the author argues that the disk in Christ's hand is not a host but a globe, derived from pagan Roman triumphal images of the emperor. He seems to be unaware of the evidence presented in my article and by other writers.

61. W. Neuss (*Die Apokalypse des hl. Johannes in der altspanischen und altchristlichen Bibel-Illustration, Münster* i.W., 1931, p. 24) has suggested a possible origin of the manuscript in Catalonia. It would be interesting because of the close relations of Rodez and Gerona in the tenth and eleventh centuries, but the argument is unconvincing.

62. Werner Goldschmidt ("Toulouse and Ripoll. The Origin of the Style of Gilabertus," *Burlington Magazine*, LXXIV, 1939, pp. 104–110) is mistaken, I believe, in grouping the lintel of St.-Genis with such works as the reliefs of Split, Zara, Quintanilla, and Játiva, and speaking of them all as late decadent revivals of Hellenistic art comparable to the work of Gilabertus.

63. For the Moorish parallels, cf. Gómez-Moreno, *op. cit.*, figs. 328 (Seville), 329, 330 (Játiva marble basin). See also his remarks on the Byzantine and Moslem affinities of St.-Genis in *El Arte románico español*, Madrid, 1934, pp. 36, 37.

64. Porter, *Romanesque Sculpture* . . . , v, ills. 514, 515, 517, 518; G. Gaillard, *Premiers Essais de Sculpture monumentale en Catalogne aux Xe-XIe Siècles*, Paris, 1938; Gudiol Ricart-Gaya Nuño, *op. cit.*, pp. 20ff. Cf. also the reliefs in the cloister of Ripoll from the church dedicated in 1032, in Gómez-Moreno, *El Arte románico* . . . , pl. XLV.

65. See W. Neuss, *Die katalanische Bibelillustration um die Wende des ersten Jahrtausends und die altspanische Buchmalerei*, Bonn-Leipzig, 1922, fig. 6, 15, 90, 94, 124, 149, 193.

66. Is it far-fetched to note the resemblance of the half-circles around Isarn's head and feet to the twin circles framing the Christ of Rodez? Is there not in this great tombstone an effort to sacralize the Abbot's effigy by forms that suggest the image of Christ in heaven? I am aware that a prototype of the Isarn relief has been found in Gallo-Roman art (see Jean Adhémar, *Influences antiques dans l'Art du Moyen Age français*, London, 1939, p. 236, figs. 87, 88), but on the Roman tomb at Saulieu in Burgundy, where the epitaph is inscribed on a slab across the upper part of the figure, precisely this element of the twin half-circles is missing. On the other hand, in a Provençal manuscript of the eleventh century from Montmajour (the Lectionary in Paris, Bibl. Nat., MS Lat. 889), the full-page figure of Isaiah (fol. 6) is set in a framework of circles and half-circles suggesting the reliefs of Rodez and Marseilles.

67. See *Acta Sanctorum*, September, VI, p. 738: ". . . he used to walk among the tombs of the martyrs and was possessed by a desire to know everything about them; he persistently questioned the few brothers who had begun to live there according to the rule in the recently restored monastery."

68. Cf. the folds of Isarn's hem with those of Castitas in Paris, Bibl. Nat., MS Lat. 2077, fol. 173 (Fig. 16).

69. There was perhaps a persisting tradition of funerary sculpture in this region, if we can trust the account of a raised tomb in the Cathedral of Castres with a figure of the defunct inscribed with the date 800. It was of a Prince Beru (nephew of the Moslem ruler of Barcelona) who was converted by the prior of the Abbey of Castres and died there. See E. Martène and U. Durand, *Voyage littéraire de deux Religieux bénédictins de la Congrégation de Saint Maur*, Paris, 1717, II, pp. 49, 50.

70. See V. Terret, *La Sculpture bourguignonne aux XIIe et XIIIe Siècles, ses Origines et ses Sources d'Inspiration: Cluny*, Autun-Paris, 1914, pl. L.

71. The Abbot Odilo (994–1049) was a native of Auvergne, and members of his family held high posts in the churches of that region. See E. Sackur, *Die Cluniacenser in ihrer*

kirchlichen und allgemeingeschichtlichen Wirksamkeit bis zur Mitte des elften Jahrhunderts, Halle a.S., 1892, I, pp. 300ff, II, pp. 57ff. For the relations of Cluny and Auvergne, *ibid.,* I, pp. 85ff, 90, 208.

72. *Romanesque Sculpture* . . . , I, pp. 71–108.

73. The technical refinement of Byzantine marble relief sculptures of the tenth and eleventh centuries, e.g., the great orant Virgin in the Istanbul Museum (Ch. Diehl, *Manuel d'Art byzantin,* 2nd ed., 1926, II, p. 652, fig. 315), which recalls the delicate relief of the Rodez Christ, is a suggestive parallel that deserves further study. For the colored fillings in the relief of Rodez, one should also look into the Byzantine use of gold and silver and colored incrustation with sculptured marble, as on the destroyed tomb of the Emperor John I Zimisces (†976) in the Church of the Chalke in Istanbul, and on the surviving marble reliefs with colored fillings from St. Mary Panachrantos (Rice, *op. cit.,* p. 108, fig. 10), and the plaque with apostles in the Byzantine Museum at Athens, no. 150 (*ibid.,* p. 109, fig. 11). Such works may have been the ground of the Western practice, as in the destroyed tomb of St.-Front in Périgueux, with sculpture and colored inlay, made 1077–81 by Guinamandus, a monk from La Chaise-Dieu in Auvergne (*Bulletin archéologique,* 1904, p. 95; V. Mortet, *Recueil de Textes relatifs à l'Histoire de l'Architecture,* Paris, 1911, pp. 242, 243). Fragments survive in the museum at Périgueux. On the use of colored inlay, see also n. 37 above.

74. *Ibid.,* p. 128.

75. I have profited in this paper by discussion at the Congress, especially with Louis Grodecki, and have shifted the dating of the relief from the period around 1000 (which I had proposed in an article in 1954, "Two Romanesque Drawings in Auxerre and Some Iconographic Problems," *Studies in Art and Literature for Belle Da Costa Greene,* Princeton, 1954, p. 343, n. 64 [reprinted in this volume, p. 325, n. 64]) to the second quarter of the eleventh century.

Two Romanesque Drawings in Auxerre and Some Iconographic Problems

(1954)

THE historian Maurice Prou published in 1887 two drawings in the treasure of the cathedral of Auxerre which since then have often been cited in writings on mediaeval art.[1] One represents the Crucifixion, together with scenes from the Passion and Resurrection (Fig. 2), and the other, the Apocalyptic vision of Christ and the Twenty-four Elders (Fig. 3). Prou recognized that they were illustrations from a Missal and had belonged with the text of the Preface and Canon of the Mass. He assigned the drawings to the first half of the twelfth century but was unable to place them in a particular region—although he did not fail to note a resemblance to the tympanum of Moissac in the conception of the Elders. In 1922 Emile Mâle reaffirmed this similarity and from a more detailed observation deduced a place of origin of the two leaves and also drew some far-reaching conclusions about the relation of Romanesque monumental sculpture to mediaeval miniatures.[2]

"These drawings," he wrote, "as the following will show us even more clearly, come from the south. The Christ in Majesty, surrounded by the twenty-four seated Elders bearing viols and cups, could have been copied only from a manuscript of Beatus. A little detail will remove all doubts. The eagle at Christ's left carries in his claws not a book, like the other beasts of the Evangelists, but a roll. Now this peculiarity occurs also in the Apocalypse of Saint-Sever (Fig. 1) and on the tympanum of Moissac, and is found nowhere else; by itself alone it would suffice to connect the Auxerre leaf with the Beatus group. There were then manuscripts of the Apocalypse that showed Christ as we see him at Moissac; for, between the tympanum of Moissac and the page in Auxerre the resemblance is almost complete."[3]

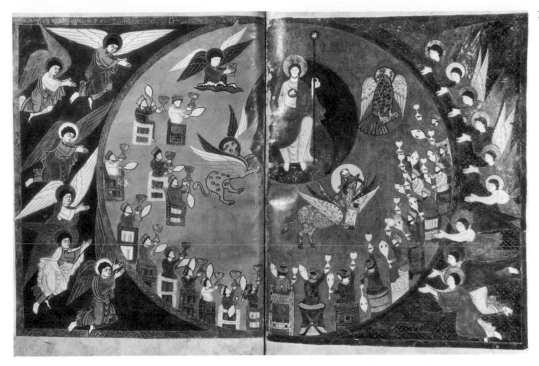

Fig. 1. Commentary of Beatus on the Apocalypse, from Saint-Sever: Vision of Christ and the Twenty-four Elders; Paris, Ms. Lat. 8878, fs. 121v–122. *By permission of the Bibliothèque Nationale*

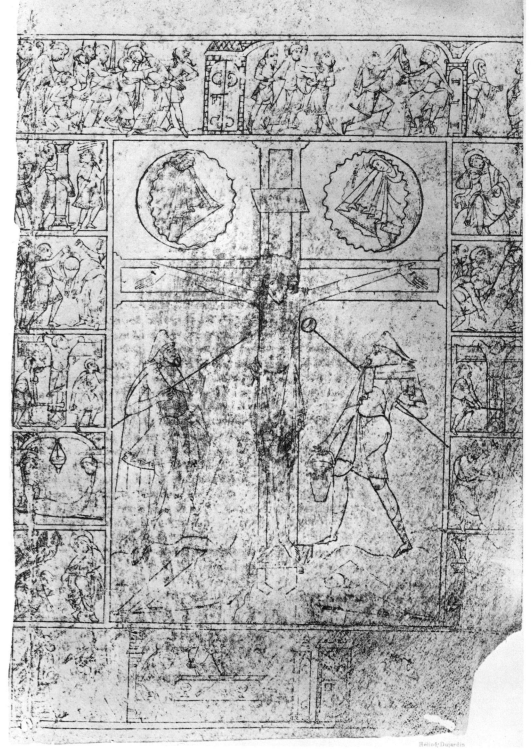

Fig. 2. Auxerre Cathedral; Drawing from Missal: Crucifixion; Scenes from Passion and Resurrection. *By permission of the Cathedral*

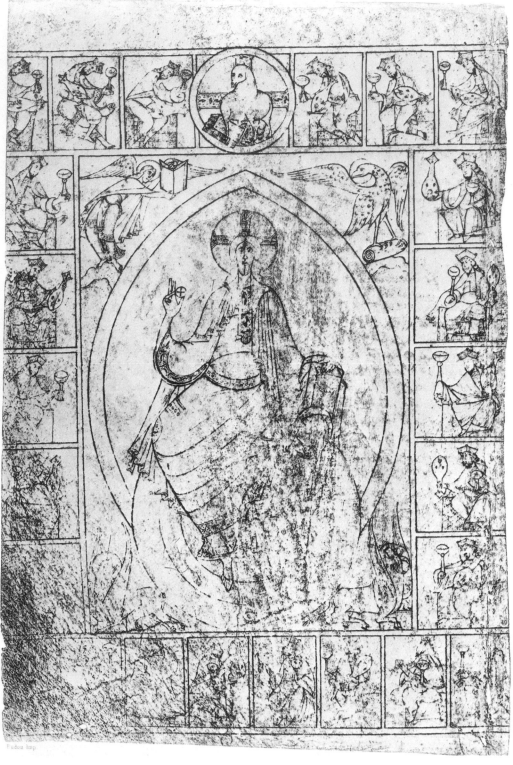

Fig. 3. Auxerre Cathedral; Drawing on Vellum Leaf: Christ in Majesty; the Twenty-four Elders Adoring the Lamb. *By permission of the Cathedral*

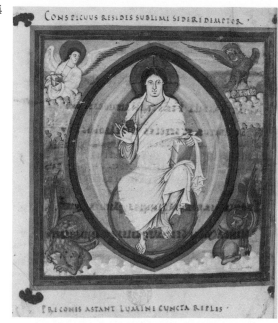

Fig. 4. The Dufay Gospels: Christ in Majesty; Paris, Ms. Lat. 9385. *By permission of the Bibliothèque Nationale*

Fig. 5. Limoges, Enamel Plaque: Christ in Majesty. *By permission of the Walters Art Gallery*

Fig. 6. Bible of Charles the Bald: Christ in Majesty with Evangelists and Prophets; Paris, Ms. Lat. 1. *By permission of the Bibliothèque Nationale*

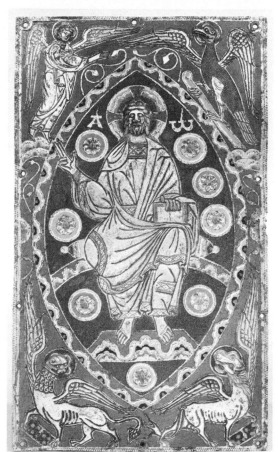

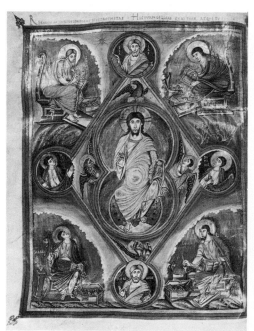

The "little detail," however, raises serious doubts. Far from being a rare element limited to the Beatus manuscripts and a few works copied from them, it is extremely common; it appears even on several portals reproduced by Monsieur Mâle in the same book and overlooked by him.[4]

The eagle with the unique roll is well known in French Carolingian art, chiefly in the school of Tours[5] (Fig. 4) and in centers which have been influenced by it.[6] In the twelfth and thirteenth centuries the roll is usual, not exceptional, in Limousin enamels of Christ in Glory (Fig. 5).[7] The concentration of this detail in French monuments[8] is so striking that one may reasonably conclude that the non-French examples[9] ultimately stem from French Carolingian or Romanesque works. It occurs not only in images of Christ surrounded by the four symbols, but also in isolated images of John and the eagle where there is no Apocalyptic sense.[10]

Why should the eagle alone among the four symbols bear a roll instead of a codex in so many renderings of Christ in Majesty and the Apocalyptic vision?

It could hardly have been an aesthetic adjustment to the claws of the eagle, as one eminent scholar has supposed.[11] The artists of the early Middle Ages, who were surely as much concerned with theological correctness as with nature and art, would not have changed a canonical attribute because of its incongruence with the form of a bird. There are enough examples of the eagle with the book[12] in Carolingian art and of all four symbols with rolls in Carolingian and later styles,[13] which are sufficiently sensitive to aesthetic and naturalistic requirements, to discredit this explanation. In a manuscript of Tours even a lamb is shown with a roll instead of the usual book, in spite of the "unaesthetic" relation to the feet of the lamb.[14]

More likely, the unique substitution of the roll for the codex in the eagle's claws had a religious significance. It suggests at first thought the prophetic aspect of John, his presumed authorship of the Apocalypse. In a Sacramentary of about the year 1000 in Ivrea, in a drawing of a group of saints, the distinctive sign of John is the roll, and the inscription beside him reads: "vaticinatio vel domini gratia."[15] This phrase, designating John as prophecy or God's grace, is taken from Jerome's Interpretation of Hebrew Names,[16] which is so often included in manuscripts of the Bible. The eagle's roll would agree then with the current attribution of rolls to Prophets (as in the wall paintings of S. Angelo in Formis, Reichenau, and Saint-Savin) and of codices to Evangelists and Apostles[17] (Fig. 6), a distinction that corresponds to the historical development of the form of the book from roll to codex. For Durand, a thirteenth-century writer on symbolism and ritual, this distinction expresses the difference between the incomplete or imperfect knowledge possessed by the men of the Old

Law and the perfect knowledge that came with the New.[18] But this hardly applies to John; for if the prophetic sense of the Apocalypse and the proposed Hebrew etymology of his name might warrant for him a symbol shared by the Prophets of the Old Testament, it is incompatible with the mediaeval conception of John's superiority as an Evangelist.

This contradiction should not disturb us. A religious symbol, like an ordinary word, can mean different things according to the context. Since the eagle's roll singles out John as somehow unique among the four Evangelists, it probably conveys the special theological and mystical character of the fourth Gospel more than the prophetic aspect of the Apocalypse. In attributing both the fourth Gospel and the book of Revelation to the beloved disciple, Christian tradition placed him above the other Evangelists.

Of the four, John alone has what might be called a "natural" symbol. He is the eagle in an apter, more personal sense than Mark is a lion or Matthew a man and is more often referred to directly as an eagle than are the others as lion, man, or ox. John flies, soars to heaven, looks at the sun, and reveals the divine nature of Christ. The others are terrestrial and speak of Christ's human nature.

John's sublimity as an Evangelist was a common topic of Carolingian thought. In a homily by the greatest Carolingian thinker, John the Scot (Eriugena), enthusiasm for the Evangelist reaches a climax of rapture. The author of the fourth Gospel is admired as more than human. Transcending himself and all being, he is truly divine: "non enim aliter potuit ascendere in Deum, nisi prius fieret Deus."[19] Already before Eriugena, the notion of John's superiority had been expounded at length by Alcuin, the abbot of Saint-Martin in Tours, where the symbol of the eagle's roll seems to have been developed first:

> And among the writers of the Evangiles the blessed John is surely the most eminent in depth of insight into the divine mysteries. . . . Beyond doubt he intended especially to show the divinity of our Lord Jesus Christ in which he is equal to the Father. . . . And so he is elevated far before the three other Evangelists; these you see, as it were, on the earth conversing with the human Christ, while him you see mounting above the cloud which covers the entire earth and reaching the liquid light of heaven where he beheld, with a most acute and powerful mind, the Word in the beginning, God issuing from God, light from light. . . . And if there are other facts that intimate the divinity of Christ and his equality to the Father, John alone has set them forth fully, as if he were drinking the secret of Christ's divinity in private and abundantly from the very breast of the Lord on which he reclined at the last supper. . . .
>
> For this reason, he is rightly compared to the flying eagle in the

image of the four beasts; indeed, of all the birds, the eagle flies highest and, of all living creatures, he alone dares to fix his gaze on the rays of the sun. The other Evangelists walk upon the earth, as it were, with the Lord; expounding both his generation in time and his temporal deeds, they say little about his divine nature. But John flies up to heaven with the Lord and in speaking of his temporal acts recognizes also the eternal power of his divinity through which all things are made, his mind in lofty flight and limpid speculation, and by his writing transmits to us what we should know. . . .[20]

These ideas about John are not Alcuin's creation. They are taken almost literally from Augustine[21] and Bede,[22] who depend in turn on earlier Greek thought. But it was Alcuin, I believe, who transmitted to the Carolingian world this older sentiment about John's sublimity and prompted the distinction of John's symbol through the roll in Carolingian art. Alcuin's interest in John was a personal devotion since his early youth in England, when he learned the fourth Gospel in school. His biographer tells how Alcuin, while reading the text before his teacher and fellow pupils, experienced a mystical rapture. "When he came to that portion which only the pure in heart can understand, from the passage where John speaks of himself reclining on the Lord's breast to the place where he tells how Jesus went out with his disciples across the brook Cedron, Alcuin was intoxicated by the mystical reading; sitting before his master's couch, he was carried away in an ecstasy of the spirit" and had a strange vision of the world as an enclosure (like a sheepfold) encircled by Christ's blood.[23]

Before Alcuin's time the Gospel of John enjoyed a special cult in England and Ireland. It was copied there as a separate book detached from the others. An example has been preserved from the tomb of the great Northumbrian saint, Cuthbert;[24] another is bound with the Stowe Missal in Dublin.[25] Of all the Gospels, Bede chose John's for translation into Anglo-Saxon. In the portraits of the Evangelists in the Lindisfarne Gospels (*ca.* 700), John alone does not write, but sits in an attitude of contemplation; and in a later colophon of that manuscript, where the sources of the Gospels are named, Matthew is said to have written from Christ's words, Mark from Peter's, Luke from Paul's but John from direct inspiration by the Holy Spirit.[26]

Like much else in Carolingian art, the vogue of John comes perhaps from insular tradition. However, in France in the ninth century the enthusiasm for John apparently was also stimulated by the renewal of theology. In the singling out of the author of the fourth Evangel, there is a possible connection with the dogmatic controversies of the time. Alcuin himself took part in the struggles over adoptionism and the *filioque* for-

mula (the issuance of the Holy Spirit from both Father and Son), for which the testimony of John was believed to be decisive. But beyond these particular factors, we observe in Carolingian art itself a quality of restless, excited being, a pervading exaltation—especially visible in the images of the Evangelists—of which the conception of John as the loving disciple and the aspiring, visionary mind is a true counterpart.

We may ask, also—without offering a positive answer—whether in the attribution of the roll to the eagle old values of these symbolic objects still operated. In ancient tradition both the eagle and the roll pertain to the celestial.[27] Isaiah (34:4) and the author of the Apocalypse (Revelation 6:14) speak of heaven as a roll.[28] It was a sign of divinity in a stronger sense than the codex, the roll having served as an attribute of the Roman emperor[29] and later of Christ, long after the codex had become the standard form of the book. At one time *logos* meant the roll.[30]

Before the roll was used to distinguish John, at least three other devices had that function in the art of Tours:[30a]

(1) Where the four symbols are set in a lozenge around Christ, the eagle is at the top.[31]

(2) Where all four figures carry codices, only the eagle's is open (Fig. 6).[32]

(3) In the oldest surviving set of portraits of the Evangelists from Tours, in a Gospel manuscript in Stuttgart written under the rule of Alcuin's disciple, Fridugisus (807–834), all four symbols have rolls, but these rolls are uncolored except the eagle's, which is sky blue.[33] Even more remarkable here is the image of the Evangelist (Fig. 7). John alone does not write; he is shown instead seated on a globe, in a posture of teaching, much like Christ in heaven. This altogether exceptional portrait of John—apparently never copied in the later manuscripts of Tours—is no caprice of the artist or accidental confusion with a picture of Christ. It anticipates Eriugena's daring assimilation of the Evangelist to God. The teaching posture may be explained by a tradition quoted by Alcuin while he was abbot of Tours. In the letter prefacing his Commentary on John, Alcuin writes that John not only surpassed the other Evangelists in the profundity of his insight into the divine mysteries, but differed from them also in his method of teaching. Whereas they taught by their writings, John until almost the end of his life preached the Gospel by pure word of mouth: "from the time of the passion, resurrection and ascension of the Lord to the end of Domitian's reign, for nearly sixty-five years, he preached the Word of God without any written aids."[34]

Whatever the reasons for the final adoption of the eagle's roll, it is surely not limited to the three examples noted by Mâle, nor is it typical of the twenty-odd Beatus manuscripts. On the contrary, the instance in

the Beatus of Saint-Sever is exceptional; Mâle could cite no other example in the early manuscripts of Beatus. I have not found a single Beatus miniature of the vision of Christ and the four symbols earlier than the Beatus of Saint-Sever (about 1060), in which the eagle clearly bears a roll and the other creatures, books.[35] In certain Mozarabic manuscripts of the tenth century, with other texts, all four are sometimes shown with rolls,[36] but this is not in essence the symptomatic detail on which Mâle has built his theory.

As for the manuscript of Saint-Sever, it is exceptional among the early copies of the Beatus Commentary in three important respects. It is the only one which is not of Spanish origin.[37] Of all the Beatus manuscripts of the eleventh century, it is unique in its substitution of the French for the Visigothic script, which in the late eleventh century was replaced by the former throughout western and central Spain.[38] And this difference of script is accompanied by as marked a difference in the style of painting. It is not "Mozarabic," like the other early copies, but is closer to the style of Aquitaine and western France. Professor Neuss, who has attempted the only comprehensive study of the illustrations in the Beatus manuscripts, recognized the stylistic uniqueness of the miniatures of Saint-Sever among all the others.[39] But he undertook no study of the qualities of these paintings and explained their exceptional and surprising naturalism by the copying of the pre-Moorish models of the original Beatus cycle, presumably a work of "Hellenistic" style.[40] Ignoring the Romanesque art of Aquitaine in the eleventh century, he overlooked the many traces of local regional character in these miniatures of Saint-Sever. The remarkable un-Mozarabic mobility of the figures—it reminds us of the choice of *agilitas* as the distinguishing trait of the Gascons in an inventory of the vices and virtues of the people of Europe in a Romanesque manuscript from neighboring Maillezais[41]—their activism and energy, are not so much Hellenistic as Romanesque qualities which were intensively cultivated in the South French art of this period. A comparison of the style of painting of the Saint-Sever Beatus with the style of such manuscripts as the *Life of Saint Radegund* in Poitiers[42] and various books produced in Limoges[43] would confirm the local, native character of the Beatus of Saint-Sever. The name of the artist, Stephen Garsia, should not mislead us on this point; it is no more Spanish than Gascon. Few names appear so frequently in the documents of Saint-Sever as Garsia.[44] In the thirteenth century, an abbot Garsia ruled over the monastery.[45]

Hence, if the drawing of Auxerre and the tympanum of Moissac resembles a Beatus miniature, it is a French miniature which is little characteristic of the Beatus cycle. Not only the detail of the eagle's roll, but the larger conception of the vision of Christ in Glory among the Twenty-four Elders deviates from the usual aspect of this scene in the preceding Beatus

manuscripts and agrees with French Carolingian and Romanesque versions.[46]

The circular arrangement of the Elders, very different from the horizontal banded composition of the great Roman mosaics, occurs earlier in the *Codex Aureus* in Munich, a Gospel manuscript executed in 870 in northern France.[47] Here the Elders adoring the lamb are bearded figures, as in Auxerre and Moissac and Saint-Sever, and unlike the beardless *seniores* of the Mozarabic Beatus miniatures. The circular grouping has been explained as a transposition of a concave image of the Elders—there was such a mosaic on the dome of Charlemagne's chapel in Aachen[48]—to the plane surface of a page. But the circle of Elders in the *Codex Aureus* also retains a depth more or less faithful to the Apocalyptic vision of the Elders around the throne of God, *in circuitu sedis* (Revelation 4:4). In the Mozarabic manuscripts all intimation of depth has disappeared. We have only a schematic *plan* of the vision; the Elders are drawn more primitively, in an "Egyptian" manner, as the radii of the circle.[49] In the Carolingian and Romanesque versions, no matter how simplified, the Elders sit up vertically in a circle (or segment of a circle) as if beheld face to face by the spectator. The three-dimensional "perspective" form in the painting of Saint-Sever, more than any other Romanesque example, agrees with Carolingian taste. The artists of the ninth century had produced a similar convex grouping in the related themes of the Pentecost and Ascension,[50] which throughout the Middle Ages were most often conceived as if all the participants were on a single plane. The drawing of Auxerre, with its typically post-Carolingian conversion of the aroundness-in-depth into a closed group in one plane on the surface of the image, is nearer to the stratified tympanum of Moissac than either is to the painting of Saint-Sever. The latter, created by an artist of extraordinary realistic imagination in suggesting movement and a space adequate to the agile figures, unexpectedly revives (or recreates by an independent leap) the old Carolingian form; arranged in depth, some of the Elders are seen from behind, and the whole grandiose composition exhibits a precocious freedom of spacing.[51] The drawing of Auxerre, on the other hand, is closer to Carolingian images of Christ in Majesty, like the one in the *Codex Aureus* (Fig. 8), in its rich compartmenting of the field; but it is more characteristically Romanesque in the rigid, clearly systematized, regular architecture of the page. This systematic, constructed form is a common feature of French, if not European, art at the end of the eleventh century. It penetrates all aspects of design. We see it in the drawing of the single figures, in the costume and folds, in the clearly marked parallel, concentric and radial lines, in the accented mannikin articulation of the active bodies. It gives a rational, analytic savor to the style.

* * *

7

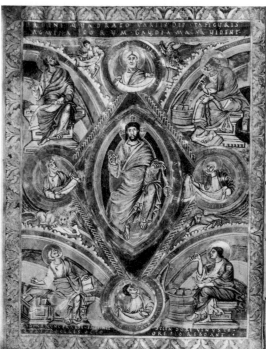

8

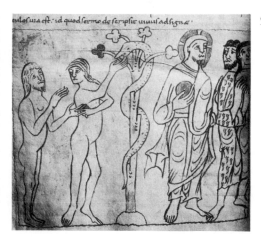

9

Fig. 7. St. John the Evangelist;
Stuttgart, Ms. HB.II.40.
*By permission of the
Württembergische Landesbibliothek*

Fig. 8. Codex Aurens: Christ in
Majesty; Munich, Clm. 14000, f.
6v. *By permission of the Bayerische
Staatsbibliothek*

Fig. 9. Halitgarius, On the Vices
and Virtues: The Fall and Expulsion;
Paris, Ms. Lat. 2077, f. 162v.
*By permission of the Bibliothèque
Nationale*

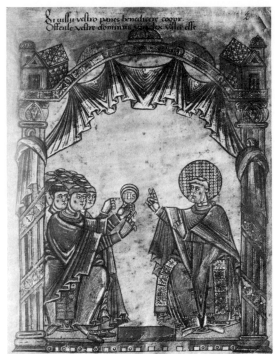

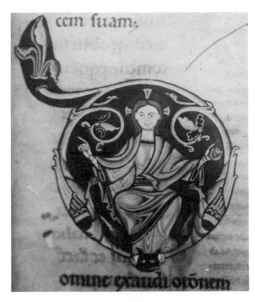

Fig. 10. Scenes from the Life of
St. Aubin; Paris, Ms. nouv. acq. Lat.
1390, f. 2. *By permission of the
Bibliothèque Nationale*

Fig. 11. Psalter with Commentaries;
Tours, Ms. 93, f. 134. *By permission
of the Bibliothèque Municipale*

Fig. 12. Augustine, Commentary on
the Psalms; Tours, Ms. 294, f. 1.
*By permission of the Bibliothèque
Municipale*

The connection of the Auxerre drawing with Carolingian art is supported by another interesting detail: the tiny disk in Christ's right hand. This, too, is found in Carolingian miniatures of Tours (Figs. 4, 6) and of the schools which have borrowed from it (Fig. 8).[52] In the later eleventh and twelfth centuries the disk appears in other images of Christ in the Loire region: a miniature from Rennes,[53] a wall painting in the church of Parçay,[54] and miniatures in several manuscripts in the municipal library of Tours.[55] The Christ of Parçay is in other respects remarkably like the Christ in the drawing at Auxerre.

The meaning of the disk is not clear. It has been interpreted as the globe symbolizing the world dominion of Christ,[56] but also as the eucharistic Host.[57] During the period of the Carolingian empire, which was so familiar with the globe as a symbol of imperial power, is it likely that an artist working for Charles the Bald would have rendered it as a thin unsubstantial disk set between the thumb and one finger? In the Carolingian and Ottonian representations of the emperor, the globe of power is a massive sphere, usually carried in the palm of the left hand, an unmistakable imperial *insigne*.[58] Since the sixth century the orb had been shown in this way on Byzantine and western coins. That is also how it appears in the celebrated bronze statuette of the equestrian Carolingian ruler, perhaps Charlemagne, of the Musée Carnavalet.[59] When the Ottonian artists wished to represent Christ as a supreme power at whose feet kneel the emperor and his wife, they placed the same large sphere in the palm of his left hand, as we see on the resplendent gold altar frontal from Basel in the Musée de Cluny.[60] In a drawing of the Lord expelling Adam and Eve from Paradise in a manuscript of the eleventh century from Moissac (Fig. 9),[61] he carries a large yellow globe in his right hand.

Beside these undoubted world spheres, the little disk held between the thumb and fourth finger of the blessing right hand of Christ in the Carolingian paintings requires another interpretation. The manner of holding the disk between the two fingers recalls mediaeval representations of the eucharistic rite in which the priest holds the consecrated wafer delicately and ostensively between his thumb and the index or middle finger. There is a painting of the eleventh century from Angers, in a series of scenes from the life of Saint Aubin, where we can observe directly the relation of the disk in the images of Christ to ritual and theological ideas. A set of wafers—the outer one is inscribed IHS—is held between the fingertips of an evil monk who compels the unwilling saint to bless them (Fig. 10).[62] In a Sacramentary from Saint-Denis, in a painting of the last communion of the martyr, Christ offers him the Host with this very gesture.[63] It is precisely the position of an isolated hand exposing the tiny wafer in the initial V of the *Vere Dignum* of the Preface of the Mass in a Carolingian

Sacramentary in Tours.[64] The eucharistic controversy of that time would account for the presence of this detail in Carolingian images of Christ in Glory. The treatise of Paschasius Radbertus on the body and blood of Christ (*ca.* 830) precedes all the known examples.[65]

The problem of the meaning of the disk would not have arisen, had not some later artists interpreted the Carolingian models in a new way. On an ivory carving in Berlin, the disk, still held between the fingertips of the right hand, is convex, as if the artist wished to represent a sphere;[66] there is, moreover, in Zurich a drawing of the tenth century with Christ holding the little disk, marked with a cross, in the palm of his left hand;[67] and conversely, on an ivory carving in the Bargello Museum in Florence[68] the globe in King David's left hand has become a tiny disk set between the fingertips like the sacred Host. In Spanish miniatures of the tenth century the disk in Christ's hand, held in the ostensive Carolingian manner, is actually labeled *mundus* (Gerona Beatus, A.D. 975),[69] as if to clarify an obscure foreign symbol, or is accompanied by a lengthy inscription explaining it as the *molem orbe* (Codex Vigilanus, 976).[70] These Spanish miniatures were very probably copied from French Carolingian works; the mandorla, especially in the manuscript in Gerona, is shaped like an 8 and is enclosed in a lozenge, like the combined globe and mandorla around the Christ with the eucharistic wafer in the First Bible of Charles the Bald (Fig. 6). In Gerona the accompanying symbols of the Evangelists Mark and Luke turn their heads back in order to look at Christ,[71] a motif unknown in the Early Christian and Byzantine versions of the four symbols as a group but frequent in Carolingian art where it appears to be indigenous. On another leaf of the same codex in Gerona,[72] in a series of full-page paintings of the Evangelists and their symbols, there is a vaguely formed, misunderstood roll in the claws of the eagle; it is unknown in the same context in the other early Beatus manuscripts and betrays the intrusive influence of Carolingian art.

Does the disk in the drawing at Auxerre and in the related Romanesque works from the Loire region retain the old eucharistic sense, or is it the globe of the earth as in these Spanish copies which were made far from the originating centers where the eucharistic controversy had taken place? It is not easy to decide. By the eleventh century there are examples of both the globe held in the eucharistic manner[73] and the Host enlarged like a globe and carried in the palm.[74] In a later manuscript of Tours from the middle of the twelfth century, in an image of Christ holding a large disk or sphere in the palm of the left hand,[75] we cannot readily determine whether the eucharistic or cosmocratic meaning is intended (Fig. 11). Such a confusion or mutual assimilation of types is hardly surprising. Symbols of like form, applied to the same object or comprised within closely related spheres of meaning, tend to become interchange-

able (as in poetry and dreams), especially in primitive and provincial cultures; here both forms and meanings are not highly differentiated and analogy is still a powerful method of argument. The eucharistic Host itself had acquired an imperial connotation. It was at one time not much larger than a coin, the *denarius*, and was impressed with the cross or abbreviated name of Christ (IHS), and hence could be compared by Honorius of "Autun" with the coinage of the emperor.[76] In some cases we are even inclined to ask whether the artist has not deliberately created an ambiguous form in order to evoke the double aspect of Christ as ruler and sacramental body. In the painting of Abraham and Melchizedek on the vault of Saint-Savin, Melchizedek, the original priest-king of the Old Testament, is crowned and holds a chalice in his left hand and a huge cross-inscribed disk or sphere in his right palm, before the receptive Abraham. There can be no doubt that the object in the right hand is eucharistic; but in the context of the crown it suggests also the royal dignity of the priest.[77]

However, in the Loire valley the reappearance of the original eucharistic disk in Romanesque art would not be "accidental" or an inert survival from older art. For it is here that was revived in the eleventh century the eucharistic debate of the Carolingians which underlies the pictorial image of Christ in heaven holding the wafer, as if to identify it with his body. Toward 1050, Berengar of Tours exposed the current view to sharp dialectical criticism and started a controversy that was to trouble Christendom for centuries to come. He maintained that in the eucharistic sacrifice the body and blood of Christ were not present *substantially* in the consecrated bread and wine, but only symbolically and sacramentally.[78] Lanfranc, who asserted the real, mysterious presence of the body in the wafer, taught in opposition that it was there invisibly and interpreted a prayer in the post-communion of the Mass—"May your sacraments, Lord, complete in us that which they contain, in order that we may grasp in reality what we now celebrate in symbolic form"—to mean that the body of Christ, presented in the guise of bread and wine in the eucharist, will some day be disclosed in a clear vision of heaven.[79] The image of Christ in heaven holding the wafer seems to correspond to this thought. The revival of the Carolingian type in the eleventh century in the region of the Loire affirmed the official teaching of the reality of Christ's presence in the eucharist.[80]

In the light of these relationships of the drawings with the Carolingian and Romanesque art of Tours, we are not surprised to read on the back of one of the leaves in Auxerre a list of objects and clothes belonging to a monk of Saint-Julien at Tours.[81]

This writing is in a hand of the fourteenth century, but we have only to compare the drawings with those of manuscripts of the late eleventh

century from Tours to recognize that the fragment in Auxerre was also executed there. The crowned David in a manuscript of Augustine on the Psalms in the library of Tours (ms. 294)[82] is so similar to the crowned musicians in the drawing in Auxerre that I am tempted to attribute them to the same hand (Fig. 12). A related style appears in the miniatures illustrating the life of Saint Martin in the same library (ms. 1018).

The leaves in Auxerre were identified by Prou as fragments of a Missal of which the text on the back of the drawings was rewritten in the fourteenth century. But two lines of the original writing from the Preface of the Mass ("Dominus vobiscum et cum spiritu tuo. . . .") are preserved on the verso of the Crucifixion; these are in the same ink as the drawings and recall the script of the Loire region at the end of the eleventh century.[83]

A new basilica of Saint-Julien of Tours was dedicated in 1084, and relics were translated there in 1097.[84] It was perhaps for one of these occasions that the Missal with our leaves was written.

The choice of the two central themes of these leaves—the Crucifixion and Christ in Majesty—for the pages between the Preface and Canon of the Mass, is standard in French liturgical manuscripts of the period although fairly restricted before this time.[85] Its distribution in the earlier manuscripts points to an origin in the Carolingian art of the large region of Tours, Paris, and the northeast of France. For examples from the region of Tours we may cite a Missal written in Marmoutiers in the eleventh century[86] and a second one from Le Mans in the early twelfth.[87] The leaves in Auxerre are unique, however, in the bordering figures of the Apocalyptic Elders acclaiming Christ and the Lamb, and in the scenes from the life of Christ; they suggest a monumental cycle, rather than the decoration of a single page, and in their arrangement about the central dominant themes they remind us of ivory book-covers of the Carolingian age.[88] I do not know of another example in a Missal or Sacramentary.[89] Yet these smaller figures and scenes were not added arbitrarily. The Elders with their musical instruments and vials of incense belong to an Apocalyptic vision which is close in language and feeling to the Preface of the Mass. The four beasts in the text of Revelation acclaim Christ with the triple *Sanctus* that also concludes the Preface, and the Elders are a heavenly model of the adoration of Christ and the sacrificial Lamb with music and incense. The singing of the *Sanctus* in the Mass called up in the mind of an earlier writer, Saint Germain of Paris, the thought of the Twenty-four Elders.[90] In a similar way, the bordering scenes of the Passion and of the reappearance of Christ in the flesh after his death, including the eucharistic Supper at Emmaus, illustrate more directly and fully than the usual scene of the Crucifixion the historical content of the sacrifice of the Mass. Exceptional as it is, this attempt to represent pictorially

the dramatic, historical precedents of the Mass is part of a general tendency of the time evident within the liturgy itself. We see this, above all, in the rapid growth of religious drama and of the Easter play in particular, a development which was especially intense in the region of the Loire.

Such extended cycles of scenes from the Gospel are characteristic there in the Romanesque period. The wall-paintings in Vic, Le Liget, and Tavant,[91] only incompletely preserved, exhibit series of incidents from the Passion of Christ. We have no Apocalyptic cycle from this time in the Loire, although there are examples farther south in Poitou; but undoubtedly they existed in Tours in the eleventh and twelfth centuries. The walls of the great abbey church of Saint-Benoît-sur-Loire were decorated with scenes from the vision of John.[92] What subjects were chosen, and how they were disposed, is unknown. But the chronicle of the eleventh century that records the work has preserved the artist's name. He was Odolricus, a monk of Saint-Julien of Tours.[93]

Since the Apocalyptic theme of the Elders in Auxerre frames an immense Christ in Majesty which is singularly close to the wall painting in Parçay, we may also ask whether the artist of these leaves was not inspired, at least in part, by a monumental painting. This theme of the Elders was one of the most constant subjects of wall painting and mosaic in western Europe since the Early Christian period; its presence on the Romanesque sculptured portals continues that tradition, the later Middle Ages transferring to the exterior of the church and to the more plastic material a conception of kingly homage to Christ which, in earlier times, had been confined for the most part to the interior of churches, although it confronted pilgrims in conspicuous grandeur on the outer wall of Saint Peter's in Rome. It is not necessary to assume, as Mâle has done, that the vision of Christ and the Elders could have been introduced into Romanesque sculpture only from the pages of an illuminated manuscript.

The localization of these drawings of Auxerre in Tours is doubly important for our knowledge of mediaeval art. It points to the continuity of Carolingian and Romanesque art in one of the great Carolingian centers—a continuity which should have been suspected because of the corresponding relations of the Ottonian and Carolingian schools in Germany, and yet has been disregarded by students of French art. It may be asked now, in a more general way, whether the older themes and the types of figure, drapery, and ornament in French Romanesque art reached Burgundy and southern France through the roundabout mediation of Anglo-Saxon art, as Professor Morey has maintained, or are native revivals and developments of Carolingian art. In the second place, the origin of these drawings in Tours permits us to locate in the Loire region in the

late eleventh century one of the richest cycles of post-Passion and post-Resurrection scenes of the Romanesque period and opens up new possibilities in mapping the relationships among various works in England, France, and Spain. No other French examples of so extensive a cycle are preserved from before the mid-twelfth century, nor English ones from before about 1120. But the further investigation of the two drawings with respect to these problems of historical continuity is beyond the scope of this short paper.

NOTES

1. "Deux dessins du XII^e siècle au trésor de l'église Saint-Etienne d'Auxerre" in *Gazette Archéologique*, XII (1887), pp. 138–144.

2. Émile Mâle, *L'art religieux du XII^e siècle en France*, Paris, 1922, pp. 8, 9, 30–32.

3. *Ibid.*, pp. 8, 9.

4. *Ibid.*, fig. 154 (Saint-Benigne, Dijon), fig. 221 (Saint-Loup-de-Naud), fig. 223 (Saint-Trophîme, Arles).

5. In the Dufay Evangeliary, Paris, Bibliothèque Nationale, ms. lat. 9385: A. Boinet, *La miniature carolingienne*, Paris 1913, pl. LVI B; Laon, Bibliothèque municipale, ms. 63: *ibid.*, pl. XXXIX A; Wolfenbüttel Evangeliary, Herzog-August Bibliothek, ms. 2186: Wilhelm Koehler, *Die karolingischen Miniaturen. Die Schule von Tours*, Berlin 1930, vol. I, Album, pl. 41 d.

6. Cf. the *Codex Aureus*, Munich, Staatsbibliothek, Clm. 14000: Boinet, *op. cit.*, pl. CXIX B, and G. Leidinger, *Der Codex Aureus*, Munich 1925, pl. 92; note also an example in the Canon Tables of this manuscript: Leidinger, *op. cit.*, pl. 13; the Metz Sacramentary, Paris, Bibl. Nat. ms. lat. 1141: Boinet, *op. cit.*, pl. CXXXII A; Gospels of Noailles, Paris, Babl. Nat. ms. lat. 323: Boinet, *op. cit.*, pl. CXXXV B; the ivory cover by Tuotilo, Saint Gall, *Evangelium Longum*: A. Goldschmidt, *Die Elfenbeinskulpturen*, Berlin 1914, vol. I, no. 163 A, pl. LXXV. On an ivory cover in Berlin, only Matthew's symbol has the roll, but he is in the upper right—the eagle's place: Goldschmidt, *op. cit.*, vol. I, no. 23, pl. XIII; in Saint Gall, Stiftsbibliothek, ms. 51 (E. H. Zimmerman, *Die vorkarolingischen Miniaturen*, Berlin 1916, vol. III, pl. 190) there is a similar Matthew with a roll in the upper right corner, but the other symbols here are without books and the relevance is uncertain.

7. Ernest Rupin, *L'oeuvre de Limoges*, Paris 1890, vol. II, figs. 311, 312, 329, 331, 338, 381; André Michel, *Histoire de l'art*, vol. I, pt. 2, p. 871, fig. 458; A. Bouillet and L. Servières, *Sainte Foy*, Rodez 1904, p. 94. (reliquary of Sainte Foy from the abbey of Grandselve, now in Ardus); enamel plaques in the Berlin Schlossmuseum: *Pantheon*, IV (1929), p. 559, fig. 8, the Victoria and Albert Museum, London (no. 651–1898) and the Metropolitan Museum of Art, New York (from the Bardac and Hoentschel collections). See also W. L. Hildburgh, *Mediaeval Spanish Enamels*, London 1936, *passim* and pl. VIII, fig. 8c, who attributes several of these works to Spain, for reasons criticized by Marvin Ross in *Speculum*, XV (1940), pp. 113, 114.

8. Cluny, destroyed portal of abbey church: *Millénaire de Cluny*, Mâcon 1910, vol. II, pl. II, after old lithograph; Romanesque sculptures in Angers: A. K. Porter, *Romanesque Sculpture of the Pilgrimage Roads*, Boston 1923, ill. 1501; Issy: *ibid.*, ill. 1489; Foussais: *ibid.*, ill. 1064; Saint-Junien: *ibid.*, ill. 452; Saint-Menoux: *ibid.*, ill. 1257; Lyons, Saint-Martin-d'Ainay: *Congrès archéologique tenue à Avallon en 1907*, pl. opp. p. 532; Angoulême: Porter, *op. cit.*, ill. 929, restored; and many manuscripts: Paris, Bibl. Nat. ms. lat. 4, vol. II, fols. 135, 136v., 137, tenth century, from Le Puy; Reims, Bibliothèque municipale ms. 214, fol. 9v., Sacramentary of Saint-Thierry, tenth century; Paris, Bibl. Nat. ms. lat. 11550, Psalter, eleventh century: Mâle, *op. cit.*, fig. 4—Mâle mistakenly attributes this manuscript to Limoges and cites the miniature as an example of the influence of the Beatus manuscripts in the south. P. Lauer calls the manuscript Catalonian:

Les enluminures romanes des manuscrits de la Bibliothèque Nationale, Paris, 1927, pp. 124–126; but it was surely written in Saint-Germain-des-Prés, as I pointed out in the *Art Bulletin,* x (1927–1928), p. 398 and as was proved conclusively by Charles Niver in *Speculum,* III (1928), pp. 398–401. Saint-Omer, Bibliothèque municipale, ms. 56, fol. 14v; New York, Pierpont Morgan Library, ms. 641, fol. 170, Missal from Fécamp; Paris, Bibl. Nat. ms. lat. 3778, fol. 77v, from Saint-Maur-des Fossés; Bibl. Nat. nouv. acq. lat. 1890, the Barbéchat Missal, written for a priory in the diocese of Nantes in the lower Loire; Bibl. Nat. ms. lat. 8823, fol. 4, Bible of Pontigny. Note also an example in the recently discovered Romanesque fresco of Saint-Plancard (Hte.-Garonne): see Jean Laffargue and Georges Fouet, *Peintures romanes, vestiges gallo-romains,* Toulouse, 1948, p. 15, fig. 12.

9. In Spain, a manuscript in the cathedral of Tortosa (photo Mas 12047, 12048-C); a niello book-cover in the Cámara Santa in Oviedo: *Art Bulletin,* VI (1923), fig. 39, opp. p. 56; an embroidered standard of Saint Ot, bishop of Urgell, in the cathedral of Urgell: *Anuari,* Institut d'Estudis Catalans, VI (1915–1920), frontispiece and pp. 755ff.; Vich, painted altar frontal: *Art Bulletin,* VIII (1925), p. 74, fig. 24; Barcelona, Espona Collection, altar frontal: *ibid.,* p. 56, fig. 1, p. 59, fig. 2; Oviedo, Cámara Santa, ivory and gold diptych: Hildburgh, *op. cit.,* pl. XV, fig. 19a; Burgos, Museum, enamel altar frontal from Silos: *ibid.,* pl. V, fig. 6c; sculptures in Carracedo: Porter, *Spanish Romanesque Sculpture,* New York 1928, vol. II, pl. 93, and in Santibañez Zarzaguda: *ibid.,* vol. II, pl. 114. All these works are late Romanesque.

In England, we note examples of the eagle's roll in Cambridge, Corpus Christi College, ms. 2, Bible from Bury St. Edmunds: E. Millar, *English Illuminated Manuscripts from the Tenth to the Thirteenth Century,* Paris 1926, pl. 39b; Copenhagen Royal Library, Thott ms. 143.2°, fol. 15v; Munich, Staatsbibliothek, Clm. 835 (Psalter from Gloucester); an ivory in the Metropolitan Museum of Art: Goldschmidt, *op. cit.,* vol. IV, pl. I, 1, which may be north French.

Among examples in Germany, Switzerland and Belgium—Aschaffenburg, Lectionary from Fulda: E. H. Zimmermann, *Die Fuldaer Buchmalerei,* Halle 1910, fig. 19, p. 34; the Bamberg Apocalypse: Wölfflin, *Die Bamberger Apokalypse,* Munich 1921, pl. 7; The Hague, Meerman ms. 10 B 7, fol. 11v, Gospels of the tenth century (copied from the Carolingian Xanten Gospels: Boinet, *op. cit., pl.* LX B); New York Public Library, ms. 1, a south German Evangelistary, tenth century; London, British Museum, Harley ms. 2821, Evangeliary from Echternach; Trier, Stadtbibliothek, ms. 23, tenth century: S. Beissel, *Geschichte der Evangelienbücher,* Freiburg in Br. 1906, fig. 46, p. 159; Saint Gall, Stiftsarchiv (Pfavers) ms. VII: Bruckner, *Scriptoria Medii Aevi Helvetica,* Geneva 1935, vol. I, pl. XXVIII; Paris, Bibliothèque Ste.-Geneviève, ms. 2657, fol. 1v., Pontifical, *ca.* 1000, Rhineland; Berlin, Schloss Museum, silver-gilt book-cover from Enger, twelfth century; New York, Pierpont Morgan Library, ms. 709, gold book-cover, Flanders, eleventh century: Greene and Harrsen, *The Pierpont Morgan Library. Exhibition of Illuminated Manuscripts held at the New York Public Library,* New York 1934, pl. 18; and Belgian and Rhenish ivories of *ca.* 1100 reproduced by Goldschmidt, *op. cit.,* vol. II, nos. 170–171.

In Italy—Milan, Biblioteca Ambrosiana, Cod. B 48 Inf., Bible of the twelfth century: *Bolletino d'Arte* (1933), p. 59, fig. 6; Parma, baptistery, lunette over doorway, twelfth century; Città di Castello, silver antependium, 1143–1144; Detroit Institute of Fine Arts, tympanum, early thirteenth century.

10. Paris, Bibl. Nat. ms. lat. 8850, Gospels of St.-Médard de Soissons: Boinet, *op. cit.,* pl. XXII B; London, British Museum, Cotton Tiberius A.II, fol. 164, Gospels of Athelstan, written in Lobbes, late ninth century; Cologne, Dombibliothek, cod. 14: Boinet, *op. cit.,* pl. CVIII D; Brussels, Bibliothèque royale, ms. 5573, Gospels from Gembloux; Einsiedeln Stiftsbibliothek, cod. 17: A. Merton, *Die Buchmalerei in Sankt Gallen,* Leipzig 1923, pl. 36, no. 2; Brussels, Gospels of the Duke of Arenberg, from St. Severin in Cologne, early eleventh century [now Morgan Library, ms. 869].

I have listed so many examples because of the possible value of this detail as a "tracer" in studying the relationships of mediaeval works and schools.

11. Wilhelm Koehler, *Die karolingischen Miniaturen: Die Schule von Tours,* Berlin 1932, vol. I, pt. 2, p. 245: "offenbar ist diese Abweichung veranlasst durch den Wunsch, die ästhetisch kaum lösbare Aufgabe der Verbindung von Vogel und Buch zu umgehen."

12. Stuttgart, Landesbibliothek, II 40: Koehler, *op. cit.*, vol. I, pl. 20; Bamberg Bible: Boinet, *op. cit., pl.* XXIX; Gospels of St. Gauzelin, Nancy: *ibid.*, pl. XXVII; Bible of Moutier-Grandval. British Museum, Add ms. 10546: *ibid*, pl. XLV; Paris, Bibl. Nat. ms. lat. 1: *ibid.*, pl. XLVIII B; Bibl. Nat. ms. lat. 266: *ibid.*, pl. XXXI—all from Tours Cf. also Cambrai, Bibliothèque de la ville, ms 327: *ibid.*, pl. CIX D.

13. Trier, Stadtbibliothek, ms. 22 (The Ada Gospels); the Gospels in Aachen Cathedral: Boinet, *op. cit.*, pl. LX; the silver book-cover of the Gospels in Nancy Cathedral: Michel, *Histoire de l'art*, vol. I, pt. 2, fig. 451; a gold book-cover in the treasure of Aachen Cathedral; a châsse in Mozac: Rupin, *op. cit.*, vol. I, fig. 166; a book-cover in Cologne, *ca.* 1170: P. Clemen, ed., *Belgische Kunstdenkmäler*, Munich 1923, vol. I, p. 127, fig. 107; Vatican lat. ms 3741, fol. 8, Beneventan: S. Beissel, *Vatikanische Miniaturen*, Freiburg im Br. 1893, pl. 7; the fresco in Knechtsteden. Also several Spanish manuscripts—Codex Aemilianensis, Escorial, d I 1, fol. 457, *ca.* 994; Codex Vigilanus, Escorial, d I 2, fol. 454, *ca.* 976; the Bible of San Isidoro in León, fol. 2 (960). There are also many examples of the four symbols in which two or three carry rolls.

14. Bamberg Cathedral, Bible: Boinet, *op. cit.*, pl. XXIX B.

15. L. Magnani, *Le miniature del Sacramentario d'Ivrea*, Città del Vaticano 1934, pl. XLII. Andrew holds a cross, Peter, keys, and Paul, a book, but Bartholomew (pl. XLIV) holds a roll.

16. *Ibid.*, p. 39.

17. Cf. J. Sauer, *Symbolik des Kirchengebaudes und seiner Ausstattung in der Auffassung des Mittelalters*, 2nd ed., Freiburg im Br. 1924, p. 229. A clear example is the miniature in the Bible of Charles the Bald, Paris, Bibl. Nat. ms. lat. 1: Boinet, *op. cit.*, pl. XLVIII.

18. Cf. *Rationale Divinorum Officiorum*, ch. III, 11. But Durand adds that some Apostles, who wrote nothing, or at least nothing canonical, and taught only by word of mouth, are also portrayed with scrolls. In the translation of Durand by Neale and Webb, *The Symbolism of Churches and Church Ornaments*, London 1893 (first published 1842), p. 51, it is said that the "patriarchs and prophets are painted with wheels in their hands." This absurdity is due to the translator's confusion of the abbreviated *rŏtis* (= rotulis) with *rotis*. This error has been reproduced in E. G. Holt, *Literary Sources of Art History*, Princeton 1947, p. 65, in reprinting the Neale and Webb translation of chapter III of Durand.

19. *Homilia in prologum sancti evangelii secundum Joannem*, cap. I, 1–14, Migne, *Pat. lat.*, vol. CXXII, cols. 283–285: "vox spiritualis aquilae auditum pulsat Ecclesiae. . . . Vox altividi volatilis, non aera corporeum vel aethera vel totius sensibilis mundi ambitum supervolitantis, sed omnem theoriam, ultra omnia quae sunt et quae non sunt. . . . Non ergo Joannes erat homo, sed plus quam homo, quando et seipsum, et omnia, quae sunt, superavit. . . ." See also his *Commentarius in sanctum evangelium secundum Joannem, ibid.*, cols. 297–348.

20. *Commentariorum in Joannem*, lib. I, Migne, *Pat. lat.*, vol. C, cols. 741, 742, 743, 744, including the *Epistola ad Gislam et Rictrudam*, published as a preface.

A miniature in a North French Bible of the early fourteenth century in Saint Patrick's Cathedral, New York, illustrates this conception of John in the initial of his Gospel: an eagle-headed Evangelist writing; the Holy Trinity with Christ on the Cross; the Last Supper, with John on Christ's breast.

21. Cf. his *De consensu evangelistarum*, I, 4, Migne, *Pat. lat.*, vol. XXXIV, col. 1045, and the anonymous preface to his *Tractatus in Joannis evangelium, ibid.*, vol. XXXV, col. 1377. Passages of the first text are also included in the prologue to John's Gospel: "Tres evangelistae in his rebus maxime diversati sunt," J. Wordsworth and H. S. White, *Testamentum novum latine secundum editionem S. Hieronymi*, Oxford 1899, vol. I, pp. 487–488, which is copied in several Carolingian manuscripts (e.g., the Bible of Le Puy, the Evangiles in Nancy Cathedral. Cf. for the latter, Koehler, *op. cit.*, vol. I, pl. 37 b, c). For a related view of John's superior spirituality, cf. also Jerome's prologue to the Gospels: *Plures fuisse . . .*, Wordsworth and White, *op. cit.*, vol. I, pp. 13–14; and for earlier Greek statements, Eusebius, *Historia ecclesiastica*, III, cap. 24: "he commenced with the doctrine of the divinity, as a part reserved for him by the divine spirit, as for a superior."

22. Cf. his *Homilia VII,* Migne, *Pat. lat.,* vol. XCIV, cols. 38ff. and *Homilia VIII, ibid.,* col. 46.

23. *Vita Alcuini,* Migne, *Pat. lat.,* vol. C, col. 96.

24. It is in the Stonyhurst College Library; see E. A. Lowe, *Codices latini antiquiores,* Oxford, Clarendon Press, 1935, vol. II, no. 260. Note also that a Gospel of John was placed in the reliquary of the holy shirt of the Virgin in Chartres; this manuscript of the fifth or sixth century is now in Paris, Bibl. Nat. ms. lat. 10439. It is interesting that in the same reliquary was inserted an ancient cameo of Jupiter and the eagle, which was identi-fied with John and his symbol and inscribed with a text from his Gospel: E. Babelon, *La gravure en pierres fines, camées et intailles,* Paris 1894, p. 219, fig. 163. For the persistent copying of John as a separate work, note the manuscript of his Gospel, Bibl. Nat. ms. lat. 9396, probably written for the Holy Sepulchre in Jerusalem in the twelfth century: P. Lauer, *Les enluminures romanes,* Paris 1927, pp. 104–105, pl. LXVIII. The reading of John's Gospel at the Mass also contributed to its copying as a separate manuscript.

25. Dublin, Royal Irish Academy, ms. D.II.3, fols. 1–11; it is dated around 800. Another Irish manuscript of John is Saint Gall, Stiftsbibliothek, ms. 60: S. Berger, *His-toire de la Vulgate,* Nancy 1893, p. 416. I may mention at this point that in another Irish manuscript, Saint Gall, ms. 51 (E. H. Zimmermann, *Die vorkarolingischen Miniaturen,* pl. 190), on a page with the four symbols, only the man has a book, and it is a roll; but he is at the upper right, the eagle's usual place. What bearing this exceptional fact has upon our problem, I have been unable to decide.

26. For the text of this tenth-century colophon, see Eric G. Millar, *The Lindisfarne Gospels,* London 1923, pp. 4–5. The substance of this idea comes from Early Christian writers, cf. Eusebius, *Historia ecclesiastica,* III, 39; V, 8; VI, 14, 25, who quotes Papias, Irenaeus, Clement, and Origen; but the words of the colophon concerning John: "in pro-chemio deinde eructavit . . ." are taken from Jerome's prologue "Plures fuisse . . ."

27. On the eagle in pagan antiquity and early Christianity, see the article, "*Adler,*" by T. Schneider and E. Stemplinger in *Reallexikon für Antike und Christentum,* hrsg. von Theodor Klauser, Stuttgart 1950, vol. I, cols. 87–94; and s.v. "*Aigle,*" in Cabrol and Leclercq, *Dictionnaire d'archéologie et de liturgie chrétienne.* Note in Byzantine ritual in the image on the pavement of the church at the place of ordination of a bishop, a city surmounted by an eagle with wings illuminated by the sun's rays; the eagle signifies the divine grace and the sublimity of theological knowledge which should adorn the bishop's soul (Cabrol, *loc. cit.*). On the eagle as the solar bird and the agent of apotheoses, see also F. Cumont, *Recherches sur le symbolisme funéraire des romains,* Paris 1942, pp. 97, note 2; 240; 337.

28. For this conception of heaven as a roll, see F. Boll, *Aus der Offenbarung Johannes,* Leipzig-Berlin 1914, p. 9, 17.

29. Theodor Birt, *Die Buchrolle in der Kunst,* Leipzig 1907, p. 68.

30. *Ibid.,* p. 69. Note also the tradition that the original roll of John's Gospel was pre-served as a relic in Ephesus. In the later Byzantine portraits of the Evangelists the con-tainer with rolls is reserved mainly for John: K. Weitzmann, *Die byzantinische Buchmal-erei des 9. und 10. Jahrhunderts,* Berlin 1935, p. 6.

[30a. The eagle with the roll appears already in the early ninth century in a gospel manuscript in the Bürgerbibliothek of Bern (no. 348), attributed to Fleury by Koehler and connected with Tours ms. 22 (ca. 800 from Fleury). See Otto Homburger, "Eine unveröffentlichte Evangelienhandschrift aus der Zeit Karls des Grossen," *Zeitschrift für Schweizerische Archaeologie und Kunstgeschichte,* 5, Heft 3, 1943, pp. 149–164, pls. 39–45. Homburger considered the eagle with the roll an exceptional detail (p. 155).]

31. Cf. Stuttgart, Landesbibliothek, ms. II 40: Koehler, *op. cit.,* vol. I, pl. 20; Bibl. Nat. ms. lat. 1: Boinet, *op. cit.,* pl. XLVIII; the Moutier-Grandval Bible: *ibid.,* pl. XLV A; the Nancy Evangiles: Koehler, *op cit.,* vol. I, pl. 35c. This elevated position of the eagle is also characteristic of the tetramorph in illustrations of Ezekiel's vision: W. Neuss, *Das Buch Ezechiel in Theologie und Kunst . . . ,* Münster in W. 1912, figs. 34, 43–46, 60, 63. It recalls the place of the eagle at the top of Roman funerary monuments: Cumont, *op. cit.,* pl. XLV, opp. p. 458. The place of the eagle at the upper right in rectan-gular groupings of the four symbols is probably also a place of honor.

32. As in Bibl. Nat. ms. lat. 1. In the Stuttgart Gospels, all four symbols hold closed books, but Christ's book is open. In the Nancy manuscript (Koehler, *op. cit.*, vol. I, pl. 37d), in the portraits of the Evangelists, only John's eagle is set in a great jeweled circle or mandorla and seems to hold a roll. The prologue of John (*Tres evangelistae . . .*) in this manuscript has a quite prominent initial: *ibid.*, pl. 37 b, c.

A possible disposing factor in the theme of the eagle's roll is the taste for variation of repeated elements in groups in Carolingian and Romanesque art. Striking examples in the school of Tours are the title pages of the Gospels in Laon, ms. 63; the same words (*evangelium secundum*) are contracted differently each time. But this aesthetic reason would not account for the character of the variation in the present instance—the choice of the eagle as the carrier of the roll.

33. Stuttgart, Landesbibliothek, ms. II, 40: Koehler, *op. cit.*, vol. I, pl. 22; see also vol. I, pt. 2, pp. 251–52.

34. *Epistola ad Gislam et Rictrudam*, preface to the commentary on John: Migne, *Pat. Lat.*, vol. C, col. 741. Alcuin reproduces here the text of the anonymous preface to Augustine's *Tractatus in Ioannis Evangelium*, *Pat. Lat.*, vol. XXXV, col. 1377 (and Eusebius' *Historia ecclesiastica*). Alcuin's words are mistakenly attributed to Bede in Migne, *Pat Lat.*, vol. XCII, cols. 635ff.: *Expositio in S. Ioannis Evangelium*, cap. I; "Bede's" commentary on John consists of Alcuin's and Augustine's commentaries; see Anton E. Schönbach, "Ueber einige Evangelien Kommentare des Mittelalters" in *Sitzungsberichte d. Wiener Akademie d. Wissenschaften*, 146, IV (1903), pp. 34ff. In Byzantine art of the middle period, John is often singled out among the Evangelists as one who dictates to a secretary, Prochorus, rather than writing like the others.

35. A possible exception is a prefatory miniature, independent of the Beatus cycle, in the Gerona Beatus of 975, fol. 2, reproduced by W. W. S. Cook in *Art Bulletin* VI (1923), pl. XVIII, fig. 31; it represents Christ in Majesty rather than the scene of the Elders, and, like the adjoining miniature of the Crucifixion, has been copied from a French Carolingian model. Christ sits in an 8-shaped mandorla, as in the Bible of Charles the Bald (Paris, Bibl. Nat. ms. lat. 1), and holds a little disk mislabeled *mundus* (on this detail, see below); the symbols of Mark and Luke turn their heads as in Carolingian art. The eagle has an exceptional square halo, which is interesting for the special value assigned to John. [See p. 294 above, and Fig. 17.]

36. They are listed in note 13. These, too, have been influenced by Carolingian art, to judge by the turned bodies of the symbols in the Codex Aemilianensis, fol. 457. Individual symbols are rendered this way in earlier art, but the conception of all four in a group around Christ, turning back to see him, appears to be a Carolingian fusion of the two opposed Early Christian types—the eastern symbols directed away from Christ, like the beasts of a chariot, and the western ones directed toward him, as in courtly homage.

37. For the Beatus manuscripts, see Wilhelm Neuss, *Die katalanische Bibelillustration um die Wende des ersten Jahrtausends und die altspanische Buchmalerei*, Bonn-Leipzig 1922, and his later book, *Die Apokalypse des hl. Johannes in der altspanischen und altchristlicher Bibelillustration* (*Das Problem der Beatus-handschriften*), Münster in W. 1931, two volumes. The Italian copy in Berlin (Hs. theol. 561) is of the twelfth century and its drawings are independent of the Spanish tradition of Beatus manuscripts.

38. The Beatus manuscript of Burgo de Osma, 1086, and of Santo Domingo de Silos, *ca.* 1091–1109, are still in a Visigothic hand. On the significance of this change, see my article in the *Art Bulletin*, XXI (1939), p. 367, with references [reprinted in the present volume p. 60]. The French script is more solid and constructed than the "linear" Visigothic.

39. Neuss, *Katalanische Bibelillustration*, p. 66.

40. *Ibid.*, p. 68; idem, *Apokalypse*, p. 246. For a criticism of this view, see my remarks in *Art Bulletin*, x (1927–1928), pp. 398–399, where I have pointed out the importance of French art for the Beatus of Saint-Sever. In his more recent book, *Apokalypse*, on pp. 162 and 238, note 1, Professor Neuss observes, *contra* Mâle, a French influence in the famous Adoration of the Elders and the miniature of the old men fighting. See also the review of Neuss's later book by Miss Dorothy Miner in *Art Bulletin*, xv (1933), pp. 388–391, who summarizes on this point the unpublished part II of my Columbia University dissertation, *The Romanesque Sculpture of Moissac*, 1929.

41. Paris, Bibl. Nat. ms. lat. 4892, fol. 243; their vice is *luxuria*.

42. E. Ginot, "Le manuscrit de Sainte Radegonde à Poitiers" in *Bulletin de la Société française de reproduction de manuscrits à peintures, sér.* 4, vol. I (1914–1920).

43. Cf. among others, Paris, Bibl. Nat. mss. lat. 1121, 1993, 1987. Note that the theme of the old men pulling each other's beards, which Mâle has reproduced (*op. cit.,* p. 15, fig. 9), occurs not only in the sculpture of Poitou, but closer to Saint-Sever in a manuscript from Saint-Maurin, near Agen, a priory of Moissac: Paris, Bibl. Nat. ms. lat. 2819, fol. 87, toward 1100. An evidence of the South French milieu of the Beatus of Saint-Sever is the relative abundance of South French sites in the *mappamundi* on fol. 45. Vasconia is separated from Aquitania by the Garonne River, and many more French sites are named than Spanish ones: thirteen in Aquitaine, including two in Septimania; four in Spain; eleven in Gascony; six in Burgundy and the Lyonnais. The charters of Saint-Sever in the eleventh century refer to the ruling counts of Poitiers.

44. See P. D. Du Buisson, *Historiae monasterii S. Severi,* Vicojulii ad Aturem 1876, vol. I, pp. 145, 150; vol. II, pp. 71, 132, 134, 157, 158, 167, 169, 170.

45. *Ibid.,* vol. II, p. 71. Gómez-Moreno (*El arte románico español,* Madrid 1934, pp. 17–18) believes that Stephen Garsia was a Spaniard, because of the resemblance of his paintings to the other Beatus manuscripts and to the Diurnal of 1055 in Santiago and a charter of 1054 from Najera: pls. V, VI; he observes also that the style of the Saint-Sever paintings corresponds to that of a drawing of the Three Marys from Silos (Paris, Bibl. Nat. ms. nouv. acq. lat. 2176: *ibid.,* pl. X) which must have been done by a pupil of Stephen Garsia. But this drawing is not of the eleventh century, like the writing of the manuscript, as Gómez-Moreno mistakenly supposed; it is an addition of the twelfth, several generations later than the Beatus of Saint-Sever; see on this point *Art Bulletin,* XXI (1939), p. 365 [reprinted above, p. 94, n. 179]. As for the Spanish miniatures of 1054 and 1055, these already betray the existence of the new Romanesque art in Spain and were probably affected by South French painting; but they retain clear traces of a "Mozarabic" heritage.

46. As Neuss recognized without indicating the northern examples: *Apokalypse,* p. 238 note 1.

47. Boinet, *op. cit.,* pl. CXVI A; G. Leidinger, *Der Codex Aureus,* Munich 1925, vol. I, pl. 11. It may be based, like the Christ in Majesty page of the same manuscript, on a lost Touronian model.

48. Paul Clemen, *Die romanische Monumentalmalerei in den Rheinlanden,* Düsseldorf 1916, pl. I, figs. 5, 6, 8; pp. 12ff.

49. Neuss, *Apokalypse,* pl. LXVI; Schapiro, *op. cit.* in *Art Bulletin,* XXI (1939), p. 362, fig. 37 [reprinted above, p. 33 and Fig. 37]. There are also in the Beatus manuscripts horizontal groupings of the Elders as in the Early Christian versions and in Carolingian miniatures derived from them; but these do not concern us here.

50. As in the Drogo Sacramentary Bibl. Nat. ms. lat. 9428: Boinet, *op. cit.,* pls. LXXXVII B, LXXXVIII A; cf. also the Pentecost in the Bible of S. Paolo fuori le mura in Rome: *ibid.,* pl. CXXVIII A; several miniatures in the Utrecht Psalter: E. T. DeWald, *The Illustrations of the Utrecht Psalter,* Princeton n.d., pls. LXXII, CXLIII; the presentation page in the First Bible of Charles the Bald: Boinet, *op. cit.,* pl. LI.

51. There are several other Romanesque examples: in the Stavelot Bible of 1097, British Museum, Add. Ms. 28106-7; in a leaf from Bury St. Edmunds in the Victoria and Albert Museum, ms. 661; on the bronze font at Saint-Barthelémy in Liège, etc.

52. First Bible of Charles the Bald, Bibl. Nat. ms. lat. 1: Boinet, *op. cit.,* pl. XLVIII B; Munich, *Codex Aureus: ibid.,* pl. CXVI B; the Lothaire Gospels, Paris, Bibl. Nat. ms. lat. 266; *ibid.,* pl. XXXI; the Dufay Gospels, Bibl. Nat. ms. lat. 9385—the eagle here is in form precisely like the eagle in Auxerre and holds a roll: *ibid.,* pl. LVI; the Metz Sacramentary: *ibid.,* pl. CXXXII A.

53. In a Gospel manuscript of the second half of the eleventh century, formerly in the collection of the Comte de Kergarious [now in the National Museum in Stockholm]. See the *Catalogue de la Collection J. Martini,* Lucerne 1934, no. 267, pl. VII. The style is close to the art of Angers at this period. Another hand on folio 77 (*ibid.,* pl. VIII, Mark writing) is very similar to, if not identical with, that of the artist of Vatican ms. latin 4951, from Angers. The disk is also represented on the silver cover of the manuscript.

54. See Abbé Jean-Baptiste Mortier, "Les fresques de l'église de Parçay" in *Bulletin Monumental*, xcv (1936), pp. 31–43, and *ibid.*, ci (1943), p. 192. Parçay was a dependency of the abbey of Marmoutiers in Tours. The Abbé Mortier observed the similarity of the Parçay Christ to the Christ of the Auxerre leaf.

55. Ms. 93, fol. 134, Psalter with commentaries, *ca.* 1175, initial D; ms. 193, fol. 59. Missal, *ca.* 1150–1170, painting of Trinity; ms. 321, fol. 330v., Gregory on Job, *ca.* 1140, initial Q, with Christ in heaven, above Job and Satan.

56. F. van der Meer, *Maiestas Domini, théophanies de l'Apocalypse dans l'art chrétien*, Città del Vaticano 1938, pp. 333ff.; W. W. S. Cook, *op. cit.* in *Art Bulletin*, vi (1923), pp. 57–58, but Professor Cook admits the possibility of a eucharistic meaning in some of the early examples. See also W. Neuss, *Katalanische Bibelillustration*, pp. 42ff.

57. Le Prieur, in Michel, *Histoire de l'art*, vol. i, pt. 1, p. 354; Koehler, *op. cit.*, vol. i, pt. 2, p. 135, who cites the treatise of Paschasius Radbertus on the body and blood of Christ as the source.

58. For monarchs with orbs of power, see Percy E. Schramm, *Die deutsche Kaiser und Könige in Bildern ihrer Zeit—751–1152*, Leipzig-Berlin 1928, figs. 8, 28, 41, 62, 64, 68; the globe is generally held in the palm, but in a few instances in all five fingers. See also the reliquary arm of Charlemagne in the Louvre, reproduced by Hermann Usener in *Marburger Jahrbuch für Kunstwissenschaft*, vii (1933), pp. 109–110, and other examples in figs. 21–24. In Parma, Biblioteca, ms. Pal. 386, an Italian Romanesque Bible, David (fol. 93) and Solomon (fol. 185v) with orbs.

59. Schramm, *op. cit.*, figs. 8 a, b; Michel, *Histoire de l'art*, vol. i, pt. 2, pl. opp. p. 836. The statuette is now exhibited in the Galerie d'Apollon at the Louvre.

60. R. Hamann, *Geschichte der Kunst*, Berlin 1938, figs. 241–242. Other examples: the cover of the Poussay Evangeliary in Paris Bibl. Nat. ms. lat. 10514; M. Burg, *Ottonische Plastik*, Bonn-Leipzig 1922, fig. 44; a miniature of a manuscript of Augustine on Genesis in Beauvais, late eleventh century (Didron, *Iconographie chrétienne, Histoire de Dieu*, Paris 1843, p. 218, fig. 58); a Spanish ivory carving, formerly at Brummer's, New York; Arras ms. 435, vol. 2, fol. 1, Bible of eleventh century; Zwiefalten *Collectarius*, Stuttgart ms. Brev. 128, fol. 9v; K. Löffler, *Schwäbische Buchmalerei in romanischer Zeit*, Augsburg 1928, pl. 19—here the circle in Christ's left palm is identified as the earth by an inscription: *terram palmo concludit,* and a phial-shaped object in his other hand is identified as the heavens: *celum palmo metatur;* Copenhagen, Royal Library, Thott Saml. 143.2°, fol. 13, English Psalter of later twelfth century: a globe in left hand of God the Father above the Baptism is marked with the T schema of the continents; Vatican, Pinacoteca, panel of the Last Judgment, Christ with scepter in left hand and large globe in palm of the right, inscribed: *Ecce vici mundum;* Chantilly (Musée Condé), ms. 1695, Ingeborg Psalter, Pentecost, globe in left palm of Christ.

61. Paris, Bibl. Nat. ms. lat. 2077, fol. 162v; it illustrates a passage in a treatise by Halitgarius on the vices and virtues.

62. Paris, Bibl. Nat. ms nouv. acq. lat. 1390, fol. 2. For a description of the manuscript, see P. Lauer, *op. cit.*, pp. 146–148.

63. Paris, Bibl. Nat. ms. lat. 9436, fol. 106v: Leroquais, *Les Sacramentaires et les Missels*, Paris 1924, pl. xxxii. For another illustration of the same scene, with this gesture, see Paris, Bibliothèque de l'Arsenal, ms. 162, fol. 215v, from Saint-Arnoul-de-Crépy, *ca.* 1120. Cf. also the last communion of a dying man on a window in Chartres: *Eucharistia, encyclopédie populaire sur l'Eucharistie,* ed. Maurice Brillant, Paris 1934, pl. opp. p. 248; other examples, from later periods, in plates opp. pp. 254, 260, 346, 348, 349, 386, 570. The same gesture of the hand with the wafer appears in scenes of the Last Supper: Pierpont Morgan Library, ms. 44, and in the Gospels of Matilda of Tuscany in the same library (ms. 492, fol. 100v). Still another unmistakable example of the Host held between two fingers is a miniature in a Canterbury manuscript of the early twelfth century in the Laurentian Library in Florence (ms. xii, 17, fol. 199v); it is in the initial C of book xxi of Augustine's *City of God* and shows an enthroned figure of a bishop with a book in the left hand and a tiny disk between the thumb and index finger of the right. It represents probably Augustine himself and refers to chapter 20 of Book xxi, where Augustine quotes Paul, I Cor. 10:17: *unus panis, unum corpus,* and goes on to say that those Christians who have lapsed into sin and heresy will not be punished for eternity, but only for a

time, if they have been baptized and have partaken of the body of Christ (*manducaverunt corpus Christi*).

64. Ms. 184, Koehler, *op. cit.*, vol. I, pl. 124b. I may cite here some post-Carolingian examples of Christ with the Host which seem to depend on Carolingian models: Paris, Bibl. Nat. ms. nouv. acq. lat. 1541, Evangelistary from Trier: Nordenfalk in *Acta Archaeologica*, VII (1937), p. 285, fig. 5; Coblenz, Staatsarchiv ms. 701/81: *ibid.*, p. 284; Paris, Musée de Cluny, capital from Saint-Germain-des-Prés, *ca.* 1000; Rodez, Musée Archéologique, fragment of an altar frontal, which I venture to date around 1000 in spite of its resemblance to later Romanesque sculptures. The disk appears also on the embroidered standard from Urgell cited in note. 9. [In an article on the Rodez relief, 1963, I have proposed a dating in the second quarter of the eleventh century; see pp. 285–305 in this volume.]

65. Migne, *Pat. lat.*, vol. CXX, cols. 1267–1350. The book was first edited in 831 and again in 844; it was dedicated to Charles the Bald. On the life of Radbertus, who was a monk and abbot of Corbie, see the article "Radbert" by H. Peltier in *Dictionnaire de théologie catholique*.

66. See Cook, *loc. cit.*, pl. XXI, fig. 41. Cf. also the Spanish ivory carving from Brummer's mentioned in note 60.

67. Stadtbibliothek, ms. C. 80, Alcuin's *Dialectic and Rhetoric*: A. Merton, *Die Buchmalerei in St. Gallen*, Leipzig 1923, pl. LIV, 2 [reproduced above, Fig. 11 of "Rodez"]. Another example in the Winchester Psalter, British Museum, ms. Cotton Nero C IV, fol. 20, Last Supper; Christ holds a large wafer marked with a cross in his right palm and a chalice in the left.

68. Goldschmidt, *op. cit.*, vol. I, no. 113, pl. L (attributed to Metz school).

69. Reproduced by Cook in *Art Bulletin*, VI (1923), pl. XVIII, fig. 31, and by Neuss, *Apokalypse*, fig. 5. [It is reproduced above, Fig. 17 of "Rodez".]

70. J. Domínguez Bordona, *Spanish Illumination*, Florence-Paris 1930, pl. 25. The inscription is an attempt to explain the disk held between the fingertips in a foreign model: *dominus in tribus digitis dextere molem orbe libravit*.

71. See above p. 322, notes 35–36.

72. Fols. 6v, 7: Neuss, *Apokalypse*, fig. 13.

73. E.g., the ivory carving cited in note 68, and a miniature in Bibl. Nat. ms. lat. 9448.

74. See note 67 above.

75. See note 55 above. In ms. 93, fol. 134, the circle is held from above and is probably a Host; in ms. 321, fol. 330v, it is held in the right palm and is probably a globe.

76. See the *Gemma Animae*, lib. I, cap. XXXV, *De forma panis*: "Imago Domini cum litteris in hoc pane exprimitur, quia in denario imago et nomen imperatoris scribitur, et per hunc panem imago Dei in nobis reparatur": Migne, *Pat. lat.*, vol. CLXXII, col. 555. [In the Hortus Deliciarum of Herrade of Landsberg, the personification of Avarice, labeled "Judas Mercator," is a richly dressed figure holding scales in his left hand and a coin inscribed with an X, ostensively like the wafer, in his raised right hand—ed. Straub and Keller, pl. LX, f. 238.]

77. Cf. a similar conception of Melchizedek in an English Psalter in Munich, Clm. 835.

In the assimilation of Host and globe of power in the eleventh century, we may suspect also the action of the papal reform and its temporal claims. The eucharistic Host is not only a miraculous sacramental body; but as the body of Christ who is a ruler (and indeed the first pope) it is the symbol of papal authority, which now excludes from the Host and excommunicates the enemies of the church.

78. On Berengar, see A. J. Macdonald, *Berengar and the Reform of Sacramental Doctrine*, London 1930; the articles "Bérenger" and "Eucharistie du IXe au XIe siècle," by F. Vernet in the *Dictionnaire de théologie catholique*; Lanfranc, "De corpore et sanguine domini" in Migne, *Pat. lat.*, vol. CL; and A. Harnack, *History of Dogma*, London 1899, vol. VI, pp. 46ff.

Berengar (998–1088), a pupil of Fulbert at the cathedral school of Chartres, later taught in Saint-Martin of Tours, directed the cathedral school in Tours, and was archdeacon in Angers. His views were condemned by seven church councils in Italy and France between 1050 and 1079, and he was twice made to recant his beliefs.

79. Lanfranc, *op. cit.*, col. 436.

80. That it was a revival is suggested by the fact that the Host is not indicated at all in an earlier eleventh-century image of Christ in a Missal of Marmoutiers (see note 86 below); on the other hand, an active interest in making the eucharistic meaning of the Host explicit is evident in the page of Christ and the Elders in the Beatus of Saint-Sever (Fig. 1), which belongs to the third quarter of the eleventh century. Here, Christ holds a scepter in his left hand, and in his right hand a disk on which a lamb has been represented, as if to affirm the sacrificial meaning. An example of the local concern with Berengar is the transcript of his recantation in a Psalter from Saint-Denis (Paris, Bibl. Nat. ms. lat. 103, fol. 142), at the end of the *Symbolum Apostolorum*, not long after the event. In this manuscript of the first half of the eleventh century—its precise date is worth determining—there is on folio 87v, at the head of Psalm 101 (*Domine exaudi orationem meam*), a drawing of a poor man praying to Christ in heaven, who holds an obscure disk in his *left* hand—a disk that might well be an orb of power. In a Psalter with commentaries, more than a century later, Tours ms. 93, the corresponding initial, fol. 134 (Fig. 11), shows a similar ambiguity. [For the persisting interest in the eucharistic controversy during the tenth century and the continued reading of Paschasius, see my article on the Rodez relief, reprinted in this volume, p. 303, n. 59.]

81. Prou, in *Gazette archéologique*, XII (1887), p. 141. There is also in the treasure of the cathedral of Auxerre a Missal of the thirteenth century from Saint-Julien of Tours (ms. 6). See Leroquais, *Les sacramentaires et les missels*, Paris 1924, vol. II, pp. 160–161; and *Bulletin de la Société des Sciences de l'Yonne* (1892), pp. 197–198, for the inventory of the cathedral treasure and these manuscripts which come from the collection of Germain Duru, bequeathed in 1869.

82. It is described in the *Catalogue général des bibliothèques publiques de France, Départements*, vol. XXXVII: *Tours*, by M. Collon, 1900, p. 215. The manuscript comes from the library of the cathedral of Saint-Gatien in Tours (no. 128). The miniature is also reproduced by E. K. Rand, *A Survey of the Manuscripts of Tours, Studies in the Script of Tours*, Cambridge, Mass. 1929, vol. II, pl. CXCII; Rand dates it in the eleventh century (vol. I, p. 199).

83. The photograph made for me through the kindness of Monsieur Jacques Dupont shows the script too faintly to be worth reproducing. I judged from my examination of the original that it belongs to the western Loire region at the end of the eleventh century or the first years of the twelfth. It is more formal, precise, and stable, and less modeled and contrasted than the script of Tours ms. 294. It looks a bit earlier than the pages of Paris, Bibl. Nat. ms. lat. 9430, which Professor L. W. Jones dates at the beginning of the twelfth century (fol. 282v—see his article "The Art of Writing at Tours from 1000 to 1200 A.D." in *Speculum* XV, 1940, pp. 286–298, pl. IIIa) and later than the specimen dated 1062, *ibid.*, pl. IIC. For the date and artistic peculiarity of the drawings, it is also interesting to compare them with the drawings from the abbey of Saint-Maur-des-Fossés toward 1100, in particular Bibl. Nat. ms. lat. 12054, fol. 79—a remarkable drawing of the Last Supper in which the relation of the gigantic Christ to the small apostles calls to mind the Auxerre leaves and other works of the Loire region.

84. *Gallia Christiana*, new ed., vol. XIV, 1856, cols. 238 and 244. A chapel of Saint Nicholas was dedicated in 1097.

85. The early history of these two themes in liturgical manuscripts is ably discussed by Prou, *op. cit.*, pp. 142–143. He observes that in the Auxerre leaves the Crucifixion originally preceded the drawing of Christ in Majesty—an order that is unusual before 1200.

86. It is published by L. A. Bosseboeuf, "Un missel de Marmoutiers du XIe siècle" in *Revue de l'art chrétien*, XXXIX (1889), pp. 289–308, 420–433, and by Léon Palustre in *Mélanges d'art et d'archéologie, objets exposés à Tours en 1887*, Tours 1888, pls. XXVIII, XXIX. The present location of the manuscript is unknown to me; it was formerly in the Seminary of Tours.

87. E. G. Millar, *The Library of A. Chester Beatty, A Descriptive Catalogue of the Western Manuscripts*, Oxford 1927, vol. I, pp. 77ff. and pls. LXI–LXIII.

88. E.g., the Bodleian cover: Goldschmidt, *op. cit.*, vol. I, no. 5, pl. III, and the Dôle cover: *ibid.*, vol. I, no. 29, pl. XV.

89. For a unique example in a Collectarius, see the manuscript from Zwiefalten in the Stuttgart Library, listed in note 60 above. Next to the page with the drawing of Christ and the Twenty-four Elders is a cross with the Lamb, the four Evangelists writing, and symbols of the Virtues and Rivers of Paradise. These two pages were perhaps elaborations of the drawings in a Missal.

90. Migne, *Pat. lat.*, vol. LXXII, col. 91.

91. They are illustrated in Focillon, *Peintures romanes des églises de France*, Paris 1938, pls. 80–88 (Vic), pls. 59–64 (Le Liget), pls. 65–76 (Tavant), and *passim* for other paintings of the Loire region (Angers, Saint-Jacques-des-Guérets, Montoire, Saint-Aignan-sur-Cher).

92. Vita Gauzlini (1005–1029): V. Mortet, *Recueil de textes relatifs à l'histoire de l'architecture en France au moyen-âge, XIe–XIIe siècles*, Paris 1911, p. 37.

93. *Ibid.*, pp. 36–37.

New Documents on Saint-Gilles

(1935)

I

IN this article I wish to offer new documentary proof of a dating of the facade of St.-Gilles which has already been loosely proposed by several writers, but has been accepted by no French scholar because of the lack of evidence other than that based on analysis of style.

Because the facade of St.-Gilles is a central monument of a protorenaissance, the determination of its date has been an important problem to students of mediaeval art. A difference of seventy-five and even a hundred years exists between the dates assigned to it.[2] These datings are not merely neutral assignments to points in time; they are also judgments of the character of the work and its historical position in the growth of mediaeval art. The French archaeologists, for example, believe that the Romanesque art of Provence was a belated product, subsequent to the early intimations of Gothic in the Ile-de-France, and that its classical plastic qualities were, therefore, not the predecessors of Gothic, as others had maintained, but a provincial parallel to the Northern developments of the second half of the twelfth century.[3] For German scholars the Provençal works are anterior to the Northern and are the anticipation of the latter's tendency toward a monumental mediaeval style.[4] According to Richard Hamann, the facade of St.-Gilles was designed as early as the end of the eleventh century and was the starting point of a protorenaissance that spread throughout Italy, Germany, and France.[5]

The problem of the dating of St.-Gilles includes more than the sculptures of the facade. The history of architecture is also in question. For if we accept the earlier datings of the sculptures, we must admit that the cross ribs of the crypt, of which one keystone is carved in the first style of

the facade,[6] are older than the corresponding ribs in the Northern region where Gothic construction was systematically developed.[7]

It is true that the date of a unique work tells us very little about its style or its historical position. These must be discovered by analysis of the work itself and by comparison with related works. But without a correct dating the relationships cannot be clear, for the historical order of creation is an essential and revealing aspect of the form of a development, and the form of a development points to otherwise unnoticed aspects and qualities of historically arrayed works.

We can imagine how shocking it would be to our ideas of the necessary relations of an art to its own generation and to other products of its time, as well as to its historical antecedents, if we learned that Cézanne painted in the first third of the nineteenth century and Delacroix in the last. We would have to reorganize our whole knowledge of nineteenth-century art as well as our ideas concerning historical possibility. The analogy is all the more pertinent because the twelfth century, like the nineteenth, was a period of cultural mobility during which the forms of art underwent a rapid change, so that pronounced differences in the dating of an event or a monument imply pronounced differences in the conditions ascribed to its occurrence.

*　　*　　*

Robert de Lasteyrie attempted to show in a celebrated work on the sculptures of Chartres and Provence that the facade of St.-Gilles was created after 1142,[8] since that is the date of the two oldest inscriptions (Figs. 2, 3) incised on the western wall of the crypt which was built to sustain the sculptured facade.[9] This limiting date has won general acceptance[10] but can hardly be considered a rigorous *terminus post quem.* For it was not at all proved by de Lasteyrie that the two obits of 1142 were cut immediately after the construction of the crypt wall or immediately before the carving of the sculptures. There are, in fact, three other inscriptions (Figs. 4–6) on the same wall which have not been discussed because they bear no dates, but which in form betray a period earlier than 1142. Fortunately, the *terminus ante quem* of these inscriptions can be readily fixed.

One inscription reads HIC IACET FROTARDUS QUI OBIIT XVII KL SEPTB.; the second reads HIC IACET PETRUS DE BROZET; the third refers to HUBILOTUS Q. OB. V. IDUS OCTOB.[11]

In the necrology of St.-Gilles now preserved in the British Museum (Add.ms. 16979) in a manuscript of the Rule of St. Benedict, dated by a colophon of indisputable authenticity in the year 1129 (Fig. 12)[12] these three names occur in the same hand as the rest of the manuscript. FROTARDUS (Fig. 8) is written beside *xvii kl. sept.* (fol. 13v) and

HUBILOTUS (Fig. 9) beside *v. id. oct.* (fol. 16v), precisely as in the inscriptions of the crypt. There are two entries which might refer to Petrus de Brozet; the first (Fig. 10) beside *iii id. jan.*—PETRUS BROZET (fol. 1v)—is in the original hand, and a second (Fig. 11), beside *xii kl. mar.*—PETRUS DE BROSETO (fol. 3v)—in a slightly later script.[13]

It follows from the study of these inscriptions that the western wall of the crypt existed in 1129, and hence that the facade was already planned, if not begun, by that year.

There is one possibility of error in this reasoning, namely, the contingency that Hubilotus, Frotardus, and Petrus were not buried here until fifteen or twenty years after their deaths, and that the inscriptions were commemorative, having been placed here long after the burials. The same contingency would limit also the certainty of the *terminus post quem* asserted by de Lasteyrie. I think it is highly improbable. Nothing in any of these inscriptions indicates a commemorative purpose subsequent to the original burial. The inscriptions of about 1129 give no year, whereas those of 1142 (Figs. 2, 3) refer to the full date of burial. All of them are cut in the original masonry of the wall, and could not have been incorporated from an earlier building. The inscriptions recording the earlier deaths are the more ancient in palaeographic style and are related more closely to the well-known inscription of 1116 (Fig. 7) which records the beginning of the construction of the church.

If we compare the inscriptions of 1142 with those of the men who died before 1129 we find a clear difference in epigraphic and aesthetic style. No two inscriptions are by the same hand, but those of 1142 have a common character distinct from the common character of the three inscriptions recording the earlier burials. In the later pair, the funerary formula reads HIC SEPULTUS EST, followed by the name, the year of burial, and the words ORATE PRO EO; whereas in the earlier three we find the more primitive HIC IACET, the name, and, in two cases, the phrase QUI OBIIT. The date is limited to the day and the month, without the year.

This difference in epigraphic content corresponds to a difference in the form of the inscription as a whole. The later inscriptions are enclosed by molded frames, set well within the single block of stone. The earlier are unframed, except by the jointing of the stone. The later works omit the guiding horizontal lines incised between the lines of the earlier inscriptions.

In these respects the epitaphs of about 1129 agree with the inscription of 1116 recording the beginning of the church. The inscriptions of 1142, on the other hand, agree with dated epitaphs of the second half of the twelfth century in the cloister of St. Trophîme in Arles.[14] Besides the formula ORATE PRO EO, these later epitaphs of Arles include the year of

Fig. 1. London, British Museum:
Genesis; Harley 4772, f. 5.
*Reproduced by permission of the
British Library Board*

Fig. 2. St.-Gilles; Inscription: Epitaph
of Causitus, 1142

Fig. 3. St.-Gilles; Inscription: Epitaph
of Gilius, 1142

4

Fig. 4. St.-Gilles; Inscription: Epitaph of Frotardus, before 1129

Fig. 5. St.-Gilles; Inscription: Epitaph of Petrus de Brozet, before 1129

Fig. 6. St.-Gilles; Inscription: Epitaph of Hubilotus, before 1129

Fig. 7. St.-Gilles; Inscription: 1116

5

6

7

death, which is rarely given in funerary inscriptions of southern France prior to the second third of the century.[15] For Christian commemorative purposes only the day and the month are necessary. The mention of the year is a non-religious intrusion, expressing a secular conception of time and the historic significance of individual lives.

That this change should occur in Provence during the second third of the twelfth century is in accord with the protorenaissance in art and the secular movement of Provençal culture at this time. It is also the period of the formation of Gothic art.

The following observations are offered to corroborate the chronological order of the inscriptions of 1116, 1129, and 1142. In the inscription of 1116 (Fig. 7), the letters are tangent to the ruled lines; in 1129, they are between these lines, but no longer tangent to them; and in 1142, they are unbounded, except by an embracing frame. This formal development, which merits the attention of historians of art, is accompanied by a change in the relation of the shapes of the letters to the ideal lattice or grill structure of the epigraphic field. In 1116, the measured horizontal framework extends considerably beyond the letters, and the letters, though formed regularly and simply, are varied in spacing and show a great range in proportions, some being extremely narrow and elongated, others, very broad. This irregularity corresponds to the frequent occurrence of joined letters (AE, TH, TE, HE, NI) in the same inscription, and to the varied, rather than uniform, level of the middle horizontal strokes and junctions (A, E, R, etc.). Hence, despite the classical tendencies in the rounded and clear forms of the individual letters, the whole is "accidental" in spacing, unclear and unpredictable, rhythmically intricate without the expected conformity to a regular underlying structure and a canonical proportioning.

In the inscriptions of about 1129, the ruled lines are again horizontal, but they are limited by the extent of the inscription and therefore suggest a latent vertical border or enclosure. In the inscription of Frotardus (Fig. 4) the ends of the ruled lines are accented by vertical serifs. The letters maintain the irregular, individualized proportioning of the earlier inscription, but with a more energetic variation and fantasy, like successive capitals in a Romanesque colonnade. Several letters are of substandard height. Note also the expanded O in OBIIT. More interesting in the inscriptions of about 1129 is the introduction, besides the persisting joined letters, of linked forms which cross each other or are enclosed one by the other (TA, QI, TR, DE). Such forms negate the normal serial order and direction of an inscription and are fundamentally opposed to classic design. (A comparison of the B in the OBIIT of the epitaph of Frotardus with the B in OCTAB of the inscription of 1116 will reveal this change within a single letter.)

In 1142 the letters form a more compact and regular mass, with the least variation. They are enclosed by a rectangular frame, maintain a fairly uniform spacing and proportion, and show few traces of linear fantasy or linking of letters. Of all the inscriptions they are the nearest to a classic norm.

This development corresponds also to a change in the larger epigraphic proportions. The inscriptions of 1116 and about 1129 are spread across three (or two) lines, the inscriptions of 1142, across four. The earliest inscription is the most extended in a horizontal sense, the latest ones are the most developed in the sense of a page of a mediaeval and modern book, a more restricted visual field. It is further significant that in the epitaphs of 1129 the names of Hubilotus and Frotardus are both broken up and spread over two lines of script, in contrast to the completeness of the names as epigraphic entities in the relatively narrower epitaphs of 1142. In the latter the addition of the line ORATE PRO EO is perhaps significant formally, as a closed, symmetrical formula (O O).

A statistic of the individual forms of the letters is an unsafe guide to the chronology of inscriptions belonging to a fairly short period of time (1116 to 1142), unless we possess a very large number of dated inscriptions and are attentive to many aspects and elements. The simple enumeration of square and rounded letters (as practiced by Deschamps),[16] if evaluated in terms of the larger development of Romanesque palaeography, would be misleading or inconclusive. If we consider the inscriptions of 1116, about 1129, and 1142 as three groups and tabulate the frequency of square and rounded forms of C, E, and T, we shall find that in the inscriptions of

 1116, there are 3 rounded and 11 angular forms,
 c. 1129, there are 4 rounded and 20 angular forms,
 1142, there are 2 rounded and 18 angular forms.

The evident decrease in the ratio of rounded to square letters in the later inscriptions would appear to contradict the common idea of a development from square to uncial forms during the course of the twelfth century. But in the single inscription of Frotardus (c. 1129) there are three uncial and six square forms of E, C, and T, not to mention the pronounced uncial tendencies in the shapes of other letters. That this inscription nonetheless belongs with the epitaph of Hubilotus may be inferred not only from the content and larger aspects of the form, discussed above, but also from the presence of uncial h and d, of minuscule b, and of the combination of square C and uncial E in IAℂЄT in the inscription of Hubilotus.

It is evident that during the period between 1116 and 1142 uncial or, in general, rounded ornate forms became more common in St.-Gilles and

were followed by regular classical types. The unusual shapes in the inscription of Frotardus seem to have been taken from manuscript writing. But the taste for these calligraphic majuscule elements is relevant to this investigation, for such forms are characteristic of the manuscripts of the 1120s and 1130s. A corresponding stage appears in an epitaph of 1126 in Vienne.[17] The more marked curvature of the lines corresponds further to the character of the earliest sculptures of St.-Gilles, the little figures of Cain and Abel and the hunting scenes on the podia of the central door, and the large St. Thomas. A more attentive study of all the inscriptions, not so much for a finer statistical analysis, but with an eye to the aesthetic qualities, would show that in the inscriptions of 1142 the square or angular letters have a slightly greater tendency toward plastic, articulated shapes. Witness the curvature of the X's and the barbed endings of C, H, E, etc. The serif terminations of the E are not only tectonic accents in the classical manner, but produce a confluence of vertical and horizontal strokes unknown or less developed in the inscriptions of 1116 and c. 1129. Noteworthy also is the change in punctuation and abbreviation from the simple dot and circle to the triangular notch and pointed ovoidal O. (This is comparable to changes in the architecture of the corresponding period.)

These observations show that the larger grouping of the inscriptions according to epigraphic content, frames, and mode of composition is not arbitrary but corresponds to genuine stylistic differences which can be illustrated by formal minutiae. The attribution of the undated inscriptions to the period immediately before 1129, an attribution based on the necrology of the abbey, is therefore supported by the palaeographic evidence.

I know that one can raise the objections already presented by Labande[18] in criticizing the conclusions of de Lasteyrie—namely, that the crypt wall is not homogeneous and that the epitaphs cut on the lower and older part of the crypt wall belong to a period before an upper church was even planned. Labande would suppose that what is now the crypt was once intended as the church itself, and that the upper church with its sculptured facade might accordingly have been begun long after 1142; further, if an upper church had been planned from the beginning, the space before the crypt would not have been used as a cemetery. The staircase to the portal, according to Labande, was a later addition, which concealed the tombs and the inscriptions. Therefore, the inscriptions would indicate that in 1142 (or 1129) an upper church had not yet been planned.

There are several objections to be made to this argument. In the first place, is it credible that a church of the scale of St.-Gilles, belonging to one of the most powerful abbeys in France, was planned merely as a

crypt? For the form of the present crypt, with its irregular eastern bays, its plain, prismatic piers[19] and unmolded narrow western doorways, alone indicates that it was only the substructure of an immense project for an upper church, like the later basilica of St. Francis in Assisi. In the second place, the few burials in front of the western wall of the crypt do not necessarily imply a cemetery before the church, unconcealed by a staircase. On the contrary, such burials, underneath a western staircase, satisfy in an ingenious way the desire to bury notable individuals within holy ground, yet outside the church itself. For this is the one spot which unites these two seemingly irreconcilable conditions. It is outside the western wall of the crypt, yet within the church enclosure. The irregular placing of the five epitaphs on the crypt wall indicates further that this unornamented wall was not intended as an exposed monumental facade.

Finally, and most important, Labande seems to overlook the fact that the primitive part of the wall, on which the obits are inscribed, includes the central projection that supports the similarly projecting podia of the portal above.[20] This projection of the crypt wall could have been built only in anticipation of the upper portal; it is not demanded by the vaults and abutment of the crypt. The planning or design of the upper portal must therefore antedate the obits of the men who were buried here toward 1129. And the hypothesis of Labande that the crypt wall was intended as an exposed facade falls to the ground.

But how long before 1129 was this wall constructed? And how long after the completion of the wall was the anticipated portal begun?

In the absence of further documents it is impossible to refer these events to fixed points. We are certain only that the crypt wall was built after 1116, the date of the beginning of the church.[21] But a difficulty arises here because of the unhomogeneous character of the crypt wall. The construction appears to have been interrupted at a level of about 2.30 m. According to Labande,[22] this interruption lasted many years, and it was not until after 1142 that work was resumed. He infers from the fact that the inscriptions of 1142 are on the lower and earlier part of the wall that the upper part is necessarily later than 1142, on the assumption that in a building the higher the part, the later its date. But this assumption hardly applies here. One could very well inscribe an epitaph on the lower part of a wall years after the wall had been completed. The position of an epitaph on a wall is not ordinarily dependent on the height of the wall. It is unlikely that the epitaphs were placed at levels of four and six feet merely because the (supposedly) uncompleted wall was only seven feet high. Even if the wall had been higher, the epitaphs would probably have been inscribed, like most epitaphs, at just these levels, if only for the sake of legibility.[23]

There is a text of the period which suggests that already before 1124, if

8

9

10

11

Fig. 8. London, British Museum: Obit of Frotardus; Add. Ms. 16979, f. 13v. *Reproduced by permission of the British Library Board*

Fig. 9. London, British Museum: Obit of Hubilotus; Add. Ms. 16979, f. 16v. *Reproduced by permission of the British Library Board*

Fig. 10. London, British Museum: Obit of Petrus Brozet; Add. Ms. 16979, f. 1v. *Reproduced by permission of the British Library Board*

Fig. 11. London, British Museum: Obit of Petrus de Broseto; Add. Ms. 16979, f. 3v. *Reproduced by permission of the British Library Board*

Fig. 12. London, British Museum: Colophon Page; Add. Ms. 16979, f. 62r. *Reproduced by permission of the British Library Board*

12

13

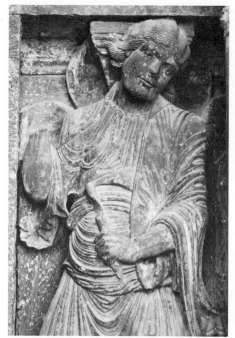

14

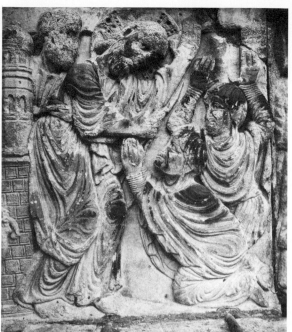

15

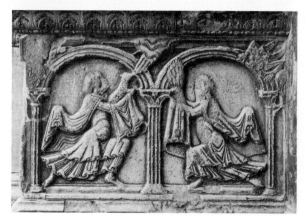

Fig. 13. St.-Gilles; Detail of Portal:
St. Michael

Fig. 14. St.-Gilles; Detail of Frieze:
Christ Addressing Mary and Martha

Fig. 15. St.-Gilles; Sculpture, Podium
of Central Doorway: Offerings of
Cain and Abel

not 1121, the walls had risen well above the level of seven feet fixed by Labande. The author of the *Miracula Sancti Aegidii*, a monk of St.-Gilles, reporting the miraculous protection of the faithful during the demolition of the old church and the erection of the new, says:

"non post multum tempus [after 1116] cum jam paries ecclesiae novae aliquantum in sublime provectus esset. . . .[24] (not long after [i.e., 1116], when the wall of the new church had been carried quite high. . . .)

Since the salience of the central portion of the crypt wall already appears in the first stage of construction, there can be no doubt that the portal was intended from the very beginning. If so, then the burials of about 1129 imply the completion of the crypt wall by that date. For if burial before the crypt was hardly possible unless the space in question were covered or enclosed, then an evidence of burial by 1129 implies the existence of the stairs and hence the completion of the western retaining wall of the crypt before that time.

Several writers[25] have pointed to disorders in the monastery of St.-Gilles which precluded any work in the period between 1117 and 1125. Some have gone further and declared that work was improbable before the middle of the century.[26]

These disorders really indicate very little concerning the construction of the church. They occur elsewhere at this time during building campaigns, and may even be cited as a sign of building activity. For when abbeys collected funds for building operations, they were sometimes subject to depredations and had to fight for the possession of their valuable properties.[27] This was the case in St.-Gilles. The papal bulls issued during the disorders were designed to protect the funds and property of the abbey as well as the independence of the church.[28] The violations of sanctuary mentioned in the bulls were aimed at the cashboxes and at the offerings brought to the altars.[29] Even the monks and the abbot were guilty of such thefts.[30] But the main source of disturbance was the conflict between the feudal lords of the region and the abbey and burghers of St.-Gilles.

Actually, there is no mention of continuous violence, but only of sporadic raids. Like nomads attacking a settled people, the predacious counts seized the monastic treasure and the offerings on the altars, and returned after a period when treasure and offerings had accumulated again. If Bertrand, Count of Béziers, seized the abbot Hugo in 1117, the abbot was free in 1118 and sufficiently prosperous to entertain the pope in great state in the same year.[31] And even during the worst period (1119 to April 1122) the church continued to receive donations and papal protection.[32] The last reference to disorders is dated April 22, 1122.[33] I

do not think that we can infer from such disorders that the *chantier* was entirely inactive. Since the nobility of the region invaded St.-Gilles to seize church moneys from the altars, we may suppose, on the contrary, that donations *ad opus ecclesiae* were continuous and that some construction was in progress. It is precisely at this time, toward 1121, that Petrus Guillelmus, a monk of St.-Gilles, composed the *Miracula Sancti Aegidii* which records only recent or contemporary miracles and pilgrimages and rich offerings to St.-Gilles.[34] A passage in one miracle suggesting that work continued above the level of the crypt in the early twenties has already been cited. At the most, work might have been interrupted for periods of several months during the years 1118 to 1122.

Hence we believe that work on the facade was possible in the twenties and that the burials before 1129 belong to a time when the staircase was completed and the sculpture of the facade had been begun.

We do not have to depend only on deductions from epigraphical documents to reach this conclusion. The study of the sculptures themselves and comparison with other dated works will confirm this view.[35] By stylistic criteria the oldest figures of the facade, like the St. Thomas, were possible in this region as early as 1129. If the tympana of Vézelay and Autun are of the first third of the twelfth century,[36] and the tympanum of Moissac no later than 1115,[37] then the facade of St.-Gilles may well have been begun in the 1120s. This problem would be considerably simplified if we had Provençal sculptures of the first two decades of the twelfth century. We do not possess the materials for studying the local development of sculpture; but in the scattered remains of the manuscripts produced in Provence in the beginning of the twelfth century we can observe tendencies in mode of drawing and also various elements of representation that recur in the sculptures of St.-Gilles. These manuscripts are few in number, and their miniatures, like the sculptures of St.-Gilles, are hardly uniform in style. But a casual comparison of the four figured pages reproduced in this article (Figs. 1, 16, 20, 21) with the sculptures of the facade will, I think, convince the reader that sculptures and miniatures belong to the same general period.

Figure 20 is from a manuscript produced in the abbey of La Grasse, near St.-Gilles, between 1086 and 1108.[38] Figures 1 and 16 are from a Bible in the British Museum (Harley 4772) which was once in Montpellier.[39] This Bible is slightly less developed in script and ornament than the manuscript of the Necrology and Rule of St. Benedict executed in St.-Gilles in 1129 (Fig. 21).[40] We can safely attribute it to the late 1120s.

The early manuscript from La Grasse has been included in order to show that already before 1108 there existed in the region of St.-Gilles many of the presuppositions of the sculptural forms of the facade. We see

16

POSTQVAM MORTVVS EST SAVL.

18

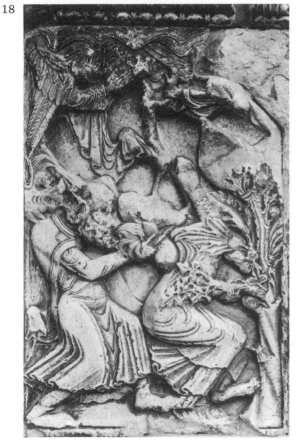

17

Fig. 16. London, British Museum:
II Kings; Harley 4772, f. 140v.
*Reproduced by permission of the
British Library Board*

Fig. 17. St.-Gilles, Detail of Portal:
Apostle Thomas

Fig. 18. St.-Gilles, Podium of Central
Doorway: Murder of Abel

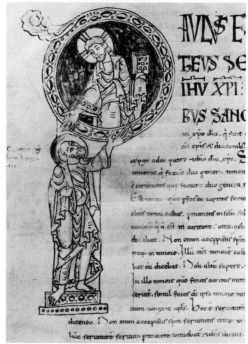

Fig. 19. St.-Gilles, Detail of Frieze:
Payment of Judas

Fig. 20. Nîmes, Bibliothèque
Municipale: Ms. 36

Fig. 21. London, British Museum:
Add. Ms. 16979, f. 21v.
Reproduced by permission of the
British Library Board

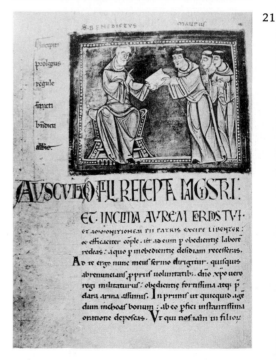

in this manuscript the characteristic presentation of isolated figures standing before pilasters as in the niches of St.-Gilles, the elaboration of an abstract, spatially suggestive environmental framework, and the minute subdivision of draperies, which swathe the body, into numerous angular and radially clustered lines.

In the Bible from Montpellier the abstract environment is further developed and subtly complicated, the figures are set within spatial frames and are themselves shaded and modeled. The draperies have become more fluent, more substantial and natural in the pleating of folds and movement of contours. In the third manuscript (Fig. 21) the draperies are simplified. They adhere more closely to the body. But the body has acquired a new voluminousness and is set more prominently in space, which is suggested by the structure of the frame and the overlapping of solid bodies. The draperies exhibit a corresponding development of substance and modeling, although constructed schematically.

The miniatures of the Bible offer analogies not only to the earliest sculptures of the facade, but to the slightly later friezes as well. The Christ addressing Martha and Mary in the Raising of Lazarus (Fig. 14) resembles the figures of the Lord in the second and third medallions of the initial I (Fig. 1), and the upper part of the Christ in the Denial of Peter is related to the Lord in the first medallion. The draperies of the latter should also be compared with the St. Michael of the south door (Fig. 13). The peculiar chevron folds of Michael's arm and shoulder recur on the drapery of the Lord between the second and third medallions.

A second initial in the same Bible, by another—undoubtedly contemporary—artist, provides further material for comparison (Fig. 16). The king, with his forked beard, wavy torso folds, and unstable posture, is, I think, a product of the same regional school and the same period as the St. Thomas of the facade (Fig. 17), which, of all the apostles there, is nearest to the stage of the manuscript from Grasse. The king recalls also the unclassical posture of one of the flagellants of Christ on the frieze of St.-Gilles. The animated drawing of this initial has an even closer resemblance to the carvings of the podium of the central portal, especially the sculptures of Cain and Abel (Figs. 15, 18) and the hunting scenes. The peculiar involvement of the frames, the excited peripheral beasts and figures, the violence and energy of highly flexible, impulsive beings, all these aspects of the sculpture reappear in the initial, embodied in similar schematized forms.

Instructive for the tendencies of the later sculpture of St.-Gilles is the comparison of the miniature of 1129 (Fig. 21) with the relief of the Payment of Judas (Fig. 19), which belongs to the 1130s or 1140s. The latter is more advanced plastically and spatially; but the simplification of the

more plastic and more naturalistic masses, the richness of spatial rela-
tions, the overlappings, penetrations, and movements in depth, already
appear in the miniature in however schematic a form.

The reader will discover further parallels if he will compare these mini-
atures with photographs of other details of the facade of St-Gilles.

I do not mean to conclude that the sculptures and the miniatures coin-
cide exactly in date. I wish only to indicate here that the tendency toward
the formal types of the sculptures of the facade is already evident in Pro-
vence at the end of the eleventh or beginning of the twelfth century, and
that closely related forms were produced in the manuscripts of the region
during the 1120s. Hence the probability that the sculptures are in great
part of the 1120s and 1130s is very much strengthened.

The consequences of these documents for the interpretation of the
Romanesque art of Provence cannot be drawn without a detailed study of
the sculptures themselves. They impose on us, however, the necessity of
reconsidering the Provençal works which seemed to have been classified
forever by the researches of de Lasteyrie. We can no longer assert with
Aubert that "de Lasteyrie . . . has established with complete proof, basing
his views on style of drapery, armor, iconography, and above all, inscrip-
tions and documents, that the masterpieces of Provence cannot be dated
before the middle and second half of the twelfth century."[41] Aubert did
not undertake to quote the arguments, most of which seemed to him
incontrovertible, but he expressed the fear that "those who wished to date
the sculpture of Provence too far back made too free a use of the
volumes we possess upon the churches of that region."

Among these was Arthur Kingsley Porter, who, without knowledge of
the earlier inscriptions, had concluded from analysis of the figures and
from comparison with various dated monuments that the sculptures of
St.-Gilles were created in great part between about 1135 and 1142.[42] He
had deduced also an early dating for the ribbed vaults of the crypt. It is
impossible to accept the whole of his argument—especially his inversion
of the relations of the friezes of Beaucaire and St.-Gilles,[43] and his theory
of an Angoulême Master in Provence—but I believe that he was correct
in his insight that the sculptures of St.-Gilles antedate those of the west
facade of Chartres. The first styles of St. Gilles were probably created as
early as 1129.

NOTES

1. I publish this study in memory of Arthur Kingsley Porter.

2. For example, Richard Hamann (*Geschichte der Kunst,* Berlin, 1933, p. 904, and
Burlington Magazine, LXIV, 1934, pp. 26–29) dates the beginning of the facade before
1100 or around 1096, whereas Robert de Lasteyrie (*Études sur la sculpture française au
moyen âge,* in *Monuments Piot,* VIII, 1902, pp. 96–115) places it after 1142, or about

1150, and dates the completion of the sculptures at the very end of the century. A more recent French opinion (Augustine Fliche, *Aigues-Mortes et Saint-Gilles*, Paris, 1925, pp. 75 ff.) would advance the date of the sculptures to the first half of the thirteenth century.

3. André Michel even considered the sculptures of St.-Gilles and Arles dependent on more northern art. "Far from having been the initiating models of the statues of the portals of the North, they (the apostles of St.-Gilles) were, on the contrary, only an imitation of the latter adapted to the exigencies of the architecture in which they were set." (*Histoire de l'art*, I, 2, 1905, p. 666.)

4. Cf. especially the excellent book of Wilhelm Vöge, *Die Anfänge des monumentalen Stiles im Mittelalter*, Strassburg, 1894.

5. See the references in note 2 and also his *Deutsche und französische Kunst im Mittelalter I. Südfranzösische Protorenaissance und ihre Ausbreitung in Deutschland.* Marburg, 1922. Hamann will publish shortly a three-volume work on St.-Gilles. We await also the publication of a doctor's thesis on St.-Gilles by Walter Horn. [See now Richard Hamann, *Die Abteikirche von St.-Gilles und ihre künstlerische Nachfolge,* Akademie-Verlag, Berlin, 1955, 3 vols., and Walter Horn, *Die Fassade von St.-Gilles, Eine Untersuchung zur Frage des Antikeneinflusses in der südfranzösischen Kunst des 12. Jahrhunderts* (Diss. Hamburg, 1933), Hamburg, 1937.]

6. Reproduced by A. K. Porter, *Romanesque Sculpture of the Pilgrimage Roads* Boston, 1923, ill. 1330, and by Hamann in the work just cited, fig. 46.

7. On the question of Provençal ribbed vaults, see Robert de Lasteyrie, *L'architecture religieuse en France à l'époque gothique*, I, 1926, pp. 26–27, and Porter, *op. cit.*, I, p. 293; and more recently, Marcel Aubert in the *Bulletin Monumental*, 1934, p. 16. Aubert writes: "Celles [the diagonal ribs] de l'église basse de Saint-Gilles, d'une construction très savante, ne datent, comme les voûtes d'arêtes qui les avoisinet, que du troisième quart du XII᷉ siècle; celles des travées occidentales ne remontent qu'à la fin de ce-siècle."

8. *Etudes*, p. 96. This dating had already been deduced from general stylistic criteria by Quicherat (*Mélanges d'archéologie et d'histoire. Archéologie du moyen âge*, Paris, 1886, pp. 176 ff.), Dehio (*Jahrbuch der preussischen Kunstsammlungen*, VII, 1886, pp. 129 ff.; *Die kirchliche Baukunst des Abendlandes*, I, 1892, p. 629), and Vöge (*op. cit.,* 1894, p. 130).

9. De Lasteyrie, *Études,* p. 96, and fig. 24.

10. Especially after the observations of Labande (*Congrès Archéologique de France LXXVI᷉ session tenue à Avignon en 1909*, Paris, 1910, pp. 168 ff.) See below, p. 333 ff.

11. They have been published before by Revoil (*Architecture romane du Midi de la France*, Paris, 1874, II, p. 52) and reproduced by the Abbé Nicolas in the article of Delmas, *Notes sur les travaux de restauration et de conservation de l'église de Saint-Gilles* (1843), first published in 1902 (*Mémoires de l'académie de Nimes, VII᷉ série,* XXV, 1902, p. 108), with minor inaccuracies. I am able to reproduce photographs of these inscriptions (Figs. 2–6) as well as of other details of St.-Gilles (Figs. 13–15, 17–19) through the kindness of Prof. Richard Hamann.

12. Folio 62 r.—"ad honore(m) s(ancti) Egidii Petrus Guil(e)lmus fecit h(un)c lib-bru(m) i(n) te(m) pore domni Petri abb(at)is anno i(n)carnati verbi MCXXVIIII regna(n)te Lodoico rege." This colophon has been reproduced by Deschamps in *Bulletin Monumental*, 1929, pl. XVII, fig. 32. That the necrology and the Rule were originally conceived as a single manuscript is evident not only in the similarity of script, but also in the fact that the opening pages of the Rule belong to the same gathering as the last pages of the necrology.

13. Mr. Francis Wormald of the Department of Manuscripts of the British Museum has kindly verified these entries for me. He has noted the originality of these entries, but thinks that the second Petrus (*de Broseto*) is an addition, though contemporary.

14. Like that of Pons Rebolli, 1183 (De Lasteyrie, *Études,* p. 61, fig. 16).

15. This is evident from a study of de Castellane's corpus of Latin inscriptions of southern France, published in the *Mémoires de la Société Archéologique du Midi de la France*, II, 1834–35 (Toulouse, 1836), III, 1836–37, IV, 1840–41. Cf. especially IV, pp. 280, 283; III, pp. 81, 102. The corpus is full of inaccuracies. The readings and reproduc-

tions must be used with the utmost caution and constantly controlled with the aid of photographs of the original inscriptions.

16. *Bulletin Monumental,* 1929.

17. *Ibid.,* fig. 33.

18. *Loc. cit.,* pp. 168 ff. See note 10 above.

19. Fliche (*op. cit.,* p. 76) says that in 1116 no crypt was planned, only a church—"une église qui vraisemblablement, étant donné la forme des piliers, ne devait pas comprendre de crypte." But the prismatic form appears in the crypt of Montmajour nearby. Although such piers are frequent in churches of the eleventh century, they are practically unknown in naves of large, three-aisled Benedictine churches of developed Romanesque style begun as late as 1116. In St.-Gilles several of the piers of the crypt are without bases. The incorporation of the walls of the still earlier crypt, with its tomb of St.-Gilles in the substructure of 1116, and the consequent two-aisled, irregular form of the eastern bays of the crypt also speak against the theory of Labande and Fliche.

20. The inscription of Gilius is cut in this projecting wall.

21. An altar was consecrated in St.-Gilles in 1096, but this altar evidently belonged to the preceding church and was dedicated in that year, like the altars of so many other churches, because of the opportune visit of a pope. Although the bull of Pope Urban, referring to this event of 1096, speaks of a new basilica ("post hec divine voluntatis dispositione actum est, ut apud beati Egydii monasterium basilice nove aram omnipotenti Deo nostris manibus dicaremus," Paris, Bibl. nat. ms. latin 11018, f. 21 r; *Histoire de Languedoc,* new ed. V, col. 744; Goiffon, *Bullaire de St. Gilles,* Nîmes, 1882, pp. 35–36), we have no reason to assume, as Hamann does (*Burlington Magazine,* LXIV, 1934, pp. 26–29), and as did the Abbé Nicolas before him (cf. de Lasteyrie, *Études,* p. 84), that this church was still in process of construction in 1116, and that its supposedly uncompleted parts—the crypt and the lower part of the facade—were preserved and incorporated in the newer church begun in 1116. We must, of course, await the publication of Hamann's large monograph for the detailed evidence of his theory. Since there were at least three churches in the monastery prior to 1116, according to the contemporary description of the building of the church of 1116 (*Miracula Sancti Aegidii,* in *Mon. Germ. Hist.* Sc., XII, 1856, p. 289, n. 15, and in Mabillon, *Annales Ordinis Sancti Benedicti,* Paris, 1713, V, p. 623), it is hardly certain that the altar of 1096 was even on the site of the church begun in 1116. An eyewitness of the new construction tells us that the preceding church was demolished and that *foundations* of the new building were laid in 1116: "Dum enim anno incarnationis dominicae MCXVI fundamenta basilicae novae poneremus, quia ecclesia alia minus continens erat et multitudinem adventantium capere non poterat, subversioni ecclesiarum operam dedimus. Cum autem ecclesiam maiorem, quae cum tribus cryptis, maximis et quadratis lapidibus antiquitus exaedificata fuerat, destrueremus, nec non et ecclesiam sancti Petri, quae octoginta fratres in choro capere poterat, simul cum porticu lapidea, quae ei adhaerebat, a parte septemtrionis et a capite superioris ecclesiae usque ad extremitatem ecclesiae sancti Petri in longum protendebatur, in qua fratres ad processionem diebus sollemnibus egredi soliti erant et antiquitus Via Sacra vocabatur, nec non et ecclesiam sanctae Mariae destrueremus" (*loc. cit.*). The ingenious hypothesis of Professor Hamann would permit him to date some of the sculptures of the facade as early as 1096 and enable him to derive the Lombard sculptures of the first decades of the twelfth century from St.-Gilles. The latter hypothesis can be rejected on stylistic grounds alone. Cf. on this point the dissertation of a pupil of Hamann, Dr. Trude Krautheimer-Hess, *Die figurale Plastik der Ostlombardei von 1100 bis 1178 (Marburger Jahrbuch für Kunstwissenschaft,* IV, 1928). "The dependence of Modena on Saint Gilles," she writes, "cannot be established."

22. *Loc. cit.,* pp. 173–174.

23. Cf.the epitaphs of the north gallery of the cloister of St.-Trophime in Arles, which are all later than the wall above them.

24. *Analecta Bollandiana,* IX, 1890, p. 405 (19th miracle); *Mon. Germ. Hist.* Sc., XII, 1856, p. 289, n. 15; *Annales,* 1713, V, p. 623. For the date of the book see note 34 below.

25. Notably de Lasteyrie (*Études,* pp. 92 ff.) and Labande (*loc. cit.*).

26. Cf. Beenken (*Repertorium für Kunstwissenschaft,* 1928, p. 201), Fliche (*op. cit.*),

Frankl (*Die frühmittelalterliche und romanische Baukunst,* Wildpark-Potsdam, 1926, pp. 257–258), etc.

27. The abbey of Vézelay, for example, was the scene of uprisings, conflicts, and pillage during the short period in which the Romanesque church was constructed. Cf. Oursel, *L'art roman de Bourgogne,* 1928, pp. 114–116.

28. Goiffon, *Bullaire de Saint-Gilles,* Nîmes, 1882, pp. 58–68.

29. *Ibid.* Such violations were common in St.-Gilles in the period preceding the beginning of the construction of 1116 and even at the moment before the dedication of the altar of 1096. A bull of Pope Urban II in 1095 states that Count Raymond abandons his claims to the offerings on the altars of St.-Gilles and returns them to the church: "partem imo rapinam quam ex parentum suorum invasione in altari sancti Egidii et reliquis ipsius ecclesiae altaribus habere solitus erat" (Goiffon, *op. cit.,* p. 30; cf. also pp. 38–45 and 53).

30. A papal bull of 1119 (Calixtus II) decrees "ut nullus abbas vel monachus tesaurum vel honores ecclesiae qui aut modo habentur, aut in futurum largiente Domino, adquirentur, distrahere vel inpignorare audiat," unless for ransom, famine, or fiefs (Goiffon, *op. cit.,* pp. 53–54). On the part of the neighboring bishops in despoiling St.-Gilles, see L. Ménard, *Histoire civile, ecclésiastique et littéraire de la ville de Nismes,* I, 1750, p. 195.

31. Goiffon, *op. cit.,* pp. 51–52, bulls xxxiv, xxxv, and *Gallia Christiana,* VI, 1739, p. 486: "Hugonem abbatem huic pontifici diu ibidem cum frequenti comitatu moranti sumtus liberalissime suppeditasse et equos decem obtulisse."

32. Cf. *Gallia Christiana,* VI, p. 486, and the *Miracula Sancti Aegidii* (*Mon. Germ. Hist.* Sc., XII, 1856, pp. 320 ff.) which mentions donations by Boleslaus III, king of Poland, at this period ("Bolezlaus, dux Poloniae, cuius larga beneficia ad honorem quem erga sanctum Egidium habere videtur, saepius experti sumus"). His *pincerna* visited the tomb of St.-Gilles and made an offering toward 1121. It is interesting in this connection to record the fact that a *frater Bratizlaus* is listed among the monks of St.-Gilles in the necrology of the abbey, written in 1129 (British Museum Add.ms. 16979, f. 20v).

33. Goiffon, *op. cit.,* pp. 66–68. The next document published by Goiffon is a bull restoring St.-Gilles to the Cluniac rule (*ibid.,* p. 69, April 2, 1125).

34. The author states in the prologue that he is composing this work "ad consolationem tribulationum quas incessanter patimur" and expresses the hope that through it "et impugnantium nos saevicia, audito virtutum eius [S. Egidii] praeconio, a fervore maliciae suae aliquatenus compuncta resipiscat" (*Mon. Germ. Hist.* Sc., XII, 1856, p. 316). Pertz, the editor of this text, correctly infers that the *Miracula* were composed before 1124 and after 1121 from the fact that they are addressed to the abbot Hugo who died in 1124, and include an allusion to an event of 1121 (*ibid.,* p. 288). The Bollandists (*Analecta Bollandiana,* IX, 1890, p. 399–404) have published another text which includes several miracles of the mid-twelfth century. But these are evidently additions to the original text and were probably composed in Germany, since they pertain to Germans alone and are preceded by a preface which speaks of the exceptional devotion of Germans to St. Gilles. The earlier nucleus contains no indication of an event after 1121, but several which can be dated around 1113, 1117, 1120, 1121, by historical evidences. The author states, besides, that he is describing only miracles of his own time, witnessed by himself or trustworthy people, omitting the doubtful or unauthenticated ("recolens ea solummodo, quae nostris temporibus per eum [S. Egidium] Dominus operatur"). It is significant, further, that in the manuscript containing the additional German miracles the scribe has omitted a passage from the first of the original set of miracles, stating that it took place before the time of the writer and that "cetera, quae sequuntur, nostra aetate provenerant." (*Analecta,* IX, p. 392, n. 8.)

35. The inscriptions on the sculptures are undated and have not yielded any precise evidence concerning the periods of the individual carvings. They are by other hands than the inscriptions of the crypt wall, but seem to belong to the same general period— the second quarter of the twelfth century.

36. This dating is accepted by Porter, Oursel, Hamann, Terret, Aubert, etc. The growing acceptance of the Cluny ambulatory capitals as works of 1089–1095, or at least prior

to 1113, also strengthens the attribution of the earlier sculptures of St.-Gilles to the 1120s.

37. According to Aymeric de Peyrac, the mediaeval chronicler of Moissac, who attributed the portal of Moissac to the abbot Ansquitilius (1085–1115). See Rupin, *L'Abbaye et les Cloîtres de Moissac,* Paris, 1897, p. 66 note 2. This dating has been questioned by many writers, but I have presented new corroborating evidence in my Columbia University doctoral dissertation on Moissac (May, 1929). The foliate capitals of the narthex of Moissac, which are slightly later than the tympanum (cf. the Samson, reproduced by Porter, *Romanesque Sculpture of the Pilgrimage Roads,* 1923, ill. 338, with the figures of the tympanum and porch), were copied in the cathedral of Cahors on the north pier between the choir and the nave. This portion of the cathedral was consecrated in 1119.

38. Nîmes, Bibliothèque municipale, ms. 36. It is a commentary on Paul's epistles composed of excerpts from the works of St. Augustine. The manuscript is dated by the colophon on the first page—"Domnus Rodbertus, Crassensis coenobii abbas, [in] sancti Pauli apostoli aepistolas opusculum beati Aurelii Augustini. . . . notasse narratur." Rodbertus was abbot of the monastery of La Grasse from 1086 to 1108. The guard leaf includes a copy of a charter of Bernard Guillem, count of Cerdagne, giving St.-Martin-du-Canigou to the abbey of La Grasse in 1114. For a description of the manuscript see *Catalogue général des manuscrits des bibliothèques publiques des départements,* VII, Paris, 1855, pp. 545–547.

39. A later inscription on fol. i reads, "ad usum fratrum capucinorum conventus Monspeliensis catologo inscriptus sub littera B [and another on the same page records that in January 1621 it belonged to the chancellor of the medical school of Montpellier]." The Provençal origin of the manuscript is confirmed by the script and the ornament. [I am less certain now of the place of origin of this Bible manuscript. Certain features suggest that it was done in the Rhone region closer to Savoie and perhaps Grenoble.]

40. British Museum, Add. ms. 16979. The manuscript of 1129 exhibits more fracture and ligature than the Bible, but the scripts are practically contemporary. In the latter, f still descends and sometimes terminates above in a hooked curve, two details already abandoned in ms. 16979, in which, on the other hand, we observe the unions oc, pp and rr—advanced details beyond the stage of Harley 4772.

41. Marcel Aubert, *French Sculpture of the Beginning of the Gothic Period 1140–1225,* Pantheon, New York, 1930, p. 56.

42. *Romanesque Sculpture of the Pilgrimage Roads,* Boston, 1923, I, p. 297.

43. Like de Lasteyrie (*op. cit.,* pp. 122 ff.), Porter overlooked the numerous evidences in Beaucaire of the simplification, reduction, and schematization of the frieze of St.-Gilles. A comparison of the groups representing Pilate and the Flagellation in Beaucaire and St. Gilles (Porter, *op. cit.,* ill. 1296, 1322) will reveal the process and its direction. The misconception of the flagellants in Beaucaire, the arrested and undirected movements, the unstable seat of Pilate, betray the imitation of St.-Gilles on a lower aesthetic and conceptual level. It is necessary to correct the mistaken view of Beaucaire; otherwise our dating of St.-Gilles would seem to imply the attribution of Beaucaire to the very beginning of the twelfth century. We must point out, finally, that the Virgin and Christ relief in Beaucaire (Porter, *op. cit.,* ill. 1299) is probably of the second half of the twelfth century. The inscription alone would indicate this.

(1937)

II

When my article on Saint-Gilles (published in *The Art Bulletin*, XVII, 1935, pp. 414 ff.) was already in press I learned that Marcel Gouron, the archivist of the department of the Gard, had discovered a document possibly bearing on the date of the facade. According to a brief report by Marcel Aubert in the *Bulletin de la Société Nationale des Antiquaires de France*, 1934, pp. 138–139, this document in the archives of the department of the Gard mentions a Petrus Brunus in Saint-Gilles in 1171. Later, in 1186, he was designated as an "artist in wood and stone." Aubert believes that this Petrus Brunus "might well be the sculptor of the statues of the portal of Saint-Gilles, one of which is signed 'Brunus'; this would confirm the dates of the execution of these works given by Robert de Lasteyrie and Monsieur Labande and, more recently, by Monsieur Paul Deschamps and himself."

In the absence of further and more precise information it is impossible to draw a valid conclusion concerning the identity of this Petrus Brunus and his relation to the Brunus who carved certain of the figures on the facade of Saint-Gilles. That they are the same person is simply a conjecture; and that the presence of this sculptor in Saint-Gilles in 1171 and 1186 implies a date of 1150 to 1180 for the sculptures of the facade is an inference supported by no evidence. It is conceivable that Petrus Brunus was the son of the Brunus who signed the sculpture or that the work in question was executed by Petrus Brunus thirty years before the document in question. In documents of the period such names appear in the same family in succeeding generations.

I open at random a cartulary from southern France, from the abbey of Sainte-Foy at Morlaas, and I find there a Petrus Aldebertus (Aubert!) in 1131 and 1154, and his son, Aldebertus, in 1154—"*Petrus Aldebertus et Aldebertus ejus filius.*"[1]

* * *

I take this opportunity to call the attention of students of Romanesque art to two interesting texts bearing on the cult of Saint-Gilles in the period when the church was in construction.

The poet-biographer of the bishop Adalbert of Mainz, writing in 1141 or 1142, tells how the latter, while a student of science, visited Saint-Gilles toward 1137 on his way to Montpellier nearby. I have already referred in note 34, p. 341, of my article to the special devotion of Germans to St. Gilles; but more significant here is the motive of secular studies and natural science which brought this German student to the region of Romanesque classicism.

"Set quia sanctorum pervenit fama locorum
Ad tam devotum iuvenem: non esse remotum
Egidii Sancti templum, veniale precanti,
Pervenit huc hilaris. Astansque salubribus aris,
Egidium poscit, quod fas aut utile noscit;
Munera sic dando vel fletibus ora rigando.
Exit, iter rapitur, letis successibus itur."[2]

(As the fame of the holy places reaches
The devout youth, he travels joyfully
To the nearby temple of Saint Gilles
And prays for grace. Standing before
Its wholesome altars, he begs the saint
To teach him what is right and needful.
So, offering gifts and with a tearful face,
He departs, he finds his path and happily proceeds.)

About thirty years later, in the 1160s, another student from the North, Guy de Bazoches, who had made the journey from Montpellier to Saint-Gilles, wrote an enthusiastic letter describing the beauty of the site, its fertility and joyousness, and the splendor of the church and town.[3] It is worth summarizing and quoting here as a document on the milieu in which were produced the sculptures of Saint-Gilles, so remarkable for their revived classic forms and the many signs of urban consciousness in the conception of the religious scenes.

He recounts how, while residing at the school, he was inspired by heaven "to visit the sacred abode of God's beloved confessor, Egidius [Gilles]." In his florid style he describes at length the site where the saint had founded an abbey and a church. "Now, because of the crowds frequenting the place, attracted by the saint's merits, a town had risen there, with proud walls, lofty buildings, a teeming population of extremely wealthy merchants, a town not inferior to the most famous cities. Around it are fertile fields; vineyards clothe the hillsides and quicken the townsmen's spirits, animate their talk, beget ideas and promise strength. Delightful shrubbery and beautiful gardens grace another part. Oh, how the fragrance of herbs fills the air! How the trees strain under the burden

of their fruit and lament their fecundity, how sweetly the lascivious converse of birds resounds with harmony in the trees! No less inviting are the green meadows in their lovely aspect of festive beauty. Cutting its way through these fields the proud Rhone forces a channel and, nearing the sea, reaches its end at its birthplace.

"Beside the gifts of nature which contend in blessing this site, the revered church, a memorial of the most worthy confessor, like an image of the sun among the stars, claimed for itself the throne of brightest eminence. The church, I say, noble indeed through the dignity of the buildings, but far nobler through its precious treasure of the saint's body, is more splendid still through the brilliant glow of its frequent miracles and more beautiful through the holy life of the army of monks under God's great leadership. Hence it is that a countless multitude hastens to this place with prayers and gifts. Its piety which has been proved so often in many things, its holiness—celebrated everywhere—attracts as many people from the farthest ends of the earth as from the neighboring region; religious devotion brings not only crowds of ordinary worshippers, but even the summits of secular glory who incline humbly in the saint's honor. Before his sacred altar, with knees bent, hands raised, eyes downcast, with mind and body turned to the face of the sublime heavenly court, addressing the faithful advocate of my cause, fearing no shipwreck in the flood of my tears at the port of his mercy, I composed this prayer. . . ."[4]

In the poem the reference to altars in the plural (*aris*), though possibly determined by the leonine rhyme alone, suggests that the upper church of Saint-Gilles was already in use in 1137; and the praises of Guy would also imply that in the 1160s the construction was well advanced. Though the texts are not explicit enough to require these conclusions, they may be adduced as confirmations of the larger, more pointed complex of evidence drawn from the character of the building, its decoration, and the documents cited in my first article.

NOTES

1. See Léon Cadier, *Cartulaire de Sainte Foi de Morlaas,* 1884, p. 21.

The documents concerning Petrus Brunus are cited also in articles by Marcel Gouron, *Dates des sculptures du portail de l'église de Saint-Gilles, Bulletin de la Société d'histoire et d'archéologie de Nîmes et du Gard,* no. 1, April 1934, and by Marcel Aubert, *Les dates de la facade de Saint-Gilles. A propos d'un livre récent, Bulletin Monumental,* 95, 1936, 369–373. See also by Aubert, *La Sculpture francaise au moyen-âge,* Paris, 1946, pp. 148ff.

2. See the *Bibliotheca Rerum Germanicarum,* edited by Jaffé, Berlin 1866, III, p. 592. The author, Anselm, describes also Adalbert's studies at Montpellier.

"Ergo manens didicit breviter, quod phisica dicit,
Perspiciens causas naturae, res sibi clausas;
Non ut lucra ferat vel opes hoc ordine querat,
Set quia de rerum voluit vi noscere verum." (*Ibid,* p. 593.)

3. The letter has been published in part by W. Wattenbach, *Aus den Briefen des Guido von Bazoches,* in the *Neues Archiv der Gesellschaft für ältere deutsche Geschichtskunde,* XVI, 1891, p. 78. I have made some slight changes in his text and added several passages after the original manuscript in the *Bibliothèque Nationale* of Luxemburg. On Guy de Bazoches, whose chief interests were in "*ludis et studiis,*" see Wattenbach's article, *Die Briefe des Canonicus Guido von Bazoches, Cantors zu Châlons im zwölften Jahrhundert,* in *Sitzungsberichte der königlich-preussischen Akademie der Wissenschaften zu Berlin,* 1890, pp. 161–179; and Max Manitius, *Geschichte der lateinischen Literatur des Mittelalters* III, 1931, pp. 914 ff.

4. The Latin text from this point on is omitted by Wattenbach: "Hinc est quod ad eum multitudo ruit innumerabilis cum precibus atque muneribus, cuius totiens probata pietas in multis, experta benignitas, sanctitas ubique celebris, non minus quam finitimos, fines ultimos orbis invitat, nec solum de plebe catervas devotio religiosa precipitat, sed huic etiam non dicam honeri, sed honori termicem humilem ipsa celsitudo glorie secularis inclinat. . . . Ante sacrum cuius altare flexis genibus, erectis manibus, supinis oculis, corpore simul ac mente profusus, ad sublimis curie faciem, fidelem cause mee dirigens advocatum, famulante fluvio lacrimarum ad portum misericordie sue nullum timens repulse naufragium, navigium huius orationis impegi."

Index

To facilitate use of index, note page numbers of the articles in table of contents